National Visions, National Blindness

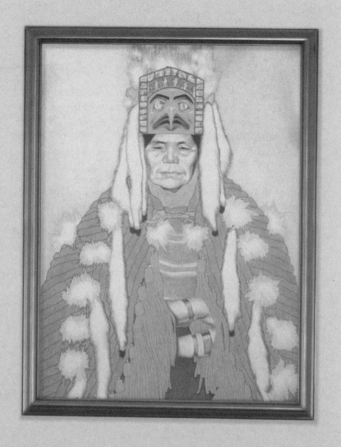

National Visions, National Blindness

Canadian Art and Identities in the 1920s

Leslie Dawn

15 14 13 12 11 10 09 08 07 06 5 4 3 2 1

Printed in Canada on ancient-forest-free paper (100% post-consumer recycled) that is processed chlorine- and acid-free, with vegetable-based inks.

Library and Archives Canada Cataloguing in Publication

Dawn, Leslie Allan, 1950-
 National visions, national blindness : Canadian art and identities in the 1920s / Leslie Dawn.

Includes bibliographical references and index.
ISBN-13: 978-0-7748-1217-7
ISBN-10: 0-7748-1217-6

1. Nationalism and art – Canada – History – 20th century. 2. Indians of North America in art. 3. Landscape in art. 4. Art, Canadian – 20th century. I. Title.

N6545.D39 2006 709.7109'042 C2006-903165-7

Canadä

UBC Press gratefully acknowledges the financial support for our publishing program of the Government of Canada through the Book Publishing Industry Development Program (BPIDP), and of the Canada Council for the Arts, and the British Columbia Arts Council.

This book has been published with the help of a grant from the Canadian Federation for the Humanities and Social Sciences, through the Aid to Scholarly Publications Programme, using funds provided by the Social Sciences and Humanities Research Council of Canada, and with the help of the K.D. Srivastava Fund.

Printed and bound in Canada by Friesens
Designer: George Kirkpatrick
Copy editor: Robert Lewis
Proofreader: Barbara Czarnecki
Indexer: Frederike Verspoor

UBC Press
The University of British Columbia
2029 West Mall
Vancouver, BC V6T 1Z2
604-822-5959 / Fax: 604-822-6083
www.ubcpress.ca

Contents

Acknowledgments

ANY UNDERTAKING SUCH as this is deeply indebted to many. It is impossible to list everyone who contributed to its realization, but at the risk of omitting some, I would like to name a few. John O'Brian, Charlotte Townsend-Gault, and Ruth Phillips, who advised me during my early work on this book, have been instrumental in the development of the ideas and histories presented herein. I would also like to thank Gerta Moray, whose close scrutiny and generous reading of initial drafts and willingness to share her own research on both Kihn and Carr saved me from many errors. Those that still exist are entirely my own responsibility.

No historical researcher could achieve anything if not for librarians, archivists, and curators as well as those who aid in gaining access to them. I am especially indebted to Cyndie Campbell at the Archives of the National Gallery of Canada (NGC), Benoît Thériault at the Canadian Museum of Civilization (CMC), Nora Hague at the McCord Museum, and Danielle Blanchette at the Montreal Museum of Fine Art. Marie Mauzé assisted me in navigating the bureaucracy of the Louvre archives and was generous with her own research. On a less institutional note, I would like to express my profound gratitude to Clifford Bragdon for his gracious hospitality and his generosity in sharing his family archives and his store of personal knowledge.

Gaining access to works as well as permission to use them is also impossible without those who give their time to assist. Frédéric Paradis and Annie Laflamme at the CMC were extraordinarily helpful in supplying me with archival images of Kihn's Skeena oeuvre. Tanya Richard at the NGC, Shiri Alon and Heather NcNabb at the McCord Museum, Danielle Currie and Bita Vorell at the Vancouver Art Gallery, Angela Raljic, Ken Lister, and Nicola Woods at the Royal Ontario Museum, Karen Kisiow

at the Winnipeg Art Gallery, Quyen Hoang at the Glenbow Museum in Calgary, Christine Braun at the Art Gallery of Hamilton, and Anna Hudson and Liana Radvak at the Art Gallery of Ontario all helped immensely in tracking down artworks and related information. I would also like to thank Brian Grison for his help as an informal research assistant.

I am also deeply in debt for the contributions of my colleagues at the University of Lethbridge. Victoria Baster has been particularly adroit in pointing out nuances within the British precedents of the Group of Seven. Anne Dymond contributed significantly to the discussion of French regionalism, nationalism, and modernity, and conversations with Marc Léger obliged me to refine a host of theoretical points, while Victor Semerjian provided ongoing moral support that got me through many difficult moments. I would particularly like to extend my thanks to Brian Titley for allowing me to quote extensively from his innovative study of Duncan Campbell Scott.

But no one working on a topic in Canadian art, especially in the early twentieth century, could proceed without the generosity and precedents established by both Charles Hill of the National Gallery of Canada and Dennis Reid of the Art Gallery of Ontario. Although we may differ on our opinions on specific points, their dedication to enlarging the history of Canadian art serves as a model for everyone engaged in this field of study.

However, none of this could have been done without the support, encouragement, professional advice, assistance in research, and endless proofreadings of Frederike Verspoor, who has patiently put up with so much for so many years. This study is dedicated to her persistent belief in its possibility.

I would also like to extend my thanks to my editor at UBC Press, Jean Wilson, who has been a source of both continual encouragement and information throughout this process.

The University of Lethbridge, my employer for the past decade and a half, supported the project with study leaves and travel allowances, which allowed me to both start and complete the work.

Finally, I would like to thank Serge Guilbaut for advising me to pursue the topic and opening my eyes to the broader possibilities within the study of art history.

National Visions, National Blindness

Introduction

In British dominions such as Australia, Canada, and New Zealand
from the 1890s ... artists ... presumed that the nation lacked
an identity, and that it was their task to invent one ... The deep
association between indigenous people and the land provided strong
and condensed reference points for a colonial culture that sought
both to define itself as native and to create national emblems. Settlers
also ... wanted to emphasize their modernity and their connections
with Britain and Europe.

— Nicholas Thomas, *Possessions,* 12

The white Canadian looks at the Indian. The Indian is Other and
therefore alien. But the Indian is indigenous and therefore cannot be
alien. So the Canadian must be alien. But how can the Canadian be
alien within Canada?

— Terry Goldie, *Fear and Temptation,* 12

THE TWO PRECEDING PASSAGES provide a useful framework for mapping out the formation of independent national identities within the British dominions after colonization. Thomas describes three co-ordinates for positioning such inquiries: namely, the relationship of these identities with the imperial centre, with the nation's indigenous peoples and their lands, and with modernism. However, the paradoxes Goldie articulates imply that the emergence of national differences was complex and difficult to realize. More specifically, they suggest that the construction of a modern Canadian identity in the early twentieth century, such as that associated with the landscapes of the Group of Seven, may not have been as straightforward as sometimes presented. By offering alternatives to conventional narrations of the nation, I propose that the historical conditions

unique to Canada, especially those that influenced its representations of its Native peoples and their lands, rendered its new visual identity open to challenge. I suggest that the construction of this identity — although often posed as a historicist inevitability based on stable binary oppositions (mediated through landscape) both between the nation and its colonial parent and between the nation and its indigenous peoples — was fragile and involved a multiplicity of ambiguities, which were (and remain) disguised and kept from sight. I conclude that along the fault lines created by these ambivalences initial attempts to foster an essentialized national identity faltered, fractured, and in the end failed — but also pointed the way to new, more pluralistic possibilities.

One of the primary factors underlying this instability was that the presence of indigenous peoples in colonial territories made it evident that the nascent nations lacked an element thought necessary to validate claims to nationhood. Most pressingly, the primarily English-speaking inhabitants did not have an ancient *volk* whom they could cite as ancestors, thereby legitimizing their entitlement to these territories by continuous occupation. In Canada in the 1920s this problem was obscured partly because the diverse indigenous peoples were seen as a single race with a common history and (non)future — that is, they were collectively identified as "Indian" and continuously portrayed as bordering on inevitable and imminent extinction or assimilation.[1] Their identities, cultures, and arts — and consequently their persisting claims to their lands — were represented as belonging only to the past. This belief had been extended into a truth that appeared everywhere. In this context, the "discourse of disappearance," as I refer to it, served several important functions. Put somewhat simplistically, essentializing the Indian as a single race ensured that the dualism of indigenous and colonialist remained stable, while at the same time privileging the second term by erasing the first. This erasure allowed for an unimpeded construction of the subsequent dualism through which the colony could be transformed into a singular nation; a modern Canadian national presence, set in opposition to a colonial past, could now be predicated on and negotiated around the assumed absence of the "primitive." Native populations had no viable place within the new "native" Canadian culture, except as emblems of their own disappearance. It was no accident, then, that the emerging Canadian visual identity took up and occupied the spaces vacated by this presumed absence to proclaim an essential national character different from that of its colonial parents because of its profound attachment to the (representation of the) emptied landscape, which became, in many ways, a substitute for the lacking *volk*.

But in the years following the First World War, the seemingly stable notion of Native disappearance confronted a combination of mounting internal contradictions and external opposition, not the least of which came from Native peoples themselves, who asserted their visibility, cultural continuities, and claims to their lands, especially in the western provinces. The clamour threatened to destabilize what had long been held as foundational truths for the discipline of ethnography, for the principles of museum collecting, for enacting government policies and legislation, and for acquiring territories – as well as for practising art in Canada. However, at this point, the ruptures that would eventually lead to a complete fragmentation of the discourse of disappearance were just forming. The conflicts and threats that they initially produced resulted in a countercampaign to stabilize the nation's foundational structures; managing, policing, and disciplining the imaginary representation of the Indian, both at the imperial centre and at home, became as much a matter of concern as managing and policing the peoples themselves. However, continually maintaining the principle of Native disappearance in the face of a growing body of evidence to the contrary produced a phantasm that corresponded less and less to its intended subject. As this division became increasingly apparent in the following decades, the principle of disappearance would have to be abandoned and accommodations made to allow for a continuing Native presence. This ultimately resulted in an entire reformulation of the position of the "Indian" within Canada.

Concurrently, the image of Canada as represented by the Group of Seven in their empty wilderness landscapes faced equal challenges, despite the support of the National Gallery of Canada. These became evident when their work was taken abroad for ratification of their national difference at the imperial centres of London and Paris. In England their project was certified but at a risk. The positive critical reception came dangerously close to revealing that the principles and claims underlying their works were primarily based on English landscape precedents. Although this intimate, but concealed, relationship assisted in the ratification process, it undermined the Group of Seven's basic premise that, free of outside colonial influences, their work grew from a direct experience of a primeval nature specific to the nation. Shortly thereafter, in Paris, the French critics, who lacked the same sympathies, did not find expressions of nationalism, modernism, and mastery in the Canadian landscapes. This invalidating reception was experienced as a traumatic failure best kept from sight. It has been largely overlooked ever since. Further, it was also in Paris that both Canada's native and its Native arts were shown

together for the first time. The two mutually supporting discourses that surrounded them – a distinct Canadian presence and a disappearing Native one – could be kept intact as long as they remained separate. When they intersected in France, and when they subsequently confronted each other directly on several other occasions, their conjunction exposed the fragility of each. This resulted from the difficulties involved in using Native material, which could be interpreted as establishing a Native presence, to demonstrate the absence of the Native and placing it next to (and, indeed, in overlap with) the new painting of the national landscape, which was initially dedicated to excluding images of the Indian. In retrospect, it appears that the moment of greatest triumph for both interlocking discourses was also the threshold of their fragmentation.

The series of case studies that I present in which this fragmentation played out occurred more or less simultaneously within a few brief years. Some began somewhat earlier, some ended a little later, but they were all intertwined, concurrent, and part of a small, tightly knit community whose policies overlapped but were not always harmonious. I have separated these detailed studies into eleven chapters, each dedicated to one of a series of closely related projects. These extend geographically from the national capital of Ottawa and the metropolitan centres of London and Paris to the regional and rural areas of Banff, Alberta, as well as to the more remote, at least from a non-Native perspective, Gitxsan territories in the Upper Skeena River Valley in British Columbia. The specific projects include a sequence of national and international exhibitions organized by Eric Brown of the National Gallery of Canada between 1924 and 1927 that attempted to solidify a new national image but, in the end, disrupted it. I also look at initiatives and alternatives for depicting the Native in art, in ethnography, and in a new genre of literature that combined the two. Intimately linked to both art and ethnography are a number of museum and tourist projects. These are further joined to the work of several artists who were engaged in representing western Canada's Native peoples, including the American Wilfred Langdon Kihn, who worked with the ethnologist Marius Barbeau; A.Y. Jackson and his associates; and finally Emily Carr. Such textual divisions may tend to create the perception that the events can be considered in isolation. This is not the case; rather, they overlap. Thus each chapter is predicated on the previous one but also related to those further in the study. Equally, because they occur in both a parallel and a sequential manner, strict chronological order must sometimes be violated both to initiate and to complete the

discussion of each aspect of this set of imbricated events. I hope that I have taken sufficient care to preserve historical specificity and to establish a precise chronology, even if this sometimes means moving back and forth in time as well as between the various subjects and locations under discussion.

This brief but complex and conflicted period was a crucial time of transition and disruption when the nation was both formulating its own identity and renegotiating who would be granted visibility and a voice on the basis of this identity. In showing how the ruptures that forced these reappraisals were formed and either dealt with or disguised and ignored, I have attempted to examine the mechanisms that directed their progress. This process was neither static nor singular but continuously disturbed in complex ways by a variety of factors arising from both within the nation and outside its borders, factors that have, until now, been largely overlooked. Expanding the area of study has also meant moving away from any essentialized and dualistic concepts of either Canada or the Indian. It has meant recognizing the instability and even volatility of the first, viewing the latter in terms of the specific histories that each Native group underwent in the period following colonization, and positioning both within the international context in which they were situated.

But questioning conventional narrations of Canada's nationhood has also meant departing from one of the norms of discourse theory and practice: the tendency to privilege the suprapersonal while occluding individual agency. To this end, I have attempted to demonstrate that discourses have a human element by paying attention to how individuals and their personal relationships, institutional allegiances, disciplinary affiliations, and so on – as well as the classic triad of race, gender, and class – modified outcomes within the larger frameworks. In so doing, I have tried to show how human agency plays an integral part in determining the specific operations of discourse within day-to-day activities. But I am also interested in how individuals who are embedded in discourse react both to fragmentation from within and to challenges and threats from without – that is, how confrontations with larger conflicts and ruptures play out on the personal level. Although this may diverge from prevailing directions within current methodologies, which see the construction of history solely as a textual matter to be deconstructed, I think that the risk is worth taking and that the area is worth exploring.

Chapter 1: Canadian Art in England

We should not be misled by a curious, but understandable, paradox:
modern nations and all their impedimenta generally claim to be the
opposite of novel, namely rooted in the remotest antiquity, and the
opposite of constructed, namely human communities so "natural" as
to require no definition other than self-assertion.
 – Eric Hobsbawm, "The Nation as Invented Tradition," 76

THE 1920S WERE A heady decade for Canada. As the general histories
tell us, the young Dominion, although not yet an independent coun-
try separate from England, was "coming of age" and "cutting the apron
strings" that bound it to the imperial centre. However, this was not an
easy maturation. Less metaphorically, it can be said that in the years
before and after the First World War, the emerging nation underwent a
complex and contested transformation. Various agencies, cultural institu-
tions, and individuals were attempting along many fronts to imagine and
establish a singular, modern national identity that would clearly signal the
independent status to which the nation aspired politically and for which it
sought international recognition.[1] The process was not without problems.
Until 1900 the Dominion had closely identified itself with its dominant
colonial parent. Further, in attempting to define itself as different from
the imperial centre in the twentieth century, Canada was already follow-
ing the lead of England, which had been engaged in a project to establish
its own unified national culture since before the turn of the century.[2] A
similar attempt had been under way in France since the 1890s.[3] Somewhat
ironically, then, attempts in Canada to proclaim independence through
recourse to a homogeneous national identity also reaffirmed its allegiance
to and dependence on Britain and France, which served as models for
its enterprise. This paradoxical situation corresponded to the Canadian

foreign policy that was developed throughout the war, which served to maintain imperial solidarity while asserting independence from England. Here we can see the first signs that declarations and constructions of colonial dependence and independence as well as of national difference and similarity were entwined in contradictory and even paradoxical ways.

Many factors within Canada militated against this nationalist project. Even though the war is usually cited as consolidating the drive to independence, it did not assist in unifying the nation. English- and French-speaking groups – the latter bitterly opposed to the introduction of conscription and each already distinguished by its own identity, history, and cultural agenda – now further separated politically, particularly after the 1917 elections, when voting split along linguistic lines. The war also led to the repression of many ethnic and immigrant groups whose members were not British, especially those from Germany and the Austro-Hungarian Empire, as well as to a clampdown on organized labour.[4] Consequently, those who wished to foster and articulate a homogenous nationality faced both a coercive element within and resistance from without. There appears to have been little unanimity on the question of what shape the unity would take. However, the necessity of an identity that, at least ostensibly, cut across the borders of the two official languages was evident.

But other problems were also present. Canada did not possess many of the core qualities deemed essential to nationhood. As a recently colonized area, the Dominion had neither a deep history nor an ancient *volk* with distinctive lore, ceremonies, costumes, architecture, language, and so on who had inhabited the land since time immemorial and to whom the present occupants could trace their ancestry, thereby justifying their claims to the unified territory and underwriting their claims as a nation. In addition, Canada spanned a vast and diverse geography, contained differing colonizing and immigrant groups, many of whom had only recently arrived, and had a broad spectrum of resident indigenous populations predating colonization. The latter, which were seen as a single essentialized race of "Indians," posed special problems. Since it was repeatedly stated in many forms that these diverse peoples were collectively on the edge of either extinction or complete assimilation and since they were seen as racially distinct from the colonizers and as having a different, and potentially competing, history that went back for millennia, they could not be claimed as an ancestral *volk*. This was doubly the case because, despite the prevalence of a "discourse of disappearance," Native peoples were

still asserting their presence and still agitating for the resolution of land claims and other outstanding problems, especially in western Canada. In addition, the state was pursuing a policy of actively repressing Native cultures, identities, and ceremonies. This program reached its peak in the 1920s. Recognizing the "Indians" as the nation's *volk* at this time would have validated their rights to their disputed territories and obviated the need to destroy their traditions. The alternative, then, was either to exclude them from the emerging emblems of the nation or to place their cultures irretrievably in the past.

These complex problems were widely recognized at the time. Bertram Brooker, an artist and cultural broker of the period, addressed this condition succinctly in 1929 in his summation of the arts of Canada: "Geographically we are not unified ... Racially we are split 'forty ways' ... Historically we have no past as a people." He concluded: "We are *not yet* a people!"[5] He solved the problem of the longstanding claims of the indigenous peoples by asserting sameness with the colonizers. All were typed as recent occupants, or as he put it, "foreigners." Casting everyone as immigrants levelled any claims to the nation's lands but also dispensed with any possibility of an ancient national *volk* with a deep past. Instead, according to Brooker, the nation could give up being a "colony" and become "*our* homeland" only when we "forget the old countries."[6] For Brooker and those who thought like him, the foundation of nationhood was amnesia rather than remembrance. Yet, even given these shortcomings and paradoxes, nothing less than a new, singular, seamless, and some would even say racial identity was projected and occupied a place in popular and political circles as well as in Brooker's own cultural publication, which was dedicated to the national uniqueness of the Dominion's various arts.[7] Insofar as this cultural construction can be construed as a discourse, it had to be disseminated, reproduced, and circulated as a new "truth" according to which Canada and its differences could be legitimately discussed, defined, and known.[8] Decisions had to be made about who would belong to or be excluded from this constructed identity, who would be "Canadian" and who would be "other," what the qualities of this identity would consist of, what forms it would be represented in, who had the authority to speak of and for it, and how to deal with the lack of some essential items. In addition, the tricky question of what it would be based on also had to be broached. Consensus on these issues was not easy to achieve even within the institutions that promoted them. Overlapping, but also conflicting, views existed simultaneously. Given the problems confronting the pro-

ject, it was perhaps doomed to failure from the start and thus could never have been anything but a convenient, if difficult to maintain, fiction based on a sequence of shifting and ambiguous boundaries and definitions that had to be continuously renegotiated.[9] But the stakes were high; with some exaggeration, it was argued that the future of the country rested on the success of the venture, so the project proceeded apace.

On the artistic side, programs were going well. The paintings of the Group of Seven, formed in 1920, were presented as embodying an auto-nomous, modern, visual culture rooted in the soil, severed from colonial ties, and ostensibly inclusive and independent of language. In fact, Canada seemed to have been at the forefront in using primarily the visual arts, but especially landscape painting, as part of what Hobsbawm would call an "invented tradition" to assert a unified national identity.[10] However, this was not a straightforward or simple enterprise. Bhabha's theories on what he terms "the narration of nations" provide access to the ambiguities and uncertainties that underscore the broadly accepted concept of the unified nation as well as the hierarchies and binaries on which this concept is based.[11] I hope to demonstrate not only how such simplified relationships were put into play during this period, but equally how unstable they were and incommensurable with the problems confronting the representation of Canada as a nation. But first I would like to argue that the work of the Group of Seven was necessary for this new Canadian identity not so much because it reaffirmed an essential Canadianness already existing and awaiting form, one different from the identities of its colonial parents, but because it filled an imposing lacuna in the text of the nation that threatened its very construction.[12] National necessity, not nature, was the mother of this "invention."[13] I would also like to claim that, rather than effecting a separation from England, the works of the Group were in fact meant to establish a closer tie and solidarity with the imperial centre. It is also my contention that one of the major achievements of the Group was its negotiation of the difficult and complex terrain that joined the drive for a uniquely Canadian art with formats and forms that were also linked directly to England and, further, that this paradoxical problem was clearly understood from the start. The Group's role in filling the first lack, solid-ifying the second connection, and establishing a series of clear dualities around colony and nation accounts for the broad institutional support that its members received from the moment that they first emerged.

Eric Brown, the director of the National Gallery of Canada, was at the forefront of the institutional and state-sponsored drive for a singular

national visual identity from before the war.[14] Brown, who, after several failed careers, emigrated from England to Canada in 1909 without firm prospects for employment, was not a professional in the field of art. His wife later attested to his somewhat thin credentials for the elevated positions that he was given shortly after his arrival by citing his direct experience with the principles and practices of British landscape painting. He learned these from "his elder brother Arnesby ... [who] had acquired a reputation as a landscape painter ... In the summer months Arnesby and [his wife] Mia joined the artist's colony of St Ives, known as the Newlyn School of open-air painters, and here again when Eric was with them he learnt much of the artist's outlook."[15] These experiences and connections, although limited, would have served Brown well and could even have recommended him in the forthcoming task that he faced in Canada.[16] Both the Newlyn School and the later St. Ives art colony played a role in appropriating what were seen as Cornwall's Celtic territory and history, as well as its folk costumes and practices, into a larger English national identity in a relationship of centre and periphery expressed through landscape painting in the late 1800s.[17] Both groups also advocated the principles of picturesque plein-air painting, especially in rural surroundings at some remove from urban centres, a setting deemed so much the better if it required painters to rough it in inclement weather.[18] Arnesby Brown contributed to this drive in the early twentieth century to foster a distinct, native British landscape, separated from urban areas and representing the unindustrialized south, that could become emblematic of an English national identity.[19] Through close contact with his brother, then, Eric Brown would have obtained a rudimentary education both in the history and principles of British landscape painting and in how a modern national identity could be figured within a nation's contemporary artistic production.

Eric Brown's competence in and knowledge of a British nationalist tradition expressed through a native English landscape, although second-hand, provided him with a life-long career in Canada, where he was soon introduced to Byron Edmund Walker, the president of the Canadian Bank of Commerce, who had become chairman of the Advisory Arts Council to the National Gallery in 1909.[20] Walker, the consummate Canadian capitalist, thoroughly understood the relationships between political power and cultural formations, and he positioned himself accordingly. He was, above all, a staunch supporter of maintaining close ties with the empire. He was even prepared to abandon his own political party to ensure this

end. In 1911 he "led the way" in bringing down Wilfrid Laurier's Liberal government, of which he was a member, for its proposed policy of reciprocity with the United States, which it was felt "put continentalism ahead of the British connection" and "'would weaken the ties which bind Canada to the Empire.'"[21] During this crisis, Walker hired Brown as curator in 1910 and appointed him director in 1912. The following year, under Robert Borden's new Conservative government, which Walker helped to form, the National Gallery of Canada (NGC) was given official status as an autonomous entity. It would, unlike many of its counterparts, intervene directly in the formation and direction of a national art. The major problem seemed to be fostering and displaying an image of national difference and independence that at the same time remained loyal to the empire, which was an imperative for Walker. This paradoxical problem complicated the otherwise simple binary between colony and imperial centre.

A mandate to underwrite a unique national art founded in landscape and paralleling that developed in England appeared as soon as Brown took office at the NGC. By 1912 he was publicly calling for such.[22] From this moment, he took a concentrated interest in the painters who would later officially form the Group of Seven in 1920. Despite claims in the conventional narrations of the Group's history that its members faced opposition and neglect before being vindicated, they were, since their first appearance, the handmaidens of the NGC, and consequently of the state, in the birth of this identity invested in the visual arts.[23] The rewards for these relative unknowns were substantial and immediate. Within a year, Brown, despite a limited acquisitions budget, was buying significant quantities of their work as well as works by Tom Thomson, with whom the Group was associated but who would die before its actual formation.[24] By 1914 Brown was communicating with and receiving advice from the Group's two principal members: A.Y. Jackson and Lawren Harris.[25] Brown's rapidly acquired predisposition toward the nascent group is remarkable given his newness to the country, the newness of the painters, and the newness of the style and subject that they had suddenly adopted and in which they were all now working. Nonetheless, from this date forward they received the continued favourable attention of the most prestigious and powerful art institution in the country.

This did not mean that Brown neglected his brother, who was favoured by Walker. One of the NGC's first acts under its new status in 1913 was to acquire a large oil painting by Arnesby Brown, *In Suffolk* (157.5 x 183 cm),

which had been illustrated that year in the leading English art magazine, *The Studio*.[26] This journal, which in many ways defined art for a broad English-speaking public both at home and in the dominions and colonies, was an important site for the construction of the rural landscape as essentially British.[27] It also became the primary vehicle for soliciting recognition of Canada's emerging independent national imagery at the imperial centre. Arnesby Brown's work shows, as does almost all of his production, a placid herd of cattle in a tonal, peaceful, cultivated landscape set in the south of England, which stood in opposition to the industrialized north.[28] Untroubled by implications of nepotism, Eric Brown justified the purchase, also in *The Studio*, as "worthy of the very finest traditions of the British school of landscape painting. Bold in design, innovative and generous in its handling, it has an incomparable richness of beauty, and is at once peace giving and heart-satisfying to its observers."[29] But its importance lay beyond its purely aesthetic and pacifying qualities. As Brown's assessment indicated, it was an emblematic representation of England and English identity invested in a contained, ordered, and civilized bucolic plenitude, which despite claims that it was innovative, followed formulae developed over the previous century. It is no coincidence, then, that the new emerging imagery of the Group of Seven was to be defined as the opposite – that is, as open, empty, wild, and geographically situated in the North – although both represented nonindustrialized landscapes. This dualistic relationship (mediated through nature) between civilized centre and wild periphery was a trope already familiar in England in depictions of other areas on the margins of the empire, namely Ireland.[30] It was also to become essential to the formation of the image of Canada. In fact, Brown's painting represented precisely the conventions against which the Group would later rail as representing an outmoded European vision of Canada, although this oppositional definition of difference, in deference to both Eric Brown's filial relationship and English allegiances, was almost always associated with the Hague School – that is, with Continental rather than British precedents.

By 1915 Brown was able to announce to the imperial centre his first thoughts on the formation of a Canadian movement in the pages of *The Studio*. Although it was embryonic and its existence overstated by Brown, the early signs of this movement contained the germ of what was to follow: "Canadian art is undergoing a great change, a renaissance almost. The earlier Canadian painters ... [who] at best paint[ed] Canada according to European tradition, are passing. A younger generation is coming to the

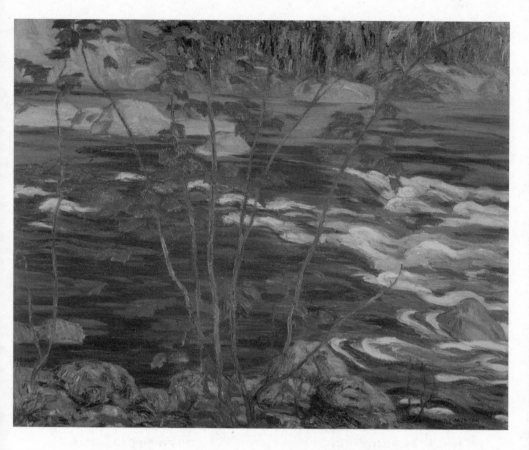

FIGURE 1: A.Y. Jackson, *The Red Maple*, November 1914, oil on canvas, 82 x 99.5 cm.

fore, trained partly in Canada, believing in and understanding Canada ...
They are painting their own country ... The hopeful are convinced that
they are looking into the dawn of an art era in Canada which will realise
some of the true glory of the country."[31]

That Brown solicited recognition of this movement abroad before
it was even fully formed at home indicates that the intended audiences
were as much international as local. He accompanied his birth announce-
ment with illustrations of A.Y. Jackson's *The Red Maple* and Lawren Har-
ris's *Winter Morning*, both recently acquired by the NGC (see Figure 1).
Although Brown's article also reported the acquisition of two Impressio-
nist works by Claude Monet and Alfred Sisley, he drew no genealogical
links between them and the fledgling Canadian school. This separation

of Canadian and French modernisms echoed concerns in England, where "involvement with Continental traditions in modern art was deeply ambivalent, at once fascinated and fearful."[32] Such involvement would remain a major problem in Canada as well.

The programmatic campaign to have the new Canadian image ratified in England would extend over the following decade. The second instalment, appearing in 1916 when Brown was given the opportunity to expand on the concept of a distinctly national art that could be seen as part of the British Empire while remaining separate from Europe, figured largely as France and centred in Paris. Midway through the war, *The Studio* published a special edition entitled "Art of the British Empire Overseas."[33] Its appearance corresponded to the need for convincing displays of solidarity and unity within the empire at a time when some dominions were calling for national autonomy. Despite its inclusive title, which figured the empire as possessing a homogeneous art that transcended borders, continents, and hemispheres yet allowed for national variations, the issue was devoted only to Canada, Australia, New Zealand, and South Africa.[34] All of the dominions at the edges of the empire were presented as fostering national schools of painting derived from the specifics of their respective topographies. Lavishly illustrated both in black and white and in colour, the publication was further limited in that it contained only landscapes outside of the urban sphere.[35]

Although Brown's ideas were still not fully developed at this point, in the section on art in the Dominion that he contributed to this publication, he began to construct a summary of Canadian painting and national identity based on the history of representations of the land and English precedents.[36] Admittedly sketchy, it still had significant exclusions and inclusions that would come to characterize his later expansion on these concepts. In keeping with *The Studio*'s prejudices, he made no mention of current French modernist influences while also omitting Canada's unique French colonial histories. Nor were Native arts discussed. Rather, Brown began with representations of Canada's Native peoples by Paul Kane and progressed through Cornelius Krieghoff and the British "pioneer" painters down to the beginning of the war. Although at this early stage his narrative lacked great detail, he was already certain of its impetus and conclusion. His opening remarks indicated that "Canada as a country possesses such a striking individuality that it was inevitable that sooner or later a generation of landscape painters would arise who would see her without let or hindrance from European traditions, conventions, or teaching" – that is,

those learned in Paris. His naturalized historicist progression, in which European influences were gradually expunged, culminated in a "group of younger landscape painters" who, although not yet named nor numbered, were located in "a certain studio building in Toronto." Even though these painters had been engaged in their project for fewer than four years and would hardly have been known in Canada, works by Harris and Jackson as well as by Tom Thomson and future Group members Arthur Lismer and J.E.H. MacDonald were illustrated in the publication and said to represent the emerging nation.[37] Discussion of these painters was also given a significant portion of his text, with Thomson and Jackson taking up the lion's share. Thomson was already figured as the woodsman/guide on the home front, and Jackson was the loyal soldier wounded while fighting in the trenches for the empire. Many of the other claims that later came to surround the Group of Seven were also present. Although their work was framed as part of the overseas empire, Brown again spoke of it as "the dawn" and "hope of a distinctly national school" that drew upon a direct experience of "primeval nature."[38] Although he cited their "decorative arrangement and brilliant colour," he mentioned no French sources in late Impressionism or post-Impressionism. Rather, the French influence on Canadian art was either deplored or downplayed. James Wilson Morrice, who was undoubtably Canada's most internationally recognized artist at the time but who was loyal to French modernist traditions and resided primarily in Paris, received scant attention. Indeed, his work was not featured in any of the twenty-two illustrations, although he did many luminous and richly coloured landscapes both abroad and on his regular return trips to Canada.[39] Instead, Brown universalized the trend toward colour and light as "world-wide" or naturalized it as being based on Canada's distinctive seasons. However, he did suggest modern Scandinavian parallels. He concluded with the prediction that "the next few [years] will see definitely established a Canadian school of landscape painting which will be one of the greatest impulses in the national progress, and compel the attention of public and dealer alike."[40]

The paradox here was that Brown and his three coauthors all declared the uniqueness of their emerging national images in the same manner and with the same rhetoric. Australia also claimed "a distinct school [of landscape artists] with a national character ... uninfluenced by the older schools of painting," while the contention found in this section that settler societies did not produce art in their early stages would reappear in Brown's later writings.[41] Even New Zealand projected that "there is no

need to go to Paris to learn how to paint the New Zealand landscape ...
Nature will provide all that is necessary ... There is not the slightest doubt
but that shortly there will come an era of first-rate landscape art in New
Zealand, conceding pride of place to none and owing allegiance to no
other school."[42] These similarities in declarations of difference were seen
not as problematic but as forming a unity within a diverse empire in which
the divergent terrains of the dominions were brought together under the
banner of an English non-Parisian tradition. Thus the project undertaken
by the future Group of Seven was neither unique to the Group's members
nor unique to Canada but part of a larger, coordinated movement that
spanned and unified the empire during a time of crisis.

Yet another ratification of Canada's national project by England was
orchestrated in the postwar period immediately after the Group's official
formation in 1920. Two critics from London were brought to Canada to
view and write about the work: Lewis C. Hind and P.G. Konody. These
were excellent choices. Hind was well known, having been one of the
founders of *The Studio*, although his role in its actual production was limited
because of other assignments. He wrote extensively on British landscape
painting, including works by J.M.W. Turner, and subsequently published
a two-volume survey, *Landscape Painting from Giotto to the Present Day,* which
was reviewed with great irony in the *Times Literary Supplement*.[43] Taking
time out from what amounted to heavy-handed sarcasm, the reviewer
did note as a redeeming feature that Hind had turned his attention to the
landscapes of the dominions, which were almost unknown.[44]

Konody already had some experience with Canadian art and its claims
to nationhood. During the war, he had worked closely with Canada's
agent in London, the newspaper magnate Lord Beaverbrook, who, like
his friend Walker, also possessed both financial and political clout.[45]
Beaverbrook's political assignment was to pursue a policy of maintaining
solidarity with England and the empire while at the same time promoting
Canadian independence. As part of this effort, he headed the Canadian
War Memorials Project, which documented Canada's unique contribu-
tion to the war, when it was in danger of being absorbed into English
initiatives. Konody was his right-hand man in this undertaking. As well as
directing the Canadian War Memorials Fund, Beaverbrook was rewarded
with a peerage and a Cabinet post in the British government as minister
of information. He became "responsible for propaganda in Allied coun-
tries and in the British Dominions." This new position led him to abandon
the Canadian War Memorials Fund and to become head of the British

Pictorial Propaganda Committee. He took Konody with him. The Canadian project was more or less handed over to Walker. Konody, then, was well connected to political power and also to imperial propaganda and national positions. Linked as he was to two of the major press barons in England – Lord Beaverbrook and Beaverbrook's friend and business partner, Lord Rothermere, for whom Konody also served as art advisor – the critic occupied a prominent position within British art circles, although there were those who questioned his credentials and his taste.[46] He had written several books, including an essay for a deluxe edition on the Canadian War Memorials Project, and much criticism. His voice carried authority and power. While in Canada, he and Hind "visited the Canadian National Exhibition, and their laudatory opinions of the new landscape painting were published in the papers," providing proof of "foreign recognition" and additional validation from the centre, which would have confirmed the correctness of Brown's claims of 1916.[47] Their voices would be heard again on the matter.

Nonetheless, despite these carefully controlled criticisms, ratification from England was not a foregone conclusion. While the project was recognized in principle, it was not fully accepted in practice by *The Studio*'s critics writing from Canada. Dangerous internal rifts were exposed at the local level within what was supposed to be a seamless structure. These disruptive voices, by also appearing in issues of *The Studio*, gained both a larger audience and authority. In a review of the Royal Canadian Academy (RCA) exhibition in 1921, Ramsay Traquair acknowledged that the "most interesting exhibits were in landscape. A number of painters are taking their inspiration from the wild scenery of the Canadian woods." However, he qualified this appreciation of the nascent national painters by stating, in opposition to Brown, that "the Canadian landscape painters can hardly at present be called a 'school,' and would possibly resent any such appellation, but on their foundation a real school seems to be being built up."[48] In 1923 Traquair again reviewed the RCA exhibition and claimed that Cullen, who was not part of the Group and who clearly showed French Impressionist traits, was "the best all-round painter in Canada." He did recognize, however, that the "Toronto school is alive and sincere. By dint of hammering away, its members have broken down the old prejudices, and their art is now almost accepted." He went on to further qualify this somewhat patronizing observation by withholding mastery of their medium. "Their weakness is technique. They do not put their paint on well enough. Their pictures show joy of colour, joy of

pattern, joy of nature, but very little joy of paint."[49] This ambivalence, which recognized the possibility of a Canadian national landscape yet did not unreservedly accept its current manifestations, continued in an article devoted only to the Group of Seven that appeared in 1923. "B.F." called them "vital to Canadian painting." He pointed out the English connection through MacDonald, F.H. Varley, and Lismer, on whom he focused. Although he noted that they were "three North-country Englishmen" who had emigrated to Canada before they joined the Group, he indicated that the latter had become "a thoroughly native interpreter of landscape." Nonetheless, he also discerned a conflict between their Britishness and their adopted national subject. MacDonald was characterized as

> a distinctly progressive landscape artist. His sketches are full of interest, although unequal. They show an elaborate sense of design spontaneously at work side by side with a Wordsworthian submissiveness to Nature. The two often conflict as they do in his recent canvases. The same conflict shows itself right through the younger landscape movement in Ontario. To be quite up-to-date, one might call it the clash between expression and impression. It is not peculiar to Canada, but it takes on a distinctive character here because it grows out of the nature of the country-side.[50]

This equivocation problematized Canada's uniqueness and its painters' debt to England as well as the essential qualities of the Canadian landscape and the means of rendering it. This effect was only compounded in 1924 when the British critic William Gaunt cited Harold Beament and G.N. Norwell, again non-Group members, as the leaders of the new, unpeopled, and uniquely Canadian landscape. Gaunt also stated that any such "school" was only developing.[51] Obviously, a corrective confirming both the Group's preeminent position and their success in having already established an image of national difference separate from any outside influences was in order if ratification in England was to be assured.

However, things were also progressing in a different direction. By the time the Group of Seven was actually in place in 1920, Brown, together with others sympathetic to the cause and with the aid of the Group itself, had constructed, reproduced, and put into circulation a critical jargon and historical narrative that articulated how their works sprang from the land itself; were not subject to outside, or at least to colonial and conti-

nental, influences; were modern and new; showed a mastery of primeval nature situated in the Northland; and represented a unique national identity that went beyond the divisions of language and geographic barriers.[52] Throughout the early 1920s, a critical literature, resulting from a series of important exhibitions in Canada and the United States, rapidly arose announcing support of this assertion to a growing and receptive public. By the mid-1920s the project, with the active support and even subsidization of various institutions beyond the NGC, had undergone several trials and, despite the occasional oppositional voice at home and abroad, appeared secure. The time had come to test these claims to a new, national, native visual identity in the international arena and to silence any dissenting voices. The final stage in the ratification process presented itself in the two shows of Canadian art held as part of the *British Empire Exhibitions* at Wembley in 1924 and 1925. These shows were of great importance for a variety of reasons. The location itself was significant. England was the colonial parent, the so-called "mother country," from whom the maturing nation was, at the time, gaining its own autonomous cultural and political identity. The link between Canadian art and political policies was identified by Ramsay Cook. He equated the two Wembley exhibitions with the Balfour Declaration of 1926. This initiative, which was several years in negotiation, "provided the theoretical explanation for the autonomy of the Dominions within the British Commonwealth. The Dominions were now recognized as nations in the traditional sense of having the right to control fully both internal and external policies."[53] In both politics and art, Canada was returning ritualistically to the colonial centre for recognition of its independence and difference gained during the war, while at the same time redeclaring its solidarity with the empire. Much rode on these shows, in which various audiences and publics compared Canadian modern landscapes with those from other areas of the empire, such as Australia, India, New Zealand, Burma, and South Africa, as well as England.

Although art had taken an important place in world fairs and colonial exhibitions since Paris's *Exposition Internationale* in 1855, many of the issues in London in 1924 and 1925 that influenced the Canadian works' reception were unique to the time.[54] England staged the two back-to-back spectacles to proclaim primacy of place in postwar Europe. However, this assumption of innate imperial superiority was extremely precarious and under threat on several fronts. Although Germany had been defeated, America and Japan were in the ascendancy. Further, the imperial centre

was fragmenting internally in a postwar depression accompanied by unprecedented unemployment and general strikes, while socialist and antimonarchist movements threatened the stability of the social and political structure. On a less well-publicized note, then, the exhibition of 1924 was designed to shore up support from audiences at home for nationalism, capitalism, and the Crown through recourse to a ritualistic display of solidarity within the empire.[55] However, the expected crowds did not materialize, and the exhibition was repeated, with some alterations, the following year.

But the exhibitions had a larger dimension. They were also designed to showcase the developments and progress of the loyal colonies and dominions. This demonstration was especially important at a time when the empire itself was undergoing an anxious transitional period. Critical questions about its identity were arising as it took on the form of a Commonwealth composed of independent dominions. King George V gave voice to some of these concerns in his opening address on 23 April 1924. Basing the empire on a contained model that conflated the intimacy of family and the breadth of international capital, he stated:

> The exhibition may be said to reveal to us the whole Empire in little, containing ... a vivid model of the architecture, art, and industry of all the races which come under the British flag ... We believe that this exhibition will bring the peoples of the Empire to a better knowledge of how to meet their reciprocal wants and aspirations, and that where brotherly feeling and the habit of united action already exist the growth of inter-Imperial trade will make the bonds of sympathy yet closer and stronger ... Co-operation between brothers for the better development of the family estate can hardly fail to promote affection.[56]

One of the main factors causing disaffection and dissent in the imperial family during the postwar period was the growing recognition of the separate national identities and independent aspirations of its constituent parts, such as Canada.[57] The exhibitions were a means of drawing these potentially disruptive elements together through a representation of the empire as a harmonious, spectacular, unified, and contained miniature, albeit one reproduced on a monumental scale.[58] The importance given to these considerations was emphasized by the dimensions of the site. It sprawled over 220 acres, more than half again the size of White

City in Shepherd's Bush, where exhibitions were held from 1908 to 1914, and cost over £10 million before it even opened. The 1924 exhibition was expected to attract over 30 million visitors in its first year.[59] It was accompanied by the publication of a twelve-volume set that addressed the problems of unity in an empire made up of diversity.[60] A review of the first four volumes spoke of "the Empire as a union of apparent incompatibles." Problems were also seen as stemming from the lack of constitutional or formal unity and from the emergence of the competing League of Nations, to which various members of the empire were independently linked. Canada was singled out as causing concern with its "recent claims in the matter of treaty negotiations."[61]

The arts, as was usual, played a secondary role in the overall spectacle, whose main displays centred on British genius in the area of technology and industry. In the volume on *The Literature and Art of the Empire* in the set noted above, the visual arts received only a cursory treatment and were relegated to a few pages at the back of a text devoted primarily to literature.[62] Nonetheless, the review of this volume noted that "a true nationalism is not inconsistent with the highest form of art" and that in the painting of the dominions there were "the beginnings of a truly national flowering of art bearing beneath its soil seeds which may some day be fructified by a wider vision and deeper humanity."[63] It was precisely this fructification that made the Palace of Arts, even if far smaller than the nearby eleven-acre Palace of Engineering, a major draw. In the compilation itself, Canada was given pride of place with an opening suite of six illustrations, four of which were by Group of Seven members and Thomson. The author of the five-page text on Canada spoke of the "birth of a definite school" of national art and noticed that "our children overseas are growing up, and are becoming powerful sons of the Empire."[64] This filial imperial loyalty was continuously measured against French influences. Franklin Brownell received praise for having "the right spirit and fortunately [being] not too much influenced by the French school."[65] Thomson received special attention as "representing at its highest the Canadian school of painting ... produced under local conditions of hardship, and not through French impressionism." Harris was also noticed for being "more Swedish in his outlook than French."[66] This animus against French influences, which was cast as a type of cultural contagion and even disloyalty to England, may explain one outstanding omission, James Wilson Morrice, who received neither an illustration nor any mention in the text.

The exhibition of Canadian art within the Palace of Arts was displayed along with exhibitions by England and the other colonies and dominions. The two rooms of Canadian painting, sculpture, printmaking, and drawing were, then, situated apart from the imposing Canadian Pavilion. This large, if somewhat solemn, concrete edifice did not feature any indigenous architectural features, which Canada lacked, but was in a generic imperial style termed "Neogrec." One of several similar pavilions placed at the heart of the exhibition around a picturesque park and lake, it shared its central location with those of Australia and India, whose pavilion, in contrast to Canada's, was an Orientalist fantasy based on the Taj Mahal and the Jama Masjid at Delhi.[67] The Canadian pavilion was flanked by two smaller structures dedicated to the country's main railways, the Canadian National and the Canadian Pacific, which, all acknowledged, had played the role of nation builders for the Dominion. In both of its exhibitions, Canada used the opportunity not only to further assert its own identity as a separate nation, but also to capitalize on the chance to encourage tourism, for which the picturesque landscape was an important attraction.

But if the arts played a lesser, albeit not insignificant, role in the overall exhibition, Canadian Native peoples, cultures, histories, and arts played almost none at all. Contrary to King George V's opening statements claiming that the exhibition featured all the races of the empire, the indigenous populations of Canada were conspicuous by their absence, in contrast to the presence of indigenous peoples in many of the other colonial pavilions.[68] As Jonathan King has pointed out, this exclusion was not within the established tradition of British colonial exhibitions and world fairs in general as they had developed since 1851.[69] He notes, for example, that in the 1886 *Colonial and Indian Exhibition*, "of the 81 [Canadian] exhibits eleven were contributed by Indians," including "argillite materials."[70] Rydell states that "following the example of colonial villages established at the 1889 Paris exhibition, [to which Canada did not contribute,] living ethnological displays of Native Americans and other nonwhite people were introduced en masse at the Chicago fair and appeared at subsequent expositions [such as in St. Louis in 1904] as well."[71]

However, these exhibitions were not under the auspices of the Canadian government or the Department of Indian Affairs. The reconstructed Northwest Coast Native village and its attendant ceremonies at the Chicago World's Fair in 1893 were, for example, seen as profoundly embarrassing to the Canadian government, who experienced their "barbarity" as a defiance of Canada's policies of "civilizing" assimilation,

featured elsewhere in the exhibition in displays of children from residen-
tial schools.[72] Protests were launched and an injunction sought to sup-
press the popular performances. However, these actions were ineffective,
as the display was not part of the country's official contribution but was
organized by the American ethnologist Franz Boas, who had views on the
validity of Native traditions that were in direct conflict with Canadian
policies. Similar exhibits would occur again at St. Louis in 1904.

In London, the 1908 White City exhibition featured no works by
Canadian indigenous peoples, although the 1911 *Coronation Exhibition*, also
held in that city, featured Kahnawake Iroquois from a reserve near Mon-
treal. Two exhibitions at Earls Court included a "North American Indian
Village of 1905 and the Red Man Spectacle of 1909."[73] By the 1920s, how-
ever, they were no longer to be seen in England.[74] By this point, Natives
officially played no role as exemplars either of the persistence of tradi-
tional cultures or of the success of assimilationist "civilizing" policies in
the construction and exhibition of a Canadian identity within or without
the empire.[75] They were certainly not presented as Canada's *volk*.

Thus the only full Native figures standing at Wembley, despite their
proven track record in England and elsewhere as a popular draw, occur-
red in a butter sculpture of the Prince of Wales in the Canadian pavilion.[76]
The refrigerated diorama, sculpted for the second year, was ostensibly
meant to showcase the progressive dairy productivity of the now domesti-
cated and colonized Prairies. This spectacle of oleaginous virtuosity
featured the prince dressed in Native regalia that included a feathered
headdress and beaded buckskin robes. He sat relaxed and at his ease next
to and in front of a butter teepee housing a Native nuclear family from the
Stoney Reserve outside of Banff, Alberta. Native presence here was twice
displaced, once in the material and again in the prince's "cultural cross-
dressing." The "civilized" butter stood in contrast to their "primitive" life,
now past, while their regal, exotic robes and names, and the powers and
possessions that these conveyed, were now appropriated by princely, and
hence imperial, prerogative. In the exercise of colonial power, the Prairies
became colonized homesteads, extensions of the empire supported and
preserved by the triumphs of superior English technology. In the process,
the Native seems to have been displaced into this double simulacrum.[77]

As King has concluded, even as Canada's postcontact history was spelled
out in detail at a special pageant at the exhibition, "little was left to the
imagination except the history and culture of the aboriginal population
of the country."[78] Wembley became, for Canada, a site for the "symbolic

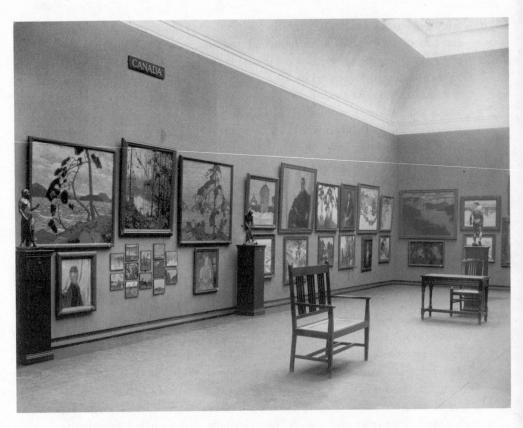

FIGURE 2: The Tom Thomson and Group of Seven room in the Canadian Section of Fine Arts at the *British Empire Exhibition,* Wembley, 1924. The three paintings from the left, top row, are Thomson's *The West Wind; Northern River,* with his twelve sketches beneath; and *The Jack Pine.* Lawren Harris's *Pines, Kempenfelt Bay* is sixth from the left, top row. MacDonald's *Solemn Land* is tenth from the left, top row.

erasure of Indian presence."[79] Given this absence, neither establishing the racial "difference" between the colonizer and the colonized populations nor constructing a knowledge about these populations was an issue for Canada, unlike for the other pavilions, especially those from Africa. The ratification of a national identity that did not include the Indian was far more important. Thus the Canadian art exhibition invested with this aim was exclusively a showcase for white artists. In distinction to previous colonial and international exhibitions, nothing produced by the indigenous peoples of Canada, presented as either art or artifact, appeared. In

the absence of Canadian Indians and their deep histories and different cultures, the English audiences were offered an alternative, unified view of what constituted the "native, autochthonous and indigenous" arts in Canada in the form of the new and modern landscapes of the Group of Seven, which, up to this time, were in harmony with this national vision in that they also excluded Native representations.[80]

Both Canadian exhibitions at Wembley in 1924 and 1925 were organized by the National Gallery, whose board of trustees appointed the jury for selecting the works. The first was a large and mixed affair, with 270 works by 108 artists. The composition of the jury and Brown's backing ensured that both the Group and Tom Thomson were well represented with twenty canvases and numerous wood-block prints and lithographs as well as twelve oil-on-panel sketches by Thomson.[81] Unlike any other "group," they were given their own salon (see Figures 2 and 3). Further, Brown's foreword to the catalogue "took on the tone of a Group manifesto."[82] The cover design, featuring their signature motifs – a lake, canoe, rocks, and a single pine tree – was done by J.E.H. MacDonald. The Group was separated out, highlighted, and flagged in both installation and text as deserving special attention apart from the one hundred or so other artists. This treatment led to protests both by the RCA, which felt that it should have been placed in charge of the exhibition, and by those left out who felt that Brown was featuring the Group at their expense. Scandal erupted. A public campaign arose calling for Brown's resignation on the grounds of bias both in his selection for these and other international shows and in his collecting policies, which had favoured the Group even before its official formation in 1920.[83] But even with these setbacks, the Wembley shows were seen as triumphs by the fostering institution. Any gains were worth the troubles, risks, and divisions that they may have exposed.[84]

This was the case because these ruptures were easily concealed through recourse to imperial authority. Most of the British critics proved highly receptive to the Group's landscapes and to their message of national unity. The NGC collected the reviews from both exhibitions, which highlighted the Group, and handed them on to the Canadian press for national distribution to the widest possible audiences across the country. This tactic justified the composition of the exhibitions, which now had been unequivocally ratified at the imperial centre. The National Gallery also shouldered the expense of publishing the reviews in two booklets as a permanent record of the exhibitions' successes. The opening lines of the first booklet stated:

The Canadian Section of the Fine Arts at the British Empire Exhi-
bition is the most important exhibition of Canadian art ever held
outside of the Dominion and the first opportunity Canadian art has
had of measuring itself against that of the other British Dominions.
The verdict and views of the British and other art critics therefore
becomes of great importance to all Canadian artists and art collec-
tors and it is for the purpose of placing them on record and to show
the very great interest and high opinion of Canadian art held abroad
that the Trustees of the National Gallery have decided to publish
this summary.[85]

It appears from these compilations that British critics of all stripes were
now ready and able to distinguish and critically appreciate the Group of
Seven and their project and to fully recognize the aspirations and unique-
ness – that is, the modernism, nationality, and difference – of the new
Canadian landscapes. They perceived no threat to the unified empire in
this declaration of artistic independence. The following selection of com-
ments, all from 1924, confirm Brown's earlier predictions, recapitulate
the jargon as it had appeared in Canada, and characterize the overall
positive critical reception: "Canada is developing a school of landscape
painters who are strongly racy of the soil."[86] "The first impression of the
Canadian Galleries is that there is emerging a native school of landscape,
awaiting a wider recognition abroad."[87] "Landscape is the strength of the
collection, as is the case with Canada's, but the latter brings surprises,
for there is evidence of an original school absorbing 'modern' tendencies
in the representation of native scenery."[88] Hind was again responsive,
stating: "These Canadians are standing on their own feet, revealing their
own country with gay virility."[89]

In the first year, Anthony Bertram, the critic for the *Saturday Review*,
displayed the most competence at deciphering the nationalist codes of
the Group's section of the exhibition. Dismissing the work from the
other colonies and dominions as of little significance or originality, he
declared that, "with Canada ... we can sincerely acclaim a vigorous and
original art." Although he did not name the Group of Seven, he listed
almost all of its members (with some others) as representing this vision
and noted that their works offered "genuine modes of national feeling."[90]
The British critics, albeit to varying degrees, seem to have had no trouble
either discerning what could be called the vocabulary of the new Cana-
dian landscapes, including their coded nationalist messages, or singling
out and praising those artists whose work was fraught with this meaning,

even though this was for many their first encounter with the paintings.[91] Despite a lack of consensus on these points in Canada, there seemed to be such in England. The recognition of cultural equality and independence, as well as the position of the Group, was completed when the Tate Gallery acquired A.Y. Jackson's *Entrance to Halifax Harbour*. This was a significant choice. Although it was not a characteristic wilderness landscape, it did illustrate Canada's commitment to the protection of the empire and the "mother country," even at the expense of great loss of life.[92]

This confirmation by England of Canada's cultural independence and its unified national identity, which paralleled a growing recognition of its political autonomy, was reaffirmed at the second staging of the *British Empire Exhibition* in 1925, at which all the galleries were reorganized. England was represented by a series of themed offerings, including portraits of "Empire Builders," a selection of scenes featuring "English Life," and a "Civic Gallery," which included, among others, a landscape by Arnesby Brown.[93] In the new Canadian section, the Group of Seven and Tom Thomson now had 21 oils and 12 drawings among the 198 works on display, roughly 15 percent of the total. The six reviews from the London papers cited in the NGC's publication indicate that while the second exhibition attracted fewer critical responses than did the first, these were more precise in their claims.[94] The *Times* noted that the Canadian exhibition was "more solid than last year."[95] "Our Art Critic" of the *Sunday Times* noted that "the brilliant and original work of the Canadian painters stands out even more prominently than it did last year. The Empire will have to recognize now that Canada possesses a distinctive national school of landscape painters of the highest merit." However, he did not separate out the Group's artists and mentioned only Thomson and Harris.[96] The *Christian Science Monitor* asserted that "the exception to the general dullness of the galleries is that of the Canadian rooms, which show us incontrovertibly that Canada is well on the way to producing a school of painting entirely her own. And this because her painters show more audacity, and a greater thirst for experiment than those of any other colony."[97] As Hill has pointed out, "once again Thomson, Harris, and Morrice received the greatest attention from reviewers, and the Group's success in creating an identity for Canadian art was reconfirmed ... The artists, the pioneer collectors, Canada, and Canadian art were all vindicated at Wembley."[98] Again, not all fully concurred. *Connoisseur*, an art magazine devoted largely to specialized and wealthy collectors, scholars, and educated amateurs, declared that "each of the principal colonies – Australia, Canada, New Zealand and South Africa – has a gallery full of modern pictures and other works

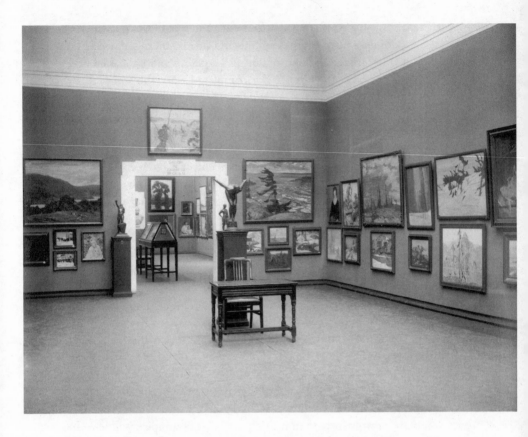

FIGURE 3: A second view of the Tom Thomson and Group of Seven room in the Canadian Section of Fine Arts at the *British Empire Exhibition*, Wembley, 1924.

of art which, while not showing the high standard of the mother country, indicate promise and an earnest pressing forward."[99] However, this was a quibble not reported in the NGC's compilations.

Within this second wave of appreciation, one response stood out: Konody's review for the *Observer*. He responded to the second Wembley exhibition with some favour and fervour. Konody's coverage within this prestigious paper, which was aimed at a more privileged, if much smaller, readership than that targeted by the general press, placed Canada and its art at the top of a hierarchical ordering of the colonies and dominions.

Whereas Australian art presents itself as an offshoot of the Royal Academy, slightly modified by Australian atmosphere, and South African art has not begun to show any sign of individual life, Canada

has not only gained artistic independence, but can boast of a real national school that owes little or nothing to European influence, is racy of the soil, and expresses Canadian landscape and Canadian life in an idiom of its own. Canadian art has progressed with rapid strides. Not more than seven years ago when I visited Toronto and Montreal, the pioneers of this movement, the 'Group of Seven,' who had just lost their leader Tom Thomson, the artists' 'discoverer' of the Canadian landscape, were still an isolated clique fighting bravely against the prejudice of the ignorant public. Now, at Wembley, they have it all their own way. They practically fill the two rooms with their daring, decorative and intensely stimulating landscapes ... I know of no European school that shows such unity of effort, a similar combination of nature-worship and respect for the laws that rule pictorial design, or a similar balance of the representational element and abstract aesthetic principles, as are to be found in the work of these Canadians, and particularly of Tom Thomson, Lawren Harris, A.H. Robinson, Langdon Kihn, F. Carmichael, C.A. Gagnon, Stanley Turner, A. Lismer, J.E.H. MacDonald, and A.Y. Jackson.[100]

Not only did Konody name the Group and Thomson, singling them out from the rest of the exhibition, but he also repeated all of the key elements of the narrative that had been put into circulation in Canada. Going beyond what was available in the catalogue, he recapitulated a story of struggle, neglect, and opposition that was already in place as the basic structure of their official history.[101] He cited their unified stance, pointed out the philistine public opposition to their work, reinforced their direct relationship with the land, named their pioneering father figure as Thomson, outlined their successful forging of an independent national identity, and noted the absence of any European influence, which implied that the work sprang up spontaneously from the soil, without colonial precedent, and that it was therefore truly Canadian. His figuring of the Group's members as brave combatants equated them with soldiers at the front fighting the good fight against an evil, albeit unnamed, enemy. Indeed, this enemy could not be named. Silence on this point was essential. Somewhat ironically, the foe was England itself as represented in Canada by the colonial institution the Royal Canadian Academy. Konody's tact kept the myth intact while preserving Canadian-British solidarity.

Konody's militarist trope both confirmed the Group's patriotism, dedication, and even sacrifice for their country and positioned their work within the definitions of the avant-garde, as did the terms "discovery"

and "daring." As modern pioneers, these artists were not only charting out new territory and literally "discovering" the land and their art, but also bravely doing battle with those who would oppose their explorations to map out, define, and claim this new topography. This claim was confirmed by Konody's comparison of the Group's project with other movements and by his deployment of the word "decorative," which occurred extensively in the British critical responses as a catchword indicating a flattening of space, a simplification of form, a richness of colour, and a boldness of facture associated with modernist, European movements since neo-Impressionism. However, he again tactfully evaded making this Continental connection explicit, as it would have called into question the Group's previous claims to being free of European influence.

While explicit, Konody's understanding of modernism must be qualified. His normalizing and privileging of "balance" implies a conservative attitude that rejected any of the more radical Continental innovations of the previous three decades.[102] While he claimed a knowledge of Cubism, Futurism, and Vorticism and saw the necessity of artists having something of these as a background, his own taste ran to the eclectic: everything from salon society portraits to the less "unbalanced" work of the English avant-garde. Although his critical stance could accept some of the Vorticists' activities, it did not embrace any of the recent work in Russia, France, or Germany, which he cast as extreme, unbalanced experiments. For the main part, the other English critics who reviewed the exhibition displayed only a slight knowledge of modernism as expressed elsewhere in Europe and, both there and on the home front, rejected the examples of modernism of which they were aware. Konody seemed the most knowledgeable, but even this was tempered. It must be kept in mind that England did not have a long tradition of modernism, that radical art had gained a foothold there only in the previous two decades, and that what did exist at the time was breaking up. Yet both the modernism and nationalism of the Group's landscapes were ratified by Konody and his audiences. In short, Konody was extremely receptive to the message of the work. He was able to read it and to rearticulate its many and varied, but related and even contradictory, claims with great proficiency. And he had the reasonable expectation that his English audiences, who would be less familiar with the works, would understand and be in sympathy with them.

Chapter 2: England in Canadian Art

The British Empire Exhibition has for the first time made possible the assembling under one roof of the paintings of today, not only from the United Kingdom, but from every Dominion of the Crown. Now first can be seen in one place how the Daughter Nations have developed their art from that English School which is represented so splendidly in the Retrospective Galleries.

> – Lawrence Weaver, "Introduction," *Catalogue of the Palace of Arts British Empire Exhibition*, 8

CONVENTIONAL NARRATIVES OF Canadian art invariably view the critical responses to the two Wembley shows as a vindication of the agenda of the Group of Seven and the National Gallery and a triumph of both over the Royal Canadian Academy and *retardataire* European formulae. This success is then presented as confirmation of the Group's independent, nationalist, and modernist position. Having established a clear-cut binary between the new nation and the imperial centre, ratified by the latter and expressed in landscape, these narratives stop their assessments of this relationship at the point where the preceding chapter left off. However, the statement of purpose for the overall exhibition by Lawrence Weaver, the director of the United Kingdom Exhibits in the Palace of Arts which included the Canadian works as one part, indicates that another imperial agenda, as of yet unaccounted for, was also at work at Wembley. Weaver's statement raises several questions. Are his claims about the purposes of the larger "art of the kingdom" exhibition and those made by Eric Brown for the smaller Canadian section mutually exclusive and in conflict, or can they be reconciled? Can derivation and dependency be compatible with independence and autonomy? In other words, were the works of the Group able to express both solidarity with the empire *and* national independence?

Could they have negotiated the difficult terrain that would have allowed them to be registered as both distinctly Canadian and also "developed from the English School"? And if this were so, why then would this achievement never have been acknowledged publicly and even celebrated? The answer here would be that any such possibility would have to be denied, kept from sight, or ignored, since acknowledging it would destabilize and undercut the particulars of the national narrative on which that claim was generally constructed. Giving Weaver's claim validity means questioning the assertions that the new Canadian landscapes were without colonial influence, born from the land, autochthonic, native, indigenous, and modern. It also means examining the possibility that the Group of Seven's compositions were, as has been suggested from the links between Canadian and English national landscapes found in *The Studio*, deeply indebted from the very beginning to the colonial parent from which they were also meant to signal a separation and a difference.

This broader view is given added impetus by recent writings demonstrating that, in order to properly and completely decipher works of art, audiences must already be versed in the codes by which these works are constructed, and that a group identity and a sense of inclusion and belonging can be shared by those having access to these codes, while those without such access can be cast as outsiders. The French sociologist Pierre Bourdieu has shown that "the readability of a work of art for a particular individual varies according to the divergence between the more or less complex and subtle code required by the work, and the competence of the individual, as defined by the degree to which the social code, itself more or less complex and subtle, is mastered."[1] According to Bourdieu, the mastery of these codes occurs gradually, and even unconsciously, through a series of "little perceptions" that lead to a familiarity and then to internalization. Thus, just as one acquires an understanding of grammar through usage, through "little perceptions," one internalizes the codes associated with the production of art.[2]

Given that the works by the Group displayed at Wembley were, by and large, the first British experiences of the new Canadian landscape painting outside of a scattering of articles in *The Studio*, some problems in either accepting their claims or deciphering them should have been anticipated, especially among those critics who ostensibly were not previously familiar with the work or competent in its complex, subtle, and sometimes contradictory claims.[3] That no such difficulties seem to have occurred appears problematic, given the assertions of newness and difference.

Yet the complete understanding and appreciation by the English critics suggests that the Group's works were fully legible in England because, in some manner, they recapitulated the already familiar subject matter, pictorial conventions, painting practices, and nationalist content of British landscape traditions.[4] Paradoxically, this would mean that the positive responses of the English critics, which have been taken as proof of the independence of Canadian art, also confirmed the dependence of that art on English precedents.

In any case, the implications of both Weaver's statement and Bourdieu's theories require an examination of the degree to which the paintings of the Group of Seven may have been based on the principles of British landscape practices. Such features would include not only the general principles of the British picturesque tradition, but also other aspects that are now recognized as being part of English representations of nature, especially as practised and codified in the colonies. These encompass what Malcolm Andrews has identified as the "issues of property and territorial control," "the propagandistic transmission of national identity," and the ability to represent "pictorial colonization," or what Young calls "re-territorialization."[5]

The presence of such elements within the Group of Seven's works would not be without instrumentality. Their existence, albeit unspoken, would imply that the Group's works and the unified national identity that they signalled were, very much like the Dominion's political institutions of the time, largely monocultural, Anglo-Canadian, and colonially derived. They would also ensure that the representations of Canadian nature and nationhood would appeal to the particular competencies of British audiences already familiar with the forms and the issues of the work from their own history of landscape painting. Such competencies would have been "mythologized and therefore naturalized as part of a shared heritage" – that is, a heritage shared by both England and English-speaking Canada.[6] Further, this conjunction would reassure anyone who partook of this sensibility that he or she was included in and belonged to both the nation and the empire. In this manner, the imperative of imperial solidarity and sameness could be confirmed at the same time that national independence and difference were paraded, a paradox that corresponded to Canada's political position of the time.

The search for English precedents in the painting practices of the Group of Seven in Canada responds to W.J.T. Mitchell's call for an investigation into the imperial landscape in terms of its "historical function in the formation of a colonial and national identity" and for an exploration of the

"ideological use of their conventions in a specific place and time."[7] Such projects, in turn, have been made easier by the vast expansion in research into the history of landscape painting in England, especially the picturesque tradition, and into the historical continuity of this tradition in the various colonies.[8] Equally helpful have been the even more recent works by Annie Coombs on the relationships between nationalism and colonialism and by Nicholas Thomas on the links between landscape painting, colonization, nationalism, indigenous peoples, and possession of the land in Australia. In fact, Thomas's theme of possession within the colonies, dominions, and nascent nations of the empire invokes the earliest stages of landscape as it developed in England.

Landscape painting in England achieved recognition as a separate and equal subject matter, which could claim a place next to history painting in importance, in the mid- to late 1700s. Earlier English landscapes had originated, in large part, as portraits of the estates of the new landed gentry and were intended to take the place, one assumes, of a hall of titled ancestors in order to prove title to the land under surveillance. The term "to survey," in both senses here, meant to declare ownership. Landscape was seen at first merely as utilitarian and without independent artistic merit or status. To qualify as art, it had to overcome its lowly origins and lack of prestige by proclaiming its uselessness and its unique aesthetic. Charles Harrison has stated that "landscape achieves autonomy as an artistic genre in England only when the countryside can be viewed as other than the property of the landed gentry – or rather, to be precise, only insofar as the task of representation of the countryside comes to be distinguishable from the business of reinforcement of title. The act of imagination required is clearly not primarily artistic ... it entails that the countryside is viewable under some aspect other than its aspect as property." However, Harrison notes that this other autonomous quality could coexist with that of affirming property, as in the work of John Constable.[9] Throughout the late 1700s, the transition was effected when figures of such renown as Thomas Gainsborough promoted landscape as an independent genre. While it became endowed with other possibilities, English landscape painting never fully lost this claim to entitlement and possession of the land.

The Group of Seven's works can also be traced to the aesthetic codes of the picturesque. The formation of these codes in the mid- to late 1700s is viewed as one of the beginnings of independent British landscape painting. They received their widest and most influential distribution when

they were popularized, deprofessionalized, and democratized at the end of the 1700s and during the early 1800s by the Reverend William Gilpin, whom Ann Bermingham calls "the first real theorist of the picturesque."[10] She asserts that "the picturesque as a practice or way of viewing nature was popularized largely by the guidebooks of Gilpin. The rage for these books peaked in the 1790s and influenced the touring habits of several generations of Englishmen."[11] Bermingham also points out that, "though theoretically the picturesque was supposed to resist artistic codification, its popularization as an aesthetic threatened such resistance."[12]

Gilpin's formulae, identified by Bermingham as a purely pictorial code by which a landscape was judged according to its "fitness to make a picture,"[13] were published in several books and essays in 1792, the most important of which was *Three Essays: On Picturesque Beauty; On Picturesque Travel; and On Sketching Landscape.* The wide distribution of these codes was essential to the broad amateur pursuit of picturesque art and tourism, with which it was linked, throughout the 1800s. Even though the cult of the picturesque, together with its public, was so widespread by the beginning of the 1800s as to warrant being parodied for its vulgarity in both literature and the visual arts and despite innovations by Constable and J.M.W. Turner and challenges by the English critic John Ruskin, the basic conventions survived in England, and even more so in the colonies, into the late 1800s. Malcolm Andrews has pointed out that although in the early to mid-1800s, "the Picturesque gives way to innovations which we associate with Constable's naturalism, and, later, Ruskin's call to artists to observe Truth in their paintings of the natural world ... the old formulary mode was tenacious ... These highly stylized modes of both execution and design survived long into the nineteenth century, in spite of Ruskin's polemics."[14]

But the other, "dark" side of this movement has also been exposed. Bermingham and John Barrell have pointed out that the picturesque tradition of English landscape was still, at the moment and place of its formulation, as much about dispossession as it was about possession, namely the displacement of the rural peasantry from the increasingly enclosed properties claimed by the landed gentry: "The picturesque embodied an early ideological response to this decline of rural paternalism during the [Napoleonic] war years ... The picturesque, like the political debates of the period about the problem of rural poverty, mystified the agency of social change so that fate, and not the economic decisions of the landowning classes, seemed responsible. In this respect, the picturesque

represented an attempt to wipe out the fact of enclosure and to minimize its consequences."[15] As is shown in later chapters, this mystification, too, found expression and was adaptable to colonial representations.

Indeed, issues of possession and displacement played an important role in all of Britain's imperial ventures. Mitchell provides reasons why the picturesque reached its greatest dissemination and prominence in the colonies, where land was being claimed as British. Linking the preeminence of landscape in several locations, but especially in Britain, with the rise of imperialism and colonization, he states that the "semiotic features of landscape, and the historical narratives they generate, are tailor-made for the discourse of imperialism, which conceives itself ... as an expansion of landscape understood as an inevitable, progressive development in history, an expansion of 'culture' and 'civilization' into a 'natural' space in a progress that is itself narrated as 'natural.'"[16]

This process produced a "re-shaping and re-presentation of the native land" into picturesque "emblem[s] of national and imperial identity."[17] As has been seen, even after the empire stopped expanding, these emblems were still of importance in formulating a British national identity in the late nineteenth and early twentieth centuries. Concurrently, Canada, Australia, and New Zealand were engaged in an incomplete process of colonizing their own territories and people. Consequently, in the dominions and colonies, landscape also continued to play a vital, if historically unique, role.[18]

The arrival of the picturesque, along with other aspects of British landscape painting, in Canada corresponded to the history of English military conquest and colonization in the mid-1700s. Befitting and confirming their status as British upper-class gentlemen of the late 1700s and early 1800s, military officers were trained to render landscapes in watercolour at the naval academy at Woolwich by teachers of such renown as the picturesque watercolourist Paul Sandby.[19] Aside from attesting to the officers' inherent taste and hence to the legitimacy of their class and rank, this instruction served other dual, but contradictory, purposes. In wartime it allowed them to record the topographic layout of strange lands for strategic purposes of reconnaissance, which demanded precision and accuracy – that is, truth to vision. In peacetime, while the officers were at leisure and their sojourns in colonies such as Canada, Australia, New Zealand, and India were recast as part of an aristocratic Grand Tour, their acquisition of the codes for rendering nature offered the pleasure of depicting the landscape in the artificial conventions of the picturesque,

which demanded that the elements of nature be selected and rearranged to suit its requirements.[20] The two opposing British landscape movements were conflated and confused in the colonies, where both truth to nature and artificiality were frequently found in the same works.

As already stated, British topographical landscapes had their origins in the depiction of the estates of the wealthy and were tantamount to a declaration of rightful possession. The fortuitous carry-over to imperial conquest was not coincidental. In British eyes, to represent the land was to justify ownership, to reterritorialize, and again it must be stressed that both ownership and dispossession of the land were as important here as they were in other settler countries, such as Australia. What Nicholas Thomas says of landscape painting in Australia also holds true for Canada: "Arguably, if white people are to define an alien land as their own, they are bound to dispossess its prior occupants, and establish and celebrate their own investments of labour and sentiment in it."[21] Thus class, imperial occupation, the imperial landscape, colonization, possession, and tourism were joined in complex colonial relationships.

Canada was still identified with colonial dependency, imperial expansion, the picturesque/topographical, and the Grand Tour until well after Confederation, even though by this time other influences, especially German and American, were also shaping landscape production within the Dominion. The monumental publication *Picturesque Canada*, which appeared in the mid-1880s, is an excellent example of this hybridity, in which non-British elements were subsumed (one could say colonized) under the banner of the picturesque.[22] The images, done largely by American artists and published by American entrepreneurs, were chosen by Lucius O'Brien, the first president of the Royal Canadian Academy, which was based on the British Royal Academy and was therefore a colonial institution. Despite the source of the pictures, the two-volume travelogue, first published in serial form, represented Canadian territory as a sequence of picturesque encounters: souvenirs of a Grand Tour from coast to coast, sent out in advance of the trip that would soon become available on the railways, which joined Canada politically, economically, and geographically.[23] Lynda Jessup has outlined how a similar format was employed in the display of picturesque Canadian scenes at the *Colonial and Indian Exhibition* in London in 1886.[24] Until the turn of the century, then, Canada represented itself as proudly British in image and institution. The system of representations of landscape still known as the picturesque played a central role in establishing the new Dominion's colonial

status and connections as well as its claims to nationhood. Indeed, the picturesque and Canada were, and to a degree still are, considered synonymous.[25]

The situation shifted again in the late 1800s when both French academic training and modernist conventions derived from Impressionism had a profound effect on Canadian landscape painting. Canadian artists of this period were assimilated into a hegemonic French visual culture, either *retardataire* or modernist. Coming from outside of England, these tended to displace the picturesque. The recognition of "Frenchified" conventions in Canadian art produced a rebuke from British critics at the *Colonial and Indian Exhibition* in 1886 and a call for Canada "to develop its own style of painting, one true to the countryside it portrayed."[26] The inference was that the French styles were somehow false. Despite these influences, the "true" English landscape tradition was tenacious. It survived in Canada, even if in a somewhat hybrid form, both in academic landscape productions and within the realm of commercial art and popular illustrations. Picturesque travelogues were far more widely disseminated than the works of artists experimenting with new representational modes.[27] Still, it is often claimed that, following the turn of the century, the Group of Seven turned against the picturesque, or at least against colonial and European influences that sometimes went unspecified, and developed a new, national, modern, and native vision of the landscape that was equally outside of French innovations.

This generally accepted narrative construction posits a profound rupture at this point marked by the adandonment of all colonial and most direct foreign influences. As Dennis Reid succinctly summarized it, "The artists who exhibited together in Toronto as the Group of Seven in May 1920 had by that time developed a doctrine and a style of painting based on the idea that Canadian art could find sufficient sustenance in Canada alone."[28] Consequently, any connections between British landscape traditions and the production of the Group of Seven and Tom Thomson have been studiously ignored or pointedly denied.

Yet, despite the denial of its presence down to the present, discerning the picturesque, and other aspects of English landscape practice, in the works of Thomson and the Group of Seven is not a difficult chore.[29] Indeed, most of the Group were trained in picturesque traditions and had internalized and naturalized them as the codes of artistic production before their sudden conversion to a "Canadian" style in 1912 and 1913. This is certainly true for F.H. Varley, Arthur Lismer, and

FIGURE 4: A.Y. Jackson, *Landscape with Willows*, 1903, watercolour over graphite on wove paper, 28.3 x 39.1 cm.

J.E.H. MacDonald, who were born in and received their schooling in England.[30] The pre-1913 work of A.Y. Jackson is also based on picturesque formulae (see Figure 4).[31] However, this material is not widely published or exhibited and is generally excluded, downplayed, or cast as that which was discarded after the "discovery" and "originality" of the new landscapes were formulated.[32]

This opposition was not always the case. The term "picturesque" was frequently found in the early writings on the Group. Even F.B. Housser identified their work as such. Speaking of Thomson's "discovery" of the "northland," he stated: "This was a more important discovery than it now seems. Just as Krieghoff, the German, nearly fifty years before had come to Quebec and seen in the French habitant new and picturesque art material, so in Northern Ontario these painters found [a] new and picturesque

landscape, typically expressive of the Canadian spirit. The discovery was to give direction to Canadian art."[33]

From our present perspective it is difficult to see how the picturesque could have been perceived as "new," a "discovery," and "expressive of the Canadian spirit," when in fact it was old, well-traversed, and redolent of England. Yet Housser had naturalized, universalized, and internalized the picturesque so completely as the proper and only way to view nature for artistic purposes that he was unaware that his deployment of the term implied a colonial rather than national vision. Barker Fairley's review of MacDonald's work, mentioned in Chapter 1, which linked him with Wordsworth and hence with a picturesque vision, also recognized the problematic connection. The question, then, is when did this change and the binary between the picturesque and the Canadian begin?

The contention of an absolute difference between Canada and England, nation and colony, and the picturesque and the Group's works was already made explicit in 1929 by Bertram Brooker, who stated: "I assert with all the force of my convictions that the aim of artists in Canada today *should not be the same* as those of artists in England in the nineteenth century."[34] Brooker's principle was taken up and made definitive in an important essay by Northrop Frye written in 1940. The influential Canadian critic was interested in discerning and defining colonial presences and national differences in Canada, especially in relationship to nature and its representations. He declared that the work of Tom Thomson was explicitly not picturesque, a term he equated with the colonial. Frye repeated the claim that Thomson drew his inspiration from a direct confrontation with the uninhabited land. On the other hand, Horatio Walker, an earlier and widely celebrated Canadian artist, with whom Frye compared Thomson, "looked around wildly for some spot in Canada that had been thoroughly lived in, that had no ugly riddles and plenty of picturesque clichés." A few lines later Frye concluded: "And for all Canadians and Americans under the bedclothes who wanted, not the new problems of form and outlines, but the predigested picturesque, who preferred dreamy association-responses to detached efforts of organized vision, and who found in a queasy and maudlin nostalgia the deepest appeal of art, Horatio Walker was just the thing."[35] This was a damning assessment of one of Canada's most recognized artists, and of his audiences, but an assessment that Frye felt was needed in order to rescue Thomson from any association with colonial affinities.[36]

More recently, Ann Whitelaw has indicated that this denial of the picturesque continues today in the current display of Canadian art at the

National Gallery, and "it is motivated by a quest for a specifically Canadian aesthetic vocabulary; an artistic language that would reflect Canada's distinct identity and signal its separateness from the former colonial power. For many historians, this distinct Canadian aesthetic took shape in the work of the Group of Seven ... who foregrounded a new style in painting that broke with the European picturesque style of their predecessors and set the agenda for the development of Canadian art."[37] She notes that this view is also rehearsed in the "art historical survey texts on Canadian art."[38] Thus the narrative of Canadian art, and consequently Canadian identity, has been and still is generally written and displayed *against* the picturesque.

In following a different path and searching for traces of the picturesque, as well as for traces of other British landscape conventions, in the Group's work, I would like first to examine the four major Canadian landscape paintings from the 1924 Wembley exhibition, discussed in Chapter 1 – Tom Thomson's *The Jack Pine, Northern River,* and *The West Wind* and Lawren Harris's *Pines, Kempenfelt Bay* – which commanded the main wall and dominated the installation (see Figure 2). These large paintings demonstrate how conventions drawn from the picturesque were employed, adapted, and transformed in the creation of what are considered to be among the most essentially Canadian, and hence the least colonial, of the works by the Group and Thomson. The basic composition of each echoes Gilpin's delineations of the necessary elements, conventions, vocabulary, and devices used to assemble a picturesque landscape.

Gilpin insisted – and English and colonial followers of the picturesque, no matter how far removed from him as a direct source, concurred – that the spatial recession in a landscape must be tripartite; that is, it must be composed of a depth of field that is clearly divided into three grounds. The foreground is generally dark, irregular, and rocky, with little detail of interest, although this could vary. This area should also feature a framework of trees, which contain and screen the scene, as Malcolm Andrews says, "to prevent one's eye from straying outside the canvas." "The dark foreground frame ... might extend round the top to an overarching bough."[39] As Mitchell summarizes, "the standard picturesque landscape is especially pleasing ... because it typically places the observer in a protected, shaded spot (a 'refuge'), with screens on either side to dart behind or to entice curiosity, and an opening to provide deep access at the centre."[40] Andrews also notes that "the incisive angularity of withered trees was preferred," as were pines.[41] The composition may, as a variation, have the tree (or trees) placed centrally, as long as it is not symmetrical. The

mid-ground usually features water, either a lake or winding river, with reflecting light playing on its surface. The background should recede to harmoniously arranged but asymmetrical hills or distant mountains seen in aerial perspective. These fundamental compositional elements of rocks, trees, screens, frames, shades, refuges, water, hills, and spaces – that is, the entire apparatus of the picturesque as it was formulated by Gilpin and as it was still practised over a century later in its generalized form – are not only all present in the Thomson and Harris works, but are taken almost to the point of exaggeration and even caricature. For example, in *Northern River* Thomson's withered spruces have proliferated from the edge almost to the centre, creating the "screen" of foliage that has often been spoken of as a unique feature of the Group's work (see Figure 2). Through this interlace of branches, which has usually been traced not to British but to either Scandinavian or Art Nouveau influences, one views the winding river, which recedes to the distant hills.

Yet it is often implied that Thomson, being largely self-taught, could have avoided such exposure. Conversely, while developing his Canadian imagery, he worked under the direction of MacDonald, who had been trained in England and was himself influenced by Constable. Joan Murray, in a recent publication that isolates Thomson's paintings of trees – that most picturesque of subjects – makes these connections explicit, although this is not her intent.[42] Her compilation of Thomson's tree oeuvre outlines in some detail both the transformation and the continuation of the picturesque in his work's invented Canadian tradition.[43] The earliest drawing that she presents, *On the Don River*, done in 1908 while Thomson was working under MacDonald, is, beyond any doubt, a picturesque pastoral.[44] It contains all the necessary elements arranged in proper order: rocky foreground, a small herd of sheep, a central yet asymmetrical deciduous tree, and groups of irregular foliage in the background. The three sequential spaces are neatly divided, with a pool occupying the mid-ground. It is, in fact, a saccharine cliché of the picturesque and could easily have served as a model of precisely the type of work that the Group supposedly never indulged in and continuously resisted. A few pages later Murray reproduces a second contemporaneous study in watercolour of a leafy tree, the preferred picturesque medium, done with all of the attention to washes and neutral tones that Gilpin would have prescribed.

By flipping forward through Murray's compilation, which is more or less chronological, extending from 1908 to Thomson's death nine years later, it becomes apparent that the central, emblematic pines in his two key iconic images are direct scions of the single or central trees of his early

formulaic picturesque works. It also becomes evident to what degree he repeated this standard compositional format throughout his career, always operating within a set of variations that could be readily accommodated.[45] Thus, insofar as *The Jack Pine*, *Northern River*, and *The West Wind* are seen as emblematic of the discovery of a new and essential Canadian identity, the discovery of "Canada" in the "wilderness" also contained the revelation that both were, as Housser indicated, always already British.

But given that the English audiences at Wembley in 1924 would have been unaware of this background to Thomson's work, how could this connection have been effected yet have remained unstated? Or, to phrase this another way, how could difference and similarity be proclaimed at the same time within the exhibition and by these few key works that lay at its heart? The pivotal point at which the transition occurred did not happen so much in Thomson's painting as in one of the pictures by Lawren Harris chosen by Eric Brown and the jury. *Pines, Kempenfelt Bay* hung on the same wall and just two works away from the Thomson grouping (see Figure 5). *Pines* appealed to the English audiences. It was featured in the volume on literature and art that accompanied the exhibition and was singled out, illustrated, and received positive critical attention by Leonard Richmond in *The Studio*.[46] The reviewer was familiar with the Group of Seven from his 1925 Grand Tour across Canada.[47] In addition, his proficiency as a graphic artist would have also given him a sympathetic understanding of the background of many of its members. He was also familiar with the history of British landscape painting and the use of the picturesque in promoting railway tourism. Like Konody and Hind, then, he was in an excellent position to effect a link between the Canadian display and its British audiences. As the perfect intermediary, he chose the perfect intermediary work. After identifying the Group as "an enterprising little band of painters who have made a profound impression on the national standard of Canadian art," he gave *Pines* the highest praise, finding it worthy of comparison to the British canon. He noted that it was "the antithesis of the Pre-Raphaelite movement in art" and, in a comparison that was a bit unlikely, contrasted it to John Everett Millais's well-known, intensively detailed image of Ophelia floating in a flower-strewn stream: "Lawren Harris has had the greater problem to handle – the cutting away of nearly everything that is visible to the ordinary eye in nature, so as to reveal that form of architectural growth that underlies the outer clothing of natural forms." Richmond also noted of Thomson's *Jack Pine* that it was "a large two-dimensional design, rich in colour" and that he "was the original founder of the Group of Seven."[48] Richmond understood, then,

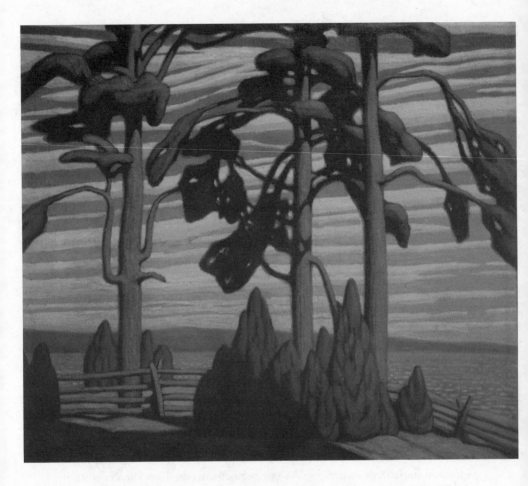

FIGURE 5: Lawren Harris, *Pines, Kempenfelt Bay*, [1921], oil on canvas, 97.6 x 112 cm.

that *Pines* would appeal to a cultivated, British critical taste and could pro-
vide access to, and an understanding of, the works that accompanied it,
including *Jack Pine*. Here Richmond was assuming on the part of his audi-
ences a previous familiarity both with the codes by which the picture was
constructed and with the interlocking claims that it and its compatriots
made. His assurance was not misplaced.

Although a mature work by Harris, *Pines, Kempenfelt Bay* is anything but
a wilderness landscape. Rather, it was one of a series that recorded the pic-
turesque garden and the vista from the Harris family's country property
on Lake Simcoe.[49] Thus it readily fit into the British convention of using

landscapes to portray, and proclaim entitlement to, one's own land. English viewers would not necessarily have been aware of the personal connection of the artist to the estate, but they would have readily recognized the signs of domesticity discernible in the lawn and fence. Compositionally, however, *Pines* corresponds more to the picturesque, thus conflating the two English landscape genres. The extremely abbreviated foreground consists of a neat, grassed area with small evergreen shrubs, the nearest of which shares a sheltered area of deep shadow with the viewer. The three conifers of the title, with their stylized clumps of foliage, abstracted curving limbs, and contrastingly straight, tall, and vertical trunks, serve both as framing devices for the view across the lake and as a screen extending from top to bottom of the canvas, which locks the composition to the surface. They are assisted in this function by the rustic rail fence running beneath them, which is also constructed of contrasting straight and curved lines. In addition, the fence serves as another nostalgic remnant of an English colonial pioneering past, a sign of the boundary of the property and the point of visual access to what lies beyond. The panoramic space clearly, and even excessively, continues the tripartite demarcation with an abrupt transition to water in the mid-ground and then another transition to a background of distant irregular hills whose curving horizon slopes downward to the right in contrast to the straight horizontal waterline. All of these elements are set in brilliant summer light under a cloud-streaked sky. The image speaks of leisure and bucolic harmony in a civilized, rural, nonindustrialized setting, in which civilization is defined by British models and in which ownership and possession, through viewing and the right to representation, extends beyond the fence into the whole of the picturesque, albeit wild, landscape. Further, this claim to ownership of the land, which invokes the entire history of colonization, rests on British precedents and validates British occupation and appropriation. With so many clear signals of the English derivation in the work, is it any wonder that the English critic compared the image with an English painting and placed it within an English canon and history? Indeed, Harris's painting facilitates an easy transition from an English to a Canadian view and, in fact, conflates the two.

But if the distance from Harris's home to Britain is not very far, then neither is it any great distance from his *Kempenfelt Bay* to Thomson's wilderness canvases. In case *The Studio*'s audience missed their proximity in the exhibition, Thomson's *The Jack Pine* was illustrated on the page facing that depicting Harris's *Pines* in Richmond's *Studio* review. This direct

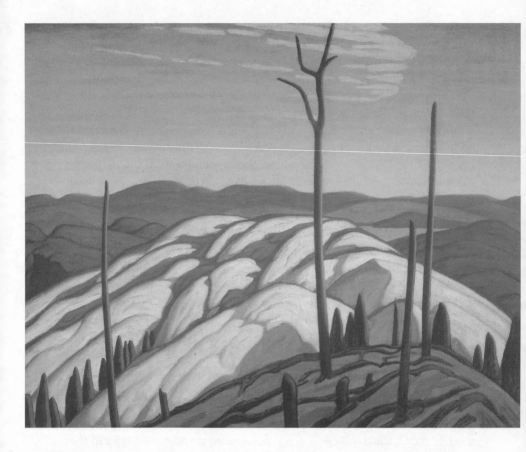

FIGURE 6: Lawren Harris, *First Snow, North Shore of Lake Superior*, 1923, oil on canvas, 123.4 x 153.5 cm.

editorial conjunction underscored that each relies on the same subjects and compositional devices – excepting, of course, the fence and the mowed lawns of the Harris canvas, which are absent from the Thomson. The painting by Harris supplied the transition from sameness to a break with the English tradition that was lacking because of the absence of the early drawings by Thomson.

However, Richmond's review of *Pines* comes dangerously close to rendering these connections completely transparent, as Barker Fairley had done earlier in the same journal. While these links account for the painting's initial inclusion and positive reception, neither the Group nor Brown wished to make the links visible. Rather, they wanted the Group's work

to be seen as distinctly Canadian instead of as a holdover from British traditions. The review, then, did not appear in the anthologies published by the National Gallery of Canada. It also became necessary – despite, or rather because of, this critical recognition – to remove *Pines* and replace it with a similar composition that could also effect the smooth transition to the myth of the wilderness. A work depicting the Algoma region, *First Snow, North Shore of Lake Superior*, was chosen as its substitute for the 1925 version of the exhibition (see Figure 6).

Superficially, *First Snow* is the opposite of *Pines*. The contrasts between cold and heat, tame and wild, summer and late autumn, barren and luxuriant foliage are obvious. Yet these differences do not fully disguise the fact that the two are variants on the same underlying pictorial structure.[50] Although the fence is eliminated and the trees are situated closer to the edges as framing devices, our attention is still directed from a small foreground to the two receding distances, with the water in the mid-ground and irregular rolling hills in the back. The similarities between the two demonstrate how even the park-like images of a tamed and owned landscape such as might be found in the English picturesque or even earlier in portraits of estates, which reappeared in the neatly fenced foreground of the family home in *Pines*, could then be adapted to what was presented as the Canadian national wilderness in an almost seamless transition. Such compositions became the stock and trade of Thomson and the Group and were endlessly repeated and varied within a set of limitations, as were picturesque images. In short, when Group members chose a scene to represent and composed it on their canvas, they, in many ways, returned to the picturesque conventions that they would have assimilated through training, constant exposure, and unconscious naturalization.

This catalogue of corresponding conventions does not, of course, preclude the presence of nonpicturesque elements. Indeed, the Group's works are not simple recapitulations but are complex and entangled hybrids, cobbled together from a variety of sources, including Art Nouveau graphic design; the much documented, if not overly emphasized, Scandinavian influences; and French post-Impressionist conventions. I do not wish to dispute these other sources. They are all present and accounted for. The problem historically and with the literature, as it stands, is that while these have legitimately been pointed out, their roles have become overvalued in the absence of the other essential English component.

It is apparent that many of the Group's characteristics, such as they can be generalized, come from outside the picturesque and, in fact, are

resistant to it. Colour is a major point. Gilpin, and by and large the pic-
turesque practitioners in general, resisted brilliant colour and favoured
sepia tones, which would give a sense of aerial perspective. The Group's
hues are, conversely, sharp and clear. The use of intense colour could be
cited as evidence that the Group drew their inspiration from an unmedi-
ated response to the brilliant autumn hues of the Canadian wilds.[51] Or,
conversely, it could be claimed that this use of colour demonstrated their
modernism and awareness of post-Impressionist chromatic theories. In
any case, the Group's oscillation between these two possible sources of
influence could obscure the underlying adherence to old British (i.e.,
colonial) sources and reinforce claims to being modern, autochthonic,
and independent.

In addition, practitioners of the picturesque favoured watercolour over
oil as well as light washes over impasto and facture. The facture here,
especially in the Thomson, is categorically not picturesque. Yet it must be
kept in mind that the Group added a watercolourist to their ranks when
they brought in Frank Carmichael.[52] We also should note that the richest
surfaces occur in the small sketches, and sketching was of course part and
parcel of picturesque tourism. Twelve sketches by Thomson accompanied
his larger works at Wembley. But if excessive facture was a point of differ-
ence, so was excessive smoothness. Gilpin declared the smooth anathema.
The surface of the Harris painting and his polished, sculptural forms look
much like how Gilpin would prescribe not to do a picture, even though
the composition's framing trees, spatial recession, mid-ground lake, and
distant hills all are picturesque.[53] Thus, even while resisting the pictur-
esque, Harris limited his innovations to those that highlighted what the
picturesque rejected rather than moving on to something else entirely. In
this sense, he paradoxically stayed within its bounds. But then we must
also recognize that Harris's surfaces and forms were unique within the
Group. Indeed, of the seven, his interests and training were the most
German, a sympathy that caused him many problems during the war and
after.

Finally, Gilpin prescribed that landscapes be stocked with other than
natural elements, which had to be rearranged or invented to suit picto-
rial requirements. Recommended additions included peasants, although it
was essential to show these as idle since labour would have disrupted the
picturesque pleasantness. These figures of local colour could add inter-
est but must never be prominent. In the works examined here, figures
are nowhere to be found. The Group's compositions were constructed as

largely unfigured, "empty landscapes" devoid of human occupation. Gilpin also recommended ruins that could add a note of melancholy and that were also suitably "irregular" and "rough" in appearance. They, too, have no place in these pictures. But while not present here, both conventions occur elsewhere and are examined in due course.

We must recognize all of these differences. But although they are of sufficient number and variety that we could concentrate exclusively on them, we should not allow them to blind us to the similarities. A multiple rather than singular vision is essential in coming to grips with Canada's identity. Indeed, the presence of English landscape conventions and claims is far more comprehensive than shared or resisted compositional and surface treatments and goes to the very heart and structure of the mythology of the Group.

For example, on the topic of texture, we know that Gilpin preferred "rough" surfaces.[54] He advised the tourist/artist to seek out those areas that were unbeautiful and irregular. And it is here that Thomson's, Harris's, and the Group's reliance on picturesque practices goes beyond formulaic formal conventions to the very manner of production. The ritualistic and redemptive treks into the "unbeautiful" woods and sites of tourism in Ontario to make sketches also retraced the paths of the picturesque.[55] Thomson's trips to Algonquin Park and the others' boxcar excursions to the Algoma region parallel the romantic rustic walking tours into the Lake District in England to experience picturesque nature.[56] This area in Britain was an intermediate terrain, wild yet park-like. Not coincidentally, the area between the wild and civilized was also the preferred location for the Group, despite the claim that they were "wilderness" artists. Algonquin Park, as its name implied, was a vacation playground north of Toronto but south of the 49th parallel. It was accessible by train and supplied with hotels, and it no doubt offered canoe rental facilities for the picturesque artist and tourist alike. As Paul Walton pointed out, having already been logged over, it was anything but untouched, virginal nature. Group members also went to the cottage country around Georgian Bay, another logged-over tourist area, which became a "well-appointed holiday resort created by private enterprise" precisely because here Ontario nature closely duplicated the British conventions of the picturesque landscape. It "was hardly a wilderness area." Instead, "Dr. MacCallum's cottage provided a comfortable base from which his artist friends could explore the region's picturesque possibilities ... Eventually ... the scenery came to be viewed with reference to an orderly set of expectations as visitors learned

what to look for with the aid of the Group of Seven and their followers. Their works evoked romantic communion with the 'wilderness' by means of a set of traditional conventions, sublime panoramas, beautiful valleys, and picturesque details, but they were cast in a modernist, 'poster-esque' style."[57]

Allan Fletcher also pointed out that the Algoma region on the north edge of Lake Superior, which Harris's image depicted, was far from being a raw and untouched wilderness. Rather, having been logged and mined, it was at the time being rehabilitated as a site of picturesque tourism in order to revitalize the local economy.[58] In short, the very sites that these paintings represented and the ritualistic treks that preceded them, as well as the sketches that were produced, followed and fostered the well-trodden paths of picturesque tourism.

We should also keep in mind that in England "mass travel to such accessible places [as the Lake District] jaded the appetite, and the field of discovery was broadened to include continental Europe, especially such dramatic regions as the Alps."[59] The Group of Seven again recapitulated this expansion in Canada in the late 1920s when they travelled to the Rocky Mountains of Alberta and British Columbia as part of a Grand Tour to the picturesque tourist locations of Banff, Lake Louise, Lake O'Hara, Jasper, and the Upper Skeena Valley.[60]

Beyond the pictorial conventions and the sites and processes of production lies the proposition that the work of the Group of Seven was a direct, nonacademic, unmediated response to nature and consequently was uniquely Canadian. Paradoxically, the very foundation of this claim to national difference is British and originated with the birth of landscape painting as an independent genre in England. Over one hundred years before the Group's formation, Joshua Reynolds saw "Gainsborough's work as a direct response to nature" and claimed that it was "not indebted to the Flemish School, nor indeed to any school, for his grace was not academical, or antique, but selected by himself from the great school of Nature."[61] Compare this with Housser's claim about Thomson: "His master was nature."[62] Bermingham observed that "writers on the picturesque derived Gainsborough's landscapes not from [foreign] schools of landscape painting but from the English countryside itself,"[63] and it was asserted that only "nature was his teacher and the woods of Suffolk his academy."[64] Again, compare this with Housser's claims: "The modern Canadian so-called school was inspired as a direct contact with Nature herself."[65] The easy conflation of these English claims with those made about the Group

indicates that despite the Group's aspiration to being distinctly Canadian and to rejecting colonial influences, its landscapes proclaim their colonial dependency and their solidarity with English precedents for expressing national identity.[66]

If a lingering British imperial influence on the Group of Seven is given a place equal to the other sources from which their hybrid work was assembled, then a paradox in the Canadian narrative becomes visible. But even this echoes the previous British situation. Contrary to the claims that British landscape sprang from the land, "it is an irony often noted that the rapid growth of interest in views of British scenery was largely prompted by a foreign initiative" – that is, by Italian and Dutch painting, with which English landscape painters became increasingly aware through various means in the 1700s.[67] English commentators had been adept in the eighteenth and nineteenth centuries at turning a blind eye to outside influences on their own landscape traditions. It could be said that they were also adept in the twentieth century at not seeing their own influence on Canadian art. It appears doubly ironic that this wilful blindness to outside influences was as much a part of Canada's colonial heritage as was the claim that the nation's landscapes sprang directly from an unmediated, nonacademic response to the land.

This ambivalence was not without function. Even in the face of a declaration of cultural and artistic independence, English audiences could be reassured of the Group's colonial allegiance by its renovation of their own landscape traditions but at the same time could overlook this to see the Canadian work as new, unique, and different. Further, Canadian claims to its territories could be conflated with the legitimation of British presence at a time when it was necessary to assert both independence from and solidarity with the empire. British critics, familiar with their own country's art and its claims, practices, and conventions, to the degree that they had been "naturalized," could immediately "read" the meaning of the Canadian work and recognize through their own history the validity of its claims to nationalism. At the same time they could concentrate on its unique qualities and see it as so different and independent that no point of overlap was discernible. I would also argue that this relationship of dependency had to be disguised by both parties and that, down to the present, it is privately understood and accepted but publicly ignored and denied in a paradox of identification and differentiation.[68]

This also goes a long way toward explaining why Scandinavia could be overvalued as a source for the Group of Seven even though only two of

the members made the famous pilgrimage in 1913 to the travelling exhibition of Scandinavian art at the Albright Museum in Buffalo that has now been enshrined in the history of Canadian art. The other possible source of Scandinavian influence remains a few black and white, and one or two colour, illustrations published in *The Studio* magazine, which indicated a British acceptance of these models. By all historical standards, this is scant evidence on which to base a major influence, particularly to the exclusion of the picturesque and other imperial conventions. But an important distinction separated Scandinavian landscapes from those of England. The former was not a colonial parent. To point to it as a source would be, as Eric Brown had done in 1916, to identify a parallel development, not a colonial derivation. Indeed, it could be used to disguise the latter. The myth of cultural autonomy could be managed and maintained through recourse to a broader, universalized, myth of the "North," a vague and flexible term that included any similar nation making similar claims.

But, as with many of the elements from which the Group cobbled together their style and myth, this one, too, could prove problematic. The Canadian painters were, of necessity, blinkered in what they saw and recognized as useful to their aims.[69] They focused exclusively on landscapes that corresponded to their own experience and to the British traditions and precedents of landscape painting. They blinded themselves to the fact that Scandinavian nationalist art was only in small part composed of landscapes. In fact, it was primarily narrative and figurative. Nationalism in Scandinavia, as it was produced in the late nineteenth century, was based on reproducing a mythic past and an ancient *volk* with a deep history within a particular geographic area to which they had a longstanding claim. All of these aspects figured in the work of the Finnish painter Akseli Gallen-Kallela, who is cited as one of the influences on Harris's treatment of snow.[70] Gallen-Kallela was of great importance in the representation of Finnish nationalism in the late 1800s. But as Varnedoe points out, this nationalism was evident in more than just his landscapes: "During the 1890s, Gallen-Kallela became increasingly interested in heightening public consciousness of a separate Finnish national identity. With this purpose, he began to execute paintings illustrating episodes from the Kalevale, a collection of legends gathered by the philologist Elias Lonnrot earlier in the nineteenth century. Lonnrot visited Karelia and recorded these stories which had passed from generation to generation through oral tradition. They comprise a mythic history of the Finnish people from the Creation until the birth of Christ."[71]

These figurative paintings of mythic and ancient narratives were freighted with Gallen-Kallela's nationalist message. But it was not just these paintings, let alone his imagined Finnish geographies, that gave credence to claims for a Finnish national identity; rather, this credence was the sum effect of Finland's oral myths, ancient *volk*, deep history and claims to the land, and its indigenous architecture, literature, sculpture, costumes, rituals, and decorative style. The display of this conjunction of integrated elements in the Finnish pavilion at the Paris exposition of 1900 led to the recognition of an autonomous and new Finnish nationalism by French critics.[72]

No mention of these broader fundamental aspects of the construction of Scandinavian nationalisms was ever made by the Group or their commentators. This omission occurs for good reason. To bring these aspects forward would point out that the very connection invoked to justify Canada's national image revealed the reverse – that is, that Anglo-Canada lacked a deep past, a mythic literature, an ancient claim to a precise geography, and a primitive *volk* possessed of folkloric and artistic traditions. Any comprehensive comparison of the construction and display of Finnish and Canadian nationhoods would have made Canada's seem deficient, if not spurious. Thus it was deemed better to focus only on, to overvalue, and to universalize the equation of landscape with nation and to turn a blind eye to the missing elements, which put Canada's claims at risk rather than legitimating them.[73]

The 1924 and 1925 Wembley exhibitions confirmed the recognition of a distinct Canadian national image but at a certain cost, which made the claim precarious. The one recourse to an ancient *volk* that Canada possessed – that is, its indigenous populations – had, for reasons explored in subsequent chapters, to be erased and replaced by the Group of Seven. This meant that the works by the latter were laden with a large responsibility with which they were not necessarily commensurate. Nonetheless, the fragile, ambiguous, and equivocal claims to a unique, homogeneous identity represented in depictions of the land in Canada was secured at the imperial centre and projected as a stable duality. This outcome, which met with little resistance from an audience willing and needing to overlook the Indian's exclusion and to focus only on the differences in Canada's landscape art, was achieved through a carefully disguised, but artfully continued, identification with established British vocabularies of national identity and imperial power.

The measure of the Group of Seven's Wembley successes is evident

in the place that they have taken in the histories of Canadian art. These successes play a prominent role in the nation's narratives as the crowning moment of the Group's triumph over what is posited as opposition to its work up to this point. However, this has not been the fate of the follow-up exhibition, where these same institutions and artists solicited validation of their artistic and nationalist enterprise from the country's other major colonial parent, France.

Chapter 3: Canadian Art in Paris

The artists invite adverse criticism.
> — Lawren Harris, "Foreword," *Group of Seven Catalogue of*
> *Paintings, 1920*

THE GROUP OF SEVEN's critical triumphs at the Wembley exhibitions
are usually figured as victories for the Group and the National Gallery
(NGC) over the Royal Canadian Academy (RCA). Reducing the proceed-
ings to this simplified conflict privileges the Group as the beleaguered
and heroic champions of a marginalized modern national vision versus an
entrenched but outmoded colonial institution demanding a return to *retar-*
dataire, European, and foreign formulae. The precariousness and insta-
bility of this duality became evident, however, when the two Wembley
exhibitions were consolidated into a third show held in Paris at the Musée
du Jeu de Paume, which occupies a prominent site adjacent to the Louvre
in the heart of the city known as "the art capital of the world"[1] (see Figure
7). The *Exposition d'art canadien*, billed as the debut of Canadian art in
France, opened in April 1927. Like its forebears, it was composed of a
range of Canadian art but was focused on the Group's work. Its distinc-
tion from the Wembley exhibitions was the inclusion of retrospectives
of works by two prominent but recently deceased artists, James Wilson
Morrice and Tom Thomson, the first of whom had died in 1924 and the
latter in 1917 (see Figures 8 and 9). It also included a small sampling of
the arts of the indigenous peoples of the Canadian Northwest Coast, an
aspect of the exhibition that is dealt with separately in the next chapter.
In the wake of the critical successes in England, the Paris show was con-
ceived as a final validation of the Dominion's claim to a unified and mod-
ern visual identity as exemplified by the "empty wilderness" landscapes
of Thomson and the Group. Although deemed the best of the three, the

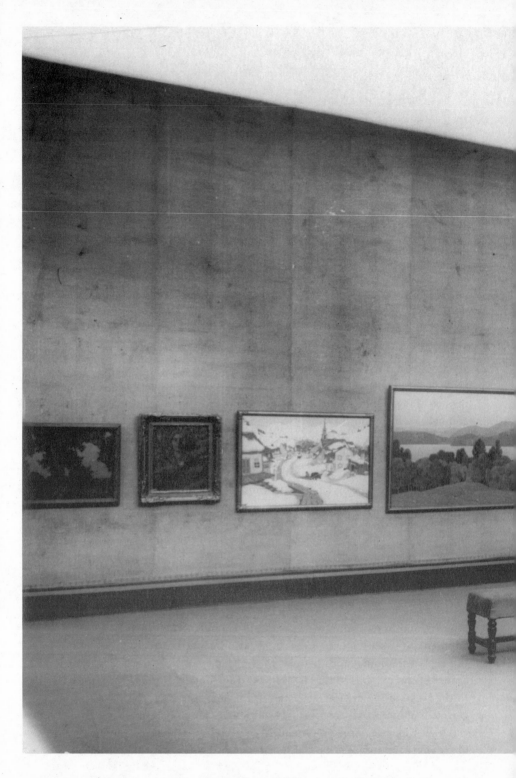

FIGURE 7: A general view of the *Exposition d'art canadien*, Musée du Jeu de Paume, Paris, 1927. Clarence Gagnon's *Village in the Laurentians* is third from the right.

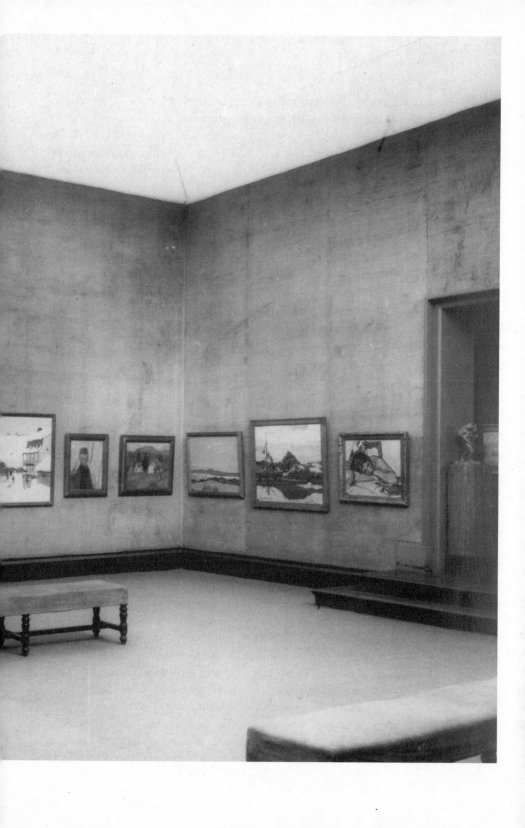

exhibition nevertheless frustrated its organizers' objectives. Contrary to
all expectations and in contrast to the preceding reception in London,
the critical responses in Paris did not produce a vindication of the NGC's
and the Group's agendas. The responses were less than enthusiastic, as
many critics denied or withheld confirmation of the Group's nationalism,
modernism, and mastery.

The negative reaction was experienced as an embarrassing, if not trau-
matic, failure that was best concealed and forgotten. While the laudatory
reviews from London were collected and republished by the NGC, those
from Paris were collected but suppressed. Canadian historians have fol-
lowed suit. Unlike the Wembley reviews, which are mentioned every-
where, the Parisian responses have been expunged from the record.[2] Only
in the more recent catalogue of the Group of Seven by Charles Hill has the
exhibition itself begun to take its proper place.[3] But even he downplayed
its importance. While giving it greater depth, he distanced it from the
Wembley successes, positioned it out of chronological order, and offered
no reasons for its failure.[4] Taking again something of the position of a
contrarian, I would like to make the responses, and the issues that they
raise, visible. This is important for several reasons. First, when the Jeu
de Paume show was mentioned, it was misunderstood. For example, it
has usually been asserted that the exhibition originated with an invitation
from French authorities.[5] This implied an already established recognition
and appreciation of the new Canadian landscapes at the centre of modern-
ism. The spin put on the show after the fact by Eric Brown, the direc-
tor of the NGC, in his annual report underwrote this perception: "As a
direct result of the unusual interest aroused in European art circles by the
Canadian Section of Fine Art at the British Empire Exhibition in 1924 and
1925, the French Ministry of Fine Arts invited the National Gallery to
form an exhibition of Canadian art in Paris."[6] This was not the case.

Brown, in fact, knew his claim to be unfounded, as he organized most
of the Canadian side. However, he was obliged to carry on negotiations
in Paris through the artist Clarence Gagnon, a painter of Quebec genre
scenes and an etcher of great accomplishment who studied there prior
to the war, lived in the city off and on until 1919, and returned to take
up residence in late 1924 (see Figure 7).[7] Gagnon was well placed within
the Parisian art world and provided the necessary connections to influen-
tial and powerful figures, which made the exhibition possible. Politically
astute, he realized his own ambiguous role within Brown's agenda. Not
a member of the Group, he occupied the conflicted position of using his

insider status in Paris to promote the Group against his own potential interests.[8] Nonetheless, he appears to have also used the privileges that the position gave him to his advantage by gaining concessions and acting independently to stake out and promote his own claims.[9] His role in shaping the final product, and its reception, should not be underestimated.[10] French officials who had a hand in its production included: Armand Dayot, Inspecteur Général Honoraire des Beaux-Arts, an early champion of post-Impressionism and publisher of *L'Art et les Artistes*, who enjoyed, in his old age, this honorific position; André Dezarrois, the young conservateur-adjoint du Musée national du Luxembourg, responsible for the Section des Écoles étrangères and the Musée du Jeu de Paume; Charles Masson, the newly appointed conservateur du Musée national du Luxembourg, which administered the Jeu de Paume; and the architectural historian and cultural administrator Paul Léon, directeur des Beaux-Arts.[11]

Negotiations for the exhibition were involved and conflicted. The first issue that arose concerned when and where it was to take place. Dispensing with Brown's claims for a French invitation stemming from Wembley, it can now be recognized that the exhibition had its origins in Dayot's interest in publishing articles on Gagnon and Canadian art, which he had expressed to Gagnon as early as 1920.[12] Dayot's attention to Gagnon begins to clarify the conditions of artistic production and reception, as well as the place of Canadian art, in France in the postwar period. This era has been known as the *rappel à l'ordre* (call to order) and was characterized as a reaction against the radical, international avant-garde innovations of the first decade of the century as well as a rejection of Dada and Surrealism and a return to what was seen as a classical, traditional French style, based on a timeless lineage, which confirmed the nation's nationalism.[13] But the postwar years were marked by more than a *rappel à l'ordre*. During this period several factions in France moved toward an idealization of regionalism – that is, agrarian peasant imagery specific to a particular area that could be associated with the land as part of a *petite patrie* and thus seen to represent the continuity and antiquity of French traditions and national identity.[14] This claim was figured within inhabited landscapes done in diluted modernist conventions showing the presence of peasants who, as an originary *volk*, could claim to have been there for centuries. Dayot's journal promoted this movement. It has in fact been termed "arch-regional."[15] Gagnon's nostalgic images of rural Quebec, shown as untouched by industry and inhabited by rural folk, fit precisely within, and would have seemed to emulate, this regionalist

movement, which occupied the *imaginaire*, or self-image, of France during the 1920s (see Figure 7). Thus Gagnon's genre scenes would have initially represented "Canada" and appealed to Dayot. This helps to explain why Gagnon easily reconciled himself with his ambiguous position; that is, he may have understood that his work would prevail within the critical climate in Paris. As will be seen, he made every effort to align himself with the *rappel à l'ordre* and regionalism.

Dayot remained the sole contact between the NGC and Paris for several years. Despite his proddings, the proposals remained on hold until Gagnon returned to France. But with an agent in Paris and the Wembley shows in place, the prospect of a follow-up exhibition in Paris emerged. Matters now proceeded with some urgency. Just prior to Gagnon's departure in late 1924, Brown instructed him to pursue the possibility with Dayot of an exhibition in Paris to be held in 1926.[16] The initiative, then, for an exhibition began with the NGC, not France.

The first attempts miscarried because of misunderstandings and miscommunications. Several venues were proposed, including Dayot's recommendation of leasing the private Charpentier Galleries, a prestigious "select" locale that was beyond political interference from either side.[17] Negotiations fell through; despite being touted as "the gallery" in Paris, the site was rejected as inadequate.[18] In the fall of 1925, Harry McCurry, the competent if somewhat staid secretary for the NGC, who would later become its director, worked with Gagnon to secure another space. Three possibilities were mooted: the Petit Palais, a section of the Louvre, and the Jeu de Paume, which had been reserved since 1922 to host a series of foreign exhibitions.[19] McCurry acted on Brown's desire, voiced the previous fall, that the exhibition occur immediately after the second Wembley show.[20] On this basis, he proceeded to approach the proper authorities through Dayot and submitted a formal request for the Jeu de Paume.[21] However, he and Gagnon were brought up short when Brown cabled back withholding authorization, as he now had other plans to tour Wembley within Britain and had not yet gained approval from the NGC's board of trustees for the Paris exhibition.[22] In fact, they were kept in the dark about the prospect. Inadvertently, an embarrassing fiasco was avoided. Although the initial request for a date in the spring of 1926 was submitted and acknowledged in October 1925, it was, fortunately, rejected by both sides.[23] For its part, the French government had already committed the venue to Holland.[24] France's rejection letter arrived in early December. Brown formally acknowledged the refusal in February and proposed a

later date in the spring of 1927.[25] By March, Gagnon and Dayot, despite voicing misgivings over the postponement, were on side, with the latter promising to publish an article written by Brown on Canadian art in conjunction with the exhibition.[26] Brown thought that "the delay will do more good than harm."[27]

The second solicitation from Canada in the competition for the space was officially accepted in May 1926: "Vous avez bien exprimé le désir d'obtenir au printemps 1927, le prêt des salles du Jeu de Paume en vue d'y organiser une exposition de peinture canadienne. J'ai l'honneur de vous informer, qu'après examen des demandes de même nature, émanant d'autres nations, le Jeu de Paume pourra être mis à votre disposition, du 10 avril au 10 mai 1927."[28] By July much was still left to sort out. Brown was in the dark as to how success had been forthcoming, with whom he was dealing in the French ministry, the precise content of the exhibition, and whether a jury would be necessary.[29] He appointed Gagnon as his official representative for negotiations on the grounds that he could approach the proper French officials personally while leaving the NGC and himself out of it.[30]

The reasons for this oblique approach lay in the other major hurdle. Brown needed to make it appear to the trustees, and the Canadian art world, that the exhibition had been initiated by the French government rather than solicited by himself and the NGC. He reasoned that if it were seen as the NGC's undertaking, then the trustees would demand another jury, as had occurred at Wembley, where a conflict between himself and the RCA had arisen over his policy of backing the Group of Seven. This had led to a public protest and a call for his resignation on the grounds that he was promoting what was perceived as a nonrepresentative group of artists.[31] Even though he had easily outmanoeuvred the RCA, depriving it of control of the foreign exhibition, to which it had a certain claim, Brown needed to avoid any further imbroglios. Yet he also needed to exclude the already alienated RCA from any position of influence. As he confided to Gagnon, "This, I am sure would mean a difficult and inferior jury and a flood of inferior work. I hope I make my point clear."[32] However, if the French were seen as inviting the show, they could also be held responsible for the final selection, freeing him to claim that they, and not he, had set the standards for choosing the works. The fiction of an "invitation" was continuously, if not obsessively, insisted on from as early as the summer of 1925 and picked up in the second round of negotiations by July 1926.[33] Sensitive to the delicacy of such situations, the French officials obliged.

The announcement of the "invitation" was made to the trustees by Brown in early September 1926 when he presented them with the project.[34]

Other areas of the negotiations were less ambiguous. It was clear from the start that Canada would bear the cost of the exhibition, including shipping the work and refurbishing the gallery space. In a diplomatic manoeuvre, a decision was made to hand over the admission receipts to the French government "for the benefit of the French artist disabled and to the families of those who fell in the Great War."[35] It was also decided early on that Brown would choose the works from the two Wembley exhibitions and add supplemental material as needed, although it took some time to sort this out.[36] The Canadians were also responsible for the posters and catalogue, the latter designed again by J.E.H. MacDonald with concessions to a French connection, such as the insertion of a fleur-de-lis.

Further problems arose. A second diplomatic prevarication was needed to give Brown and Gagnon carte blanche in their selections and exclusions. In late 1926 Brown wrote to Gagnon that he required a letter from the French ministry that "would completely satisfy the Board of Trustees and give me a free hand to carry out the exhibition in the very best way. It will enable me to take only the best of the Wembley pictures and to keep out work which has no place in such an important foreign exhibition." He would write the draft, which would be sent to France, translated, handed on to and signed by Dayot or Masson, and then "forwarded to me."[37] The letter was designed to allow Brown to claim that any exclusions were not his responsibility but the desire of the French government, thus avoiding a confrontation with the trustees or any others who objected to his selections. The letter states: "Given that this is the first exhibition of Canadian art to be held in Paris and given equally that the space available in the Jeu de Paume is limited, the Minister of Fine Arts respectively submits the wish that only the most distinguished Canadian artists be represented in this exhibition and that it be mostly composed of the best works shown in the Canadian Section of the British Empire Exhibitions of 1924 and 1925."[38]

The document goes on to outline in detail what could be substituted in case of prior sales of work, or if work of importance had appeared in the interim, or if an omission had occurred. But it also states: "The Minister of Fine Arts particularly desires that this exhibition be, as much as possible, representative of Canadian contemporary works created in Canada and consequently that the works of ex-Canadians permanently resident abroad, whose works are often seen in Paris, are not included." In his formal response to Masson, Brown stated, "Sir: I have the honour to

acknowledge the receipt of your esteemed communication of January 9th, containing suggestions with regard to the proposed Exhibition of Canadian Art in the Musée du Jeu de Paume. The National Gallery is quite in accord with the views expressed and I am directed to thank you for your letter and to assure you that the exhibition will be arranged in accordance with this plan."[39] The last directive was aimed at several specific artists, including Frank and Caroline Armington, Canadians resident in Paris at the time and competitors of Gagnon in the etching trade.[40] (But if rigorously interpreted, it could equally have applied to Gagnon or Morrice.) In the end, even though Brown publicly insisted that he was working within guidelines set out by the French ministry, it was he, with Gagnon, who created the list of artists to be included in the exhibition. All of this was carefully controlled from the first.

Conversely, the idea for the Morrice retrospective was not part of Brown's vision for the show but came from the French government.[41] This unanticipated turn of events caused problems for Brown, who did not welcome the prospect. French modernism, but especially that occurring after Impressionism, was an embarrassment to Brown. His distaste for it is evident in his correspondence with Gagnon. Both rejected post-Impressionism and more contemporary avant-garde developments in French art. Gagnon was particularly vocal on the topic. In his letters to Brown, he railed against recent, and not so recent, modernist works. He disparaged Paul Gauguin, Vincent Van Gogh, and Paul Cézanne: "They knew well [what] they wanted to paint but they could not do it, hence the tragic lives they went through."[42] He was harsher in his assessment of current work, which he saw as morally degenerate hallucinations.[43] Douglas Ord has pointed out Brown's published antipathy toward post-Impressionism. In the early 1920s Brown also actively opposed anything beyond post-Impressionism, which he referred to using the blanket term "futurism," as morally and artistically "degenerate" and linked to Bolshevism.[44] However, his assessment was based on prejudice and ignorance since his knowledge in this area was extremely limited. His tastes in French art, as expressed in his letters to Gagnon, ran to Georges D'Espagnat, Maxime Maufra, Gustave Loiseau, André [?], Henri Moret, Jacques-Émile Blanche, Lucien Simon, Maurice Denis, Alfred Lombard, and Charles Cottet.[45] Almost all of these had reached prominence before the turn of the century. Although several painted in Brittany and had contact with Gauguin and the group of French artists known as the Nabis, most worked in an Impressionist and/or Realist, rather than post-Impressionist, style

that Jensen has termed *juste milieu* – that is, a commercially viable blend-
ing of academic and Impressionist techniques.[46] Since Brown thought that
"the latest French painters are very bad indeed," it was to the earlier *juste
milieu* artists that he turned in 1925 when "thinking over the question of
improving our representation of modern French paintings ... Our British
section is fairly strong." He also asked Gagnon to approach Dayot for sug-
gestions.[47] Brown wanted a show of such "modern" artists for Canada but
warned Gagnon to keep "clear of the ultra modernists."[48] Consequently,
nothing from any of the modernist movements of the twentieth century
entered the collection at this time.

Within this context Morrice posed particular difficulties. Trained and
living primarily in Paris, he had adopted aspects of post-Impressionism
and Fauvism. He was, then, the Canadian artist most associated with
the French avant-garde. Travelling extensively, he had painted side by
side with Henri Matisse in Tangier in 1911 and 1912.[49] Indeed, he had
established Canada's claims to modernism in France, and vice versa. His
works were greatly appreciated both in Canada and internationally and
had been avidly collected from Montreal to Moscow since at least 1904.[50]
He exhibited at the most prestigious venues in Paris. Yet Morrice's works
had not been claimed as part of Canada's national patrimony during the
period when the NGC was supporting the Group. If anything, the reverse
was true. Although the NGC owned three Morrice works by 1912, fur-
ther purchases abruptly ceased after Brown became director. Morrice's
exclusion from the national collection after the first peak in his grow-
ing fame corresponds to broader acquisition patterns. Shortly thereafter
the NGC placed a virtual moratorium on collecting all works by French
modernists.[51] This coincided with the construction, valorization, and dis-
semination by the NGC of a narrative history of a unique Canadian art
residing in nationalist wilderness landscapes by artists such as Thomson
and the Group's members that resisted influences by foreign sources,
bypassed French modernism, and arose spontaneously from an unme-
diated experience of the land, depicted as uninhabited wilderness. The
presence of a French Impressionist and post-Impressionist collection in
Canada that could have been pointed to as a direct influence would have
undermined this narrative in which the Group's modernism was seen as
arising spontaneously from direct contact with the elements of Cana-
dian nature.[52] Morrice's works were, naturally, unwelcome. Conversely,
between 1912 and 1925 the NGC acquired seven paintings by A.Y. Jack-
son, eight by MacDonald, and so on. Insofar as no additional works by

Morrice were added during the same thirteen years, it can be said that Brown had adopted a fairly narrow view of what his mandate to collect Canadian modern painting entailed. The institution acquired additional Morrices in 1925 only after the artist's death and just prior to the Jeu de Paume show. Although the acquisitions from the estate were quantitatively high, the expansion was not met with any enthusiasm nor deemed to be of significance. Brown downplayed them. His annual report listed them collectively as "Twelve panels" and "Nine sketches" rather than giving them separate titles, which he almost always did for works by all other artists in all media from all periods.[53] The selection of what were portrayed as minor, unnamed, smaller pieces indicates a low level of interest and uncertain commitment to the works. But even more telling is that Brown's entry is truncated and omits at least two larger paintings on canvas from the selection.[54] The NGC made no effort to exhibit these recent additions as a body of work by an important Canadian artist.[55]

Exhibition records confirm this marginalization in collection policies and correspondence. Despite Morrice's wide international acclaim and exposure abroad, his work was seldom shown in any number by the institution in Canada, nor was his modernist production represented in exhibitions shown outside the country. Only the early Le Cirque, Montmartre (c. 1904), a dark tonal study done prior to his adoption of a post-Impressionist palette and similar in style to work by the English artist Walter Sickert, acquired in 1912, was seen regularly, but it was the exception rather than the rule.[56] Each of the catalogues for the two exhibitions at Wembley cites only two Morrice entries, even though his death was recent and he was well known in London, where his works would have been readily available for loan.[57] In the years immediately after his death, and despite the recent acquisitions, the NGC did not mount a Canadian retrospective, leaving this to the Art Association of Montreal (AAM), which assembled 111 works, mainly from Canadian collections, in 1925, only two of which came from the NGC.[58] Neither the show, nor any portion thereof, travelled within Canada, although some of it, as will be seen, went to the Jeu de Paume.[59] The NGC's own "memorial" exhibition of Morrice's works would not be held until 1937, when the construction of Canadian identity was undergoing another shift that would allow for the inclusion of French modernism.[60] Contrary to the popular narrative that the Group was neglected during the 1910s and 1920s, in actual practice, it was Morrice's work and French modernism that were systematically marginalized by the NGC.

This was not the case in France. Following Morrice's death, he had been celebrated in two posthumous exhibitions in Paris, the first hosted by the Société du Salon d'Automne in late 1924.[61] Dayot published an article on him in 1925 and wrote a catalogue essay for the second memorial exhibition of fifty-three works at the Galeries Simonson held in January 1926.[62] This was accompanied by a note by Matisse himself. The French government was planning yet another retrospective.[63]

Although Morrice was undeniably an artist of great ability, the questions still remain: Why the intense interest in France in this Canadian at this time? Why was he visible in Paris but not in Ottawa? The answer lies in the second aspect of French artistic programs in the 1920s. After the disasters of the First World War, France wished to establish its primacy as the leader in art, especially against what was perceived as "international" – that is, German – influences.[64] In contrast to regionalism, the *rappel à l'ordre* linked French national identity with a modernism that had been modified and refined by a classical French tradition with a glorious genealogy.[65] Morrice's exquisite, representational paintings, with their emphasis on subtle colour and smooth surfaces, and the simple, clear compositions of his larger works (in contrast to his more spontaneous paintings on small panels, called *pochades*) would have both fit within the parameters of the *rappel à l'ordre* and established France's claim to being the source of modernism in the arts in Canada. Dayot, then, who also supported the *rappel*, was as interested in Morrice as in Gagnon, both of whom fit into the French critical climate of the period. In fact, the two occupied the two poles of the postwar years: the *rappel* and regionalism. Their work could be used to support and illustrate a historical narrative in which French modernism in both its current forms could be seen as having influenced and even as having been the basis for current Canadian painting since both clearly demonstrated what Silver has called the "propagation of French taste" within Canada.[66]

Brown, however, had another, conflicting narrative in mind that privileged neither Morrice nor French modernism, in whatever form. Instead, it was explicitly written against the influence of French modernism on Canadian art. How, then, to deal with the situation? Having been confronted with the inevitability of a Morrice retrospective, his initial plans called for an equal balance between Morrice and Thomson, with each represented by between fifteen and twenty paintings. Yet the NGC held back all of the 1925 acquisitions and again sent only Morrice's by then dated *Au Cirque*. This indicates that Brown collected the works from the

estate in order to make them invisible. He contributed little else and acted only passively after this point. In February 1927, somewhat late in the game, he displayed his indifference by handing responsibility for the Morrice retrospective to a trustee who was also on the Board of the Art Association of Montreal, Dr. Francis Shepherd.[67] Brown was precise in his instructions: "The French Government has specially requested that the exhibition include a retrospective of from fifteen to twenty pictures by Morrice and Thomson and it is the representation of the former that I am writing about, as I know that you are aware where most of the best ones are and can probably obtain the loan of them without much trouble. There are about half a dozen which the French Government would like to include from France, either owned by the Luxembourg or privately. That leaves fifteen or so."[68]

By abdicating responsibility, Brown allowed the retrospective to slip from his control. Given free rein, Shepherd pursued this task with more than due diligence. Even with the short notice, the works he assembled from Montreal and Ottawa collections exceeded twenty.[69] Many had appeared at the AAM's 1925 retrospective. Four came from the AAM and two from the Mount Royal Club. Most came from private collections. Mrs. J.R. Wilson loaned two, and Morrice's niece Mrs. Allan G. Law did likewise, while several came from other members of the Morrice family. Several individual loans also contributed to the twenty-three works listed in the catalogue as coming from Canada. By the time Brown sent out the letters to the collectors asking for loans, he had to acknowledge that his initial limit had been exceeded. However, he assumed that only a small number of additional works would be added in Paris. He was in error.

It is uncertain who took the initiative to solicit paintings from the Parisian collectors, although the NGC was certainly not involved.[70] In any case, it was here that the exhibition expanded well beyond Brown's initial limits. As with the AAM's exhibition, the previous retrospective at Simonson's was a major source of Morrice canvases, and again there was little reliance on public collections, with a single work coming from the Musée national du Luxembourg. However, private collectors were exceedingly generous. Eleven came from Simonson, including recent works from Cuba and Trinidad.[71] This enormous addition shifted the emphasis away from Morrice's Canadian works, which Brown wanted to highlight. The remaining lenders were a prestigious lot: Jacques Rouché, the director of the Paris Opera, an important collector of Morrice's works, loaned four, as did both André Schoeller, who was associated with the important

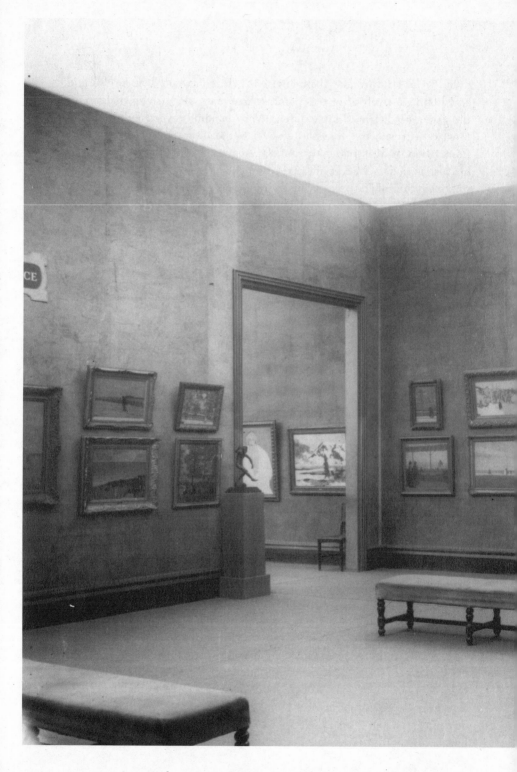

FIGURE 8: James Wilson Morrice section, *Exposition d'art canadien*, Musée du Jeu de Paume, Paris, 1927.

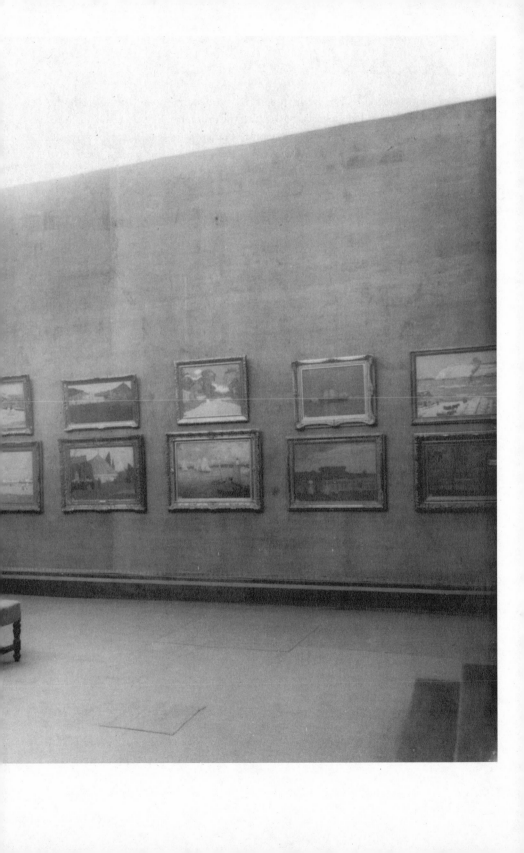

gallery owner George Petit, and Franz Jourdain, president of both the Syndicat de la Presse artistique and the Société du Salon d'Automne. Charles Masson also loaned a work. The presence of Morrice's works within these official and elevated private circles indicates the degree of importance attached to him within France.

With the addition of the French contributions, the Morrice retrospective ballooned. In stark contrast to both Wembley shows, Morrice ended up with far more works than any other artist: forty-eight oils, which was two to three times Brown's initial proposal. All were of significant size. There were no drawings listed in the catalogue, as there were for many other artists, nor were any deemed sketches or *pochades*, as had been the case in Montreal. Given their sheer quantity, Morrice's paintings were set apart in a separate room, rather than integrated into the Canadian exhibition (see Figure 8). They were hung in two rows, one above the other, rather than in a single line. Intentionally or not, the Morrice retrospective took on the image of a separate, unified show that paralleled that of the NGC. Although the division in the installation corresponded to Brown's construction of the narrative of Canadian art by placing Morrice outside of the Canadian context, it would present serious problems for the critical evaluations by setting up a contrast between the two and allowing for a conflicting historical interpretation.

Despite the final proportion of Morrice's works, Brown had another vision of the exhibition's priorities. Writing to Dr. MacCallum in February of 1927 to request the loan of work by Thomson, Brown stated: "I want to make the Thomson group as important as possible" – that is, privileged over Morrice.[72] This would not be so easy. Thomson's career had been far shorter, he had died much earlier, his output had been less, and MacCallum declined to lend an important piece, although he was accommodating with four others.[73] In the end, Brown was able to access only thirteen works (see Figure 9). Over half came from institutions: four from the NGC and one each from the Art Gallery of Toronto, the AAM, and the City of Sarnia. Two came from the artist's family. The total included a repeat of the trio of large studio pieces shown at the first Wembley exhibition but not seen in 1925: *The West Wind*, *The Jack Pine*, and *Northern River*.

There were also additional pieces to compensate for some odd omissions earlier in England, such as the absence of works by Maurice Cullen, and to stave off criticism, but the additional loans from both private and public sources were largely intended to buttress Group representation.[74]

In the end, the Jeu de Paume exhibition was more finely focused than either Wembley show. Sixty-four names were listed in the catalogue with 268 entries, a far larger number of works than in England but with far fewer artists represented.[75] This meant the potential to display more works by each artist. However, the difference was not evenly distributed. Rather, the proportion of the Group's works at the Jeu de Paume greatly exceeded that at either Wembley show. Of the fifty-nine painters, ten were associated with the Group, including all seven as it then stood, plus Thomson, Edwin Holgate, and Johnston, the latter two of whom either had been or would be members. They were represented by more works each than anyone else, excepting Morrice, Gagnon – who was represented by four paintings, three etchings, and an unnumbered selection of his coloured *Le Grand Silence blanc* illustrations – and, oddly, W.J. Phillips, the woodcut and watercolour artist, who attracted little critical attention. Jackson was represented by eight entries, including three drawings; Holgate by eight, with four woodcuts; Harris by seven, of which three were drawings; Lismer by six, of which two were drawings; MacDonald by five, including one drawing; Varley by five, including one drawing; Carmichael by four, one of which was a watercolour; Casson by three; and Johnston by two, including a tempera – forty-eight works in all. Although this was equal to Morrice's total, with Thomson's entries the number rose to sixty-one, about one-quarter of the paintings, drawings, and prints in the exhibition. This ratio would have shifted upward if Brown's initial limit of fifteen to twenty Morrices had been followed. With Morrice's canvases, the number of works by him and Group members or associates came to almost half of the total, leaving the other half for everyone else.

In contrast, beginning alphabetically, Paul Alfred was represented by four; Dorothy Stevens Austen by two, both prints; Harold Beament by four, including two drawings; J.W. Beatty by two; Franklin Brownell by two; William Brymner by two; F.S. Challener by four, three of which were drawings; Ronald J.A. Chalmers by two, both drawings; E. Grace Coombs by one; Maurice Cullen by four; H. Valentine Fanshaw by two, both colour woodblocks; L.L. Fosbery by one; Margaret Frame by one; W.F.G. Godfrey by one; Thomas Garland Greene by one; Edmund Geoffrey Grier by one; Fred S. Haines by one, a print; and so on. All of these others appeared as isolated artists working more or less alone, as did Morrice. Only the Group of Seven had an overall agenda, which would give strength to their message through constant repetition. The genealogy of

the Group, and thus of modern Canadian art, was established through the retrospective of Tom Thomson's work. The history of the influence of French modernism on Canada was obscured.

This unequal balancing of the exhibition substantiated the protesters' case. They claimed that in selecting works for international exhibitions, Brown was less than impartial and was promoting the Group to the exclusion of the majority of other artists in the country. The proportions of works within the exhibition indicate that Brown consciously weighted the exhibition in favour of the Group to ensure their separation and recognition and to clearly establish the difference and uniqueness of this Canadian national art. In this respect, despite often repeated claims of neglect, institutional support was never a problem for the Group. Rather, precisely the reverse was true: there was a lack of institutional support for Morrice and modernism.

Given the exhibition's clear focus, expectations were high. A repeat of the Wembley triumphs was anticipated. Jackson was confident that the claims for the Group would be legible to the Parisian public. Positioning himself and his associates as the heroic proponents of modernism and nationalism in Canada, he initially represented the show in terms of the conflicts that had occurred at Wembley between the the RCA and the joint forces of the Group and the NGC. In his eyes, it was no contest. By this time he saw the RCA as a straw dog that was easily outmanoeuvred. Jackson outlined his pleasure at baiting an institution now marginalized and deprived of power: "It's kind of fun skating round them [the RCA] and knocking the puck between their silly legs. In the meantime everything they touch fades away and dies."[76] Anticipating success, he still noted the potential problems that Brown faced at home: "Brown is having a rough time: the Academy gentlemen will be filled with anguish if the exhibition is a big success and they will do anything to reduce it to mediocrity ... The show in Paris should be the very boldest work we can get together. It will not shock even the most conventional bourgeoisie over there. While our academic stuff will be sniffed at by their academic painters."[77]

Later, as the controversy over the one-sided selections for the exhibition flared up, Jackson redefined the principles in the conflict. The RCA refused to rise to the provocations and kept distant from the brouhaha. Although Hill, following Reid, implies that the RCA was behind this round of protests, Jackson says that this was not the case.[78] The protests that did occur were led by an independent group of artists acting autonomously. Jackson subsequently reported that Fosbury, who had only one

piece in Paris, "expected the Academy to back him up, but outside of old Hammond they kept out. it [sic] was not seemly for Academicians to join a row started by an associate."[79] However, Jackson publicly reiterated his defence of Brown's preference for the Group in terms that implicated the RCA: "To send to Paris, where every workman on the street is familiar with the most modern types of European work, an exhibit of traditionally painted stuff would be the height of folly, Paris is not interested in seeing an antiquated, colonial exhibition ... It is the modern painting that will attract attention there."[80] But Jackson was mistaken about the conditions of artistic reception in France in the 1920s. While correct in assuming that modernist works would be appreciated, he completely misread what would be seen as such.

Conversely, the Canadian organizers realized the problems that the Group's works might have with those unfamiliar with their claims. As in England, they made a concerted effort to inform the French critics and publics of the exhibition on the issues of Canadian art and to shape the critical reception of the exhibition by insisting on certain readings while foreclosing others. Brown's lengthy lead-up article in Dayot's journal, *L'Art et les Artistes*, was designed to ensure that the French critics would be educated in and able to rearticulate the claims and codes of the work.[81] Brown's first draft had been written as early as 1925 as part of the preliminary negotiations for the exhibition.[82] At first, he resisted signing the essay. Given the conflicts at home, a mask of anonymity offered tactical advantages. It would have allowed him to pose as an authoritative, but anonymous, speaker, who could have singled out the central role of the Group without being identified.[83] He could not only have avoided the further problems that such a position would have generated in Canada, but at the same time have created the illusion of an already established foreign appreciation and recognition.[84] But the French officials, especially Dayot and Dezarrois, who had been stung by a similar internal national dispute with the earlier Dutch exhibition, which had been criticized for focusing on a small group that was not representative of the diversity of that nation's art, insisted that Brown declare himself the author.[85]

Brown's fifteen-page article laid out a canonic, and now fairly complete, narrative of Canadian art that led, through a refinement of an inexorable historicist logic, to the present exhibition. However, his construction was not without exclusions and ambiguities, which he had established in his earlier compositions. By initially passing over the French colonial period, he claimed that the real issues in Canadian art arose with the arrival of

FIGURE 9: Tom Thomson retrospective, *Exposition d'art canadien*, Musée du Jeu de Paume, Paris, 1927.

the British topographical artists. For these he had high praise: although the lesser were disparaged, "the best had produced works which recalled that school of watercolourists from the end of the eighteenth century and the beginning of the nineteenth which have always been considered as one of the glorious marks of British art."[86] This reading both privileged landscape and gave a monocultural cast to his narrative. It confirmed the origins of "Canadian" painting as landscape, which in turn came from Britain, a connection that Brown was at pains to establish. He added that other, older histories were also being studied, including the work of the Natives of the West Coast and a current of traditional French carving and painting, situated on the other edge of the continent, which dated back to the colonial period. But of these he gave little account. The inclusion of the French material, in fact, was negotiated only at the last minute in a final revision at the suggestion of H.O. McCurry: "A fresh copy of the article on Canadian art is being sent to you at once. I suggested to Mr. Brown that he should introduce something about early French art in Canada and he has done so. It makes a pleasant connection with old France."[87] Nonetheless, even with this diplomatic concession, Brown placed both the Native and French Canadian work in the deep history of the new nation rather than its present.[88] With an aside to the difficulties facing Canadian artists and a nod to Cornelius Krieghoff and Paul Kane, the remainder was a schematic outline of the development of art in Canada from the past fifty years.

In accounting for Morrice, Brown's ambivalence to the artist and to the role of French modernism in Canada became clear. In contrast both to Morrice's retrospective and to Brown's publisher's and sponsor's obvious interest in the subject, he virtually excluded Morrice from the discussion. He mentioned him only in two sentences. Further, although Morrice was, at this point, coterminous with the Group, having died seven years after Thomson, and although he was associated with Matisse, Brown placed him within his discussion of the art produced decades before Thomson and the Group, let alone Matisse, situated textually between Homer Watson and Horatio Walker at a time when "the temperament of the country was still very colonial and imitative."[89] In Brown's narration, Morrice was less than original and outside the framework of current Canadian modernism, which was read as occurring after, rather than alongside or through, him. Accommodation meant temporal displacement.

Accounting for French post-Impressionist influences posed similar problems. Brown did acknowledge something of a connection in Canada

but regarded it as a "contre-coup" that "had not been completely ignored." He situated it as a parallel but separate development rather than as a direct influence.[90] He mentioned no specific connections to any artists. He then textually placed it in the past by concluding that only after this develop- ment did "the colonial spirit cede its place to the national spirit."[91] The repositioning of French modernism as a prior stage in the evolution of a "later," national Canadian modernism may not have played well with his French audiences, his sponsors, or even his publisher, but it was one of the risks that Brown had to take to ensure the fundamentals of his narrative structure, which produced a "native," uninfluenced, modern Canadian art that was nevertheless tied, if surreptitiously, to England.[92]

This Canadian modernism, of course, began not with Morrice, who was referred to in passing as a stepping stone, but with Tom Thomson and the Group of Seven, on whom Brown expounded at length and to whom he directed the reader's attention. Brown included a brief biography of Thomson, named all the Group's members, gave them a genealogy and a collective program, and cited their separate characteristics. He included almost all the elements of the established story and provided the critics with a lesson in the necessary jargon. He explained how Thomson and the Group, as "pioneers," had encountered the "primitive wilderness" armed with "canoes and tents" and how they had drawn their inspiration directly from the land. By reiterating that Thomson was virtually without formal training and that he had gained his competence through commercial art, Brown got around any indebtedness to French post-Impressionism and supported the claim that Thomson and the Group's members were not influenced by outside sources but were at once "indigenous and spontane- ous" as well as modern. This was an ingenious argument but one that eventually would lead to several problems. He also positioned them, rather than Morrice, as marginalized, outlining their neglect by the public, especially the buying public, and their hostile reception by the critical press. He never mentioned institutional neglect. With his name on the article, and the number of their works that came from the NGC, this would have been too obvious a contradiction. He insisted on their nationalism, modernism, and mastery and claimed that this had all been proven by the triumphant responses at Wembley, where their clarity of colour, hardiness of design, and the mastery with which they had cap- tured the characteristics of the landscape were all noted. He concluded that Canada, although young, had produced a "great national art" and left it to the French critics to give it recognition.[93]

The article was richly illustrated. Of the twenty images, eleven
were devoted either to Gagnon, represented by the lead picture, or to
Thomson and past, present, or future Group members. Yet even within
this plenitude, there were no examples of Morrice's work.[94] Both
textually and visually, he remained outside the construction of modern,
or even historical, Canadian painting. Nor were there any illustrations of
works by any artist that might have been said to exhibit modern French
influence.

A second, albeit smaller, and nonillustrated lead-up article was pro-
duced by Thiébault-Sisson, a prominent Parisian critic who had been
engaged by the NGC to smooth the path between the Canadian work and
the French public.[95] It was here, however, that problems in transmitting
the message across the ocean must have first become apparent. Thiébault-
Sisson's notice appeared in Le Temps in late March 1927. Although it was
meant to inform the audience of the forthcoming show, he made several
errors of tact and fact. He opened by making it clear that the exhibition
had been initiated at the request of the Canadian government and subse-
quently "conceded" by the French. He recovered, however, by declaring
the newness of the young artists' work and its direct relationship to an
unmediated, if excessively romanticized, experience of the wilderness.
He also declared Thomson an autodidact, thus emphasizing the absence
of French influence. However, he went on to improvise on his mythic
status by having him killed by marauding Indians.[96] He then detracted
from this central figure, who had produced his modernism without Pari-
sian influence, by offering an alternative. He recounted a romantic tale
of an unnamed trapper artist who saved to go to Paris in order to learn
to properly paint the wonders of the Canadian wilds.[97] This undermined
the premise of the lack of French influence in the Canadian narrative of
woodsmen artists. But probably most disturbing for Brown, he provided
further ammunition to the protesters back home by making transparent
the intimate relationship between artistic production and the state-run
gallery: "The Canadian authorities have followed with a passionate inter-
est the formation and development of this new painting. The director of
the National Gallery of Canada, M. Eric Brandt [sic], who has a penetrat-
ing and lucid intelligence, has understood the importance and the national
character of the movement, and has encouraged it with all his power, and
it is thanks to him that the government of Canada is determined to take
charge of the cost of an exhibition limited to this modernist art, destined
to be made known in Europe."[98] In the brief interim before the exhibit

opened, Thiébault-Sisson must have become more informed about the program, its protocols, and its personnel. As will be shown, he was far more compliant in his second attempt, at least initially.[99]

The second avenue for prompting the critics occurred in the catalogue.[100] It contained a trio of short essays by Brown, Thiébault-Sisson, and Marius Barbeau, an ethnologist, who wrote on the small collection of art by the indigenous peoples of the Northwest Coast. The texts were again meant to educate Parisian audiences and to give them some competence for seeing, decoding, and appreciating the work.

Given its importance, Brown's two-page essay was sketchy.[101] Although titled "Quelques mots sur l'histoire de l'art canadien," it offered only the briefest outline of that important narrative.[102] Truncating his previous essay, he tersely divided his history into two parts. He separated the early stages of colonization and cultural dependency, both French and British lumped together, from a recent school that expressed autonomy and a distinct, true, independent, national art isolated from outside influences. He was also clear that the transition between these historic and modern periods hinged on their respective relationships with the land and its representation – that is, nationalism was embedded in landscape. In early states of colonization when the land was first being worked rather than painted, there was little room for the arts. The French period had, then, only imitative church decorators.[103] Again, it was with the first topographical landscape artists – that is, British army officers with leisure time who arrived after the 1750s – that Canadian landscape art began. By not discussing German and American influences of the mid- to late 1800s, or the Parisian academies' role at the same time, or the influence of French modernism, Brown implied that the English landscape tradition had dominated art in Canada to the end of the 1800s. But then things had changed. Brown claimed that immediately after the turn of the century, a dramatic shift occurred in the depiction of Canada. Any colonially dependent style was suddenly but completely supplanted by a new national image of the land, isolated from outside influences. But while forceful, he was sketchy and his French audiences were left to fill in the rest. From present perspectives it is clear that he could only have been referring to the Group of Seven and Thomson. Although it was they who fulfilled Brown's vision of Canada's nationalist destiny, he could not single them out publicly without confirming precisely what was being claimed by his detractors, who had been clamouring for his head since Wembley. The resulting lacunae in this crucial text may be partly to blame for the confusion among the

French critics, who, if they had not read the earlier article, were left to sort out the Group and their new, uninfluenced, nationalist landscape enterprise within this forest of signs without a reliable guide. The catalogue's illustrations may have helped in this matter. Of the twenty-six, two were of Thomson's work and nine were of works by Group members (all of whom were featured) and their associates, including Holgate and Johnston. Several of the others showed artists who worked with similar imagery. Morrice's single image looked, in this company, as out of place as an urban *boulevardier* wandering a woodland trail.

Many of Brown's points were elaborated in more purple prose in the four-page essay by Thiébault-Sisson, "La première exposition d'art canadien à Paris."[104] Following Brown, Thiébault-Sisson was explicit about the relationship between colonial parent and colony, emphasizing the break that must occur between them in the form and formation of an autochthonic, uninfluenced, unified national art.[105] Keeping with the official story of the opposition to the RCA, he framed the cultural rupture in terms of an antagonism between sterile imported European academic formulae – "un académisme figé" – and an indigenous originality. While he identified only Thomson, he echoed Brown in describing a new unnamed school of artists who would pursue a direct confrontation with nature, camp like trappers in the woods, and discover how to represent the land in rude forms. Again, he could only have been reiterating the mythology of the Group as woodsmen having an unmediated experience with nature. But in so doing he gave them a broader legitimation. Indeed, between Brown and Thiébault-Sisson the audience was cued to sort out pictures that were nationalistic, uninfluenced, unacademic, and showed a wilderness landscape.

But conflicting and unexpected alternative narratives of modernism now arose. Notwithstanding his more-or-less orthodox representation of the Group, Thiébault-Sisson diverged from his earlier article. He now excluded the Group from modernism. He hinted that this quality belonged to Morrice, whom he distinguished from the Group as being European rather than Canadian. He acknowledged that the Group's painting was "new," "hardy," and "fresh" and that it possessed accents pertaining only to itself that were "étourdissants de puissance," but he insisted that the Group's work "had nothing to do with our art which was nuanced, full of fine and delicate passages," such as that by Jules Flandrin, Pierre Laprade, Édouard Vuillard, Pierre Bonnard, and Charles Camoin. Although this evaluation validated national differences, it came at a cost.

He did not restate what he had written before he was fully familiar with and had actually seen the Canadian work – that is, that it fell within the codes of modernism as discerned in and claimed by France as part of its national heritage. Instead, the Canadians' unique accents now separated their work from the language of French modernism. He concluded: "All of this is but a beginning, but a beginning full of promise, which bears already fruit of the richest kind." This placing of Morrice in the present, both as the exemplar of the mastery of modernism and in opposition to the Group, whose members showed promise but whose work pointed to a future fulfillment, is precisely what Brown must have been hoping to avoid.[106] It would have dire consequences.

Thiébault-Sisson ended his essay with an extended appraisal of the Native material, but again he was ambivalent. He noted that it was "veritably autochthonic, but went back several centuries into the past." The emphatic "veritably" cast into doubt his initial use of the uninflected "autochthone," used to describe the Group's art, which, unlike its French regionalist counterpart, did not have claims to a prolonged occupation of the land.

Working within these ambiguous, and at times conflicting, narratives, the press was allowed in on Friday, 9 April, with the official opening ceremonies taking place on the eleventh, prior to the Parisian spring salons of the following month.[107] As at Wembley, Canada's assertion of cultural autonomy was countered by a deference to colonial authority in the personages chosen to grace the occasion. Confirming the Dominion's allegiance to the empire, and the fact that it did not yet have its own ambassadors, Brown's first choice as official patron was the Prince of Wales, although at the opening the British sent only their ambassador to France, the Marquis of Crewe, joined by Philippe Roy, the Canadian high commissioner to France.[108] They greeted the French president, Gaston Doumergue. Many others were listed as patrons.[109] Some consideration was also given to placing a token French Canadian on the honour list, but various candidates were rejected for their association with the RCA. After some discussion of who would be the most suitable choice, the designation finally fell to Senator Raoul Dandurand.[110]

After the opening, the reviews were collected by a clipping service.[111] As with Wembley, the intent was to publish them for the home audience in order to proclaim the triumph of the Group of Seven on the international scene.[112] The responses were numerous. The French reviews, along with those from English-language papers, are now contained within

two albums in the archives of the NGC, where they remain unpublished, except for brief excerpts, to this day.[113] The critical assessment is neither monolithic nor homogeneous, but the trend of the majority is obvious. Hill characterized the reviews collectively as "poor and uninformed," as if there was a privileged and singular way of viewing the work – that advocated by Brown, who, he complained, was "misquoted."[114] What Hill did not recognize was that the Canadian work entered a conflicted and shifting critical discussion precisely around the terms of nationalism, national identity, modernity, and landscape in the visual arts that did not necessarily correspond to Brown's or British formulations.[115] The importance of these issues is indicated by the sheer volume of the reception as well as by those who responded. While many are simple notices that the exhibition was occurring, a good proportion attempted a more complete assessment, much more so than in England. Several eminent and esteemed critics from varying positions wrote more than once, and several journals published more than one review.

Gustave Kahn, the venerable avant-garde critic who had helped found the Symbolist movement, produced two reviews, one for the prestigious journal of the arts *Mercure de France* and one for *Le Quotidien*.[116] The two overlapped substantially. In both, he went on at some length about Morrice, whom he called "un maître incomparable." Kahn discerned aspects of French modernism that gave Morrice's work value and pointed out its finer features' links to French traditions; his mastery, despite the country of his origins, confirmed a French national identity invested in modernity. But Kahn did not recognize a similar possibility for the other work. He brushed by Thomson, dismissing him as a lesser painter, "beaucoup moins fort," thus withholding mastery.[117] This established a comparison, which the two retrospectives invited, but one that did not work in Thomson's favour. Nonetheless, he did note, with a qualification, that Thomson was "the most autochthonic. His motifs are purely Canadian, sought out in the picturesque locales of the scenes and seasons."[118] The term "autochthonic" was a key word within the French regionalist movement for establishing a national identity and claim to the land, but it was invested in peasant imagery that did not correspond to Thomson's and the Group's empty landscapes. This may be why Kahn did not see the picturesque references of the empty landscapes as redeeming, nationalist features, as they were viewed in England. Although he praised MacDonald's *Terre de silence*, he did not single out the Group or their nationalist agenda – indeed, he implied their British precedent.

René-Jean, author and critic, wrote twice for *Comoedia*.[119] His first two-page article was illustrated with Holgate's *Le Bûcheron* and Gagnon's *Laurentian Village*, which he called "Le village de Maria Chapdelaine." These choices, depicting a rustic, rural population, reaffirmed French regionalism's concomitant focus on peasant imagery.[120] Setting Morrice apart, he rhetorically stated (twice) that "at first sight ... the present collection will no doubt appear lacking interest." But striving to find positive things to say about the other work, he lumped together Thomson, Varley, Cullen, Gagnon, Lismer, and MacDonald with Albert Robinson, Marc-Aurèle de Foy Suzor-Coté, Harold Beament, Herbert Palmer, G.A. Kulmala, Percy Woodcock, and Homer Watson. That is, he did not recognize the differences that set the Group apart, nor did he appreciate all of their works, as he excluded Harris and Jackson. He cited the complete absence of any possible comparison to the French painter André Dunoyer de Segonzac, whom Golan has identified as "a former modernist turned naturalist," or *terrien* (son of the national soil), whose recent peasant imagery was exemplary of the regionalist/modernist movement.[121] It becomes evident here that the Canadian landscapes (outside of Gagnon's), with their emphasis on the empty wilderness, fit only partially into this construction. The uneasy comparison led René-Jean to describe the landscapes as "undeniably strong, even a little brutal."

In his second long article, René-Jean regretted the inclusion of Morrice, who he felt was not Canadian.[122] Yet, rather than defining this term, or how it might be invested in the other work, he pointed out what was "lacking" — that is, nuance, subtlety, refinement, and a critical sense. Through this negative comparison, the Canadian work confirmed the classical principles associated with the French *rappel à l'ordre*. But it also confirmed the regionalist position, which, as Golan has pointed out, "linked France's cultural vitality to the strength of its rootedness in the soil" through the presence of an autochthonic peasantry.[123] Again, René-Jean brought up de Segonzac's peasant productions in which, as with a number of other French landscapists, "one feels always the presence, intangible but real, of man ... [of] the successive generations of laborers" — that is, an occupation of the land by an ancient *volk*, which gave their works national character. "It is quite the reverse with the Canadian painters," who, while "hardy," "do not trouble themselves with useless analysis." Picking up on Brown's cues, he did note the vigour, health, and robustness of the Canadians, and saw them as entering the woods with an "Indian canoe, only a tent, some blankets, food and painting materials."

However, he used this image, which Brown offered as quintessentially Canadian, as a point of contrast to speak at length about the virtues and superiority of French art. This hierarchy devalued the Canadian painting, which, outside of Morrice's and Gagnon's work, seemed to occupy a no-man's-land between the extremes of the *rappel* and regionalism. He wondered what Matisse would have thought of Thomson's followers, who "shout. They do not understand the art of suggestion ... mystery." "Their art lacks the power to portray the subtleties, the evanescent charm of atmosphere, in which the painters of our Salons so excel."[124] He then questioned Brown's claim that Canadian artists developed unaware of current movements, citing the flow of information in journals and collections as well as the presence of Fauvism in Morrice. Dismissing the rest of the exhibition, he concluded with a paragraph on the superiority of French art and the absence of French names from the Canadian roster.

Even those directly associated with the exhibition went astray. Arsène Alexandre, who is listed in the catalogue as Inspecteur Général des Beaux-Arts and who was on the Comité de patronage, was also a critic and art historian of some esteem.[125] He was no stranger to asserting national identity in the visual arts. Since at least the First World War, he had played an active role in defining race and culture in French national modernist art that was part of the *rappel à l'ordre*.[126] He, too, wrote twice. At first, he endowed the Canadian material with the qualities to which it aspired, noting in *Le Figaro*: "This Canadian School is really new. It has not felt the influence, either of cubism, or of the old impressionism, or yet of mud painting" – that is, the deleterious effects of wayward trends in modernism.[127]

Following up in his own journal, *La Renaissance des arts français et des industries de luxe*, which rivalled Dayot's review as "among regionalism's most vocal champions," Alexandre did a credible job of reiterating Brown.[128] "In Canada, he [Brown] says, we are isolated from outside stylistic influences; the seasons are extraordinary, splendid, the climate at home is exceptionally clear. These circumstances have given birth to a school, more or less a particular manner of painting." Despite the equivocation implied by his "more or less," Alexandre was able to isolate most of the Group and their associates.[129]

It was, however, in their claims to mastery and modernism that things went amiss. Alexandre's title referred to the new school of Canadian landscape artists as "Primitives," a category suggested by Brown in terms of the "primitive wilderness" that they painted. Yet it was not

taken up as such in France. "Primitive" was an ambiguous term with an overabundance of possible significations. It could place the work within the complex discourse of the tribal Other, which was reaching a peak in Paris precisely at this moment. But in the context of the exhibition, this connotation would have been reserved for the Native art. Alexandre was instead referring to the artists through a related, but distinct, meaning of the term, as being innocent of influence or academic training.[130] Although unstated, and perhaps unrealized, this was also an integral part of Brown's argument for the Group's native originality, their absence of outside influence, and their separation from colonial ties. In this instance, Alexandre was extending these arguments to their logical conclusion. If the artists from this nascent nation were autodidacts, as was claimed, then it proceeded naturally that they were untrained, untutored, and hence rude but potentially fresh, vigorous, and sincere. Such words and phrases appeared repeatedly throughout the reviews. The problem with such an assessment was that it was double-edged. On the one hand, it attempted to fit the Canadian national movement within the discussion of regionalism and nationalism as it had taken shape in France — that is, to offer it validation for its attachment to the land.[131] A new wave of "primitive" artists had, in fact, emerged in France to justify these claims. Yet it also reduced the status of the Group and their associates to less than that of the modern masters and opened them up to patronizing remarks.[132] In this sense, "primitive" would have meant not yet having attained or mastered the full possibilities of the art and would thus have implied "childlike" and "*naïf.*" This became particularly evident when it was placed in opposition to the French sophistication and refinement figured in Morrice. Such condescension would have been particularly painful for a country that was just emerging from colonial status and that harboured fragile, unproven pretensions to its own mature and fully formed identity.[133] For the Canadians in France, the appellation of "primitive" undercut, rather than confirmed, claims to a unified nationalist position and a mastery of modernism. This assessment was reiterated by other critics who employed it to different ends — that is, to indicate that although the Group might have desired to be modernist and nationalistic, it fell short of the mark, showing only a "promise" that had not yet fully matured.

Such was the importance of, and consensus on, this point in France that it was shared by both the left and the right. The reviewer for the ultra-right-wing journal *Action Française*, "R.R.," was the most explicit on this point.[134] Writing at some length, he theorized that those French

Canadian artists who came to France to study were inevitably assimi-
lated into a French artistic sensibility. It was a different matter for the
English-speaking landscape artists, whom he linked to England through
their subject matter. He claimed that the new national painting could not
have emerged without the experience of French art both in Europe and
in Canada: "It would have been nothing short of marvellous, had they
had the strength to liberate themselves from the French manner, however
poorly suited they felt it was to the Canadian landscape. They have failed
to attain their end. With the greater number, we might even say, with
all of them, a conflict is apparent between an accepted technique, fine
perhaps in its way, and the subjects they want it to depict."

This assessment, of course, excepted Morrice, who was "in a class by
himself." R.R. noted that Thomson, while "a true Canadian painter," was
not up to the task before him: "How can we fail to see in his work the
unequal struggle between the subject of a superb novelty, and the means
of interpretation not supple enough for what it wishes to render? His paint-
ing turns easily to the vignette style." The others are tarred with the same
brush as "awkward and archaic": "They recall to our minds the agreeable
clumsiness of our exotic poets of the descriptive school, trying to make
us feel the beauties of the tropics in the language and the versification of
Voltaire. Other Canadian painters, however, have let themselves slip into
a rather too easy ruggedness ... A.Y. Jackson, Lawren Harris, Franklin
Carmichael, F.M. Johnston, Alfred Casson, Albert Robinson, sensitive
poets all, whose language has not yet reached maturity." Even as *naïfs*,
then, the Canadian artists failed. Gagnon, however, who fit more readily
within the regionalist discourse, particularly as it was conceived on the
far right, got high praise as a "finished painter and very original."[135]

The recurring, but embarrassing, references to an immature "primi-
tivism," without a corresponding mastery, since Morrice had been both
claimed by the French and rejected by Canada, were never again men-
tioned by Brown or the Group in subsequent discussion of the latter's
art.[136] Recognizing the validity of the term would have contravened any
claim by the Canadian artists to being masters of modernism, an impor-
tant component of their image that had been undermined by the com-
parisons with Morrice. This apparent, but as yet unstated, contradiction
– now made explicit by the French critics – partly accounts for the need
to erase this response from the history of Canadian art, to conceal rather
than publicize the reviews, and to ensure that mastery was reclaimed and
that primitivism, in this sense, was either denied or displaced elsewhere.

But these were not the only problems. Charles Chassé, writing at length for *Le Figaro hebdomadaire*, produced another extensive response.[137] He, too, opened by faithfully recapitulating Brown, but then abruptly parted from the given script. Over half of the article linked the Canadian artists with the indigenous peoples of Canada in terms of their shared relationship with the land, explaining that this commonality was why Native work had been included and how it was the true foundation for Canadian artists. "In seeking to be themselves, they were surprised to discover that they too had become followers of tradition; they saw that they were the sons, not in blood, but in heart, of those dusky foes of their forefathers" (des Indiens que leurs grand-pères à eux avaient pourchassés).[138] Chassé, however, unaware that the "Indians" were at the time being erased by these very artists from the representations of Canada, implied their continued presence as the ancient, autochthonic, and originary *volk* from which Canadian culture sprang. He declared that in using Native art as a base, the new Canadian artists had become truly national, citing as a model the return among contemporary French artists of the regionalist movement to the art of the Middle Ages, which Golan has termed "neo-medievalism."[139] "Canadian artists are looking for inspiration, not to the English School of the 18th century, nor the French School of the 19th century (which has some representatives in the Province of Quebec) but to that primitive Indian art, the direct descendants of which they feel they are."[140] This assertion, which attempted to reconcile the Group's enterprise with another aspect of the critical discourse of regionalism within France, by placing it within an ancient tradition tied to the land and an ancient past, flew in the face of the assertion that the former was absolutely new, without precedent, or at most arose from an intimate union of Thomson and nature, both of whom were presumably virgin beforehand. The problem here was that the term "autochthonic" carried different meanings in France and in Canada, or at least in white Anglo-Canada. In the former it was tied to an ancient *volk*, a peasantry that had occupied the land for centuries, while in the latter, which lacked such a group, it meant arising directly and spontaneously from the land itself.

But equally devastating must have been the reviews by those writers who mentioned neither the Group nor their enterprise. Xavier d'Orfeuil, writing for *Gaulois*, cited fourteen artists, but mentioned only Varley and Thomson.[141] Or by those writers who seemed to appreciate the Group, but then qualified their stance, as did Paul Fierens, who praised Thomson, offered faint praise of Jackson, but criticized Harris as "a little dry,

a little hard, a little *en fer blanc*."[142] Or the review by Marthe Maldidier, who began by stating that the "exhibition ... surpasses in interest that of our own official salons" but ended by saying: "But how tired one gets! The exhibition appears dull, monotonous, thin. One longs for a few bright spots. One wishes a ray of sunshine pierce just a little the gloom of this congealed iciness. Few portraits, and these crudely painted, without flexibility or transparency. No nudes. Are there no lovely women in Canada? Nothing but landscapes, landscapes, landscapes."[143] The writer for the popular conservative weekly *L'Illustration* also began by citing the official line but finished by calling the work promising but unfilled: "Yet, in this collection, where the gropings of the primitives are still in evidence, we discern a power, which strives to become more disciplined, and more supple."[144] Or the reviews by those who seemed to recognize the Canadian landscape movement, but then ascribed it to a noncanonic list, as did René Chavance, writing for *Liberté*, and the reviewer for *Petit Parisien*.[145] Or by those who, as in the important journal *L'Amour de l'art*, mentioned only the Native material.[146] Or by those who saw nothing of interest at all, such as the anonymous writer for *Intransigeant*, who stated that the exhibition "did not reveal any outstanding artists" and referred to Thomson as "Louis."[147]

Things worsened outside of France. The reviewer for *Nation belge*, L. Dumont-Wilden, expressly denied the nationality of the work. He asked, "Can these new or renewed countries, whose national consciousness, still in an embryonic stage, ... have a really original school of art? For my part, I greatly doubt it, and this exhibition of Canadian art will surely not cure me of this doubt." He saw little difference between the work of such artists as Casson, Cullen, Harris, and MacDonald and "that of their European confreres of the same epoch."[148]

There was even trouble in the normally reliable English press. Wyndam Lewis, writing for the *Weekly Dispatch*, treated the show with great irony. Playing on the stereotypes fostered by Brown, he stated that the works were "all (no doubt) painted in log shacks by great hairy men with clearcut bronzed features, keen eyes and open necks." He perceptively summarized the double-edged nature of the Parisian response, albeit in British terms: "The Paris art critics rightly praise the virility and robust good-health of these Canadian painters, at the same time noting their lack of subtlety, almost in the words of the gentleman who criticised Dr. Johnson's stageplay: 'Strong sense ungraced by sweetness or decorum.'"[149]

This is not to say that there were not good reviews that read the exhibition as it seemed to have been intended. The anonymous writer for *Le*

Temps was more than laudatory, singled out Thomson and the Group, and omitted mention of Morrice.[150] René-Jean, writing for the *Petit Provençal*, who used a Jackson illustration, the only one in the reviews, also kept the story straight.[151] G. Denoinville, writing for *Le Journal des arts*, although he spent much of his review rhapsodizing about Morrice, did give Thomson his due: "He has portrayed, with a very real ability, the characteristics of its [Canada's] superlative but often austere beauty. His art has a marked personal character. It does not suggest the slightest foreign reminiscence. His native land has given him an infinite variety of subjects, which did not even call for interpretation." He also identified the majority of Group members as "the real innovators of this youthful art of Canada ... who, in following their own inspiration, have strived to depict the aspects of their country, by synthesizing the aspects of its lofty mountains and its vast and frozen solitudes." The only sour note here was in his conclusion: "These pride themselves on being the real exponents of primitive simplicity."[152] A similar position was taken by Roger Dardenne in *Le Figaro artistique*.[153] There was also a review that managed to reconcile the work of Thomson and the Group with the regionalist discourse, *terroir*, and modernism without recourse to primitivism or the Native as well as to position Thomson as more interesting than Morrice without referring to the latter's refinement.[154] Unfortunately, the anonymous author of this short assessment did not expand on these points. This review, which appeared belatedly in June, and was almost made to order, may have been too little too late. There is no translation in the files, indicating that by the time it was received, the NGC had given up on the publication project. This would be understandable, as the four previous notices were, by far, in the minority. Even if allowances are made for other positive reviews that were not present in the file, the total would not have come close to providing the number necessary to furnish a volume for Canadian audiences. Indeed, calling attention to the reviews would have been a dangerous proposition. If Brown's opponents had gotten hold of the responses, they might have used them against him and the Group. It is easy to see why the plan to publish was scrapped.

Yet, from other perspectives, there is enough that is positive in the reviews, despite the failure of the Group and the NGC to achieve their goals, to warrant calling the show a success. If, for example, the NGC had been interested in integrating Morrice's work into its nationalist message, or even Gagnon's, a selection of the clippings could have been given banner headlines reading "Morrice's modernism triumphs in Paris." The fact that no such collection appeared, nor was even mentioned as a

possibility, clearly indicates that "success" and "Canadian" art had highly restricted meanings for Brown. Morrice's triumph, as well as the emphasis on Gagnon, only compounded the failure of the exhibition to validate the Group of Seven's work, on which the claims of national identity were based.

After the exhibition, Brown was confronted with the difficult task of dealing with the positive critical reception to Morrice and the preponderance of negative responses to the Group.[155] He made various attempts to put a positive spin on the situation. Writing to A.H. Robson to turn down the request from the Art Gallery of Toronto for the Jeu de Paume exhibition, he stated that the latter "was an immense success in Paris. It received the best press that any exhibition at the Jeu de Paume gallery has received and the critics and interested people were enthusiastic over its novelty, originality and nationality ... The Wembley and Paris exhibitions have been a very great success and the criticisms have been excellent and will stand for all time as the British and French opinions on Canadian art."[156] It must be kept in mind, however, that the reviews had not yet been translated and that what he seems to have been referring to was the response to Morrice and French nationalism.

After the reviews were translated and the decision made to suppress them, Brown could not deny what had occurred, but he could attempt to minimize and contain it. In his *Annual Report*, Brown laid out his intentions and his version of the outcome of the enterprise:

> In forming the exhibition, the suggestions of the French government were closely followed and the collection which resulted undoubtedly constituted the most important and comprehensive exhibition of Canadian art which has ever been brought together outside Canada. The first official appearance of Canadian art in what is generally regarded as the art capital of the world, was therefore made under appropriately *favourable* circumstances.
> The reception accorded the exhibition by the French art critics was extremely *favourable*.
> The general tone of the press comments and articles was as *favourable* as those of the British press at the Wembley Exhibition and the prestige of Canadian art was thereby firmly established in France and greatly enhanced generally.[157]

He demonstrated the validity of this compulsive repetition of "favourables" with a selection of eight of the reviews. He was judicious in his

selections and chose the most positive. Even so, he was forced to include
reviews that were at best stinting in their praise and even some with
negative comments.[158] From the latter, he edited out the worst, such as
Alexandre's mention of the "primitive" and R.R.'s damning assessment
of Thomson. The impression for the limited readership would have been
credible but not representational.

Simultaneously, for a broader audience, Brown published an article
in *Canadian Forum*, which by this time had become the mouthpiece of
the Group.[159] Again, he attempted to put a positive spin on the nega-
tive French critical reception. Reiterating his invention of the "invita-
tion" from France, based on the presumed prior Parisian recognition of
the Canadian work at Wembley, he nonetheless warned from the start
that "Paris is the most critical and capricious art audience in the world."
Noting the "trepidation" experienced by exhibiting there, he voiced his
apprehension, stating that "the critical verdict not unnaturally [was]
awaited with some anxiety." The anxiety was justified. "This verdict,
while it contained a modicum of the inevitable effort to be funny for the
sake of the tabloid addict, was generally uniform, and greatly generous in
its appreciation." Given the actual reviews, this attempt to downplay the
negative by dismissing it as lacking in seriousness – that is, as being both
capricious and meant for a lowbrow audience – and to qualify the positive
as "generally uniform" is about the best he could do in the circumstances.
He acknowledged that Morrice, "enshrined in the Parisian tradition as
a Frenchman, was obviously expected to run away with the honours, if
not to monopolize them." But rather than claim him and capitalize on his
success abroad, Brown placed him outside of Canada and in competition
with "the Thomson group," as he called them, which he asserted, in spite
of Morrice, still inspired epithets of "originality, nationality, individual-
ity, not to mention *épatant*." But even this was qualified by what Brown
termed the "difficulty" that the French critics experienced in coming to
terms with the exhibition, owing to their belief that France was the cen-
tre of art, to their "ignorance of Canada as a country, which seemed far
more complete than ... in London," and to their "shock" at the "hard bril-
liance of light, the sharp contrasts of colour and the immensity of forms."
In Brown's summation, the negative responses, although addressed only
elliptically, lay not in the art but in the inadequacies of the audience.[160]

A broader analysis, however, indicates that the exhibition's failure was
the result of more complex and nuanced factors that went beyond the
works or the critics. Much of it had to do with how landscape, far from
being "natural," was constructed during this period to serve different and

competing claims for modernism and national identity. France was sympathetic to the idea of using landscape in a nationalist cause, but the means for doing so differed between the older nation and the new Dominion, despite substantial overlap. However, these differences were sufficient that when critics tried to validate the work by placing it within the confines of nationalism as it was being defined within the regionalist discourse in France at the time, they continuously ran afoul of the Canadian narrative. The Canadian work, as per Brown's insistence on its newness, was portrayed as resisting historical depth and ties to tradition or genealogy. Yet the claim to being without influence translated into the French interest in the "primitive." This led to assessments of the work as "immature" and, while promising, not yet fulfilled. Landscape in both Canada and France was portrayed as autochthonic. In the Canadian works, this was figured as empty wilderness landscapes devoid of people. In France, by comparison, being "autochthonic" implied that the land had long been occupied by a native peasantry, an ancient *volk* who had inhabited the region since time immemorial. Other similarities also produced conflicts. The Canadian work, in being representational and not extreme in its formal properties, should have fit readily within the *rappel à l'ordre* given that it depicted landscape with no reference to Cubism or abstraction and that it conveyed a nationalist message and made a claim to the land. This was countered, however, by the double retrospective, which set up from the beginning a duality that was easily essentialized into an opposition between Morrice's work, which was French, refined, and sophisticated, and the Canadian work represented by Thomson, which was rude, crude, brutal, and primitive. This made the work easy prey for those who wanted to capitalize on this difference in order to validate France's claims to cultural supremacy. In the end, however, the similarities as much as the differences brought about the exhibition's failure to meet its ends, just as the attempts of sympathetic French critics to fit the Canadian work within the critical discourse of the period had inadvertently invalidated many of the works' claims. The point here is that critical successes and failures are frequently as much a factor of the critical discourse as they are of any essential or aesthetic attributes. Taste does not seem to transcend national interest.

The ironies of the situation demonstrate both how Canada's national identity was shaped during this period and how fragile and unstable it was. The competence of the French viewers who withheld ratification could not be easily questioned, especially after their opinions had been openly solicited and were a necessary component of gaining recognition

for a Canadian culture on the world stage. Their reaction was doubly troubling because it offered an alternative vision from a source that was considered authoritative within the hierarchies of modernism.

But the exhibition also exposed many of the myths underlying the narratives generated by the Group of Seven and their supporters. For example, the Group claimed to be marginalized – that is, heroically working without support or subsidy. This claim is countered by the fact that they were directly underwritten and promoted both at home and abroad by the most powerful artistic institution in the land, the National Gallery, and by its curator/director, Eric Brown. This fact, however, had to remain concealed. In actuality, it now appears that Morrice was placed outside of the construction of a modern Canadian national art and ignored. This exclusion resulted from Morrice's embrace of a cosmopolitan French modernism. As has been shown, recognition of his artistic presence in Canada would have fractured the fragile narrative construction based on the principle that the Group's source of inspiration lay almost exclusively in the essentialized features of the Canadian landscape. This denial of European influence, in turn, led them to claim modernism but only as they defined it, a definition that was not recognized in France. Further, while the Group invited and even exaggerated adversarial criticism, they did so only insofar as it could be used to their advantage by being made to appear as the voice of an outmoded, academic, and foreign conservatism that resisted a modern Canadian image. Such responses were exploited to confirm the Group's claims to modernism and nationalism, to increase their visibility by generating a prolonged, yet contained, "controversy," and to establish a myth of oppositionality on the home front.[161] The negative reactions from modernist Parisian critics produced no such advantages. Insofar as they disrupted the nationalist narratives and identities that the Group's work was designed to foster, they had to be misrepresented or concealed. However, they are an integral part of the history not only of this movement, but also of the country's art and its place in Canada's attempts to define itself as a nation, and should be returned to their proper place. One of the signs of a secure maturity is, after all, the ability to look back, recognize, and embrace previous failures that, for whatever reasons, have been rendered invisible.

Chapter 4: Canadian Primitives in Paris

Nations, like narratives, lose their origins in the myths of time and
only fully realize their horizons in the mind's eye ... Nationalist
discourses persistently ... produce the idea of the nation as a continu-
ous narration of national progress, the narcissism of self-generation,
the primeval present of the *Volk*.

 — Homi Bhabha, "Introduction: Narrating the Nation," 1

BY REFUSING TO validate the Group of Seven's claims to modernism,
nationalism, and mastery, the French critics effectively repudiated the
triumphs of the Wembley exhibitions. This was not, however, the only
problem generated by this response to the Paris exhibition of Canadian
art. A second and equally vexing issue emerged around the meaning of
the term "primitive," which the critics associated with non-Western or
tribal arts even though Eric Brown had used the term in reference only to
the "primitive wilderness" that the Group painted. The confusion arose
because, in contrast to the complete exclusion of Native material from
the Wembley shows, the Paris venue included a small group of remark-
able carvings done by the indigenous peoples of the Northwest Coast.
These eleven sculptures were mostly miniatures made for a non-Native
market. The selection included three masks, two listed as "Tsimsyan" and
one as Haida, three model totem poles in wood, and five Haida argillite
carvings. The latter, comprising miniature totem poles, figures of chiefs,
a group of shamans, and an image of a non-Native, were attributed to
Charles Edenshaw, the recently deceased Haida master carver, and to
other, unidentified artists. These objects did not form part of the initial
conception of the exhibition. Their position within it seems uncertain.
An archival photograph shows them installed in a dark, draped alcove,
separated from, yet framed and dominated by, the much larger context of

paintings (see Figure 10). No links or affinities between the paintings and sculptures are immediately evident. One questions why they are there, looking, as they do, out of place. Nonetheless, this ambiguous interruption within the larger exhibition profoundly affected the reading of the Parisian exhibition and served to further divert its intended statement. Despite their modest number and size, the carvings were anything but inconsequential. Indeed, the Jeu de Paume exhibition was significant not only because it was the debut of Canadian art in Paris, but also because it was one of the first times that the arts of the indigenous peoples of the Northwest Coast had been exhibited in such an elevated institutional setting in the international arena as "art" rather than artifact. At this moment, Canada was, with some ambivalence, taking a leading role in this redesignation. Paris would be appreciative, but, somewhat ironically, Canada would not welcome Paris's response.

Like the exhibition itself, the inclusion of this sampling of Haida and mainland material was based on a series of prevarications. According to a letter in the Archives of the National Gallery of Canada (NGC), it was first mooted as the result of a request by Armand Dayot conveyed through Clarence Gagnon. In January of 1927, as the exhibition was being finalized, Gagnon wrote to Brown: "By the way, Dayot suggested that we add to the sculpture some of those Pacific Coast carvings in black slate, miniature totem poles or wood-carvings of the same nature. Duncan Scott has some very interesting ones. I was told if I am not mistaken that there are still some Indian craftsmen doing these things. If so we should see that their names are included in the catalogue with those exhibits. You might find something among these carvings that could be included in our exhibition. They certainly would add interest to our show."[1]

This letter deserves a close critical reading.[2] Gagnon's offhand and somewhat late suggestion, made conspicuously casual by his rhetorical "by the way," strains credulity. It raises several questions. For example, would Dayot have been aware of argillite carvings? His journal, *L'Art et les Artistes*, gives no indication that he was; there are no articles on any form of primitive art in the 1920s, argillite or otherwise. In fact, precisely the reverse. He was not a supporter of the influence of "primitive" art on modern production and probably saw it as a type of cultural contagion. Further, knowledge of argillite in Paris at the time was scant. There is no historical evidence that Dayot's knowledge of these black slate carvings was such that he would have recognized the need for a special intervention to ensure that they would not be overlooked, nor is there any reason

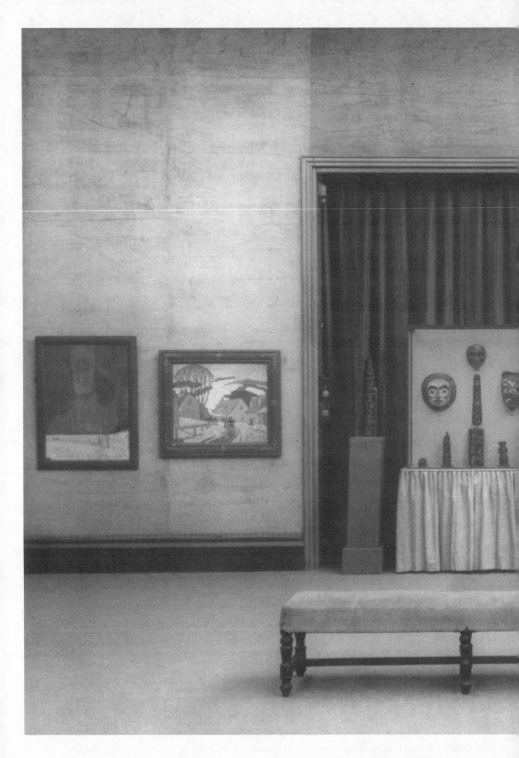

FIGURE 10: Northwest Coast material, *Exposition d'art canadien*, Musée du Jeu de Paume, Paris, 1927.

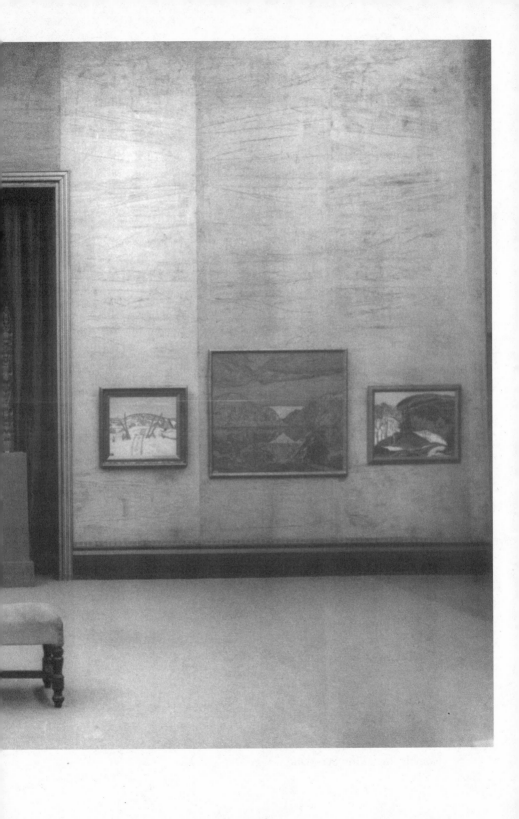

to believe that he would have been inclined to demand their presence. Gagnon's equally offhand suggestion for a ready source in the office of Duncan Campbell Scott is also too pat.[3] It passes over the fact that the deputy superintendent of the Department of Indian Affairs now had in his personal possession a selection of Kwakwaka'wakw carvings confiscated from the Cranmer potlatch in 1922. These pieces, displayed on his office walls like trophies, went well beyond argillite miniatures. Pointing indirectly to this more formally aggressive material suggests the possibility of a much broader and more prominent display than actually occurred. Gagnon added to the murkiness four days later, when, in writing to Scott, he switched the source of the request and attributed it to the "Director of the Luxembourg gallery" – that is, Charles Masson rather than Dayot.[4]

Gagnon's inability to keep his story straight, combined with his excess of references to two French authorities in order to make his case, indicates that another voice must be present here, a voice that could be transposed as Dayot's and Masson's but that was not identified. Perhaps the most pertinent clue to this other "authority" lies in Gagnon's insistence that he had been told that argillite carvers still existed and that they could and should be given authorship. Such information would not have come from either Dayot or Masson since "primitive" art in Paris at the time went unnamed. Rather, this detailed knowledge points directly to Marius Barbeau, the folklorist and ethnologist who had joined the Victoria Memorial Museum (later the National Museum) in Ottawa in 1910. Barbeau specialized in Northwest Coast cultures and was raising interest in them in Canada. He advocated the widespread proposition that Native art of the Northwest Coast should be recognized as art and made visible as part of Canada's past cultural heritage. He specialized in the study of argillite carving and later published books outlining the individual styles of named artists working in the material. As is discussed later, at this moment he was also promoting certain Native villages of the Northwest Coast and their totem poles as a potential "Canadian" subject for contemporary Anglo-Canadian painters and sculptors, including the Group of Seven. Joining these ideas, he was at work on a major exhibition that would bring together, among others, the Group of Seven, Emily Carr, and Native art. This exhibition, titled *Canadian West Coast Art, Native and Modern*, was scheduled to open at the National Gallery in the fall. I would propose, then, that part of the impetus for the addition of the Native material to the Jeu de Paume exhibition in the spring may have come from this source through roundabout channels, including Scott and Gagnon.

Why, then, did Gagnon feel obliged to frame his modest proposal via evasions and substitutions? What was he hiding or avoiding? To be effective, stratagems must be superficially plausible and difficult to unravel. This one was particularly knotty. First, such a direct and radical intervention, for which no previous negotiations had occurred, could have been seen as a breach of Brown's prerogatives, which the latter would have resented, resisted, and easily dismissed as arriving too late for appropriate action. But beyond this factor, Gagnon's letters to Brown express a wish to avoid any perception that he was acting out of self-interest in his selections for the exhibition or that the inclusion of the material would have been to his own advantage. The publication of the limited collectors' edition of Louis-Fréderic Rouquette's Alaskan novel Le Grand Silence blanc was in the final stages. Gagnon's illustrations for the book were included in the show. His designs employed variations on Native motifs in what he called his "totem style."[5] The Native work would have complemented these images, produced an aura of authenticity and a source of artistic influence within a Canadian *volk*, and provided him a further opportunity to secure his own position within the French regionalist critical discourse as well as a chance to profit financially. These unstated consequences constituted the unspecified "added interest," mentioned to Brown, that the carvings would bring to the other work.

How would Gagnon have encountered Barbeau? The answer here is far more straightforward. The previous year, Gagnon had requested that Scott be on the lookout for "any good books" or photos detailing Northwest Coast and Eskimo art that Gagnon could use as sources for his designs.[6] Scott would have directed him to Barbeau, with whom he was closely collaborating at the time. But why would Gagnon have avoided naming him and substituted his French sponsors? This is more difficult to answer since it leads directly to the relationships of sameness and difference that separated the various parties interested in formulating the new Canadian national image. Let it be said at this point that Gagnon was nothing if not politically astute and highly attuned to interpersonal tensions. By early 1927 Brown and Barbeau were entering a period of competition, if not open conflict, precisely over the matter of the inclusion of Native art from the Northwest Coast within the visual identity of Canada. Within these troubled circumstances, raising the ethnologist's name would not have been advantageous and could have been potentially disastrous. By comparison, posing the suggestion as having come from a higher French authority added urgency and would have been in keeping

with the initial claim of a French "invitation" and selection. Brown would have little option but to comply. His alternatives would have been either to challenge Gagnon (and thus Dayot), thereby putting in danger the relationship(s) on which he depended to ensure that everything went well, or to refuse outright, which would have undermined his claim that the French were responsible for the selection of material, risked the possibility of an official complaint from his French sponsor, and resulted in a diplomatic reprimand. Given that Brown's position was already precarious in light of the protests back home, the choice of least risk was to opt for the route of greatest discretion.

Brown delayed for several weeks before taking action, an indication of a lack of enthusiasm for the addition, but he ultimately capitulated. At this point confirmation of Barbeau's intervention in the exhibition appeared. By late February 1927, he and Brown had taken on joint responsibility for choosing the selections, which came from the large collection of the National Museum rather than from Scott's office. At first, continuing with the growing number of prevarications that had characterized the organization of the exhibition from its inception, Brown attempted to minimize the number, inventing the claim that only a "small group" of "six to eight pieces" had been requested.[7] Barbeau probably argued for more but was able to raise the number only to the eleven small works that were displayed. However, he was engaged to write a separate section on the Native works for the catalogue of the exhibition. Barbeau's text, which he must have produced fairly quickly, took up more than one-third of the publication and ranked the Native pieces as equal with the other, numerically superior material. This would have been yet another shift that Brown could not have anticipated when first assembling the exhibition. The elevated status given to the Native material would cause no end of problems.

However, Brown would have recognized the other difficulties occasioned by such an added intrusion into his carefully planned exhibition. He was well aware, as we will see in later chapters, that he and Barbeau differed in their ideas on what constituted legitimate representations of Canadian culture and the formation of a cohesive national identity. Barbeau, who had complex and sometimes contradictory interests and ambitions, was taking a deep interest in this construction and was doing much to modify Brown's primarily monocultural, Anglo-centric view. Countering Brown's British bias, Barbeau insisted that traditional French Canadian culture be given its own unique and privileged place within any

formation of an official Canadian identity. He worked hard at this project, using his offices, connections, and abilities as a writer in both English and French on the arts at every opportunity.[8] Wearing his other hat as a folklorist specializing in traditional French Canadian culture, which he saw as vibrant yet endangered, he did all that he could to promote and preserve it, bringing it to the attention of the largest possible public.[9]

Some competition between Barbeau and Brown also existed in directing the vision and activities of the Group of Seven. By 1920, at a time when the NGC and the Victoria Museum were sharing premises, Barbeau had recognized the Group's growing importance and that of the NGC in formulating a national image. He consequently became interested in both. He cultivated key members of the Group, especially Jackson and Lismer, and directed their attention to culturally and historically significant sites in Quebec. Their depictions of these rural locales, executed under Barbeau's auspices, varied from the Group's standard "empty wilderness landscapes" in that they included preindustrial signs of civilization and prolonged occupation. Such images established and validated a French Canadian presence predating that of England through both a historic claim to the land and an ongoing, active, and vital, albeit nostalgic, place within Canadian culture that, as we have seen, was threatened by Brown's preference for works that were exclusively monocultural and that erased all signs of previous occupation. In this sense, Barbeau and Gagnon were working toward the similar end of establishing a French Canadian *volk*.

This prior French Canadian presence was reconciled with and made palatable to Brown's agenda by being represented in an English mode. Buildings, such as Jackson's series of paintings of quaint Quebec barns, one of which was included in the Jeu de Paume exhibition, fit within the picturesque conventions as the French Canadian equivalent of English peasant huts and rustic shelters.[10] But the inclusion of buildings brought the subject matter of the Group's art very close to the work of Gagnon, who painted scenes of inhabited, rural villages, which were frequently described by English-speaking critics as picturesque but which would be seen by the French as evidence of a long-established *volk* and thus as a claim to a national culture. The barns, then, were subject to a double reading depending on their audiences.

Representing the inhabited Quebec countryside as part of the imaginary Canadian visual identity added variety to the Group's repertoire of empty "wilderness" landscapes. But the inconsistencies and contradictions inherent in doing so also began to indicate the growing instability of the

discourse of identity as it was formulated by various parties with various agendas, interests, and cultural histories. Far from sharing a common vision or voice, many of these parties were in conflict or competition with each other just below the surface, despite keeping up the appearance of a unified public front. The new Canadian identity, then, was not based on a simple binary between a newly unified nation and a colonial parent, although it was often presented as such. Indeed, still other conflicting voices were added to the cacophony. These contestations, in turn, reflected deeper divisions within the emerging nation that the singular identity was meant to conceal. They went well beyond a simplified opposition between an outmoded, derivative Royal Canadian Academy (RCA) and a "modern" indigenous Group of Seven. Here, the difficulties in producing univocality within a polyvocal context without forcibly silencing, ignoring, muting, or at least translating some voices begin to appear. Conversely, insinuating an unwelcome voice requires strategic manoeuvring. Barbeau and Gagnon were, if anything, strategists par excellence. They needed to be so in order to ensure that both Native and Quebec material was included in the National Gallery's collection and in the representations of the nation.

The basis for Barbeau's insistence that Native art be visible within the construction and display of a national identity – an insistence out of step with Brown's concept of the nation yet in line with Gagnon's interests – is fairly complex. His educational experience and profession would have been instrumental in his efforts to ensure the inclusion of Native works. Barbeau became a Rhodes scholar at Oxford in 1907, where he studied the new science of anthropology. Barbeau worked with Raynold Marrett, an ethnologist and folklorist. Marrett was a proponent of evolutionist theory, which ranked cultures hierarchically, with European civilization at the apex.[11] Coombes has outlined some of the other issues that were circulating within the practice in England at this time. Of special importance was the new discipline's anxiety over proving its worth to the state by demonstrating its value in affirming a unified British national identity.[12] Barbeau, then, would already have been primed for such developments in Canada after he returned in 1910 and joined the National Museum the following year.[13] Other close relationships also joined the state's interests and Barbeau's ethnographic practice. Andrew Nurse has pointed out that Barbeau changed his approach to the issue of the current viability of Native peoples and cultures as soon as he joined the National Museum. Working in conjunction with Scott's, and the state's, desire to abrogate treaties and decrease reservation sizes and seeking to prove that Native

cultures and peoples were bordering on extinction, Barbeau went from speaking of Native cultures having continuity into the present to referring to them as belonging to the past and as being in a state of discontinuity, decrepitude, and disappearance.[14] He would amplify this position, which united all Native cultures within a single tragic fate, over the coming decades, particularly on the West Coast, where unresolved land claims were also an increasingly urgent issue.

But Barbeau was also aware of Native art's potential, albeit placed in the past, to serve as a source of a purely Canadian image and to be characterized as art rather than as ethnographic artifact. He understood that such a recognition would require a substantial shift in the discursive frameworks that defined both what was "Canadian" and what was "art" within the Dominion, which was somewhat late in coming to acknowledge the possibility of conceiving Native art anew. He also knew that there was a foundation for this transition already in place. Such ideas, drawn from outside sources such as America and Europe, where this shift was already occurring, had been circulating within the ethnographic and museum world in Canada for some time. Harlan Smith, an archaeologist with the Geological Survey, had been developing and publishing on the subject since at least 1917. Smith, an American who joined the National Museum as an archaeologist in 1911, had previously worked with the Pueblo and also in Wyoming. He had his own particular ideas on the role of Native art in contemporary Canadian culture. Based on his interest in petroglyphs and other archaeological material, he wrote several articles on the use of prehistoric motifs as a source for commercial designers searching for distinctly Canadian iconography.[15] He even produced a museum handbook of useful images of Native art for adoption by corporations.[16] He actively promoted these ideas throughout the 1920s. By 1923 Edward Sapir, the head of the Department of Anthropology and Barbeau's immediate superior, acknowledged the trend of European "progressive" art to utilize Japanese and "primitive" art forms and themes. In keeping with theories proposed by his teacher, Franz Boas, Sapir stated in a preface to Harlan Smith's *Album of Prehistoric Canadian Art* that "primitive art is art as well as ethnographic material."[17] Smith's *Album*, in addition, was produced with the idea that Native motifs could be appropriated by commercial firms for a distinctive and purely Canadian design aesthetic.[18] These ideas would have been reinforced by an awareness of corresponding movements in the United States at the time, although Native cultures in America were by then seen as ongoing rather than as disappearing.

Aware of these trends, Barbeau realized that the failure of Canada to recognize the value of its own Native art had resulted during the previous decades not only in a serious loss of this work to foreign collectors and museums, but also in a loss of prestige. On a more personal level, its inclusion within Canadian identity would raise his own status since he would become the reigning expert in the area and its primary custodian. Aware of the interest in France in "primitive" art as art, he was assured of a positive critical response to the work and confirmation of its status and importance. Given the Dominion's concern with establishing recognition of its cultural autonomy from its imperial centres, and following the axiom that recognition abroad, especially by the acknowledged centre of modernism, would be followed by recognition at home, Parisian appreciation should have guaranteed its subsequent reappraisal in Canada.

Although Barbeau was adamant that Native material be included as art within the structure of Canadian identity, he nevertheless saw it having a completely different role than the endangered but still vibrant traditional arts of French Canada. Native cultures, were, in his view, no longer vital and either had completely disappeared or were bordering on extinction.[19] They were temporally and spatially displaced, then, to what Barbeau would call the "background" for Canadian art – that is, the validity of Native arts was of the past rather than of the present. These arts could serve as a subject for modern non-Native artists interested in new sources of national imagery, or they could be shown by themselves as part of the nation's heritage.[20] However, since there were no ongoing, continuous Native cultures and traditions, the possibility of current production was denied. This denial functioned both to ensure the stability of the new national imagery and its claims to being the sole native art form and to confirm the state's policy toward Native peoples. Critically disciplining audiences' interpretations of Native culture assisted in maintaining this perception; whenever Native objects were presented as "art," they were surrounded with texts that foreclosed any possible readings of them as part of ongoing traditions and were presented as items from a past and discontinuous culture. Nonetheless, despite these provisos and safeguards, the inclusion of Native art – in whatever quantity, from whatever groups, and under whatever circumstances – within the project of forging and securing recognition of a unique Canadian identity and culture on the national and international stage had far-reaching implications that were not anticipated by the organizers of the exhibition.

Recognizing that the various audiences in Paris would be unfamiliar

with these conflicted discourses of national identities, colonial histories, and racial disappearance as they existed in Canada, Brown and Barbeau began to stake out their respective positions for their French audiences. Brown was, at first, ambivalent about the Native material. The text for his lead-up article in *L'Art et les Artistes* is equivocal. He begins enthusiastically, describing the Native work as powerful and as exhibiting "a mastery of form" that "proclaim[s] a race imbued with aesthetic sensitiveness and possessed of marvelous skill." Recognizing the aesthetic value of the Native objects elevated them from crafts and ethnographic curiosities by placing them within the realm of fine art. But the current role of this art was problematic. Brown reports that "their designs are beginning to be adapted to modern production" and mentions an ongoing government-sponsored program for totem-pole restoration, but he notes that "there remains today hardly a remnant of the ancient tribal carvers." He ends, then, on a less positive and more qualified note than that on which he began: "There is hope that the revival of interest in the old designs will produce at least some recrudescence of the tribal craft."[21] His conclusion returns the Native pieces to their original, devalued position. His equivocation would produce unexpected problems.

Brown's shorter essay in the exhibition catalogue gave more space to the image of the Indian in the history of Canadian art than to the Native art itself. He showed greater concern with demonstrating how the Indian had long since disappeared and vacated the landscape so that it could be occupied by the depopulated images of the Group of Seven. However, to support this important point, Brown found it necessary to add a supplement to his brief text. He brought forward two historical artists who dealt with Indian subject matter: Cornelius Krieghoff and Paul Kane. Neither was in the exhibition, nor would they have been known to his Parisian audiences, but both were crucial to his nationalist narrative, which, with the addition of the West Coast material, had to account for the Native.[22] He generalized that these artists' images were sometimes the only remaining record of a race that had disappeared in the previous century. Presented as images of absence, their work reinforced the host of interlocking ideas that made up what I have termed the discourse of disappearance. This second discursive framework, which circulated everywhere at the time, although not without a growing number of alternative and oppositional voices that threatened to disrupt it, included the proposition that the diverse Native populations in Canada formed a homogeneous group and a single race, that they had long been absent from the contemporary scene,

and that they had left a vacant site to be filled by Anglo-Canadian artists who could produce the image of a nation based on their absence. Brown's historical gloss acknowledges that the discourses of the death of Native peoples and the birth of Canadian identity were interdependent.[23]

Thiébault-Sisson made no mention of the Native material in his March article in *Le Temps*, indicating that he was unaware of its inclusion.[24] By the time he wrote his catalogue essay, however, he must have seen the works. He appended an extended note on the Native material. We have already seen that he had called the Native work "veritably autochthonic, but went back several centuries into the past," and we have noted that his use of "veritable" in this context cast into doubt his initial use of *autochthone* in reference to the Group's art. But he went further in undermining Brown's claims for the Group. While he affirmed the Natives' disappearance, he expressed appreciation for their art. He described it as having "a rare perfection of execution, a remarkable decorative character and a stylization which had nothing of the banal."[25] This was higher praise than he gave the Group's work, which he regarded as *rude*, or rugged and unrefined – that is, not yet fully matured but showing potential. By ascribing the qualities to the Native sculpture that he had withheld from the Canadian painting, he inverted the cultural and aesthetic hierarchies between the two and linked the Native pieces to the attributes of French modernism as they were then being formulated and as he had presented them. To bolster his assertion, he ranked the Natives of the Northwest Coast using another hierarchical scale, one that positioned them as members of "a relatively more advanced civilization" than that of both the ancient Aztecs and the contemporary makers of African tribal art. While such a ranking was ethnocentric and would undoubtedly have had European, and specifically French, culture at its apex, it demonstrated his great regard for the work.[26] He concluded: "It is curious to observe that this taste for stylization and this dominant decorative instinct is part of the essential character of the young Canadian painters. There is here, for our archeologists, a subject of passionate discussion."[27] This suggestion that the Group, and any essentialized Canadian identity, was dependent on the precedent and presence of Native art and culture, that there was a possible dialogical relationship between the two, and that the Native arts were more refined than the Canadian painting would have to be countered almost immediately in Canada, where the ideology of the Natives' absorption and disappearance as well as that of spontaneous generation and mastery on the part of the Group precluded any direct influence.[28]

Barbeau's essay was placed at the back of the catalogue.[29] His initial list of a number of art forms not in the exhibition, such as Chilkat blankets, clearly showed up the poor sampling that arrived in Paris and promised other riches, of which the eleven pieces were only a small fraction.[30] His brief history, while recognizing that the art forms existed prior to contact, postulated that they had come into their own only after the introduction of European tools. But this period of greatness, made dependent on contact, was now over. It "preceded their final degeneration towards the end of the century" – that is, just prior to the rise of the Group of Seven. The disappearance of Native art was made to coincide with the emergence of a new Canadian culture that replaced it. He mentioned no possibility of revival.

Despite Barbeau's affirmation of Native decrepitude and national ascendancy, his position was ambivalent. It bifurcated on the point of current viability. He noted that most museum artifacts dated from at least fifty years ago, which placed them in an ancient past and a discontinuous culture. Nonetheless, he did single out and identify, as proposed in Gagnon's letter, the work of the Haida carver Charles Edenshaw, which was featured in the exhibition. This master carver, who was a contemporary of Thomson and Morrice, had died only recently. He, and his art, could also be said to belong to the present, a point that Barbeau suggested but did not make explicit. Barbeau also recited the story of Edenshaw's "Tlingit slave" and their rivalry, which, although subsequently exposed as an invention, introduced a modicum of contemporary biographical detail into the meagre image of the Native artist and implied the continuity of ancient traditions and social relationships into the present. In addition, he countered the essentialized image of the Indian as a single race by dividing the production of the various Northwest Coast groups into specific styles, indicating a potential for distinctions that were excluded by the lack of comparative pieces. Finally, he gave a brief but detailed summary of the meaning, mythic references, and iconography of each of the eleven pieces, thus making his written entries longer than those by either of his co-essayists and more specific regarding the work's significance. Between Barbeau and Thiébault-Sisson, the Northwest Coast work received substantial textual recognition, well beyond what the few displayed pieces might have been expected to warrant and more than was received by any other work, even if they were relegated to the rear. Insofar as they were also given two of the twenty-six illustrations, they may be said to have figured prominently.

There were, then, enough variations in the positions of Brown, the Anglo-Canadian curator; Thiébault-Sisson, the French critic; and Barbeau, the French Canadian ethnologist/folklorist, to indicate the problems within the discourse surrounding the work as it was textually presented. Conversely, as we have seen with Morrice and the Group of Seven, these works had to confront the critical discursive framework that already existed in Paris. Doing so would have a deleterious effect. The French critics again seem to have read this portion of the exhibition in a manner other than that intended by Brown. They tended to value the Native pieces over the Group's paintings, which reversed the expected order of things. The critical success of the Native pieces, as with Morrice, came at the expense of the Group.[31]

I would like to account for this reception by again extending the theories of Pierre Bourdieu. I have contended that the broadest of English audiences was already versed in the underlying picturesque and nationalist codes of the Group because this work recapitulated British traditions and that the English were eager to assist Canada in its claims to a national identity by overlooking or even wilfully blinding themselves to colonialist presences in the work in favour of seeing only the "differences." Conversely, the French critics, who had no stake in reifying this ideology, who were less "educated" and "competent" in the "cultural codes" of the picturesque, which the British and Anglo-Canadians had naturalized, and who had their own ideas about nationalist landscapes, failed to "decipher" the message of the English-based Canadian art and offered an entirely different reading.[32] On the other hand, a discursive critical framework for discussing "primitive" art, such as that of the indigenous people of the Northwest Coast, already existed in Paris, although it was lacking in London.[33] It had circulated broadly at many levels and with many audiences and publics since at least the turn of the century and had supplied codes and what Bourdieu calls social structures for the consumption of such work.[34] I propose that it was familiarity with this discourse that led the French critics to give priority and "cultural capital" to what the organizers (or at least Brown) considered of negligible value and importance.

The Parisian discourse around the term "primitive" as meaning *sauvage* is complex and interdisciplinary. At the level of "high" art, it had been developing since before the turn of the century. It reached its first peak with the works of the Fauves, the Cubists, and, outside Paris, the German Expressionists. Although all these groups and movements had waned

since the war, the interest in primitive art was rehabilitated in the 1920s and underwent significant changes. After 1925 the Surrealists gave primitive art and its attendant discourses a new cachet. The Surrealists were dedicated to nothing less than a complete transformation of society – that is, a surrealist revolution – through direct access to desire, the unconscious, and the marvellous, which would challenge and overcome what they saw as the cretinizing banality of bourgeois ideology and existence. The art of the indigenous peoples of both Africa and North America played a primary role within Surrealist thought in demonstrating how art could function in this capacity. In this context, then, it was invested with a certain critical capacity as well as an ongoing link to modernity.

Concurrently, and not coincidentally, primitive art had also been the subject of ethnographic activity in Paris.[35] A school for the study of ethnology, the Institut d'Ethnologie, opened its doors under the direction of Paul Rivière, Lucien Lévy-Bruhl, and Marcel Mauss. In addition, in the mid- to late 1920s there were links between the Surrealists and the ethnographic community through Michel Leiris, Georges Bataille, and others. Although there is nothing to indicate whether these figures attended the Canadian exhibition, one wonders what they might have thought of it and whether they would have considered incorporating it into what Clifford calls an ethnographic-Surrealist subversive cultural criticism.[36]

But there were other audiences and publics that this exhibition, and its critics, would have addressed. The Parisian interest in things primitive extended far beyond both the specialized nascent discipline of ethnology and the outré salons of the Surrealists. At the level of popular culture, l'art nègre, which seems to have had an imprecise and inclusive meaning, was sweeping the city, popularized by performers such as the American Josephine Baker. Here, it was more engaged with spectacle and consumption than with cultural critique or academic investigation. Clifford offers a vivid summation:

Paris 1925: the Revue nègre enjoys a smash season at the Théâtre des Champs-Élysées, following on the heels of W.H. Wellmon's Southern Syncopated Orchestra. Spirituals and le jazz sweep the avantgarde bourgeoisie, which haunts Negro bars, sways to new rhythms in search of something primitive, sauvage ... and completely modern. Stylish Paris is transported by the pulsing strum of banjos and by the sensuous Josephine Baker.[37]

He continues, noting that in the 1920s the Trocadéro museum

> was riding the crest of the wave of enthusiasm for *l'art nègre*. During
> the twenties the term *nègre* could embrace modern American jazz,
> African tribal masks, voodoo ritual, Oceanic sculpture, and even
> pre-Columbian artifacts. [And Northwest Coast masks and model
> totem poles.] It had attained the proportions of what Edward Said
> has called an "Orientalism" – a knitted-together collective represen-
> tation figuring a geographically and historically vague but symboli-
> cally sharp exotic world.[38]

Native art and performances had been spectacularized in Paris for popular
audiences since the turn of the century when they were included within
the Paris exposition. One must also recall the Buffalo Bill shows in Paris,
which were seen as part ethnographic exhibit and part popular amuse-
ment. In short, the experience, construction, and consumption of the
modern had become conflated with the "primitive" in complex and even
contradictory ways.[39]

The audiences and publics for the Native work in Paris, as well as their
possible responses to it, were diverse and cut across class and disciplin-
ary lines. They differed from those of either England or Canada in their
breadth of interest in this material. This difference centred mainly on the
artistic front. Although Surrealism did not enter the critical discussion,
the Northwest Coast material was identified as being the same as or simi-
lar to African tribal art. It was also made to correspond to the presence
of a *volk* who had long occupied the land and supplied a deep history on
which the claims to nationhood were based. In addition, it fit into the
interdisciplinary discourse of the ethnologists and popular audiences. It
is not surprising that in this context and at this time, the eleven carv-
ings received more attention and became more visible than their quantity
would seem to warrant.

We have already noted that Charles Chassé, writing for *Le Figaro heb-
domadaire*, produced one of the longest responses to the exhibition of
Canadian art.[40] In keeping with the ideology of regionalism, he equated
the Canadian national landscape artists with the indigenous peoples of
Canada in their relationship with the land. However, this equation and
reference to tradition disrupted the mythology and the genealogy of the
Group as it was then constructed. Chassé's association of the Group with
Native peoples might have been passable if he had affirmed that these
peoples, and their artworks, were of the past, which is how they were

perceived and presented by Brown and Barbeau and how they were to be represented that fall in Canada. However, unaware that the "Indians" were at that moment being erased from representations of the nation, Chassé implied their continued presence as the ancient and originary *volk* from which Canadian culture sprang rather than their disappearance. This flew in the face of the assertion that the Group sprang from the land without parents or, at most, from an intimate union of Thomson and nature.

The layout of Chassé's article confirmed the relationship established in his text. But in so doing, it reversed the hierarchical format of the exhibition. Rather than showing the paintings as privileged and surrounding the small selection of sculptures, it featured two large illustrations of the wooden model totem poles framing, supporting, and enclosing Thomson's *Jack Pine* and Gagnon's *Village in the Laurentians*. This grouping made the totem poles appear monumental and twice the size of the large paintings. The grouping was accompanied by Barbeau's detailed and lengthy explanation of their iconography. This caption ascribed far more specific meanings to the sculptures than to any of the paintings, including those illustrated, which went without comment. In the end, the article cued the reader to take the most interest in the Native works. A continued refrain in France would be that the work of the Group, who remained unnamed either collectively or individually, was of lesser importance than the Native art, for which the critical response could only be termed a triumph.

René-Jean's response to the Native material was also disproportionate to its quantity or place within the exhibition. He had, it will be recalled, patronized the Group's painting. By comparison, he was unequivocally enthusiastic about the Native work. Giving it privilege of place, he opened his lengthy review with a discussion of its merits and claimed that, despite the small number of pieces, it constituted one of the "two distinct sections" of the exhibition. He regretted the small number of works and proposed that an entire room should have been devoted to this art so that it could be "clearly differentiated." However, his enthusiasm did not keep him from being misinformed. He thought that argillite was a type of modelled clay and that totem poles were carved from living trees "with roots undisturbed."[41] He also pointed out the affinity between the model totem poles and Gagnon's illustrations for *Le Grand Silence blanc*.

Chassé and René-Jean were not the only ones to show a disproportionate interest in the Native works. The interest that the carvings aroused, despite their small number, is evident in that some received billing equal to or greater than all the other works in the exhibition. *Excelsior* featured

two photographs: an installation shot with visiting dignitaries strolling by Lawren Harris's work, seen in severe parallax, and a close-up, frontal view of the Native pieces, shown in detail as items of equal or greater interest.[42] However, this presentation would not have been as devastating to the Canadian organizers and the Group as the response of Gaston Varenne, who wrote for *L'Amour de l'art*, an important arts journal. He focused only on the Native pieces and ignored everything else.[43] This type of isolated appreciation was something of which the Group could only dream.

Paul Fierens' article for *Journal des débats* also featured a paragraph on the Native sculptures.[44] He called them original and admirably stylized. Although placed at the end of his review, he gave the works more space than he did Tom Thomson, who had an entire retrospective. Precisely the same can be said for René Chavance.[45] He, too, praised the sculptures for their "expressive style and vigor" and the "remarkable assurance of their primitive design." He noted the growing audiences for such works but only briefly mentioned Thomson and the other Group members. Gustave Kahn was circumspect in his approval, but he, too, wished for more and called for a Canadian author to take up the story of Edenshaw and bring it to the attention of the Parisian audiences.[46] Conversely, he made no such request for the narrative of Thomson and the Group.

Some critics conflated the Native pieces with pieces from Africa and pointed out the links to current fashion and popular culture – that is, to modern life. These included Jean Bretigny, writing for *La Presse*.[47] Marthe Maldidier, writing for *Rappel,* opened her review with this discussion and called for more of these works, which she describes as "pleasing" and "interesting." She queried: "Is it the vogue for jazz and negro dances which makes us look with such interest at the sculptures – too few in number – done by the 'Red Indians,' at this exhibition?"[48] R.R., writing for *Action française*, made a similiar observaton but carried it into an extended, if ethnocentric, discussion on the origins of art.[49] He may have been, like many, following on Thiébault-Sisson's statements, which saw the sculptures as a provocation leading to a further discussion around their ethnographic interest, as did Henri Charliat, Vanderpyl, and Roger Dardenne.[50] Others, such as the writer for *Intransigeant*, noted the Native works briefly but called them, in contrast to his dismissal of the painting, "very beautiful."[51] Some made only the briefest of mention without comment.[52] However, the works' appeal was not universal, indicating the problematic position of "primitive" arts in Paris at this time. Although

no one questioned their aesthetic value, many made no mention of the works.

Nonetheless, the attention that they did receive was uniformly positive. Despite their small number, the unqualified and enthusiastic response upstaged and displaced the Group. Far from providing a backdrop for the Group's work or confirmation of its modernism and mastery and far from being emblematic of the Indian's disappearance, the Native art challenged the Group of Seven and the discursive nationalist narrative surrounding their work. The success of the exhibition as defined by Brown, which had already been undermined by the recognition of Morrice as an exemplar and master of modernism, was further compromised by the "primitive" Native sculptures placed there by Barbeau. The success of the Native work and its validation as masterful and modern only made more clear the exhibition's failure to secure recognition of the Group's work, recognition on which the claims of national identity were based. The first time that Native art was exhibited alongside native art, the contradictions inherent in the claims made about the Group's art became apparent. It is unclear which was more damaging to the Group, Morrice's work or the small group of Native carvings, but together their presence at the exhibition was disastrous for the Group of Seven, who were seen as primitive in the sense of *naïf*. This one-two punch, which knocked the Group flat, explains why the show was defined as a failure best to be forgotten and why in the forthcoming fall *Canadian West Coast Art, Native and Modern* exhibition, the Group were posed as modern masters of Canada's national image, while Native arts were denied all of these traits and were cast as "primitive" in both senses.[53]

In the meantime, how was Brown to deal with the situation? As we have seen, he was adept either at containing the discourse through suppression of material or at putting a positive spin on things. He did include a selection of the reviews in his *Annual Report*. However, despite the upcoming fall exhibition, he excluded all mention of the critical responses to the Native pieces.[54] The small audience for this bureaucratic publication would have been led to believe that even if the responses to the Group's works were qualified, the Native material, to the extent that any was present – and it is mentioned nowhere in Brown's personal statements – was extremely minor and went largely unnoticed.

Brown's position changed, however, in his *Canadian Forum* article.[55] Here, he did admit to the inclusion of and response elicited by the Native art as well as to the relationship between the native and Native established

by the French critics: "A small group of West Coast Indian sculpture ... produced so much interest from both sculptors and critics that it will be surprising if totem poles and mask motives do not appear in subsequent Salons ... Mr. Thiébault-Sisson ... of *Le Temps*, went so far as to discern in the decorative treatment of some of the modern landscapes the same indigenous impulse which had produced the highly stylized and decorative motives of the B.C. Indians."[56] However, Brown pointedly departed from Thiébault-Sisson's evaluation of the possible outcome of this conjunction, which the French critic saw as promoting a passionate discussion. Brown recast this as confrontation and conflict by stating that the relationship between Native and Native arts "may be made a future battleground in the studios and round the club fires during the coming winter."[57]

Brown's displeasure at having his project for creating a modern, national Canadian image and identity in painting made tenuous and fragile by a small and intrusive group of Native sculptures, which threatened his monocultural construction, is evident in his metaphor of an artistic "battleground." Rather than promote the positive possibilities of the fall exhibition, this term replayed the same image that had been deployed in the jargon of the Group to characterize its hostile relationship with the RCA. The conflicted terms were now established in which the relationship between the two art forms would be discussed in the months leading up to and following Barbeau's exhibition featuring both.[58] There was no doubt who would be the eventual victor after the winter campaign. Indeed, having already vanquished the RCA, perhaps the Group and Brown were up for another scrap, one that could be played out in a more controlled environment, in which Brown was already predicting the conflict and prejudicing the outcome. In any case, war had been declared.

Indeed, any suggestion that Native art forms should be perceived as foundational or originary for modern Anglo-Canadian artists could never have been a topic of disinterested debate given the discussion's evolution in Canada. Such an assertion would have to be challenged since it reversed the accepted order of things, which saw Native art as, at best, subject matter, not as a point of origin or derivation, and which saw the conventions of the Group of Seven as springing from the soil, not from the indigenous cultures that had previously (and still) inhabited the land. The only point of contact between the two was that they both claimed their origin in the land, but, this commonality aside, they were entirely distinct, especially since Native art was portrayed as having relinquished any such claim, while the Group's art sought to validate territorial acqui-

sition. Any overlap between the two bodies of work would be pointedly denied in the responses to the fall exhibition. But in the meantime, much else would occur to make matters more complex and conflicted, including not only a wilful blindness to the presence and validity of the Native populations, but also the continued and unresolved problem of producing a univocal image in a polyvocal context.

Chapter 5: Barbeau and Kihn with the Stoney in Alberta

An outsider, when he belongs to a stock that is too far removed from ours, cannot be bullied into accepting tales and beliefs which seem preposterous to him ... It is clear that the Indian, with his inability to preserve his own culture or to assimilate ours, is bound to disappear as a race.

 — Marius Barbeau, *Indian Days in the Canadian Rockies*, 7-8

WHILE IT IS true that the Native art of the Northwest Coast appeared only at the Jeu de Paume exhibition in Paris, the 1925 Wembley exhibition was not entirely devoid of Native imagery. However, this imagery was restricted to representations *of* Natives rather than *by* them. The 1925 exhibition included F.S. Challener's *Mounted Indian Fighting*, J. Henderson's *Weasel Calf, Blackfoot Chief*, and W.E. Huntley's *Big Chief*. But only one artist worked exclusively with such subject matter, did so in a manner that engaged elements associated with modernism, and was ratified by Konody, along with the Group of Seven, as representing Canada's new, modern self-image.[1] The American artist W. Langdon Kihn showed two landscapes, done in 1924, depicting the traditional carved totem poles, architecture, regalia, ceremonies, and territories of the Gitxsan people of the Upper Skeena River Valley in northwestern British Columbia. The titles in the catalogue identified for each work the Native group, the place, and the objects and activities depicted: *Gitksan Indian Totempole* [sic], *Village of Gitwincool, B.C.*, and *Potlach* [sic] *among the Gitksan Indians of B.C.*[2] Kihn's two paintings serve in an important way to further distinguish the English and French exhibitions. Although shown at Wembley, they were omitted from Paris. This occurred even though the second painting was one of the

twenty works illustrated in Eric Brown's lead article in Armand Dayot's journal, *L'Art et les Artistes,* a clear indication that it, at least, was expected to be part of the exhibition until close to the opening day.[3] In addition, Kihn's images of Native peoples had been the subject of an illustrated article in Dayot's journal in 1925.[4] Kihn was also planning an exhibition in early 1927 at the Charpentier Galleries, the site first proposed for the Canadian exhibition, although this did not occur until 1930.[5] He had, then, a responsive audience in Paris that overlapped with that solicited by Brown and the other organizers of the Paris exhibition. In addition, his paintings of peoples, totem poles, and regalia would have provided a counterpoint for the group of Northwest Coast carvings selected by Marius Barbeau. Conversely, Kihn's works would not have been dropped on the grounds of their affiliation with the conservative Royal Canadian Academy (RCA). Rather, the stated reason was that, although the works were of Canadian subject matter and done in Canada under Canadian patronage, Kihn was not a Canadian artist, even though this had not been a consideration at Wembley, from which works for the Parisian show were selected. Nor was it a consideration in Ottawa, where his works were slated to be exhibited in the fall as part of a major exhibition of Canada's West Coast art. I would like to contend, therefore, that his exclusion in Paris was part of a larger pattern and of greater significance.

The omission of Kihn's West Coast images from the Jeu de Paume exhibition points to a growing crisis in the discourses that surrounded the representation of Indians and their role in Canada's nascent identity, particularly as displayed in the imperial centres and the capital.[6] Kihn's Canadian paintings, which were mostly portraits of western Canadian Natives, with some landscapes showing primarily their village sites, done in 1922 and 1924-25, when taken as a whole, presented enormous, albeit unspoken and unspeakable, problems for those who saw their task as articulating a coherent "narration of the nation" both at home and abroad. These problems went beyond the nationality of the artist. Rather, they lay in the relationships of his imagery to the essentialized dualisms embedded in the convention of the "empty landscape" and the corresponding assumption of the disappearance of Native identity, upon which the first was dependent. Kihn's Native imagery tended to destabilize both by exposing internal and external inconsistencies and contradictions that, although not visible at the outset, became increasingly difficult to ignore. They did this both by making the Indian present, rather than absent, and by referring to and being based on a conflicting discursive framework

emerging in the southwestern United States, which saw Native cultures as ongoing and continuous and as contributing to an autochthonic American national art. The gap between these two ways of knowing the Indian and placing this construction within a national culture became evident by 1927. When this lacuna became too great to be overcome, his works had to be eliminated. Their omission from Paris, then, was just the beginning of his exclusion from Canada, which was, after the Ottawa fall exhibition, to became more systematic.

The conditions of the production, patronage, and publication of Kihn's paintings, his contribution to and subsequent exclusion from the Canadian art scene, the unusual aspects of their collection, and differences in their critical reception within and outside of Canada show that the relationships that came into play around his works were complex, entangled, and at times contradictory and contested. These relationships involved not only the institutions of the art world, such as galleries, together with the histories of art practice and reception, but also museums and their personnel, together with the disciplines of ethnography, literature, and history. Also at work were the forces of capital, as represented by the railways, which had a major role in Canada's economy and national identity and which were Kihn's primary sponsors. The railways, in turn, invoked colonization and tourism. Beyond or alongside these variables lay government agencies, aside from museums and galleries. The Department of Indian Affairs was always a factor in anything to do with Canada's Native population, especially as Duncan Campbell Scott's goal during his tenure as deputy superintendent of the department from 1913 to 1932 was to eliminate anything that could be defined as Indian in Canada as well as to fight unresolved land claims and to reduce the allocations of reserve lands. Like Marius Barbeau at the National Museum, with whom he collaborated, Scott was a complex individual with diverse interests.[7] A career bureaucrat, he was at the same time a poet of some renown. He had a profound interest in the role of art in creating a monocultural national identity based on British precedents and was, in this sense, in sympathy with Brown. In clearing the path for a purely British-based Canadian culture, Scott employed the image of the vanishing Indian extensively in his writings. He also actively intervened in the visual art world as a critic, writer, art dealer, and host. He closely associated, both professionally and personally, with the personnel of both the National Gallery and the National Museum as well as with many artists, including Clarence Gagnon and members of the Group of Seven. In many instances, these varied but

closely knit governmental and private interests worked in harmony, but on some crucial matters, such as the place of Kihn's paintings in Canadian iconography, critical differences arose among the various parties. However, to preserve the integrity of the myth of unity, such fissures had to be covered over or rendered invisible.

Despite his later exclusion, Langdon Kihn's initial presence in Canada in the early 1920s was seen as a boon on several fronts but especially for the national railway system, the tourist industry, ethnographic study, and the print media. At this time, Canada's two major railways employed both artists and ethnographers as well as the Native population to promote rail travel to the western provinces. The Canadian Pacific Railway (CPR) was the first to link the three elements. The CPR's general publicity agent, John Murray Gibbon, was instrumental in this regard. Born in Ceylon to Scottish parents and educated at Oxford, Gibbon had come from England to Canada in 1913 at a time when rail tourism in western Canada was reaching record levels and formed a major part of its revenue.[8] Gibbon had an abiding interest in Canadian history and in "the cultural traditions and abilities of the diverse racial groups in the country," which he saw as valuable both to the railway and to the promotion of a Canadian identity.[9] Throughout the 1920s he used various ethnic performances in a series of ceremonies to promote a pluralistic Canadian culture and the railway, which he saw as intimately linked.[10] His view of Canada's emerging identity, then, was broadly inclusive and based on the remembrance of various European traditions, albeit placed in a hierarchical order, with England at the top. He was already entertaining the idea of a Canadian "cultural mosaic," a term that would serve as the title of his book published in the late 1930s.[11] However, before the 1920s were over, this multicultural view would put him in conflict with Scott and, by implication, with Brown. Conversely, Gibbon was aligned with Marius Barbeau, especially concerning the position of French traditions within Canada. Gibbon was aware that Barbeau specialized in the study of French Canadian folk art and lore as well as in the study of the indigenous cultures of Canada.[12] Both recognized the potential to use tourist spectacles as a place for establishing unique regional and ethnic identities and the prospect of coordinating them within a national context.[13] Campaigns to make such use of traditional French Canadian cultural activities and arts, such as weaving, carving, painting, and music, had proven popular with tourists at the CPR's Château Frontenac hotel in Quebec City since 1920.[14] For Barbeau and Gibbon, who worked jointly on these efforts, French Canadian arts were

not just exotic and arcane curiosities to be encouraged and exploited as spectacular commodities in order to enhance the tourist trade; rather, they formed part of a continuing cultural heritage in Quebec and were a future source for a purely Canadian culture.[15] Barbeau saw French Canadian traditions and identities as vital but under threat. To counter this situation, he worked tirelessly to ensure that they were recognized as an integral and living part of Canadian culture and identity. He emphasized their value to the railway as tourist draws, and used this as a lever in negotiations to ensure the largest possible audience to validate the economic and cultural contribution of French Canadian traditions.

As an ethnologist specializing in the indigenous peoples of Canada, especially those of the West, Barbeau was also valuable to the railways. It is this relationship that brought him into contact with Langdon Kihn. As Charles Hill states: "Barbeau and Gibbon shared common interests and would work together on a number of mutually profitable enterprises throughout the twenties. Their first co-venture resulted from Gibbon's invitation to the young American artist Langdon Kihn to visit the Stoney reserve at Morley, Alberta, in 1922, in order to publicize the annual Indian Days celebration held at the Banff [Springs] hotel. The Canadian Pacific Railway purchased eighteen of Kihn's portrait drawings and commissioned Barbeau to write *Indian Days in the Canadian Rockies*, paying for the illustrations which reproduced Kihn's drawings."[16]

Although Hill explains how Barbeau and Kihn became collaborators in the promotion of Native culture and imagery, he does not explain why. Why were Banff Indian Days in need of representation? Why was an American chosen rather than a Canadian or a British painter? Why did Gibbon select the relatively obscure and young Kihn? The answer to this last question lies in Kihn's background, particularly in the fact that he had trained under the "decorative" painter Winold Reiss, a German émigré to the United States known for adapting aspects of modernism to precise realism, especially in portraits of Native subjects.[17] Reiss was also employed by American railroads to paint Native images for tourist promotions. Kihn had already painted among the Blackfeet Indians in Montana with Reiss under the auspices of the Great Northern Railroad, and, "encouraged by the American ethnologist, Charles W. Lummis," whom he met while in California, he had branched off on his own and travelled to the Pueblos in New Mexico in 1920 and 1921, where he had painted in the vicinity of Laguna, Acoma, Santa Fe, and Taos.[18]

Kihn's style differed from that of the early portrayers of Indians of the 1800s, such as George Catlin and Paul Kane. But it was also free from the

conventions employed by those painters who depicted the West and the Indian, such as Frederic Remington and Charles Russell, who were then popular. Both invented an "authentic," albeit romantic and fictional, image of a past era by painting Indians in carefully detailed and dramatic settings that bore little or no relationship to contemporary reality.[19] Kihn bypassed these nostalgic narrative conventions, which, despite their immediacy and drama, did little to dispel the notion of disappearance. Instead, taking a more modern view, he sought to give his subjects contemporary presence. At this point in his career, he insisted that his portraits "are made from life by living with and among the Indians in their own territory" and, one might add, in their own time.[20] He also eschewed popular conventions for picturing women, particularly Native women. He employed no suggestive glances or gestures, no décolleté, no subservient poses – in fact, nothing to suggest a hierarchical arrangement between the sexes and a privileging of the white, male gaze.

Kihn's images demonstrated a hybridization that owed much to Reiss and that would serve him throughout the decade. His subject matter consisted primarily of portraits that combined two contrasting sets of conventions within a fairly standard format. His early Blackfeet and Pueblo pictures generally show the head and upper body of the sitter, in either a frontal, three-quarter, or profile pose (see Figure 11). The faces are drawn in precise detail, carefully delineating the subject's distinctive physiognomy. The sympathetic, intimate treatment conveys a strong sense of individuality, while the subtle chiaroscuro and precise contours create a full sense of volume and physicality. Had this naturalism been carried through the entire composition, the images would have approached the banality of standard portraiture and stood as a testimony to non-Native attempts to contain, and hence to control, the Native image within Western conventions. However, the final versions set up a striking contrast. The sitters' clothing and accessories were frequently rendered without shadow or depth in flat, textureless patterns that emphasized the bold, colourful, graphic, abstract motifs of woven blankets, beadwork, pottery, feathers, and silver jewellery. This linked the Native motifs to the tropes associated with modernism and set up an ambiguous space in which the sitter partook of both a traditional culture and a modern setting. The conflation of the two placed the sitter in the present and allowed a dialogue to open up between the Native and the non-Native in which the latter could accommodate and even be influenced by the former. Even in these "decorative" treatments, Kihn had a keen eye for accurate ethnographic detail, which he did not sacrifice in the interest of simplification – that

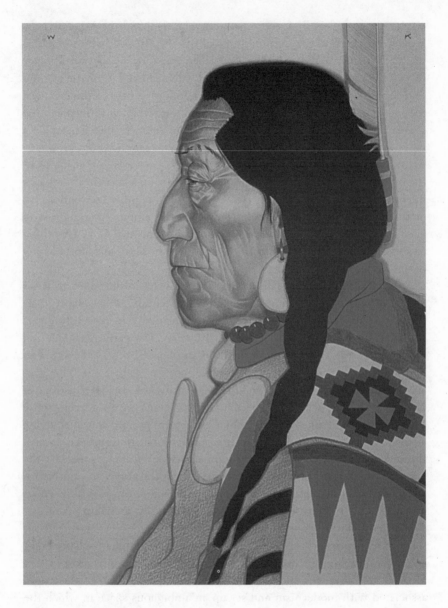

FIGURE 11: W. Langdon Kihn, *Curly Bear Acawyutsishe*, 1920-25, coloured pencil, crayon, graphite on board, 63 x 49.9 cm.

is, in the service of a crude and direct technique generally associated with Western adoption of "primitive" motifs. The distinctive, and sophisticated, features that characterized the costumes of each group were carefully demarcated, thus ensuring that their cultural differences were clearly established, despite the similar formats. The backgrounds were usually left as flat, blank, white fields. The different treatments produced abrupt transitions between the three zones of the pictures. Kihn made no attempt to integrate them by softening their edges, although they do work harmoniously together.

It may well have been Kihn's ability to clearly articulate both individual features and tribal characteristics, as opposed to any generic formula for "Indianness," that attracted Gibbon and intrigued Barbeau. The work's ethnographic detail and its close scrutiny of the faces of the sitters loaned itself readily to the possibility of using the images to define racial characteristics and origins, a process in which Barbeau was engaged.[21] On the other hand, the vitality of his work and the documentary portrayal of the costumes, which formed a large part of Banff Indian Days attractions, as well the work's adaptability to graphic design would have served Gibbon's purposes splendidly. Kihn's works had, then, many audiences. However, other elements would also have proven attractive and useful.

Although relatively young and lacking in experience, Kihn was rapidly gaining an international audience and exhibiting extensively across the United States to the same prosperous bourgeoisie whom the railroads would be courting as passengers. A large collection of eighty-eight of his works appeared in the spring of 1922 at his first, highly successful, and innovative New York showing at the Anderson Galleries under the auspices of the Santa Fe Museum and with the support of the Great Northern Railroad.[22] The Brooklyn Museum of Arts and Sciences, in conjunction with the Denver Art Association, sent the fifty pieces that were not sold on an extensive tour of galleries throughout the United States.[23] Kihn's paintings from the Anderson show were reproduced in the article "Immortalizing a Disappearing Race: What One Painter Is Doing to Perpetuate the Indian Physiognomy," which appeared in *Arts and Decoration*, a prominent American arts magazine, in the spring of 1922.[24] This may have served as an introduction to his Canadian sponsors.[25] Both the article and the exhibition were prescient regarding Canadian developments in several ways. The author commented on the unique format of the exhibition and noted that "certain specimens of American Indian craftsmanship, ancient and modern, [were] ... so arranged as to add the

proper atmosphere to the eighty portraits and landscapes." This must
be one of the first instances of such a combination, which included "the
more modern specimens of blankets, jewellery, basketry and pottery to
be placed on sale ... to develop an appreciative market in the East for
objects of art, seldom offered for sale here." The exhibition also featured
an eighteen-foot teepee with a "draftsmanship and a simplicity of compo-
sition that might well be envied by our modernists."[26] The organization of
the exhibition was a complex affair. The Native material was supplied by
"the Great Northern Railroad ... and such material as I am to secure from
Mr. Culin and from the Central Museum of Brooklyn, comprising mate-
rial from the Indians of New Mexico."[27] There was "also to be some Indian
blankets, pottery, basketry, bead work, etc., which will be distinct from
the loans mentioned above."[28] These were loaned by Dr. Edgar Hewitt,
director of the Museum of New Mexico in Santa Fe. The format, as well
as the collaboration between art gallery and museum, was later employed
in 1927 by Barbeau and Brown for the exhibition *Canadian West Coast Art,
Native and Modern*, held at the National Gallery of Canada (NGC), as well
as for the Jeu de Paume exhibition.[29] The article also called for the incor-
poration of Native motifs by "our designers," who could adapt the "simple
forms" to "our own vigorous, but complex civilization."[30] This too, as has
been seen, had parallels in Canada.

But certain ambiguities and disjunctions pervade the article. Both the
title and concluding paragraph, which bracket the text and the illustra-
tions, underscore the disappearance of the Indian in the most general, but
definitive, terms. Although neither offers any specific evidence in support
of this assertion, its validity seems to have been an a priori assumption.
Conversely, little in the body of the article confirms or even addresses the
premise of disappearance. If anything, the reverse is true. The images on
display were, as the article says, "obviously portraits of actual people, not
the fanciful studies of an idealist." The accuracy of their likenesses, which
the article praises, and the fact that their names, although anglicized,
supplied the paintings' titles spoke to their existence and presence rather
than to their disappearance. In addition, contrary to the generalization
of racial sameness in the title, all of the individuals were further distin-
guished by tribal affiliation, which tended to speak against a common
history or predicament. Further, the "modern" Native work on display
in the exhibition, examples of which are also worn by those in Kihn's
portraits, indicated that the makers of this work were in possession of
and producing their distinctive cultures, notwithstanding the misidenti-

fication of one person as the last to know the secrets of Acoma pottery. The contemporary Native pieces were also conflated with modernism in non-Native art – that is, they were given a context in the present, not placed solely in the past. This link between the primitive and the modern was confirmed by the similarities between the flat, two-dimensional designs of the Native works and Kihn's simplifications of form and flattening of space. Lastly, that the "modern" work was featured in an attempt to create a potential market recognized the present production and future viability of Native culture, albeit in a commodified context.[31] The body of the text, like the illustrations, speaks eloquently against the premise of disappearance embedded in the title and conclusion.

This gap was indicative of the emergence in the American Southwest and certain urban centres of a growing challenge to the perception of Native disappearance in the United States. Throughout the 1920s there was a gradual, although by no means uncontested, transition from a policy of assimilation to one that saw Native cultures and peoples, especially those from the Southwest, as surviving and as occupying an integral place within a broader American national identity. This reversal in the construction of the Indian as it had existed for over a century has been attributed to several complex, interlocking factors. Of primary importance, although perhaps less studied, was the persistence of the Natives themselves, who negotiated the survival of their culture and identity during a period marked by a systematic attempt to undermine the Native, particularly after the Dawes Act was passed in 1887.[32]

They were assisted in their efforts by the arrival of the tourist trade, which flourished after the railways were constructed through the area in the 1880s. That is, Western technology actually aided the cause of the preservation of Native cultures rather than irreversibly disrupting this cause, as is often claimed. Investigations into the activities of the Atchison, Topeka, and Santa Fe Railway have shown that by 1900 it had begun successfully using Native art and ongoing ceremonial activities as tourist draws in the American Southwest, thus giving Natives an audience and a legitimacy that were at odds with government policy. The Fred Harvey Company, which by and large took over from the local traders, specialized in providing tourists with railway travel and picturesque hotel accommodation where Natives sold textiles, pottery, and jewellery produced under the auspices of the company. As well, by 1926 the company was responsible for arranging extended motorized tours to Pueblo villages so that visitors could watch displays of traditional rituals and dances by costumed

performers.[33] Indeed, "success in saving Pueblo ceremonies from govern-
ment policy was assisted immeasurably by their increasing value through
the 1920s as tourist attractions."[34]

Another major factor that contributed to the persistence of the
Natives during and after the war was the arrival in the area of an urban
elite of intellectuals, artists, and wealthy and powerful easterners, who,
for various reasons, took an active role in championing the Native cause
and formulating a new purely American national identity with links to
the Indian as opposed to Europe. There was a reaction "against the coer-
cive, assimilationist policies of the federal government and of Christian
missionaries" by a "generation of eastern Anglo-American intellectuals,
artists, and art patrons" in the American Southwest who were interested
in the "preservation and the national appropriation of Indian cultures" in
"remapping the geography and aesthetics of American identity – away
from Europe and from colonial New England" during the 1920s.[35] After
the First World War, "Anglo supporters of Pueblo sovereignty, such as
it could be conceived by them, promoted Pueblo art as a strategy in
support of Pueblo cultural survival."[36] This centred on initiatives intro-
duced in the early 1920s that threatened Native lands and restricted
ceremonies.

Alice Corbin Henderson, Mabel Dodge Luhan, Mary Austin, and
Amelia Elizabeth White, four wealthy and powerful patrons of Pueblo
arts and supporters of the Pueblo's concerns, were instrumental in
defending both Pueblo land rights and traditional ceremonies, which were
under increased attack at precisely this moment.[37] They were joined in
their endeavours by artists such as the American painters John Sloan and
Marsden Hartley.[38] Pueblo art became a prominent factor in the battles
carried on in urban centres by these artists, patrons, and sponsors to
"save the Pueblos" and to employ "American Indian art ... [as] an autoch-
thonous foundation for a uniquely American aesthetic."[39] Sloan arranged
for display of Native material at the exhibition held by the Society of
Independent Artists in New York City in 1920. The recent watercolours
by Pueblo artists were valued by the critic Walter Pach for their "primi-
tive" qualities, linking them directly to the past.[40] This is evidence of the
beginnings of a critical framework that would position Native work from
both the present and the past as a purely American national aesthetic. The
modernist artist Marsden Hartley also wrote in 1920 that "in the aesthetic
sense alone, then, we have the redman as a gift. As Americans we should
accept the one American genius we possess, with genuine alacrity. We

have upon our own soil something to show the world as our own, while it lives."[41] By 1922 follow-up shows were said to mark "the birth of a new Art in America."[42] Also in 1922, when Kihn was exhibiting at the Anderson Galleries, White opened a gallery featuring Native art on Madison Avenue in New York City. The purpose of both was to "encourage a market for American Indian Art."[43] This concurrence suggests that Kihn was, by this time, drawn into the program to create a critical, aesthetic, and commercial framework that would validate the current and future contributions of ongoing Native arts and traditions to an American identity.[44] White continued to arrange exhibitions of Pueblo work, at times using material gained through Henderson, throughout the decade both at home and abroad. She was instrumental, with Sloan, in organizing the *Exposition of Indian Tribal Arts* in 1931, which is seen as the culmination of these efforts to have Native art recognized as a distinctly American art.

The concentrated activities of these powerful individuals led to substantial reforms in Indian policy in the 1930s under Franklin D. Roosevelt's New Deal and the administration of John Collier, "the progressive social activist" who became the commissioner for the Bureau of Indian Affairs.[45] Collier had earlier taken an active role in attempting to preserve Pueblo culture and to enlist the assistance of the group of artists and patrons. In an effort to gain recognition for the viability of Native culture and the possibility of its preservation into the future, he had brought thirteen Pueblo "officials to New York in early 1924 and presented them to New York society at a Cosmopolitan Club reception. The Pueblo visitors danced and Collier spoke."[46] By the mid-1930s, under his administration, the government had reversed its policies and implemented the "Indian Arts and Crafts Board ... and other initiatives to support and encourage arts production."[47]

It is no coincidence, then, that Kihn had met with Mabel Dodge Luhan and her husband on his trip through the Southwest in 1919, before his first excursion to Canada.[48] Here, he would have encountered a concept of the role of Native culture and art completely different from that which subsequently framed the review of his work in *Arts and Decoration*. His connection to this group continued and expanded. He received a letter of introduction to Mary Austin from Sheldon Parsons of the School of American Research, Museum of New Mexico, Santa Fe, who had exhibited Kihn's early work in 1920 and 1921.[49] He was invited to the Pueblo event in New York City arranged by Collier. He was also in communication with the Eastern Association of Indian Affairs, the umbrella

organization assembled to promote the cause of the Pueblos, of which White was the secretary.[50] However, Kihn was not completely converted to this new view. He would still, in the future, speak of the inevitable "death of the Indian," but at the same time his exposure to the ideas espoused by the likes of Luhan, Austin, Hendersen, White, and Collier as well as his partial integration into their programs meant that his artistic production took on an ambiguous role. In the end, his ambivalence and oscillation on precisely the point of disappearance or continuity, and on the role that Native arts could take in the formation of a national identity, would be most problematic for his position in Canada, where, as will be shown, conditions were substantially different. In the meantime, Kihn's direct involvement with the American programs designed to promote railway tourism to the Southwest, rather than any links to those who professed a desire to preserve Native culture and art, would have made him an ideal candidate for similar promotions in Canada, where preservation was a moot point.

Nonetheless, the potential for a Native presence to draw tourists would militate against the official position of the Canadian state. This occurred at several sites. One such example was Banff, during Indian Days, which had their beginning around 1889, three years after the CPR reached the Pacific Coast, when Natives from the Stoney Reserve were asked to entertain passengers who had been stranded in Banff by inclement weather. By the end of the century it was an organized annual event that may have provided the model for developments south of the border.[51] The CPR had also started to engage artists to paint the picturesque scenery of the West in 1886, a program that had parallels in America but that, in Canada, did not involve Native imagery unless it declared the Indian to be part of the past.[52] Although in Canada this practice had diminished by 1920, it had continued in the United States, as we have seen.[53] The success of the American enterprises, especially in the Southwest and in Montana, and Kihn's indirect involvement in them, may well have predisposed Gibbon to favour Kihn as the candidate most likely to enhance Banff Indian Days and to revive the program of railway-sponsored artists. The potential was obvious. The *Arts and Decoration* article as well as Kihn's travelling exhibitions featured the type of broad publicity that the Canadian railways coveted.[54] Employing Kihn may have been seen as a way to compete with the growing draw of the Southwest in a manner that no Canadian artist could accomplish.

In any case, events proceeded quickly. In May 1922, the month in which

the *Arts and Decoration* article appeared, Barbeau and Kihn were working in conjunction with Gibbon and the CPR – although possibly independently of each other and without formal introductions – in a program that would duplicate features found south of the border but with significant differences that distinguished the experience on the western Prairies and the Northwest Coast from that in the American Southwest.[55] This joint, albeit at times troubled, alliance between museum personnel, artists, and railways would continue until the following decade.

Arriving in Montreal from New York in the spring, Kihn met Gibbon, who had provided him with railway passes, and then travelled west. His stay was extensive. He spent "seven months from late May to December 1922 in western Canada and B.C."[56] His main focus was the Stoney Indians of the Morley Reserve, which was situated just outside the mountains in the foothills west of Banff. He remained there for several weeks, with a side excursion south to the rugged Kananaskis area. He seems to have been well integrated into the Native community, which he viewed very positively. During his stay, he was privileged to be invited to a sun-dance, "a thing that is forbidden all whites to see," since such ceremonies were at the time prohibited by law.[57] His witnessing the traditional ceremony, however, caused "difficulty with the [Indian] Agent."[58] This was not the only problem that arose. Kihn's initial itinerary was also intended to include what he called the "Totem Pole Indians" of Alert Bay, situated on an island just off the northeastern tip of Vancouver Island, which was a popular stop for cruise boats. However, he was diverted from this destination when he was informed through Gibbon that the totem poles there had been sold.[59] Gibbon made no mention of the problems surrounding the now famous prosecutions of the participants in the Cranmer potlatch, which formed the peak of the repression of Native traditional ceremonies on the West Coast, commonly known as the "potlatch ban." Nor did Gibbon mention the attendant confiscations of traditional regalia, which were then under way. Instead, Kihn was redirected to the remote west coast of Vancouver Island to depict the Nootka (i.e., Nuu-chah-nulth). He described his destination, which was well away from the railway and only accessible by water, as "entirely an Indian totem-pole village."[60] On his return trip Kihn was again diverted and directed to travel south, this time by the Arrow Lakes steamer to the small community of Brilliant, where he did portraits of "seven or eight of British Columbia's Doukhobors including John E. Konkin, Anastasia Verigagan [sic] and Billy Chernoff."[61] Although done at Gibbon's behest, Kihn's work among this small

and reclusive group had little value to the tourist trade. However, the Doukhobors were seen as politically problematic, even potentially subversive, and thus in need of infiltration and surveillance.[62] Any information that Kihn could accumulate from his intimate contact would be useful to the state. Back in Invermere, he painted Kootenay subjects as well as Bliss Carman and others who were in attendance for a pageant that took on aspects of Banff Indian Days.[63] Gibbon, who was also present, was pleased with Kihn's work and extended his pass until the end of November. Gibbon assigned him the task of recording his experiences and collecting stories from his Native contacts while hinting at substantial, albeit "confidential," plans for a forthcoming project, although no firm commitments were made.[64] Duncan Campbell Scott's name was mentioned as someone to whom the work would be shown, but Barbeau's name did not occur, and the extent of his involvement at this point remains unknown. The project of the book was brought up, but Kihn assumed that it would "contain most of my writings and legends that we gather, and will be illustrated with *colored* reproductions of my Indian portraits."[65] Kihn finished up with a further stay outside of Banff on the Morley Reserve. He remained in the Banff area until early winter, when he took the train back to Montreal and met Gibbon, who "was pleased with the results of [the] trip" and purchased eighteen portraits.[66] Two of these were sent to the British Columbia Provincial Museum in Victoria.[67] While in Ottawa, Kihn also met "Barbeau, [Edward] Sapir [who was Barbeau's immediate superior] and National Gallery Director Eric Brown."[68] Kihn then returned to New York. By this point, Gibbon's plans must have coalesced. By January, Gibbon had given the project for a book on the Indians of Western Canada to Barbeau, and it was to feature reproductions of Kihn's images.[69]

So how and where did Kihn go astray? Kihn's paintings, for all their aesthetic and useful qualities, opened up a contested site. The contentious issues that they revealed concerned the perceived and actual state of Native cultures and peoples, their presence in public performances, which were part of tourism and local economies, and their position in the construction of a unified and homogeneous national identity. Duncan Campbell Scott, who was taking a concentrated interest in any Native ceremonial activity in western Canada as well as in Kihn's works and Gibbon's projects, did not share the latter's view on the pluralistic possibilities for Canadian identity. Scott was certainly not in sympathy with what was going on in the Southwest. His ideas were more monocultural and excluded the contribution of indigenous cultures. Christopher Bracken

has given an accurate account of Scott's position on art and nationhood and on the place of Native peoples and culture.[70] Bracken notes Scott's "conviction that the poet's [i.e., his own] foremost ethical responsibility is to contribute to the building of a nation ... It is their duty to help raise people from barbarity and lead them toward nationhood ... the crowning achievement of human civilization, its ultimate, rational 'social state' ... Aboriginal cultures have a place in Scott's nation only if they consent to die and leave their remains — such as their names or confiscated potlatch regalia — in national archives and museums to be remembered by future generations of homogeneously white citizens."[71]

Along with ceremonial activity on the West Coast, Kihn's primary subject, the Stoneys, was a sore point for Scott and those working under him, particularly given the Stoneys' role in Banff Indian Days and their presence at the parallel Calgary Stampede, also in its nascent state in the 1920s. Brian Titley's thoroughly researched study helped to reshape established perceptions of Scott and to focus attention on his role as a bureaucrat rather than as a poet. His detailed account of Scott's reactions to events in Alberta and Saskatchewan is worthwhile recapitulating and supplementing with additional material.[72] This is especially so since the repressions of Natives on the Prairies are less well known than those that they parallelled on the West Coast. But most important, the history that he recounts opens up for critical evaluation the question of Native culture's role in Canadian identity and tourism. Indeed, his work can be used to demonstrate one important aspect of the crisis that occurred within representations of the Indian during the 1920s.

It must be kept in mind that although this discussion will focus on Scott, he did not act alone. Insofar as he was able to hold onto his position for two decades while governments came and went, he must have carried out his policies with their approval. His overall policies, with some exceptions, reflected the will of all the parties that came to power rather than being specifically his own. Neither was Scott responsible for introducing the federal government's repressive Indian policy, which had begun in the previous century. In 1895 the Indian Act was revised, such that Section 114, "which sought to extend the prohibition of the potlatch to the dances of the plains," now attached a prison sentence to such "crimes."[73] Still, at this stage, imprecise wording made the law difficult to enforce against all dancing, as did variances in opinions between the Royal Canadian Mounted Police (RCMP) and overzealous and punitive Indian Agents on the precise targets and purposes of the law.[74] Those convictions that

did occur on the Prairies were proclaimed a deterrent but often, in fact, proved less than effective, if not counterproductive.[75] In the first decade of the century, at the local level, W.M. Graham, an Agent at Qu'Appelle, and J.A. Markle of the Blackfoot Agency were adamant advocates for the repression of all dances of whatever type, which were associated with "evil," "debauchery," "paganism," and "indolence" and were regarded as "inimical to progress," especially farming.[76] However, by 1907 the Prairie Natives had enlisted legal counsel and were actively resisting the law; contrary to the bureaucracy's expectations, dancing ceremonies, especially the sun-dance, had become increasingly frequent.[77]

It should also be noted that at this point, early in the twentieth century, the Natives on the Prairies found support in unexpected places for their case for continuing traditional ceremonial activities. Titley reports: "The 'recrudescence' of dancing had a further disturbing dimension. Around this time, the organizers of fairs and exhibitions began to invite Indians to perform their dances as a form of entertainment ... Undoubtably, fair organizers sought to exploit the dancers as inexpensive entertainment ... It must have been reassuring to know that not all elements of the dominant society perceived their dances, songs, and costumes as relics of a barbarism that ought to be ruthlessly stamped out."[78]

Banff's longstanding and successful Indian Days may well have served as the intermediate model for these exhibitions and fairs. In addition, they may have been regarded by the various Native groups who participated as a venue for gathering to discuss problems associated with educating white audiences about the value and validity of their traditions, to hand on or modify those very traditions, and to assert their potential contributing role in contemporary Canadian society. A pamphlet from Banff's 1931 Indian Days indicates that the Native participants may have had a view of the event that was entirely different from that of their non-Native audiences. Not only does it give the number of ceremonies performed and handed on during the event, but it also describes their significance:

> Were the Stoneys not brought periodically to Banff, the rising generation would not see the "mustcosch" (cattle) [bison] of their father's stories and the narratives of wonderful hunting would not mean so much to them. Thus the annual trip of the Stoneys to Banff assists in keeping alive the precious stories and legends of that race. Go out to the village at some hour when the tribe is at liberty and note the number of Indians taking their small sons over to the ani-

mal corrals. Follow them up and, if you understand Sioux, you will find the fathers relating stories of past great days. Particularly will you find this so at the buffalo paddock. You will also find the youngsters are being given a first hand natural history lesson.[79]

A Native presence, then, at local fairs, festivals, and stampedes was also a strategy for resisting the opposition of the bureaucracy and some of the missionaries while, at the same time, negotiating the validity and vitality of Native culture within the modernist context.

Indian Days, however, seemed beyond containment. This was not so with the Dominion Exhibition in Calgary, which began in 1908 and became the Calgary Stampede in 1912. It was feared here that the presence of costumed Natives might gain worldwide press exposure and give "the wrong image of the Dominion abroad."[80] This anxiety was undoubtedly in response to what was perceived as a disaster at the Chicago World's Fair, where the Native dances were seen as a tarnish on the image of Canadian civilization. Despite concerted attempts by the Department of Indian Affairs, under Scott's predecessor, Frank Pedley, to have the Indians excluded, their inclusion had already been established under the auspices of Reverend John McDougall, who "undermine[d the] Department's efforts to prevent Indian dancing at public events. In 1909 McDougall was responsible for the presence of about three hundred Stonies at the Dominion Day celebrations at Banff. A few days later, and again with the missionary's involvement, close to six hundred Indians, including Stonies, Crees, Blackfoot, Sarcees, Peigans, and Bloods, attended the Provincial Exhibition in Calgary where they were the main attraction. Department officials viewed these events with dismay and complained bitterly to headquarters both about their inability to control the situation and about McDougall's activities."[81]

Throughout this period Scott was rising to prominence and power, first as superintendent of education within the department in 1909 and then as deputy superintendent in 1913, when it was discovered that his predecessor had been found privately disposing of Native land for his own profit. During Scott's initial period in office, while establishing his policies, he encountered powerful politicians with vested interests in the exhibitions and fairs, especially the Stampede, who began to resist his initiatives. Worse yet, they were succeeding. On taking over the department, Scott realized that he would have to strengthen Section 149 (formerly Section 114).[82] Consequently, an amendment to Section 149 was drawn up

forbidding Indians in the four western provinces and in the territories from participating in "Indian dances" outside of their own reserves and from appearing in shows or exhibitions in "aboriginal costume."[83]

By 1915 convictions had been secured in Saskatchewan, but Native resistance was strong, and it appears that dances continued as before. The war provided Scott with the context that he needed to further amend aspects of the potlatch and dancing ban in order to make it more enforceable.[84] These changes were passed in 1918, based, Scott claimed, on the "urgent necessity of conserving everything, especially food. Those who participated in 'give away' festivals of any kind [either on the Prairies or the West Coast] could now be prosecuted and tried without reference to a higher court."[85] By changing the nature of the crime to a summary, rather than an indictable, offence, "the law gave them [the Indian Agents] the power to act as prosecutor, judge and jury."[86] This assured the elusive convictions. Although the ostensible context for these measures disappeared in the same year that the bill was passed, the law did not. It became the basis for increased prosecutions in the early 1920s. On the Prairies, W.M. Graham, who had by 1920 risen to the rank of Indian commissioner of the Prairie provinces and who was related to the new prime minister, became an adamant foe of dancing.[87] He was more zealous than the Indian Agent responsible for the Cranmer prosecutions, William Halliday, in his support for the new outbreak of repression after 1920 and was positioned to enforce his will.[88] The only difference that he had with Scott on the matter concerned the degree of harshness that was to be employed in meeting their ends. With the increased cooperation of the recently reorganized RCMP, now on the lookout for anything deemed "subversive," and with the new law in place, convictions for the crime of dancing should have become an easy matter. As in British Columbia, "1921 and 1922 were the peak years of prosecution for violation of Section 149 on the prairies."[89] At this moment, just after the formation of the Group of Seven, confidence was high that the programmatic extinction of Native culture and identity in both regions was on the verge of success.

This belief soon proved to be misguided. The Natives on the Prairies again sought legal counsel and found ways to get around the law. "On a visit to the west during the summer of 1922, Scott saw for himself the tenacity with which the Indians clung to their customs."[90] He realized that a measure of compromise might be essential to preserve a sense of control and avoid admitting outright defeat. Recognizing that he had failed in halting dances, he thus proposed a limit on the time spent at such

events but with little effect. The Prairie dances went on as before and, as Kihn reported, increased in number throughout the 1920s.[91] All of this provoked apoplexy in Graham, who fulminated against any dances, now even including polkas and two-steps. However, he had lost his connection to the prime minister's office in the 1921 election and consequently was more easily defied.[92] His worst humiliation would be occasioned by the Calgary Stampede: "Indian resilience succeeded in negating the depart-ment's efforts to suppress their dance festivals throughout the 1920s. And they were equally successful in their defiance of regulations forbidding performances at fairs. The Calgary Stampede was revived in 1919, and it proved to be the principal source of difficulty in this respect."[93]

By 1923, defying disapproval from Scott's office and knowing that they could count on the support of the new inspector general of Indian Affairs, Charles Stewart, a former premier of Alberta, the Stampede's organiz-ers went ahead and included Native participation. Graham and Scott, who now found themselves outflanked from below and overruled from above, had to accede and thus became active participants in regulating, rather than in prohibiting, the events.[94] Graham attempted one last time to forbid Native attendance at the Stampede in 1925. As the Stampede's organizers had decided that they were going to feature a recreation of the North West Mounted Police's ride to the West in commemoration of its fiftieth anniversary, in which the Native presence played a major role, this was unthinkable. Graham had to settle for keeping the young and able-bodied Indians on reserves, presumably hard at work on their farms, while the elderly were allowed to take part.[95] Graham and Scott found the consequences of this period of tolerance to be calamitous. Other com-munities throughout the Prairies, on seeing the success of the Stampede and knowing that they could bypass Scott, followed with fairs of their own. By the end of Scott's tenure in 1932, the frequency of dances on the Prairies had reached new heights, and he was more or less obliged to admit a measure of defeat respecting his policies and was left wishing that he had imposed more draconian measures, which would have turned the reserves into virtual prisons under constant surveillance.[96]

Several questions now arise. What impact did this continuing conflict between the state's policies of repressing Native cultures and identities and the successful resistance to these programs have on either the pro-duction or reception of Kihn's representation of the Native peoples of Alberta and British Columbia? Could it not be said that Kihn's works, and what Bourdieu would call the "field of cultural production," were

at some remove from a bureaucratic, administrative, and legal problem contained within one government department?[97] Further, why was it possible or even desirable at the height of repressive activity in 1922 to have an artist render, and later publish, images of the very peoples who were causing so many problems by refusing to give up their cultures and identities, defying the law and winning support for their case? Why would a government-employed portraitist be involved in such a project? Would not these images have run the risk of being seen as emblematic of resistance and continuity, thus further exposing the divisions and contradictions emerging from behind the official façade?

Part of the answer to these questions lies with how such images would have been viewed and interpreted and, second, with how they were framed by the texts that surrounded them. Scott was not unfamiliar with projects to paint portraits of Native peoples in traditional costumes. Nor did he oppose the practice, so long as the images could be used to further his, and the state's, own ends. He had already undertaken a similar venture when negotiating Treaty No. 9 in 1906 with the James Bay Native groups. At the time, Scott's friend, the artist Edmund Morris, was commissioned by the Ontario government to accompany him and paint the images of the chiefs with whom Scott would be negotiating. Morris went on to pursue further work on the Prairies in 1907 and 1908. This led to the commissioning of Native portraits by the governments of Saskatchewan and Alberta.[98] These images were seen by both Morris and his audiences as valuable to the extent that they preserved the last remnants of the culture. Morris stressed to the premier of Saskatchewan the "importance of losing no time as the last of the fighting Indians will soon be gone and then it will be impossible to get true records of the old type of those who held land before the coming of the whites."[99] The critical reception echoed this view. A 1909 review stated: "The pictures recently exhibited in the Canadian Art Gallery by Mr. Edmund Morris ... are a series of portraits of the most prominent living redmen in Canada, and [gain value] both as pieces of portraiture and as the finest possible souvenirs of a race which will soon be no more than a tradition."[100] Such assertions of imminent disappearance, and the necessity of preserving the last images before they were gone, were in keeping with critical responses that went back as far as Paul Kane. They formed, then, the expected framework for both the production and the reception of Kihn's work in Canada. The title and conclusions of the 1922 *Arts and Decoration* article on Kihn's American production would have confirmed that he was the ideal

person to carry on this urgent task after Morris. It was only a matter of ensuring that Kihn's works were viewed in the correct manner. Critically disciplining their interpretation was the answer. However, as will be seen in the next chapter, it was not always possible to control how they were perceived. In certain quarters, the peculiar nature of Kihn's pictures and the discursive framework from which they originated tended to militate against the prevailing, and conflicting, view in Canada.

Given their source in the American Southwest, Kihn's pictures tended to resist being made emblems of disappearance. He approached his subjects in western Canada with the same set of hybrid conventions that he had employed in Montana and New Mexico, where an alternative view of the Indian was emerging. As in his earlier work, each individual is centrally placed, either frontal, three-quarters, or profile, and shown from the chest up (see Figure 12). The heads are carefully drawn in three dimensions, showing a detailed recording of the distinct features of the sitter, who generally, but not necessarily, wears a traditional costume. Some wear contemporary Western dress. This posed the possibility that the individuals portrayed could move between and negotiate their positions within each culture. It also avoided the romantic representation of what has become known as the "ethnographic present," which signified an idealized and stable, but lost, state of cultural purity existing prior to contact. In contrast to the sitters, the costumes, including robes, shawls, shirts, hats, and headdresses, are generally treated in a flat, decorative manner, as graphic patterns without modelling or detail. Those portrayed are not placed in a picturesque landscape, or in a setting of any type, but sit before a blank, flat background, which tends to remove them from any specific geographical or cultural context.[101] Conversely, as much as the white backgrounds decontextualize and exoticize the sitters, the flatness of both the backgrounds and the costumes and accessories is a trope associated with modernism. It could thus be inferred that the sitters were placed in and inhabited the generalized realm of the modern and contemporary and that they negotiated their presence and specific identities within this space. Such ambiguous possibilities oscillated between the general and the specific and spoke of continuity and presence. It was primarily the latter readings that required rigorous textual disciplining to ensure a singular, stable interpretation.

Barbeau, who shared his position on the state of Native cultures with Scott, began this critical disciplining almost immediately, before the book commissioned by Gibbon was published. He used the same venue as

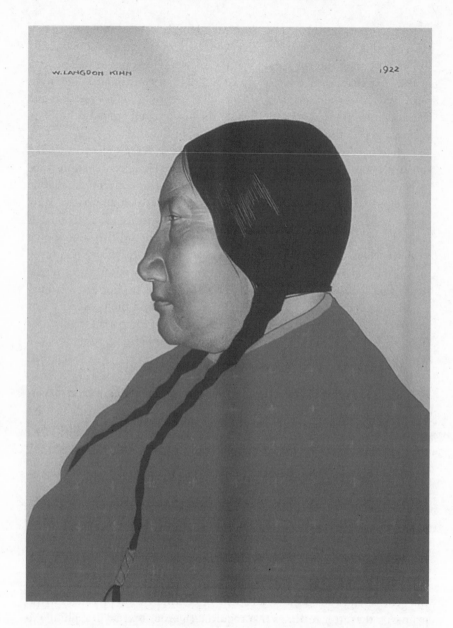

FIGURE 12: W. Langdon Kihn, *Rosie Coyote-Woman, "Sunktoya-wiya,"* 1922, coloured pencil and graphite, 61.2 x 48.5 cm.

the article "Immortalizing a Disappearing Race," which had reproduced Kihn's paintings from the Anderson show — that is, *Arts and Decoration*. Barbeau's article, "An Artist among the Northwest Indians: Langdon Kihn Has Pictorially Recorded Some Types of a Little-Known Race," appeared in May 1923.[102] The title is again misleading. The text actually had little to do with the illustrations of Kihn's pictures. Rather, it was concerned with responding to and stabilizing the potentially dangerous ambiguities presented in an article on Kihn that had appeared in the same journal the previous year. Barbeau's strategy was elegant. He took the themes of "disappearance" in the title of the previous article, but absent in the body, and supplied the missing material. He began by clearly distinguishing between two of the peoples whom Kihn had painted in Canada: the Stoneys and the Nuu-chah-nulth. Although speaking in the past tense, he differentiated their respective village sites, landscape habitats, houses, hunting practices, diets, travel, rituals, and physiognomies — that is, he catalogued the cultural traits of these separate peoples through his ethnographic vision. When he turned to history, however, his text bifurcated on the point of differentiation. Instead of pursuing the unique histories of the two western Canadian indigenous groups, which were substantial, he outlined a generalized account of the common history of all Native peoples in North America after the advent of contact and the acquisition of firearms. Here, he told a tale in which the generalized "Indian," now seen as a homogeneous mass, having gained the means of efficient destruction from cultural contamination, initiated a common act of continental self-annihilation. Reduced to a single, collective, nondifferentiated, and essentialized subject with a single mind but no vision, "they never thought of living in peace together, of offering a solid front to the real conquerors of their lands. Instead, they engaged in bloody feuds that were made more destructive through the introduction of improved weapons and facilities of transportation. They blindly used the advantages they derived from their white allies against their enemy kindred, without considering that a few years later the balance might turn against them, as it often did."[103]

"Blood revenge" led to "ultimate extermination," a term repeated throughout the essay, which was laid squarely at the feet of intertribal warfare. This continental "war of attrition was proceeding along its fatal course. Pestilence and small-pox, around 1840, were to do the rest, so that years before the white settlers were ready to open up the country, Indian wars and European diseases had nearly stripped it of its former

occupants."[104] According to Barbeau's vivid historical gloss, the North American landscape was emptied of all Native peoples before colonization began. The Group of Seven's images of vacant lands became, by implication, accurate, while the impression created by the text of the previous article on Kihn, which documented the continuity of Native peoples and cultures, was placed in error. Barbeau never mentioned Native resistance to this occupation, any colonial campaigns against the indigenous populations, or their survival into the present. To ensure the inclusion of all of the race within his construction, he extended this process across the continent. "The lot of the west coast Indians at the hands of their white conquerors seems not to have been unlike that of the plains and mountain tribes," although he did concede that "the damaging contacts in most places were established rather late in the nineteenth century."[105] Conquest, rather than treaty negotiation, which was never mentioned, became the active force in Native displacement.

Barbeau's historic narrative, which literally reframed Kihn's Canadian Native portraits, although it did not yet address them, established an alternative context for reading them in which they became emblems of a single disappearing race set within a simplified opposition to their collective colonial conquerors, who were equally nondifferentiated. The general assumption, although historically inaccurate, would have gained credence insofar as it was in keeping with the longstanding notion of what is now called the "salvage paradigm," which saw the ethnographer as engaged in the urgent task of gathering what remained of fragmenting Native cultures. Yet this paradigm was itself fragmenting at this time. Barbeau was now aware that an alternative and competing construction was emerging that was in conflict with both his own position and the state's policies. This construction had already appeared in the article to which he was responding. As he had done earlier in the century, he chose to maintain his allegiance to the state and to Scott, who had just passed his most draconian legislation to ensure the end of Native cultures.[106] This choice, in turn, meant denying the evidence of continuities that he was witnessing. Barbeau's problem lay in reconciling a narrative of Native extinction as occurring in the not recent past with the obvious presence of the sitters in Kihn's portraits, which had been noted in 1922. Barbeau accomplished this inversion by recourse to the romantic notion of the artist as a person of superior, clairvoyant vision who could "penetrate under the surface, and give a clear, individual reading of human souls even at a time when they seem about to fade away from the material world."[107] The

individuality of the persons portrayed and their distinct characteristics were thus not part of their intrinsic identities. Nor did these elements attest to their presence. Rather the portraits represented the Euro-American artist's heightened vision and ability to perceive and render that which was already gone, somewhat like looking at a pile of dead ashes and seeing the vibrant flames of a previous fire. This privileged the colonial gaze while denying that of the Native peoples, who were blind to the fatal consequences of their own actions. As a corrective to the earlier article on Kihn and a rebuttal to the repositioning of the Indian that was emerging in the Southwest, Barbeau's text was the first salvo in a discursive conflict. It would not be the last.

At this early stage, Barbeau expressed no sense of disjunction between his ethnographic and historical texts and Kihn's images. His preliminary article reconciled the three. His main problem in the book project would have been reconciling his and Scott's views on the status and role of Native cultures in Canada with Gibbon's desire to flout the law and use the Stoney and other groups, with their costumes, pageantry, and presence, as a tourist draw in Banff.[108] Barbeau's title, *Indian Days in the Canadian Rockies*, appears to acknowledge Gibbon's position, but the book's content exposes the lie in its title.[109] If Gibbon had hoped for a popular handbook that would introduce his Banff audiences to the Stoney and outline specific aspects of their culture, such as religious beliefs, territories, histories, habitats, social structures, ceremonies, and costumes, which would have illuminated aspects of Indian Days, he must have been disappointed.[110] In fact, insofar as Barbeau had done no fieldwork among the Stoney, of whom he knew little, he was not suited for the task. However, the ethnologist had another agenda in mind, noting that the book's intent was to "visualize the advent of the white man into the northwest from the Indian standpoint."[111] Or as the promotional material put it: "Volumes have been written on this period, but these have been all from the standpoint of the white conqueror; Mr. Barbeau has endeavoured to give us that conquest as seen through Indian eyes – and he has succeeded."[112] Even though he drew largely on non-Native sources for his material, this collection of tales and histories from throughout the western groups was promoted as offering a sympathetic view that positioned Barbeau as speaking for his subject. However, adopting the "Indian standpoint" not only usurped Native voices, but also posited these voices as prophetically predicting and then acting out the Native's own inevitable, fated, and naturalized demise. The richly embroidered tales and histories

that Barbeau presents, in which he literally creates dialogue, scenarios, and characters in order to give the stories a fictitious historic verisimilitude, offer different accounts of how various Native groups, ranging well beyond those involved in Indian Days, were all similar in that they foresaw the coming of the white man and/or experienced contact as the end of their way of life. The first chapter discussed the Carrier and Gitxsan people of British Columbia, who were neither near Banff nor even on the CPR lines.[113] However, their territories were the home of a precontact Native seer named Beeny, who foretold the end of their traditional life. Barbeau's highly coloured and vivid invention of this figure sets the stage for the second chapter, which expands on the theme of intertribal warfare and how it, combined with disease, "strip[ped] the country of its native occupants," who have now become invisible.[114] The third chapter offers various tales from across the country on Native responses to the first appearance of the white man, which destroyed the social fabric of Native cultures. The Stoney make their appearance only in chapter four.[115] The fifth and last chapter, "Crestfallen Indians," wraps up the central theme. Only in an appendix does Barbeau actually include brief "Ethnographic Notes" on the distinct characteristics of the various groups, but these are largely devoted to claiming, incorrectly, that all were the same in that their populations were dwindling.

In pursuing this principle of collective disappearance, Barbeau again departed from the rigorous and detailed aspects of his ethnographic writing. As in the *Arts and Decoration* article, and as when addressing popular audiences in general, he resorted to the nondifferentiated concept of the essentialized "Indian" as a common race with a common history leading inexorably to a common, tragic conclusion of which all Indians were prophetically and fatalistically aware. This suppression of difference between Native peoples and their histories placed all Indians in a dualistic relationship with an equally homogeneous non-Native culture. Whereas one was decrepit and dying, the other was nascent and virile. In opposition to Gibbon, Barbeau's attitude was largely retrospective and confirmed, if not surpassed, Scott's position. The theme, repeated throughout the text, is most clearly expressed in the introduction, where phrases such as "the Indians have vanished out of sight, almost out of existence" abound.[116] Barbeau does admit to some exceptions. He notes that "picturesque stampedes take place every summer in the July celebrations at Banff, when the Stony warriors don their regalia, paint their faces, pitch their tipis ... These are the 'Indian Days' as we now understand them, in which

memory delves into ancient experiences, the experiences of the *real* Indian days that are no more."[117] Distinguishing the past "real," which is divorced from the present simulacra, he states: "The present-day Indians of the western prairies and the Rocky Mountains are no longer what they used to be. They have dwindled in numbers; their ancient customs are gone, their character is lost. They are a vanishing race."[118] Nonetheless, Barbeau notes that there could be some misapprehension in the popular mind, to which he offered a corrective: "In the white man's pageants or in silver screen views of the wild west, they may still appear to us, when garbed in buckskin and feathers, as spectacular personalities dwelling in a sphere apart from the rest of mankind; but when visited at home, on the reserves, they seldom live up to the fanciful expectations we derive from literature and pictorial art."[119]

Although Barbeau agreed with Scott on the disappearance of the Indian, he differed from him on one essential point. Referring to all Indians as "outsiders" – that is, as part of Canada's foreign "other" – he declares: "It is clear that the Indian, with his inability to preserve his own culture or to assimilate ours, is bound to disappear as a race."[120] Assimilation was not an option. Instead, in a remarkable twist of logic, the Native peoples of Canada were made alien rather than indigenous and had no place within the country or its emerging national identity. Their exclusion from the nation, and thus their fate as passive victims, was sealed. However, the non-Native artist is given an active and creative role: "The only tragedies that leave any impression are those which are suitably staged by artists and poets, and even the obliteration of a score of human races arouses little attention if it remains obscure and unspectacular."[121] Barbeau proposed a new genre of Canadian art, a tragic mode that encompassed both the visual and the literary. Scott's poems, Barbeau's texts, and Kihn's paintings were all players in formulating, validating, reproducing, and distributing the spectacle of racial "obliteration" as one of the "great tragedies" that make up the story of the nation.[122] Staged within these multiple venues, which extended across disciplines and media, the narrative of decrepitude written by a contrasting virile culture would become deeply embedded within the fabric of the national culture and identity. Unwary readers, with no broader experience of the "recrudescence" of Native ceremonial life on the reserves, would easily add this version to the many similar tales heard elsewhere, accept this description as authoritative, and use it to modify their perception of the Indian presence that they saw before them, adding a poignant and melancholy aspect to the

pageantry and positioning the viewer as among the last to witness such rare and disappearing events.

The main problem directly confronting Barbeau was again Kihn's images, which undercut this dualism through their attention to details that defined the people as individuals living in the present and their cultures as unique, contemporary, and ongoing. Barbeau's solution to this problem was again ingenious. As in his *Arts and Decoration* article, he gives Kihn's documentary realism a fatal twist that signifies death rather than life and that confirms the superiority of the Western gaze. Barbeau introduces Kihn's detailed portraits with a stock version of simple, superstitious Indians terrified of the deadly power invested in examples of the Western mastery of realism: "Portraits like those of Mr. Kihn therefore might prove dreadful magic. It was only too easy for the artist, if he meant mischief, to draw a rope, an arrow, a long knife, or a tomahawk, and the evil was done. The days of another Indian were numbered."[123] Apparently, either photography had not reached the Native population in the last half-century or the Indians were still in a state of stupefied shock at its potentially fatal powers.[124] Thus Kihn's pictures could be made not only to point out Western cultural superiority, but also to predict, act out, or be the agent for the demise of Indians at their own hands, even if inadvertently. That it was actually the author of the book who was attempting this particular trick of using a represented image and ritualistic incantations of death to kill off the subject was not mentioned.

However, Kihn's portraits convey a different message than that of the morbid texts with which Barbeau surrounded them, and they did much to undermine Barbeau's "magic" act. The relationships between images and text are quite loose, if not in conflict. In total, fifteen portraits are included. Portraits of Kootenay and Cree individuals are added to those from the Stoney Reserve. The paintings depict an almost equal number of each gender: seven women and eight men. They all have similar titles. Each of the portraits bears a name in English and, if known, the sitter's Native language, tribal affiliation, and in some instances, social position (e.g., *George McLean, Walking Buffalo or Tatanka-Mani, Stony Indian*; *Hector Crawler, Calf Child of Tatanka-Cinca, head medicine man of the Stony tribe*; and *Joe Nana, Running Calf or Kan-a-hun-kan-goya-kathlam, Kootney Indian*). Inscriptions written on others provided even more detailed information, such as "Good Singer – Ksuk-Kla-Klu-Uk Mary Isaacs (daughter of Albin) 27 years / Kootenay Indian / Kootenay Indian Reserve / Fairmont (Hot) Springs, B.C. / Her husband was only Kootenay engaged recent war."[125]

More so than in his Pueblo pictures, Kihn's titles and inscriptions identify the individuals as distinct people currently living within and taking their identity from the language, the social structure, and at times the history of a particular group. They are not synecdoches for the race as a whole nor traces perceived after its "extermination." On the contrary, both individual and tribal differences are pointed out as being very much of the present. This quality was noted at the time, albeit not by Canadian writers. Helen Comstock, writing for an American publication, stated: "It might be said that most artists have seen the Indians as a race, collectively, while Mr. Kihn sees them as individuals with all their differences of feature and character."[126] Jackson Rushing has commented on this construction of the "Indian" as a singular concept: "By ignoring the specificity of [Native] culture(s), Euro-Americans had in 'The Indian' an actor without subjectivity, whose perceived identity was manufactured by the visual and verbal discourses of explorers, priests, politicians, soldiers, and, not least of all, social scientists and artists." Through this process, the "diverse native peoples ... [became] a malleable substance that could be shaped to any form/image and filled with any content desired by the politically dominant culture." Rushing continues: "Euro-Americans were forever prevented from seeing the first Americans as real people. Calculated or not, this was the specific function of the Indian as idea or concept, as opposed to Indian as human, existing in a different but valid and historically produced culture."[127] The emphasis on humanity, presence, names, social positions, and realness within Kihn's paintings tended to make his subjects visible as living individuals. It is here, then, that Kihn's images and Barbeau's ethnographic practice corresponded to each other but also came into conflict with the state's policy and with the latter's position on Native disappearance and the generalized concept of the Indian, which he used in his popular and historical writings. However, in 1923 this ambiguity in both Barbeau's writings and Kihn's pictures was not yet a major problem.

This first round of work by Kihn for the railway and Barbeau was successful. His output included some eighty works that circulated widely. They were published in Barbeau's book, which appeared in September 1923.[128] In 1922 they were shown at the Banff Springs Hotel, Château Lake Louise, and Lake Windermere. In the spring of 1923, before the next summer's tourist season, they were exhibited in back-to-back shows at the prestigious Ainslie Galleries on Fifth Avenue in New York City, the Salons of America at the American Art Galleries, and Moyer Art Galleries

in Hartford, Connecticut.[129] The following spring, Kihn's paintings were displayed at the Arts and Letters Club and the Art Gallery of Toronto (AGT; now the Art Gallery of Ontario).[130] He was, as the culmination of his contribution to and inclusion within Canada, shown at Wembley in 1925. However, an anticipated show at the NGC in 1924, following those in Toronto, fell through. His major sponsor with both the national institution and the AGT, Sir Edmund Walker, had just died, and Brown now resisted the opportunity, even though the thirty-one drawings were shipped to Ottawa.[131] Although, as the railway had hoped, the works received wide international exposure and enjoyed multiple audiences, further purchases in Canada proved to be problematic. Neither the government, through Scott or others, nor the NGC, nor the AGT acquired any of this series.[132] The sixteen CPR portraits ended up, for a time, in an out-of-the-way location off the main tourist routes and well away from any urban centre: the new David Thompson Memorial Fort Museum in Windermere, British Columbia.[133] These were not retained by the CPR and were ultimately dispersed. Several subsequently entered the Glenbow collection in Calgary, while others remain in private hands.

Chapter 6: Barbeau and Kihn with the Gitxsan in British Columbia

THE HISTORY OF THE relationships between the formation of a national identity and the image of the Indian within Canada's arts occupied a unique place that separated it from the histories of such relationships in other colonies and dominions. But there were also regional variations within this history, especially in British Columbia, where conditions were different from those in the rest of the emerging nation.[1] These differences spanned a wide spectrum of issues that included the varying results of colonial contact in the region, the individual histories of the various Native groups, the question of unsettled land claims, the nature of the arts produced by both the Native and non-Native peoples in the area, the types of ceremonies targeted for banning, the disposition of the railways, the role of the tourist, and so on. Nonetheless, the histories of the representation of the Native peoples on both sides of the mountains overlapped in many ways, particularly in the further projects of Marius Barbeau and Langdon Kihn.

In the end, Barbeau and John Murray Gibbon, of the Canadian Pacific Railway (CPR), did not see eye to eye on the representation of Indians and their role in either the tourist trade or Canadian culture. Although Barbeau would continue to work with Gibbon in Quebec on projects confirming the vitality of French Canadian culture, he almost immediately switched railways in western Canada. Going over to the competition, he began a correspondence with Gibbon's counterpart, C.K. Howard, the general tourist agent for the state-owned Canadian National Railway (CNR). Howard was not encumbered with Gibbon's pluralistic ideas of a Canadian mosaic, nor did he have any interest in using Native ceremonies and presence as tourist attractions. But above all, the western extension

of the CNR, the former Grand Trunk Pacific Railway, took, as part of its route from Prince George to Prince Rupert on the West Coast, the path of the Skeena River Valley. The upper reaches of this valley were the home to the group of Native people whom Barbeau had been studying since 1914, namely the Gitxsan, who occupied a series of villages that were becoming famous for their stands of carved totem poles. Barbeau and the railway saw great potential for these poles as tourist attractions that could challenge Banff Indian Days in several respects. Kihn was soon drawn into this second project. Although Kihn was not in Canada in 1923, when Barbeau was in the Upper Skeena, by 1924 they were in the field again in this new area. However, their second joint venture was as complex as their first.

The Gitxsan were important and under close scrutiny for more reasons than just their tourist potential. Relatively isolated, and experiencing contact much later than other groups on the coast, they had a reputation for maintaining both their traditions and their territories. They were, in turn, the focus of a complex array of interrelated government programs, of which the railway was only one aspect. Barbeau's own ethnographic work there led in 1929 to the publication of his scholarly and detailed study and inventory of the Gitxsan totem poles, aimed at a specialized audience.[2] It corresponded to a joint undertaking by the National Museum, the CNR, and the Department of Indian Affairs to restore the poles among the Gitxsan villages, which were seen as both a valuable artistic heritage and a tourist attraction.[3] The trip initiated a project that Barbeau would subsequently develop to make the Gitxsan villages and the Skeena Valley a site for Canadian artists painting a purely Canadian subject matter.[4] In addition, Barbeau produced another book, this one pitched at a popular audience. *The Downfall of Temlaham*, which appeared in 1928, was loosely based on a selection of Gitxsan stories and histories that he had collected in the field, again on the mythic/historic contact with non-Natives but much reinterpreted.[5] Kihn was contracted to provide the design and the illustrations for the publication in what appeared at first to be a second happy collaboration among artist, author, and railway.[6] This is not how it would end.

Barbeau was aware that his own work, the work of artists such as Kihn, and the National Museum were beneficial sources of advertising for the railways in the Skeena region. He frequently outlined how his ethnographic interests overlapped with those of both the state and the tourist industry, noting the mutual benefit that might result from their collabo-

ration with him. He is said to have declared in Ottawa in the winter of 1925 that "much more use might be made from a tourist point of view of totem pole villages in British Columbia, as they proved a great attraction to those who knew of them. Already some of the Western Canadian cities [particularly the tourist town of Banff, already mentioned] were adopting Indian Days as a means of advertisement."[7] Totem poles, teepees, and Natives in costume would be the emblems of this tourist attraction. However, totem poles, especially those among the Gitxsan villages that flanked the railway in the Skeena Valley, would now be uppermost in his mind. Individuals in regalia would fall away almost completely. Speaking on the subject of totem poles at the National Museum, Barbeau emphasized their importance to the railway: "He considered them to be an economic asset to the country, in that they attract foreign tourists to patronize the railway."[8] By the mid-1920s Barbeau saw the National Museum and the national railways as working jointly in an area of common interest – that is, with the Indian population, who were in turn viewed as an exploitable resource and as subject matter for Canadian art. However, there would be much more than this at stake.

By March 1924, while Kihn's works from his first trip to western Canada were on display in Toronto, the artist had begun making arrangements to travel to the Skeena region that summer.[9] Through Barbeau and the National Museum, he negotiated with Howard to have the CNR cover transportation and other living expenses for himself and his wife and also requested some guarantee for the sale at the end of the enterprise "of the paintings and drawings I made in connection with your publication *The Downfall of Temlaham*."[10] Even though Howard understood the publicity value of the expedition, he proved more parsimonious than Gibbon.[11] Neither transportation from New York to Montreal, nor living expenses, nor the guarantee of purchases, nor for that matter, access to the parlour car on the long trip were forthcoming. Kihn was obliged to lay out a substantial amount of his own money with no certainty of a return.[12] Nonetheless, the opportunity was too good to pass up, and the museum assisted with transporting household material needed for the extended stay and picked up the added expense of the parlour car.[13] In keeping with Barbeau's proposed itinerary, Kihn and his wife left New York for Montreal on 8 June 1924, where they met with Howard, H.R. Charlton (an agent for the CNR), and Gibbon.[14] They then caught the evening train west. The Barbeaus joined them in Ottawa. Together they travelled via Winnipeg, the Prairies, Jasper, the Yellowhead, Prince George, and then

down the Skeena River Valley. On 14 June they set up headquarters in Terrace, a small settler community downriver from Gitxsan territory. After finding suitable accommodation, Kihn had little to do but wait for Barbeau to proceed to the Native villages, and he spent his time doing landscape studies, which, somewhat to Kihn's surprise, Barbeau encouraged and praised.[15] By late June he and Barbeau had arrived in Kitwanga, a village that lay near the tracks and whose totem poles had become a primary tourist attraction. They returned several times. It was here that he began sketching poles and negotiating with chiefs to pose in their regalia, while Barbeau collected recordings of songs, myths, information, and objects.[16] By early July, Kihn reported that they had travelled to various other villages, including Usk; the two deserted village sites of Kitselas; the small settler community of Hazelton, where Barbeau had relatives who ran the local store; and the nearby Carrier community of Hagwilget, where they observed a potlatch ceremony, but more on these events and their trip to Kitwancool later.[17] They also visited Kispiox, a Gitxsan village north of Hazelton, where he painted a number of the totem poles, as he did at Gitsegukla, where they stayed in late September after the trip to Kitwancool.[18] All of this was done in the company of Barbeau, with whom his relationship remained very good.[19] In their spare time, they played horseshoes, explored, and spent evenings in which Barbeau instructed Kihn on the short future of any remaining Native culture: "He regretted we had not the time nor means to gather more of the last surviving culture, which though there were but feeble tracings left of a rich past, we realized it would be but a little while before it would be snuffed out."[20] After Barbeau left, Kihn and his wife stayed on, as he had in Alberta, until just before Christmas. He then travelled back to Ottawa at Barbeau's invitation, arriving 23 December 1924.[21] He remained there into March of the following year, working up unfinished pieces and possibly new ones in space supplied by the National Museum.[22] He also began an active round of meeting officials and dignitaries and arranging for exhibitions and possible sales, which were always held out as just around the corner.[23]

"During his six months stay among the Gitksan tribes of the Skeena, he was associated with Mr. Barbeau in a thorough scrutiny of past Indian life, and produced an imposing collection of over sixty Indian portraits with carved headdresses and traditional costumes, and totem pole canvasses [sic]."[24] Not all of these were completed on site. Writing home in November, he outlined plans to stay in Ottawa for a month "working on oil can-

vasses [sic] mostly. Have about 20 oil canvases complete already but have some important composition sketches that I must work up." However, he had finished his larger 75 x 100 centimetre portrait drawings, which he later numbered at five, although some work still remained on the smaller 50 x 75 centimetre and 37.5 x 50 centimetre ones, of which there were five and thirty-five respectively, for a total of forty-five. At this point, it appears that he had completed only one large canvas featuring totem poles but a "half dozen or so of about 20 x 25 [inch] canvases of totem-poles, mountains and figure groups, and a lot of smaller ones of mountains." In December he placed the figure for the latter at seven, which he called "sketches," for a total of fourteen landscapes – a substantial downward assessment from November. More landscapes must, then, have been done in Ottawa to bring the total up to eighteen. In addition, he also did an unknown number of pencil sketches of totem poles. He placed a total value on the collection, if sold as a lot, at $14,150. As he said, this was "quite a lot of work for six months."[25]

This achievement depended on full cooperation from his subjects and may have had something to do with both his attitude toward and his representations of them. As with his images of the Stoney, his portraits were sympathetic to his sitters. Again, he depicted both men and women, showing little discrimination between them; that is, absent were the familiar tropes associated with the "feminine," especially the Indian feminine, that were then popular. He again avoided both romanticizing his subjects and placing them in dramatic narrative situations. In addition, he continued to show a range of attire, from Western dress to traditional ceremonial regalia, to avoid placing his figures within a timeless ethnographic present. All ages were also represented. Accompanied by names, the portraits of the Gitxsan, by virtue of being portraits, confirmed his subjects as individuals who were living, despite Barbeau's view, in the actual present. In works such as *Portrait of Chief Hlengwa, Earthquake of Kitwanga Village*, which had been sent but not shown at Wembley in 1925, and *Solomon Harris*, he paid great attention to the details of the traditional costumes (see Figures 13 and 14).[26] Here, and elsewhere, Kihn carefully rendered elaborately carved and painted frontlets, some inlaid with blue-green abalone shell, bear claw headdresses and necklaces, button and Chilkat blankets, ermine robes, cedar-bark neck rings, spruce-root hats, raven rattles, staffs, and other objects. He also recorded the names and social positions of his sitters as well as the name of each object and its meaning in inscriptions on the backs of the works.

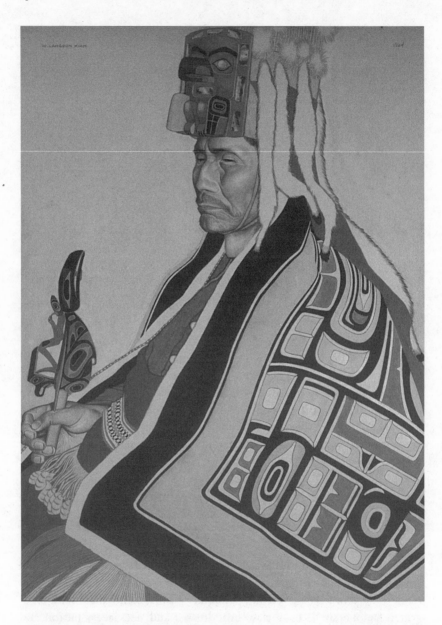

FIGURE 13: W. Langdon Kihn, *Portrait of Chief Hlengwa, Earthquake of Kitwanga Village*, 1924, coloured pencil and graphite, 110.8 x 85.3 cm.

Insofar as the sitters had to be entitled to display these inherited crests, and given that their social positions, Gitxsan names, and clan affiliations were included in the paintings' titles, the paintings proclaimed each sitter's status and place within his or her community and gave the impression that the regalia still remained in the possession of their owners. On the other hand, the identities of the sitters are not without ambivalence. Neither Kihn nor Barbeau was entirely rigorous in ensuring that the objects represented with certain people were in fact the crests of those individuals. These details were, in some cases, confused.[27]

Although Kihn continued to employ his three-part system of representation, he also did justice to the subtlety and complexity of the forms of the regalia. He obviously studied them closely and came to grips with their characteristic design principles. By and large, he abandoned the simplifications and flattening devices of his former style and allowed spatial conventions, such as foreshortening and chiaroscuro, to enter his depictions of carved objects. In turn, the richness of the hues of the button and Chilkat blankets, which contained striking contrasts of intense and pure reds and blues, in the first, and of blue, yellow, black, and white, in the latter, seems to have led him to a bolder use of colour.

Kihn maintained the use of frontal, three-quarter, and profile views, but in several instances he modified their positions. This is particularly true of the striking portrait *Martha Mawlhan of Laksale* (see Figure 15).[28] The female sitter, a chieftess from Gitsegukla, is attired in dyed cedar-bark robes decorated with swan's down and wears a carved frontlet representing Mawdzeks, the Hawk, with frogs. In a frontal pose, with her head placed high on the page and her braceleted arms crossed in front, she looks down on the viewer. Breaking with conventions for the depiction of an anonymous, submissive, eroticized, Native, female Other, her presence is magisterial and austere, and it emanates an authority that is in keeping with the matriarchal aspects of Gitxsan social structure, in which women could hold positions as chiefs. In addition, her face, as with several of the other Gitxsan works, is more expressive than the blank masks of his earlier works. Although shown in profile, the portrait of *Mrs. Johnny Larhnitz* is equally imposing (see Figure 16).[29]

Despite certain errors, it can still be postulated that Kihn attempted to find conventions through which the "otherness" of the Gitxsan could be preserved and represented positively. This now extended beyond their costumes and names and invaded the formerly blank backgrounds. In contrast to the careful detail and full volumetric rendering that characterize

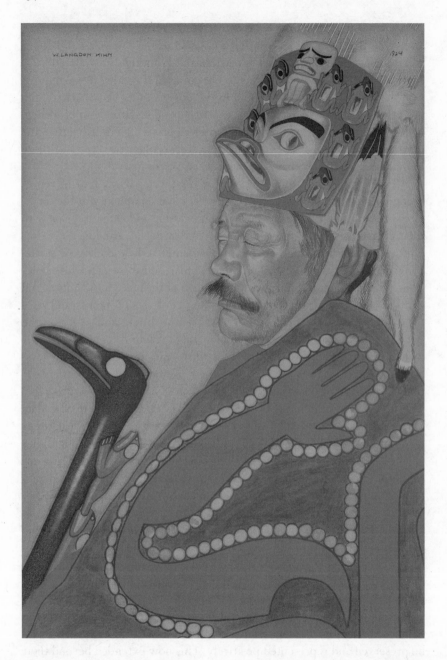

FIGURE 14: W. Langdon Kihn, *Solomon Harris*, 1924, watercolour on paper, 75.3 x 49.6 cm. Known elsewhere as *Lelt*.

his treatment of the sitter, he still frequently resisted the use of an accompanying deep space. Instead of the blank white of his Pueblo, Blackfeet, and Stoney pictures, he experimented with a series of coloured grounds that stood in contrast to the costumes. In at least one instance, he applied gold leaf to the background area.[30] In addition, he also adapted design motifs based on the crests of the peoples whom he depicted, incorporating them in flat, decorative fields. One example is listed in the inventory as *Hanamuk or Hanamuh – "Perforated Ear" [or Sunbeams] Fanny Johnson, Gitseguykla, Fireweed phratry, shown wearing a head-dress of ermine skins and mallard duck feathers which were her family crests* (see Figure 25).[31] Other crests of the sitter – the stars, the moon, and the rainbow – appear behind her as two-dimensional background motifs. In *Tseewa or Thick Thighs, George Derrick, a medicine man of Gitwinlkool, Raven phratry, background figures: the crest of Semgeek – "Woodpecker,"* Kihn carefully replicated the complex formline design from a screen that had been collected by Barbeau, but that, although originating in the village of the person portrayed, displayed a crest that was the property of someone other than the sitter.[32] In *Weegyet (or Mark Weegyet) – Big Fellow – Head Chief of the Gitsgyukla, Fireweed Crest,* where the subject is shown wearing a head ring and collar of cedar bark, Kihn attempted a third variation on this approach, using a stylized abstraction of totem-pole motifs that appear to have been chosen arbitrarily.[33] While such usages might be seen as appropriation – which, to a degree, they were – they were also, by dint of being placed within the context of the peoples who owned them, an affirmation and recognition of difference mediated through a modern sensibility. This is much different from the proposal to have decorated plates made by non-Natives and sold to tourists. Kihn's works could, then, despite problems with the placements of his objects, be interpreted as testimony to the continuity of the culture, its survival, and its vital influence on modern conventions. One could say that his imagery attempted to establish a link between traditional Gitxsan culture and the modern and that they allowed for the possibility of the former finding a valid, vital, and contributing place within the context and history of the latter.

Kihn's approach to his subjects was in keeping with developments in American policy, especially in the Southwest, where he had worked and his ideas had initially been formed. As has been stated, a new discursive framework for viewing Native culture was emerging there. But significant differences separated the two national programs. The project in the American Southwest was based both on the growing, if contested,

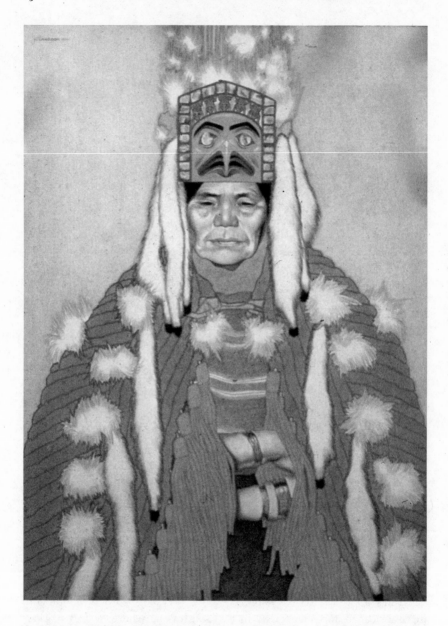

FIGURE 15: W. Langdon Kihn, *Martha Mawlhan of Laksale (A Woman Chief of the Raven Clan of Gitsegukla, B.C.)*, 1924, coloured pencil on paper, 100 x 75 cm.

recognition of the continuity of Native culture into the present and on its integration into the fabric of a larger American culture, each of which was supported by a group of powerful and influential individuals. In Canada, on the other hand, nothing short of the obliteration of Native culture, and with it all traces of Native identity, was the current goal of the federal government. Although, as has been seen, many non-Natives sided with the indigenous populations on many issues, there was an almost complete absence of the sort of powerful patrons with access to influential politicians that were present in the American Southwest. Thus, while any of the individuals whom Kihn portrayed appeared ready and able to take an active role in any performances similar to those during Banff Indian Days or those organized in New York City by John Collier, commissioner for the Bureau of Indian Affairs, this was not to happen. Given the views of Barbeau and Duncan Campbell Scott, and given that no one with sufficient power had a vested interest in the economic welfare of the province, no such activity could occur, no matter how much it would have enhanced the railway's potential revenues or those of the local hotels.

As in Banff and on the west coast of Vancouver Island, Kihn did not restrict his output to portraits. He also did a series of landscapes, both with and without totem poles. One of these, *Gitwinlkool Totem Poles*, is an oil in the collection of the National Gallery of Canada (NGC). The remote village had been presented by Barbeau to Kihn as a special attraction since it had not only what Barbeau considered to be the oldest and best stand of poles but also a widespread reputation for not welcoming non-Native intrusions and for maintaining claims to its traditional territories. In his unpublished memoirs, the artist reported on their attempt to set up a base camp there.[34] The two undertook negotiations to enter the region and arrived in September with the intention of a prolonged stay of several weeks, during which Barbeau was intent on photographing the totem poles and collecting other material. Almost immediately, they were told by the local people to cease their activities. However, they were able to continue to draw and photograph "surreptitiously." "Often Beynon would stand lookout and warn us if anyone approached for if we were caught it would jeopardize our whole expedition and besides the Ind. [sic] might demand we destroy what he had already done."[35] A series of meetings ensued in which both artist and ethnographer were asked to explain their projects. The major problem seemed to be that the Kitwancool people would receive no benefit from this activity, whereas the artist

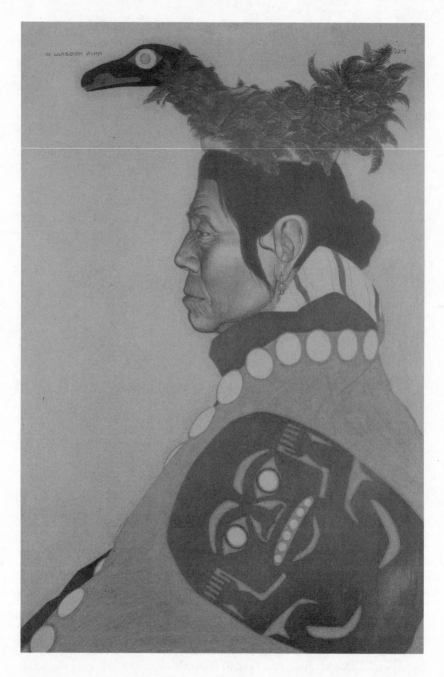

FIGURE 16: W. Langdon Kihn, *Mrs. Johnny Larhnitz*, 1924, pastel on paper, 85.5 x 60.5 cm.

and ethnographer stood to profit handsomely. However, this was not the only issue of concern:

> They would gain nothing in the assistance of our obtaining such records. Our many reiterated statements as to the altruistic purposes and the effect of greater better understanding of them by good people and the big men in the east thru our propaganda work had but little affect. We had told them that recording them in writing and drawing painting [sic] them would create great interest among the people who were in control of their country and because these people would be able to see them in their true light and learn of their conditions ["traditions" in an earlier version of the manuscript], they would try and preserve them. They replied that they would prepare a history themselves when the need came ... Surveyors had already marked off their land. They felt that some fine day the time would come when they would even be compelled to defend their homes from the encroachment of land settlers. This they were prepared to do with their lives is [sic] necessary. If that time came they would then call a High Council of the tribes of the Tsimsian and the Nskai [sic] their neighbors to the north the people of the Nass River. These brethren [sic] and freinds [sic] would witness that this was their land, the land of their fathers and the white man had no right to claim any part of it. Then would a history be prepared by them. We were told that for more than thirty years the tribe had sent petitions regarding their land question to the government and much money had been spent.

Unable to overcome these arguments, even though Barbeau agreed "to lay their case before the proper authorities ... so far as he was able," cooperation was not forthcoming. With no prospects that anything fruitful would develop despite some support within the village, in a state of anxiety over their deteriorating relationships with the Native population, and worried that "the existing situation might terminate in really serious consequences," they resolved that the best course of action was to return immediately to Kitwanga.[36]

Although Kihn later worked up this material for potential publication, *Gitwinlkool Totem Poles* suggests none of these problems.[37] Although work at the site was difficult, if not impossible, the painting appears to be a fantasy, probably composed after the fact from photographs, rather than a

documentary image done from life. It shows a host of richly carved poles, all – except one that tilts slightly – standing rigidly upright. In addition, Kihn added brilliant reds, greens, yellows, and blues to the poles that were not in fact there.[38] A small female figure with a baby on her back turns away from the viewer and wanders into the picture. A mountain, probably Rocher De Boule, not visible from Kitwancool to this extent, towers in the back and, despite its distance, can be seen as a means of limiting and flattening the space, a device that Kihn employed throughout his landscapes of the region. Any sense of precise place, then, was lost. The image, as with most of the landscapes, is in strong contrast to the precision of his portraits.

A second landscape with figures, titled *A Feast among the Skeena People*, shows in the foreground a group of eleven people of various ages, from infants to elders, dressed in an array of traditional costumes, including Chilkat and button blankets. They also wear masks and frontlets and are placed before a large old-style dwelling. Between the figures and the house stands a large totem pole with a canoe attached, identifiable as a pole at the village of Kispiox. A killer whale figure at left also seems to come from Kispiox, but the house does not correspond to contemporary photographs of the buildings in the village and may be a composite from the deserted Coast Tsimshian village of Kitselas, in which Barbeau had a great interest. Again, a large mountain rises up and flattens the background space. It would appear that once again the figures, landscape, and setting are largely a fantasy created more to render the Indian as a spectacular attraction to tourists than to document a specific incident or place. There is, then, a significant difference between his portraits and landscapes.

By 1925 Kihn's paintings were generating precisely the type of publicity that the railways wanted on the international stage. In fact, they were probably exceeding all expectations. Barbeau had initiated the process by publishing his article on Kihn's work in *Arts and Decoration* in 1923, but the ethnologist was not alone. The artist was, unlike any of his counterparts in the 1925 Wembley exhibition, singled out for individual recognition in a lengthy article in *The Studio* devoted solely to his Canadian work.[39] The author, Leonard Richmond, who had written on the Canadian pavilion at Wembley and had toured western Canada, met Kihn in the spring of 1925 while Kihn was in Ottawa.[40] His Kihn article contained seven small and four full-page illustrations, including one in colour. This was the type of international recognition of which most individual Canadian artists, including all of the members of the Group of Seven, could only dream.

Still, even if the article did place Kihn in a better light than his Canadian coexhibitors, the text was in keeping with Canadian policy. It reiterated the position that his Native subjects were on the edge of extinction. Richmond may well have obtained such views from his close contact with the Canadian administration.

When other writers, working without such direct contact, approached Kihn's work, different interpretations arose. An article by Helen Comstock, cited earlier, appeared in October 1925 in *International Studio*, an outgrowth from *The Studio* but based in the United States.[41] It was Comstock who asserted that Kihn portrayed his figures as individuals rather than as a race.[42] Her point was substantiated by the six paintings that were illustrated, five of which were portraits. She praised these for their reconciliation of decorative and documentary elements and for their lack of romanticization.[43] Gender equality again prevailed, as two were women, two men, and one a boy. As with the representation of the Stoney, three of these wore Native costumes, while two were clothed in Western attire.

As well as giving a brief history of the career of the artist and listing numerous other artists using Native subjects, she outlined Kihn's projects in Canada. In reviewing his trip to the Skeena River Valley, Comstock commented extensively on the state of Gitxsan culture:

> Like all Indian tribes those of the Tsimsians and the Carriers are losing their native culture as a result of their contact with the white man. The members of the younger generation have little interest in the arts of their forefathers. They are not interested in the carving of totem poles, ... nor are so many blankets woven, ... although ... a chilkat blanket is worn by Semedeek, Eagle head chief of the Kitwanga tribe, in one of Mr. Kihn's portraits. There are only a few carvers left, says Mr. Kihn, who are capable of doing the fine work on headdresses.[44]

This is precisely the rhetorical phrasing that often appeared in Barbeau's assessments and may well be attributed to his influence, coming through Kihn. Conversely, there is room for ambiguity in Comstock's text that Barbeau would not have allowed into his own utterings. Comstock implied that blankets and carved frontlets were still present, still made, and still worn, just not in the same quantity. Any impression of cultural disruption that might have been conveyed was further modified when she went on to outline the continuing role that such objects played in

confirming the elaborate crest and social structures, all in the present tense. Doing little to reinforce the notion that Gitxsan culture had disappeared were statements such as "each family has a crest of its own, for instance there is the Wolf family, the Raven, the Grizzly, the Eagle, the Fireweed, and there is a chief for each family within the village and these families are connected with families in other villages who, of course, also use the same crest." Similarly, countering the idea of the Indian's absence was the claim that the button blanket worn by "Many Grouse Flying," a woman chief from Gitsegukla, was "frequently used." Comstock even gave an account of the potlatch as a ceremony with many positive aspects. She never once referred to it as an evil that had to be eradicated or that was being suppressed by the state.[45] She concluded: "To Mr. Kihn these members of an alien and incomprehensible race are of exceeding interest and his pictures of them recreate them for us."[46] According to Comstock, Kihn's works played an ambassadorial role in their ability to negotiate an understanding between the Gitxsan and the broader world. Even though Comstock's writing contained reiterations of cultural and racial decrepitude and made Native peoples the subjects of a Euro-American discourse, other sections of her text produced ambiguous meanings that were not necessarily in keeping with Canada's official position. Aspects of Comstock's essay could be taken to imply continuity and vitality, a reading that the accompanying paintings would only have reinforced.

Attention to Kihn's Native images was not limited to North America and England. It spilled onto the Continent. In October 1925, the month in which Comstock's article also appeared, Armand Dayot's journal, *L'Art et les Artistes*, published an article on Kihn's entire Native output. Odette Arnaud's four-page introduction, which summarizes Kihn's career to that point, precisely parallels a summary that would appear a year and a half later in the same publication in Eric Brown's lead-up article for the Jeu de Paume exhibition in Paris. The resemblance between Arnaud's claims for Kihn and Brown's later claims for Canadian art, from which Kihn was excluded, except in illustration, is uncanny. Although the subject is different, the terminology and structure of their respective histories are the same. Arnaud begins by giving a brief overview of American painting from the 1700s, noting its dependence on European models, especially the French influence after the Revolution. Arnaud then reports the formation of "an autochthonous American art, representative of the genre and its country and its race" in the early twentieth century. In this context, Kihn is "a young independent who does not belong to any school and

who has formed himself only by the profoundest roots of his country."
However, Arnaud's subsequent statements, such as the following, differ
from what Brown would write later about Tom Thomson: "Like the art-
ists of Taos, but in a different sense, he had made the Indians of America
his subject in order to perpetuate that colored life of theirs, so full of
tradition." The suggestion of the continuity of these traditions, which was
a part of the program of many of the Taos artists, is developed as Arnaud
goes on to romantically extol Kihn's subjects and his involvement with
them and to place their existence and life in the present: "He was enam-
oured at once with the savage charm of that Montana reserve where the
Blackfeet live like men of the primitive ages ... The friendship of their
medicine men and of their chief being once acquired, the Indians ceased
to be suspicious, and willingly came to pose, at the same time recount-
ing their legends." Of the Pueblos, Arnaud writes: "Their artistic sense is
of millennial growth and unchanged by time." Arnaud, in keeping with
the American stance, also confirms the principles of French regionalism,
which linked national identity to an original and still existing *volk*. While
this confirmed continuity to this point, the critic adds that their art "is
irretrievably disappearing from this world." The article conflates Kihn's
modern, decorative style with essentialized notions of his subject matter:
"His portraits, from first to last, constitute a double document; as much
by the visage, painted with startling realism as by the costume, for which
the artist shows himself as arbitrary as the natives themselves, and where
he renders in full the decorative and elementary side of their love of colors
and of simple forms." Arnaud summarizes Kihn's Canadian experiences
among the Stoney, Kootenay, Nuu-chah-nulth, and Gitxsan. Concerning
the latter, she notes that "in company with the ethnologist Marius Bar-
beau, he [Kihn] ventures along the shores of the Skeena River, where the
Kitwinkools [sic] detain them for judgment during three days before driv-
ing them from their territory." Arnaud's description, which places Bar-
beau before the Kitwancool tribunal and under their juridical power and
which includes the expulsion of the two from a domain described as still *in
their possession*, must have caused considerable concern for the ethnologist,
who at no point ever published an acknowledgment either of the event or
of the article's existence, although it undoubtedly came to his attention.
This confirmed continuity in Canada of Natives' control of their culture
and lands. Implying the existence of separate nations, Arnaud reiterates
the notion that Kihn's work was ambassadorial: "Kihn bears witness for
them, with all his power, and in a manner confers immortality upon them

by the unforgettable interpretation that he has given of them."[47] Although ambiguous, Arnaud, like Comstock, suggests the possibility of the continuity of Gitxsan and other Native cultures. Between the two critics, one American and one French, an alternative image of the condition of Native culture in Canada and its link to national identities was opening up that differed strongly from the image found in Barbeau's published texts and favoured in Brown's constructions.

Kihn contributed to this ambiguity. In an illustrated article published in early 1926 in the prestigious and widely circulated *Scribner's Magazine*, he gave an account of his experiences in the Native villages of the Upper Skeena region.[48] This text is of some importance both as a record of the continuity of traditional cultural activity among the Gitxsan in the mid-1920s and as a document of the discursive tensions between the Canadian and American views that existed at the time. Kihn's text opens as a conventional travelogue in the picturesque tradition, describing the wonders of the landscape as a "paradise" and the attractions of the people and their art. After the preamble, however, it seems to be torn in two over the state of the Native culture that he was witnessing and recording. On the one hand, he recapitulates Barbeau's rhetoric on the state of the Indian as a generalized and nondifferentiated race. Discussing the deleterious effects of contact, Kihn states: "The Indians deteriorated into a race without any conscious social power. Their culture is gradually disappearing. Many of their old villages with their picturesque houses and totem-poles have been burned or abandoned." While this may have been true for other Northwest Coast groups with whom he did not have contact, it was not so with the Gitxsan. Thus, when he becomes more specific, his position changes. Disagreeing with Barbeau's assessment that all the coastal peoples suffered the same common, tragic history as those east of the mountains, Kihn offers an alternative: "But here and there along the coast some of these tribes are still preserved. In remote localities one can see the old villages with their totem-poles still standing. And the Skeena is one of the last strongholds of this unique people."[49] Here, he speaks from his own experience rather than relying on a well-rehearsed rhetoric about something that he had not seen. Kihn thus endows the Gitxsan with an exceptional strength, rather than with a common decrepitude, and gives them a separate history.

He then proceeds to supply a thorough inventory of aspects of the survival of traditional culture among the Gitxsan. Like Comstock, he adopts the present tense in speaking of the refinements of their art and its role

in their social structure, including the crest system. The captions accompanying the five portrait illustrations give specifics about the relationships between the sitters and the paraphernalia in which they are attired: *"Lelt,"* or *Snake. A chief of the Raven phratry of Kitwanga. Head-dress-"Mawdzeks," the carved image of a hawk with frogs. Cane — Images of Raven and Snake devouring a frog. Blanket — Button blanket. Represents the crest of the "People of the Copper Shield"* (see Figure 14).[50] This indicates not only that the Gitxsan were still a "stronghold" in possession of their traditional material culture, aside from their totem poles, but also that this material still played its traditional function in the social structure.

Most important in this regard, Kihn reports having attended a week-long set of traditional ceremonies that may well have involved precisely the type of costumes and regalia seen in his painting *A Feast among the Skeena People*. Again, his position is conflicted as he oscillates between received ideas and actual experience. He initially claims that "these ceremonies are practically extinct now. The missionaries have discouraged them and the government prohibited them until, like the withered arm of a paralactic [sic], they are still a part of the body but have no function." Yet this allegorical image of amputation and decrepitude is tempered, and he does not have Barbeau's hesitancy about reporting events that opposed disappearance: "It was my extreme good fortune to be the invited spectator at one of these amazing ceremonies. The ceremony lasted about a week, and such a wealth of costumes, characters, and color I have never seen."[51] The subsequent detail in which he describes the proceedings, including the specifics of the costumes and dancing, is convincing and speaks to continuity even if Kihn ends his article by declaring that these aspects of Native culture have no future. As he states, such traditional ceremonies ran contrary to the official government policies of the time, which prohibited any such Native cultural activity, even though they could have been used to advantage as a summertime tourist draw.[52] Certainly, few such reports of continued ceremonial activity could be found in the Canadian literature of the time, either popular or scholarly.[53] Aside from Kihn's brief mention, such ceremonies went, for the most part, unrecorded in the country's history and its retellings. Only recently has this begun to change. Kihn's works, then, both his detailed portraits and his imaginary landscapes, serve as valuable documents in this crucial period in Gitxsan history.

While the history of the potlatch ban and Gitxsan resistance to it will be covered later, suffice it to say here that the Gitxsan were among several

groups whose members had preserved much of their traditional culture, had actively resisted and protested the legislation as an unwarranted and irrational interference with their traditional cultural prerogatives, and were negotiating a space in which these could be preserved. Of interest here is that even though Barbeau was in the field at precisely this time, there is no record in his ethnographic work of the continuity of these important ceremonies. Although he recorded ceremonial activity during his 1920-21 field trip, there was no follow-up, nor did he publish his findings.[54] After intensification of the potlatch ban in 1920, he must either have judiciously turned a blind eye to them or have not been present. Thus a gap opens up between Barbeau's account, or rather his absence of it, and Kihn's images, in which the discursive framework within which the former had attempted to contain the image of the Indian threatened to disintegrate. Kihn's paintings and text can be cautiously viewed as a document of these activities. Indeed, the existence of a full-scale ceremony, lasting days, occurring only shortly after the crackdown at the Cranmer potlatch among the Kwakwaka'wakw on Village Island, must have caused grave concerns. Kihn's report, which appeared in 1926, at a time when a growing resistance to cultural suppression and the denial of land claims was becoming increasingly evident, would not have helped the situation.

This raises several questions: Was this sequence of articles – which appeared in fairly rapid succession in 1925 and 1926, after Barbeau's initial publications – viewed as an embarrassing excess of critical success? Did Kihn's Canadian sponsors get more than they bargained for? Could the differences between Barbeau's readings of the paintings and those presented by subsequent authors have been taken as evidence that the representation of the Indian was slipping out of control? Kihn's growing international recognition posed serious problems. Insofar as the Group of Seven's members did not receive this type of concentrated publicity abroad, it would begin to appear to the English, French, and American audiences of these five articles that Kihn, an American, had begun to represent not only the Indian but also Canada and that the two were closely associated.[55] Although in keeping with French and American principles, this was precisely the opposite of the position of the Canadian state, the Group of Seven, and their supporters, as has been shown by the exclusion of Native peoples and their arts from the Wembley exhibitions of 1924 and 1925, at which the Group was put on centre stage. There was the distinct possibility, then, of Kihn's supplanting the Group. More important, he brought with him the presence of the unwanted Other

and destabilizing alternatives. While this presence was tolerable and even desirable as long as the interpretation of his paintings could be critically disciplined within controlled texts to be taken as emblematic of Native disappearance, problems arose when ambiguous and oppositional views began to enter the arena. These links begin to indicate why, by the spring of 1927, Kihn was excluded from the Jeu de Paume exhibition, despite his earlier recognition in the very journal on which, and by the very person on whom, Brown was depending for his show's success – that is, *L'Art et les Artistes* and its publisher, Armand Dayot, Brown's primary French connection.

Even with Kihn's work's growing national and international visibility, or perhaps because of its conflicting messages, both the exhibition and disposal of the Skeena works in Canada proved more problematic than had been the case with Kihn's images of the Stoney. Initially, they received wide exposure. In 1925, following his return from the Skeena and his residency in Ottawa, two of his landscapes featuring totem poles were shown in the Canadian section at Wembley.[56] Several were also featured in March at the National Museum during a "Geological Convention."[57] This was followed by a larger exhibition of over twenty works in the Railway Committee Rooms at the Parliament Buildings in Ottawa, one of the few times an artist has been given such a privilege. The reviewer for the *Ottawa Citizen* was deeply impressed by the "extraordinary richness of colour" in the "portraits of Indian chiefs and warriors and women in ceremonial dress and in ordinary clothing. It is plain to see that the portraits are actual and truthful for the artist has not attempted to idealize as [have] so many others." The writer also noted their authenticity and the rich designs of the regalia.[58] In April an even larger exhibition, including work sent up from New York, was held at the Arts Club in Montreal and accompanied by a catalogue outlining the names of the sitters and their regalia.[59] Kihn attended the opening. Both the decorative and documentary aspects of his work were commented on by the press.[60] In January 1926, despite Kihn's national origins, his paintings were deemed "Canadian" enough to be included in the annual exhibition of national art at the NGC. Throughout the remainder of the year, the *Temlaham* book project and the exhibition *Canadian West Coast Art, Native and Modern*, slated for the fall of 1927, also continued apace.[61] However, his broad exposure within the official spaces of the state prior to the Jeu de Paume exhibition, and even afterward, was countered by the lack of any corresponding exhibitions in Toronto, the home of the Group of Seven, despite the

earlier enthusiasm for his Stoney images. Without access to Toronto, his Skeena works received fewer exhibitions than did his previous Canadian production.

At first, sales were piecemeal. The state-owned railway showed no interest in acquiring any of the works despite the recognition of their value to the project of attracting tourists to the region. Early negotiations for a purchase by the government fell through.[62] By March 1925 Kihn, still in Ottawa, was strapped for cash but able to secure a $600 commission from Gibbon for a poster, although this would not have been based on his Skeena excursion.[63] By May, after he had returned to New York empty-handed, and undoubtedly disappointed if not embittered, seven of the pictures were sold for a total of $600, about the price of one modest Group of Seven canvas at the time.[64] These had been picked out by Barbeau, negotiated through the prominent Montreal dealer F. Cleveland Morgan, paid for by the press baron F.N. Southam, and presented to the Montreal Art Association, but they were soon transferred to the McCord collection, which was then at McGill University.[65] Although this modest purchase would have come nowhere close to covering Kihn's personal expenses for the Skeena venture, which were considerable, the possibility of further purchases was still proposed. This did not happen immediately. Almost a year went by before four more "Indian Heads" were purchased by F.N. Southam in April 1926 for $250. Southam was acting as an agent of the state; the acquisition, which included three portraits from the Skeena trip and one from Kihn's earlier excursion to Vancouver Island, was presented to Walter C. Nichol, who had just retired as lieutenant governor of British Columbia.[66]

In July 1926, two years after the Skeena trip, the situation suddenly changed. A letter from Cleveland Morgan arrived in New York while Kihn was in Montana asking for the price of "all of his *Canadian* Indian Pictures. This would include both West Coast and Plains."[67] No explanation was given for why, at this late date, the totality, rather than a representative selection, was required. Sir Edmund Walker, Kihn's major backer with the NGC, was dead, so the initiative did not come from him. Nor was the apparent interest in Kihn's work a matter of conscience; it was now known that Kihn was no longer short of buyers. Not only had he been able to continue his more lucrative arrangements with American railroads, which were not shy about guaranteeing purchases and covering all expenses, but he had recently come to the attention of the prominent collector Sir Henry Wellcome in London, England, who, possibly inspired

by Kihn's Wembley showings and Richmond's article for *The Studio* as
well as by his own interest in Native artifacts, was purchasing substantial
quantities of Kihn's production.[68] Further, Kihn had been informed that
Wellcome, who had enormous resources at his disposal, was planning to
open a museum in London dedicated to Native art, which would feature
his work and thus give it continual exposure at the colonial centre to a
broad variety of publics.[69] In addition, Kihn was planning exhibitions in
Paris. The state had already demonstrated its concern about the issue of
Native representations in foreign locales, especially in England, and was
soon to pull his paintings from the Canadian exhibition in the French
capital. The disasters of the Chicago World's Fair had preceded the exclu-
sion of Native participation at Wembley. As has been shown in the criti-
cal writing, these new potential displays, in both imperial centres, which
would also have been beyond Canadian control, had the potential to be
interpreted as demonstrating the continued presence of Native peoples
and their traditions within Canada, thus compromising the effects of the
exclusion of the Indian seen at Wembley. These prospects, especially the
potential Wellcome museum, which would undoubtedly occasion sub-
stantial critical attention in the press at many levels, were taking place
at precisely the moment that Native groups were asserting their presence
in London by pressing to take the case for their land claims in British
Columbia to the empire's highest court, the Privy Council. These unwel-
come possibilities account for the sudden, and belated, interest in the
acquisition of all of Kihn's remaining Canadian work. By obtaining the
totality of the works, Canadian interests could control the placement and
viewing, as well as the institutional and critical framing, of all of Kihn's
Canadian Native images.

The negotiations were complex and protracted. Not until late 1926 and
early 1927 were arrangements finalized for the purchase of twenty-four
pictures for $3,500, paid for yet again by Southam through F. Cleveland
Morgan.[70] The final selection did not, in fact, include the totality of Kihn's
Canadian production but was almost exclusively from his Skeena trip and
comprised almost all of those works both in the artist's possession and
being held by the NGC from the Wembley show of 1925.[71] Clearly, the
British Columbia images were of greatest concern. In keeping with Kihn's
general production, most were portraits, but five were landscapes.

This collection of works was then fragmented and sent to various gal-
leries and museums across Canada.[72] However, finding welcoming homes
for them was not easy. Six, including a large landscape, were sent to the

National Museum,[73] which, despite Kihn's close association with Barbeau and the works' ethnographic value, proved ambivalent about the donation and decided not to keep all of them. One from this group was immediately sent on to the Royal Ontario Museum and another to the McCord collection.[74] Five, which was more than were kept for the National Museum, were sent to Vancouver, where they were intended to become part of the collection of an art gallery that was yet to be built – that is, they went into limbo.[75] Seven were not committed to any city at the time of purchase.[76] Of these, *Rosie, Coyote-Woman*, went directly to the McCord Museum, while the other six, again a greater number than were retained by the National Museum, ended up at the Winnipeg Art Gallery, which had no connection with the artist.[77] Five were initially intended for "Toronto," although the correspondence listed no specific institution.[78] Although the Art Gallery of Toronto had exhibited his works and despite its earlier negotiations with Walker and the NGC to purchase some of his Stoney production, it refused any portion of the donation. Rather, in keeping with their lack of exposure in Toronto art galleries after Walker's death and before the *West Coast Art* exhibition, the "Toronto" works were deposited in the ethnology collection of the Royal Ontario Museum (ROM).[79] That this location had not been selected at the time of the purchase further indicates that the works were acquired without a clear idea of where they were to go or for what purpose they were intended, except that their placement in the most prominent locations and their display to the widest possible Canadian art audiences were not on the agenda. In addition, in an ironic twist, the works were primarily given to ethnographic collections, where they became ethnography, not art, precisely the reverse direction that was being encouraged for Native work.

At the National Gallery the problematic nature of his works became most clear. A significant difference of opinion on the value of the work emerged between Eric Brown and the late Edmund Walker, who had been the initial force behind the earliest attempts to acquire Kihn's Canadian works in quantity and would have wished a substantial portion to remain in the NGC. Even though the works were being offered free of change and although many pieces had no immediate placement, Brown ensured that only the absolute minimum entered the national collection. He selected one work, which now bears the title *Gitwinlkool Totem Poles* and is dated 1925, one of the two landscapes that had been included at Wembley, where it was listed as *Gitksan Indian Totempole* [sic], *Village of Kitwancool, B.C.*[80] In keeping with his refusal to exhibit Kihn's works as

a body, he made no moves to acquire either of the other two works that had been sent to England as part of Canada's national image or any of the more characteristic portraits, despite his knowledge that Kihn was to be featured at the *West Coast Art* exhibition in just a few months time. Brown's antipathy to the work, and especially to the portraits, was symptomatic of a pronounced shift in the position of the artist within the Canadian context.[81]

This reversal can be discerned by comparing Kihn's position in Canada in 1925 with his role at the time of and just after the 1927 *West Coast Art* exhibition. While in Ottawa in early 1925, Kihn moved in socially and politically elevated circles, which required having his father forward a full dress suit from New York. He had been introduced to leading figures, including the heads of the railways, their agents, Duncan Campbell Scott, Eric Brown, Edward Sapir, Harlan Smith, various ministers, and even the prime minister. Such lavish attention indicated the importance of his production within the Canadian administration and testified to the significance of efforts to control the representation or image of the Indian. Even with the stress that the general reluctance to purchase his works would have caused, in mid-1925 Kihn was still working closely with Barbeau, with whom he was in constant communication. Barbeau even attempted to enlist him in his project to bring artists such as Arthur Lismer and A.Y. Jackson to Quebec during that summer to paint French Canadian images in and around the Île d'Orléans.[82] Despite Barbeau's inducement of picturesque and *volk*-ish subjects, Kihn declined.[83] He was included at Wembley, had received favourable attention both in France and in England, was cited by Konody with the Group of Seven as representing Canada in Konody's review of the Wembley exhibition,[84] and had found another patron, Wellcome, which clearly demonstrated the recognition and desirability of his works at the highest levels. In early to mid-1925 Kihn could not have felt more included in the creation and distribution of a distinctly Canadian cultural national heritage both at home and abroad through his representations of the Native peoples of the western regions of the Dominion.[85]

By the time the third Southam sale was completed in early 1927, the situation had changed dramatically. The reversal began slowly but accelerated in late 1926 immediately after the appearance of the spate of international articles on Kihn's work and the announcements for the potential Wellcome museum and just when Scott was having to concede defeat of his policies to eradicate Native culture and identity, both on the Prairies

and on the West Coast; when the Allied Tribes were pressing their land claims with the most vigour and were on the verge of taking them to London; when the entire principle of disappearance was in danger of collapse; and when control of the image of the Indian was becoming paramount. The situation would become a crisis by 1927, when Kihn, through a complex series of events, would find himself and his subjects positioned as "outsiders" and his work excluded from Paris.

This reversal can be mapped out through his relationships with Barbeau and the Canadian institutions that had encouraged and supported him. In early 1926, as subsequent chapters show in greater detail, the ethnologist embarked on an expanded program to create a new Canadian subject matter based on what he saw as the remnants of a near moribund Native culture set in the picturesque landscape of the Skeena Valley.[86] Here, Kihn, who had initiated this proposal, was replaced by members of the Group of Seven and other artists, who would repaint the area in a less ambiguous manner and one more in keeping with state policy. Barbeau approached A.Y. Jackson, Lawren Harris, and Arthur Lismer. Harris proved intractable, and Lismer ultimately demurred, but Jackson came to the Skeena Valley in the summer of 1926 accompanied by his good friend from Montreal Edwin Holgate, who, not coincidentally, was a portraitist. At the time, Kihn was in Montana painting for the Great Northern Railroad. The Canadian artists, as members of the Group of Seven, would have understood the necessity of representing the Indian as having long disappeared and, indeed, would have had a personal stake in doing so. Thus their position on the status of the Indian differed from the positions espoused by those affiliated with the Eastern Association of Indian Affairs in the United States, in which Kihn was active.[87]

In February 1926 all still seemed in place when Barbeau wrote at length to Kihn. He stated that he had received Kihn's *Scribner's* piece and gave it modest praise, acknowledged Richmond's article for *The Studio*, asked for a painting, and reported the inclusion of Kihn's work in the annual exhibition of Canadian art at the National Gallery.[88] Most important, he indicated that he was arranging for Kihn's pictures for the *Temlaham* book project to be paid for by the CNR, which, he hoped, would "furnish them for free to Macmillan, having in mind their own publicity." He went on to name several pictures of interest, added the possibility that Kihn would produce more for the book, and asked for an estimate of the cost. He also mentioned his next proposed trip to the Skeena Valley that summer and the possibility that Jackson and Lismer as well as "some other members

of the Seven" would attend, although he knew that Kihn was now committed to working in Montana in the Glacier area for the Great Northern Railroad and could not accompany them.[89] By November 1926 relationships were still pleasant, at least on the surface. Barbeau invited Kihn to join him and the other artists the following summer, although he began to make it plain that Kihn would no longer play the starring role: "We are planning for an interesting Southern exploration of the Nass River. If everything goes well, Jackson, Harris, Holgate (of Montreal) may join my party. And, although this is far ahead, we would like you to join us."[90]

Shortly thereafter, the mass purchase and distribution of Kihn's Canadian works were finalized.[91] It would have been a logical extension for the Canadian institutions involved to promote and capitalize on this substantial investment by showing it off that spring in Paris. They did not. But this exclusion was only the beginning. Kihn was soon to become invisible and his work, quite literally, to be kept from sight. By early 1927 Kihn was beginning to grasp the extent of the situation. Unlike the paintings in the Wellcome collection, those purchased in Canada were now unavailable for any Parisian exhibitions, either at the Jeu de Paume, or in the proposed show at the Charpentier Galleries, or, for that matter, anywhere else:

> After my Canadian sale of twenty-five (25) pictures, of which I have just written you, I have made another sale of sixteen (16) Blackfeet Indians of Glacier Park to a London client of mine ... This client was good enough to loan the pictures he purchased, for the exhibition at the Minneapolis Museum, January 11th. He also offered to loan them for the exhibition I may have in Charpentier's galleries in Paris. The Canadian pictures have been shipped to Canada and are now being distributed to various museums, so that these are *not available for exhibition purposes*. This means that if I have an exhibition in Paris, it will be practically all the work of the Blackfeet Indians of Glacier Park.[92]

The strategy behind the policy to collect Kihn's Canadian production en masse now becomes clear. The policy was intended to ensure not the visibility of Kihn's works to the widest possible audiences through their purchase and distribution but, in fact, the opposite. The acquisition of Kihn's images of western Canadian Natives showing them in possession of their cultures and identities ensured that they would not be seen in Paris,

London, or the United States, either in his own private exhibitions, at the Jeu de Paume, or at any museum opened by Wellcome. Their subsequent history bears this out. In the following decades, after the fall exhibition, Kihn's Canadian portraits remained largely unexhibited either here or anywhere else.

By June 1927, just after the completion of the sale and distribution of Kihn's works and following the exclusion of his pictures from the Jeu de Paume exhibition, Barbeau's relationship with the artist began to show signs of a growing ambivalence.[93] It was no coincidence that this shift in his attitude came shortly after the Special Joint Committee's denial of the land claims in British Columbia put forward by the Allied Tribes. The committee based one of its six arguments, delivered the previous April, on the lack of continuity among the British Columbia Native peoples of traditions through which Native title was transferred and claimed.[94] The report stated: "Tradition forms so large a part of Indian mentality that if in pre-Confederation days the Indians considered they had an aboriginal title to the lands of the Province, there would have been tribal records of such being transmitted from father to son, either by word of mouth or in some other customary way. But nothing of the kind was shown to exist."[95]

Barbeau would have been well aware that the traditional regalia displayed by many of Kihn's Gitxsan portraits featured crests handed down through generations that were directly linked to the possession of land resources.[96] However, even if he had been called to testify to this knowledge, Barbeau's position would have been clear; he had already implied publicly on many occasions that if such claims had once existed, this was no longer the case since all traditional culture had disappeared. The proof of this argument was that the Natives were no longer in possession of such material nor were they holding ceremonies featuring them. Yet Kihn's paintings and the texts that were appearing around them suggested otherwise.

In the summer of 1927 Barbeau began planning another trip to British Columbia accompanied by artists. However, he now withdrew his earlier invitation to Kihn to join them, writing in June: "You might naturally like to join me on the Nass River if it were feasible. But I don't think my plan this year would suit you very well."[97] Conversely, the Canadian contingent were assured of their welcome. Holgate had received news of the trip over a month previously and was instructed to "apply early for passes."[98] Two other artists, Anne Savage and Florence Wylie, had already received their passes.[99] Needless to say, Kihn was not informed

of their presence. Somewhat belatedly, Barbeau presented Kihn vague, if not confusing, alternatives, suggesting that he go to Prince Rupert, Port Hazelton [sic], or even Banff – that is, elsewhere than the Skeena Valley or Nass River. Barbeau also indicated that Kihn could apply for passes if he wanted. However, it was now too late in the season for Kihn to cancel other plans and arrange new ones. Barbeau also informed Gibbon of his position: "I have written to Kihn today, telling him about possibilities on the Nass and the Skeena and rather discouraging his coming there this year." He continued: "I told him that what seemed to be more interesting this year was the possibility of your getting in touch with him and possibly inducing him to come to your part of the Rockies."[100] This clarified the situation. Handing Kihn back to Gibbon would keep the artist out of British Columbia and away from further work in the area. By comparison, Alberta was not subject to Native land claims or to the Allied Tribes. Kihn's presence in British Columbia was to be resisted, as were further collaborations between himself and the ethnologist.

Barbeau also began the process of reversing his decision to have Kihn design his *Temlaham* book project in its totality, hinting that Kihn's work would play a somewhat smaller role than had originally been negotiated. Barbeau laid the blame for these alterations on "Mr. Charlton of the C.N.R. and Mr. [Hugh] Eayrs," the president of Macmillan publishers.[101] By November 1927, six months after the closing of the Jeu de Paume show and a month before the opening of the *West Coast Art* exhibition, relations cooled further. Barbeau had sent thirteen paintings by Kihn to the Macmillan Company of Canada for reproduction.[102] These included nine portraits and three or four landscapes. He also wrote to Kihn to confirm that sixteen of his "portraits and paintings will be reproduced in colour ... from the sets purchased by Mr. Southam for Montreal." In the same letter Barbeau announced that A.Y. Jackson "will be asked to design the whole volume and the cover," an arrangement that, despite his use of the future tense, had been in place at least since the previous May – that is, prior to his last letter to Kihn. Barbeau again cited Eayrs and Charlton as behind this change. Although he confirmed Kihn's inclusion in the fall exhibition in Ottawa, which he described in detail, Barbeau now noted inclusion of the Canadian artists who had accompanied him into the field in the Skeena Valley since Kihn's departure while avoiding mention of his own role in bringing this about. Barbeau also looked forward to introducing Emily Carr, whom he now mentioned to Kihn for the first time as "a recent discovery of first magnitude ... whose work has remained entirely unknown till this year ... [but who] will be ranked among that of the

best Canadian painters."[103] In addition, Barbeau noted that the exhibition would include "two or three primitives, whose work will also be exhibited." Barbeau insisted that Kihn send to one of the Natives in the Skeena area, Joe Brown of Gitsegyukla, at least a photograph of the portrait that Kihn had painted of him:[104] "This is quite important for the reason that he has shown himself hostile last spring to the work of totem pole preservation in his village. As you know, Mr. Smith bungled the affair with him, but we should for that reason try and be especially nice to him so that he may not prove an obstacle in future attempts to resume the work there. At least write him some plausible explanation."[105]

The necessity of resorting to a "plausible" rather than a clear explanation bespeaks a need for subterfuge. Sensitive problems that could not be spoken of openly were beginning to emerge in the Skeena area between, on the one hand, ethnographers, archaeologists, and the institutions that they represented and, on the other hand, the subjects of their studies, who were beginning to demonstrate a clear resistance that threatened the progress of the various programs. Kihn was placed in the middle and threatened to come down on the wrong side. Significantly, Barbeau made no mention of the *West Coast Art* exhibition and did not extend an invitation to its opening. Even though Kihn was to be featured – albeit, as will be seen, not without some problems – he was personally excluded from the event and from Canada.

Events again moved against Kihn in the course of arranging the final form of the *Temlaham* publication. Around this time a preliminary list of illustrations was drawn up that now included only five works by Kihn, two landscapes and three portraits. By January 1928, when the exhibition featuring works by Kihn and Carr alongside Native material was touring and when Kihn's work was receiving its widest exposure, Barbeau reduced Kihn's contribution even further.[106] Barbeau wrote Eayrs that sixteen new pictures would be available for the book after the closing of the exhibition.[107] Rather than supply all of the illustrations, Kihn would now provide only four. By February other artists to be included, such as Holgate, had been informed of their good fortune.[108] Conversely, some were omitted when Jackson, who was now in charge of the design, reversed his choices, such as the "primitive" artist Frederick Alexie, who had been slated for inclusion.[109] The news that Kihn's contribution was to be substantially reduced did not immediately reach him, even though Barbeau continued to correspond with Kihn on various related matters.[110] Finally, in March 1928 Barbeau wrote "in haste," thus avoiding elaborate explanations, that "the plans for the illustrations have changed consider-

ably ... It has been decided to use Skeena River pictures not only by yourself, but also of Jackson, Holgate, Miss Carr and Miss Savage, and the total number of pictures instead of being 16 will be 14."[111] The concept for the book and its illustrations had shifted and not in favour of portraits of living individuals who could testify to the continuity of their culture. In the end, of the four works by Kihn illustrated, only two were portraits, and the others were landscapes. Among the ten illustrations by other artists, only one was a portrait, a drawing by Edwin Holgate.[112] This was the last time that Kihn would collaborate with Barbeau to paint for the National Museum or for the railways.

By early 1928, then, Kihn's position had changed from one of close involvement in Canadian cultural production to one of almost total exclusion; his portraits of Native peoples were no longer seen within the country, and he, personally, was no longer welcome. The causes for this complete reversal in his relations with Barbeau and with Canada and its culture remained unexplained on every front. Although he expressed further interest in returning to the Skeena River Valley to continue his work, his hints were never taken up.[113] Although widely collected and distributed, his portraits were buried within the storage racks and drawers of the Canadian museums and galleries that they entered and were rarely seen again.[114] They were taken out of circulation despite the international attention that they had gained, which could easily have taken on even greater dimensions if the purchase had not taken place.[115] The effect was immediate. With Kihn's work consigned to obscurity and no longer exhibited and with no more Canadian works by Kihn being produced, there were no more independent articles or exhibitions suggesting unwanted messages to international audiences. Other artists stepped into the place that he had been obliged to vacate, but they did so in substantially different ways. Their work was more in keeping with the developing orthodoxy on the representation of the Indian as absent and the Canadian landscape as picturesque. This corresponded to a marked diminution in the number of portraits of Native sitters and to a proliferation of images of totem poles and landscapes, at times completely empty of people, as Canadian artists arrived on the scene. Already primed by Barbeau about the decrepit state of Native culture and the disappearance of the Indian, these artists had no American experience upon which to draw in formulating their ideas about the Indian.[116]

Kihn's marginalization and exclusion by Barbeau and Brown in 1927 and 1928 was only part of the solution to the complex problems posed by the multiple readings that could be attached to his works. The conflicting

messages that his production had already promulgated had to be contained and countered. Measures were necessary to resituate Kihn's work and forestall any suggestions of cultural continuity that might have arisen from their contact with alternative discursive formations. After 1925, Barbeau once again took an active hand in critically disciplining the interpretation of Kihn's work, presenting it to the public in such a manner that its initial message could be obscured and the work used instead as evidence of discontinuity. He immediately began countering the claims that Kihn had made in his *Scribner's* article, which had been reinforced in other publications on the artist's work. Barbeau used differing venues to reach the widest possible audiences.

By late 1926 Barbeau had already given a clear indication of the differences in viewpoint that were opening up between himself and Kihn along with anyone else who suggested cultural continuity and presence for the indigenous peoples of western Canada. Barbeau began to explicate why the American painter's images were no longer acceptable. In October 1926 he delivered a series of five lectures at the University of British Columbia, where he was hopeful of receiving a chair in a proposed department of anthropology.[117] Here, he encountered Emily Carr, who had painted the Gitksan people and their totem poles years earlier and whose work, I have suggested, he may already have known.[118] Again, Barbeau attempted to shape the state of Indian culture for his audience. He left little room for ambivalence or ambiguity in his public presentations. He indicated the need for immediate and urgent action in the province: "'The population of British Columbia Indians is decreasing rapidly' ... In a few years, he said the field will be closed to study, as the last traces of Indian civilization were rapidly disappearing."[119] In a second lecture, he elaborated his position. Here he directly contradicted any impressions of cultural continuity that might have arisen from Kihn's images of Native peoples dressed in traditional regalia: "The Indian, he explained, had adopted the dress, food and habit of the whites, and they had lost all their material culture."[120] Again, through use of the term "lost," he stressed the total dispossession of the Native. In reference to their artistic traditions, he once more deployed the term: "The possibility of a revival among the Indians of former talent seems out of the question ... They have long since lost the natural pride which makes possible great feats in the field of art. The best we can hope for now is to preserve the remnants within our borders."[121] Of course, using the rhetorically loaded term "revival" indicated that the culture had already been lost and was now of the past. Although

he did admit that there were still some "in possession of many of their old traditions," work had to be done soon to study them "before it passes away, with the extinction of the old Indian races."[122] Any indication of presence was, then, paradoxically and inextricably linked to disappearance. Similarly, his talk titled "The White Man vs. the Indian" stated that "the results of the white man's coming have been ruinous and devastating for the Native tribes of British Columbia ... Contacts with the whites were fatal to Native pride and ethics at a very early date." He concluded that "the white invasion had practically caused the destruction of the Indian race. We have taken their lands and their culture and destroyed what could have been a resource to the country had it been allowed to live."[123] This presumed state of affairs, which had been recognized, it would seem, some time ago by the Indians themselves, validated his own collecting for the National Museum and the program of totem-pole restoration. It also contradicted Comstock's, Arnaud's, and Kihn's claims that the culture and art were still ongoing, if in a diminished state. Further, Barbeau's categorical statements confirmed the inability of the Gitxsan to represent themselves or to possess their own culture or territories. But above all, it conformed to the federal government's assimilationist policies, which by this point needed reinforcing, as well as to the state's position on land claims.[124] The government's failure and the oppressive nature of its Indian policies were becoming increasingly evident in the ever-more-draconian measures that it was now employing to ensure success. At the same time, Kihn's portraits and landscapes as well as his writings were beginning to look like first-hand testimony to continuity.

An article published in 1929 in the organ of the Canadian National Railway is probably Barbeau's most complete statement on the subject. He again attempted to make Kihn's images emblematic of disappearance, but he did so in a manner that exposed his other concerns. The title, "Ancient Cultures, Vignettes Past," gives some indication of the problem. Even though Kihn's portraits proclaimed the presence of the sitters and the continuity of their culture, the title placed the Indian always already in a nondifferentiated, ahistorical "ancient" past. Barbeau's further comments bear this out. In constructing the history of the artistic activity in the West Coast region in the mid-1920s, he recounted his role in bringing artists there to paint the Gitxsan under the auspices of the CNR: "After the artist Langdon Kihn had brought back and exhibited his brilliant *landscapes* of totem poles and mountain crests, and his decorative Indian portraits, it was easy for me to induce other painters to invade our preserves.

It had become clear to all that the Skeena and West Coast were a new country for Canadian art, so far unknown, unrevealed and full of promise ... Gitksan and Tsimsian chiefs donned their regalia, perhaps for the last time, and courted the fame conferred by a stately portrait from an expert hand."[125]

Barbeau's reference to Kihn's output was filled with reversals. Kihn did very few landscapes of totem poles and mountain crests, although two of these have been seen as significant despite their fantastic qualities. Conversely, he did many accurate portraits showing Native individuals displaying their own traditional regalia. But Barbeau downplayed these. He attempted to invert the reading of Kihn's pictures posed by writers such as the artist himself and Arnaud by using the sentimental and urgent phrase "for the last time." This temporal reversal is symptomatic of his position on the vitality of Gitxsan culture. His adherence to this position despite growing evidence to the contrary led to several anomalies in his professional writing, in which he attempted to treat any evidence of cultural continuity among the Gitxsan as testimony to discontinuity. These instances will be investigated later as they arise in various contexts. However, some are already visible here. His text proposed that the Skeena was pregnant with promise as a present and future site for non-Native, Anglo-Canadian artists producing a national art that spoke to a unified identity. At the same time, he depicted the subject of this art, the indigenous people of the Skeena region, who in his account literally "court" the artists for the privilege of sitting for their "stately" pictures, as having more than one foot in the grave – that is, as being on the verge of disappearance.[126] The life of Anglo-Canadian artistic production was once again made contingent on the death of the Native and on occupation of the vacant spaces that the absent Native left behind. Within the context of Barbeau's abrupt reversals and prevarications, Kihn's portraits lost their guise as documents of living people within a vibrant culture that demonstrated this culture's continuity into the period of modernity. Instead, they became death masks, and the regalness of the sitters, in turn, was seen not as arising from their positions and power within an ongoing social structure but as a function of their willingness and even desire to be represented "for the last time" in the manner of Western artistic conventions. Indeed, having no culture and no voice, they were not in a position to represent or speak for themselves. Being powerless and silent, they had to seek or "court" representation elsewhere – that is, within the context of a dominant Anglo-Canadian culture. Representation, and the

desire for it, on the part of the Gitxsan was equated with absorption and disappearance. Within the confines of Barbeau's text, such portraits could have functioned only as dark mirrors in which the sitters could never see their living reflections but only their own imminent absence.

Barbeau's textual disciplining of how Kihn's pictures were interpreted was part of a larger program that sought to similarly regulate any locations where Native peoples could negotiate a validation of their own cultures or their active contribution to Canadian culture, including the Calgary Stampede, Banff Indian Days, local fairs, and the reserves, where this negotiation happened within their own communities and through their own art. Also subject to control were representations of Natives by non-Native artists, Native informants, or ethnographers. Barbeau's practice involved providing an authoritative rhetorical framework that cut off any possibility of these sources of Native validation being viewed as an indication of a vital and ongoing culture and identity. Although neither Kihn nor the Gitxsan seemed to share these views – and although there were numerous other oppositional voices, including, as will be shown, important ones within the discipline of anthropology itself – their positions on the matter were seldom heard. By this time, in fact, Kihn was no longer on the scene to object to this reinterpretation, and the opinion of the Gitxsan was not solicited. Kihn's paintings were rarely seen again in Canada, although he continued his career with some success in the United States.

Chapter 7: Giving Gitxsan Totem Poles a New Slant

ONE OF THE PRIMARY sites where the discourses of Native disappearance and Canadian national identity came into conflict with the reality of First Nations' presence and cultural continuity during the 1920s was in the Upper Skeena River Valley of British Columbia. This conflict centred on the Gitxsan people, the territories that they claimed, and the representations of both by white artists and ethnographers. Much of the discussion centred on their distinctive totem poles, which were found throughout their villages and which everyone viewed as being of great importance. They were the subject of a second coordinated program by the federal government and the railway to restore, stabilize, and preserve them. The motivations behind this program were again complex. Aldona Jonaitis has demonstrated that by the beginning of the twentieth century, totem poles were seen as icons of Indianness by tourists travelling to the Pacific Northwest and, in turn, by the non-Native North American population in general.[1] However, this does not explain why these particular poles were given such priority by the Canadian government and why extraordinary attempts were taken to save them, while others elsewhere, which were in more danger, were left to decay. What I propose here is that the Gitxsan poles were important not only because they lay on the tourist routes and because of their concentration and number, but also because they belonged to a people who still claimed continuity with traditional culture and maintained their land claims. As the state, ethnologists, and the Gitxsan knew, the totem poles were testimony to their own territorialization of the region. They were manifestations of presence and icons of resistance to the government's policy to eradicate Gitxsan culture and its land claims. As with Langdon Kihn's paintings, these significations had to

be either erased or redefined so that the poles became images of "decay" – that is, nonrenewable and rotting ruins in need of restoration by caring outside agencies. Cast as such, the poles could act as metaphors for the "decrepit" condition of a culture that could no longer claim links to the past. By reversing and stabilizing their meanings, the state could transform them into emblems not only of "Indianness," but also of the absence of the Indian. Thus placing the totem poles in stasis by restoring them also meant fixing their dangerously ambiguous meanings.

The visibility of the Gitxsan poles and their position within inhabited village sites necessitated a different strategy than that employed in response to the continuation of traditional ceremonies. The restoration program was professed to be based on cooperation, consultation, concern for an endangered cultural heritage, and respect for Gitxsan ownership of the poles. Behind this benevolent public façade, however, the program was based on the same firm belief in the imminent disappearance of the Native population, the same intent to appropriate Native culture and redefine it as part of a Canadian monoculture, and the same desire to demonstrate that Native cultures were dead; that is, that the potlatch ban had apparently served its purpose. As will be seen, Gitxsan cultural vitality and political perspicacity prevented the program from proceeding as envisioned and revealed the erroneous premises on which it was founded. That the program was not simply a disinterested attempt to restore the totem poles as valuable art forms is nowhere more evident than in the coordinated efforts made by various agencies to define and discipline the public perception of their context and meaning. This portrayed the Gitxsan as no longer competent to produce, or even to appreciate, their own art as cultural capital. While the Native work was elevated to the position of a national "art," the people and culture that produced it were degraded to a state of "nonexistence" and deemed no longer able to produce or possess either the work or what it might represent. This left a gap in the meaning and ownership of the objects that could be filled in by those who now claimed that the totem poles and lands were "ours." A proper knowledge and possession of the poles was thus shifted to newly competent non-Native institutions and audiences, which could consume and possess the poles as part of their national identity and appropriate the territory that they represented as part of Canada.

This transference of meanings and the production of newly educated audiences were not a simple matter. They necessitated the coordinated interventions of the ethnographic and archaeological divisions of the

National Museum and of the Department of Indian Affairs, and the coop-
eration of both the Canadian National Railway (CNR) and, concurrently,
the tourist. Later, they included the artistic community and the National
Gallery of Canada (NGC), or what Bourdieu calls the "art world."[2] They
also involved the mass media and the publishing industry. The distribution
of these redefinitions to the broadest possible publics occurred through a
wide variety of means, including museum and gallery exhibitions, maga-
zine articles, public addresses, advertising, and books and their illustra-
tions. In short, the entire project to reposition the Gitxsan poles within
the secular Canadian state was extremely complex and formed another
important stage in the formation of a Canadian identity, the representa-
tion of Indianness, and the territorialization of the country.[3]

The project to restore the Gitxsan totem poles has already been admi-
rably narrated by David Darling and Douglas Cole.[4] Their research has
been supplemented by Ronald Hawker, who adds many pertinent details.[5]
However, additional material shows that the implications of the program
went further than their analyses allowed at the time. For example, Dar-
ling and Cole were bewildered by the conflicts that dogged the program.
They had trouble explaining the conflicts within the ranks of the various
government personnel as well as the Gitxsan resistance to the project.
In terms of the first, they speculate that the disputes that arose between
Duncan Campbell Scott, Marius Barbeau, and Diamond Jenness, on the
one hand, and Harlan Smith and Edward Sapir, on the other hand, were
based largely on petty professional and personal jealousies rather than on
major issues.[6] Cole attributes the same motivations to the Gitxsan resis-
tance, offering the possibility that it might have come down to something
as simple as government agents renting the wrong house. This argument
underrates much more important issues that had a profound impact on
the success and failure of the project, particularly its relationships with
the potlatch ban, the prohibitions on dancing, the attempts to eliminate
any Native economy, and the need to invalidate Native land claims, all
of which were primary concerns of the Department of Indian Affairs in
British Columbia at the time.[7] In addition, divisions within the govern-
ment departments countered and undermined Scott's policies and Bar-
beau's practices, and these need to be enumerated. I would also like to
relate the totem-pole project and its underlying assumptions more closely
to the series of artists who came through the region specifically to paint
the results of the project as part of the construction of a Canadian culture
and identity. At this point, Native resistance to these projects and to the

federal government's initiatives as a whole begins to emerge most clearly. In fact, the Native presence would lead to the failure of both the painting and the restoration program and to the final stage in the crisis that emerged concerning the Indian's representation and disappearance.

The restoration project had part of its origins in the construction by the Grand Trunk Railway of the Grand Trunk Pacific Railway (GTPR) line from Jasper to Prince Rupert in 1912. It was the first road of any type into the remote Upper Skeena Valley, the home of the Gitxsan, which until this time had been extremely isolated. Up to the 1870s, the inland region was accessible only by steamboat partway up the Skeena River followed by several miles of slogging through the dense brush on foot or with pack horses. Few made the trip. Until this period, white presence in the area was extremely limited since powerful coastal chiefs who wished to monopolize the profitable fur trade kept the Gitxsan from descending downriver and white traders from going upriver. The area had little settlement, aside from a small trading post at Hazelton that was first established in 1866 but was unsuccessful and abandoned almost immediately.[8] That year also saw the beginning of work on the Collins Overland Telegraph and is given by McDonald and Joseph as marking the point when "the first Non-Aboriginals [were] seen by many Gitksan" – that is, a full century after contact had occurred on the West Coast.[9] The telegraph line was rendered obsolete almost immediately, and economic activity in the region declined until the brief flutter surrounding the Omenica gold rush in 1871. Trading posts were reestablished in the early 1870s, but these, too, were not productive. By the 1880s the population of Hazelton, the only non-Native community in the area, was 200, about one-eighth of the Native population. And a stockade had been built out of fear of the dominant Native population, who were noted for their effective resistance to occupation of their lands, a resistance to colonization that lasted well into the next century. Full-scale missionary activity also arrived later and was less intense than on the coast. The disruptions caused by extensive and prolonged contact, which had occurred in other areas, were not as evident here. Under these unique geographic and historical circumstances, the Gitxsan preserved their culture and identity into the twentieth century, although not without modifications.

The GTPR, which brought increased contact during the First World War, especially to the two villages along the tracks, was financially unsound from the start and went into receivership in 1919. By 1923 it became part of the CNR, an amalgamation of five railways under the

federal government's ownership. Since expected revenues from ore ship-
ments did not materialize, tourist traffic was seen as one way to make
up for the shortfall. There were major and unique attractions along the
route, including the picturesque mountain scenery and the totem poles
of the Gitxsan villages. Poles had been established as a ready draw since
the 1880s in Alaska and on the West Coast of Canada, but these villages
were the only sites where they were visible in their original locations to
the Canadian railway tourist.[10] To increase their distribution beyond their
traditional locations, the GTPR had already moved Haida poles from the
Queen Charlotte Islands and Nisga'a poles from the Nass River close to
their railway stations at both Jasper and Prince Rupert and had begun
the process of making the poles a trademark for the route. The CNR
continued this campaign to entice passengers on its Triangle Tour, which
included land and sea transportation between Vancouver, Prince Rupert,
and Prince George.[11]

 While Haida and Nass poles, taken from deserted villages, seemed
open to appropriation and redistribution, Gitxsan poles were not. First,
they were located in inhabited village sites. Second, although there were
some limited dissensions, the Gitxsan by and large refused to part with
the poles and maintained their authority over and ownership of them.
They were noted as being extremely conservative in their ways, highly
suspicious of government interventions, and capable of effective opposi-
tion.[12] Consequently, the initial plans to purchase the poles and remove
them had to be abandoned. Barbeau reported in his initial investigations
that following this earlier plan would create immediate opposition to
the project: "His recommendation was therefore to leave the Indians as
owners of the poles, yet persuade them to allow the government to pre-
serve them *in situ*,"[13] where they could serve as tourist attractions for the
railway. "A problem existed, however. Many of the totem poles in the
Upper Skeena villages were deteriorating. There was nothing unusual
in this itself, as traditionally old poles were allowed to decay and fall to
be replaced by new ones as the occasion demanded. The process was
interrupted, however, when the Department of Indian Affairs moved to
enforce the 'potlatch' ban in the early 1920s. Included in the ban were the
traditional ceremonies which had to accompany the raising of a new pole,
if it were to have any significance and validity."[14]

 Enforcement of the ban was central to the restoration project since
the need for the restoration program was based on the belief that no new
poles were ever to be erected. The project was presented to the public in

terms that elaborated extensively on the assumed disappearance of Native culture in general, while only briefly, if ever, mentioning the law itself. The validity or intent of the legislation went unquestioned. As the ban was never phrased in terms of active repression of Native culture, any direct relationship was hidden from pubic view. A brief overview of its historical development, particularly in relationship to the Gitxsan and including research that has occurred since Darling and Cole published their work, will clarify its role in the restoration project and the divisions that it caused within the Canadian ethnographic community.[15]

The potlatch ban was officially enacted in 1884 but was, as first written, largely unenforceable.[16] Part of the problem lay in the term "potlatch" itself. Christopher Bracken has explored the evolution of its meaning and significance since it first appeared in Chinook jargon as a word meant to signify any ceremony at which a gift was given.[17] From the time of its origins in this polyglot, pidgin trade language, the term had been inherently ambiguous, general, and universalized. Individual groups had more specific words in their respective languages for ceremonies that might be subsumed under this category. Yet it gained currency as a term signifying a universal practice among the First Nations of the Pacific Northwest.[18]

Bracken theorizes that the concept of the "potlatch" as it circulated within the legal and administrative system of Canada in the late 1800s and early 1900s was an invention and construction by Anglo-Canadian authorities that had little to do with actual traditional practices. They absorbed the term and gave it a meaning that suited their own ends. As with the term "Indian," vastly different, if not contradictory, meanings of the term "potlatch" existed simultaneously and could be employed with great flexibility depending on its intended use. Ultimately, the term came to define its object, rather than the other way around.[19]

The term's ambiguity was purposefully maintained. In particular, it could not be decided by Anglo-Canadian officials whether it denoted a ceremony in which a gift was given without a corresponding counter-gift – that is, an act of sheer expenditure without hope of return – or whether it referred to gift giving for which a return, and a profit, could be expected and was obligatory. The difference was crucial. The practice associated with the first meaning was seen as a reprehensible waste by many colonial observers, thus placing the potlatch outside the limits of bourgeois culture and in opposition to the ethics of capitalism and making it an inherent vice that defined the indigenous population as savage. In this sense the potlatch stood as an obstacle to civilizing the primitives.

Its eradication was a moral imperative. The practice defined by the latter meaning, which coexisted with the first meaning in early texts on the subject, corresponded to Western economic principles and would have positioned the potlatch within the limits of European civilization. That is, attaching the latter meaning to the term "potlatch" would have rendered the Indian civilized, by European standards, before contact. However, as this interpretation was unthinkable, the first definition, as erroneous as it was, prevailed. When the potlatch ban was challenged, the issue of waste became paramount, and the exaggerated narratives of wholesale destruction of property, which was said to accompany the ritual, were pointed out as the ceremony's primary feature and as defining its "evil" nature.

Early resistance to the ban in the Upper Skeena region was widespread and came from various quarters and from various communities, in additon to the Gitxsan: "In the winter of 1890 Captain Napoleon Fitzstubbs, the stipendiary magistrate at Hazelton, and C.W.D. Clifford, a Hudson's Bay Company manager on the upper Skeena, wrote the attorney general of British Columbia to condemn the logic behind the suppression of the potlatch."[20] This support from the non-Native community may have been due to the increased business that the trading post enjoyed because of the ceremonies and to the losses that it would incur with their suppression. That the resistance to the ban was backed up by the local magistrate indicates divisions within officialdom on the issue and that the Gitxsan were not suffering under imposition of the law at this time.

Initially aided by internal government squabbling over who would pay for the cost of enforcement, resistance was successful throughout the province.[21] The first ban was struck down almost immediately. Initial prosecutions were unsuccessful, and the law was revised in 1895 to make it more draconian and to suppress all aspects of Native economies.[22] Even so, the law was not enforced with any rigour, nor was there a shortage of ways around it. Under the direction of the deputy superintendents of Indian Affairs prior to Duncan Campbell Scott – that is, up to 1913 – dissent existed within the government ranks, and the law was enforced with discretion. Few arrests and fewer convictions occurred. The eminent American anthropologist Franz Boas entered the fray in 1897 with a letter published in a local Victoria paper condemning prosecutions of the potlatch and attempting to educate the non-Native readership about the value of the ceremonies.[23] It had some effect, including focusing public attention from this point onward on the Kwakwaka'wakw and their particular ceremonies, an outcome enhanced by his further studies.[24]

There were no trials between 1897 and 1913. The prevailing belief among those who foresaw the potlatch's extinction was that it would not need to be killed but would die of its own accord. Faith in the inexorable forces of assimilation remained strong, and if this did not work, there was the steady decline in the Native population, which confirmed the inevitable. However, these forecasts proved misguided, and in certain areas the potlatch, or ceremonies subsumed under that heading, continued unabated and even grew in scale through the period of the non-enforcement of the ban. This was certainly the case among the Gitxsan and the Kwakwaka'wakw.[25] Just prior to the First World War, the continued vitality of ceremonial activity and flourishing Native economies produced a paradoxical situation, as administrators were compelled "to repeat over and over that the potlatch was nearing extinction. But there was also a drive toward life because, even as they were consigning the potlatch to its grave, the same administrators were nevertheless compelled to admit that it had been resurrected − or that it had never died in the first place."[26] There was, then, a continued insistence that the potlatch had died, but had been revived.[27]

It is now clear that with Scott's ascension to the position of deputy superintendent of Indian Affairs in 1913, traditional ceremonies had not disappeared and were, in certain areas, on the increase. Scott set out immediately to rectify this situation, with 1914 seeing the first potlatch trial in almost two decades. The new crackdown, which would last for the next two decades, met with renewed protests, including representations to the government from various groups on the West Coast. These voices gained some support within official circles.[28] Decisive action was required to head this off. Scott needed to rally support. In early 1915 he requested a report on the topic from Edward Sapir, who since 1910 had been the head of the Division of Anthropology within the Geological Survey of Canada, but the results were not what Scott had expected.[29] Sapir, who seems to have had little interest in aligning himself with the state's position, advised Scott to read Boas's accounts, which were undoubtedly a sore point for Scott. If this was not sufficient, Sapir added that "it seems to me high time that white men realized that they are not doing the Indians much of a favour by converting them into inferior replicas of themselves."[30] Sapir went further and solicited the opinions of his colleagues: "On 1 March he sent Scott letters from James Teit, Harlan Smith, Charles F. Newcombe, Charles Hill-Tout, John Swanton, and Franz Boas. They all advised against enforcing the law."[31] Significantly, Barbeau's name is

missing from this list. Although he was among those directly asked for support since he knew the situation among the Tsimshian, who were "disturbed about the present potlatch law," he contributed nothing to Sapir's campaign to demonstrate to Scott "reasons for considering it unjust and unwise to abolish the potlatch."[32] As we have seen, however, in the following years Scott ignored Sapir and the others, redoubling his efforts and having the law amended yet again.

In 1919, to reassert his position of authority in the face of opposition both from within and from without as well as to respond to demands that he fulfill his commitment to conduct an inquiry into the potlatch, Scott now claimed that he had a report from Barbeau, rather than from Sapir, supporting his position of authority on the matter. His new choice of allies in the campaign is significant. He stated in early 1920 that "the facts are already available in this Department and in the anthropological division of the Geological Survey and lately a complete survey of all our papers on the subject was made by Mr. [Marius] Barbeau of that division ... As a matter of fact we probably know more about the aboriginal custom of the potlatch than do the Indians themselves."[33] Scott's rejection of Sapir's position and his reliance on Barbeau indicated that he was aware of internal divisions on the matter of Native culture in general within the administration at this time and also aware of whom he could rely on publicly. Recognizing the division within the ethnographic community and even within government institutions over this fundamental issue and aware of the growing body of empirical evidence of cultural continuity and expansion within the Native groups both on the Prairies and on the West Coast, Scott turned to Barbeau rather than to Sapir.[34] In 1920 he issued an edict instructing his agents to begin rigorous enforcement of the ban.

Both Bracken's and Cole's accounts suggest but do not make explicit what appear to be growing divisions within the ranks of ethnographers, archaeologists, and administrators on the issue of the continuity of Native culture and the policies of assimilation and repression. It now seems that on this matter Sapir and Smith were on one side and Barbeau, Jenness, and Scott were on the other. The divisions are telling. Sapir and Smith were both students of Boas, who in turn had advocated a theory of cultural relativism that placed cultures on a level playing field rather than in a hierarchy. Such considerations led Sapir to resist the principle of cultural suppression, even though he believed that Native culture was on the wane.[35] Barbeau had read anthropology at Oxford at the same time as Jenness and would have developed a different perspective, one more in

keeping with Scott's hierarchical and evolutionary notions, which saw the inevitable destruction of Native cultures through assimilation as something to be actively striven for since it would raise the savages or primitives to the level of those within a superior Western civilization.[36] And, as has been shown, Barbeau had backed the theory of cultural decrepitude since the beginning of his tenure at the National Museum and was more in tune with the needs of the state.

In any case, Sapir was now aware of Barbeau's usefulness to Scott and his policies. Not only could the discipline of ethnography be called upon to support cultural repression, the denial of land claims, and so on, but it could serve as a form of government surveillance by which to keep an eye on any potentially troubling or subversive Native activities. However, Sapir's ideas were not consistent with these possibilities. He expressed his concern on the matter directly in a letter to Barbeau: "Once more to make it perfectly clear that there are to be no communications touching Indian affairs sent to the Department of Indian Affairs without the consent of the proper authorities within the Geological Survey, nor is any money to be accepted for incidental work[. Otherwise,] we will find ourselves fitting into the position of genteel spies for the Department of Indian Affairs. We cannot afford to be misunderstood by any Indians in Canada."[37]

In 1920 "Sapir forbade Barbeau to communicate with Indian Affairs without department consent since he feared department identification with Indian administration."[38] This confrontation between Sapir and Barbeau over the latter's employment with Scott for "incidental work" occurred when Barbeau was in the field in the winter of 1920-21, researching the persistence of the potlatch among the Gitxsan. Barbeau's research, then, was connected to Scott's edict to the Indian Agents, which also went out during these months, that they finally stamp out the potlatch. In addition, Barbeau was on the selection committee for Indian Agents at this time, when Scott was looking for a replacement for R.E. Loring, the Agent in the Upper Skeena region. These conjunctions are more than coincidental. They point to the possibility that Barbeau may have been working for two masters. Henceforth, the relationship between Sapir and Barbeau remained troubled until after Sapir left the National Museum in 1925.[39] He was replaced as head by Jenness, who was more in sympathy with the state's position.[40] After this point Barbeau and Scott were free to collaborate openly again. Barbeau also became less guarded in his statements on Sapir. Discussing the possibility of a hall featuring Native art alongside works by Langdon Kihn, Barbeau indicated that "as

you know it was always precarious with Sapir, on account of his jealousies and pettiness, and he always tried to discredit the affair with the director. But now we are all breathing more easily, and are making interesting plans for the work of the Division in the future. I've never realized until the moment he left what a nuisance he was in every way."[41] Barbeau was probably unaware that Kihn was also in communication with Sapir at the time.[42]

How, then, did these divisions and conflicts within the government departments and agencies as well as within the discipline of ethnology play out in the field with the people who were the subjects of this wrangling? It appeared at first that Scott had gained the upper hand. Ignoring Sapir's advice, along with that proffered by those whose views Sapir forwarded, and relying on Barbeau to back him, Scott had the law revised yet again in 1918 – the year that Barbeau was to issue his report – using the war as an excuse to validate the end to the "wasteful" practice of the potlatch.[43] In the two years immediately after the war, prosecutions began in earnest, even though the cause given had disappeared. Although much attention has been focused on the Cranmer potlatch on Village Island, also targeted were those Native communities in the Cowichan area of southern Vancouver Island and the Gitxsan of the Upper Skeena River. Up to this time, traditional ceremonies among the latter had been going on more or less uninterrupted, a fact not officially acknowledged: "Also in 1920 the department received a secondhand report from a missionary complaining about the 'revival' of the potlatch in Gitksan communities on the upper Skeena. He described the rebirth as a fall from whiteness. 'At first it began in a small way by having small feasts of the dead and conducted in a half Christian manner,' he writes, but 'year after year the evil increased until today they potlatch as if they were heathen.'"[44]

Once again those who saw their purpose as civilizing the primitive savages were unable to recognize the continuity of the Native traditions, being obliged to report that these had died and then been miraculously reborn and were increasing in number. Equally, the "relapse" had to be dealt with firmly. By late December 1920, when Barbeau was on his extended field trip in the area, the retiring Indian Agent, Loring, had posted notices in the various Native communities indicating that the Royal Canadian Mounted Police (RCMP) were now prepared to enforce the newly revised law. The notices stated:

Let it herewith be known that, according to Section 149 of the Indian Act, every Indian or other person who engages in, or assists

in celebrating or encouraging either directly or indirectly another to celebrate any Indian festival, dance or other ceremony of which the giving away or paying or giving back of money, goods or articles of any sort forms, or is a feature, whether such gift of money, goods or articles takes place before, at, or after the celebration of the same, etc., is guilty of an offence and is liable to imprisonment for a term not exceeding six months and not less than two months.[45]

Bracken reports that, "ironically, more than twenty years earlier he had argued that it would be better to repeal the statute than to enforce it because, he said, the winter dances had already died and the potlatch was about to follow them (NA, vol. 3629, file 6244-2, 15 July 1897)."[46] This might not have been as ironic as Bracken thought. Evidence exists that Loring may have persisted in his views and not have interpreted the new legislation as literally as did other Indian Agents, such as William Halliday, or as Scott had intended. The local paper gave a modified version of his announcement:

The order was issued recently, signed by Indian Agent Loring, forbidding the holding of potlatches. This is only to enforce an act that has long been on the statute books. The Indians, however, are very indignant that their ancient custom should be thus abolished by the white man, and the first of the week a meeting of chiefs of many tribes from various parts of the interior was held in Hazelton, to protest against the order ... The Indians are to send a petition to the government protesting against the order. There seems to be a little misunderstanding on the part of the Indians in regard to the order. They had an idea that all feasting was to be stopped, as well as the potlatch which is not the case.[47]

The Gitxsan protests were, of course, ineffective. Indeed, appealing to Ottawa was probably the worst possible move. Alerting federal authorities, particularly Scott, to continued resistance could have resulted only in yet more disciplinary actions, increased surveillance, and more severe punishments. Nonetheless, their stance indicates the value that they placed on the institution, that it was still viable and continuing, and that they still held on to the possibility of negotiations. Concealing the ceremonies did not seem an option at this time.

On the other hand, since Barbeau had been sent into the area in the winter of 1920-21, the Department of Indian Affairs would have been

aware of continuing ceremonies anyway. Insofar as any reports of such activities would have been of interest to Scott, Barbeau's field notes of the extensive ceremonies that season took on a political cast and broadened the relationship between the practice of ethnology and the interests of the state; there is little question that Barbeau was spying for Scott during the period when Sapir had forbidden collusion. Members of the Native population identified him as having done so. His role as Scott's agent in the field interfered with his ethnographic aims when he was asked to leave ceremonies in Kitwancool in August 1920.[48] The local police also identified him as a covert operative: "In the first part of this report [on the aforementioned meetings of the Gitksan chiefs and officials from Hazelton to protest the ban] I made mention of a Mr. Marcus [sic] Barbeau. Mr. Barbeau is in the Government employ as an Anthropologist, and has been in Hazelton all summer studying the Indians and their customs, it is not officially known, but he was to make a report to the Indian Department in Ottawa concerning the use or abuse of the so called 'Potlatch.'" The police report also confirmed the continuity of traditional ceremonial activity: "The reason for Mr. Loring having placed this notice up, was that in recent years, the Indians have held these potlatches and that much money had been passed around, and further and by far the worst is the fact that the Indians, men women and children were at a standstill for about 6 weeks attending these potlatches." It also outlined the arguments put forward by the Natives on the absurdity of the ban: The Natives argued that "it was their own money," cited the ceremony marking the 100th anniversary of the Hudson's Bay Company, at which gifts were distributed, and stated that they had already given up those aspects of the potlatch that non-Natives found offensive.[49]

No local legal moves against the potlatch appear to have been taken while Barbeau was in the field. He attended the large Hagwilget potlatch in the summer of 1921, which went on unimpeded.[50] The first confrontation came in late 1921 and early 1922 when four individuals "from Kispiox were charged with taking part in a 'giving away celebration.'"[51] This action, which resulted in suspended sentences from now Justice of the Peace Loring, seems to have been the height of the prosecutions in the Upper Skeena area. The local population soon learned to operate within the loophole created by Loring – that is, within a narrow interpretation of what constituted a potlatch – and recognized that the prosecutor may have been onside. "Potlatches" of some scale were reported at nearby Hagwilget in the summers of 1922 and 1923, although the local

newspapers stated of the first that "the natives had a good enough time, but they were not able to get away with much of the old time stuff."[52] In the face of what subsequently occurred, this appears as little more than hopeful, or perhaps helpful, editorializing. By 1923 it was conceded that the ceremony was "to be one of the biggest affairs held for years."[53] It went on "for several weeks."[54] In addition, that same spring, the *Daily Province* reported that Wasm la tha Robinson, who "lived in an old style house," had died at the age of 102. "The funeral ceremonies were carried out according to old customs. The feast before the funeral was for Indians only, and in the feast afterwards the whites participated. All the old songs were sung with great solemnity, the service being very impressive."[55] In early 1925 the local papers noted that "Johnson Alexander ... the new chief ... adopted his new official name ... [that] of the first chieftess of the tribe. The ceremony ... took place during the potlatch in Hazelton during the holiday season and which was attended by Indians from far and near ... [with] presentations ... made by chiefs of all the tribes along the Skeena River."[56] Kihn's report, cited in the previous chapter, also documented extensive ceremonies from later in 1925 that constituted an open and flagrant disregard for the law,[57] at least as conceived by Scott, and that contradicted pronouncements, such as those by Halliday, that the potlatch was now dead.[58] The local paper confirmed the continuity of Gitxsan culture in 1926 when it stated that "although the white man's ways are being rapidly adopted the Indians are still carrying on their old practices."[59]

McDonald and Joseph report that "in 1927, Agent Hyde brought charges against Silas Johnson and Sam Disk under the potlatch law. They received a warning and a lecture."[60] In comparison with what had occurred under Halliday, this was indeed small punishment, little more than a slap on the wrist, and spoke more of open complicity than of enforcement and prosecution.[61] Such carefully circumscribed responses certainly did not curtail ceremonial activity. Nor were they designed to. Contrary to many assessments of the period, such as that given by Barbeau in 1929 that Gitxsan culture had experienced a "total collapse," and despite later claims by others that it had died and been reborn, a growing body of evidence now exists that the traditional life of the Gitxsan had not ceased but was ongoing until the early 1920s, when the prosecutions began, and that it continued throughout the decade and to the present day with the cooperation of both local officials and citizenry.[62]

Into this situation, then, stepped those involved with the project of totem-pole restoration, one predicated on a fading Native presence. The

history of Scott's Indian policy and its failure is germane to the situation here, particularly since it reached its height in the 1920s. The simultaneous return of Barbeau to the field on his collecting and study trips, the presence of white artists and tourists, and the announcement of the restoration program at the same time as the federal government was attempting to enforce the ban on all traditional ceremonial activity caused understandable suspicion among the Native population. Nonetheless, the project went ahead. Hill gives the most succinct version of its initiation: "In June 1924, a 'Totem Pole Preservation Committee' was established, composed of Duncan Campbell Scott, the deputy superintendent general of Indian Affairs, J.B. Harkin of Parks, and Edward Sapir and Marius Barbeau of the Victoria Memorial Museum. The Department of Indian Affairs would finance and supervise the restoration of the poles in the villages (with the permission of the owners), siting them so as to be visible to tourists, and the C.N.R. would provide free transportation for the men and materials plus the services of one of their engineers."[63]

Although noted in passing as "owners," no Gitxsan representatives were included on the committee. Privilege of place went to Scott, whose department was to oversee the project. It is impossible to divorce, then, his recent policy of potlatch prohibition from the project, especially since the arrests and confiscations in connection with the Cranmer potlatch on Village Island. Much of the confiscated material entered the collection of the National Museum, and some remained on display in Scott's office, visible to anyone who paid him an official visit.

As we have seen, the potlatch ban marked a significant difference between the Canadian program of totem-pole restoration and the American program for employing Native cultures as tourist draws. The latter, at least in Santa Fe, included tours to performances of traditional rituals and dances on the reservations. These were seen as alive and as ongoing manifestations of traditional cultures. Given the ban on dancing in Canada and the program of systematic cultural suppression, no such practice could be suggested, although it would have substantially enhanced the CNR's program, as proved by Banff Indian Days, by the success of the Calgary Stampede, and by later events at the Indian museum of 'Ksan in Hazelton after the ban was eventually dropped in the early 1950s. At this point, in the Skeena Valley, Scott and Barbeau were directing events although neither was in direct control of the restoration project in the field.

In 1925 the project was under the direction of Harlan Smith, who was an odd choice given that Barbeau's initiative had gotten things started and

given that he had done the actual groundwork. Cole identifies Smith's
long experience in the field in dealing with Natives as probably the great-
est consideration in this choice.[64] As well, Barbeau's close affiliation with
Scott and the similarity of their views, which was already recognized by
the Kitwancool, might have disqualified him from delicate negotiations
with the Gitxsan. The tasks that lay ahead were not simple. First, permis-
sion had to be obtained from the owners of the totem poles. This seems
to have been a crucial sticking point, as this deference is insisted on again
and again in the correspondence and reports of the program. The chiefs
of the Gitxsan villages of Kitwanga, Kitsegucla, Kitwancool, Kispiox,
and Kitanmax, as well as the nearby Carrier village of Hagwilget and the
Coast Tsimshian village of Kitselas, all received a letter written by Smith
explaining the program. Although lengthy, the letter should be cited in
full because it does much to clarify the federal position, as presented to
the Natives, and because it has not been previously published. It is also as
important for what it leaves out as for what it states:

To All Whom it May Concern,

Mr. Barbeau, who was at Kispiox, Skeena Crossing, Hazelton and
Hagwilget, as well as Kitwanga last year, went to Ottawa, where he
lives, and told many of the good white people, members of Parlia-
ment and Dominion Government officials, about the Indians. There
are a few other men who go to all parts of Canada to find out about
the Indians, the way they live and the things they make, also to find
out about the trees, rocks, stones, flowers, fish, animals and birds.
These men return to Ottawa and teach people free of charge about
these things as they are working all the time for the Dominion
Government.

The men who study the Indians all come to be good friends of
the Indians. For many years these men have tried to get justice and
help in sickness for all the Indians. It is the very same in the United
States. It is very hard work, as some white people will not believe
them. The bad people who want the Indian lands, or to get his furs
too cheap, or to get him drunk and rob him, do not like these men
and try to make trouble for them.

At last these men have succeeded in a small way a little bit. So
there is now a Dominion Government committee at Ottawa which
is trying to help save the totem poles and help the Indians keep the
totem poles on the places where they where [sic] where the Indians'

children and their children's children can always see them and remember their fathers and the old customs.

These white people also want to see the poles, learn how well the Indians could carve and paint, hear the stories and know of the honour of the chiefs.

As I have worked among the Indians since 1897 (twenty-eight years), am known by all the Bella Coola Indians, Mr. Andrew Paul and the Rev. Peter Kelly, I was sent by the Dominion Government to see if the chiefs wished me to help.

I was given money for this work and have put it in the Hazelton bank. This I am to use if I can pay the people for their labour and to buy cement, oil and such things, to try and fix the poles so they will not fall down and be rotted by the rain and weather.

First I must get permission from the chiefs. I will not touch a pole until I have permission to do so. Then I am to fix it below the ground so it will not rot. For this, cement and tar or paint will be used, but not so that it will show above the ground. Then I am to oil the pole like the one at Prince Rupert, so that it will not rot, and put colour where it should be, but not much colour.

Nothing must be done that the chiefs do not want. If anyone does wrong, come and tell me.

The newspaper in which Smith's letter was cited added a significant editorial comment: "It will be remembered that the Indians in the district about Kitwanga and Kitwancool have shown a disposition to resent any persons going through their domains, and last year several parties were turned back from the Kitwancool Valley. Dr. Smith is endeavouring to educate these people to the value of their own artistic monuments and is seeking their co-operation in the work."[65]

The parental tone of the letter is evident throughout and contrasts strongly with the erudition of the journalistic addition, which is addressed to a different readership. But beyond the letter's tone, there is a blatant attempt to pull the wool over the eyes of the Native readers. In going out of its way to convince the chiefs of the good intentions and offices of the benevolent paternal government of which they are wards, it fails to mention anything about the potlatch ban, which in turn constituted a ban on raising totem poles since no pole could be erected without the attendant ceremonies to validate it. Although Scott was on the committee and was known to the Gitxsan, his name is not mentioned, nor are the other mem-

bers of the committee. Scott's open involvement would have produced immediate resistance and suspicion. Instead, the letter diverts attention to unrelated matters of health and trade while employing the simplistic trope of good white people versus bad white people, with all government agents cast as the former. Nor does it outline the "death of the Indian," nor the extinction of Native culture, nor any attempt to arrest its final decay and place it in an embalmed hypostasis. Yet these were the underlying *raisons d'être* for the project and were clearly explained in Barbeau's addresses to white audiences, as seen in the previous chapter. Indeed, whereas Barbeau stated that the Natives had forgotten almost all their past culture, Smith attempted to sell them on the idea that the restoration program would be a cause for remembrance into the distant future. Smith also skirted any mention of the tourists or of the profits anticipated by the railway. It was presumed that sharing in these profits was not of interest to the Gitxsan, whose gratitude for government assistance and benevolence would blind them to their exploitation.

But above all, the letter fails to mention that the totem poles' significance would change forever once they became part of the program. Although ownership was stated as residing with the chiefs, authority over the poles would be transferred to non-Native institutions. The poles would lose their traditional significance within Gitxsan culture. Under the panoptic gaze of the railway, the tourist, the administrator, the anthropologist, and the artists, all of whom would be properly educated in how to look at them, the poles would gain significance as static emblems of the death of Gitxsan culture and as artifacts to be preserved and used as tourist and artistic attractions for Anglo-Canadian audiences. The Gitxsan were denied competence as viewers of their own art. The *Daily Province* stated as much when it deemed them unable to see "the value of their own artistic monuments" and in need of education on the matter. Such assumptions excluded them from authority over their own culture and located the proper viewership for the productions of this culture with the newly competent non-Native audiences. The implications did not escape the Gitxsan. Nor, as the *Daily Province* and Smith himself suggested, were they blind to land claims, maintaining control and possession of their own traditional territories to which they had never ceded title. Indeed, it seems that the Gitxsan were (in)famous among the populace of Canada and the readers of the popular press at this time for more than their poles.

Shortly before Smith's letter appeared, a lengthy article was published

in *Saturday Night*.[66] The lurid headline reads "Halt! Red Men Bar Whites from B.C. Lands – Surveyors Taken Prisoners and Tried by Indian Tribunal for Trespassing in Kitwancool Valley – Ceremony Grotesque, Pathetic and Impressive – Allied Tribes Lay Claim to All Lands in Province and Ask Pay for Alienation." The manner in which Gitxsan resistance to territorial appropriation was represented to the Canadian public is significant.[67] The first part of the article outlines the substance of the land claims put forward by the Allied Tribes as well as the federal government's duplicity and stonewalling on the matter, including its broken promise to consult with Native interests before ratifying the report of the Indian Affairs Commission. Indeed, the report was tabled "without the knowledge of the parties chiefly interested. The question of aboriginal title is apparently disposed of by this document, though the Allied Tribes contend the powers of the commission were practically limited to defining the boundaries of Indian reserves."[68] This issue and the potlatch ban were the major disputes brewing at the time.

The article, meant for a national Canadian audience, contains numerous errors of fact. Some are simply careless misidentifications. But in certain instances, they seem suspiciously close to deliberate misrepresentations and reveal an underlying duplicity in treating its subject. In this context, the article at first goes out of its way to portray the people of Kitwancool as completely assimilated: "They have razed their painted houses, chopped up most of their totem poles for firewood, and listened to the exhortation of the missionary, but they remain sincerely unfriendly towards their pale-faced brother." It seems odd that a national publication should authorize such a statement when the federal government, or at least its Indian Department, railway, and museum, were trying to promote the area based on precisely the opposite grounds. Indeed, at exactly this time, it was becoming public knowledge that the Gitxsan, and most assuredly the Kitwancool, had kept their totem poles intact, as Kihn's paintings would testify and as Barbeau's book would soon document. The point here, of course, was to cast doubt on their cultural continuity in order to undermine their land claims, while simultaneously trying to explain their well-known hostility to territorial appropriation.

But the major part of the article is a free interpretation of an incident in which Mr. A.P. Horne, a forestry engineer from Hazelton, and James Bennett, an assistant, were confronted by the residents of the remotest of the Gitxsan villages, Kitwancool. The two cedar surveyors were put through a trial, sentenced for trespassing, and then expelled. In this sec-

ond, more elaborate narrative, in which anxiety is cloaked with humour, the familiar tropes for representing the Native that we have seen used by Barbeau are deployed once more. However, one new aspect is the denial of language. The Indian is literally deprived of speech on more than one occasion. In a passage exploited for its comic potential, the Kitwancool sentinel is reported to have forgotten the word for halt. Having remembered it, he asks, "What do you want in um valley?" One of the chiefs is later reduced to "inarticulate cries of rage." Lacking the ability to articulate ideas, the Indian was infantilized and denied cognitive authority. The "Big Chiefs," who were wearing ceremonial regalia, described as "gaudy finery," are said to have "looked ludicrous." The trial was described as a "slavish copy" of Western judicial practice. There is more in this vein.

Toward the end, the story steps out of its tragicomic mode and becomes deadly serious. The occasion, for all of its "grotesque," "child-like," and "pathetic" appearances, was recognized as being of great importance historically: "For possibly the first time in Canadian history, white men were being brought to trial before an Indian tribunal, charged with trespassing on aboriginal territory."[69] This was described as an "uncanny experience." Indeed, palpable throughout the article is the anxiety produced by a trial that mimicked the forms used in prosecuting the Gitxsan for potlatching and for protesting the expropriation of their lands. At a time when British, or now Canadian, justice and law as well as prerogatives to the land were being usurped and even ridiculed by those who were aware of legitimate prior claims, the Gitxsan, or more specifically the Kitwancool, were representing themselves in the legal sense and placing themselves in a position of power and authority over their territories.[70]

In the final paragraphs, the article reverses itself and acknowledges the erudition of the Gitxsan speakers. It quotes at length a declaration reported to have been delivered at the trial by a Gitxsan spokesperson:

"We, the Indian residents of the Kitwancool Valley of the Skeena River district of British Columbia, in solemn meeting assembled, here and now declare that it was the wish of our ancestors, as it is our wish, that all the products of that area north of the nine-mile post in this valley, and for a distance in that direction of 115 miles by 60 miles east and west, are and shall remain ours.

"When we effect a settlement with the government, we will dispose of the said products on a royalty basis, but until that time no white man shall enter there. You are therefore requested to return

to the place whence you came, and there be about your business.

"God made land, God made salmon, God made cedar, God made animals, for everybody, Indian as well as white man. Much he gave to the white man, and a little he gave to the Indian. This territory he gave to the Kitwancool Indians, and what we have we hold."[71]

From this public declaration by the Kitwancool of title to their lands, it now becomes evident that much more was at stake in the elaborate plans and undertakings of the federal government than simply the totem poles' preservation, redefinition, and representation. The landscape being invaded by technicians, tourists, and artists was itself contested. And the position of the Other was shifting. What had been regarded as contained and confined – and, if Barbeau and others are to be believed, condemned to extinction – was threatening to break through the borders of its enclosure. The disappearing Other was threatening to return. Native continuity and its denial, the totem poles and their "preservation," and representation of the land and claims to Native territory all became inextricably linked to the representation of the Indian. Given what was now at stake, the borders of this discourse, which were now in danger of imminent collapse, had to be carefully patrolled. Artists, ethnologists, archaeologists, tourists, railway officials, and functionaries of the Department of Indian Affairs were sent in to do the job.

At precisely this anxious moment, then, the restoration project got under way, although any mention of these issues in Smith's letter to the chiefs (or in later accounts) was carefully avoided. Native views were not welcomed. Permission was reportedly obtained from most of the villages, but especially from the communities of Kispiox and Gitsegukla. However, work began in Kitwanga, where the totem poles were clearly visible from the tracks. In July, Smith issued a preliminary report on the progress of the project.[72] The situation looked promising.

Smith indicated that he had permission to work on ten totem poles near the railroad. He listed the Natives whom he preferred to employ and "one white foreman who lives on the reservation married to an Indian of influence." In addition, he mentioned the engineers of the CNR. Questions arose about the amount that the company was willing to underwrite and the portion that would have to be paid through National Museum expenses. Although no poles had been "finished" at this time, Smith had to admit that it was costing $250 a pole, noting that "this is probably more than was expected but we have no apologies to make for this job. The last

month was largely making inspection, getting permission and awaiting gear. It is a more expensive and difficult job than appeared at first but we are all to the lowest Indian labourer proud of it." Some poles had been repaired and painted and were being re-erected. He also recorded the progress, albeit with some difficulty due to lack of time, with both still and movie shots. He noted that his work was a "benefit to R.R. passengers who twice a day walk through and to Indians who live here."[73]

The project continued in 1926 at Kitwanga, restoring eighteen totem poles and two figures. Although two poles that the owner refused the restoration crew permission to touch remained a sensitive issue, in 1927 the crew was ready to move onward. Gitsegukla, which was also along the track, became the next focus. But here things started to go amiss. The carefully solicited cooperation of the Native population evaporated. The restoration crew was denied the right to work on or to "restore" any of the poles in the village.[74] The village chiefs had even gone so far as to obtain legal counsel to ensure that their rights over their property would not be violated. That is, they were, as they had in the past, using the legal system and institutions of Anglo-Canadian society against its own actions. But opposition to the program was not confined to this one village. Resistance was spreading and vigorous. The restoration crew was also denied permission to repair a totem pole at Hazelton that had been knocked down by a truck earlier in 1927.[75] By this time the Gitxsan were no longer amenable to having their culture and its physical manifestations or themselves appropriated by the national institutions of the CNR, the National Museum, and the Department of Indian Affairs. Nor were they willing to be declared the last remnants of an almost dead and meaningless culture, a people waiting for a new significance to be placed on them from without. Rapidly realizing the meanings of the restoration program, which had been either hidden from them or misrepresented, they took a vital role in resisting it. Indeed, they now demanded that if the poles were to be taken down and/or put up to meet the interests of the CNR or National Museum, then appropriate ceremonies had to be conducted and payments made; that is, the potlatch ban had to be lifted. They insisted on representing themselves, as this was the only way that they could declare and negotiate the vitality of their culture while asserting their authority over it in the face of attempts, both veiled and overt, to negate this vitality and possession.

The restoration program sputtered on for two more years at Kitselas, a deserted Coast Tsimshian village site that was visible from the tracks,

but did not return to the occupied sites, which had been reclaimed by the Gitxsan, who had again thrown out the white intruders. Even at Kitselas, the issues of ownership and authority over the totem poles became a tricky problem. Both Chiefs Mark McKay and Walter Wright insisted on their proprietary rights over their poles and demanded that Smith not commence work until they had arrived to supervise it. McKay also dictated whom he thought would be the best carver to replace the Eagle at the top of his pole: William Brown from Hazelton, whom he claimed was · a good totem-pole carver. Smith was obliged in June 1927 to issue a statement to the "Indians of Kitselas" stating, "I hereby agree that I will not change the ownership of your Totem Poles *or your lands* in any way."[76] The statement makes it apparent that both the Gitxsan and the government agents understood the links between authority over the poles, the vitality of the Gitxsan culture, and the validity of their land claims. In fact, at this very moment, Scott was fighting the last battle to keep the Allied Tribes from reaching the Privy Council; he won but only by passing the most draconian measures yet. He was obliged, against all tenets of democracy, to forbid the exchange of money over the issue of land claims so that unless lawyers were willing to work *pro bono,* legal challenges virtually ceased. In any case, accepting land claims as the price of the restoration project was too much for the government, and the project ended. Smith's involvement with it terminated in 1928, with Scott issuing a statement thanking him for his work.[77] It staggered on for two more years under T.B. Campbell, the engineer who had directed the actual work, but made no headway.

One other aspect of the program under Smith needs to be mentioned. In his 1925 report, Smith noted in shorthand form: "Souvenirs badly needed for sale at Kitwanga. Only postcards are sold by Mission. Everyone should sell larger pictures and models of totem poles (good ones not fakes) bracelets, earrings, etc. as an ad. for Ry."[78] He was probably recalling the enormously successful precedent of the Santa Fe Railroad and the popularity of pottery, silver work, and weaving by Natives of the American Southwest, where, it will be recalled, he had spent time. It appears that Smith may have been thinking of a similar "revival" of Northwest Coast art, albeit no longer for traditional purposes but specifically to enhance the tourist trade. Several mentions of such a revival have already been noted. Eric Brown touched on the subject in his *L'Art et les Artistes* article but gave no source for the idea, although his comments were accompanied by notice of the totem-pole program under Smith's direction.[79] One of the French critics picked up the idea as well. However, as we have seen, Bar-

beau adamantly opposed any such notion. Smith seems to have been un-
deterred. The Canadian Museum of Civilization (CMC) Archives contains
a 1927 letter from J.H. Ticehurst to Smith that lists the names of local
Indians who can do carving and weaving. The list is extensive and is worth
citing in full. Named from Hazelton are "William Brown, age 64, wood-
carver, Totem poles. Mask. etc.; Tom Campbell, age 55, wood carver, and
canoes, baby's [sic] cradles; Abel Oaks, age 50, wood carver and silver and
makes bracelets; Mrs. James White, age 40, weaves pack straps, almost
anything in the weaving line; Sam Green, age 40, makes fish traps, canoes,
spoons, etc." Named from Kispiox are "James Green, age 69, carves totem
poles, makes canoes etc.; Saloman Johnson [who had been portrayed by
Kihn], age 69, carves totem poles, masks." Named from Glen Vowell are:
"Nathan Brown, who makes spoons and masks, age 50; Jennie Dick, age
25, weaving of any kind and makes snow shoes; and Charlie Sampson,
age 30, wood carver and makes masks." Ticehurst notes: "I did not get
any Kitwanga Indians names[.] I thought you would have them your self
[sic]." Nor are any artisans named from Kitwancool. The evidence of such
a list, which goes well beyond naming only those who would be suitable
for lending a hand to the restoration program and which gives assurances
that all those listed "are firstclass workmen," indicates Smith's interest in
organizing a revival of Native work rather than just in soliciting names to
help him with the restoration project. At the same time, the length of the
list places in question the concept itself. Why would a "revival" be neces-
sary if all of these people still practised their arts? Was (and is) the term
still used to sustain the view that Native culture had died?

Despite Smith's continued insistence on the necessity of Native arts
as a part of the program, they were never incorporated into the resto-
ration project. Such a move, even if undertaken only for the benefit of
the railway, would have validated Native art and culture in the present
and provided a point at which the Gitxsan could have negotiated a valid,
intercultural relationship, even if based on commodified, transcul-
tural objects.[80] Conversely, Barbeau saw no hope of a revival of what he
believed to be lost arts. Scott, too, would have resisted any such plan.
Darling and Cole indicate that Barbeau worked extensively behind the
scenes to discredit everything Smith did, to the extent that Jenness, who
sided with Smith, had Barbeau removed from the restoration commit-
tee.[81] Nonetheless, Barbeau's strategy succeeded. Smith would have to
wait some decades – until the position of the Indian within Canada had
again undergone a major shift – for a so-called "revival" to occur.[82]

Smith had one more opportunity to place his views before the public. He wrote an article for the *London Illustrated News* reporting on the restoration program. The profusely illustrated article, published outside of Canada, is notable in that it is written entirely in the present tense. It makes no attempt to place Gitxsan culture in the past, nor does it mention the death of the race. He states, for example, that "totem poles are not gods or idols ... They *are* made ... These are the emblems of brotherhoods, clans, and families ... They illustrate ... A carver on the father's side of the family *is* employed," and so on.[83] Smith also writes that "in recent years some of the Indians have been using tombstones bought from white men" not only in place of, but also in addition to, totem poles. While noting the presence of Euro-Canadian influences, he also gives a clear indication that carving was still ongoing. But it was the Euro-Canadian influences that were assimilated, not vice versa. In addition, he underlines the current value of the poles to the Gitxsan and their resistance to having their meanings and audiences change: "I quickly discovered that the owners of these poles had objections to our touching them ... One young man said: 'These poles are monuments like grave-stones, and we do not want a show made of them for white people to stare at.'" Smith's claim that the youth was interested in preserving the traditional meaning of the poles flies in the face of the repeated claims that it was the young who were most active in abandoning their Native culture and identity. Simultaneously, this resistance to the panoptical gaze of the new non-Native audiences, who were recognized as turning the Gitxsan into a contained and static spectacle, speaks to a clear understanding of those aspects of the program that had remained underarticulated by Smith himself when he first wrote to the chiefs.

In contrast, an article that had appeared two years earlier in the same publication took an entirely different viewpoint. Ostensibly a review of Charles Harrison's *Ancient Warriors of the North Pacific: The Haidas, Their Laws, Customs, and Legends; with Some Historical Account of the Queen Charlotte Islands*, published in 1925, it was accompanied by many illustrations supplied by the National Museum of Canada, which, by adding Kwakwaka'wakw material to the Haida, ensured that the conclusions drawn could be applied across the region. The opening column rehearsed the jargon of disappearance: "Once a powerful tribe ... the people are gone ... decaying and disappearing ... all that are left ... The villages are in ruins ... Those who occupied them are now all dead ... remnants ... of this decaying nation ... inability of the North American Indian race to

survive in contact with European civilization ... beginning of the end," and so on.[84] Not one instance of this liberal assortment of terms, which circulated widely within the writing on the Indian, can be found in the Smith article. But Smith was not the only one attempting to shape public opinion.

Barbeau was also adamant that the restoration project be perceived in a singular and nonambiguous manner. He took every opportunity to express his view in both his popular and scholarly writings. In his 1929 published report on the Gitxsan, dedicated to academic audiences, he again places them in a retrospective past: "Totem poles were once a characteristic form of [Indian] plastic art ... This art now belongs to the past. Ancient customs and racial stamina are on the wane everywhere, even in their former strongholds ... Totem poles are no longer made."[85] He offers conclusive proof of this claim: "Only one of them among the Gitksan has been cut down and disposed of to a museum, a few years ago; and this forfeiture could happen only after the total collapse of the ancient customs and memoirs."[86] He then notes that the owner had to repay the relatives for the initial cost of the pole. But does not this transaction along with the odd use of "only" that opens the sentence, especially in the context of the voracious appetite among various international collection agencies for such poles, reasonably lead to precisely the opposite conclusion? "That only one pole was sold and compensation had to be paid, and that poles were still being raised while Barbeau was doing field work [although he omits mention of this fact], would indicate that the Gitksan were still in possession of their traditional culture, and the poles still retained their social significance. The Gitksan had not reached the point of the Nass River natives who had been persuaded to burn their poles, and sell the rest, or of the Haida, who stopped raising them [in the 1880s] and similarly, destroyed others."[87]

I have suggested that such authoritative, oracular statements, backed up by little evidence, as made by Barbeau, are symptomatic of his response to the fracturing of the discursive framework. As on the Prairies, it becomes increasingly clear that by the late 1920s Barbeau found it necessary to cite every instance of continuity among the Gitxsan as its opposite. Any sign of cultural continuity was conflated with collapse. This strategy centred largely on their totem poles, whose ambiguities became emblems of a conflict that could be overcome only by taking possession of them, redefining them, and re-presenting them. He made a claim that the Gitxsan poles were no longer being raised and that the culture supporting them was

moribund or next to it. Consequently, in his eyes, the poles lost their original meaning and significance as direct representations of Gitxsan culture, which no longer existed except in his own records. The poles became quite literally either decaying emblems of Native decrepitude or empty signifiers awaiting the imposition of a new and stable meaning and the arrival of new audiences. Barbeau, the CNR, and the artists who would come under his direction filled the vacuum that was created. Insofar as the poles could be disconnected from or invalidated in terms of their original social and cultural significance and could now be seen as emblems of the death of this culture, they could successfully be appropriated by Anglo-Canadian artists working under the auspices of several institutions, such as the National Museum, National Gallery, National Railway, and the Department of Indian Affairs, as well as by the discipline of ethnology, the popular and high arts, and the tourist industry. The image of the Indian could become purely and nationally Canadian since it no longer needed to be recognized as distinctly Other. Indeed, the act of representing the poles reassuringly declared the disappearance of the Other who had produced them. Successfully using the poles as the token of the death of the Other allowed them to be incorporated and absorbed as a sign of a living Anglo-Canadian culture, "our" culture, as it was called. The anxiety of the hybrid could be overcome as long as this definition could be successfully shaped and contained. But given that the Indian Other refused to die on schedule and given the variations in viewpoints within the discipline of ethnology, gaps began to open within the normalized knowledges. Indeed, ironically, it was not so much the Gitxsan poles that needed propping up and supporting as it was the discourse by which they were known.

Chapter 8: Representing and Repossessing the Picturesque Skeena Valley

Canadians are often told that the challenge to visualize this territory, to confront and psychically own the land of Canada has been the highest task of her writers and artists. But few question the relation of this tradition to historical reality.

– Scott Watson, "Race, Wilderness, Territory and the
Origins of Modern Landscape Painting," 93

Rather than mere depictions, landscape paintings often testify to "political intentions." Articulating with state designs, they summon nature to perform a "cultural purpose," to mark the frontiers of a state's territorial consolidation and the boundaries of its national culture.

– Michael Shapiro, *Methods and Nations*, 106

THE GITXSAN'S TOTEM poles and village sites and their disputed territories in the Skeena Valley also formed the subject for the next phase of state intervention in the region. In early 1926 Marius Barbeau announced a plan to bring in another group of artists under the auspices of the Canadian National Railway that would not include Langdon Kihn. Barbeau was already beginning to distance himself from the American artist and his problematic images and starting to search for an alternative vision more in keeping with his and the state's position on Native representations, one that would be clearer and more stable in its message. The necessity of finding and legitimizing this replacement was becoming increasingly apparent. Nineteen twenty-six also marked the second year of the project under Harlan Smith to restore the totem poles, a project that had produced growing

resistance to federal policies among the Gitxsan. In addition, Native groups on the West Coast were becoming increasingly vocal in pressing for recognition of their land claims, which they were determined to take to the Privy Council in London.[1] The state's reaction to these initiatives entailed passing even more draconian and coercive federal legislation that outlawed the hiring of legal counsel to pursue such claims. There was also an increase throughout the decade in the enforced placement of Native children in residential schools, thereby destroying families and, it was hoped, any remaining cultural continuity.[2] But another factor must also be accounted for. During the 1920s the Canadian Native population had turned a critical corner and was now, for the first time in decades, on the rise.[3] This was not the trend that had been anticipated by the government.

Within this contradictory and conflicted context, Marius Barbeau's plans took on a new direction. The Canadian artists whom he brought in would capture, take possession of, and reterritorialize the Skeena region as part of a broader image of the nation. In this new vision, Native presence and cultural continuities would not be issues. This stage of his project involved enlisting the major members of the Group of Seven and redirecting their attention to the Skeena, where they would repaint the villages, landscapes, totem poles, and people previously depicted by Kihn.

Letters between Barbeau and A.Y. Jackson, Barbeau's primary contact with the Group, indicate that Lawren Harris, J.E.H. MacDonald, and Arthur Lismer were also approached. Alfred Casson, Franklin Carmichael, and F.H. Varley seem to have been left out, although Varley was now resident in Vancouver. Barbeau had good reasons for anticipating positive responses given his earlier work with Jackson and Lismer visiting and painting images of rural Quebec, the manner in which he draped the invitation in the garb of nationalist identity, the free passes offered by the railway, the fact that all were already doing extensive painting elsewhere in British Columbia, the prospect of a major exhibition, and the picturesque attractions of the Skeena Valley landscape and its Native villages and poles.[4] However, Harris, MacDonald, and Lismer made various excuses for not participating.[5]

This aversion on the part of the other Group members except Jackson has never been sufficiently explained. In the face of Barbeau's incentives, the polite excuses that were offered, such as pressing family matters and loyalty to the Canadian Pacific Railway (CPR), do not seem convincing. More likely, the other members responded negatively at least in part because they sensed, but could not acknowledge, that a direct confrontation of the Native subject matter with the myth of the "empty landscape"

would endanger the latter. If so, they would have been accurate in their assessments. In the first summer of the project, this resistance left only Jackson and his friend from Montreal, Edwin Holgate, who had recently returned from study in Paris and who specialized in portraits and woodcuts. Barbeau wrote to Holgate: "Mr. Jackson recently told me in Toronto that he hoped to induce you to visit the Skeena River, northern B.C., this summer with him ... In the course of several lengthy visits I have had ample opportunity to become acquainted with ... this mountainous and picturesque district." Barbeau added the draw of "the possibility of some exhibitions in Toronto, Ottawa and Montreal, of Indian carvings (masks and totem poles in miniature) and interpretative paintings of Kihn and, if you come with Jackson, of yourself and others available. This would be next winter or spring."[6]

Jackson published two accounts of his trip to the Skeena with Holgate for popular consumption. His first-hand reports enumerate the objects that were at stake, how they were represented, and how they were intended to be consumed by the Canadian public. In December 1927 his article in *Maclean's Magazine* appeared concurrently with the opening of the *West Coast Art* exhibition.[7] Jackson's article, one of several that had appeared on the Gitxsan nationally and internationally, was crafted to ensure a singular, stable reading of the state of both these people and their arts. The implications of Jackson's eloquent title, "Rescuing Our Tottering Totems: Something about a Primitive Art, Revealing the Past History of a Vanishing Race," are clear enough. It links Barbeau's program to bring artists such as himself to the Skeena, his own work in the area, and the government-sponsored restoration project. But it also unequivocally declares the state's position on the condition of the Gitxsan and their culture. In contrast with Kihn's reports on the same people, which allowed for cultural continuity into the present, Jackson ensured that their historical position was made absolutely clear. He posited the narrative of the Gitxsan, which is his rather than theirs, as revealing a "past history," displaced from the present, while their "tottering" poles, with which the Gitxsan are identified, vividly imply their decrepit state. Salvaging what remains of the poles, through the humanitarian action of "rescuing" this art form from decay, implies taking possession of them for the nation, as affirmed by the pronoun "our." The title and text are accompanied by a black and white drawing that extends over the whole page. It depicts a central image of an erect totem pole, inserted over a village scene, with mountains in the background. The pole is literally placed within the viewer's space. Its upright/restored posture indicates that it is now stabilized and securely

"ours"/ Canada's. This process of dispossessing of their culture those who are excluded from participation in the nation, followed by a subsequent repossession of this culture by the nation, also corresponds to the state's treatment of the picturesque landscape beyond.

Decades later, Jackson gave a second recitation of the restoration project in his memoirs. Minor, but telling, discrepancies distinguish the two accounts. In the later version, he reported that Barbeau "was particularly anxious to investigate the state of the Indian totem poles, for he had been instrumental in having Mr. T.B. Campbell, a C.N.R. engineer, sent out to make an effort to preserve them."[8] This (mis)accreditation is a case of selective memory and extended loyalty. Jackson was well aware that Harlan Smith was in charge of the project, as he had stated earlier in the article in *Maclean's Magazine*. In his memoirs, however, Jackson omits any overt mention of Smith, although he does add an oblique disparaging assessment of the results:

> The restoration of the colours was absurd ... The government official [i.e., Smith] in charge of the job got a complete line of garish colours from Vancouver and asked the Indians which should be used. The Indians, of course, advised the use of yellow, blue, red, and the poles were made to look ridiculous. The Indians were suspicious of the project and the people in charge of it, and they had good reason to be. The building of the Grand Trunk Pacific to Prince Rupert had ended their isolation and the white man was crowding in to their country.[9]

Conversely, in the 1927 article Jackson recounted the care taken in the restoration program: "The whole pole is soaked in linseed oil, painted as far [as] possible in its original color and re-erected on a concrete foundation ... In some cases, the restoring is so perfectly done that there is no visible evidence of it, and yet the pole has been given another hundred years lease of life."[10] Jackson, then, sided with Barbeau in the dispute that arose between Barbeau and Smith.

Jackson's identification with Barbeau's position extended beyond these minor modifications. In his memoirs, he recited Barbeau's theories on the history and contemporary situation of the poles. Jackson claimed that they "were not ancient" but only appeared "when the white man's tools became available."[11] He concluded that "they were no longer being made," that there were "few remaining totem poles," and that "the big powerful

tribes, Tsimsyans [i.e., Gitxsan], Tlingits, and Haidas, have dwindled to a mere shadow of their former greatness. They produce little to-day in the way of art."[12] As much as the poles were an expression of Native culture, both their genesis and their demise, as well as their subsequent preservation, were attributed to European contact.[13] In this sense their role as icons of Indianness became both ambiguous and advantageous. The slippage between what was presented as the polar opposites of Native and non-Native inherent in this history, regardless of its accuracy, allowed for the totem poles' easy passage into current Canadian culture and identity, a passage that was restricted to the poles at the exclusion of the people, who were of the past.

Jackson's 1927 article testified to the extent to which Barbeau had shaped the artist's vision of the poles as objects that had lost their initial cultural significance and were awaiting the imposition of a new meaning. But Jackson also had to reconcile Barbeau's varying views on Quebec and Native culture with the Group of Seven's already established agenda. Jackson recognized the necessity of this difficult task. He reiterated Barbeau's position that postcontact Canada lacked an ancient *volk* but credited him with filling in this gap by "giving the country a background." Both French Canadian ("Canadien" in Barbeau's terms) and Native culture, specifically in the Skeena Valley, were seen as a plenitude that could give presence to what was absent in the history of English colonization. The Skeena could supply "a history of invasion and conquest, adventures, myths and legends old enough for history and legend to become one." The idea of conquest, of course, was a timely and strategic fiction that Barbeau had already deployed. It was also one of the six justifications that had been put forward by the state the previous April for denying Native land claims, for prohibiting Natives from hiring counsel to pursue them, and for preventing them from taking their claims to the Privy Council.[14] The collapse of history into a myth of conquest and of both into a national identity and a claim to the disputed territories could be effected and given legitimacy through "these poles [that] stand on the banks of the Skeena [as] a monument to a vanishing race."[15] Herein lay the difference that separated French Canada and the Indian, which were now in danger of being confused and conflated into a single "background." Indian art, culture, and identity could have a role in the construction of a greater Canadian identity only if, unlike French Canadian culture and peoples, it was represented as staging its own disappearance and being supplanted by the Group of Seven and other Anglo-Canadian painters who took on the

task of appropriating and representing it. This vanishing act, followed by a reappearance in a new guise, announced in the title of Jackson's essay and extended in the body of his text, was represented, reproduced, and distributed by non-Native ethnologists and artists working for the state to the broadest possible audiences through the auspices of a national media under cover of tourist, museum, and artistic appreciation. Conversely, French Canadian culture, again through Barbeau's initiatives, was seen as vibrant, ongoing, and capable of being foregrounded in the present.[16] There was, in addition, no question of dispossessing French Canadians of their land. However, maintaining this difference was not to be an easy matter to negotiate.[17]

At the same time as these confident assertions were being made about the decrepitude of the Gitxsan, implicitly in contrast with French Canadian culture, problems concerning the precise relationships between Native Canadian art and Canadian *native* art arose. Unsettling challenges appeared from an American critic who claimed that only Native art was "truly Canadian."[18] This was a substantial charge, one that stemmed directly and unavoidably from the act of appropriating Native culture and transposing it into the mythic history or "background" of Canadian national culture. The issue, which arose from the alternative American position on Native art, could not be ignored. Jackson rallied to the defence of the Group of Seven. After assuring the audience that the attack came from without through an unnamed "American," he countered with two points. He avoided discussing the complex mechanisms within which his own work was situated. Instead, he denied the American viewer competency. He pointed out that Canada's neighbouring national Other could not recognize the real new *native* art of Canada (i.e., the Group's work), which had supplanted Native art, because American art still followed old European colonial models, which, according to the Group myth, had been abandoned in Canada. Despite turning the argument back on the inquirer, and ignoring the history of American modernism, Jackson's diversionary tactic did little to explicate or justify the precise relationships in Canada. Unable to marshal any follow-up arguments, Jackson truncated his response and turned to other topics. Some paragraphs later, however, echoing Eric Brown's notion that this relationship would form a battleground, he inserted: "as to whether the totem pole is the only native art in Canada there is room for controversy."[19] This was a tacit admission that the subject was still open to contestation and a clear indication of the rivalry between Native and *native* Canadian art as well as between

the Canadian and American positions. Unable to deny that these conflicts existed, he was unable to resolve them. His usual confidence and bluster had been shaken by doubts raised in the direct confrontations between his own paintings and the totem poles that they depicted as well as by the reviews from Paris, which had already reached him, by Kihn's own narrations, and by the Gitxsan themselves.

Nor could he avoid the fact that other voices, or the voices of the Other, were also raising objections. Jackson reported that there were already resistance and suspicion among the Natives concerning both the restoration project and his own appropriation of the Gitxsan poles as subject matter. In Jackson's view, the disputes centred on Barbeau and exploitation. While sketching in one of the villages, Jackson "noticed the local chiefs looking unkindly at him. Finally, one came up and said the chiefs did not want anything done to the poles. He explained that: 'white man always make money out of Indian, Indian get nothing. One man write big book full of pictures sell that book fifty cents. Indian get nothing.' He was no doubt referring to Marius Barbeau's 'Indian Days.'"[20]

By attributing Native resistance to the combined projects to simple-minded desire for a share of the "fifty cents" from book sales, Jackson trivialized the far more profound cultural, political, territorial, and economic issues that were at stake. Further, by testifying to the successful completion of Barbeau's project, Jackson implied that such protests had been without effect and that the chiefs were powerless to stop it. Similarly, by deploying the trope of rendering the Indian as not yet in command of the language and thus without a voice, Jackson portrayed his Native speakers as lacking the ability to articulate the other pressing problems.[21] Jackson associated this lack of language with a loss of identity. He reported that "the younger Indian is inclined to belittle his ancestry, ignore his history and legends and often even his native tongue; as one Indian said to me regretfully: 'We are no longer Indians and we are not white men, I dunno what we are.'"[22] The Gitxsan, then, are not only without voice or language but without identity, being neither Gitxsan nor Canadian. They have neither place nor future. Ironically, it was actually Jackson who remained mute and who policed his own speech by failing to mention that the people of Gitsegukla had not only resisted the program to restore the totem poles, but had also successfully halted it. Nor did he mention the delegations sent to Ottawa to articulate Native land claims or opposition to the potlatch ban. Indeed, at this moment the Gitxsan were becoming increasingly vocal. Given that reporting such a

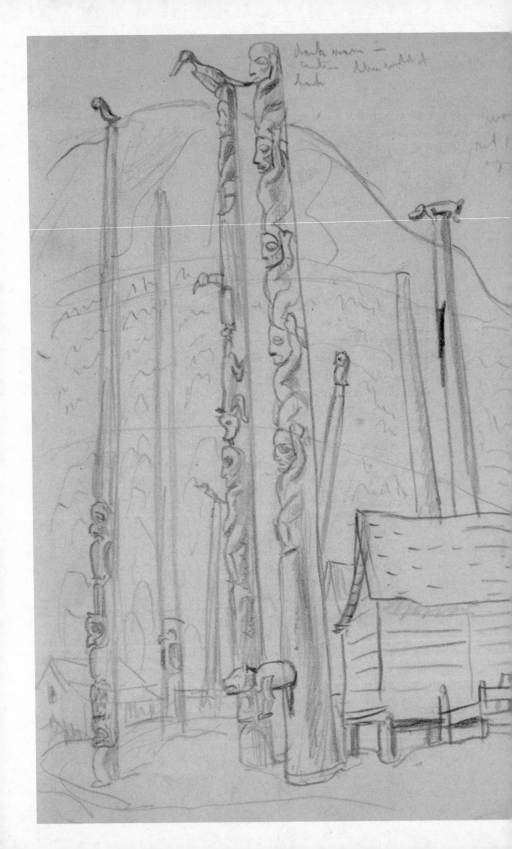

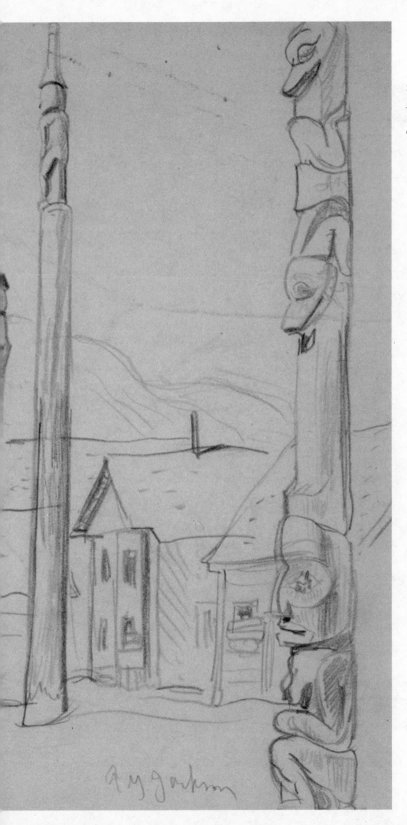

FIGURE 17: A.Y. Jackson, *Kispiox*, 1926, graphite on wove paper, 20.4 x 25.2 cm.

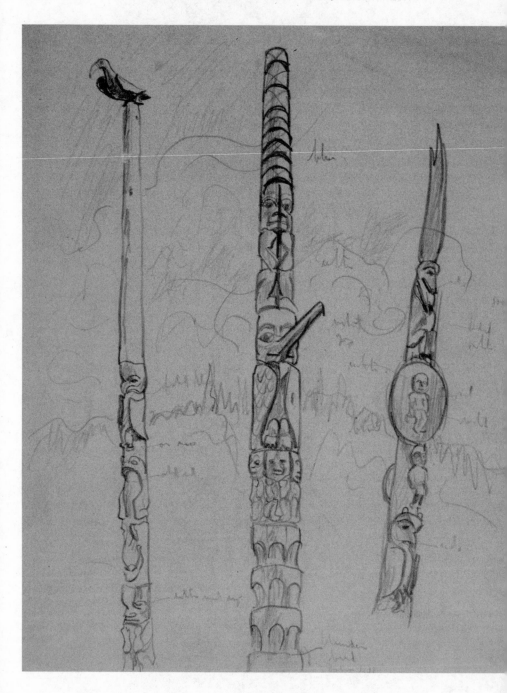

FIGURE 18: A.Y. Jackson, *Three Totem Poles, Gitsegukla*, 1926, graphite on wove paper, 25.2 x 20.4 cm.

voice would have had the effect of disrupting the carefully constructed, but now increasingly precarious, façade of Canadian identity, this voice had to be either denigrated or silenced.

Thus the problems facing Jackson were manifold. His task was not simply to assimilate and reterritorialize a new landscape, linking it to the Canadian national image in conjunction with other state projects, but also to confront another art form and a people who were resistant to his project. Further, he had to represent this art form and these people in a manner that could link them to Barbeau's "Canadiens" as "background" for Canada while proclaiming them to be distinct and disappearing.

Jackson and Holgate arrived in the Skeena Valley to take up the project in early July 1926. Whereas Holgate stayed until late September, Jackson remained until October, a length of time approaching that of Kihn's visit.[23] Although his four-month stay demonstrated a commitment to seeing the project through, at some point he began to realize that this confrontation between Gitxsan art and that of the Group of Seven was not going to be as fruitful as initially anticipated. Although he supported the program of totem-pole restoration, at some point he seems to have become uncomfortable with Barbeau's project.

Jackson's discomfiture and doubt may be discerned in both qualitative and quantitative discrepancies between the drawings done on site and the final paintings done largely after his return to Ontario. While in the area, Jackson produced over 100 sketches.[24] His initial enthusiasm should have given rise to a prolonged period of production. It did not. Even with a major exhibition and the publication of his illustrations in Barbeau's *The Downfall of Temlaham* in front of him, Jackson took little initiative in working up the sketches. The resulting paintings are extremely few in number: Hill counts only six.[25] But other differences also separate the sketches from the paintings. The sketches, as Hill has noted, serve more of a documentary function than do the conventionalized paintings. The drawings concentrate less on the picturesque possibilities of the landscape than on the distinctive features of their primary subjects: the unique totem poles and grave houses of the Gitxsan villages (see Figures 17 and 18). These are rendered in detail, with fidelity, and in proximity to their subject matter, making the act of drawing more a process of recording than of creating. Jackson did not attempt to adapt or appropriate the sculptural style of the poles to his drawing style as had previously occurred with tribal arts within avant-garde practice in Europe and would later occur in the United States.[26] However, the literal rendering of the monumental Native sculpture in his drawings reduced the latter to a secondary importance. It must

FIGURE 19: A.Y. Jackson, *Indian Home, Port Essington*, 1926, *in situ* drawing, graphite on wove paper, 14.5 x 22.7 cm.

have become apparent that neither drawing nor painting could success-fully contain the monumental, public sculpture and that, if placed next to each other, even in a carefully controlled museum setting, the paintings, with their smaller format, would suffer by comparison. Jackson redressed this problem when he transformed his drawings into finished paintings done back in the studio. As will be shown, when present in the paintings, the totem poles depicted in the sketches consistently lose the features, scale, and presence recorded in the drawings, and are reduced to general-ized images in a landscape, with little detail or distinction. In fact, in all the subsequent paintings done off site, in direct contrast to the drawings executed *in situ*, the totem poles are relegated to the background or are simply placed outside the picture.

Jackson indicated his dissatisfaction with his painting production in terms of both quality and quantity. In January of 1928 he wrote to Bar-beau in reference to the *Temlaham* project: "I think you would do well to use none of the other stuff [of mine] in your book. Mine is rather a fizzle ... I would just as soon keep it out of the book. I might make a[n] illustra-tion of Gitseguklas from across the river. I have a pencil drawing which has possibilities."[27] On the matter of the limited production of paintings to result from his excursion, he later commented: "We stayed at Usk, Port Essington, and other places on the Skeena. Holgate painted a couple of bold totem-pole canvases and made a number of studies of Indians. I made many drawings and sketches, but I worked up few canvases of this country. The most successful one, now owned by Isabel McLaughlin, was *Indian House*."[28]

Despite Jackson's personal assessment of *Indian House* (or *Indian Home*), critical opinion of the achievement of the work is divided.[29] Nevertheless, *Indian House* is worthy of close examination since Jackson's evaluation of its position in his suite of Skeena works demonstrates how he conceived of his task, the manner in which he thought that it could be best accom-plished, and what he saw as the successful achievement of his goals. The painting seems to have been worked up later from a sketch done at the coastal cannery village of Port Essington, situated at the mouth of the Skeena and well away from the upriver Gitxsan territory. The first draw-ing, done *in situ*, is identifiable by the presence of the unique roof of the local Methodist Church in the Native village near Port Essington, which peaks out from behind the side view of the house (see Figure 19).[30] The painting, which evolved through a series of compositional sketches in both pencil and paint, differs in many significant ways from the first drawing.

The final painting eliminates the distinctive church that established the location and focuses on the small European-style cottage, complete with a bit of English Carpenter Gothic trim at the gable.[31] Except for a puff of smoke coming from the chimney, the structure appears uninhabited. Its sagging roof, missing shingles, and ornamental trim combine to form an updated variation of the familiar picturesque convention of the Gothic ruin, albeit transposed to a Canadian setting.[32] The house sits, isolated and surrounded by even more decrepit outbuildings, in the middle of the brush, with giant skunkweed and small spruce blocking out the foreground and threatening to engulf the decaying structures. Were it not for the title, and a set of four generic totem poles that Jackson added to the background, the house could be an abandoned miner's home, a deserted farmstead, or a part of a derelict mining community of which there were several in the vicinity.[33] In fact, the once booming town of Port Essington had been in decline since the Grand Trunk situated its terminus at nearby Prince Rupert. By itself, the house could be taken as an emblem of the failure of Anglo-Canadian colonization in its encounter with a vital, but less than hospitable, nature.

However, both the title and the addition of the four totem poles shift the reading to one of Native failure, following attempts at assimilation into Western culture and economies, signified by the style of the house and its location. In fact, by adding the tilting poles, of which there were none in Port Essington, Jackson further dislocated the image and secured it as a generalized image of the Indian.[34] He first considered other possibilities. In a compositional study entitled First Sketch for "Indian House," which was based on his first drawing, he supplemented the landscape with a towering scrag, a dead coniferous tree with barren and broken limbs, which he placed prominently in the foreground in front of the house (see Figure 20).[35] The scrag is another allegorical picturesque cliché of loss and death. This is doubly true given the contrasting meaning that members of the Group of Seven ascribed to living evergreens, which by this time had become emblematic of the vitality of the non-Native presence in the Canadian landscape.[36] Not coincidentally, in Indian House half a dozen young conifers are growing up in the foreground, signs of a virile new culture that soon will screen the remnants of the Indian house from view. However, Jackson rejected the scrag, and replaced it with the poles, possibly because the combination of the dead conifer and the decaying house could be read as the failure of a non-Native presence. This would have been an intolerable ambiguity.

FIGURE 20: A.Y. Jackson, *First Sketch for "Indian House,"* 1926, graphite on wove paper, 14.5 x 22.7 cm.

*much bolder than what
richer color in foreground
First sketch for Indian Home*

In finalizing his fictionalized image, which transcends any particular place and may be taken as an allegory of the ruined state of Native culture and the processes of failed acculturation in general, Jackson changed other significant details from his first impression. Most importantly, he altered the state of the house. The first drawing shows the roof in good repair and running straight across, with all its shingles intact. The roof in a painted preliminary study, while apparently lacking some of its shingles, is also depicted as structurally solid. By redrawing the roof with an exhausted sag, which first appears in the compositional study with the scrag, Jackson exaggerated the building's decrepit state for effect to ensure that his meaning of inevitable decay and disappearance was not lost.

A second major alteration occurs in the addition of figures, which do not appear in the first drawing done on site, but are introduced in the intermediate study titled *Composition Sketch for "Indian Home."* In the final painting, Jackson placed a woman and two children at the side of the house. This was an unusual practice for Jackson, who, except in his Quebec images, generally eliminated all figures. Painted summarily, these small, passive images have no presence as individuals. Their heads are featureless, devoid of faces or identities, while their bodies are limbless. Dressed in Western clothing, they appear to be moving away from the viewer, into the painting's misty background. Despite their brilliant autumnal colours, in this context they have a spectral quality, as if trapped inside and haunting the ruin. Thus they appear as the opposite of Kihn's figures, who exude a physical presence and are dressed in traditional ceremonial regalia.

Aside from adding the out-of-place totem poles, Jackson painted in a low drifting mist that surrounds their bases and gives them a melancholic, and even macabre, aspect, which is further enchanced by the dismal heavy grey clouds looming overhead. The generic mountains in the final painting are higher than in *First Sketch* but are still listless, rather than dramatic, and give no sense of any specific location. In sum, Jackson's gloomy final placeless product lacks the qualities of the best of his Quebec barn paintings, done at the same time.

This again raises the question of why Jackson valued this mournful and atypical production as his "most successful" work. Here, the image's success as a painting seems beside the point. Other issues were at work that supplanted aesthetic considerations. *Indian House* was "successful" to the degree that it demonstrated, more than any other of Jackson's Skeena works, a programmatic depiction of the complete failure and loss

of Native culture and identity and a clear statement of Native absence. Despite the title, he did not choose a traditional-style Native house, a "picturesque" example being readily available at Kitwanga.[37] Rather, in painting an image that would counter Kihn's representation of a living Native presence and culture, Jackson selected and then modified a structure that demonstrated the inevitable process of assimilation into the dominant colonial Anglo-Canadian culture. But this transition did not mean survival for those who gave up their "Indianness" for the comforts and benefits of "civilization" and "enfranchisement" as full Canadian citizens. Instead, Jackson's carefully constructed constellation of motifs signifying desolation, decrepitude, and death indicated that even after this transition, the race still disappeared. In keeping with Barbeau's often repeated assessments on the impossibility of the Indian race adapting to non-Native culture, there was no other future but extinction. Jackson's composition, then, was the perfect foil for Kihn's paintings. Although a fiction, it was precisely what was required to shore up and reinforce the tottering discourse of disappearance. It fulfilled the function of redefining and stabilizing Kihn's ambiguous images. In doing so, it also fit within Barbeau's call for a genre of tragic Canadian art that would bear witness to the extinction of the Indian race.

But more was at stake in Jackson's representations than a pictorial confirmation of an endangered ethnographic theory and a state policy. Like Barbeau and Scott, Jackson had personal and professional interests in seeing the Indian as absent. As I have attempted to demonstrate, the very myth of the Group of Seven, which included their claim to representing Canadian national identity, was founded on the premise that they were the autochthonic, indigenous, native artists of Canada. The validity of this claim rested on the proposition that the Native population, which had formerly occupied this role, had by definition to be excluded and demonstrably proven to be long absent, along with the contention that their culture and consequently their art were no longer being produced. This absence cleared the way for the Group to claim the vacated position, reterritorialize the land, and locate Canadian identity within their characterisitic "empty landscapes." *Indian House*, then, also reproduced this discursive truth. Not only had any Native inhabitants lost their "Indianness," but the race had disappeared in the process. The painting confirmed Barbeau's theories and Scott's policies as well as the very foundational myth of the Group of Seven and that of Canadian identity itself.

The claim to this position was also a claim to the land. Here again,

we return to the title of the article with which Jackson proclaimed his perception of the landscape and its peoples to the general Canadian public. "Rescuing Our Tottering Totems: Something about a Primitive Art, Revealing the Past History of a Vanishing Race" explicitly summarized the issues at stake.[38] The Gitxsan had been correct in their perception that the restoration program could result in their losing possession of their totem poles and lands. The possessive pronoun "our" in the title clearly indicates who Jackson, the Canadian press, and their audiences thought were now the rightful owners of the poles. Coupling this possession with the phrases "tottering," "past history," and "vanishing race" justified the alienation of the poles from the Gitxsan, who were represented as either in extreme decrepitude or almost no longer existing. Thus their art and lands were open to appropriation by Anglo-Canadian culture and hegemony. In case the title left any doubt about this prospect, the text drove it home. The Skeena region, according to Jackson, "is becoming a white man's country and the totem poles forlorn are about all that is left to speak of the greater days." Apparently, there was no Native voice to claim Native culture or territories. The initial function of English landscape art – that is, to declare title to what was surveyed – still survived in Jackson's final paintings. On the other hand, at precisely this moment, the Native peoples, especially on the West Coast, were the closest that they had ever been to getting their land claims before the Privy Council. Only by the most coercive means had their attempts been averted by the federal government. Within this complex of contested categorical imperatives, Jackson's otherwise minor canvas becomes, literally, his "most successful" work from the Skeena area. Far more than any other painting that he did from his experiences there, *Indian House* sums up the issues and places them in what he would see as their proper perspective. The multiple, overlapping, and mutually reinforcing positions staked out by *Indian House* indicate how Jackson's Skeena works were to be read in terms of their generalized representations of the state of Native cultures and peoples. However, when he turned to upriver locations, which brought him into direct confrontation with the Gitxsan's presence in their own villages and territories, the works became more problematic and ambiguous.

The substantial differences separating the sketches done in the field from the paintings done in Toronto are symptomatic of Jackson's struggles with his subject matter. Indeed, the remainder of his paintings appear to be variations in a sequence of experiments in finding the appropriate balance between his desire to represent the distinct features of what he saw before him, including the totem poles, the villages, the people, and the

landscape, while at the same time reducing all of these to a homogeneous structure signifying a unified "Canada." In addition, as Lynda Jessup has demonstrated, he was charged with attempting to ensure a reading similar to that produced by his Quebec pictures and with providing a "background" for this national identity.[39] Jackson also needed to proclaim difference and shift the meaning within the Skeena works to one of disappearance rather than continuity.[40] All the while, he had to maintain the framework of the British-based, picturesque landscape traditions on which the Group's works were based. This task produced many problems and some omissions. For example, none of Jackson's recorded paintings depict Kitwanga, yet the preponderance of his Skeena sketches in the National Gallery were drawn in this community.[41] His intense interest during his stay corresponds both to the restoration program and to the fact that Kitwanga was where the train stopped to allow the passengers to disembark and view totem poles. Images of Kitwanga would have been of most value for the purposes of the museum and the railway, which were his sponsors. The discrepancy between drawings and paintings is thus of concern. In his memoirs, Jackson claimed that this omission was based on aesthetic considerations. He disagreed with the decision to apply fresh coats of "garish" paint to the poles, which would have made them appear not only unauthentic, but also too new. Further, he was nonplussed by their vertical placement. He felt that they should have been tilted. Such angularity would have given them the appropriate aura of picturesque ruins, set in a perennial state of arrested decay. He even attempted to intervene to have them so positioned but was unsuccessful.[42] The restoration and renovation of the poles ruined them as ruins for Jackson. Although it would have been easy for him to reposition them in his paintings, as T.B. Campbell, the engineer in charge, had suggested that he do, he abandoned any further efforts to paint the village.

In his paintings, as opposed to his sketches, Jackson favoured the villages of Kispiox, which the restoration project had not reached, and Gitsegukla, which had resisted it.[43] *Kispayaks Village* is one of the most ambitious of Jackson's depictions of these two communities. Significantly, its composition duplicated many of Jackson's earlier series of Quebec barns. *Kispayaks Village* thus featured a series of rustic buildings scattered across a clearly defined mid-ground. By deploying this conflation of compositions, Jackson directly confronted the problem of depicting Quebec and the Gitxsan both as the same – that is, as "background" for an English-speaking national identity – and as different, the former being ongoing and the latter being discontinuous. This overlap, which tended to

blur the boundaries separating the roles of the two cultures, led to certain ambiguities. The buildings of Kispiox may have been discernibly old, but given the inhabited state of the village, they were neither decrepit nor swallowed up by nature. They could not function "successfully" as tropes signifying ruin or disappearance, as did the structures in *Indian House*. Further, their rustic construction and viability brought them dangerously close to the Quebec barns. This resemblance tended to collapse their separate meanings into a sameness that failed to differentiate between the distinct readings as present and absent cultures.

The ambiguities that arose from the similarity between the Gitxsan and Quebec buildings were further problematized by a small group of people and dogs sitting around a campfire in the foreground. Although such figures were highly unusual in Jackson's empty landscapes, we have already seen them appear in *Indian House*. But here, given the change in context, they seem to serve a different function and could even be taken to signify an ongoing Native presence. Would it not have been more expedient, therefore, to have eliminated them? In answering this question, we must keep in mind the necessity of redoing Kihn's images. Kihn, it will be recalled, showed his figures in ceremonial regalia, either as portraits with an individual presence or actively participating in a forbidden ritual, thus rendering his figures a force of resistance to government policy and the pressures of assimilation. In contrast, Jackson's figures are nondescript. As in *Indian House*, they are unidentifiable as either individuals, a specific Native group, or even a race. They have no distinct identity. The signs that identified them as Gitxsan in the Kihn portraits have been erased.

Jackson's treatment of the totem poles in *Kispayaks Village* followed the same pattern. Back in the studio, he rejected most of the sketches that he had done in the community, which closely detailed the crests on the poles. Instead, he chose as the basis for the painting an exceptional drawing that placed the poles in the background behind the houses, showed none of the features of their distinctive carvings, and reduced their monumental presence.[44] The unique characteristics of Gitxsan art were thus reduced to simple, angled silhouettes, dwarfed by other features. Given Jackson's assessment of the significance of upright poles, their angles, while not precarious, became the sign of cultural decay missing in the remainder of the image. In the process, they lost their material and sculptural presence, as well as the details that conveyed their artistic and cultural heritage, and became little more than tropes for Indianness and a means of pictorial transition from the mid-ground village to the looming wall of

distant mountains. This background of towering peaks, covered with an early autumn snow, done in Jackson's distinctive palette of blues, whites, and ochres, with which he rendered the Canadian landscape from coast to coast, occupies a third of the canvas. It dwarfs the village, the people, and the poles, thus becoming, again in contradistinction to the sketches, the dominant image of the painting. By refocusing in his paintings on the topography of the Canadian landscape, which in Jackson's overall oeuvre tends to a sameness, signs of difference are diminished, if not swallowed up and erased. Yet even this solution did not seem to satisfy the artist. Even though Barbeau included it as one of three by Jackson in the illustrations for *The Downfall of Temlaham*, the artist abandoned any further attempts at the time either to paint this village or to use these compositional devices.[45]

The majority of the few paintings that Jackson did from his excursion into the Upper Skeena depict the village of Gitsegukla. Again, this site was an unusual choice; although on the railway line, it was neither a stopping-off point nor the most picturesque of the communities. However, it seemed to have produced the greatest challenge to the artist. In a work entitled *Gitsegyukla Village* but now known by its anglicized name, *Skeena River Crossing*, Jackson varied his conventional compositional approach in a manner that better accommodated the depiction of difference between Quebec and the Gitxsan.[46] In an unusual move, not seen in his Quebec paintings and seldom repeated, he took a side view of the village and almost eliminated the foreground. Unlike *Kispayaks Village*, this canvas shows some of the buildings and poles in closer proximity and in greater detail. But at the same time, any indications that the unique aspects of Gitxsan culture were actually surviving and ongoing were carefully counterbalanced or eradicated. This is evident in Jackson's representation of the main structure on the left, which occupies almost the entire lower quadrant of the painting. The old-style plank construction that Jackson depicts appears to have been transposed from a sketch done at another site, entitled *Collapsing House*.[47] The title of this sketch signifies the structure's near ruinous state, which, along with its missing planks, serves as a metaphor for Gitxsan culture in general. Conversely, the subsequent drawing that appears to be the study for the painting shows a structure in a much better state of repair.[48] The final composite result, then, is far less ambiguously a "ruin" than the actual houses and buildings at Kispiox. This clear statement of the state of Gitxsan culture, although a pictorial fiction, allowed for a more detailed rendition of three of the

eleven poles, which are shown in the foreground. Their upright stance and crest images, which, if seen in isolation, could provide testimony to the vibrancy of the Gitxsan social structure, are counterbalanced by the context of the adjacent ruin. Conversely, the background poles, by far the majority, become blurred into obscurity. But this solution also did not appear to satisfy the artist, and again he did not repeat it.

A small panel, possibly painted on site, points to yet another variation in Jackson's experiments to construct a set of conventions that would include the image, or at least the territory, of the Gitxsan while excluding any testimony to their current cultural viability. It features another village site, probably Hagwilget, but the title does not identify the community. The panel is known as *Rocher de Boule*, the name of the prominent mountain situated behind the village.[49] In this case, Jackson tilted the balance completely in favour of the landscape. The village, composed of only a few houses nestled in the distance at the base of the mountain, bears little evidence of any Native presence, aside from what might be a pole on the far side of a Western-style dwelling. There are no figures. Gitxsan presence has thus been almost fully erased. However, this configuration did not point to further potential; no corresponding larger canvas exists. It was another dead end.

Several studies for a poster for the Canadian National Railway (CNR) are also present in the National Gallery's collections of sketches.[50] Although these do not appear to have been used for their intended purpose, they were worked up later into a gouache painting titled *Native Town of Git-Segyukla, on the Upper Skeena*. While a minor work, it demonstrates what must have been Jackson's growing exasperation with his recalcitrant subject and the difficulties arising from the conflicting goals that had been given to him. Here he removed himself from the village and positioned himself at a distance across the river, on which he placed a carved canoe. On the far shore, he placed a number of minuscule figures, small buildings, and a rank of vertical, albeit tipping, poles that again, as in his image of Kispiox, contrast with, and are absorbed by, his standard and conventional background of undulating horizontal lines in the hills and clouds. Again, no details of the poles are visible, even though they were supposed to be the major selling point in the poster and the unique attraction of the region. It is not surprising, then, that it did not meet the requirements of the railway. Instead of being highlighted, signs of difference were diminished and absorbed by the encompassing Canadian landscape. The village, poles, and people were again represented, even if against their desires, as

part of the greater program of the Group of Seven. They are no longer Gitxsan but Canadian. This picture, although apparently not used as a poster, was included in Barbeau's book *The Downfall of Temlaham*.

Recent discussions of the Skeena works point to what was felt to have been omitted from Jackson's drawings and paintings, such as all signs of contact and assimilation, which placed the villages in a timeless, ahistorical "ethnographic present."[51] However, this argument is hard to sustain in the face of *Indian House*, other works from Port Essington, and the Western clothing of the Natives. Nonetheless, something is indeed missing from Jackson's depictions. What has been eliminated is any sense that this landscape was, at the moment, a site of contestation and struggle. Jackson reported resistance to both his own presence and the restoration project. As has been shown, in 1927 Gitsegukla occupied an important position for the ongoing negotiations and ultimate cessation of the totem-pole project. At precisely this moment, the restoration crew was being denied the right to work on or to "restore" any of the poles in the village. Jackson himself later reported that "the Indians were not too friendly when I was there" and expressed concern for artists who were to follow in his path.[52]

None of this dispute is openly evident in either Jackson's drawings or his paintings, which were done far from the scene. Insofar as both the passivity and decrepitude that pervade the paintings have been fictionalized and idealized, they may again be linked to the practices of British landscape art, specifically John Constable's landscapes of East Anglia from the mid-1820s. As John Barrell has pointed out, these were done at the moment when both depressed economic conditions and land reforms in England were producing violent clashes between tenant farmers and landowners, with the artist belonging to the latter group.[53] Constable's bucolic paintings, which placed the workers at a great distance and integrated them into a peaceful landscape, erased any evidence of these conflicts and showed them as the artist wished to see them. Jackson's pictures have a similar serenity, obtained by turning a blind eye to any of the struggles of the Gitxsan either to preserve their culture and identity or to maintain ownership of their territories. In fact, Jackson followed a similar strategy of placing his diminutive and passive figures in the landscape in such a way that they became a harmonious part of it. Indeed, precisely this denied and disguised conflict may have made Gitsegukla of interest to the artist, for the village lay at the border between Anglo-Canadian culture and a resistant otherness and was thus in most need of being incorporated into non-Native representations.

In this context, the omission of any paintings of the village of Kitwancool becomes significant. Kitwancool, as we have seen, was the site of greatest resistance to programs of assimilation, land appropriation, and historical revisionism. But as Barbeau and Kihn's expulsion from the community indicates, it was also resistant to artists, ethnographers, and restorers sent in to "invade" and represent the area. This resistance to representation is evidence that the village had a clear and sophisticated understanding of the larger issues, especially as they related to land claims and control of their own history, and that they desired to maintain control over their own image and over any related discussion. The works by Jackson, and by most of the other artists who visited the region at the time, depicted none of the issues and the struggle surrounding them. Rather than painting the country "as it was," Jackson painted it as he and his sponsors wished it to be. In attempting to naturalize this desired state of things and to mystify the real relationships, Jackson again followed the traditional practices of British landscape painting.[54]

Jackson's limited output of Skeena paintings implied a growing lack of enthusiasm for the subject that stemmed from his unsuccessful attempt to work both within the program of the Group of Seven and according to Barbeau's more complex take on the construction of a stable, unified Canadian national identity. Jackson faced many problems. As previously discussed, his attempt to reconcile the two was based on a dangerous conflation of both Quebec and the Gitxsan as "background" for a Canadian culture. This resulted in what has been seen, sometimes disparagingly, as a homogeneous sameness in his depiction of different regions of the country's diverse landscapes. Kispiox could bear a close resemblance to a village in Quebec. This sameness is sometimes blamed on a lack of creativity and on a tendency to fall back on the continual repetition of a standardized set of conventions. However, this should not be thought of as necessarily undesirable. Rosalind Krauss has pointed out that the picturesque, which underwrote Jackson's compositions, was predicated on such an approach.[55] But here, repetition took on a specific ideological function. Jackson, in his travels across Canada, attempted to demonstrate that all of the country, not just the landscapes of the Canadian Shield in Ontario, could be framed by a single set of representational conventions. The perception of homogeneity was precisely the point and does much to explain why he would have at first found Barbeau's project sympathetic. The unity of the country, based on a monocultural, British-based precedent, could be visually demonstrated by blurring the differences between the various geographic and cultural regions. The Skeena, in this scheme

of things, ceased being the domain of an Indian Other, with all the anxious difference that this implied, and was, in theory, incorporated directly into the representational system that was seen to be Canadian and that encompassed all of Canada. The Gitxsan view of themselves as a unique people with a unique identity was thus overcome and displaced. Indeed, this view had to be made to vanish since any indication of the Gitxsan's presence tended to destabilize the delicate and precarious balances necessary to maintain the myth. Their totem poles, which were in the process of becoming increasingly visible in Canada as signs of "Indianness," could then form a part of the composition and be included in the artist's gaze but only insofar as they were always placed in the background and made subordinate to the larger vison of the encompassing Canadian landscape, which laid claim to the territory, the art that remained there, the remaining peoples, and their land. However, whether Jackson's few final paintings actually accomplished this objective of making the Skeena Valley a site of homogeneous Canadian identity is still in question. Indeed, the entire project of attempting to reconcile Barbeau's concerns with those of the Group of Seven in the face of the Gitxsan cannot be said to have been successful. After Jackson left the area in the fall of 1926, no Group member would return to the Skeena, although Jackson himself was to return to both British Columbia and Quebec on numerous occasions in the following decades. Nevertheless, Jackson could be assured that despite his disappointment in his own output, his friend Edwin Holgate had done somewhat better.

Holgate, who accompanied Jackson and Barbeau to the Skeena in the summer of 1926, was also from Montreal. Like Jackson, he had close ties to France and had studied there, where he picked up a limited range of modernist conventions. Later, he would briefly become a member of the Group of Seven in 1930 just before its break-up, but at the time he was only an associate. In the mid-1920s he was most noted as a portraitist.[56] One could expect that his work from the summer of 1926 would make an interesting contrast with the previously mentioned portraits by Edmund Morris of the Native leaders of the Prairies or with Kihn's work from the Stoney and Skeena areas. Yet this comparison fails since there are few finished portraits in oils and few prints from Holgate's excursion, although there are studies and drawings. Two portrait sketches by Holgate are listed in the collection of the National Gallery of Canada. One, titled *Tsimsian Indian (Jim Robinson, Hazelton)*, done in black and red chalk, is similar to Kihn's compositions.[57] It shows a highly detailed head against a flat background. The figure wears a button blanket reduced to flat graphic

patterns with no modelling, a feature obviously derived from Kihn. Less derivative is a drawing entitled *Tsimsian Chief (Samuel Gaum)*, which focuses exclusively on the head of the figure, cut off at the neck, who is without a blanket but wearing a carved frontlet.[58] It was included in Barbeau's *The Downfall of Temlaham*. Four other portraits are listed in the catalogue of the exhibition *Canadian West Coast Art, Native and Modern*.[59]

One well-known painting derived from Holgate's 1926 trip is the National Gallery of Canada's *Totem Poles, Gitseguklas*, which was also published in Barbeau's book.[60] Dating from 1927, it was done back in Montreal from studies. Not being a landscape artist, Holgate was neither integrated into nor competent in the picturesque-derived pictorial conventions of the Group of Seven. Thus he took a different view from Jackson and placed himself, as had Kihn, who was also not primarily a landscape artist, within the village. Holgate concentrated on the totem poles and buildings, rather than on the scenery, and showed them in some detail, rather than making them distant props in a repeated landscape. Indeed, they dominate the composition. One figure, a female with a child, possibly derived from Kihn's *Gitwinlkool Totem Poles*, moves away from the viewer into the background. Otherwise, the town is deserted, except for a dog. This departing figure recurs several times in various of Holgate's works. Despite his proven ability at depicting the figure, the painting is almost uninhabited and borders on being deserted. There is no community to claim the village, except for the artist and his associates. Like Jackson's works, Holgate's painting lays claim to the deserted territory.[61]

Working from sketches done while in the Upper Skeena, Holgate also made a series of woodcuts. Of the eight or so done, only one can be seen as a portrait, but its title belies this status. It is simply called *Tsimsian Indians*, although it was also known variously as *Natives of the West Coast*, *Coast Indians and Totem Poles*, and *Two Chiefs*. Ian Thom, in his study of these prints, states: "Holgate informed one of the private collectors that the chiefs were 'Chief Amihilat and Chief Hlengwah of the Tsimsian tribe.'"[62] Given the precedent established by Kihn, that Holgate withheld the names when the work was exhibited is significant, as is the fact that the middle figure between the two chiefs is seen in lost profile, her face almost completely obscured. As individuals, the Gitxsan people were beginning to disappear from the pictorial record constructed by Anglo-Canadian artists. The other prints in the series either have no figures or are seen from behind or at a distance. One of the most ambitious compositions is called *Departing People, Skeena River*, or *A Passing People*. The poignant

inference here may be found in a passage from Holgate's own thoughts: "I felt we were witnessing the rapid decline of a splendid race of creative and well-organized people. There persisted a brooding gloom which I found it impossible to dispel."[63] Holgate's words, like those of Jackson, echo the sentiment of Barbeau, who may well have primed him on the perceived plight of his subject, as he had done with Kihn. In any case, they indicate that both ethnologist and artist held Native disappearance as axiomatic, even despite the contradictory evidence before their eyes.

In 1927 two more artists went west under the auspices of Barbeau and the CNR: Anne Savage and the sculptor Florence Wyle. Although biographies or memoirs exist for both, the references to their Skeena experiences are more cursory than those of A.Y. Jackson.[64] By this time, Native resistance to the program had grown to the extent that, as Dyck points out, Barbeau felt obliged to advise them "to avoid Kitsegucla, and even recommended that they visit other villages in July and August, when most people would be away working at the coastal canneries."[65] Those involved in the program to paint the region had now been forced to act surreptitiously and to follow Barbeau's practice at Kitwancool before he was expelled from that village. However, the two artists were allowed to visit Kitwancool. Neither, in any event, produced a large body of work from the trip. Wyle's production was limited to miniature poles cast in plaster and some busts, which, although included within the exhibition *Canadian West Coast Art, Native and Modern*, are largely insignificant. Savage painted a series of small, stylized, Art Nouveau-influenced studies of the villages and landscapes, with the latter predominating. The only one illustrating Native presence that has been published shows a row of blank vertical totem poles with all of their features effaced, banded by heavy straight dark lines, set against a line of stylized houses and a mountain backdrop.[66] Tiny figures, equally abstracted, are located in front of the houses. No precise site can be attached to the image, although it may be an abstraction of Kitwancool.

After 1927 the project to bring artists to the Skeena region with the goal of incorporating this territory into a larger Canadian national landscape and subject matter began to peter out. Yet one major artist would return in the summer of 1928: Emily Carr. Carr had preceded Barbeau and the others into the field by fifteen years and had first arrived before the railway had entered the region. Claimed as a recent discovery of Barbeau, she was highlighted at her debut in the *West Coast Art* exhibition.

Chapter 9: West Coast Art, Native and Modern

The use of native reference to proclaim a distinctive culture was never the sole basis for declaring identity, but rather one strategy that was often inconsistent with others.

– Nicholas Thomas, *Possessions*, 12

IN THE LATE FALL of 1927, the complex elements presented in the previous chapters coalesced into one of the most radical and problematic exhibitions ever assembled at the National Gallery of Canada (NGC) up to that time. Although it occurred some months after the precedent of the Jeu de Paume show in Paris, the exhibition *Canadian West Coast Art, Native and Modern*, which was shown in Ottawa, Toronto, and Montreal, was the first attempt to bring together material from the indigenous peoples of the Northwest Coast with paintings done by members of the Group of Seven and other artists for Canadian audiences. It has been regarded as historically important primarily because it introduced Emily Carr to eastern Canada and, more recently, because it recognized Native art as art. But far more was at stake here than adjustments to the Canadian canon.

The origins of the *West Coast Art* exhibition were as fraught with prevarications and concealments as was the previous Paris exhibition. Eric Brown, for example, claimed that it was the first showing of Native art as "artistic first and ethnological after."[1] This was not the case. Many of its features, especially the joint display of Native and Western art, duplicated Langdon Kihn's exhibition in New York, which had been reviewed in *Arts and Decoration* in 1922.[2] In addition, at this time Native art was being shown as art in New York and elsewhere in the United States as part of a project to have it recognized as a fundamental component of a unique, non-European national identity and aesthetic; to preserve, rather than to destroy, Native culture; and to create a market for current artistic production and cultural expression. And, of course, there was the previous

show in Paris. Brown's claims to priority bypassed these precedents and diverted attention from them.

In addition, there had been a move in Canadian ethnographic circles since at least 1917, and possibly earlier, to recognize Native art as art. These initiatives were made by Edward Sapir and Harlan Smith, who, as students of Boas, differed with Marius Barbeau and Duncan Campbell Scott on the relationships between Native and non-Native cultures. However, Sapir had resigned in 1925 as head of the National Museum and had been replaced by Diamond Jenness. In his absence a consensus on the topic that was in keeping with the state's position could be more easily imposed and the exhibition given a clear, uncontested message that differed from that associated with its American precedents and counterparts.

The first proposal for the exhibition did not happen at the NGC. Rather, it was floated in January 1926 by A.Y. Jackson to the hanging committee of the Art Gallery of Toronto (AGT), of which he was a member, when he proposed a show of Indian masks. This is exactly the same time that Barbeau had approached him to do paintings in the Skeena region, thus indicating, once again, that Barbeau was behind the exhibition project.[3] Barbeau, always the strategist, may have been ensuring the cooperation of the NGC and Brown, who were not yet engaged in the project, by soliciting the prior support of other institutions and powerful individuals while disguising his own involvement. Barbeau's presence was confirmed almost immediately in the second announcement of the proposal, contained in the letter from Jackson to Barbeau in February, in which the artist accepted the latter's invitation to accompany him to the Skeena that summer to repaint the area already visited by Kihn.[4] In May, Barbeau wrote to Edwin Holgate with an expanded vision of the forthcoming exhibition, now stating that it would take place in three cities but indicating that it would include only a limited, albeit now somewhat expanded, number of Native pieces – that is, some "masks and totem poles in miniature."[5] By this point, Barbeau had clearly taken over and was beginning to enlarge Jackson's modest proposal into a more ambitious undertaking that would include the paintings from the Skeena done under his auspices and the artists who had contributed to his book *The Downfall of Temlaham*. After May 1926 it was announced that the exhibition would contain both Native and non-Native work, with the first to form the background for the latter. Even if significantly inflated from its first appearance, the proposal must have seemed fairly straightforward and simple. By late in the year, the concept for the exhibition had changed yet again.

Correspondence on the exhibition in the files of the NGC begins at
the end of 1926 with a letter from Eric Brown to Dr. Charles Camsell,
deputy minister in the Department of Mines, which was in charge of
the National Museum. Brown's December letter solicits the museum's,
and especially Barbeau's, cooperation and outlines Brown's vision for the
exhibition. According to Brown's understanding, the joint project, now
involving the cooperation and interests of the two institutions, was to
encompass "the most artistically interesting examples of this Indian craft
work procurable and to include it with as much as is possible of the best
work possible done by our modern Canadian artists in the same region
… [It] will do a great deal towards interesting the public in the life and
history of the western Indian tribes, as well as in the aboriginal arts of the
domain."[6] Brown, having been placed in the position of requesting Bar-
beau's involvement long after the ethnologist had taken over the exhibition
and of being obliged to state its purpose as if he himself had initiated it,
was ambivalent. It was not his exhibition, or idea, but rather one handed
on from the AGT, Jackson, and Barbeau, and he seemed uncertain of its
subject.[7] His vacillation between referring to the Native material as "art"
and "craft" indicates some indecision about the nature of the material.
He also emphasized the non-Native art, which, as unambiguously "art,"
would undoubtedly prevail as the dominant aspect of the exhibition.

Concurrently, Barbeau was following his own initiatives. In late
December 1926 he wrote Vincent Massey, who sat on the board of the
AGT, and solicited his patronage for a project that, he said, had been put
forward the previous spring "to exhibit jointly a considerable number of
West Coast Indian carvings and paintings and a certain number of mod-
ern paintings by Canadian artists, which might serve as an interesting
background to the Indian art motives."[8] Of course, an endorsement by
Massey, who was one of the major cultural brokers in Canada at the time,
would solidify the proposal. The balance here, designated by the con-
trast between "a considerable" and "a certain number," had now shifted
to favour Native art, which would undoubtedly have been news to both
Brown and Jackson. By February 1927 the AGT had officially requested
the exhibition.[9] With such prestigious backing, with the material from the
Jeu de Paume exhibition secured, and with Brown's letter to Camsell in
hand, Barbeau could proceed as he wished, openly take up his role as ini-
tiator and organizer, and expose the full extent of his plans. By the spring
Brown would not have been in a position to resist since he was in Europe
attending to the Jeu de Paume and since in the late summer, while Bar-

beau was in the field, he was travelling across Canada. As a consequence, after the initial proposals were debated, the customary prevarications put forward, and the necessary support solicited, most of the preparations for the show occurred only in the fall, just before its opening.

In the meantime – that is, in the course of late 1926 and throughout the first part of 1927 – unexpected and uncontained complexities and conflicts, if not dangers, arose from outside the National Museum and the NGC that further modified the exhibition's development. At the time, negotiations were under way to include the small sampling of Northwest Coast work in the Jeu de Paume exhibition. These negotiations formed the initial stage of Barbeau's project to have Native arts incorporated within Canada's national artistic heritage and identity along with the work of the Group of Seven. It can now be concluded, from the proximities of time, personnel, and formats, that Native art and the Group's work were closely linked and that inclusion of Native material at the Paris venue was seen as a prelude to Barbeau's fall show. As has been demonstrated, however, Barbeau's intervention disrupted the plans of Brown and the Group. The expected repetition in Paris of the Group's critical triumphs at the Wembley exhibitions of 1924 and 1925 did not occur, and validation of the nationalism and modernism of the Group of Seven was withheld. At the same time, the Native art, along with that of James Wilson Morrice, tended to overshadow the Group's works and was given a presence and vitality within a modernist discourse that was other than anticipated or prompted by the exhibition's catalogue essays and advance articles. Indeed, Brown's attitude toward the forthcoming Canadian exhibition in the fall must have shifted as he read the incoming reviews. Insofar as these problematized both Native disappearance and the construction of modern Canadian national identity embedded in the Group's landscapes, a proper relationship between Native and native Canadian art had to be reestablished. It should not be surprising, then, that the *West Coast Art* exhibition became a format for addressing the problems posed by the Parisian reviews. What could have originally been intended as one more stage in the triumphs of the Group in expanding the territories included within the national image now became a project to shore up its faltering foundational discursive structures.

These were not the only problems with which the exhibition and those associated with it had to contend. Closer to home, Barbeau's project for including images of the Gitxsan of the Upper Skeena River as a background for Canadian culture had also not gone as planned. Not

only was he unable to enlist the entire Group in the project to supplant Kihn's images of Native presence, which would have given the project the validity that he desired, but the one member whom he had signed up was having reservations. By early 1927 Jackson, now back in Toronto, was beginning to express his doubts about his involvement in Barbeau's project of a direct confrontation of Native and native Canadian art, was having trouble turning his sketches into paintings for the exhibition, and was reducing his involvement in *The Downfall of Temlaham* project. Jackson would have been aware of the Parisian reviews, which would hardly have served as an encouragement to place his works beside the ever-expanding Native material, which was, despite the early statements of Barbeau, to take precedence in the forthcoming display. On the positive side, at least for Barbeau, was his "discovery" in 1927 of Emily Carr. Her early paintings of West Coast Native subjects not only compensated for any lack on Jackson's part, but also offered the exhibit a greater historical depth, made it seem prescient, and provided a contrast between "then" and "now" in terms of the state of Native culture. The "now" was, of course, somewhat problematic, as Barbeau's plans had also gone awry in the Upper Skeena itself when the Gitxsan, refusing to fade into the background, had continued to assert their rights over their totem poles, the vitality of their culture, the continuity of their traditional ceremonies, and their claims to their territories. The faltering program to restore the Gitxsan totem poles, which was undertaken by several state agencies working among the Gitxsan villages and which attempted to transform their poles from images of cultural continuity and territorial possession into emblems of decrepitude and dispossession, was clear evidence of these troubles. Finally, the exhibition had to deal effectively with the discordant voice of the Native, which was being raised at this time as organized Native groups negotiated their place within this political and cultural framework by continuing traditional ceremonies and by protesting other social and legal injustices. In addition, the voice of the Other was now being heard in Ottawa by the Special Joint Committee investigating land claims. Although this voice had been silenced by the prohibition against payment for legal assistance in land claims, its presence still had to be dealt with. Representing and defining the image of the Indian, which was threatening to escape from its discursive boundaries, became as important as reasserting the validity of a distinct Canadian national identity invested in the Group of Seven. In short, the exhibition needed to harmonize these complex and potentially disruptive issues into a single disciplined and contained message.

It was necessary to shore up these crumbling edifices with a statement by authorities who could position their subject in a manner that was beyond dispute. This occurred in the summer of 1927 when Barbeau and Scott wrote two lengthy articles published concurrently for a widespread popular audience in a special supplement to the *Mail and Empire* commemorating Canada's Diamond Jubilee. Aware, as the 1920s progressed, of the continued vitality of the Native presence and resistance in western Canada, Barbeau and Scott supplied an alternative textual image of the present and future. It appears that if the Indian could not be contained and disciplined by the legalistic and administrative framework or by surveillance and punishment, then at least the *image* of the "Indian" would have to be so shaped. During the 1920s this focus on image, rather than on reality, increased the state's interest in the textual and visual representation of the Indian as well as in shaping and predetermining public responses to this representation. Being unable to ignore completely the lack of cooperation on the part of Canada's Native population in actualizing their own disappearance, Scott was adamant, as the headline of his *Mail and Empire* article declared, that "Indians Step Beyond Role of Their Ancient Romance."[10] Addressing the issue on the Prairies, he stated: "Sixty years brought a vast change in the lives of the Stony [sic] Indians. At Confederation they dominated the Western Prairies. Now they are shorn of most of their glory." While the main part of the text detailed his vision of the benevolent and beneficial policies of the paternalistic federal government, he also used the opportunity to define a public and political perception of the current role of Native costumes, dances, and culture within the larger context of Canadian culture: "It may be conceded that the typical Canadian Indian is the hunter and trapper, and, when one thinks of him, buckskins and beadwork and feathers are still cloaking him with a sort of romance. But these are rarely seen except in pageants and on holidays when the superior race must be amused by glimpses of real savages in war-paint."[11]

The implications of this statement of cultural hierarchy are staggering, but as Stan Dragland has stated, they embodied "the attitude implicit almost everywhere in Scott's prose on Indians."[12] While such phrases could have been issued with confidence in the early stages of his career and even uttered with a degree of confidence as late as 1920, by 1927 they carried more than a note of panic. His phrase "rarely seen" flew directly in the face of his own experience since he was well aware that ceremonies were on the rise on and off the reserves. The phrase "real savages in

war-paint," which reduced the Native subject to spectacle for recreational and entertainment purposes, degrades and devalues any such ceremonies, nullifying their "cultural capital." Scott saw traditional Native culture as "worthless" and the Indian, one way or the other, as inevitably disappearing into a larger British Canadian identity. Despite what he would have witnessed in 1922 and thereafter, Scott maintained his certainty that, in contradistinction to the diminishing number of those holding on to the old ways, those who had gone the route of assimilation and given up their identity had demonstrated that they were "civilized" and thus had "proved their worth, [and] only need to develop and mature under protection until they, one and all, reach their desired goal, full British citizenship."[13] He did not recognize any difference between "their" goal and his goal since full civilization and citizenship, in his sense, meant also giving up any status and/or distinction as Indian. Since there was no room for a Native presence in his formulation. of Canada, the only possible entry to citizenship was for Native peoples to collectively deny their cultural heritage and identity. His position that the best way to achieve this and to "protect" them was to repress all aspects of former, presumably uncivilized, and worthless Native culture placed him in some conflict with John Murray Gibbon of the Canadian Pacific Railway, with the organizers of the Calgary Stampede, with those under his jurisdiction, and with the evidence before his eyes. To the extent that, as has been pointed out, Native dances were at this moment increasing on the Prairies, both at fairs and especially on reserves, to which he was forced to turn a blind eye, and that traditional ceremonies were continuing among the Gitxsan and other groups on the West Coast, Scott's statements and his insistence on the success of his programs represent a deep and anxious state of denial.

Barbeau's companion article for the *Mail and Empire* supported Scott's position and added the weight of ethnographic and academic authority to the latter's bureaucratic representation of the end of Native culture and identity.[14] Together the two articles presented a convincing image of the disappearing Indian. In his article Barbeau recapitulated his position that contact had "corrupted the Natives" and led to a litany of problems, including the "curse of war," "epidemics," "untold devastation," "feuds," and "ruin," "so that, years before the white settlers were ready to open up the country Indian wars and European diseases had already rid it of its former occupants." In explaining a common history, he again stated that "the lot of the West Coast Indians at the hands of their white conquerors

was not unlike that of the plains and mountain tribes." In support, he cited as an example how "warfare and massacre" had early on reduced the Tlingit. Pushing his theories on the Asian origins of these people and their cultural degeneration, he broadened his view to indicate that "one is apt to forget that our modern Indians bear little actual resemblance to their pre-Columbian ancestors ... The racial characteristics of our aborigines, their features, their bodies, their aptitudes, their intelligence – have, in the last centuries changed almost beyond recognition when they are not wholly a thing of the past." His final assessment was damning. He discounted the evidence being sent to him by his informant in the field, William Beynon, of continued ceremonial activity and cultural persistence on the West Coast: "To conclude, we may say that the ethnologist is a fool who so far deceives himself as to believe that his field notes and specimens, gathered in the raw from half-breeds or decrepit survivors of a past age, still represent the unadulterated knowledge or crafts of the prehistoric races of America. When they actually do, it is only in part."

With a language again invested with both anxiety and denial, Barbeau justified rejecting the evidence before him and foreclosed any possibility of the continuity of Native culture or of Native group or individual identity.[15] Native peoples were dispossessed of their culture and legitimacy. Both their material and nonmaterial cultures were now in the possession of the museum. Barbeau would assert continuously that all material culture was now safely collected and out of the hands of the original owners. But the Indians no longer even owned themselves. As his possessive pronoun denotes, they were now "ours," a possession of the virile "superior race."

The forceful denial of any evidence of continuity of Native culture and vitality as seen in Alberta or British Columbia, combined with the insistence on degrading and devaluing any evidence that might come from informants or that may have been observed by nonspecialists, was indicative of a deep anxiety arising from the continued presence in Canada not only of the Indian, but also of Native cultures and identities. By 1927 the premise of the Indian's disappearance must have seemed in danger of disintegrating in the face of the mounting evidence and resistance on many fronts, which threatened to undermine and destabilize it.

Under these mounting pressures, the exhibition, by the time of its realization, had evolved from a simple affair into a complex undertaking. It was a first-time collaboration between the National Gallery and the National Museum, which were still sharing premises; the Royal Ontario

FIGURE 21: *Exhibition of Canadian West Coast Art, Native and Modern*, National Gallery of Canada, Ottawa, 1927. Anne Savage's *Hills on the Skeena* is on the centre left.

Museum, which had received objects from the Cranmer potlatch confis-
cations as well as from the National Museum; McGill University; and the
Art Association of Montreal. The railways, whose interests were never far
from any such developments, also had a stake in the affair. They were kept
informed of and played a role in the proceedings, particularly in under-
writing shipping for the works. And, as always, the Department of Indian
Affairs, in the person of Duncan Campbell Scott, was present, although
Scott's role was downplayed, if not concealed. All of the parties who had
a stake in defining a Canadian national identity and the role of the Indian
within this identity had a part – except, of course, the Natives, who, as
far as can be discerned, were not consulted on the matter.

The concept, as it was finally realized, followed that of the Jeu de Paume
exhibition but with substantial differences that were more in line with the
earlier New York exhibition of Langdon Kihn's work. Anglo-Canadian
artists who had painted in western Canada in the past few years would be
exhibited with objects of Native manufacture. However, this time the lat-
ter would be shown in significant quantities, well beyond the masks and
miniature totem poles originally mentioned by Jackson and Barbeau (see
Figures 21, 22, and 23). The non-Native artists included Emily Carr, who
showed by far the largest selection of paintings (twenty-six watercolours
and oils), all of which dated back some fifteen years. She also showed
hooked rugs and pottery done more recently using Native motifs. Edwin
Holgate's production from the Skeena region was numerically well rep-
resented by thirteen works, including seven portraits and six landscapes.
A.Y. Jackson, reflecting his limited output and growing antipathy for
the project, showed only three paintings and a group of sketches. Pegi
Nichol showed four Stoney portraits, and Anne Savage showed a paint-
ing and various sketches from her trip to the West Coast. Florence Wyle
displayed a series of small plaster models of totem poles and two plaster
reliefs of heads. Kihn's troublesome paintings must have caused problems
in hanging the exhibition. Certainly, he was not personally welcomed.
There is no record that he was invited to the opening or notified of the
publication of the catalogue.[16] His name was, in fact, excluded from the
list of artists in the initial version of the catalogue printed for the National
Gallery and appeared only in an inserted addendum.[17] No mention of
this omission occurs in the files of correspondence, which is suspicious in
itself even if the omission had been an oversight. The pasted-in addendum
lists twelve of Kihn's works: four landscapes and eight portraits. These
were drawn from the collections that had been presented by the press

baron F.N. Southam to the McCord Museum, the National Museum, and
to the Royal Ontario Museum.[18] The reprint of the catalogue done for the
AGT, which did not use Carr's designs for the cover and which included
photographs of the Ottawa venue, listed the twelve works by Kihn with
those of the Canadian artists.

Not all the works were of the Skeena, nor did they necessarily have an
Indian theme. Although paintings from the region received the most atten-
tion, the concept of "West Coast" art was given a wider scope. Broaden-
ing the exhibition seems to have been a way to include a greater number
of works by the Group of Seven, whose members had declined Barbeau's
invitations to venture into the region, and thereby to more securely
link the Group to the national image. It was also a means of asserting
the emptiness of the landscape, which could counter the peopled images
produced by Kihn and Carr. J.E.H. MacDonald had two Rocky Mountain
images, while Lawren Harris and F.H. Varley also exhibited mountain
sketches. Artists from outside the Group included Walter Phillips, a
woodcut and watercolour artist from Winnipeg, who had been featured
at Wembley in 1924 and 1925 and at the Jeu de Paume. He was invited
by Brown at the last minute, after the initial proposed opening date,
and was able to muster four images of Indian villages done on Vancouver
Island.[19] Charles Scott, the head of the Vancouver School of Art, where
Varley was employed, also showed sketches. Insofar as the latter three
came from either the Prairies or British Columbia, they, along with Carr,
gave the exhibition a more national cast, an important issue for Brown at
this moment.[20] Less recent or modern were eight Indian works by Paul
Kane, including three portraits and five scenes from Indian life, and a
Selkirk landscape by Frederick Bell-Smith. Kane's works, as Brown had
previously stated in his Jeu de Paume catalogue, would signal the death of
the Indian and position their arts, cultures, and identities as belonging to
some point in a remote past.

In addition, listed under a separate heading in the catalogue were
two landscape paintings done in Western conventions by a Native artist,
Frederick Alexie. These were borrowed from the personal collections of
A.Y. Jackson and John Flewin.[21] Although apparently minor works, few
in number, and in some ways in disharmony with the basic concept of
the exhibition's mandate to show only the "best" Native material, Alexie's
images contributed greatly to the reading of the exhibition. His works
blurred the distinction between Native and non-Native art but did so in a
very precise fashion that clearly established several key principles. Their

FIGURE 22: *Exhibition of Canadian West Coast Art, Native and Modern*, National Gallery of Canada, Ottawa, 1927, featuring paintings by Emily Carr and Langdon Kihn and various Northwest Coast art pieces.

position on the border between the Native and the modern made them pivotal pieces, especially since he was the only named and contemporary Native artist present. Here, in fact, the exhibition's relationship with the Jeu de Paume debacle becomes most apparent.

The catalogue devoted a disproportionate amount of text to categorizing Alexie's paintings as "primitive." Given what had transpired in Paris in the spring, the term was now loaded. It has been noted that the French reviews had characterized the work of the Group as such. The designation became a source of embarrassment and led to the concealment, rather than to the planned publication, of the reviews since it implied a lack of mastery and an incomplete and immature grasp of the conventions being employed, especially in comparison to the modernist master Morrice. In addition, several critics had spoken of the sophistication of the Native material and had valued it over that of the new Canadian landscapes. It became necessary, then, to transfer the term "primitive" elsewhere so that the Group could reclaim its mastery, modernism, and sophistication. Given that much depended on this redeployment of the term for the home audience, the catalogue was careful to articulate what sort of work should properly be deemed "primitive":

> The two paintings by Fred Alexee ... might be placed among the primitives of Canadian art here exhibited. In European countries primitive paintings have been prized for their naïveté, their charm, and the historical perspective which they confer upon the development of art. In Canada this category has so far eluded search, if we except Indian art pure and simple. Alexee's work possesses something of the quality which we should expect from such primitive painting, and he himself is an old Tsimsian half-breed of Port Simpson, B.C. ... His sense of colour is limited; his composition is as a rule excellent; and the movement is spontaneous and spirited.[22]

The paragraph responds specifically to, and denies, the assessments of the Parisian critics. It categorically rejects the possibility that there was ever a European-style "primitive" – that is, naive – art in Canada. Since any such art had "eluded search," the term could never have been properly applied to the Group's work, which was, of course, highly visible. The paragraph also locates the term in the work of either European or Native artists, thus twice displacing it from any current Canadian non-Native painting. The French critics who identified the Group of Seven as "primi-

tives" or "*naïfs*," thereby refuting its members' claims to refinement and sophistication, were thus placed in error. Given this calculated reversal, mastery and modernism could now be reclaimed by the Group, especially if the Jeu de Paume reviews extolling Morrice remained invisible. For those who might have missed these nuances, the title of the exhibition made it clear that the Group's members were claimed to be "moderns," a term that gained its meaning from its binary contrast with "Native," which was thus reserved for work associated with the "primitive" past. In support, the paragraph supplies an evolutionary and hierarchicized model in which artistic and cultural production progresses from the naive/primitive to the knowing, or, one might say, from incompetence to mastery. Coming from an earlier stage in this development, which had Western art at its apex, Alexie's works are "limited" and lacking, especially in their "sense of colour," which was the forte of the Group's members and, from their beginnings, one of their claims to mastery. Yet the limitations of Alexie's works were also their attraction and the source of their visibility. If they had exhibited more competence, they would not have warranted aesthetic appreciation and would have disappeared. But the paragraph goes further. By employing "primitive" to mean both "naive" and Native, the catalogue strategically extended the term so that it referred not only to Native work that did not display a full grasp of the conventions that constitute Western art, but also to Native art in general. This conflation of the terms "primitive" and "naive" made Native work primitive in both senses, thus discounting the Parisian assessment of it as sophisticated and refined. Again, the Parisian critics were placed in error so that the Group could recoup the designations that its members had been denied. The opposing attributes of lack and mastery and of modern and primitive (in both senses) are made to constitute binary opposites, rather than an affinity, between the Native and non-Native artists. Within these binaries, the Group repossessed the privileged position, while mastery and modernism, which had been attributed to the Native material in Paris, were now withheld from the Native works at the *West Coast Art* exhibition.[23]

But the inclusion of Alexie's "primitive" works did more than simply produce binaries between articulation and nonarticulation, mastery and lack of competence, and modern and primitive, which could ratify the Group of Seven's claim to modernism by providing a past alternative. By conspicuously excluding from the exhibition any contemporary Native masters working in traditional forms, the organizers confirmed that these artists, under pressure from assimilation, had lost competence even in

FIGURE 23: *Exhibition of Canadian West Coast Art, Native and Modern*, National Gallery of Canada, Ottawa, 1927, featuring rugs and totem-pole paintings by Emily Carr, portraits by Langdon Kihn, and a Gitxsan screen collected by Marius Barbeau.

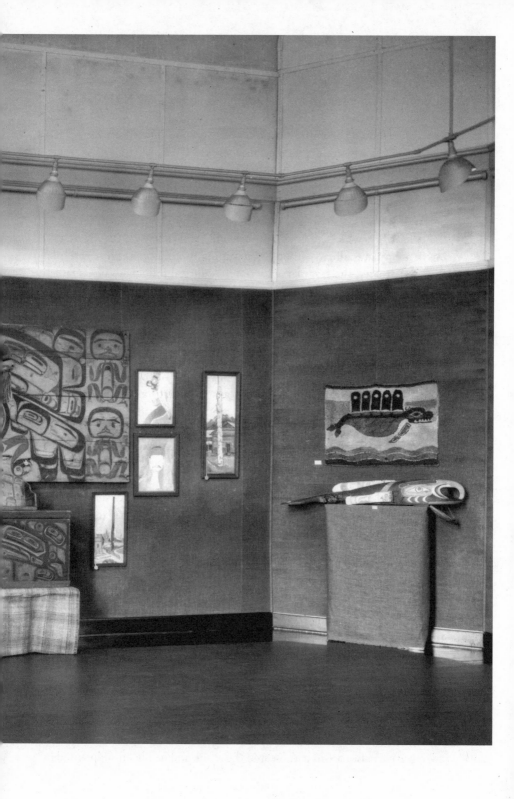

their own doubly "primitive" art forms. Contemporary Native artists, it seemed, also "eluded search" and for good reason. Their presence would have undermined the entire purpose of the exhibition. All Native art was thus placed firmly in the past. In this context of loss, Alexie's naive Western-style paintings, along with Kane's contrasting "sophisticated" works on similar subjects, became additional proof of the death of Native cultures and arts. But they were also more than this. Having lost their own cultures and arts, Native artists were still not yet competent in the art of the colonizers, which, it appeared through Alexie's works, they were trying to assimilate, albeit without ever gaining full mastery. The exhibition thus demarcated the singular direction of cultural influences in Canadian "modern" art, which was presented as a one-way street. This direction distinguished it from its European counterparts. Unlike the avant-gardes of Cubism, Fauvism, and Expressionism, the "modern" Group and its affiliates did not acknowledge an influence from the Native/"primitive" work, even when they approached it as subject matter. While the Canadian artists had gazed upon and taken possession of the Native material, the latter remained passive and did not act in turn on those who were beholding it. Insofar as the Canadian "avant-garde" had nothing to learn from the Native work, the former was never placed in a position of having not yet mastered the latter's formal complexities or social subjects. Indeed, Alexie's work was proof that the reverse was true – that is, that Natives must learn Western forms and conventions and that the process was incomplete and probably would never be completed. Given the confirmation of these assumptions, no attempt needed to be made to demonstrate that the modern work was in any way indebted to the Native work (as had been asserted by the Parisian critics), aside from adopting it as subject matter within the range and repertoire of Canadian subjects. For a third time, the Parisian critics were in error.

The only affinity between the Native and the "modern" work was that they both sprang from the land, albeit independently and at different times, and could be taken as declarations of nationalism. Brown was insistent on this point and repeated it three times within his brief, single-page essay in the catalogue. Still vacillating between art and craft, he stated: "The Indian sense of creative design and high craftsmanship was at its best as deeply rooted in his national consciousness ... so long as his national consciousness and independence remained," but this had disappeared, as had their arts.[24] A historical difference again was used to distinguish the two. Native nationalism had vacated the scene and had been supplanted by

non-Native Canadian nationalism. The crucial relationship between these nationalisms, challenged in Paris and in the international Kihn reviews, was thus reestablished. The Group now recouped nationalism. Barbeau confirmed Brown's assessment. Indeed, it was one of the key points on which they were in harmony. He stated that "a commendable feature of this aboriginal art for us is that it is truly Canadian in its inspiration. It has sprung up wholly from the soil and the sea within our national boundaries."[25] The Canadian national "us" and "our" with whom Barbeau identified both himself and his readers did not belong to the Indian, who by implication was beyond these "borders" and became "them" and the Other, or an "outsider," as he had previously phrased it. Brown employed a similar tactic when he shifted the identity of the Indian into a oneness with an exploitable nature. He confirmed Harlan Smith's early proposals on the use of Native motifs by industry, stating that although they were now gone, "enough remains ... to provide an invaluable mine of decorative design ... possessing for the Canadian artist ... the unique quality of being entirely national in its origin and character."[26] Like any other national natural resource, Native art belonged to no one since it was assumed tacitly that no Natives existed who had a valid and singular claim to it. In this absence, the art could be colonized, claimed, and "mined" at will by "Canadians." In this sense, the use of Native materials as a basis for nationally distinct commodities became an affirmation of capitalism and industry – that is, of Western economic values – rather than a potential critique. But it also assumed that the Natives, who were not cast as Canadians, owned neither their own culture nor their own lands.

The catalogue essays, it seems, were written against the claims of Native peoples to cultural continuity, ownership, self-representation, and inclusion within the nation as well as against the judgment by the French critics at the Jeu de Paume exhibition of both the Group of Seven and the Native work. The essays, for example, saw no formal affinities between the "modern" and Native work, with the exception of the possibility of adaptations for nationalistic decorative industrial designs. Indeed, the exhibition and its texts established hierarchical relationships of difference between the primitive and modern based on temporalities, influences, identities, ownerships, and a redefinition of the primitive, mastery, modernism, and nationalism. With these displacements securely in place, it was now possible to openly confront the problematic Parisian reviews. Barbeau could thus acknowledge that Thiébault-Sisson had written the previous year that "between the specimens of Canadian West Coast art

and those of the Bantus of Africa or of the ancient Aztecs of Mexico, there is an obvious analogy ... Yet, the art of the Canadian tribes has advanced further than the others and discloses a much finer culture."[27] Such an assessment could be made openly only in a context where Brown had already established a hierarchy that separated the arts (or crafts) of "the Canadian West Coast tribes," which had disappeared, from the work of "our more sophisticated artists," who, it was asserted, could not be associated with the primitive or be seen as lacking mastery. In the new context, that the Native work had been praised by the French critics no longer diminished or threatened the Group of Seven. Rather, it was made to serve as a demonstration of how much higher and even "more sophisticated" was their work. The words of the French critics were thus redeployed to reverse their initial assessments.

But if the relationships between this exhibition and its predecessor in Paris became more lucid, then those between the Native and "modern" work became less so, except to establish difference and a series of hierarchical relationships and to make one the subject of the other. Brown articulated his ambivalence and the ambiguity of the exhibition when he stated that the show was an "endeavour to analyse their relationships to one another, *if such exist*, and ... to enable this primitive ... art to take a definite place as one of the most valuable of Canada's artistic productions."[28] According to Brown, any clear relationship was cast into doubt. For Brown at least, the basic premise of the show was anything but "definite," except to absorb Native art into a hegemonic national Canadian art, where it could take on a new meaning for a newly educated audience. Here, he began to differ with Barbeau.

Nonetheless, there was an abundance, if not an overabundance, of Native material. The original proposal for a few masks and some argillite miniatures had been long abandoned as Barbeau increased the amount and variety of this portion of the exhibition. The sheer abundance must have been overwhelming. The display, as it was mounted, included monumental house posts and canoes, headdresses, statuettes, batons, painted and carved boards, food boxes and trays, ladles and horn spoons, charms and amulets, argillite carvings, Chilkat and button blankets, woven mats and capes, hats, bracelets, drums, and rattles. In short, the exhibition fulfilled all the potential of plenitude promised by Barbeau in the Jeu de Paume catalogue yet absent from that exhibition.

The Native material did vary somewhat with the venue. Most of it came from the National Museum. This appears to have been supplemented with

several pieces borrowed from the personal collection of Duncan Campbell Scott, which had been suggested as a source for the Jeu de Paume. An invoice within the records shows that six masks and two ladles were returned to him after the exhibition.[29] As the National Museum would not permit some of its collection to travel out of Ottawa, the exhibition in Toronto was supplemented there by work from the Royal Ontario Museum. This, in turn, was accompanied by work from the McCord Museum at McGill University. In short, as the exhibition grew in scale in late 1927, it came to involve not only artists from Montreal to Victoria and a host of government bureaucracies and administrations, but also almost all of Canada's entire cultural institutional framework. The scale of the resources brought out to supply, contain, and administer the work was nothing short of monumental, if not breathtaking. Such a display of coordinated cultural forces centred on one art exhibition was unprecedented in the history of the Dominion.

The simultaneous presentation of "modern" and "Native" work seems to have posed certain logistical problems. The majority of the Native pieces were not confined within glass cases but placed in the open and interspersed with the paintings in symmetrical arrangements based on the conventions for the display of ethnographic material established in the late 1800s.[30] In these, typographic, taxonomic, and comparative relationships, which were lacking here, generally formed the basis for organization. The strict balance also violated the conventions that had developed for the display of paintings. Everyone agrees that these arrangements did nothing to establish differences between the works from the various Native groups, although these were mentioned in the catalogue.[31] They also did nothing to demonstrate any similarities or affinities between the Native and non-Native pieces. Educating audiences on these points does not seem to have been the guiding principle so much as establishing a pleasing balance. I would contend, however, that the excess of pieces, the excess of order, the excess of institutional involvement, and the dearth of information were designed to ensure the proper reading of the works.[32] Locking the entire spectrum of Native production, seen as simply "West Coast Indian," into this homogenizing "fearful symmetry" within the national museum and gallery framework, combined with representing this Native work in the context of the current non-Native paintings, brought them under control and securely contained them within their disciplining discursive frameworks.[33] The dangerous propensity that the pieces and, even more particularly, their makers showed for breaking out of this

construction at this very moment was reassuringly diverted or masked by the rigid arrangement.

In this overwrought display of institutional might and order, the audience seems somehow to have been overlooked. Each venue at which the exhibition appeared was noted as being poorly attended, evidence of insufficient advance publicity or promotion. In fact, a search of the newspapers yields few preliminary notices to build interest in the exhibition, as had occurred in Paris. Nor did a series of articles appear to educate the potential audiences about the unique qualities of the works, although, as we have seen, several were published that posited the decrepit state of Native and specifically Gitxsan culture and that seem to have been given a greater priority.[34] In fact, by the time the show opened in Ottawa, it is almost as if it had become, despite its initial promise, something of an embarrassment. The unexplained delays in the opening day, which was first given as 21 November, then moved by Brown to 24 November, and finally occurred on 2 December, was the first indication of problems with installing and selecting the works and a desire to limit its exposure.[35]

Carr's journals provide further insights into this complex and conflicted situation. Her bitter disappointment at the hastily assembled and poorly attended "opening," at which she was told by Barbeau that Brown had not sent out the invitations, is well known. Less often reported is her preamble, in which she related her dinner with the Barbeaus prior to the "opening." Here, she recounted Barbeau's confident anticipation of a triumph that would have validated his efforts, his theories, and his position within the cultural structures that were formulating Canadian identity, including the galleries, museums, and railways. Barbeau raised Carr's expectations by asserting that such events usually attracted "thousands" of people.[36] But Carr also noted his wife's anxiety at Brown's suspicious statements that he intended it to be an "informal" event. When they arrived and found the paltry crowd, Barbeau realized he had been thwarted by Brown and was extremely bitter, while Brown put on what Carr saw as a hypocritically cheerful front. She did not understand what had occurred but felt personally embarrassed and humiliated.[37] It was, in fact, no simple petty jealousy or turf war between two rival bureaucrats forced to share premises and projects. At stake in the conflict between Brown and Barbeau, which had finally come to a head, was a vision of Canada and its identity as established in the visual arts and their precise relationship with Native cultures and their place within national institutions. It now becomes clear, in the context of the complex issues

surrounding the exhibition, that Barbeau's attempt to imbricate both "Canadien" and Native arts into the fabric of Canadian identity threatened the integrity of Brown's fragile monocultural constructions. The latter required that both of these be marginalized, if not excluded. It is hardly surprising that he would have opposed the exhibition, albeit not overtly, and that Group participation was kept to a minimum. Thus the Ottawa exhibition was, as Carr stated, a "fizzle." Her assessment that if momentum was lost at the opening, it would not be regained and that the show would close before it opened was probably correct.[38] What Carr did not appear to realize was that she had stepped into a conflict, a "battleground," as Brown had phrased it, and that in such a minefield she had to tread with extreme caution.[39]

The show did not do well in its other venues either. The situation was repeated at the opening in Toronto, where Edward Greig, the curator, reported to Brown a "very small attendance."[40] Further, despite the logistics, expenses, and difficult negotiations required to assemble the work and get it from one venue to the next, the exhibitions were actually open to the public only briefly. If the National Gallery followed its normal procedure of being closed by 22 December, the Ottawa show was open for less than three weeks.[41] The time at the Art Gallery of Toronto was equally short, from 6 January to 29 January, just over three weeks. Here, however, Barbeau intervened to raise the exhibition's profile by speaking at the gallery and by arranging for Juliette Gaultier to perform, both events being written up in the press. He reported that these were well attended and that people were even turned away. However, his accounts may be somewhat suspect given the reports in the Ottawa papers that the opening there enjoyed a huge attendance and given his flair for exaggerating his own successes. Indeed, A.Y. Jackson reported that attendance at the exhibition itself was small. "The West Coast show here has had no attendance at all, about ten a day at the best. It is a hopeless situation."[42]

The third venue, the Art Association of Montreal, may have been part of Barbeau's plans, but the prospect was not taken up with any enthusiasm by the NGC. Here again, Brown and Barbeau differed. Although Barbeau had announced it as a venue the previous year, Brown treated it as a last-minute addition, with evidence of his negotiations dating back only to November.[43] By 30 November 1927 – that is, after the exhibition was first scheduled to open – no fixed dates had been established.[44] The official request came only on 14 December, but dates were still being negotiated.[45] Brown, wishing to downplay the exhibition, suggested that

the entire show was probably too much for the Art Association's limited space and that only a portion be exhibited.[46] By the end of January, they were being offered the show for only one week.[47] After threatening to cancel, the Art Association finally managed to hang onto the entire show from 17 February to 22 March, the longest duration of the three.

Where it was not shown was as telling as where it did appear. In the course of its three-city run, the exhibition attracted attention from American museums, which were beginning experiments in precisely this direction. The American Museum of Natural History sent an expression of interest and asked for the catalogue.[48] This should have alerted the Canadians behind the exhibition to its importance on the international scene. On 18 January the Memorial Art Gallery in Rochester, which had shown Canadian work both in 1921 and in 1927 and which consequently had a well-established relationship with Canadian institutions, requested the show.[49] The Canadian National Exhibition (CNE) asked for a portion of the show for the following fall.[50] The correspondence also indicates that Buffalo, presumably the Albright Museum, which had previously shown Canadian work, requested the exhibition as well.[51] By February, Barbeau had informed Carr of the three possibilities. However, these overtures amounted to nothing, even though the work was crated and not committed to any other venues. The precise reasons for not extending the show do not appear in the correspondence, but there are suggestions of problems with the Native material, although ways around these were also proposed.[52] It may be speculated that antipathy to such a prospect may have arisen from several unwelcome possibilities, particularly surrounding the potential critical responses, which since the Jeu de Paume exhibition in Paris had become an important issue. Kihn's paintings, in any American venue, would certainly have been highlighted, and the Canadian institutions appeared anxious that his work be either omitted or downplayed due to its problematic content. He would have undoubtedly shared centre stage with Carr, who would have taken precedence among the Canadian painters. At the same time, the Group of Seven's work in the exhibition, because of its members' reluctance to participate, was not all that strong and would thus have been cast in an unfavourable light. But above all, there was the danger of the Native work being too highly appreciated, being interpreted as confirmation of an ongoing culture, and making a direct and present contribution to a larger national identity. Any such readings would have shifted and upset the careful and precarious rebalancing of the relationships within the exhibition. Whatever the

reasons, a more suitable show of Group work, which excluded the Native material as well as that by Kihn and Carr, was sent to Rochester and Buffalo in the fall of 1928 while the CNE received a display of British, Spanish, and Canadian painting.[53]

The indifference to the possibility of gaining an international audience for the work indicates that exposure was not, in the end, the aim of the exhibition. Nor was its purpose to inform or educate an audience, as initially had been planned and stated, except on the supposed state of Native culture. In the course of the troubling events that surrounded the exhibition, its primary purpose seems to have been to reassure the institutions themselves about their relationships with Native cultures and peoples. The process of public education, in any case, could go on in other more permanent formats, such as the continued publication of books and articles that would have a longer shelf life. Equally, since the Wembley and Jeu de Paume exhibitions, the "audiences" that mattered most to the exhibitors seem to have become the reviewers. As has been seen, Jackson, Barbeau, and Scott had already taken steps to ensure that the correct viewpoints were forthcoming.

The *Ottawa Citizen* featured the *West Coast Art* exhibition on three occasions but these were limited in scope.[54] The most complete responses were in Toronto and Montreal. The *Toronto Globe* led off on 3 December with a brief notice that in Ottawa "history in Canadian art was made," noting that the show featured "the best works of native craftsmanship" with "the best Canadian artists, showing what a tremendous influence the vanishing civilization of the West Coast Indian is having on the minds of Canadian artists."[55] The Toronto-based national magazine *Saturday Night* offered an extended commentary by Guy Rhoades.[56] Rhoades must have met Langdon Kihn while the latter was in Ottawa in 1925. He also had a deep interest in the Natives of Canada. He was in communication with Harlan Smith and may have visited the Skeena region in 1926. Writing to Kihn in March of that year, he stated, "I myself will probably be at Hazelton or thereabouts. I expect to have to hobo most or all of the way out. But there is a great deal I could write from there which cannot be done from this place owing to the Duncan Campbell Scott outfit and my intimacy with the museum bunch. But out there I would be an eye-witness free to say whatever I liked."[57]

Rhoades' unguarded candour makes it apparent that any statements about the Natives published in the national press were policed and controlled, that alternative views existed but were suppressed, and that

individuals were making the trip out on their own without museum or railway assistance. Rhoades's article thus opened with an equivocal reference to the notion of disappearance: "The vanishing Indian did a strong comeback." This metaphor of regeneration, which may have been as far as he dared or was allowed to go in this direction, was accompanied by the recognition of the Native material as art. He even referred to the works as "masterpieces" and devoted the first half of his article to them. After citing the influence of Native art on current Canadian artists, he repeated the claim made since the Jeu de Paume exhibition that the "natives of the Pacific coast possessed what was probably the greatest decorative art which has ever developed." He then went further. Linking the art to heraldry, he noted that "each design ... could be adapted to fit any field he [i.e., the artist] chose to put it in. He was permitted to distort it as much as he pleased as long as he preserved certain features that disclosed its identity. In each being which he portrayed the essential features were different." Information about these characteristics was not available from the catalogue, and the article presented a fairly sophisticated analysis of the most significant conventions of much of the work. This may indicate exposure to Barbeau's talks on the subject or have been the result of seeing an early copy of Boas's analysis of Northwest Coast art in his *Primitive Art*, which was published that year.[58] Unfortunately, Rhoades offered no further insights. Much of the rest of the review was devoted to an appreciation of Emily Carr, who was, in his view, "one of the greatest discoveries ever made in this country" and "really the feature of the show." Her paintings were seen as a historical record of "many of the phases of Indian life which have ceased to exist." Although he mentioned Kihn, Holgate, and Nichol, he did not mention any of the Group of Seven.

In contradistinction to the limited responses of the Ottawa papers, the Toronto reviews that appeared in the *Globe*, the *Star*, and the *Mail and Empire* gave the exhibition full coverage.[59] The first reiterated several aspects of the catalogue and included the invocation that "industrial leaders ... seeking something purely Canadian in design ... should not miss consideration of the art of the West Coast Indians." It also mentioned the popular vision of the totem pole made familiar in the stage musical *Rose Marie* and in film as well as citing Barbeau and Brown. It concluded with another peal of the death knell: "Trade and commerce of the white man have changed the Indian, and apparently driven from him the desire for self expression ... Perhaps the white leaders of today can do something to perpetuate the Indian's art, even though done by 'mass production.'"[60]

Apparently, those responsible for the death of the art were also its right-
ful heirs and stood to profit from its demise. No mention of any of the
paintings was made. The *Star* omitted any mention of industry but gave
a catalogue of the various Native groups and the variety of objects on
display, quoting Barbeau in saying that "their most accomplished artists
left works of art that count among the outstanding creations of mankind."
Although immensely appreciative of the aesthetic value and variety of the
work, the article placed it firmly in the past. Just before turning to the
present-day arts, it stated: "These aboriginal arts ... flourished as recently
as [the] middle of the last century." It then briefly mentioned Carr, the
members of the "school of seven," Wyle, Kihn, and Kane. It concluded: "A
visit to the Grange will end the scepticism of all who still doubt that there
is a genuinely Canadian art."[61] The *Mail and Empire*, which had published
Barbeau's and Scott's articles on the state of Native culture, continued
this very point. Its headline proclaimed "Arts Abandoned with Beliefs
of Paganism." The opening line stated that "creative art among the Brit-
ish Columbia Indians has largely passed out ... and today the art is dead,
according to Mr. C. Marius Barbeau ... who gave a talk ... last evening
at the Art Gallery of Toronto upon 'The Traditions, Music and Art of the
West Coast Indians.' 'They do not believe in traditions any longer,' he
said: 'they do not, indeed, believe in themselves. They no longer believe in
art for its own sake, as once they did.'" The remainder of the article care-
fully reiterated certain of Barbeau's theories on the origins and recentness
of the art. It concluded that "the attendance was exceptionally large."[62]

The two Montreal reviews differed from those in Toronto. Contrary
to Hill's assertion that the show was virtually ignored here, the resulting
reviews provided more information on the exhibition itself and a more
reasoned approach to the art. There were no statements on the death
of the culture or on the appropriation by industry of its motifs. In both
cases, the paintings again received only scant attention.

There was also some coverage beyond the local press. The Rhoades
article has already been mentioned. The following month, another article
appeared in *Saturday Night*, this time by Stewart Dick.[63] He dismissed
the landscapes of Harris, Varley, MacDonald, and Phillips as unrelated
to the theme of the exhibition, thus undermining any attempt to see a
relationship between their work and the Native material. Instead, he
focused directly on the "real interest of the exhibition ... the native
Indian work." Viewing this in isolation, he noted the "decorative quality"
and "the instinctive use of pattern with freedom and boldness." Although

Dick displayed no education in the field and no ability to distinguish one tribal style from another (for which the catalogue and the layout of the display offered scant assistance), his enthusiasm and feeling for the work is unmistakable. Nonetheless, Dick countered Rhoades's suggestion of a "comeback" by presenting the acceptable position on the state of Native culture. He also felt compelled to go beyond his role as critic and pronounce the art's disappearance as inevitable and unfortunate. He maintained that any attempt "to keep it alive by artificial means is hopeless and futile. The manufacture of synthetic primitives is a form of modern art production certainly not deserving of encouragement." In any case, he saw the exhibition as the terminus of Indian culture, beyond which there was no hope of revival.

The anonymous reviewer for *Canadian Forum* was less enthusiastic and seemed to have trouble forming any firm opinion on the work in the exhibition, although he was in no doubt about its final message.[64] His studied antipathy, combined with hints of irony, is odd given that it was during precisely this period, the late 1920s, that the *Forum* took its greatest interest in serious discussion about art, particularly "modern" art. MacDonald was on its editorial board and was shortly joined by Harris. For this brief period, it became one of the nodes of Canadian national identity and the virtual organ of the Group of Seven. Thus, although *Forum* had previously published Holgate's woodcut *Totem Poles at Kitselas* from his series on Skeena River and Gitxsan subjects as well as Brown's report on the attention given to Native art at the Jeu de Paume exhibition, in which he had declared the forthcoming antagonistic relationship between Native and Canadian art, the review of the *West Coast Art* show drifted from lowbrow references to physical culture to high-minded quotations from Thoreau but only cursorily touched on the art itself. It opened with the notion that "perhaps all good Canadians are bound to have something of the Indian in them having inherited this country and so put themselves in contact with that earth-memory of hers at which our mystics hint. In time we shall likely develop a better Indian type of physique. The colour and build and action of the young people crowded around a supply-boat at the summer resorts certainly suggests it."

Continuing in this vein to contrast the primitive and modern in sports, factories, and motor cars, the article eventually dealt with the art itself, noting that "one can share the enthusiasm of foreign authorities and critics over it. No knowledge of its ethnology is needed to enjoy the largeness of pattern of the formal painted designs, the elaborated finish and ingenuity

of their carved and painted boxes, bowls, and rattles, the extraordinary combinations of conventionalized birds, arm movements of the brush work in the larger patterns. To one's fancy all the lines have the roll and crescendo of waves and the swoop of great birds and fish. The play of art is not often better seen than in these grotesque carved and painted masks."

The reviewer concluded patronizingly, if not fatuously, that the Natives "are children pretending, but what clever children. This work must undoubtably go into the fabric of our Canadian art, but not too directly; our umbrellas and fountain pens are not blubber knives and harpoons." The "discovery" of Carr was not mentioned, nor was any of the other non-Native material, including that by the Group. The omission of the evidence of precisely the relationships ostensibly addressed by the article indicates that it may well have been motivated by an attempt to place Native art outside what constituted or had claims to representing a modern Canadian identity, except in its most abstract sense. In foreclosing any such debate, the review was a final skirmish on what Brown had previously called in the same journal "a future battleground in the studios and round the club fires."[65] The Group of Seven's members never again risked contributing to an enterprise in which their own work might be seen as less interesting than the "primitive" art with which it was displayed.

Still, it seems that, like Rhoades, others were not so quick to dismiss Native art as a thing of the past. Here, however, distance from a controlled discursive framework proved helpful. Precisely when the exhibition opened in Ottawa, an article appeared in *The Studio* on the subject of Native masks. Once again, the English art journal did not seem entirely onside with the Canadian vision. The text was written by Eustella Burke and illustrated with photographs by Harlan Smith and Barbeau. Burke discussed the "Indians of the Pacific Coast of Canada [who] have developed a school of art which makes them unique among the aborigines of America." This was the last time, however, that she employed anything approaching the past tense. The rest of the article described the art, its social and ritualistic functions, and its production as existing in the present: "Their principal arts *are* ... Animal motifs *are* used ... Human figures also *occur*." She spoke of the ongoing ceremonial activity in the same manner: "There *are*, among these Indians, a number of secret societies ... When an Indian, his face covered by a well-carved mask, dressed in a blue blanket adorned with red flannel applique designs and decorated with scores of small pearl buttons, dances into view of the audience watch-

ing the ceremonies, the effect is most astonishingly realistic."[66] This vivid description, which implies actual experience of such prohibited affairs, combined with the photographs from the Gitxsan villages of "Gitwinkul" and "Gitsegukla" showing actual dancers in such costumes, gives the impression of an ongoing and dynamic culture that she at no point suggested was in a state of decline or extinction.

Given the understanding that had been reached thus far on the discursive frameworks surrounding Native art, culture, and peoples, it is predictable that such an article in such a venue could not go unchallenged. The task of writing a rebuttal fell to Douglas Leechman, who had joined the National Museum in 1924, the year before Sapir left. Somewhat like Eric Brown, Leechman was another English emigrant who had few qualifications; he had no education in the discipline, nor was he a talented amateur. His major interests seemed to be library science and journalism. However, it may well have been precisely this blankness that most suited him for the position. Unlike Sapir, he would be bringing few ideas that would oppose the state's position on Native culture and peoples. The following December, his corrective to Burke appeared in the same journal.[67] He began with a reference to the *West Coast Art* exhibit, calling it a "unique experiment new in the history of Canadian art; one which has, indeed, seldom been attempted before anywhere" and a "decided success."[68] He then made reference to the Burke article and reiterated its major points. His illustrations were photographs of the Ottawa installation along with paintings by Kihn, Holgate, and Jackson, which he did not address. Although he repeated many of Burke's points, he varied from her on one essential issue. He concluded, yet one more time, with the general view that the art had reached its final stage and had no future:

> It is greatly to be regretted that this art is rapidly dying out, and once dead it can certainly never be revived. In the old days when the influence of the white man had not made itself felt, the workmanship was of the highest, but, first the introduction of our tools, which led to quicker and, therefore, more careless production, and then the adoption of our ways of living by the younger generation of Indians, have had their fatal effect. Nearly all the old artists are dead and there are none to take their places. Efforts have been made during the last three years by the National Museum of Canada to preserve the totem-poles which are left, a highly commendable move in the right direction.[69]

The funeral rites delivered by Leechman in his summation, although based on no actual fieldwork and little experience, if any, in the discipline of ethnography, again proclaimed the decline into decrepitude and inevitable death of the arts and culture of the Indian, brought about by the "fatal" contact with European culture. He also made transparent the relationships between this premise, the exhibition, and the program of totem-pole restoration. Leechman's reiteration of the state's position on Native cultures, then, was well informed but also misinforming. Significantly, he obscured or left out pertinent information. Given his position, he would, by this point, have become aware that in fact the Native population was on the increase. He would also have known that the federal government under Duncan Campbell Scott was doing all it could to suppress Native cultures, of which the potlatch ban was only one aspect. He mentioned none of this. Nor did he indicate that resistance was growing and vital, especially among the Gitxsan but also elsewhere in British Columbia and on the Prairies, and that this resistance had resulted in the failure of the "commendable" restoration program and its attempt to transform the poles of the Gitxsan into museum displays, tourist attractions, and emblems of a nonreclaimable Native past for non-Native audiences. Nothing was said about the growing issue of land claims. Whether deliberate or not, these omissions clearly indicate the gaps and enforced silences that could arise from the representation of the Native in writing, art, and museum/gallery displays.[70]

The question arises, then, of the extent to which the exhibition in its final form, together with the catalogues and the reviews, succeeded in its objectives? The answer can be only that it succeeded in part, performing less than well. Certain things were clearly established and agreed upon by all. There was a general consensus that the only relationship between Native art and Canadian paintings lay in their mutual attachment to the land and their purported national identity. Native culture, identity, and art, however, no matter how sympathetically or enthusiastically received, were deemed to be things of the past. The corollary here was that they had been supplanted by a Canadian identity that had mythically sprung, fully formed like Athena from the head of Zeus, out of a three-way relationship between the National Gallery, the Group of Seven, and a virginal nature. About this, there could be no dispute. There could be some debate about the precise date of their passing, the state of their decrepitude, and what to do with the remnants of Native culture – that is, about whether to incorporate Native motifs into a Canadian national design – but obviously

any thoughts outside this structure were carefully policed and disciplined. Needless to say, this prohibited any oppositional ethnological or Native voices. Within such circumstances, the Kitwancool people were right: their interests would not have been served by cooperating with Barbeau, and their histories would still have to be written by themselves.

At the same time, there was also little doubt that the Native art had again completely overshadowed the paintings. Almost all the reviews focused on the Native material and spent little time on the other artists, who in several cases were either not mentioned at all or dismissed as beside the point. Such neglect could be damaging to the claims of the Group, whose members were prescient in either not participating or, as Jackson did, discreetly reducing their involvement with the program. By comparison, this risk would not have been so evident before the Jeu de Paume exhibition – that is, when the winter show was still in its formative stage as a selection of masks. Afterward, of course, the risk increased as the exhibition expanded under pressures to contain the ever-more-problematic image of the Native. In the end, the reverse of containment occurred.

The installation shots and the catalogue indicate why the reviews would have focused on the Native art. The paintings were dwarfed and contained by the monumental sculpture and overwhelmed by the sheer proliferation of other Native objects, rather than the other way around. If the Native works had been limited to a fragmented selection of smaller, less consequential objects, such as a few masks, argillite carvings, and miniatures – as in Paris and as Jackson had originally been led to anticipate and support – or limited to material that would signal "handicraft" or "decoration" to a non-Native audience, such as baskets or jewellery, chances are that this could have been avoided. Bringing in monumental sculptural pieces such as house posts, boxes, and dance screens, particularly the immense, centrally placed, greeting figure collected by Harlan Smith, changed the physical and visual relationships, even if the show lacked actual totem poles. Within the final display, the smaller paintings, in which so much was invested, were not up to the task of absorbing and appropriating the plenitude of works that surrounded them. They were, in fact, incommensurate with them. Thus, instead of solidifying and shoring up a national identity, which was too heavily invested in landscape painting, the exhibition revealed yet further lacunae. Aside from a deep past, a *volk*, and an ancient claim to the land, there was also a lack of a corresponding monumental, national public sculpture, which could have

been brought in, had it existed, and helped with the task at hand.[71] There were, instead, only a few small plaster pieces by Wyle. This situation at the exhibition corresponded to the wider lack in Canada but contrasted with European countries such as France and Germany, which had invested heavily and effectively in producing national, public sculptural traditions in the previous centuries.[72]

It might also be suggested that the exhibition lacked the presence of the Natives themselves and their rituals, which could have animated the works on display. The Gitxsan people, dressed in traditional regalia, performed traditional ceremonies and gave eloquent speeches in their own language when they greeted the governor general, Lord Byng, on his arrival in their territories during his tour of the Skeena region in 1925. They could easily have been invited to attend and enhance the opening, in a manner similar to that seen in the United States when the Pueblos came to New York.[73] Of course, this was not possible. Any such performance would have violated the legal restrictions on Native dancing. Further, such ceremonies would also have exposed yet another lacuna in what Hobsbawm would call the invented traditions of the Canadian: the lack, despite Gibbon's efforts, of any coherent set of national ceremonies or rituals that could engage and unify the entire population.[74] Indeed, given Native presence in public displays in Calgary and Banff, the addition of West Coast groups would have established a spectacular network of ceremonial activity extending across western Canada that would have required a complete reassessment of the role of Native cultures within the Canadian national identity. In short, the diversity of the Native material and the suggestion that it constituted a visual culture that permeated every aspect of its people's lives made it appear that the exclusive investment in painting was focused too narrowly. Insofar as Canada aspired to recognition both at home and abroad as an autonomous nation with a distinct and singular identity, more attention should have been paid to the wider model of Scandinavian nationalist arts, or for that matter, to the model provided by the Native material in the exhibition. Depending on landscape paintings derived from an imperial tradition for a distinct national identity was an audacious experiment, and in the end it excluded far too much to be a stable construction, let alone to contain the unruly elements, such as the Native populations, that it hoped to encompass or supplant.

Burdened by the weight of its assigned responsibilities and undermined by divisions among its organizers, the *West Coast Art* exhibition failed to

reach its goals of closing up ruptures within the discourses of national-
ism and of the Indian's disappearance, which had formed the foundation
for the new Canadian identity and which by 1927 seemed threatened on
every side. Although the Group of Seven received affirmation at the impe-
rial centre, which saw itself reflected in the Group's work, the Group
was, in short, incommensurate with the nation as it stood. The Native
and the native were not to be easily reconciled, and the "narration of the
nation" was opened up to new possibilities, but only after the old positions
had broken up or had themselves disappeared. In the period immediately
following its closing, the exhibition was of little consequence, at least in
Canada. No follow-ups occurred. In fact, precisely the reverse was the
case. As has been seen, requests for the exhibition or for parts of it by
a variety of institutions both at home and abroad were denied and the
Group's work substituted instead. It would be many decades before the
NGC could ever allow itself to admit anything done by a Native artist.
From this point forward, Native art was not art, at least as defined by the
nation's arbiter of national art, until the mid-1980s.

Chapter 10: The Downfall of Barbeau

DESPITE THE FAILURE of the exhibition *Canadian West Coast Art, Native and Modern* to engage the National Gallery of Canada (NGC) in securing a place for Native art within the narration of the nation and the formation of a Canadian identity, Marius Barbeau still had another project that could salvage something of his position, namely the publication of his next book. Writing the text and selecting the images for *The Downfall of Temlaham* were fairly straightforward tasks. But, of course, the tactics employed by Barbeau were more complex, as dictated by the exigencies of his own historical and cultural situation, as he perceived it. Remaining consistent with his strategies to this point, Barbeau relied on his authority and knowledge from his years of study in order to create a convincing discursive framework using both text and images that would counter claims to cultural continuity by the Gitxsan themselves or by anyone holding an opposed ethnographic position. At the same time, he confirmed the fragmenting discourse of disappearance and consequently the correctness of the state's position on Native peoples. As this had to be seen as occurring naturally, the continuing suppression of Native ceremonies and land claims by the state is never mentioned directly. These points had to be given an indisputable closure. The finished product had to serve as the final mediation between the Gitxsan and any non-Native persons who might wish to know more about them but who would never have actually spoken with them or visited the Skeena area.

The ambitions attached to the project demanded innovations. Barbeau chose a method that diverged from his normal ethnographic practice. His book *Indian Days in the Canadian Rockies* had been too crude and blunt in its rhetoric and dry in its presentation to be broadly engaging. A more nuanced and seductive approach was necessary. He seems to have decided

that it would be good if the message could be delivered in a manner similar to that employed in Duncan Campbell Scott's poetry – that is, if it appealed to the sentimental emotions through the tropes that were the staple of Edwardian popular literature. Or as Barbeau would have it, the message had to partake of the new genre that he had proposed in *Indian Days*, which recounted the tragic history of the extermination of a race on which great national arts and identities were founded. Although such a "poetic" or "artistic" approach would lift the text out of a strictly ethnographic format and require the author to adopt a literary mode that could test his competence in an unfamiliar genre, there were many advantages to recommend the experiment. A full investigation into the complexities of the relationships between the Gitxsan and colonial presences would not be required. The necessity of providing unavailable facts to support his position or of having to account for contradictory evidence or alternative and conflicting discursive formations, such as those emerging from the United States, could be avoided. Such an approach could also address and reach the widest possible audiences and convince not only a scholarly, but also a popular, readership.[1] This approach would form a model for demonstrating how Native material could lose its original context and now be adapted by non-Native artists as the basis for a national art, which could claim an autochthonic foundation but also be one based on the cultures of dispossessed peoples who had disappeared and who had ceded, rather than maintained a connection to, the land. But especially, this approach would obviate the need to take an openly adversarial position and to expose the nature of the state's position. Indeed, it would be better if the author and the text could be identified as sympathetic with the Gitxsan. It would be so much the better if the underlying assertions of the text could be made to appear as part of their existence from the very beginning – that is, as always already inscribed in the Gitxsan's destiny through a process of mystification. Indeed, it would be best if the Gitxsan could be made complicit in the process and could appear to speak to and confirm this position themselves through their mythology and history, a process that Barbeau had developed with only partial success in *Indian Days*. It would be necessary, then, to usurp their voice and recast their complex history of resistance, negotiation, accommodation, and survival, restructuring it in a simpler and convincing narrative of capitulation, defeat, and disappearance. This would, in fact, be Barbeau's stratagem: to invert the evidence before him that spoke to cultural continuity and to the validity of the Gitxsan's claims – that is, to the survival into the present of their

traditions as invested in the stories (*adaox*) that he had collected as well as in their history of resisting pressure to abandon their traditional cultural practices – and to use both their stories and their histories as a means of demonstrating the discontinuity, decrepitude, and destruction of Gitxsan culture. It was a tactic that he had already employed and would turn to again on more than one occasion. Insofar as it confirmed what most of his audiences already "knew" to be "true" and did not challenge any fundamental beliefs, success was assured.

The *Downfall of Temlaham*, then, was highly innovative and unique in its place in literary forms. It followed the lines of *Indian Days* but was more structured and focused. It was composed of several sections that combined a highly fictionalized pseudo-history with loose interpretations of three Gitxsan myths. As will be shown, the history and the myths had a tactical relationship, or as Barbeau would say, the latter were "corollaries" for the former. In fact, he conflated the two through a series of parallelisms so that history became myth and myth became history. The timeless was thus confused with the temporal, or to put it another way, the synchronic became the diachronic. One might call this the "myth-use" of history. Although this ingenious approach violated the principles of both myth and history, it had its advantages. Barbeau used it to account for both the origins and the end of the Gitxsan and to make one foreshadow, naturalize, and mystify the other.[2]

Barbeau gave priority to history. The first and longest text in the book, "Kamalmuk," recounts the so-called Skeena River Uprising, or Rebellion, through the story of "Kitwancool Jim." Composed of three "Parts," each divided into four or five sections, it occupies almost two-thirds of the book.[3] The choice of this particular history was crucial to Barbeau's position. It was widely recognized that the Kitwancool Jim episode had served as a nucleus of resistance for the Gitxsan peoples and as a demonstration of the failure of the Western system of justice. Further, it had provided a justification for the Kitwancool people to forcibly prohibit intrusion into their territory while maintaining their jurisdiction over it and over their own culture and histories, efforts that Barbeau had experienced firsthand.[4] In short, the episode was emblematic of both Gitxsan resistance and the success of this resistance. The story of Kitwancool Jim countered government policies on several fronts. If these were to be validated, the story had to be resituated and renarrated in a manner ensuring that its "truth" testified to a precisely opposite reading and that this reading supplanted the one already in circulation. Historical accuracy was, then, not

Barbeau's aim. Rather, his narrative unfolds around the basic elements of the record but takes place through a series of highly embroidered incidents that Barbeau has freely invented. Although the outcome is already known, Barbeau gives the plot its own complexity to accord with his own interests. His version hinges on the elaboration of a subtext involving the conflict posed by the confrontation between a set of opposing and irreconcilable, but uneven, dualities: Gitxsan traditions and an invidious and invasive non-Native colonial culture, over which the Gitxsan are powerless and "whose superiority in most ways proved so overwhelming."[5] Not unpredictably, the major theme that develops is the fracturing of Gitxsan society over whether to respect tradition or to adopt non-Native ways.[6] The two approaches are posed as mutually conflicting and exclusive. No compromise, accommodation, or negotiation between them is considered. Despite Barbeau's awareness that other possibilities exist, contact is treated as a fatal form of cultural contagion. The eventual and tragic outcome, following a period of strife and confusion while the old ways still persist, is deemed inevitable.

Barbeau's major theme, in which he puts these dualisms into play, is embedded in a set of parallel domestic, socio-political, and cultural disputes that structure the narrative according to the Western literary conventions. Befitting Barbeau's amateur status in literary endeavours, the product is something of a pastiche. His characters are in general reduced to broad stereotypes and somewhat crude allegorical functions and their simplistic motivations are rendered through stilted and sentimental dialogue that parodies Gitxsan oratorial style.[7] Since these free "interpretations" of the characters, their voices, and the events are invented by Barbeau and make up the main part of the narrative, it is best to treat his account of the events, despite their historical base, as a fiction clearly meant to be instrumental in shaping the reader's vision of its subject.

Sunbeams (Fanny Johnson), who initiates the story, allegorically personifies the continuity of Gitxsan culture. She is portrayed as haughty, excessively proud, and ambitious; that is, she suffers from the fatal flaw of hubris, a familiar trope for Western readers of the tragic. Her son is the instrument on whom she depends to see her vision of the past perpetuated. He occupies the position of the potential and future of their culture. He is described as "puny" and "feeble." His decrepit state naturalizes Barbeau's vision. His untimely death by measles, a fatal disease introduced by contact, foreshadows the inevitable future of Gitxsan culture and brings about the conflict upon which the story is based. Conversely, her husband,

Kamalmuk (Kitwancool Jim), whose double name signifies his conflicted and hybrid position, sees into the future and wants to adopt the ways of the "White Man," who is "now penetrating the country on all sides." He believes that Gitxsan "custom was the idiom of an age already out of date, now on the wane everywhere; its discredit would soon be complete, final ... The triumph of the white people, the Ramkseewahs, over native primitiveness and reluctance spurred him to novel emulation ... [while] confronted with decrepit advisors who preached tradition to him."[8] He is described as "open-minded ... strong and optimistic." In short, he is heroic, even if his heroism is based on the rejection of tradition and on the welcoming of the non-Native, whom he recognizes as superior in every way, rather than based on a resistance to the interlopers. His characterization sets up a number of dualistic contrasts between himself and his wife and child, the one looking forward, the others backward; the one strong, the others decrepit; the one inviting modernity and the inevitability of the triumph of non-Native ways, the others remaining "primitive" while resisting the inevitable and clinging to the past; the one noble, the others culpable; and so on. However, being Gitxsan, all occupy tragic positions. Giving in to the relentless incitations of his wife to avenge the death of their son, he murders a rival whose witchcraft his wife blames for their son's death. His fatal flaw, then, is that he is incompletely assimilated.[9] Listening to these exhortations, he resorts to and validates this traditional method of justice, thus violating his innate heroic and prescient vision. Having turned against his own better judgment, he is doomed. This transgression of his integrity results in the string of events that lead to potentially fatal divisions among his people. However, these fractures are, at first, healed and resolved through traditional procedures.

All would be well and tragedy averted, except that the episode invokes a greater conflict. Contact and consequently cultural contagion intervene. Kamalmuk's action brings down the non-Native justice system, which Barbeau poses as the fatal opposite of Gitxsan traditions. White officialdom, portrayed as both anxious about its precarious hold on the region and easily manipulated and inflamed by unscrupulous interests into believing that a full-scale revolution is at hand, feels the need to assert its authority and to bring Kamalmuk to trial. To avoid prosecution for an affair that has already been settled by Native methods – that is, to take recourse in tradition and thus again violate his principles – Kamalmuk goes into hiding. He successfully eludes capture but is finally tracked down by white authorities and shot dead under questionable circumstances. By

portraying the non-Native actions as less than noble and possibly criminal. Barbeau appears to take the side of the wronged fugitive. However, his real purpose is to clinch his position while appearing sympathetic since the deaths of Sunbeams' son, her rival, and Kamalmuk combine to signify the inevitable death of Gitxsan culture and peoples, even those who would attempt a transition to assimilation.[10] And here, the narrative most seriously departs from the historical record, which Barbeau knew to be far more complex, nuanced, and problematic than his rendition.

Barbeau was, in fact, aware that his audience would have been familiar with other versions of this history, for which he would have to account. Thus he also reported that years after the recounted events, the outside interference had not been forgotten and that resistance persisted. He concedes that when an Indian Agent came to survey the area for the purpose of allocating reserves, he was humiliated and forced to leave without completing his task (not unlike Barbeau's own experience). Barbeau, then, is aware that this history, which he has made into a symbol of the downfall of the Gitxsan and emblematic of the futility of their attempts to hold on to their culture, is also the point of their resistance. The same history signifies their success both in maintaining their culture and identity and in staking claims to their lands into the present. Once this precarious and ambiguous point is brought up, it must be resolved without question. He attempts this by dismissing the event, by placing it in an already forgotten past, and by making its proper resolution inevitable. At the end of the chapter, Barbeau concludes that "the Kamalmuk episode is now sinking into the quicksand of tribal recollections; it forms a chapter by itself in the obscure annals of native Canadian races struggling against fate without a ray of hope ... It forms the last page of ... the earthly paradise of old lost long ago to a sinful race of man." The final sentence is most telling because it both links the historical incident to his rendition of the mythic origins of the Gitxsan, thus naturalizing the events and inscribing them in Gitxsan culture from its beginning, and absolves of all responsibility any aspects of the state's policies, such as the potlatch ban, the prohibition against payment for legal assistance in land claims, and the imposition of residential schools, none of which he mentions. But even at the moment of telling, the situation will not allow narrative closure and remains ambivalent. He adds, hinting at his own experience: "No White Man to the present day can set foot unmolested on the tribal domains of the Kitwinkul natives, domains that stretch spaciously around the lakes and beyond the mountains from Kitwanga northwards to the Nass. That

promised land, which prospectors, hunters and ranchers have coveted for a generation, is still ... an Indian country, effectively guarded – perhaps the last unconquered native stronghold of the Red Man in North America." Nevertheless, although deferred, closure is again said to be inevitable, occurring when "the last of his race has died off or surrendered to foreign domination," these being the only alternatives for the future. The possibility of cultural continuity is foreclosed and finality achieved.[11] The survival of the Gitxsan is obviated. Indeed, the remaining three sections and the illustrations ensure that the ambiguous and ambivalent situation is already overcome from the very beginning.

How, then, did the choice of the thirteen paintings that accompany the texts relate to them and to each other? That is, how did they both confirm or problematize Barbeau's message? Of considerable significance was his decision to use paintings by non-Native artists rather than photographs of the Gitxsan village sites, peoples, ceremonies, traditional regalia, or totem poles, of which he had a great supply and which might better have served the purpose of illustrating his subject. This decision ensured, from the outset, that the book would announce the disappearance of the cultural life documented by any photographic record and its replacement by the work of contemporary non-Native artists who were using the region and the reterritorialized area, with its repossessed totem poles, peoples, and paraphenalia, as the proper subject of a new and modern Canadian art. The paintings, then, proclaimed Barbeau's and the National Gallery's assertions that Native art and culture had been replaced by that of the Canadian nation, which now claimed the land, and that the voice of the Gitxsan had been silenced, except as it existed through non-Native writers.

Given that the paintings used in the book were done independently of its writing, although in collaboration with the author, the thirteen illustrations seldom correspond directly to incidents occurring within the four stories that are narrated. However, important parallelisms indicate that both the individual paintings and their placements relative to one another and to the text were chosen with far greater care than in *Indian Days*, where the selection of illustrations had been left to Langdon Kihn. In fact, the paintings tell a parallel narrative. Of the eight that accompany "Kamalmuk," Kihn's works would be the most problematic. They had already been proven to be open to alternative interpretations and a conduit through which disruptive discourses could enter. One way of dealing with this dangerous possibility had been to limit their exposure and to replace Kihn with other artists who were more in line with Barbeau's

position. Nonetheless, a certain, if substantially reduced, number of his works still had to be accommodated. Since Kihn's paintings would receive their highest visibility here in something approaching a permanent exhibition, it would also be necessary to frame them and to discipline their interpretation in a manner ensuring that the proper and restricted message was conveyed and that any ambiguity was eliminated. The book opens with four of his works, the first two of which are landscapes. *A Feast among the Skeena River People* forms the frontispiece. This fantastic and composite image is one of two works depicting totem poles from several sites together with houses and costumed figures. The first page of the story is accompanied by one of his two images of the poles at Kitwancool, which is something of a fantasy. These are followed further in the text by a portrait of a male elder, *He-Knows-the-Sky, Alimlarhae, an Old Chief of the Skeena*, shown in a button blanket and Chilkat hat decorated with abalone shells (see Figure 24). He plays no role in the story and seems to be included as an image of the state of traditional culture. He is followed by an equally elderly image of *Sunbeams*, who was still living at the time of Barbeau's narrative (see Figure 25). She is shown, as has been previously said, with her crests and regalia. The four works show a people in full possession of their culture, their art, and their ceremonies, which the text recounts in detail. If the initial conception of the book had gone forward, more of Kihn's pictures of a vibrant, continuing culture seen through individuals displaying traditional regalia, combined with his portraits set in a modern context, as had occurred in *Indian Days*, would have followed throughout the book. However, this would have conveyed a message that openly contradicted the fundamental premise and purpose of the text, which accounts for the disappearance of these people rather than for their presence. How, then, were these disruptive and excessive possibilities to be stabilized and contained? Their position within the overall text assisted in this. Although given pride of place at the beginning, this also situated them at the start of the historical narration; that is, they were given a chronological significance as well as a cultural role. This position made them exemplars of the past that Barbeau was recounting, which had been lost. As in his other textual framing of the works in his articles, they were made to appear retrospective rather than contemporary. Sunbeams' and Alimlarhae's great age, then, also served to fix them in the past. Barbeau avoided using any of the portraits at his disposal that might better have shown the characteristic regalia, such as the portrait of Earthquake, but that also depicted younger individuals, who could be seen as carrying Gitxsan culture into the present and the future.

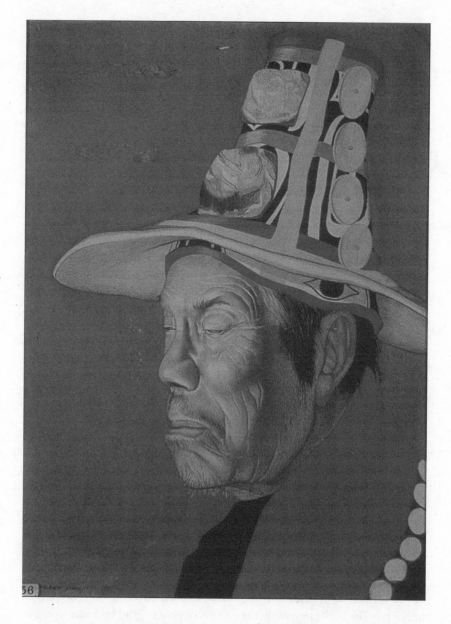

FIGURE 24: W. Langdon Kihn, *Alimlahi Waudee of Kisgahast*, 1925, coloured pencil on tinted board, 54.3 x 41.7 cm.

The second means of ensuring the stability of Kihn's works was to have them substituted with those of other artists whose vision was more in keeping with Barbeau's and the state's position. His works, then, are immediately modified by the next three images chosen for this section, namely Jackson's sequence of village scenes. These open with *Git-Segyukla, on the Upper Skeena*, a view of the village from across the river showing a row of totem poles and houses set in a larger landscape. Although this illustration still depicts aspects of traditional culture, people in traditional regalia performing illegal ceremonies are absent. This is also the case in the next illustration, *Kispayaks Village – The Hiding-Place – on the Upper Skeena*. Both villages play a role within the story, but their main purpose here is to serve as a transition to the third and final painting chosen from Jackson's limited oeuvre: *Spukshu or Port Essington, a mission village, at the mouth of the Skeena*. The work shows a coastal canning village that is over one hundred miles from Gitxsan territory, again from across a body of water. It is in stark contrast to the previous images by Kihn and Jackson. A white Christian church is set prominently in the middle of the composition, behind a boardwalk, and flanked by a row of colonial dwellings. No totem poles of any type are present, nor are Native dwellings.[12] Almost all signs of the Indian, except for a few canoes on the beach, are absent. There are no figures. All of this raises the question of the work's role in the narrative since it entirely excludes its purported subject. Why was such an unrelated image chosen when others by Jackson, despite his failure to turn his sketches into finished works, were more appropriate to Barbeau's subject? Why not choose the image of Kitwanga? Why not choose a work by another artist? Tactical considerations obviously took precedence over establishing a simple unity of place. To understand how the chosen image served these considerations, its geographic location and its position relative to both the text and the other illustrations must be considered in combination with its place in Jackson's oeuvre of works that were available. *Spukshu* is closely related to *Indian House* (discussed in Chapter 8), which was also painted in Port Essington. The background of the preliminary oil sketch for the latter is the same as the scene depicted in the former. Eliminated in the finished *Indian House,* it was recaptured in *Spukshu.* In both, however, the Indian in general and by extension the Gitxsan have either disappeared or faded into the Canadian Christian and capitalist scene of the canning village. Indeed, little separates this image of Port Essington from many other Jackson paintings of Quebec, Maritime villages, or other Canadian sites, except its title. It is, then,

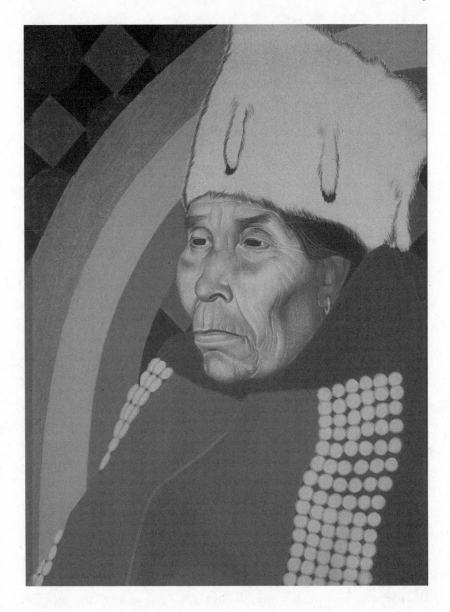

FIGURE 25: W. Langdon Kihn, *Hanamuh Kisgahast of Kitsegukla*, 1924, coloured pencil, gold metallic paint, silver metallic paint, ink on tinted board, 54.3 x 41.6 cm. Depicts Sunbeams / Fanny Johnson.

a pendant for *Indian House,* which does not appear in the book, and carries much of its meaning. The inclusion of either image was necessary to the subtext of the book in that they both demonstrated the loss of Native culture on which the text hinged and provided the appropriate conclusion to the problems of resistance that Barbeau had to admit still existed at Kitwancool. Although it bore no relation to the story, it was integral to Barbeau's subtext of decrepitude and disappearance.

The second-to-last painting in the section, Holgate's *The Upper Skeena, near the site of Temlaham – the Good-land-of-yore,* immediately follows *Spukshu.* Holgate's scene confirmed the state of contemporary Native culture found in Jackson's coastal community and in the corresponding elements of Barbeau's text but brought the focus back to the Upper Skeena. Holgate depicted an unnamed village, which Gerta Moray has identified as the non-Native community of Hazelton, which superseded the mythic Temlaham.[13] Like *Spukshu,* but opposing Kihn's *Gitksan Feast,* Holgate's image is composed primarily of brightly painted, colonial buildings and is devoid of signs of Indianness; it has no totem poles and has no Native figures to occupy or claim the land. The romanticized title and the image combine with the work's position in the chronology of the text to place the Gitxsan, as seen in the book's earlier Kihn images, in the mytho-historic past and to show them as supplanted by the non-Native, colonial present. The two images serve to confirm that the "dominant" culture had triumphed from the coast to the inland communities, thus supporting Barbeau's key propositions that Native culture had been lost, that the Indian has virtually disappeared, and that their territories were now owned and occupied by non-Natives. The doubts raised by the history itself and any possibility of resistance to this inevitable state of affairs were thus overcome in both text and image. Any anxiety about the persistence and resistance of the Other had been removed.

The final painting chosen to illustrate the story of Kamalmuk seems somewhat ironic. Again done by Holgate, it is entitled *Young Gitksan Mother with a Cradle, at the Edge of the Skeena.* The single figure of the female and child appeared first in Kihn's depictions of totem poles at Kitwancool. In this narrative context, however, she seems to relate more to the figure of Sunbeams, who lost her child and set the whole tragedy in motion. The cradle, in fact, appears empty.[14] There is no future for the Gitxsan.

The three myths that then follow are drawn from the vast selection at Barbeau's disposal. As with the individual paintings, their choice, sequence, and relationships with the first section are strategic. They

include "The Retaliation of Keemelay," "The Painted Goat of Steky-awden," and "The Downfall," which briefly tells of the loss of a mythic Gitxsan paradise named Temlaham. The last, despite giving the book its title, and its theme, is the shortest. Barbeau says that they were "given as a corollary" to the Kamalmuk story; indeed, they have a logical relation-ship to it, when taken within the confines of his purpose to mystify the history of the Gitxsan. They are "freely interpreted and paraphrased" – as was the history that Barbeau recounted – ostensibly as an example of his program to make Native myths the source of inspiration for non-Native writers. In truth, their treatment assisted in the process of collapsing his-tory into myth and making one speak to the other.[15] As with the history, these should not be thought of as direct translations of Gitxsan myths but as instrumental variations and reinscriptions that had a particular pur-pose. Again, the methodologies of myth analysis are eschewed in favour of those used for Western narrative conventions.

"The Retaliation" recounts a mythic story of warfare between two neighbouring villages in Temlaham. The conflict is caused by the behead-ing of a neighbouring transgressor, whose village rallies and attacks the other, resulting in total "death and extinction," save for two survivors.[16] The homeless, displaced, and dispossessed mother and her daughter roam the wilderness in mourning, seeking a suitor who can wreak vengeance on their behalf. They encounter Sunbeams, a powerful *naxnox*,[17] from whom the present Fanny Johnson, the "cause" of the Skeena Rebellion, takes her name. Sunbeams marries the daughter, producing six children, magically rebuilds his wife's ruined village, and destroys her enemies. In this context, a new ambivalence arises but one that is not threatening. The story concludes with the enemy village overcome. At the hands of more powerful forces, which Sunbeams possesses, the initial transgressors are defeated and lose their lands: "They gathered their possessions in haste at night, their last night in the bosom of their ancestors' homeland, the beloved country of Temlaham no longer their own. 'These strange men cannot be destroyed, O the sorrow of our hearts!' they lamented; 'their turn now it is to rule over these domains.' Yielding to the inevitable," they went into exile.[18] At this point, the selection of stories and the manner in which Barbeau presents them take on a parallelism with the present. The mythic conflict with superior powers resulting in the loss of homelands corresponds to the historic invasion of the region by colonial forces.

The paintings chosen to accompany the tale again function both indi-vidually and in sequence to convey the proper message. Because Holgate's

Totem Poles at Git-Seygukla (as the caption reads) shows close-ups of the poles, suggesting Native presence, it is necessarily and predictably separated from the conclusion of the Kamalmuk story and thus from the other works by the artist, which immediate precede it. Placed at the beginning of "Retaliation," Holgate's picture, like Kihn's landscapes, is representative of a mythic past that parallels the historic present. Holgate's next image, *Qawm, "Covetous Person," A chief of Kitsalas, the Canyon tribe*, is particularly macabre insofar as it shows a severed head with eyes closed. The connection between art and text is reinforced through the red highlighting overlaid on the black and white drawing. It is, then, an image more of death than of presence.

It becomes clear from the foregoing that Emily Carr's early paintings of Indian subjects, particularly her images of the Gitxsan, should have posed a host of problems similar to those presented by Kihn's works. Both of her illustrations that were proposed for the book showed Native villages in which the inhabitants appeared to be not only present, but in possession of their culture. Shown together, they could only reinforce each other's messages. This possibility placed Barbeau on the horns of a dilemma similar to what he experienced with Kihn. Both artists were, in many ways, his own discoveries, and their respective depictions of Native regalia and totem poles had led to the inclusion of Native art as art in Barbeau's projects and to the use of the Skeena area as the proper subject of a new Canadian art. Yet the work of each artist alone, and even more so together, could be seen to testify to Native presence.[19] Barbeau solved this problem by limiting the number of Kihn's paintings and critically disciplining how they were interpreted. He would choose the same tactics with Carr. Even though her works were, ostensibly, the most appropriate to his narratives – outside of Kihn's oeuvre – he selected only one of the many that were available to him for inclusion in his book. Of the two works by her that were initially proposed, both of which showed totem poles, houses, and people, only a single image was inserted at this point.[20] Titled *The Totem Pole of the Bear and the Moon, at Kispayaks – the "Hiding Place,"* it shows this elaborate pole together with another, an old-style house, and a group of children. In contrast to Holgate's or Jackson's illustrations, there is little in the way of landscape. Like Kihn's paintings it is problematic insofar as it shows an occupied Native village maintaining traditional ways. In its textual placement, however, it loses its documentary aspirations and joins Holgate's images as an illustration of a mythic past. Further, history

also plays a role here in the painting's affirmation of the Indian's disappearance, for it is the only dated work in the book. Her signature, with 1912 written beneath, is clearly visible in the reproduction. Carr's image becomes, like those by Kihn, which it predates, nostalgic and retrospective. Both the Carr and the Kihn illustrations, through their placement in the text and their relationships with the other images, are made to point to either a historical or a mythic past and to show how things had been in contrast to how things were when the book appeared.[21] Nonetheless, this textual disciplining could still leave room for ambiguity. Given the pattern established thus far, it is also predictable that, as with Kihn's images, Carr's work could not stand as the last word and would require a contrasting corrective.

The last two successively shorter tales are "The Painted Goat of Stekyawden" and "The Downfall." Barbeau made them sequential, with the second emerging as a later episode. In the first story, a "sinful" transgression against the rules for hunting and disrespect for the game results in retribution by the abused animals, a tribe of mountain goats, and the death of the community, except for one survivor, who acquires the single-horned mountain goat as a crest. In the second and final tale, occurring generations after the first, the transgression of the first salmon ritual results in a period of famine and the final loss of Temlaham: "The former land of bliss and plenty had ceased to be. It remained a barren prairie, forever desolate, forever accursed."[22] The survivors were then dispersed. Once again, the themes of dispossession, displacement, and disappearance are played out in mythic terms and made to parallel and predict the "inevitable" fate of the Gitxsan in the historical future.

The last painting in the book, which accompanies these final two tales, was done by Anne Savage. As previously stated, Savage painted a series of landscapes, including an image of a village with totem poles. However, this was not the work selected by Barbeau for *The Downfall of Temlaham.* Instead, he chose a small panel study depicting a wandering river drifting into a distant, melancholic, and idealized valley flanked by towering mountains, with not a soul in sight. McDougall indicates that this variation on the "empty landscape" was known as *Hills on the Skeena.*[23] Within the context of Barbeau's text, it took on a new title and a supplementary meaning. Barbeau retitled it *Where the Native Paradise Lost of Temlaham Used to Stand (near Hazelton).* It serves, in direct contrast to Carr's inhabited village scene as an appropriate coda that brings Barbeau's parallel themes to

a close. If interpreted as a site of the story of mythic Temlaham, the empty landscape shows the loss of the Gitxsan paradise, a tragedy that occurred, the reader has been reassured, through a fatal flaw in the essential character of the people that paralleled Christianity's original sin. At the same time, if it is taken as a contemporary image, it shows that the Gitxsan are now absent, having been expelled in the present. The emptied landscape has been reterritorialized, a fact made clear by the reference to the non-Native village of Hazelton rather than to any Gitxsan village. In either case, neither the Indian as a generality nor the Gitxsan specifically maintain their lands, their cultures, their identities, or their existence either mythically or historically. The inexorable process of disappearance and dispossession has been reified, mystified, and finalized both in the sequence of stories in the text and within the sequence of the illustrations.

This would have been even more clearly established if, as in the tentative list of illustrations for the book, Frederick Alexie's *A View of Port Simpson, a fort of the Hudson's Bay Co., and a Battle between the Haida and the Tsimsyan* had appeared here.[24] Alexie's "primitive" image, although completely unrelated to either the historical or the mythic aspects of the text, would have made several points. First, it would have shown that the traditions of Native arts had been lost and that Native artists were unable to fully apprehend Western conventions – that is, that complete assimilation was not a viable option. In addition, the choice of this particular image from those available by Alexie would have graphically demonstrated Barbeau's theory that intertribal warfare was responsible for emptying the landscape of indigenous peoples. Lastly, the image of the stockade would have confirmed the reterritorialization of the area and the right to colonial possession by the Hudson's Bay Company through its conquest of the region. As was stated earlier, however, Barbeau decided to keep all Native artists out of the publication.

With the final images in place, the purpose of the choices made in composing this book, which would define the Gitxsan for a broad readership, becomes clearer, as does the purpose behind Barbeau's project to bring artists to the Skeena to paint the region. Both artists and text were enlisted in his larger genre, which he had outlined in *Indian Days* – that is, the painting and writing of the tragic tale of a disappearing people, which needed artists and writers such as himself and those whom he enlisted to bring the story of death to life. The parallel narratives played out in the illustrations and the text reinforce each other in that they recount a double loss in which the mythic past is conflated with the historic present. The story of Temlaham, which recounts an expulsion from an origi-

nal Edenic Gitxsan paradise, is extended into the Gitxsan's loss of their culture and lands after contact. In Barbeau's narrative constructions, the Gitxsan are doubly damned. *Temlaham* was no more a popular book with certain academic pretensions designed to introduce a nonscholarly audience to a Native culture than the paintings by Jackson and the others were simply part of a new broader Canadian identity that had found a new area for expression. Rather, the texts and images worked together to reaffirm disappearance. The selection of myths and the specific histories recited as well as the careful choices about which illustrations to include or exclude and where to place them all played key parts. Barbeau had brought a variety of disciplines to bear on the project, whose character went well beyond the concept of hybridity. He had joined ethnology, mythology, and folklore studies with history, literature, and artistic practices in order to construct an all-encompassing framework in which the central message of cultural loss could be continuously circulated and endlessly reproduced.

As has been shown, Barbeau recognized that the purported loss of Gitxsan traditions was accompanied by the loss of their land claims, a point that was always avoided in justifications for the potlatch ban but that must have always been tacitly understood as one of its primary, if unspoken, motivations. Nonetheless, Sunbeams (Fanny Johnson) makes this motivation explicit: "In default of public gatherings in the house of festivals to sanction exchanges and promote advancement, what happens? Our customs come to the ground with a crash. No longer do we inherit our crests, our uncle's property, and their hunting grounds."[25] The theme of ownership of the land is taken up again in the middle of the historical story and recurs throughout the myths.[26] Thus, given the unspoken existence of the potlatch ban – which Barbeau never mentioned since this would have undermined the mystifying play of fate – the stories are also testimonies to the Gitxsan's forfeiture of their territories, despite the resistance of the Kitwancool. In this sense, both the ability of the picturesque landscape paintings to claim the lands that they depict and the history of British landscape painting as a site of displacement become most pertinent.

The book closes with a question posed by Barbeau in the guise of a Native speaker: "What is Temlaham to-day, what is it to us, who live on reserves conceded by the Ramkseewah, the White Man?" He answers:

A legend of the past, a barren stretch, two miles below Hazelton on the Skeena, a place which we still visit at times, when we are sad at heart.

The white usurper has staked most of our preserves for his own use and barred off our approach.

Some of us protested bitterly when the very site of Temlaham was taken away from us by three white men, over a score of years ago. The land, then, was opened up for settlement. We tried to resist the spoliation; only to be sentenced to a term in gaol for our punishment. Temlaham, even though only a forlorn symbol, was no longer ours.

This is followed by a dirge whose last lines are "Must there be only an end, O Powers above? Algyah, algyah, algyah!"[27] Important here, once again, is the claim that the Gitxsan have been defeated, have accepted the reserve system, have given up their lands, have become powerless and voiceless, are at the mercy of the non-Native judicial system, and are at the "end." They verge on an extinction that, from their very origins, has always already been embedded in their own myths. External factors are of no consequence here.

It was no coincidence that the book was written and illustrated precisely when the Gitxsan were, in fact, still actively resisting the reserve system and pressing their land claims, when they were the closest that they had been to succeeding, and also precisely when Native numbers in Canada were, despite all efforts by the Department of Indian Affairs, on the rise. Nor was it a coincidence that it appeared just as the program of totem-pole restoration and the project to have artists "invade" the territory were failing, two undertakings intended to represent the Gitxsan and their culture within a new context that would demonstrate them as already gone. Nor is it unimportant that the book appeared when alternative and opposing discursive formations on the state of Native cultures and their role in forming part of modern national identities were arising elsewhere. That the message of an already determined fate was produced and distributed just when the federal government was enacting legislation prohibiting Natives from hiring legal counsel to pursue land claims must also be regarded as more than mere coincidence. The actual state of affairs would easily have given the lie to the book's message. But for many who had no direct knowledge of the Gitxsan and who relied upon Barbeau's authority or who were convinced by the rhetoric of his subtexts, his "telling" of the Gitxsan's history would have been their sole account. Indeed, as recent court cases have pointed out, the notion of Gitxsan dispossession is still firmly embedded in non-Native perceptions.[28]

Nonetheless, the book was to be the last gasp of Barbeau's ambitious plans. After this point, his initiatives, as formulated and enacted throughout the 1920s, began to crumble and disappear. With some literary irony, *The Downfall of Temlaham* was to be his "algyah, algyah, algyah." Still, the program to send artists to the Skeena did not, in actual fact, immediately cease with the publication of his book, although from this point it did wind down. In the summer of 1928 two more artists travelled to the region: Pegi Nichol (later MacLeod) and George Pepper. Nichol had already gone west in 1927 as far as Alberta through the joint recommendations of Barbeau, Brown, and Scott. Barbeau clarified the collaboration of these three men, whose relations at this point were still harmonious, in his recommendation of Nichol to John Murray Gibbon of the Canadian Pacific Railway.

> Mr. Eric Brown, Dr. D.C. Scott and myself are very much interested in a young lady here, whose name is Pegi Nichol, who is a very successful young painter. Kihn had admired her talent when he was here and she is a special friend of the Brown's and the Scott's [of whom she did portraits] ... She would like to go out west on an Indian Reserve to make portraits of Indians. I think that Morley Reserve would be a good place for her ... Mr. Scott would facilitate her stay there. She would in all likelihood bring back a number of good portraits and landscapes which might be of use to you and to us in our Rocky Mountains exhibition next autumn and winter ... If you come to Ottawa very soon we would manage to have you meet her and converse with Mr. Brown and Mr. Scott about her.[29]

Although a number of the Stoney portraits from 1927 were included in the exhibition *Canadian West Coast Art, Native and Modern*, it was Nichol's trip into the Candadian National Railway's territory the following year that proved most fruitful. She recorded her experiences almost immediately and in some detail. Her direct impressions, which she published in the *Canadian National Railways Magazine* in 1931, are of value insofar as they confirm the structure of the program and the position of those working within it and record further signs of the change in the attitude of the Gitxsan to being represented by non-Native artists. In her article, she announced that she was "coming out to paint Indians" and stated her reasons, motivations, and opportunities: "Primed by four, or five years on portraits of the west coast people by Langdon Kihn and others, carvings

on poles [etc.] ... seen in the museum and, as a latest addition to my
interest, the reading of Marius Barbeau's book, *The Downfall of Temlaham*,
on the train, I was excited."[30]

She provided significant details of other aspects of her trip. First, she
reported the collaboration of the National Museum and the railways in
using the Natives, but more specifically their totem poles, as a tourist
attraction for the Skeena route. Like Jackson and Holgate, she saw herself
as an agent of both museum and railway, noting that at Kitwanga "pas-
sengers on the Canadian National Railways travelling to the West Coast
are allowed to disembark." She also noted the program initiated by Bar-
beau to bring artists out to the Skeena region to create a "Canadian" art
based on the Natives of the area. As with Jackson and Holgate, contact
with Barbeau predetermined her reception of her subject – that is, she
accepted Barbeau's version of the state and history of the Gitxsan. But she
also reported, more than Jackson or Holgate, the growing resistance on
the part of the Native population to the project to paint or represent them
as well as their growing awareness of its full significance. Indeed, the sus-
picion encountered by Jackson had increased. A recommended subject,
Mrs. Laknits, refused to sit: "'Blanket or not, 50 cents an hour or not,
friend of Mr. Barbeau or not,' she said, 'I receive no benefit and my people
laugh at me.' That's all she said but appeared to be thinking a lot more."[31]
Nonetheless, Nichol did manage to procure some sitters. These consti-
tuted the bulk of her work: "The paintings [Nichol] MacLeod did in the
West are basically portraits of Indians ... She reused her only extant can-
vas of totem poles as the back of one of her paintings in the Canadian War
Museum."[32] Nichol and Pepper were among the very last to take the trip
as part of the overall program to create an image of the Skeena and the
Gitxsan that would include them in a new Canadian identity. Dyck has
pointed out that "John Byers, then assistant to Arthur Lismer, travelled
[to] the coast in 1928," that "Toronto artist Lowrie Warrener (1900-83)
visited Gitxsan territory in 1931," and that "Parisian painter Paul Cozé
also travelled westward."[33] Of these visits, however, Emily Carr's return
to the Skeena in 1928 produced the most significant, and problematic,
body of work.

Chapter 11: Revisiting Carr

EMILY CARR'S EARLY and late images of the Native peoples and villages of the West Coast occupy a unique, parenthetic position in the context of the previous chapters. Her initial trip to the Gitxsan communities of the Upper Skeena in 1912 corresponded to the first phases of the project to link the two discursive principles on which the national vision came to be based – that is, the disappearance of the Indian and the empty landscapes of the Group of Seven. At that time, she would not have been fully aware of either. Carr's "discovery" fifteen years later occurred when the realization of these principles was heralded as being at its apex. However, as has been seen, this was also the period when it became evident that they were under threat. When she returned to the region in 1928 and took up the subject that she had more or less abandoned for the previous decade and a half, she was deeply immersed in these discourses through contact with the institutions and individuals by means of which they circulated. Her later works were, then, separated from the earlier ones by both a temporal and a discursive gulf.

Gerta Moray has shown that Carr's early works of Native subjects, done primarily between 1908 and 1913, took part in, but also resisted, the widespread perceptions of the Indian of the time. Moray has clearly established that Carr's peopled images of the Skeena villages from her first trip spoke of both presence and disappearance.[1] Like Kihn's works, they were ambiguous. These problematic possibilities should have provoked a predictable set of responses when the works were taken up by state institutions in 1927. If the practices and policies used with Kihn and the Group of Seven were applied consistently, we should expect that the interpretation of Carr's early productions would also be subjected to critical disciplining to make them fit within the changing context and

to stabilize their meaning within an acceptable form. As already shown, this was the case when one of her works was incorporated into Barbeau's *The Downfall of Temlaham*. More contentiously, her paintings representing Native peoples would be withheld from exhibitions representing Canada both at home and abroad and would experience a certain resistance from the National Gallery of Canada (NGC) in collection and display. Further, and even more problematic, an alienation from Eric Brown and the Group, discouragement from pursuing her Native subjects, and pressure to move to the format of the empty, picturesque landscape should also be expected with Carr. However, most of her biographers have presented narrative structures in which, after 1927, she is promoted by Brown and the NGC and embraced and encouraged by the Group of Seven, whose members are portrayed as generously including her within their ranks as a western member. In these narrations, her paintings of Natives, both early and late, were accepted without reservation. This is followed by her own "breakthrough" and discovery, through the influence of the Group, of her true métier – that is, her subsequent abandonment of her Native subject matter and her turn to landscapes featuring the distinctive forests and shores of the West Coast, which became part of the new national Canadian image. Nonetheless, a careful reexamination of the events after the 1927 exhibition *Canadian West Coast Art, Native and Modern* indicates that an alternative reading of the record is possible, one that accounts for several important anomalies that disrupt the interpretation and that have had to be overlooked or obscured. What actually transpired was probably less harmonious and more conflicted and is understandable only within the context of the prevailing discourses and the necessity to police their boundaries at this crucial moment.

The first clear sign of Carr's engagement with these new discursive frameworks occurs in the profound shift in her representation of her Native subjects. Immediately after the *West Coast Art* exhibition, she went back to the same Skeena villages that she had visited over a decade and a half earlier, which this time also included Kitwancool, as part of another, larger tour. However, things had changed since her first encounter: the territories, villages, and poles of the Gitxsan people, as well as their culture, had become the focus of a multitude of interlocking institutions and disciplines. These were jointly engaged in creating, reproducing, and disseminating a discourse around a new, virile Canadian national identity that was placed in opposition to the representation of the Indian and Native cultures, which were portrayed as being in a state of decrepitude,

disappearance, and death. Before Carr's return to the region, Barbeau was her primary source of information about the Indian. Since hearing him speak in Vancouver, where he presented his concept of Native disappearance, she knew and recognized him as an authority on the subject. Much of what he said would have been confirmed by others.[2] She would have heard few alternative voices.

Carr's encounter with this discursive framework deeply affected and altered her vision of her subject.[3] If her early imagery had been partly engaged with, but also resistant to, disappearance, her later work was more fully absorbed by it. This is demonstrated by the quantifiable, but largely unaccounted for, difference that separates Carr's earlier work from her Native paintings done during and following her second trip. After 1927 the Native is absent from her paintings of the villages in the Skeena region. In contrast to many of her early depictions, the inhabited Gitsxan sites are now devoid of life, and bear a similarity to her initial pictures of the empty and deserted Haida villages of the Queen Charlottes. While the totem poles, as Barbeau would have recommended, remained part of the artist's vision, the Gitsxan people, to whom she initially dedicated her work and to whom she had often directed her gaze as well as the gaze of her viewers, vanished. The portraits that she had once painted were no longer as numerous, if she did any at all.[4] Instead, the concentration of her Indian pictures from the late 1920s was almost exclusively on the totem poles, set in what appear to be deserted and melancholy village sites. The Indian had disappeared.

This shift in her vision may be seen already in Doris Shadbolt's 1979 monograph on Carr's paintings.[5] None of the illustrations of Native sites that Shadbolt reproduces from the works done between 1928 and 1931 shows a living human figure. Although Shadbolt does discuss Carr's concentration on totem poles as subjects, the corresponding sudden and complete disappearance of people is not seen as cause for comment, even though, just a few pages earlier, she reproduces paintings from 1912 and 1913 that are, by contrast, crowded with figures.[6] Despite discussing the formal changes that Carr's work was undergoing at this time, Shadbolt does not see any significance in the discrepancy in subject.

Gerta Moray is both more precise and perceptive. She states: "Carr's Indian images would, from 1928 on, for the first time within her work identify Indian art as something belonging definitely to the past, detached from the native reality of the present. Carr's return ... confirmed her view that the younger generation of native people were bent on acculturation

and that the traditions of the past were falling into disuse ... Carr's paintings ... make them [Native artifacts] speak for a traditional culture that was disappearing."[7] I contend that this was not simply "her view" but a view that she had adopted after her contact with Barbeau and others espousing the state's official position. The Gitxsan, of course, would have had something else to say on the matter.[8] Shortly thereafter – that is, by 1932 – Carr would abandon the Indian not only as person, but also as subject; totem poles, too, disappeared. In accounting for this second shift toward pure landscape, several figures aside from Barbeau are of significance, including Eric Brown (and the NGC) as well as Lawren Harris and the Group of Seven, all of whom contributed to the further development of the discourses of national identity and the disappearance of the Indian that we have been tracing.

Despite the conflicts that Carr observed at the opening of the *West Coast Art* exhibition, at which time Brown's resistance to the show became evident, she seemed to have a good relationship with the NGC and its director. He praised her efforts and maintained his commitment, made the previous fall, to include a significant number of her early Native works in the 1928 spring show of Canadian artists at the NGC.[9] He also assisted her in obtaining travel subsidies to return to her project of painting Native subjects.[10] Yet, by the summer of 1928, he had begun to treat her with a certain antipathy. His ambivalence made perfect sense. Her work upset his careful, if fragile, constructions in every manner. Not only was it based on European models, particularly French modernist conventions, but it bore little resemblance to British precedents, thus disrupting his monocultural bias.[11] At the same time, her Native subject matter, portrayed as at least partially present, undermined his insistence on the empty, picturesque landscape as the image of Canada, which he had been promoting since first assuming his position at the NGC. In retrospect, it is small wonder that her belated and staged "discovery" by him occurred just a few months too late to have her works included in the 1927 Jeu de Paume exhibition in Paris and that he had earlier ignored repeated attempts to call her to his attention. Given her training, style, and subject, she would undoubtedly have attracted positive critical responses in Paris, detracted further from the Group of Seven, and made it clear that there was a current connection to French modernism in Canada that had a direct link to Native cultures and to the Native works that were part of the exhibition – a connection that predated the formation of the Group. Her presence would have made his brief history of Canadian art extremely problematic.[12] If her works

had been included and if a broader representation of Canadian art had been produced, there would have been an even more disruptive outcome to the Jeu de Paume exhibition than actually occurred.

Continuing his practice of excluding anything suggestive of French post-Impressionism from the NGC's holdings, Brown confined his acquisitions of Carr's work from the *West Coast Art* exhibition to three watercolour studies, even though his new "discovery" had no works in the nation's public collections. This corresponded closely to his acquisitions of sketches from the estate of James Wilson Morrice. He paid $75 each for Carr's watercolours, or $225 total, less than one-third of the going price for a single oil by any of the Group of Seven's members.[13] Aside from being smaller in scale and in a medium deemed to be of minor significance, the studies were mostly documentary. He did not buy any of her larger oils, which, while reasonably inexpensive, would have had the status of "finished" works and been more representative of her achievements but which also displayed a mastery of modernist conventions in their use of arbitrary colour, simplified form, and broader brushwork.[14] Nor was he interested in her more recent work, which was even more radical in its forms.

Nonetheless, in an unusual move, the NGC retained the works that Carr had sent east for the *West Coast Art* exhibition, even though it had no intention of putting them on exhibit or having them enter the national collection. Rather, the reverse was true. As with Kihn's work, keeping Carr's pieces in Ottawa prevented them from being shown elsewhere. Here, it must be kept in mind that, contrary to assertions that without the NGC she would never have been noticed, Carr had been independently exhibiting extensively and internationally in Victoria, Seattle, and even San Francisco since 1924 – that is, three years before her Canadian "discovery."[15] By March 1928, responding to her direct request, Brown did return some of Carr's watercolours. However, many of these arrived in damaged condition, caused by inappropriate packaging, rendering them unsuitable for further exhibition and resulting in a request for compensation.[16] From this point, however, he began to distance himself from her.

Brown's diffident attitude accounts for several anomalies in the celebratory narrative of acceptance that have been generally obscured. It will be recalled that her Native subjects were excluded from both the Rochester and Buffalo exhibitions of Canadian art held in the fall of 1928 as well as from the summer show at the Canadian National Exhibition in Toronto, all of which had requested the *West Coast Art* exhibition, in which she was

the leading artist.[17] Instead, Brown sent paintings by the Group of Seven and other artists to each of these three venues, even though the NGC still had her oils and could easily have provided at least a small sampling. These exclusions and substitutions were based neither on the stated interests of the galleries nor on the immediate availability of the work but must be attributed to a desire to keep Carr's larger Native pictures out of circulation on the local and international scene as representations of Canada, a practice that Brown had begun when he acquired Morrice's works in 1925 only to deny them visibility by withholding them from exhibition. Carr was in no position to apprehend this immediately and may have thought, at this early stage, that she was working in harmony with the NGC. If so, she was mistaken. It is completely predictable, then, that her lengthy notification to Brown of the new work produced during the summer trip in 1928, which continued to feature Native subjects, met with stony indifference.[18]

The consistency of Brown's policy led to another surprising anomaly. In the late summer of 1928, in response to complaints of neglect from western Canada, the NGC assembled a selection of Canadian works for the *Vancouver Exhibition*. The show was ambitious. It included over one hundred works drawn from a variety of sources. Forty-seven came from the NGC collection, of which nineteen had previously been shown in Calgary. Thirty-three were borrowed directly from thirteen Montreal artists. But the greatest proportion per artist came from the Group of Seven, who were called on personally to loan eighteen works in addition to the ten works from the previous sources, or over one-quarter of the total.[19] The collection, then, although broad, was meant to establish the presence of the Group as the representatives of modern Canadian national art in western Canada. Thus A.Y. Jackson was represented by eight, J.E.H. MacDonald by six, Lawren Harris by four, Arthur Lismer by four, and so on, although F.H. Varley, now living and teaching in Vancouver, was represented by only one. Given the context, the ostensible aims of the show, and the timing, Carr might reasonably have been highlighted as the local representative of the new Canadian painting and as an equal companion of the Group. Her subject matter would certainly have been of interest to local audiences since relocated totem poles were being used as tourist attractions in Vancouver's Stanley Park at this time and were becoming emblematic of the tourist potential of Native art. Yet, instead of using the opportunity to capitalize on the *West Coast Art* show by ratifying Carr's new position, Brown held onto the oils still in his possession and included

only one watercolour study of 1912 from the three in the NGC's collection. She was not invited, as were the Group and other artists from Montreal, to display any of her recent works, which would have confirmed her, and her Native subject matter, as contributors to Canada's art. As with the shows in Toronto, Buffalo, and Rochester, she was excluded from the canon of contemporary Canadian artists on her home ground. What Carr must have thought of this sudden reversal in her position can only be surmised, but the consistent policy of exclusion must have made her feel, as had Kihn, bewildered and like an outsider. It goes without saying that no Native material was shown in the *Vancouver Exhibition*, although the NGC did include the one landscape by Kihn that it had acquired in the last gift to the gallery from the press baron F.N. Southam.

Further problems developed when the NGC refused to respond in a timely fashion to Carr's requests for a report on the status of the pieces remaining in their care and updates on sales.[20] By October of 1928 Carr must have realized that she was on her own in exhibiting her work locally, nationally, and internationally since she now requested both that her damaged watercolours, which she had sent to the NGC for appraisal, be returned to her and that she be guaranteed the prompt return of the oils for exhibition purposes.[21] Having kept the latter out of circulation for over a year, and having acquired none of them despite earlier assurances that this was under consideration, Brown complied.[22] His notice in the fall of 1928 that he was returning both her oils and watercolours pointedly informed her of his acquisition of several old masters, while making no mention of purchasing or exhibiting any of her works. This would be his last letter to her until 1932.

The pattern of continuing exclusion was confirmed when neither her old nor her new work was shown at the NGC's 1929 annual *Exhibition of Canadian Art*, which opened in January.[23] However, this exclusion was not due to lack of new work or lack of knowledge of it. By contrast, in exhibitions not controlled by the NGC, she was able to show her new works, as in the 1929 exhibition by the Ontario Society of Artists (OSA), to which she submitted two works that featured totem poles but no people and in which landscape was beginning to take precedence.[24] It appears, then, that Brown was prepared to allow Carr, Barbeau's other protégée and discovery, after Kihn, to sink back into the obscurity from which Brown thought that she had appeared. Brown's alienation of the artist, dating from the previous spring, is usually attributed to Carr's hypersensitivity to imagined "slights" and to her cantankerous personality, the latter of

which was, of course, a factor, but an examination of the record indicates that there was much more at stake here than difficulties brought on by a temperamental artist intent on alienating those around her, that she had not initiated the ruptures, and that any bewilderment, suspicions, distrust, and outrage that she may have experienced were justified and appropriate responses to Brown's behaviour and policies of exclusion. It now appears that the "slights" that Carr perceived were more real than her biographers have hitherto imagined. Insofar as the actions of Brown and the NGC toward Carr precisely duplicated those taken with both Kihn and Morrice on every level, they appear as the product of a consistent and predictable, if unspoken, practice and policy for dealing with disruptive elements that would last until 1930. In the meantime, others did not see her as beyond redemption, although her inclusion would be predicated on fundamental change.

Lawren Harris is usually figured as having been a benevolent, if paternal, mentor, source of inspiration, and spiritual guide to Carr.[25] This is certainly how he presented himself. But their relationship is more ambivalent and complex than this characterization suggests. A closer examination indicates his antipathy to any Native subject matter, either peopled or not, which he actively and forcibly discouraged. Harris understood from before his first encounter with Carr, as evidenced by his rejection of Barbeau's invitation to come to the Skeena region, that representations of Native presence could not peaceably coexist with claims that the Group of Seven's works depicted repossessed, "empty" landscapes. But beyond this awareness, there was also the problem arising from the fact that a spirtualized Native presence was completely incompatible with his own move toward a transcendent purity that he believed was part of the essential identity of the northern races as defined by their geography. What remained unspoken here is that Harris's North American "northern" races were colonial rather than indigenous. If his theories of race and place were correct, then the Native peoples of the continent, by dint of their longer presence and affiliation with the land, should have been this chosen group. Obviously, transcendent images of totem poles, which might have privileged the position of Canada's first peoples and rendered Anglo-colonial populations as spiritual interlopers had to be avoided. There was no choice but to insist that Carr abandon the totems and turn to landscapes, the emptier the better.

Harris had several methods at his disposal. Blanchard states that he was instrumental in excluding Carr's paintings on Native topics from the

February 1928 Group of Seven exhibition in Toronto, which followed the
West Coast Art show.[26] This was a significant move and counters the gener-
ally accepted claim that she and her Native works were immediately and
completely embraced and welcomed by the Group's members, especially
Harris. This move is doubly significant given that nineteen other artists
were invited to participate, including several other women, former stu-
dents, and amateurs.[27] Space, gender, and the professional quality of the
work were obviously not problems as the Group took measures to counter
charges of exclusiveness. Yet Carr and images of Native peoples seem to
have had no place within this larger body. According to Blanchard, Harris
could not find anything that he liked among the dozen or more works
that Carr had sent east but that had not been shown in the *West Coast Art*
exhibition.[28] This was the first indication that he might not have approved
of her Native images, finding them incompatible with both his own and
the Group's vision of the emptied landscape, which had to be reasserted,
especially after the Jeu de Paume fiasco. It is noteworthy, then, that at
the 1928 Group exhibition, the critics pointed to the adherence by the
Group's members and their associates to a homogeneous format depict-
ing a depeopled landscape, which Carr's early images of Native presence
resisted.[29] This was followed by an affirmation of the Group's rejection of
French modernism.[30] If she wished to be included within their mandate,
things would have to change.

Harris did not immediately communicate his objections to Carr about
her subject matter. On 28 January 1928 – at the moment when he was
rejecting her works – he wrote to Carr: "I have nothing to say – save this
– don't be influenced by anything or anybody. Shun everything but your
own inner promptings, your own purest reactions – like the plague. You
like my stuff ... But don't be influenced by it, ... stay decidedly with your
own way, your own direction."[31] Carr took him at his word. Her "own
way" was to return to her Native subject matter in an extended trip in
the summer of that year, which she began planning shortly after his letter
arrived. Although not enthusiastic about her topics, in March 1929, he did
praise *Totems, Kitwancool*, an image without human figures that had been
acquired by Hart House from the OSA show.[32] At the same time, how-
ever, he became more direct and explicit about the direction that she was
taking. In a letter in which he critiqued a picture that she had sent him, he
reversed his earlier position with some ingenious sophistry. Hearing that
she was going on yet another trip to Native villages and that she was inde-
pendently planning large exhibitions of her Native works in the West, he

openly began to influence her decision: "How about leaving the totems alone for a year or more? I mean the totem pole is a work of art in its own right and it is very difficult to use it in another form of art. But, how about seeking an equivalent for it in the exotic landscape of the island and coast, making your own form and forms within the greater form." He advised, "if you go back to totems, the old ways of seeing, not that they were not good, the old habits will assert themselves."[33] In his next letter, he further pressed his point that the totem poles represented something "old" and outmoded in her work. Here, suggestion was transformed into insistence, and encouragement become an imperative: "I thought and still think a partial holiday from totems would prove of real help to you." Stressing her response to the "peculiar atmospheric conditions of the West Coast," he added that, "the reason I mentioned the totem is that it already in itself is a definite artistic form and if you did too many you might become dependent on them."[34] Although couched in ingratiating terms, the message in the letter could not have been more clear. It was better that she become dependent on, and identify herself with, Harris and the format of the empty landscape rather than with "them" and their poles.[35] As will be seen, a "partial holiday" was not what he had in mind.

Having clearly established his preferences, Harris's directives were immediately followed by his request for three new works for a prospective exhibition of Canadian art organized by the American Federation of the Arts (AFA) that was to tour the United States.[36] While entertaining the possibility of including Carr's *Skidegate*, another image of totem poles hung in the OSA show, he critiqued what he saw as a confusion of the trees and poles.[37] Nonetheless, he informed her that both it and *Totems, Kitwancool* had been sent.[38] However, the pictures were chosen by a representative from the AFA, which was a strong supporter of the recognition of Native arts and their active place in the formation of a purely American national identity.

There were soon signs that Carr had heeded Harris's advice. She sent *Indian Church* to the NGC's 1930 annual exhibition of Canadian art along with *Gitwangak Poles* and *British Columbia [Forest]*. The first attracted the most positive attention. It was one of several on the topic that was the result of a 1929 trip to Nootka on the west coast of Vancouver Island. In a significant shift in her iconography, one obviously calculated to appease Harris and Brown, it shows a white, Christian (i.e., colonial), rather than Native, "spiritual" presence in the forest, which was more in accord with Harris's ideas as to who were the proper representatives of "northern"

spirituality and the state's position on who were the rightful heirs to these territories and resources.[39] The reception to this uncharacteristic work featuring a colonial, rather than a Native, presence was extraordinarily positive. Harris made special arrangements to have it shown in the subsequent OSA show and, after failing to place it with a gallery, purchased it for his own collection. Upon completion of his new, modernist Rosedale mansion, he hung it prominently in the dining room. Although Carr had a different perception of the picture and called it "beastly," Harris repeatedly informed her that it was the best thing she had ever done – that is, far superior to her work on Native subjects.[40] He even compared it favourably to work that he had seen in Europe during the summer of 1930: "I would rather have 'The Indian Church' than anything I saw [in Europe] ... It's one swell thing." Telling Carr that he was "glad that she was now among the blessed trees" and that he was gratified by her new feelings for the relationship between art and nature, he continued to insist that the "spiritual" in Canadian art lay in representations of nature, which, in turn, claimed the land as "our" place: "We should saturate ourselves in our own place, the trees, skies, earth and rock and let one art grow out of these." Distinguishing Canadian art from European abstractions as well as from the French modernism of Paul Cézanne, Pablo Picasso, Henri Matisse, and André Derain, the latter three of whom had made references to so-called "primitive" arts, he declared, "I have an idea – confirmed by what I felt in Europe – that we here, in our own place, on new land, where a new race is forming will find, for the present and perhaps for some time to come, that the fullest life in art for us comes by way of nature, sharing and imbibing her life; her deep, deep intimations – and establishing ourselves by getting that into our art."[41] It is difficult to imagine a clearer claim to colonial possession and dispossession driven by sacral duty and enacted through art nor a clearer call for Carr to bypass all aspects of French modernism, such as Cubism, with which she had been recently experimenting, and to keep her trees uncarved. To ensure that her representation and confirmation of Harris's first principles of race, nation, possession, and religion received the widest possible national and international exposure, he submitted *Indian Church* to various exhibitions, including the second part of the American Federation of Art exhibition in the fall of 1930, which he now controlled. It replaced her Native images.[42]

Having seen and praised *Indian Church*, and feeling confident of her new attachment to an unpeopled nature that he saw expressed in Carr's *British Columbia [Forest]*, Harris now included Carr for the first time in a Group

of Seven show, held in April 1930. Balancing the two subjects that she was now following, she submitted three of her new, empty villages and two forest scenes.[43] She went east again to attend the opening and, having demonstrated her at least partial compliance with the Group of Seven's and the NGC's agendas for an empty Canadian nationalist landscape, was richly celebrated.[44] But her acceptance was selective. The works that Harris did not mention or validate in his subsequent communications with Carr are as important as those that he did single out. One of the three Native works that Carr submitted to the Group's 1930 show was an image of two totem poles at the Haida village of Tanoo, with traditional and apparently intact houses in the background. These were obviously meant as emblems of a Native presence, spiritual attainment, and attachment to the land.[45] The title, Nirvana, signified a state of transcendent bliss.[46] The work's integration of poles and landscape elements into a formal unity intended to express this concept was in complete contrast to the separation in Indian Church of the stark, geometric, white building from the lush, organic, green background forms.[47] Nirvana, then, was precisely the kind of painting that Harris would not have wanted from Carr, and it undoubtedly provoked his forceful "encouragements" in the other direction. Although it was hung, it might as well have been invisible. Harris completely ignored it, mentioning neither it nor its potential.

For Carr, 1930 could correctly be called a "banner year."[48] It must be kept in mind, however, that this second stage of recognition did not begin in the East, nor did it hinge on nature. If the NGC showed no interest in exhibiting her work, other venues did. Carr had her first one-person show in Victoria at the Crystal Gardens in early 1930, consisting of over fifty works on Native subjects, which met with positive responses.[49] But her visibility went beyond her city of residence. Her importance as a modernist artist working with Native subject matter had already been confirmed in Seattle – where there was a receptive audience – when she was asked to be a judge in the 1929 annual exhibition there. Solo exhibitions were also planned from at least this time, indicating that there was a clear need to have the work that had been held by the National Gallery, but withheld from exhibition, returned. Although the first of these projects, which had been in the works since 1929, fell through, in the fall of 1930 Carr showed two works on Native subjects in the Sixteenth Annual Exhibition of Northwest Artists at the Art Institute of Seattle.[50] This was immediately followed by a major exhibition there in the winter, to which she sent thirty-four paintings. Tellingly, twenty-seven were of Indian subjects, and only seven were

landscapes. Her works were deemed significant enough to be noticed by two prestigious and widely distributed American journals, *Art News* and *Art Digest*, which commented on her monumental images of totem poles. In addition, her Native works had also been noted by the critic for the *New York Times*.[51] Her works were shown again: in late 1931 Carr exhibited two watercolours of poles at the the Art Institute's *Seventeenth Annual Exhibition*. One of them won a $50 first prize in its category. The potential for further recognition south of the border was ongoing during this time through her contact in Seattle, John Hatch, who promoted her work to galleries in San Diego, Los Angeles, San Francisco, and Portland. She was also heralded in the eastern United States. By 1930 her Native work had also been accepted into the *Baltimore Pan-American Exhibition*, to be held the following year. There is evidence that she may even have exhibited in Paris at this time.[52] It appears that she was aware of the preferences of her differing audiences. In precise inversion of her submissions to Ottawa and Toronto, and countering her advice from Harris, the majority of works shown in all of her western exhibitions were of her Native subjects.

After 1929, insofar as Carr's new work featuring totem poles was now attracting attention across the United States and in western Canada, and possibly in Europe, she and her images of Native art were becoming internationally recognized and of growing importance in spite of the NGC and Harris. The danger here for those with a stake in controlling the image of Canada and the Indian was the same as with Kihn's work — that is, Carr's images could easily fit within the framework for knowing that the Indian existed south of the border and be taken as a sign of Native presence and persistence. It is not surprising, then, that in failing to contain her, the Canadian institutions that saw it as their duty to police this imagery were obliged to (re)embrace her, albeit not without redirecting her subject matter.

Given her new, if precarious, *entrée* and fortified by her recognition south of the border, Carr now proceeded cautiously in her negotiations with the eastern Canadian institutions and associations, carefully balancing her submissions. Eschewing the monumental Native pieces that she had been working on and showing elsewhere, she sent *Indian Village, B.C.* to the NGC's 1931 annual *Exhibition of Canadian Art*.[53] It contained less Native imagery than many of her more focused works and was primarily composed of landscape elements. It had been accepted into the *Pan-American Exhibition*. Given its ratification by such an authority, refusing it in Canada would have been difficult to justify. In addition, she sent

a pure landscape to which neither Brown nor Harris could object: *Tree*.
Yet, aware that neither controlled the OSA, she submitted *Totem and Forest* to its March exhibition, a work that depicted a completely different
relationship between nature and the Native and that could be seen as a
contrasting pendant for *Tree* in the same way that *Nirvana* was for *Indian
Church*. Harris's response was both subtle and brutal. He allowed, with
some qualification, that *Totem and Forest* was "one of the best things in
the show" but went on to make this faint praise even fainter by clarifying
that what he meant was that it was one of the best of a very bad lot.[54]
With little regard for her feelings or accomplishment, or for her grow-
ing recognition elsewhere, and ensuring that she did not take his limited
acknowledgment of the work as encouragement to produce more of the
same, he clearly established where the "best" work was. He informed her
that in selecting the exhibition, the jury was "*hopelessly* weak kneed, blind,
deaf and particularly dumb" and that "I imagine they chucked out the best
things sent in." In all, it was a "punk show" in which any pride or sense of
achievement could be taken only by being among those excluded.[55] Carr's
response to being labelled "punk" and having her Native subjects accepted
only because the jury was blind is not recorded but can be imagined.

Following this blunt message, Harris invited Carr to send six works
to the Group of Seven's exhibition to be held in December 1930, from
which pieces were to be selected for an exhibition at the Roerich Gal-
lery in New York City early the following year. However, knowing of the
positive reception to her Native works in the United States, Carr dug in
her heels and continued to send recent works showing totem poles.[56] The
results were as to be expected. After the Group's show opened, Harris
informed her that only five of the six works that she had been asked to
send were hung. A large canvas, not mentioned by name, was excluded
because it was "not up to the others" and because of "lack of space."[57]
However, three of the forest scenes that she had submitted were included
and thus predominated. In a lengthy letter responding to her submis-
sions, he severely critiqued her "Thunderbird" picture, one of the two
Native pictures allowed into the exhibition.[58] He described at length his
displeasure with the prominence given to the carving in proportion to
the background landscape, which during this period of Carr's work was
a pastiche of his own stylistic conventions for signifying the spiritual in
nature. Obviously, fewer totem poles and more trees were needed. Nor
did he have any kind words for her other Native image. Reminding her of
the approved direction, he again praised *Indian Church* as "the best yet,"

thus implying that her more recent Native work was not up to the mark and message of this preferred piece. He countered this couched criticism by offering more explicit advice that framed her subject matter as the root of the problem. Thus, while critiquing her Native works, he ratified her recent turn toward depicting tree trunks rather than totem poles, repeatedly stating that she should do "quite a number of them."[59] This raises the question of the point at which encouragement becomes coercion. Although Carr's reaction to his increasingly specific insistence that she give up Native subjects is again unrecorded, Harris's response to her letter exists. His conciliatory remarks make it apparent that Carr was devastated at his rejection of her principal life's work to this point, which had gained her recognition both in Canada and abroad. However, Harris held firm. Having demoralized her, he now offered redemption. He instructed her yet again to limit herself to a pursuit of "tree subjects" and "a deeper search into her [i.e., nature's] deepest, most secret moods and meanings." To assist with this difficult transition away from the themes with which she had identified herself and her goals, he organized her works into periods, with the transgressive totem poles placed well in the past and a redemptive, racially pure, culturally uncontaminated, national nature placed in her recent past, present, and future.[60] In January 1932 he again advised her to avoid all pressures to conform to anyone's advice but added, with no small irony and a telling use of pronouns, "unless of course we are dead certain the suggestion is valuable in terms of our vision."[61] The terms now became visible. Her inclusion within the ranks of artists representing "our vision" of Canada, and its arts, peoples, and possessions, was directly proportionate to the degree that she gave up Native subjects and turned to depicting empty landscapes.[62] This was confirmed by the works that Harris and Brown selected from the Group's show for the next exhibitions. Harris sent on a pure landscape, *Wood Interior*, and *Indian Church* to the Roerich Gallery, while Brown selected only *Red Cedar*, one of Harris's approved subjects of trees, for inclusion in the NGC's 1932 annual *Exhibition of Canadian Art*.[63] Could the message have been clearer?

Faced with the intense pressure of Harris's moral, racial, national, religious, and aesthetic imperatives; with Brown's pointed selections and rejections; and with diminishing opportunities for exhibitions of her Native subjects south of the border, Carr appears to have capitulated. Although, in one last act of defiance, she sent two images of Native subjects to the NGC's 1933 annual *Exhibition of Canadian Art*, this being the last time that her new works were shown there until 1936, she ultimately responded to

the disciplinary series of admonishments and punishments (i.e., negative critical assessments and exclusion from exhibitions) followed by praise and rewards (i.e., positive critical assessments of approved directions and inclusion in exhibitions, leading to purchases) by doing precisely as Harris asked; that is, she internalized the discourse of national landscapes and Native disappearance into her own identity and gave up "her" subjects, at least as paintings.[64] Although Carr had kept painting totem poles into the early 1930s, after 1932 they were to disappear from her work until shortly before her death, when she was communicating only infrequently with Harris. But she did not make these concessions easily or without anguish and a sense of loss of self and direction.[65] Nor were they made in a manner meant to be entirely ingratiating. An element of resistance remained that distinguished her from those artists more deeply embedded in the discursive framework of Canadian national identity and imagery. She invented a new technique by which landscapes could be represented and given expressive significance, one that employed European post-Impressionist and modernist conventions in combination with conventions of the picturesque watercolour sketch, and she did so with a vengeance, if not a luminous and incandescent fury.[66] Adapting the format of the empty landscape but placing it in urban and suburban settings in and around Victoria rather than in an untouched wilderness, she went on to outstrip many of the former members of the Group, which by this point had broken up and whose members were being critically chastised for stagnating.[67]

Nonetheless, Carr's reacceptance was not offered unconditionally. Not surprisingly, figures in the East, and especially Brown, expressed little interest in these new works, which, while being in line with the approved subject of the empty Canadian national landscape, violated the boundaries of what had been established as "modernism" in Canada.[68] Carr had heard "on pretty good authority" that Brown had pulled two of her works from a 1932 exhibition because "they were too modern."[69] She never seems to have completely comprehended her problematic position within the various discursive frameworks that first brought her acceptance by the NGC and the Group of Seven and then led to her exclusion. She was thus constantly bewildered by her treatment and unable to adapt. However, her position on the margins had its advantages. Being some distance from the centre and lacking clear guidelines necessitated innovation and kept her from falling into the easy orthodoxy that plagued many of the followers of the Group. Instead, she went on to do some of the most outstanding landscapes of the era. But this achievement had a price. Finding herself once

again on the outside, Carr felt increasingly isolated throughout the mid-1930s and, after 1934, communicated little with either Brown, Harris, or Barbeau.[70] Still, she was isolated in good company. Given her recalcitrant modernism, she rejoined Morrice on the fringes of the accepted Canadian image. And, as with Morrice, her position within the narration of the nation would change once again. In the later 1930s, when there was a shift in the state's policies toward the Indian question and the beginnings of the programmatic "revival" of Native culture and arts, Carr was once again "discovered" and "revived," while a corresponding shift in the acceptance of modernism made it possible for Morrice to finally have his memorial exhibition at the NGC, in 1937.

Ironically, in one other respect, Carr was not alone during the 1930s. Like all other artists associated with Barbeau's projects, she never returned to the Gitxsan villages.[71] In fact, Barbeau's ambitious efforts to make the image of the (disappearing) Indian, specifically the Gitxsan of the Upper Skeena River, a background for Canadian visual identity met with complete failure. That this project was doomed from the start should be clear from the fact that the conjunction of the Native and Canadian identity had undermined the premises on which the Group of Seven and the entire concept of the Canadian nation as formulated by Brown were predicated. Not one single artist from the Group of Seven, or Kihn, or any of the others who had visited the area under Barbeau's auspices ever painted again in the region. A repeat would have been unthinkable. Given Jackson's extensive travels in western Canada as well as those of Harris and MacDonald, this avoidance of any further association with the site must be taken as evidence that it had become a forbidden zone. The paradise of Temlaham had become a non-Native hell, and Native art had become taboo.[72]

Conclusion

RATHER THAN AFFIRM THE formation of a unified Canadian national identity invested in the visual arts in the late 1920s, the preceding chapters narrate some of the fundamental challenges to the attempts to formulate this image. This project may seem perverse, if not unpatriotic. But it is not without purpose. Only at the points of their rupture and fragmentation do discourses become visible and their horizons come into view. At this time, then, the nature of these early constructions of Canadian identity can be fully understood in all their complexity. An examination of their ambiguous and unstable boundaries, which are generally rigorously policed, leads to a questioning, if not a reversal, of many accepted "truths" that have been handed down to the present. Under close scrutiny, it becomes apparent that Canada's nationalist configurations were based on a sequence of blind spots – although perhaps no more so than with any other nation – that prohibited their deficiencies from becoming visible. These concealments included a refusal to recognize that the landscapes of the Group of Seven were not unique, indigenous, and native or an unmediated response to a primal wilderness but based on imperial, colonial, and specifically English precedents; that the disappearance of the Indian, on which the nation's identity, its representations, and its claims to its lands were predicated, was not occurring, despite the state's best attempts to make it so or to represent it as such; that the conjunction of these two discursive frameworks did not support but undermined each other; that links to a "northern" nationalist movement, especially that of Scandinavia, exclusively through landscape did not confirm Canada's project but exposed the lacks within its claims to legitimacy as a nation; and that Canada's projected self-image was not modern and was not vindicated as such on the international scene, a point made clear by the French critics' comparisons of the new land-

scapes with the works of James Wilson Morrice. But above all, it must
now be apparent that a significant number of conflicting variations on the
concept of Canada were held by various parties, even within the small,
tightly knit, and overlapping cultural community.

If anything, the quest for unity provoked disunity. The artist and cul-
tural broker Bertram Brooker advocated a nationalism deemed possible
only after the European past had been forgotten. Conversely, John Mur-
ray Gibbon of the Canadian Pacific Railway projected a pluralistic nation
in which a hierarchy of immigrant folk performances would supply the
missing folk culture that Canada lacked. Eric Brown and Duncan Camp-
bell Scott both thought of Canada as a monocultural nation based on Eng-
lish precedents that excluded the Indian, while Marius Barbeau wanted
to insert a distinctly French Canadian and Native presence, with the first
seen as ongoing and the latter as discontinuous. Even within the Group
of Seven there were variations on the fundamentals of national identity.
And, of course, the various Native peoples, whose voices were largely
absent from any of the foregoing, were attempting to assert their pres-
ence and make themselves heard. It was necessary to obscure and keep
from sight the deep divisions within this multiplicity of possibilities in
an attempt to secure a seamless and unified national identity based on a
sequence of unstable binaries between colonial and national, native and
Native, and so on.

Given these problems, what were the outcomes of these innovative but
problematic attempts to foster a national consciousness? The answer, in
terms of the avowed goals, is that very few were successful. Indeed, the
challenges, denials, resistances, and ruptures provoked by these projects
precluded the possibility that anything concrete or lasting could emerge
from the conflicted confrontation, at least as initially conceived. At the
same time, the proceedings revealed the ambiguities and uncertainties
surrounding the discourses of national identity and the disappearance of
the Indian. Albeit inadvertently, the failures of these discourses, brought
on by their conjunction in such sites as the Upper Skeena River Valley,
the Jeu de Paume exhibition in Paris, and the *West Coast Art* exhibition,
initiated the end of each. Insofar as each discourse necessitated the forma-
tion and negotiation of more broadly inclusive narrations of the nation,
without claims to essentiality, as well as the recognition of continuities
within Native cultures, their failures can be regarded as extremely sig-
nificant and even, somewhat ironically, as highly successful. It took such
failures to open up a range of new, if more complex, possibilities. Some of

this can be discerned in the subsequent history of the various projects and discourses that constituted these interlocking programs.

At the moment when Emily Carr and the others were abandoning Native subjects, particularly the Skeena area and the Gitxsan, Barbeau made several efforts to pump life into his moribund art project and the faltering discourse of disappearance, but these attempts at resuscitation met with no success. In 1931 and 1932 he published a trio of articles that were remarkable more for their desperation than for their accuracy. In an article entitled "Our Natives: Their Disappearance," he spoke of the state of Native culture in terms of its relationship with fairs and exhibitions. Still arguing that the Indians as a race were on the verge of extinction through disease, mistreatment, and miscegenation, he revisited the problematic Banff Indian Days and the Calgary Stampede, which were still, despite his predictions and Scott's interventions, ongoing. He proclaimed that on the Prairies the Indians "are known mostly for their casual appearance in stampedes and parades for the benefit of western fairs. Their war paint and regalia belong to the circus. Those responsible for their survival, and perhaps improvement, are the railways and tourists ... At present the indications point convincingly to the extinction of the race."[1]

Ignoring all ceremonial activity on the reserves and reducing Native involvement at exhibitions to little more than the antics of painted clowns parodying their own former practices, Barbeau echoed Scott's earlier claims. In so doing he again invoked the rhetoric of the devalued and degraded. Native culture, such as may exist, had a role for the Native only in the lowest forms of mass spectacle, which were to be consumed by a non-Native audience who were instructed by Barbeau on the proper form of consumption. It had no other "capital." Dispossession, as the pronouns of the title implied, was a categorical *fait accompli*. The phrases "are known," "belong to," and "those responsible" are equally telling, as they indicate that Natives had no subjectivity within this discursive framework. Lacking this, they were not known to themselves; they had no identity either individually or collectively. They were "known" only by a non-Native audience, whose members had assumed the privileged position of ownership and spectatorship. Indian culture now existed only for the benefit of their gaze and "belonged" to them. In addition, the non-Native audiences were "responsible" for, and thus implicated in, Natives' wellbeing since they could not be responsible for themselves and were in need of paternal guidance. Perhaps realizing Scott's failure by this point, Barbeau located "their survival, and ... improvement" with the tourist trade and railways rather than with the Department of Indian Affairs.

In 1931 and 1932, when "Our Indians: Their Disappearance" appeared, Barbeau published a pair of articles summarizing the Skeena project and extolling artistic representations of "the picturesque Rockies" as well as "the fine wood carvings of the Northwest Coast tribes and their totem poles" as part of a new "national consciousness."[2] However, he was obliged to exaggerate the vitality, continuity, and quantity of the work produced by non-Native artists as well as the death of Native culture, the two being inextricably linked. Turning a blind eye to the actual state of both, he declared that "scenery, totem poles, native graveyards and Indian physiognomies have tumbled upon canvas or into plastic clay at a terrific pace. Gitksan chiefs once more have donned their regalia, perhaps for the last time; they are dying out."[3] These articles had little impact since what was "dying out," in fact, was his program. His presence in the field was also cut off when research funds dried up during the Depression as the western economy went into a state of decline. Nevertheless, this had the advantage of preventing him from witnessing the ongoing traditional cultural activity in the region in the 1930s. Having not witnessed it, he could later claim that it never occurred.

More successful was his attempt to integrate Quebec French culture into the fabric of Canadian identity, although this, too, did not proceed along the lines that either he or the artist Clarence Gagnon might have imagined. Using the Native art to open up space within Brown's monocultural construction allowed for the entry of French Canadian art and for its perception as a living and ongoing force, albeit one that looked backward to a *volk*-ish peasantry. But this was not to define Quebec for long. Within the decade, modernist, international, and forward-looking forces were taking effect that would soon take precedence and lead the nation in new directions.

What, then, became of the attempt to have Canadian Native art recognized as art, not ethnography? Again, little or nothing, at least in this country. In fact, precisely the opposite has occurred. The clash between the Group of Seven and its claims to national priority, on the one hand, and the Native material, on the other, set up a conflict that disadvantaged the recognition of the latter for some time, or at least for as long as the Group held a hegemonic position. Immediately following the *West Coast Art* exhibition, Brown spurned offers from Barbeau to collect Native work for the National Gallery of Canada (NGC) and chastised him for sending in unsolicited pieces for consideration.[4] The Art Gallery of Toronto also turned down his offer to acquire totem poles for their collection.

In consolidating its position of excluding Native art after the 1927

exhibition *Canadian West Coast Art, Native and Modern,* the NGC forfeited its opportunity to take the lead on the international scene. Although the format for the exhibition was not repeated in Canada, it inspired emulation almost immediately in the United States in the landmark *Exposition of Indian Tribal Arts,* held in 1931 in New York City, which is frequently cited as the first of its kind. The letter to Kihn inviting him to become a member of the sponsoring society stated:

> The art of the American Indian is just beginning to receive its due recognition as one of the world's great original expressions of design. The average white American however, still thinks of Indian art as belonging only to the remote past. Few realize the extent to which Indian arts have persisted, despite the pressure of an alien civilization, through centuries of vast changes and varying fortunes, down to our own machine age. Throughout the United States there are Indian artists and craftsmen who are producing, today, paintings, pottery, textiles, baskets, jewelry, beadwork, quillwork, costumes, embroideries, of great intrinsic beauty, conforming to an unbroken aesthetic tradition that had its origin in pre-Columbian times. This extraordinary persistence of an ancient art is perhaps unique in history. It is at once classic and modern.[5]

Clearly, shifts in the recognition of Native art and culture as an ongoing aspect of American identity were underway, but insofar as this was denied in Canada, no such follow-up was possible in the nation's state-run galleries. The NGC did not again collect Native material until the 1980s, decades after other galleries in western Canada had been exhibiting and acquiring Native work as art.[6]

Following the successes of the American program, it became evident that Canada had missed an opportunity and would have to catch up. Although the NGC did not take part in recognizing works by Native artists as art, changes occurred fairly quickly since an abundance of empirical evidence was making it increasingly evident that continuing to promulgate Native disappearance was no longer a viable option. To accommodate the persistence of these peoples and to capitalize on the emerging audiences and markets for Native arts, while at the same time validating the now discarded discourse of disappearance, a new program that saw the miraculous "revival" of Native art, culture, and identity from a pre-

sumably moribund state began to emerge in the late 1930s. As with the exclusion of the Indian from the construction of Canadian identity in the empty landscapes of the Group of Seven, this shift in the role of the Indian in the image of the nation had to be ratified at the imperial centre. This shift's first major appearance on the international level occurred when, in contrast to the 1924 and 1925 Wembley exhibitions but in keeping with the Jeu de Paume show, a small selection of Native works were included in the exhibition *A Century of Canadian Art*, held at the Tate Gallery in London in 1938, shortly before Brown's death.[7] Carr was also featured in this exhibition and received critical recognition from the British press, which saw her art as distinct from that of the defunct Group. Having been praised at the imperial centre, Carr's work was again collected by the state-run NGC.[8] In 1939, in another reversal of its previous position, the federal government commissioned two monumental totem poles from the Kwakwaka'wakw carver Mungo Martin for the exterior of the Canadian pavilion at the New York World's Fair.[9] A large collection of Native material from the British Columbia Provincial Museum was also displayed at the *Golden Gate International Exhibition* in San Francisco that year, although the text of the exhibition catalogue, by Erna Gunther, still insisted on the death of the arts, despite the new poles in New York City.[10] At the same time, Graham McInnes included a brief chapter on "Native Arts" in his survey on Canadian art.[11] All of this speaks to the beginning of the return of the Native to the fabric of Canadian identity as represented abroad and as formulated on the home front. Although this would be interrupted by the next war, it set the stage for the dramatic "revival" of Native art and culture that followed in the 1950s and 1960s.

What, then, became of Scott and the discourse of disappearance? In the end, the discourse, rather than the Indian, disappeared. Scott's policies had been disastrous because they were completely out of touch with the reality of the Native situation. By the time of his retirement in 1931, he had to admit that his ambitions had not been achieved. Neither his dream of an Anglo-Canadian national monoculture nor his solution to the Indian question had been realized. He left only a continuing legacy of conflict. However, the complex and ongoing shift in the perception of the position of Native peoples both within their own cultures and within Canada, which is proceeding along many fronts, has opened up new and constructive possibilities for renegotiating Native presence on much different terms. Just as it became increasingly evident in the following

decades that the discourse of disappearance had to be jettisoned, so, too, has it become evident that the discourse of "revival" is gradually surrendering ground to one of survival.

What, in turn, became of the Gitxsan, who were the focus of so much of this attention? Although the history of their relationships with non-Native forces is only just being written, it is now evident that they in no way suffered what Barbeau termed the "total collapse" of their culture.[12] If anything, the reverse was true. The unmentionable problem with peoples such as the Gitxsan in the first decades of the twentieth century lay in the fact that they were still in possession of precisely those things that Canada lacked and thus needed if it was to proclaim its nationhood – that is, ancient traditions and deep ties to their territories, a common language, ceremonies, and social structures as well as dance, costumes, literature, mythology, monumental sculpture, a separate and unique economy, and so on. The Gitxsan lacked only landscape painting, which became for Canada the sole measure of national unity. It is no surprise, then, that so much energy had to be expended at this crucial moment in declaring that they had lost these cultural attributes that formed a coherent identity since they were in direct contrast to, and called into question, Canada's own nascent state as a nation. The history of the continuity of these aspects into the present is now just being recovered, but it is being written against the grain of the previous ethnographic record. The recent publication of William Beynon's field notes from a 1945 potlatch, which he sent to Barbeau but which remained concealed from public view, are only the beginning of the reconstruction of a dynamic cultural record that occurred when ethnography, rather than Native culture, went into eclipse during the Depression and Second World War.[13] The danger here is that the (much belated) publication of these notes may give the impression that the events that they record were isolated. This is not the case. Beynon's notes record only a small fragment of the traditional activity that has been documented as ongoing in the region throughout the twentieth century and that continues to the present.[14] Not only have the Gitxsan preserved their identity and culture, but they are also among those involved in the process of renegotiating their position and means of expression within the nation, although, of course, this has not always gone smoothly. Old notions still persist, as was shown in the 1991 ruling in the court case *Delgamuukw et al. v. The Queen,* in which Gitxsan land claims were denied. Nonetheless, there are still many other alternative narratives yet to be told.

Finally, what became of the unified national identity to which the *West Coast Art* exhibition was supposed to contribute by providing a deep history, a mythology, a *volk*, and an ancient attachment to the land through the appropriation of the art of the disappearing First Nations? It now becomes evident that rather than unifying the narration of the nation or fostering a singular, seamless national identity, it did precisely the opposite. The exhibition, and all that preceded it, revealed and made clear that the Dominion's vision of nationhood was characterized by ambivalence and ambiguity, ruptures and enforced silences, marginalizations and limitations, cultural conflicts and competitions, inclusions and exclusions, and ultimately blindness. All of these testified to anything but unity. In short, it was a far more problematic enterprise than had been anticipated. The events of the following decades bore this out. The singular monocultural English-based concept of Canada came under increasing pressure and was, by the late 1930s, abandoned for the pluralism of a cultural mosaic. At the same time, the members of the Group of Seven itself were criticized for becoming the very things that they had claimed to be fighting against – that is, conservative, academic, repetitious, and irrelevant to a new modernism that now had to struggle against their hegemony.

In the end, that mysterious and elusive object, Canadian identity, remains as open for negotiation as it has ever been within what are now perceived as the diverse narrations within the nation. Still, a nostalgic and cherished vision of the 1920s lingers within segments of a fragmented Canadian mentality, sustained by periodic recitals of the narrative that recounts the dream of a triumphant, utopian period that never was, when the Dominion that was not yet a nation was unified under the banner of a heroic group of artists. But this, in the end, is a dream like that found in Barbeau's retelling of the Gitxsan story of Temlaham: a mythic, Edenic past from which we have been expelled but which the country can look back upon with a sense of nostalgia, melancholy, and longing.

Notes

INTRODUCTION

1 I recognize the problems inherent in these terms. I have used "Indian" to signify the constructed, homogeneous race that came into existence through the imperial and colonialist gaze. "Indigenous" and "Native" are used in reference to the various peoples of the continent who predated colonization.

CHAPTER 1: CANADIAN ART IN ENGLAND

1 See John Herd Thompson, with Allen Seager, *Canada, 1922-1939: Decades of Discord* (Toronto: McClelland and Stewart, 1985), 158; and J.M. Bumsted, *A History of the Canadian Peoples* (Toronto: Oxford University Press, 1998), 290-91.

2 Annie Coombes, *Reinventing Africa: Museums, Material Culture and Popular Imagination in Late Victorian and Edwardian England* (New Haven: Yale University Press, 1994), 187. Corbett and colleagues date this somewhat earlier; see David Peters Corbett, Ysanne Holt, and Fiona Russell, "Introduction," in David Peters Corbett, Ysanne Holt, and Fiona Russell, eds., *The Geographies of Englishness: Landscape and the National Past, 1880-1940* (New Haven: Yale University Press, 2002), ix.

3 On the formation of a French national identity, see E. Weber, *Peasants into Frenchmen: The Modernization of Rural France, 1870-1914* (London: Chatto and Windus), 1979.

4 Bumsted, *A History*, 262, 270.

5 Bertram Brooker, "When We Awake," in Bertram Brooker, ed., *The Yearbook of the Arts in Canada, 1928-1929* (Toronto: Macmillan, 1929), 5-6, emphasis in the original.

6 Ibid., 7, emphasis in the original.

7 According to Brooker, artists were endowed with the vision to see unity in diversity. This extended from the national to the universal and allowed for the possibility of claiming the country. See also Lawren Harris, "Creative Art and Canada," in Brooker, ed., *Yearbook*, 85; or F.B. Housser, *A Canadian Art Movement: The Story of the Group of Seven* (Toronto: Macmillan, 1926), 17.

8 See Michel Foucault, *The Archeology of Knowledge and the Discourse of Language*, trans. A.M. Sheridan Smith (New York: Pantheon Books, 1972). Foucault put these theories into practice in *Power/Knowledge*, 1972, *Discipline and Punish*, 1975, and the *History of Sexuality*, especially vol. 1, which appeared in 1978.

9 This uncertain state corresponds to the concept of the modern nation itself. See the various attempts to define the term in John Hutchinson and Anthony Smith, eds., *Nationalism* (Oxford: Oxford University Press, 1994). See also Benedict Anderson, *Imagined Communities: Reflections on the Origin and Spread of Nationalism*, rev. ed. (London: Verso, 1991).

10 Eric Hobsbawm, "The Nation as Invented Tradition," in Hutchinson and Smith, eds., *Nationalism*, 77. On the ways that Canadian efforts to join painting and nationalism are becoming part of a larger discussion, see W.J.T. Mitchell, ed., *Landscape and Power*, 2nd ed. (Chicago: University of Chicago Press, 2002); Malcolm Andrews, *Landscape and Western Art* (Oxford: Oxford University Press, 1999), 158-59; and Richard R. Brettell, *Modern Art, 1851-1929: Capitalism and Representation* (Oxford: Oxford University Press, 1999), 206-7. On how the Indian in Canada is beginning to be investigated in similar terms, see Michael J. Shapiro, *Methods and Nations: Cultural Governance and the Indigenous Subject* (New York: Routledge, 2004).

11 Homi K. Bhabha, ed., *Nation and Narration* (London: Routledge, 1990).

12 See Homi K. Bhabha, "DissemiNation," in Bhabha, ed., *Nation and Narration*, 292. See also Anderson, *Imagined Communities*, 11: "If nation-states are widely conceded to be 'new' and 'historical,' the nations to which they give political expression always loom out of an immemorial past."

13 See Homi K. Bhabha, "Introduction: Narrating the Nation," in Bhabha, ed., *Nation and Narration*.

14 See Anne Whitelaw, "'Whiffs of Balsam, Pine, and Spruce': Art Museums and the Production of a Canadian Aesthetic," in Jody Berland and Shelly Hornstein, eds., *Capital Culture: A Reader on Modernist Legacies, State Institutions, and the Value(s) of Art* (Montreal and Kingston: McGill-Queen's University Press, 2000), 122, for a discussion of the manner in which the National Gallery "ascribe[d] a coherence to ... a diverse set of practices and traditions that may be characterized as 'Canadian,' advancing a single unified national culture that would effect a (unified) national identity." Shapiro, *Methods and Nations*, x, calls this "cultural governance" and outlines its mechanisms, particularly in the United States, but also in other modern nation-states, including Canada, as well as in various media. He notes that "since the nineteenth century, state representatives have been active in various modes of cultural governance, seeking to complement coercive monopolies with diverse modes of cultural containment."

15 Maud F. Brown, *Breaking Barriers: Eric Brown and the National Gallery* (Port Hope, ON: Society for Art Publications, 1964), 12-13.

16 For a more complete and recent history of Brown and the NGC, see Douglas Ord, *The National Gallery of Canada: Ideas, Art, Architecture* (Montreal and Kingston: McGill-Queen's University Press, 2003), especially 55-100.

17 Philip Dodd, "Englishness and the National Culture," in David Boswell and Jessica Evans, eds., *Representing the Nation: A Reader: Histories, Heritage and Museums* (London: Routledge, 1999), 97-98. See also Philip Dodd, "Englishness and

National Culture," in Robert Colls and Philip Dodd, eds., *Englishness: Politics and Culture, 1880-1920* (London: Croom Helm, 1986), 14-15.

18 See, for example, the entry on Stanhope Forbes, one of the leading Newlyn painters, in Caroline Fox and Francis Greenacre, eds., *Painting in Newlyn, 1880-1930* (London: Barbicon Art Gallery, [1985]), 58.

19 See Ysanna Holt, *British Artists and the Modernist Landscape* (Aldershot: Ashgate, 2003), 36-37. In the same publication, Holt notes that "the deep-rooted tendency to define a connection between land, countryside and nation as somehow innately English predominated throughout the Edwardian era and into the inter-war period" (4). Holt adds that "notions of national identity and national virtues are never singular; constructions interact and compete during specific periods, but associations between an assumed spirit of Englishness and the countryside were especially emphasized during the period of this study" (5) – that is, the late 1800s and pre-war period.

20 The precise path by which Brown overcame the class barriers in a highly stratified social milieu in order to make such a contact have yet to be traced, but his rise was very rapid.

21 J.L. Finlay and D.N. Sprague, *The Structure of Canadian History* (Scarborough, ON: Prentice-Hall, 1979), 231. See also Ord, *The National Gallery*, 67-68. Ord points out that at the time of Walker's defection in 1910 and the election of the Conservatives, which promised a closer connection to England, Brown's immediate priority became the further expansion and consolidation of the NGC. As Ord states, the connection between these events is too close to ignore.

22 Eric Brown announced the NGC's agenda in "The National Gallery of Canada in Ottawa," *The Studio* 58, 239 (1913): 15-21. This article must have already been written in 1912.

23 As A.Y. Jackson stated in speaking of the origins of the Group of Seven, "Sir Edmund Walker, who was Chairman of the Board of Trustees, came around to see Harris and asked to know what all the fuss was about. Harris told him of our intention to paint our own country and to put life into Canadian art. Sir Edmund said that was just what the National Gallery wanted to see happen; if it did, the Gallery would back us up. The Gallery was as good as its word." Although, in my opinion, Jackson gets the order inverted, he still makes the symbiotic relationship transparent. A.Y. Jackson, *A Painter's Country: The Autobiography of A.Y. Jackson*, rev. ed. (Toronto: Clarke, Irwin, 1967), 28.

24 Peter Larisey, *Light for a Cold Land: Lawren Harris's Work and Life: An Interpretation* (Toronto: Dundurn, 1993), 30.

25 Douglas Cole, "Artists, Patrons and Public: An Inquiry into the Success of the Group of Seven," *Journal of Canadian Studies* 13 (Summer 1978): 75.

26 R.H. Hubbard, *The National Gallery of Canada: Catalogue of Paintings and Sculpture*, vol. 2, *Modern European Schools* (Ottawa: University of Toronto Press for the Trustees of the National Gallery of Canada, 1959), 60. Hubbard notes that a second watercolour was obtained shortly thereafter in 1916. Further acquisitions followed in the mid-1920s.

27 Holt, *British Artists*, 5.

28 See Corbett, Holt, and Russell, "Introduction," xi, xvii, on the North-South,

industrialized-rural, modern-antimodern dichotomies that characterized the construction of English identity in the late 1800s and early 1900s. Corbett and colleagues confirm "a sense that there is a specifically English landscape and an English concern with, and way of representing, that landscape" on the left and the right both before and after the war (xii). Corbett and colleagues also comment on the "fictive" nature of these images (xiii).

29　Eric Brown, "Some Recent Purchases by the National Gallery of Canada," *The Studio* 62, 255 (1914): 96.

30　Shapiro, *Methods and Nations*, 116-17: "Ireland has been historically regarded as a wild, untamed landscape (and ethnoscape) in comparison with an orderly and civilized England." See also Dodd, "Englishness," 11-15, for the other complex ways in which Irish identity was subsumed into a British identity and at what cost.

31　Eric Brown, "Studio-Talk," *The Studio* 64, 265 (1915): 209-11.

32　See Corbett, Holt, and Russell, "Introduction," xiv: "Belligerent reaffirmation of 'English' values co-existed, throughout the period, with curiosity about and a tentative acceptance of change."

33　Charles Holme, ed., *Art of the British Empire Overseas* (London: The Studio, 1916-17).

34　India's absence, for example, should be noted.

35　As an earlier article on Canadian art in *The Studio* had indicated, Canadian painting at this time treated many subjects, of which landscapes were only one; see E.S., "Studio-Talk, Toronto," *The Studio* 57, 237 (1912): 245-51. Aside from landscapes, these were listed under the headings of "Figures," "Marine Subjects," "Street Scenes," and "Portraiture and Animals." The exclusion of these other possibilities in favour of an exclusive emphasis on landscapes in defining what constituted the arts of the four dominions is not without significance. E.S. also noted that "it is proposed to hold a representative exhibition of Canadian art in the capital of the Empire in the winter of 1913-1914 ... The exhibition will certainly strengthen the ties which unite the Mother Country and the great Dominion" (251).

36　Eric Brown, "Landscape Art in Canada," in Holme, ed., *Art of the British*.

37　No paintings by future Group of Seven members were sent to England so that they could be reproduced in colour. It was probably assumed that they were too valuable to risk the dangers of sea travel during the war. Instead, a painting by Franklin Brownell, *Summertime*, was the only one from Canada to be given a colour plate.

38　Brown, "Landscape Art," 6-8. This seminal publication, which directly links the formation of the Group of Seven and the narrative structures around them to the empire from the outset, has been largely overlooked in the histories produced thus far.

39　This anomaly becomes more apparent when it is recalled that Morrice was one of the only Canadian artists to whom *The Studio* had, up to this time, dedicated a single article; see Muriel Ciolkowska, "A Canadian Painter: James Wilson Morrice," *The Studio* 59, 245 (1913): 176-82. Note that the title claims Morrice for Canada and positions him as a Canadian painter within an international milieu.

This position confirmed a previous assessment, when he was referred to in a review of works at the prestigious Goupil Gallery as "a painter who holds a distinguished position among the artists of the Dominion," that is, Canada; see "Studio-Talk, London," *The Studio* 57, 237 (1912): 238. Brown's history signalled a change in Morrice's standing.

40 Ibid.

41 James Ashton, "Landscape Art in Australia," in Holme, ed., *Art of the British*, 37.

42 E.A.S. Killick, "Landscape Art in New Zealand," in Holme, ed., *Art of the British*, 90. This indicates the presence of a coordinated move to both produce and promote distinct, national landscape schools while also displaying an allegiance to England and the empire as well as the presence of a limited set of established terms by which this nationalism could be claimed.

43 *Times Literary Supplement*, London, 14 December 1924, 817.

44 Hind recovered from this setback and remained an important figure throughout the twenties; see "Mr. Lewis Hind Broadcast," *Connoisseur* 75, 303 (1926): 190.

45 Charles Hill, *The Group of Seven: Art for a Nation* (Ottawa: National Gallery of Canada, 1995), 117. For more information on Konody in terms of both his relationship with Beaverbrook and his position in the British art world, see Maria Tippett, *Art at the Service of the War: Canada, Art, and the Great War* (Toronto: University of Toronto Press, 1984), 43-50.

46 Tippett, *Art at the Service*, 30-31. She notes that some thought him "the leading critic of his day."

47 Hill, *The Group of Seven*, 117. Hill gives the citation as "Toronto Daily Star 30 Aug. 1920; Hammond 1920c" (297 n. 22).

48 Ramsay Traquair, "Montreal," *The Studio* 81, 335 (1921): 81-82. A Maurice Cullen landscape and an F.H. Varley portrait were chosen for illustration.

49 Ramsay Traquair, "Montreal," *The Studio* 85, 361 (1923): 236-39.

50 B.F., "Toronto," *The Studio* 86, 364 (1923): 54-58. Hill, *The Group of Seven*, 347, identifies B.F. as Barker Fairley.

51 William Gaunt, "Two Canadian Painters," *The Studio* 88, 380 (1924): 260-63.

52 See Hill, *The Group of Seven*, Chapters 1-4. The classic example, albeit after the fact, is F.B. Housser, *A Canadian Art Movement: The Story of the Group of Seven* (Toronto: Macmillan, 1926). It is no coincidence that his book appeared at this critical moment. Its fundamental assertions, however, as indicated in Brown, "Landscape Art in Canada," had been in circulation for over a decade.

53 Ramsay Cook, "Landscape Painting and National Sentiment in Canada," *Historical Reflections* 1, 2 (1974): 263-83.

54 See Paul Greenhalgh, *Ephemeral Vistas: The Expositions Universelles, Great Exhibitions and World's Fairs, 1851-1939* (Manchester: Manchester University Press, 1988), especially 198-223.

55 On the role of international and colonial expositions and museums in producing "national coherence" and "a broad basis of consent for the imperial project" "in defense of nation and empire" addressed primarily to the working class in England prior to the war, see Annie Coombes, "Ethnography and the Formation of National and Cultural Identities," in Susan Hiller, ed., *The Myth of Primitivism: Perspectives on Art* (London: Routledge, 1991).

56 *London Illustrated News*, 26 April 1924, 747-49. For a prelude to Wembley, see Annie Coombes, "National Unity and Racial and Ethnic Identities: The Franco-British Exhibition of 1908," in *Reinventing Africa*. Coombes's study ends in 1913.

57 This was consistent with the tradition of international and colonial exhibitions, which as Heaman states, from the pre-Confederation period onward, "provided the developing colonies of British North America with an opportunity to construct a self-identity and to broadcast it to the world ... The story that Canada told to visitors at the international exhibitions was a story narrated by its government. These displays initiated an enduring faith that the country has a national identity that the government can authoritatively decipher and set down"; see E.A. Heaman, *The Inglorious Arts of Peace: Exhibitions in Canadian Society during the Nineteenth Century* (Toronto: University of Toronto Press, 1999), 141-42. Heaman points out that Canada hesitated to participate in this display of unity: "At the Wembley United Empire Exhibition of 1924-25, Canada hung back, because of the expense, until the Prince of Wales personally solicited its attendance." "Whether or not these international displays contributed substantially to an emerging national identity, ... they did foster an expectation that national identity existed" (215).

58 "The British Empire in Microcosm: The Largest Exhibition Ever Planned as It Will Appear," *London Illustrated News*, 19 January 1924, 104-5.

59 The projected attendance figure comes from "Wembley the Magnet: Exhibition Visitors in Their Thousands," *London Illustrated News*, 19 July 1924, 105. Attendance came nowhere close to the projections, and the exhibition was a financial disaster. The second year of its run was an attempt to recoup some of the losses.

60 Hugh Gunn, ed., *The British Empire: A Survey in Twelve Volumes* (London: W. Collins, [1924]).

61 The same review noted that in Canada railway construction served as "a political instrument ... [that] binds a nation together." "The British Empire: A Survey in Twelve Volumes," review, *Times Literary Supplement* (London), 3 July 1924, 411.

62 Edward Salmon and A.A. Longden, eds., *The Literature and Art of the Empire*, vol. 11 of *The British Empire*, ed. Hugh Gunn.

63 *Times Literary Supplement* (London), 11 December 1924, 848.

64 A.A. Longden, "The Art of the Empire," in Salmon and Longden, eds., *The Literature*, 265.

65 Longden, "The Art," 262.

66 Ibid., 264. Errors did creep in. Tom Thomson's achievement was dated 1923, and Arthur Lismer was referred to as "Arthur Lisum," while A.Y. Jackson was praised as a watercolourist, and Lawren Harris's Swedish connection was emphasized by his misidentification as "Jansen Harris."

67 All of these pavilions, except possibly India's, were in concrete; see "The British Empire in Microcosm," *London Illustrated News*, 19 January 1924, 105. Although advanced at the time in material, their paucity of innovation in appropriate design came up for criticism from arbiters of taste such as Roger Fry, who roundly attacked them; see "Architecture at Wembley," *The Nation and the Athenaeum* (London), 24 May 1924, 242-43. The journal took a rather dim view of the exhibition and pilloried it on several occasions, although the art exhibitions were never reviewed there.

Coombes, *Reinventing Africa*, 192, has discussed how the relative permanence of the various pavilions at the 1908 Franco-British Exposition at White City, which highly influenced Wembley, reflected "an arbitrary racial hierarchy. This hierarchy effectively operated as the equivalent to an evolutionary scale, with, in the case of the British exhibits, the African colonies at the bottom, Indian somewhere considerably higher up the ladder, and the Dominions of Canada, Australia and New Zealand at the top."

Greenhalgh, *Ephemeral Vistas*, 63, interprets the Wembley structures differently: "Splendid classical pavilions from New Zealand, Canada, Australia and South Africa stood as confirmation that the colonial stage had been transcended, and independence had been gained not only materially but culturally also."

68 The official guide listed the races living both in residence and off the site. These included Malays, Burmans, Hong Kong Chinese, West Africans, Palestinians, Indians, Singhalese, West Indians, and Natives of New Guiana. No Natives from Canada, Australia, or New Zealand are mentioned, although New Zealand's pavilion did feature a Maori house; see Greenhalgh, *Ephemeral Vistas*, 95.

69 Jonathan King, "A Century of Indian Shows: Canadian and United States Exhibitions in London, 1825-1925," *European Review of Native American Studies* 5, 1 (1991): 35-42. For a summary of the history of, as well as the problems associated with, displays of Native materials exhibited by Canada at international and colonial exhibitions until the turn of the century, see E.A. Heaman, "Making a Spectacle: Exhibitions of the First Nations," in *The Inglorious Arts*, 285-310.

70 King, "A Century," 38.

71 Robert W. Rydell, *All the World's a Fair: Visions of Empire at American International Expositions, 1876-1916* (Chicago: University of Chicago Press, 1984), 7. He also notes that they were used "to illustrate the progress of civilization" according to a hierarchical structure that placed Anglo-Saxon culture at the apex (56).

72 See Douglas Cole, *Captured Heritage: The Scramble for Northwest Coast Artifacts* (Vancouver: Douglas and McIntyre, 1985), 126-31; Heaman, "Making a Spectacle," 302-4; and Paige Raibmon, "Theatres of Contact: The Kwakwaka'wakw Meet Colonialism in British Columbia and at the Chicago World's Fair," *Canadian Historical Review* 81, 2 (2000): 157-90. See also Paige Raibmon, *Authentic Indians: Episodes of Encounter from the Late-Nineteenth-Century Northwest Coast* (Durham: Duke University Press, 2005). Raibmon states that 10,000 people witnessed the most extreme of the ceremonies and that an extensive sensationalized report was published in the *Sunday Times* (London) (60).

Heaman, "Making a Spectacle," 307, points out that at this time "Natives were exhibited in a way that white people were not. Ontario and Quebec battled for educational prizes, but neither sent the schoolchildren themselves, for they were children first and objects of knowledge second, unlike native children. Yet the Canadian government did not encourage the exhibition of native adults, as the United States did. Parsimony was one reason; another was the fear that such an exhibition would reveal the failure of assimilationist policies."

73 King, "A Century," 39. Needless to say, these were not put on as official representations of Canada.

74 There was a "rodeo" for which riders and stock were brought in from North

America. In England, given the presence of Buffalo Bill's Wild West Shows since 1889, a rodeo would have been associated with, and incomplete without, a Native presence. As we shall see, a disputed Native presence also characterized the Calgary Stampede, by now well established, where Native riders were frequently, at this time, the winners of the main events. Thus the lack of such representation at Wembley is of note.

75 For the claim that Kahnawake families performed at Wembley, see Trudy Nicks, "Indian Villages and Entertainments: Setting the Stage for Tourist Souvenir Sales," in Ruth Phillips and Christopher Steiner, eds., *Unpacking Culture: Art and Commodity in Colonial and Postcolonial Worlds* (Berkeley: University of California Press, 1999), 304.

76 Illustrated in King, "A Century," Fig. 8, 40. See also "The Prince of Wales in Butter: New and Old Wembley Tableaux," *London Illustrated News*, 16 May 1925, 968. The caption reads "The Prince appears in his picturesque costume as the chief, 'Morning Star,' of the Stony Indians ... The Alberta model was made by Mr. George D. Kent and Mr. Beauchamp Hawkins, sculptors to the Canadian Government Commission." The prince owned a ranch (one wants to say "spread") in Alberta, which had been the subject of the previous year's butter sculpture. The *London Illustrated News* cropped the Stoney family and showed only the prince.

77 See Beth Fowkes Tobin, "Cultural Cross-Dressing in British America," in *Picturing Imperial Power: Colonial Subjects in Eighteenth-Century British Painting* (Durham: Duke University Press, 1999). Tobin's description of a portrait of Sir John Caldwell in Native garb is instructive here: "The excess of finery alerts us to the masquerade and reveals his true identity as the British gentleman, who, in playing at being an Indian chief, reminds us of his ability to appropriate the unfamiliar without being transformed by it." "By decontextualizing the Indian artifacts, Caldwell denies to them the power to speak of Indian culture and Indian political power" (86).

78 King, "A Century," 40. These pageants were not successful in drawing audiences but had an important role in linking the colonies' and dominions' histories to that of the British Empire. A Boy Scout Jamboree at Wembley did stage an Indian attack on a Hudson's Bay Company representative but this was not part of Canada's official displays (40).

79 Shapiro, *Methods and Nations*, 109.

80 See Johnathon Bordo's theoretical study "Jack Pine: Wilderness Sublime or Erasure of the Aboriginal Presence from the Landscape," *Journal of Canadian Studies* 27, 4 (1992-93): 98-128. See also Brian S. Osborne, "The Iconography of Nationhood in Canadian Art," in Denis Cosgrove and Stephen Daniels, eds., *The Iconography of Landscape* (New York: Cambridge University Press, 1988), 163-65.

81 British Empire Exhibition, *Canadian Section of Fine Arts Catalogue* (London, 1924). Thomson's sketches were listed as a single work. Morrice, by comparison, was represented by two works.

82 Hill, *The Group of Seven*, 143. There were only two rooms in the Canadian section, indicating the importance given the Group of Seven's work. Hill exaggerates somewhat the rhetorical content of Brown's brief catalogue essay. Its use of the jargon surrounding the Group is limited to oblique references in the opening

and closing sentences: "Not all the pioneering in Canada has been done in her forests and plains by any means ... Canada will at least show that she possesses an indigenous and vigorous school of painting and sculpture, moulded by the tremendously intense character of her country and colour of her seasons"; see Eric Brown, "Foreword," in British Empire Exhibition, *Canadian Section of Fine Arts Catalogue* (London, 1924), 3.

83 The acrimonious negotiations between the NGC and the RCA as well as the scandals that preceded and plagued the staging of the exhibitions, which reflected deep divisions at home, have been covered elsewhere; see Ann Davis, "The Wembley Controversy in Canadian Art," *Canadian Historical Review* 54 (March 1973): 48-74.

84 See Hill, *The Group of Seven*, 142-51.

85 National Gallery of Canada, *Press Comments on the Canadian Section of Fine Arts, British Empire Exhibition, 1924* (Ottawa: National Gallery of Canada, [1924]), n.p.

86 "Palace of Fine Arts, Dominion Tendencies," *The Times* (London), 6 May 1924. This citation and the following are all taken from National Gallery of Canada, *Press Comments, 1924*. Interestingly, the word "picturesque" never occurs; the landscape style is described most often as "decorative."

87 "Palace of Arts, Colonial Painting," *Morning Post* (London), 22 April 1924.

88 *Liverpool Post*, 28 May 1924.

89 C. Lewis Hind, "Life and I," *Daily Chronicle* (London), 30 April 1924. Hind's Wembley review was quoted by the press in Canada as offering "authoritative recognition, not only of 'superb' work – a description which no Canadian critic has had the courage or the insight to employ – but of a spirit in these Canadian pictures which is distinctively national and as definite in expression as the art of many much older countries or schools"; see *Ottawa Journal*, 21 May 1924. The *Journal* exaggerated the negative critical home response to the Group of Seven.

90 Anthony Bertram, "The Palace of Arts, Wembley," *Saturday Review* (London), 7 June 1924. "The New Zealand painting is mostly cold and insipid ... In South Africa there is ... a rather tired vigour ... In the Indian and Burmese Gallery we find the deplorable effect of Western on Eastern art ... The pre-eminent quality of the Australian work is 'atmospheric.'" For Canada, he cites as "primarily decorative, Frederick H. Varley's dramatic 'Stormy Weather, Georgian Bay' ... Alexander Young Jackson's 'The Northland' ... and his 'Winter, Georgian Bay' ... Tom Thomson's 'The West Wind' ... and his 'The Jack Pine' ... Lawren Harris's 'Pines, Kempenfelt Bay' ... J.E.H. MacDonald's 'The Solemn Land' ... and Arthur Lismer's 'September Gale.'" Casson is missing from the list.

91 Not all concurred. The *Glasgow Herald*, 28 May 1924, dissented: "That Canada has developed a national school of landscape artists – and this has been asserted – is not at Wembley made plain."

92 Halifax harbour had been the site in 1917 of a collision between two ships, one carrying a massive supply of explosives, which had detonated in the largest manmade explosion of that time, killing thousands of civilians and destroying a large section of the core of the city.

93 "Wembley: The Palace of Arts," *Connoisseur* 73, 237 (1925): 186.

94 National Gallery of Canada, *Press Comments on the Canadian Section of Fine Arts,*

British Empire Exhibition, 1924-1925 (Ottawa: National Gallery of Canada, [1925]). The second compilation of reviews contained all of those from the first, with some minor editing, plus additional reviews of both that year's Wembley exhibition and the subsequent tour of the work, along with the notices of the 1925 version of the show and the second tour. It should be noted that Wembley's second year generated far less interest in general than did the first. The number of articles in the *London Illustrated News* declined substantially in 1925.

95 "Art at Wembley," *The Times* (London), 9 May 9 1925.

96 "Art at Wembley," *Sunday Times* (London), 10 May 1925.

97 "At Wembley," *Christian Science Monitor* (London), 25 May 1925.

98 Hill, *The Group of Seven*, 150. Hill's assertion that Morrice received a great deal of attention is problematic. Although his work, when mentioned, was praised, it was seldom cited, which, given the paucity of pieces by him, is not surprising. Nonetheless, he was one of the artists whose work was considered for purchase by the Tate.

99 "Wembley, The Palace of Arts," 186.

100 P.G. Konody, "Art and Artists: The Palace of Arts at Wembley," *Observer* (London), 24 May 1925. Langdon Kihn, who was not Canadian, is discussed in detail in Chapters 5 and 6 herein.

101 It is now understood that an image of oppositionality followed by vindication had been an essential component in the construction and marketing of the European avant-garde since the late 1800s and that this image was promulgated even after modern art had gained acceptance; see Robert Jensen, *Marketing Modernism in Fin-de-Siècle Europe* (Princeton: Princeton University Press, 1994).

102 Tippett, *Art at the Service*, 32, notes Konody's position on the war pictures: "Konody's modernist prescription for painting the Great War did have limitations. He could not fully embrace Vorticism, the most radical movement in British painting, as useful in depicting the war (he condemned the Vorticist work of David Bomberg and Wyndham Lewis as 'geometrical obfuscations') ... The kind of art Konody could accept lay between conventional illustration and the Vorticists 'picture puzzles.' He admired line, order, and harmony."

CHAPTER 2: ENGLAND IN CANADIAN ART

1 Pierre Bourdieu, *The Field of Cultural Production* (New York: Columbia University Press, 1993), 224.

2 Pierre Bourdieu, "Outline of a Sociological Theory of Art Perception," in *The Field of Cultural Production*, 601.

3 "Despite the attempt to represent Canadian art at Wembley, very little is generally known in England about this most interesting subject." "Canadian Art at Manchester," *Connoisseur* 76, 302 (1926): 128.

4 My first encounter with the idea that the paintings of the Group of Seven could be seen as an extension of the British picturesque tradition and that its members' claims to representing an inclusive, unified national identity could thus be questioned came from reading François-Marc Gagnon, "Painting in Quebec in the Thirties," *Journal of Canadian Art History* 3 (Fall 1976): 2-20.

5 Malcolm Andrews, *Landscape and Western Art* (Oxford: Oxford University Press, 1999), 157-58, 162. Andrews refers here directly to Lawren Harris. See also Robert Young, *Colonial Desire: Hybridity in Theory, Culture and Race* (London: Routledge, 1995), 169-74.

6 The phrase comes from Annie Coombes, *Reinventing Africa: Museums, Material Culture and Popular Imagination in Late Victorian and Edwardian England* (New Haven: Yale University Press, 1994), 1.

7 W.J.T. Mitchell, "Imperial Landscape," in W.J.T. Mitchell, ed., *Landscape and Power*, 2nd ed. (Chicago: University of Chicago Press, 2002), 23. Since the mid-1980s, there have been a wide variety of studies on the political aspects both of landscape painting in Britain and of the picturesque itself.

8 Until recently, research into the British topographical and picturesque representations of colonized countries focused almost exclusively on India, Australia, and New Zealand. The first edition of Mitchell's discussion of the spread of British landscape conventions within the empire privileged Australia and New Zealand. North America rated only a footnote, and Canada received no mention at all. Mitchell saw the complexities surrounding the resistance of the Aboriginal peoples as one of the factors that distinguished the production of landscape in North America from that in the South Pacific and that accounted for the lack of investigations into this area. The second expanded and revised edition of Mitchell, ed., *Landscape and Power*, included an essay on Canada by Jonathan Bordo, "Picture and Witness at the Site of Wilderness."

9 Charles Harrison, "The Effects of Landscape," in Mitchell, ed., *Landscape and Power*, 2nd ed., 215. For continuation of the tradition of using the landscape to claim possession in America, particularly in the work of Thomas Cole, see Andrews, *Landscape*, 160-61. See also Martin Warnke, *Political Landscape: The Art History of Nature* (Cambridge: Harvard University Press, 1995), 53.

10 Ann Bermingham, *Landscape and Ideology: The English Rustic Tradition, 1740-1860* (Berkeley: University of California Press, 1986), 63.
 Although Bourdieu tends to resist the notion that artistic practice can be entirely subsumed within a knowable set of codes, it should be noted that in his terms, Gilpin revealed the underlying codes for the construction and consumption of landscape art. Access to these had previously been posited by Payne and Knight as being restricted to a certain class whose members were endowed with disinterested taste. Such innate distinction was a sign by which they could identify themselves and legitimate a position of privilege. By revealing the appreciation and construction of landscapes as a set of codes – that is, by undercutting transcendent claims to aristocratic taste – and by broadly distributing these codes, Gilpin transgressed this privilege. There is a link that needs to be studied further between this transgression and the fact that he was, at the time and subsequently, much reviled and that the art produced under this expansion was largely dismissed as lacking in individuality, originality, and genius, the key words underwriting the claims to aesthetic transcendence.

11 Bermingham, *Landscape and Ideology*, 83.

12 Ibid., 84.

13 Ibid., 57.

14 Malcolm Andrews, *The Search for the Picturesque: Landscape Aesthetics and Tourism in Britain, 1760-1800* (Aldershot: Scholar Press, 1989), 33.

15 Bermingham, *Landscape and Ideology*, 75. See also John Barrell, *The Dark Side of the Landscape: The Rural Poor in English Painting, 1730-1840* (Cambridge: Cambridge University Press, 1980).

16 Mitchell, "Imperial Landscape," 17.

17 Ibid.

18 Mitchell's theories do not, for example, explain the lack of landscape painting in the French colonial period in Canada.

19 For a brief but informative discussion of this, see Gerald E. Finley, *George Heriot, 1759-1839* (Ottawa: National Gallery of Canada, 1979). More recently, see John E. Crowley, "'Taken on the Spot': The Visual Appropriation of New France for the Global British Landscape," *The Canadian Historical Review* 86, 1 (2005): 1-28.

20 Rendering watercolour souvenirs of landscape vistas that were prescribed as aesthetically pleasing because they corresponded to the paintings of Nicolas Poussin, Claude Lorrain, and the like was an inherent part of the assimilation of culture on which the practice of the Grand Tour was predicated. Finley, *George Heriot*, 8, points out that touring in Britain, and the widespread painting of British landscapes, increased during the French Revolution and Napoleonic Wars when touring on the Continent became problematic. He also indicates that the ease of access to the picturesque sites in England that were considered closest to the landscapes of Europe (i.e., those found in the Lake District) tended to democratize a practice that was previously the exclusive domain of the wealthy.

21 Nicholas Thomas, *Possessions: Indigenous Art/Colonial Culture* (London: Thames and Hudson, 1999), 22.

22 George Grant, ed., *Picturesque Canada: The Country as It Was and Is*, 2 vols. (Toronto: Beldon Brothers, 1882-84). Subtitled *A Pictorial Delineation of the Beauty of Canadian Scenery and Life*, it was originally issued in thirty-six instalments between 1882 and 1884. It was subsequently consolidated into two volumes of six books and was also published in Britain.

23 Dennis Reid, *Our Own Country Canada: Being an Account of the National Aspirations of the Principal Landscape Artists in Montreal and Toronto, 1860-1890* (Ottawa: National Gallery of Canada, 1979), 298-316. Reid indicates that O'Brien's contribution of a sepia drawing of Kakabeka Falls, c. 1881, "appears all the more picturesque in the manner of the early nineteenth century, the tiny figures silhouetted against the sublime force of the falls" (304).

24 Lynda Jessup, "Canadian Artists, Railways, the State and 'The Business of Becoming a Nation'" (PhD diss., University of Toronto, 1992), 100-6. Her chapter "Making Canada Picturesque, 1876-1886" shows the relationships between British and Canadian landscapes in the late nineteenth century.

25 It is not insignificant that the format employed in 1886 was repeated at Wembley in 1924, albeit not in the Palace of Arts nor in a sequence of individual works. *The Studio* reported that "the Canadian Pavilion had probably the largest scene painting in the whole exhibition, illustrating the Canadian Rockies, prairies, the inland port of Montreal, etc. The ingenuity shown in depicting the strata of rocks, the feeling of vast distances, and the local colour, is of a high order";

see Leonard Richmond, "The Lure of Wembley," *The Studio* 87, 375 (1924): 315. Despite the scale and quality of the work, the names of the muralists remain unknown. Richmond, who reappears in a different context in a later chapter, was a British artist and author who had a close connection to Canada. He had been commissioned by the government to sketch on the front during the war and was contracted after the conflict to execute a large painting of the construction of the railways. In 1925 he was brought to Canada and travelled the width of the country producing both landscapes and portraits. His abilities as a graphic designer of posters of picturesque landscapes were also put to good use by the railways, as they had been in England.

26 E.A. Heaman, *The Inglorious Arts of Peace: Exhibitions in Canadian Society during the Nineteenth Century* (Toronto: University of Toronto Press, 1999), 206. At the same time, Canadian paintings were praised for being "picturesque."

27 On representations of the disappearing Indian in the painting of this period, see Maureen Ryan, "Picturing Canada's Native Landscape: Colonial Expansion, National Identity, and the Image of a 'Dying Race,'" *RACAR* 17, 2 (1990): 138-49. Ryan established several principles operative in the late nineteenth century that I take up for the early twentieth century.

28 Dennis Reid, *A Concise History of Canadian Painting* (Toronto: Oxford University Press, 1973), 135.

29 This is not to say that the Group of Seven had direct access to Gilpin's theories. Although this might have been the case, I agree with Mitchell, "Imperial Landscape," that these tenacious formulations survived as independent pictorial codes long after Gilpin had ceased to be read. Nor do I claim that variations within the picturesque were limited to Gilpin's prescriptions; they were not. There were, particularly in its inception, several different and contested interpretations of both its pictorial practice and its meanings. The point here, then, is not to situate the Group within any of these variants on the picturesque since all of them had been more or less conflated into a common, nondifferentiated set of British conventions by the time they reached Canada, where specific colonial conditions modified them further. Moreover, they become increasingly hybrid within the Dominion under German and American influences. By the turn of the twentieth century, there was anything but a pure picturesque practice in Canada. The term itself had been generalized to the point where it could accommodate a host of diverse modifications. Nonetheless, I do claim that core elements persisted within the British/Canadian colonial practice that can be traced back to the very roots of the British tradition, that these were handed on to the Group and incorporated in their work, and that identifying and isolating them is the most clear method for establishing these colonial connections.

30 Varley's early picturesque production and practices are illustrated in Maria Tippett, *Stormy Weather: F.H. Varley, a Biography* (Toronto: McClelland and Stewart, 1998).

31 Jackson's early *Landscape with Willows*, 1903, National Gallery of Canada, is an example of his competent assimilation and expression of picturesque conventions. See Figure 4.

32 Harris, who studied in Germany, would be the exception to this rule, but as will be seen he soon assimilated picturesque properties.

33 F.B. Housser, *A Canadian Art Movement: The Story of the Group of Seven* (Toronto: Macmillan, 1926), 61. See also Robert Stacey, "The Myth – and Truth – of the True North," in Michael Tooby, ed., *The True North: Canadian Landscape Painting, 1896-1939* (London: Lund Humphries, 1991), 45-46, for further suggestions that the "northland" constituted and was perceived as the Canadian equivalent to the English Lake District, which was the site of picturesque pursuits.

34 Bertram Brooker, "When We Awake," in Bertram Brooker, ed., *The Yearbook of the Arts in Canada, 1928-1929* (Toronto: Macmillan, 1929), 9-10, emphasis in the original.

35 Northrop Frye, "Canadian and Colonial Painting," in Douglas Fetherling, ed., *Documents in Canadian Art* (Peterborough, ON: Broadview, 1987), 91-92. Originally published in *Canadian Forum*, 1940.

36 Since Frye's formulations, and Margaret Atwood's development of them, the discussion of the influence of the picturesque and the sublime has achieved more breadth and depth in the field of literature than in the visual arts in Canada. See, for example, Susan Glickman, *The Picturesque and the Sublime: A Poetics of Canadian Landscape* (Montreal and Kingston: McGill-Queen's University Press, 1998).

37 Anne Whitelaw, "'Whiffs of Balsam, Pine, and Spruce': Art Museums and the Production of a Canadian Aesthetic," in Jody Berland and Shelly Hornstein, eds., *Capital Culture: A Reader on Modernist Legacies, State Institutions, and the Value(s) of Art* (Montreal and Kingston: McGill-Queen's University Press, 2000), 123. Note that she characterized the picturesque as European rather than British.

38 Ibid., 134 n. 4.

39 Andrews, *The Search*, 29.

40 Mitchell, "Imperial Landscape," 16.

41 Andrews, *The Search*, 29.

42 Joan Murray, *Tom Thomson Trees* (Toronto: McArthur, 1999), 7.

43 Murray, *Tom Thomson Trees*, 5-7, attributes Thomson's interest in trees to an early encounter with the natural sciences rather than to picturesque conventions.

44 Murray, *Tom Thomson Trees*, 9. See also, for example, Tom Thomson's *The Old William McKeen House* (n.d.), *The Banks of the River* (1908), and *Young Fisherman* (n.d.), all in Joan Murray, *The Art of Tom Thomson* (Toronto: Art Gallery of Ontario, 1971), 13, 16. See also Thomson's *Stream Bank and Tree*, illustrated in Harold Town and David Silcox, *Tom Thomson: The Silence and the Storm* (Toronto: McClelland and Stewart, 1977), 34.

45 Hubbard points out that these conventions continued and were repeated in the Group's works. Speaking of their first exhibition, he states: "Most of these canvases had the same simple compositional formula of tree against sky and water, and the same bold colour schemes that expressed the austere northern landscape." He does not seem aware that the roots of this compositional formula lay in the picturesque. Hubbard, *An Anthology of Canadian Art* (Toronto: Oxford University Press, 1960), 25.

46 Leonard Richmond, "Canadian Art at Wembley," *The Studio* 89, 182 (1925): 16-23. The other works illustrated were F.N. Loveroff's *Snow on the Hillside*, Albert H. Robinson's *Melting Snows, Laurentians*, Alexander Y. Jackson's *Winter, Georgian Bay*, Tom Thomson's *The Jack Pine*, Randolf S. Hewton's *Miss Audrey Buller*, and "Francis" H. Johnston's *A Northern Night*.

47 Richmond had met members of the Group of Seven while in Canada. He discussed
current art in a public forum at the University of Toronto with A.Y. Jackson
and Lawren Harris in 1925 in an event organized by the Canadian critic and
painter Barker Fairley. Richmond also gave a series of lectures at the National
Gallery. National Gallery of Canada, *Annual Report of the Board of Trustees for the
Fiscal Year 1924-1925* (Ottawa: King's Printer, 1925), 17. The following year, he
published an article on the Group's drawings; see Leonard Richmond, "A Port-
folio of Drawings by Members of the Canadian Group of Seven," *The Studio* 91,
397 (1926): 244-47.

48 Richmond, "Canadian Art," 19.

49 Charles Hill, *The Group of Seven: Art for a Nation* (Ottawa: National Gallery of
Canada, 1995), 318.

50 Hill, *The Group of Seven*, 318, indicates that Harris painted at least three works of
the area featuring "trees in front of the bay ... in which he defines the foreground
with vertical tree trunks through which one has a panoramic view to the far
distance." Hill links their compositions to *Beaver Swamp, Algoma, Algoma Country,*
and *Above Lake Superior* and to a study by A.Y. Jackson, although not to *First Snow.*
This connection is even more apparent in the other two versions, which lack the
rail fence. The Wembley version of *Pines* was acquired by the National Gallery in
1924 but seems to have suffered further rejection and is now in the Art Gallery
of Hamilton.

51 Again, see for example, Frye, "Canadian and Colonial," 90: "What is essential in
Thomson is the imaginative instability, the emotional unrest and dissatisfaction
one feels about a country which has not been lived in: the tension between the
mind and a surrounding not integrated with it. This is the key to both his colour
and his design."

52 Watercolour was still seen as quintessentially English in the 1920s. See, for
example, G.H. Mair, "Contemporary British Landscapes in Water-colour," *The
Studio* 86, 369 (1923): 305: "I suppose that after lyric poetry there is no art more
specially and significantly British than water-colour painting."

53 Not all smoothness had to be avoided. Smoothness in water, a common feature
in Harris, was acceptable and even preferable; see William Gilpin, *Three Essays:
On Picturesque Beauty; On Picturesque Travel; and On Sketching Landscape* (Farnbor-
ough, UK: Gregg International, 1972 [1794]): "As picturesque beauty therefore
so greatly depends on *rough* objects, are we to exclude every idea of smooth-
ness from mixing with it? Are we struck with no pleasing image, when the lake
is spread upon the canvas, the *mar mareum aequor,* pure, limpid, smooth, as the
polished mirror? We acknowledge it to be picturesque; but we must at the same
time recollect, that in fact the smoothness of the lake is more in *reality* than in
appearance. Were it spread upon the canvas in one simple hue, it would certainly
be a dull, fatiguing object. But to the eye it appears broken by shades of vari-
ous kinds, by the undulations of the water, or by reflections from all the rough
objects in it's [sic] neighborhood" (22, emphasis in the original). For a further
discussion on "roughness" as a point of contention within the political meanings
of the picturesque, especially between Uvedale Price and Richard Payne Knight
in the late 1700s and early 1800s, see Ann Bermingham, "System, Order, and

Abstraction: The Politics of English Landscape Drawing around 1795," in Mitch-ell, ed., *Landscape and Power*, 2nd ed., 79-83.

54 Pratapaditya Pal and Vidya Dehejia, *From Merchants to Emperors: British Artists and India, 1757-1930* (Ithaca: Cornell University Press), 97: "In eighteenth-century Britain, where the cult of the picturesque had been established in the sphere of landscape painting, the word 'picturesque' implied the avoidance of anything precise, trim, or tame; its keynote was the presence of ruggedness, of wild or unkempt beauty. In his famous essay on the picturesque, William Gilpin specified that 'ideas of neat and smooth ... strip the object ... of picturesque beauty.'"

55 On the primacy of the sketch in the picturesque, see Bermingham, *Landscape and Ideology*, 64.

56 G.H.R. Tillotson, "The Indian Picturesque: Images of India in British Landscape Painting, 1780-1880," in C.Y. Bayley, ed., *The Raj: India and the British, 1600-1947* (London: National Portrait Gallery, 1990), 142: "The Picturesque encour-aged the aesthete to travel in search of landscapes to admire ... [This] led to the wilder parts of the British Isles, including the Lake District." See also Ann Bermingham, "The Popularisation of the Picturesque Taste," *Studies on Voltaire and the Eighteenth Century* 265 (1989): 1212-13. Her observation that the pictur-esque tended toward "the naturalization of a particular socio-cultural perception of nature by locating (and thus affirming) it in an actual landscape" is pertinent here, as is her claim that the "picturesque landscape was one free from the signs of modernity, the marks of agrarian reform, or similar industrial intrusions that were felt to spoil nature. Its sentimental and nostalgic view of the old landscape was also a way to marginalise it and to obscure the real economic injustices of the new order."

57 Paul H. Walton, "The Group of Seven and Northern Development," *RACAR* 17, 2 (1990): 173. For an analysis of the mythic "wilderness" in Thomson's work in Algonquin Park, see Andrew Hunter, "Mapping Tom," in Art Gallery of Ontario and National Gallery of Canada, *Tom Thomson* (Toronto and Ottawa: Art Gallery of Ontario and National Gallery of Canada, 2002), 19-45. For a cogent discussion of the inherent artificiality of the areas designated as "wilderness," which formed the subject for the works of the Group of Seven in western Canada, see Lynda Jessup, "The Group of Seven and the Tourist Landscape in Western Canada, or The More Things Change ...," *Journal of Canadian Studies* 37, 1 (2002): 144-79.

58 Allan Fletcher, "Industrial Algoma and the Myth of Wilderness: Algoma Land-scapes and the Emergence of the Group of Seven, 1918-1920" (MA thesis, Uni-versity of British Columbia, 1989).

59 Tillotson, "The Indian Picturesque," 142.

60 Harris's view of Maligne Lake, near Jasper, was included in the second Wembley show. These trips to western Canada recapitulated the picturesque excursions of the artists who were sent on a grand tour across Canada after the opening of the railway in the late 1880s. For an examination of the latter's role in asserting a national identity at that time, see Jessup, "Canadian Artists."

61 Sir Joshua Reynolds, cited in Bermingham, *Landscape and Ideology*, 58.

62 Housser, *A Canadian Art*, 118.

63 Bermingham, *Landscape and Ideology*, 59.

64 William Bate-Budley, cited in Bermingham, *Landscape and Ideology*, 60. As would

later occur in Canada, the first claims for a specifically national English school of painting in the mid-1700s were founded on landscape painting, see Andrews, *The Search*, 24: "In painting as in poetry, the appeal to swelling nationalism was strong pressure behind the emergence of an English school of landscape."

65 Housser, *A Canadian Art*, 24.

66 The assertion that landscape could carry a British national vision continued into the late 1920s; see "Nationality in Landscape," *Connoisseur* 77, 305 (1927): 58-9, in which the paintings of Richard Wilson, Thomas Gainsborough, George Stubbs, David Cox, John Constable, and J.M.W. Turner were seen as "redolent of the land [they] depicted, seen and realized with that intimate appreciation which is only given to natives of the country." Turner's images were judged "more satisfy-ing than post-impressionist landscapes," post-Impressionism being a movement of which the journal took a dim view.

67 Andrews, *The Search*, 35.

68 Hill's carefully researched study, *The Group of Seven*, makes no reference to the picturesque or to any British influences, although he carefully enumerates the other sources.

69 The monumental monograph by Carl Laurin, Emil Hannover, and Jens Thiis, *Scandinavian Art* (New York: Benjamin Blom, 1968), was originally published in 1922. In many ways it corresponded to the 1912-13 exhibition. The section on modern Norwegian art shows only a small percentage of pure landscapes, as with the other countries. For a more recent sampling, see Kirk Varnedoe, *Northern Light: Nordic Art at the Turn of the Century* (New Haven: Yale University Press, 1988). Again, landscape painting is in the minority. Roald Nasgaard, *The Mystic North: Symbolist Landscape Painting in Northern Europe and North America, 1890-1940* (Toronto: Art Gallery of Toronto, 1984), isolates only landscapes and thus reaf-firms the connection with the Group of Seven.

70 See Nasgaard, *The Mystic North*, 170; and Varnedoe, *Northern Light*, 93.

71 Varnedoe, *Northern Light*, 90.

72 All of these elements of Finnish identity were configured together in the decor of Finland's pavilion at the Paris exposition in 1900 and were recognized by French critics as valid proof of a unique national culture; see Gustav Soulier, "Le Pavillon de Finlande à l'Exposition universelle," *Art et Décoration* 8, 1 (1900): 11: "C'est bien en présence d'un art national propre que nous nous trouvons." Soulier is quoted in Marie-Pierre Salé, "Entre mythes et histoires: Le renouveau de la peinture nationaliste," in *1900* (Paris: Galeries nationales du grand Palais, Réunion des musées nationaux et Le musée d'Orsay, 2000), 210. Salé states that "le message était limpide: les articles parus en France insistent sur le caractère national de cet art, son autonomie et sa nouveauté" (205).

73 Finland has gone on to emphasize the "largely empty landscape" as a marker of its nationhood and identity; see Michael J. Shapiro, *Methods and Nations: Cultural Governance and the Indigenous Subject* (New York: Routledge, 2004), 117-19. One other link that draws Finnish painting closer to its Canadian counterpart is that Finland, too, had a group whose members needed to be excluded: the indigenous Sami. Shapiro cites Tutta Palin, "Picturing a Nation," in Tuomas M.S. Lehtonen, ed., *Europe's Northern Frontier*, trans. Philip Landon (Jyvaskyla, Finland: PS-

Kustannus, 1999), 208: "Not one member of the Sami people can be found in the 'typically Finnish' folk depictions by the masters of the Golden Age of Finnish Art [because] in the bourgeois culture of the turn of the century, the Sami were invisible, except in illustrations to ethnographic studies and exotic travel journals written by foreigners."

CHAPTER 3: CANADIAN ART IN PARIS

1 National Gallery of Canada, *Annual Report for the Board of Trustees for the Fiscal Year 1926-1927* (Ottawa: King's Printer, 1927), 13. Paris was not the only possibility debated at the time for establishing international recognition of the Group of Seven; see Pere Raquette [A.Y. Jackson] to Clarence Gagnon, 20 April 1926, Gagnon correspondence, McCord Museum of Canadian History Archives (hereafter MMCHA): "I think a very well selected show of modern Canadian work in Paris or a Canadian section in the Venetian International would do a lot for us."

2 Brown did reprint excerpts from nine of these reviews in his annual report, but they would have received a very limited readership; see National Gallery of Canada, *Annual Report of the Board of Trustees for the Fiscal Year 1927-28* (Ottawa: King's Printer, 1928), 9-18. Maud F. Brown also published selected excerpts in "Canadian Art in Paris," *Canadian Homes and Gardens* 4, 8 (1927): 20, 56, but her account, while not without interest, is less than objective. After this point, the reviews were ignored or misinterpreted. As early as 1929, Bertram Brooker claimed that France had recognized the "native unification" of Canadian painting; see Bertram Brooker, "When We Awake," in Bertram Brooker, ed., *The Yearbook of the Arts in Canada, 1928-1929* (Toronto: Macmillan, 1929), 9. Albert Robson, who would have a painting purchased from the Parisian show for the Luxembourg, devoted a chapter in his book on Canadian landscapes to Wembley and cited many of the reviews, but he offered only a sentence on the Jeu de Paume and did not mention it by name; see Albert Robson, *Canadian Landscape Painters* (Toronto: Ryerson Press, 1932). Graham McInnes, *Canadian Art* (Toronto: Macmillan, 1950), 60, states: "The zenith of the Group's achievement occurred during the years 1924-1927, and is underlined by the immediate and stimulating success of the Canadian art exhibitions at London in 1924-1925 and at Paris in 1927. Here their dash, brilliant colour and decorative ability found a ready response among critics and public alike." Although he cited the Wembley reception at length, he included none of the Parisian reviews. A.Y. Jackson did not recall the exhibition or its reception in his memoirs even though he was adamant about its importance at the time; see A.Y. Jackson, *A Painter's Country: The Autobiography of A.Y. Jackson*, rev. ed. (Toronto: Clarke, Irwin, 1967). J. Russell Harper, *Painting in Canada: A History* (Toronto: University of Toronto Press, 1966), 304, ends his chapter on the Group of Seven with the Wembley exhibitions and does not mention the Jeu de Paume. Dennis Reid, *Le Groupe des Sept/The Group of Seven* (Ottawa: National Gallery of Canada, 1970), 201, reduced the Jeu de Paume exhibition to an aside in the last rounds of the battle between Brown and the Group versus the RCA: "Clever politics on the part of Brown and his supporters and the continuing success of his international programme, with the opening

of the Canadian exhibition in Paris in 1927 again drew public support and forestalled a direct confrontation [with the RCA]." He gave nothing in support of his claim of continuing success. Dennis Reid, *A Concise History of Canadian Painting* (Toronto: Oxford University Press, 1973), 151, omitted any reference to Paris. The one exception in recent times is Maud F. Brown, *Breaking Barriers: Eric Brown and the National Gallery* (Port Hope, ON: Society for Art Publications, 1964), but again this is a highly partial rendition of the events.

3 Charles Hill, *The Group of Seven: Art for a Nation* (Ottawa: National Gallery of Canada, 1995), 215-17.

4 Hill, ibid., cited none of the reviews. More recent writers have followed his precedent. David Silcox's coffee-table book does not mention the Jeu de Paume, although it outlines the vindications of the Wembley exhibitions; see David P. Silcox, *The Group of Seven and Tom Thomson* (Toronto: Firefly Books, 2003), 37.

5 Hill, *The Group of Seven*, which provides an excellent summary of events from the NGC's perspective, does not repeat this claim.

6 National Gallery of Canada, *Annual Report, 1926-1927*, 12.

7 Gagnon returned to France in December 1924. Under recently passed laws, failure to do so would have resulted in his loss of a lease of a studio; see Gagnon to Duncan Campbell Scott, 10 December 1924, MMCHA. Scott, the deputy superintendent of the Department of Indian Affairs, also acted as his dealer in Ottawa.

8 Gagnon fully realized his position outside the Group but, in corresponding with Brown, placed himself with them in their conflict with the RCA; see Gagnon to Brown, 28 November 1926, National Gallery of Canada Archives (NGCA): "They appear as wanting outside artists to fight for them but don't want these in their group. In fighting the R.C.A., they forget that the very thing they are fighting against is existent in their Group, that is authority for them to dictate in art matters for their group of Seven, as if these seven artists are and will be the only ones in the land." There are four files of correspondence on the Jeu de Paume exhibition in the NGCA; see Jeu de Paume, Canadian Exhibitions/Foreign 5.4P Paris, Canadian Ex, in 1927, Files 1, 2, 3, and 4 (hereafter NGCAJP). For Gagnon's sarcastic assessment of the "Group of Seven Wonders," a poisonous reference to Fred Housser as "Lawren Harris' brother in law," and his comment on the need to get "a transit visa with a promise of keeping 'hands off the real North,'" see Gagnon to Scott, 27 February 1929, MMCHA. Needless to say, he did not voice these sentiments to Brown.

9 Gagnon came to London from Paris to assist Brown in hanging the second Wembley exhibition. He enjoyed special status, such as having the work that he had done in Paris bypass the Wembley selection jury; see Gagnon to Scott, 4 May 1925, MMCHA.

10 Gagnon to Scott, 11 February 1927, MMCHA: "All through my negotiations with the French Government I have had my own way."

11 Masson had only recently been appointed. According to Gagnon, he showed "a strong leaning towards modern art"; see Gagnon to Brown, 8 July 1926, NGCAJP, File 1. As will be shown, this made him somewhat suspect.

12 Dayot to Gagnon, 6 January 1920 and 18 January 1920, MMCHA.

13 Kenneth E. Silver, *Esprit de Corps: The Art of the Parisian Avant-Garde and the First*

World War, 1914-1925 (Princeton: Princeton University Press, 1989). On the formation of the nationalist discourse within the arts in France from 1900 to the First World War, see David Cottington, *Cubism in the Shadow of the War: The Avant-Garde and Politics in Paris, 1905-1914* (New Haven: Yale University Press, 1998).

14 Romy Golan, *Modernity and Nostalgia: Art and Politics in France between the Wars* (New Haven: Yale University Press, 1995).

15 Ibid., 25.

16 Brown to Gagnon, 5 December 1924, Clarence Gagnon – Eric Brown correspondence, File 7.1G, Correspondence with/re artists Gagnon, Clarence, File 1, 1945 [actually 1926], 1924-28 (hereafter NGCAGB). There is some overlap between the Jeu de Paume files and the Gagnon correspondence. Brown seems, at this early stage, to have assumed that Dayot had ministerial authority.

17 Gagnon to Brown, 8 July 1925, NGCAJP, File 1; and Jean Charpentier to Monsieur, 3 July 1925, submitting terms of lease, NGCAJP, File 1. The Charpentier Galleries were a major advertiser in Dayot's journal.

18 Gagnon to Brown, 16 August 1925, NGCAJP, File 1.

19 McCurry to Brown, 9 October 1925, NGCAJP, File 1. Gagnon had suggested these possible locations in August; see Gagnon to Brown, 16 August 1925, NGCAJP, File 1.

20 McCurry to Brown, 10 October 1925, NGCAJP, File 1.

21 McCurry to Directeur des Beaux-Arts, [October 1925], NGCAJP, File 1. See also McCurry to Brown, cable, 6 October [1925], NGCAJP, File 1, requesting authorization to proceed with submission.

22 Brown to Gagnon, cable, 7 October 1925, NGCAJP, File 1; and Gagnon to Brown, 11 October 1925, NGCAJP, File 1, expressing consternation over the abortion of the negotiations, which had proceeded to the point of submission for the gallery, and over potential competition from Argentina, Brazil, Poland, and Yugoslavia.

23 Paul Léon to Monsieur, 28 October 1925, NGCAJP, File 1.

24 Brown to McCurry, cable, 22 October 1925, NGCAJP, File 1, in which Gagnon is chastised for acting without authority. Greece was also in the running.

25 Director [Brown] to the Director, Ministère des Beaux-Arts, 22 February 1926, NGCAJP, File 1.

26 Gagnon to Brown, 3 March 1926, NGCAJP, File 1.

27 Brown to Gagnon, 16 March 1926, NGCAJP, File 1.

28 Le Directeur des Beaux-Arts, Paul Léon, to Monsieur, 2 May 1926, NGCAJP, File 1. See also Léon to Masson, 15 May 1926, NGCAJP, File 1, informing Masson of the exhibition; and Léon to Brown, 15 May 1926, NGCAJP, File 1 (same as 2 May 1926, NGCAJP, File 1). See also Brown to Masson, 15 July 1926, NGCAJP, File 1. Brown was in England when the confirmation was received, hence the delay in responding. He begins here to claim that "it has been the success of the Canadian Section of the 1924 and 1925 British Empire Exhibition which has interested you particularly in Canadian art." Masson made no such mention. Brown also names Gagnon as the person to talk to; see Louvre Archives, Exposition d'art canadien, 10 April to 10 May 1927 (hereafter Louvre Archives). See also, in NGCAJP, File 1, McCurry to Brown, cable, 3 July 1926,

advising Brown of invitation; Brown to McCurry, 6 July 1926, asking him to defer decision; McCurry to Brown, 7 July 1926, announcing his tentative acceptance; McCurry to Brown, cable, 12 July 1926; and Gagnon to Brown, 8 July 1926.

29 See Brown to Gagnon, 6 July 1926, NGCAJP, File 4: "I have no idea how many pictures would be required ... I know nothing of Masson or what he stands for in French art." It was soon clarified that the content of the Jeu de Paume exhibition would be drawn from the two Wembley shows; see Brown to Gagnon, 18 July 1926, NGCAJP, File 4. For confirmation, see Brown to Gagnon, 3 December 1926, NGCAJP, File 4. However, the composition had been discussed earlier; see McCurry to Brown, 10 October 1925, NGCAJP, File 1.

30 Brown to Gagnon, 20 July 1926, NGCAJP, File 1. Gagnon to Charles Masson, 5 Novovember 1926, Louvre Archives, states that he is acting as Brown's representative.

31 Ann Davis, "The Wembley Controversy in Canadian Art," *Canadian Historical Review* 54 (March 1973): 48-74, gives an excellent account of how the RCA was isolated, marginalized, and outmanoeuvred by Brown and the Group of Seven.

32 [Brown] to Gagnon, 22 July 1925, NGCAJP, File 1. See also [Brown] to Gagnon, 16 July 1925, NGCAJP, File 1.

33 In NGCAJP, File 1, see Gagnon to Brown, 8 July 1925; Brown to Gagnon, 22 July 1925; and Gagnon to Brown, 19 August 1925. In Gagnon to Brown, 11 October 1925, Brown urges Gagnon to act immediately and adds: "We will make out the list of artists to be invited, hand it over to Dayot, who will ask the Minister of Fine Arts to present this invitation to the Board of Trustees, who will advise the artists." For reconfirmation of the plan, see, in NGCAJP, File 1, Gagnon to Brown, 8 July 1926; and Gagnon to Brown, 12 July 1926, which contains the most complete rendition of "our plan." But see also Brown to Gagnon, 20 July 1926, NGCAJP, File 4: "The desire of the French Gov't to make the exhibition an invitation must appear quite definite; otherwise I think it will be difficult to accomplish." Up to this point, neither Gagnon nor Brown had been introduced to Masson or Dezarrois, yet both Canadians understood the positions that the French officials were to assume; see Gagnon to Brown, 1 August 1926, NGCAJP, File 1. It was at this point that Dezarrois first received a catalogue of the Wembley exhibition, thus ruling out the possibility of advance knowledge of the work and consequently any desire to sponsor the show because of his already established recognition of its quality. This was, however, also an integral part of the "invitation."

34 Brown to various board members, announcing the "invitation" and asking for confidentiality, 2 September 1926, NGCAJP, File 1. Responses from the board members to Brown confirming approval occur around 20 to 23 September 1926, NGCAJP, File 1. Shepherd was the only one to raise objections. See Shepherd to Brown, 6 September 1926, NGCAJP, File 1. For confirmation of ratification by the board, see Brown to Gagnon, 27 September 1926, NGCAJP, File 1. For Brown thanking the French government for the invitation, see Brown to the Director, Ministère de Beaux-Arts, 27 September 1926; and Brown to Masson, 27 September 1926, NGCAJP, File 1. The latter is also in the Louvre Archives.

35 Brown to Gagnon, 27 September 1926; and Gagnon to Brown, 9 November
 1926, NGCAJP, File 1. Given the context, this act was not just a gesture of dip-
 lomatic generosity. It had more than one precedent. E.A. Heaman, *The Inglorious
 Arts of Peace: Exhibitions in Canadian Society during the Nineteenth Century* (Toronto:
 Toronto University Press, 1999), 155, reports that for the Paris exhibition of
 1855, "the Canadian government voted £10,000 towards the display, and another
 £10,000 for French widows and orphans – to bribe the French into good humour
 with things Canadian." In addition, "foreign" modernist works, but especially
 those from Germany and those that had been associated either with German
 galleries, such as Kahnweiler's, or with German "taste" had been under attack in
 France since the war. In a move to reassure the French of their contribution and
 appreciation, artists associated with such a position took part in a Salon de Franc
 that was held in 1926 under the auspices of the journal *Paris-Midi*, organized by
 M.M. de Baleffe and Rolf de Maré "au profit du franc," which was in serious
 trouble from devaluation at the time. Featuring works by foreign artists such as
 Pablo Picasso and Kees Van Dongen, "en reconnaissance de l'hospitalité intel-
 lectuelle et matérielle qu'ils en ont reçue," it raised 746,000 francs for the cause
 and an undetermined amount of goodwill for the artists and their dealers and
 collectors; see "Echos des Arts," *L'Art et les Artistes* 71 (November 1926): 70.
36 Gagnon to Brown, 7 October 1926, NGCAJP, File 1.
37 The translation is probably the undated, unsigned typescript, in French, to
 Monsieur le directeur de la Galerie Nationale du Canada, Louvre Archives. In
 NGCAJP, File 1, see also Brown to Gagnon, 3 December 1926; and Gagnon
 to Brown, 21 December 1926, confirming receipt, translation, approval, and
 submission of the letter to Masson. Gagnon states that, "with a document of
 that kind, we will be able to work out our show without any interference, and
 by God keep out of it that 'mangy skunk Grier,'" who, it seems, had blown the
 whistle on the Wembley selection jury. Its other intent was to ensure no input
 from the Board of Trustees, which could favour the RCA; see Gagnon to Brown,
 12 July 1926, NGCAJP, File 1.
38 My translation. There are some differences in the wording of the text of the
 holograph copy that was sent back; see Masson to Brown, [8] January 1927,
 NGCAJP, File 1. Masson is not as insistent on his personal role in limiting the
 works as Brown's initial letter to him would have made him out to be. The
 importance of the letter is indicated by Brown's anxiety over its late arrival; see
 Brown to Gagnon, 17 January 1927, NGCAJP, File 1.
39 Brown to Masson, 28 January 1927, Louvre Archives.
40 See Gagnon to Brown, 28 November 1926, NGCAJP, File 1. For Gagnon's oppo-
 sition to the Armingtons and his suggestion that "we could put in a clause that
 would bar these artists from the show," see Gagnon to Brown, 13 November
 1926, NGCAJP, File 1; see also Gagnon to Brown, 12 July 1926, NGCAJP, File 1.
 Caroline Armington and Frank M. Armington, expatriate artists living in Paris,
 are almost forgotten now, but at the time they played a significant role in the
 Paris art world. They opened their studio to visits by tourists, sold large quanti-
 ties of prints, and had been included at Wembley. In 1923 Caroline had exhibited
 at Simonson's Gallery, the same one that later hosted a Morrice retrospective.

In an ironic twist, it would be they, rather than Gagnon or the Group of Seven, who would receive a feature article in Dayot's journal immediately after the Jeu de Paume exhibition; see Louise Gebhard Cann, "L'Oeuvre de Caroline Armington et Frank M. Armington," *L'Art et les Artistes* 78 (June 1927): 302-6. Brown expressed his antipathy to and confusion with this turn of events in Brown to Gagnon, 12 October 1927, MMCHA: "I was very sorry to see that Dayot immediately printed an Armington article ... He was one of the people most strongly against Armington's inclusion in the Canadian show."

41 Dezarrois "also suggested that Morrice and Thomson should be given each a retrospective show in the Exhibition"; see Gagnon to Brown, 1 August 1926, NGCAJP, File 1. For Brown's confirmation, see Brown to Gagnon, 19 August 1926, NGCAJP, File 1. Dezarrois's knowledge of Thomson must have been scant at this time, although he would have been well aware of Morrice.

42 Gagnon to Brown, 3 March 1925, NGCAJP, File 1.

43 See Gagnon to Brown, 11 April 1926, NGCAGB, on "pink elephants" and the "moral turpitude" of current modernist work. For his opinion that the sale of an Henri Rousseau for 535,000 francs was a "put up job" – that is, an attempt to manipulate the market and keep prices high, see Gagnon to Brown, 13 November 1926, NGCAJP, File 1. For Gagnon's approval of a "reaction against Picasso and his followers" and the collapse of the market for modernism in France, which he attributed to "alien artists" and "foreign buyers," see Gagnon to Brown, 18 November 1926, NGCAGB. For his opposition to rehanging the Luxembourg with "the Ultra-Modern School," see Gagnon to Scott, 27 February 1929, MMCHA. Updating the latter's collection was done under Masson. Gagnon's position is ambiguous since he resisted modernism yet also the RCA, which he thought should be "good to relegate to the scrap heap"; see Gagnon to Brown, 21 December 1926, NGCAJP, File 1.

44 See Douglas Ord, *The National Gallery of Canada: Ideas, Art, Architecture* (Montreal and Kingston: McGill-Queen's University Press, 2003), 85-96. Ord does not shy away from pointing out the unpleasant parallels with Fascist attitudes of the same period.

45 Many of these artists were associated with painting in Brittany prior to the turn of the century. The NGC acquired a Cottet landscape that Brown thought sufficiently important to illustrate in National Gallery of Canada, *Annual Report, 1927-1928*, 19. The choice is significant. Cottet, although linked with Gauguin and the Nabis, rejected the colour and light of Impressionism and painted Brittany land and seascapes in dark tonalities and in a naturalistic manner similar to that of Gustave Courbet. Both Gagnon and Brown admitted that much of his recent production consisted of "potboilers." He had died in 1925. Simon, who was a friend of Cottet and a member of the group that he had formed called La Bande Noire, had been Holgate's teacher. A Brittany seascape by Maufra had been acquired in 1911. Maufra had spent time in England and showed a British influence on French art. He had died in 1918. Loiseau (1865-1935) was a friend of Maufra's and painted in a manner derived from Impressionism. Moret (1856-1913) was also a Brittany landscapist who had been influenced by Gauguin but had returned to an Impressionist style. The Alps painter Michel Simonidy was

also of interest to both Brown and Gagnon; see Gagnon to Brown, 21 December 1926, NGCAJP, File 1.

46 Robert Jensen, *Marketing Modernism in Fin-de-Siècle Europe* (Princeton: Princeton University Press, 1994), 5. The exception is Alfred Lombard (1884-1973), a "proto-Fauve" who had his origins in Marseille, but who, by the 1920s, had become a more conservative mural painter.

47 Brown to Gagnon, 28 May 1925, NGCAGB. It should be noted that Dayot's journal was extremely conservative and did not feature anything related to Fauvism, Cubism, Expressionism, De Stijl, and so on. This is underscored by the academic headings under which the art to be reviewed was grouped: compositions, landscapes, nudes, portraits, animals, and still life. For a longer list of artists recommended by Gagnon, see Gagnon to Brown, 9 September 1925, NGCAGB.

48 Brown to Gagnon, 23 September 1925, NGCAGB. The reciprocal show seems never to have taken place.

49 John O'Brian, "Morrice's Pleasures (1900-1914)," in Nicole Cloutier, *James Wilson Morrice, 1865-1924* (Montreal: Montreal Museum of Fine Arts, 1986), 94.

50 The French state had acquired *Quai des Grands-Augustins* in 1904; see Cloutier, *James Wilson Morrice*, 165.

51 A canvas by Claude Monet and one by Alfred Sisley were added in 1914, the first acquisiton of a work by each, and as mentioned in Chapter 1, these were the last of their kind to be acquired for nine years. In 1923, in a rare move, the NGC purchased an 1896 Camille Pissarro urban scene, *The Stone Bridge in Rouen, Dull Weather*. By this time, however, as the title implied, Pissarro had abandoned his earlier experiments with neo-Impressionist colour and pointillist techniques and had returned to a more subdued palette, softer brush strokes, and atmospheric effects. Brown forestalled further similar acquisitions by claiming that "the French Impressionist Movement of 1870 ... is already well represented"; see National Gallery of Canada, *Annual Report of the Board of Trustees for the Fiscal Year 1923-1924* (Ottawa: King's Printer, 1924), 12. Although this may have contained a grain of truth, there were few post-Impressionist paintings, a movement that he did not mention. No moves seem to have been made from 1912 to 1925 to collect paintings in this area, although a suite of posthumous black and white woodblocks by Gauguin was acquired in 1925. By contrast, in 1924 the Art Institute of Chicago acquired Georges Seurat's monumental post-Impressionist masterwork *A Sunday on La Grande Jatte – 1884* and framed it with works by Rousseau and Gauguin; see Robert L. Herbert, *Seurat and the Making of La Grande Jatte* (Chicago: Art Institute of Chicago, 2004), 17. This event was well publicized in North America.

52 This becomes particularly so when one considers the diametrically opposed images of the two artists: an urbane, cosmopolitan, witty *flâneur* dressed impeccably for strolling the boulevards, carrying nothing heavier than an umbrella, and sipping absinthe versus the virile, self-trained, plain-speaking woodsman dressed in plaid, denim, and boots, with a canoe under one arm and a paintbox under the other while hiking through the woods drinking cowboy coffee. That these images were not a simple binary but sides of the same coin was not evident at the time.

53 National Gallery of Canada, *Annual Report of the Board of Trustees for the Fiscal Year 1925-1926* (Ottawa: King's Printer, 1926), 15.

54 *Jeune Vénitienne*, 48 x 37.1 cm, and *Breton Girl*, 47.3 x 35.4 cm, were both acquired by the NGC from the artist's estate in 1925 and apparently received their titles thereafter. For more on *Jeune Vénitienne*, see Cloutier, *James Wilson Morrice*, 146-47; Cloutier indicates that it was not shown until 1932.

55 According to Cloutier, *James Wilson Morrice*, 205, in 1926 the NGC exhibited a work known as *In the Orchard, Le Pouldu* (1911). It was drawn from the artist's estate rather than from the NGC's recent acquisitions.

56 Cloutier, *James Wilson Morrice*, 163, gives its exhibition list as Winnipeg, 1917; Moose Jaw, 1918; St. Louis, 1918; Chicago, 1919; Halifax, 1922; Wembley, 1924; AAM, 1925; Paris, 1927; and so on. It does not seem to have been exhibited in Ottawa or Toronto during this period. Note that its early date confirmed the narrative construction of the Group of Seven by situating Morrice, and hence French modernism, as preceding rather than paralleling or coming later than Thomson's and the Group's work. Painted in dark tonalities, it contains none of the emphasis on bravura brushwork or subtle colour that occurred in his *pochades* or later work. Listed in the Jeu de Paume exhibition catalogue as *Au Cirque*.

57 The 1924 catalogue lists *Dieppe, The Beach, Grey Effect*, NGC collection, and *Winter, Ste Anne de Beaupré*. Cloutier, *James Wilson Morrice*, 163, states that *Le Cirque, Montmarte*, was also shown but not listed in the catalogue. The 1925 catalogue lists *Gibraltar* [1913] and *Sunday at Charenton, Near Paris*. *Gibraltar* came from a private collection and had been seen in 1925 at the AAM. See Cloutier, *James Wilson Morrice*, 217. It did not go on to the Jeu de Paume.

58 *The Circus* [*Le Cirque, Montmartre*] and *Le Quai des Grands Augustins, Paris*, neither of which was in the 1925 Wembley exhibition, were from the NGC. The Art Association of Montreal, *Memorial Exhibition of Paintings by the Late James W. Morrice, R.C.A.*, Montreal, 1925. The retrospective ran from 16 January to 15 February. It included seven works from the AAM that had been presented by the estate as well as two earlier acquisitions. The contrast between the method of acquisition and the exhibitions of this work at the NGC is instructive. The number of works in the exhibition from private collectors puts paid to the Group's widely repeated claims that modernist works were not appreciated in Canada. On the contrary, there must have been a well-established identification with a cosmopolitan and Parisian modernism within these circles of primarily anglophone Montreal collectors that would have been at odds with Brown's notions of Canadian identity.

59 Not all agreed with the NGC. In reviewing the exhibition, A.H.S. Gillson repeated that he was a Canadian painter and that he formed a direct link between French modernism and the Group; see A.H.S. Gillson, "James W. Morrice: Canadian Painter," *Canadian Forum* 5, 57 (1925): 271-72.

60 In the interim, in 1933, France held yet another Morrice exhibition.

61 It is worth speculating how many of his works would have been included if he had still been alive in 1927. His death at the outset of negotiations for the exhibition changed things dramatically.

62 C.F. Ciolkowski, "J.W. Morrice," *L'Art et les Artistes* 62 (December 1925): 90-94.

63 Gagnon to Brown, 1 August 1926, NGCAJP, File 1.

64 See Golan, *Modernity*, 7, for "the reaffirmation of French cultural supremacy after the ravages of World War I."

65 Ibid., 15, points out that the movement had begun to lose its impetus by 1926, but it seems to have still done much to prescribe the critical discourse after this point.

66 Silver, *Esprit de Corps*, 367.

67 The archival material at the NGC on the Morrice section is kept in a separate file; see 5.4P Paris, Canadian Exhibition In (Morrice Retrospective) (Canadian Exhibitions – Foreign) NGC fonds, NGC Archives (hereafter NGC Morrice). See Brown to Shepherd, 3 February 1927, NGC Morrice.

68 Brown to Shepherd, 3 February 1927, NGC Morrice. For Shepherd's response, in which he forwarded a copy of the 1925 retrospective to Brown, see Shepherd to Brown, 5 February 1927, NGC Morrice. Brown returned the catalogue, asked Shepherd to mark twenty of the works and to indicate those deemed "indispensable," and insisted on Canadian images; see Brown to Shepherd, 8 February 1927, NGC Morrice. Brown made out a list, but this is not with the letters; see Brown to Shepherd, 13 February 1927, NGC Morrice.

69 Lists in the Jeu de Paume files at the NGC frequently give no specific number or titles for the Morrice works sent from Canada, although they are detailed regarding whose works and which works were to be included. Even when titles are given, a certain ambiguity prevails. For example, the list of the Content of Cases in the Canadian Section, B.E., Ex to Paris, Shipped by the National Gallery of Canada to Musée du Jeu de Paume, Paris, by Canadian Pacific Express, via Antwerp, NGCAJP, File 3, gives a total of twenty-one works but cites twenty-four by title. The Morrice files are more specific, but even here figures vary from list to list. The insurance list cites a work entitled *Venice*, which does not appear in the catalogue, was probably sent in late, and may not have been forwarded to Paris. It does not list *Le Dimanche à Chereton*, loaned by Scott and Sons, which does appear in the catalogue. There may be a small discrepancy between what was hung and what was printed in the catalogue; see Brown to McCurry, 30 March 1927, NGCAJP, File 2.

70 In March, Gagnon still did not know whether he was "to borrow in Paris additional Morrice's"; see Gagnon to Brown, 14 March 1927, NGCAJP, File 2.

71 F. Simonson was a perennial advertiser in Dayot's journal.

72 Eric Brown to Dr. MacCallum, 3 February 1927, NGCAJP, File 1.

73 MacCallum withheld *Pine Island, Georgian Bay*, 153.2 x 127.7 cm, one of Thomson's largest canvases. Its scale would have made it one of the centrepieces of the exhibition; see Brown to McCallum, 3 February 1927; McCurry to McCallum, 17 February 1927; and McCallum to McCurry, 18 February 1927, NGCAJP, File 1.

74 McCurry to Robson, 17 February 1927, NGCAJP, File 1. Harris's *Northern Lake* came from Mrs. Massey; see Brown to Mrs. Massey, 18 February 1927, NGCAJP, File 1.

75 *Exposition d'art canadien ... au Musée du Jeu de Paume, à Paris, du 11 avril au 11 mai 1927* (Paris: Jeu de Paume, 1927). By contrast, 198 works by eighty-three artists are listed in the catalogue of the 1925 Wembley exhibition.

76 Jackson to Gagnon, 11 November [1926], MMCHA. Gagnon was also aware of the behind-the-scenes manoeuvring by the Group against the RCA. He mentioned specifically Jackson's "tricks" in getting Grier elected by nominating another weak Montreal candidate; see Gagnon to Brown, 10 November 1926, NGCAJP, File 1. However, the stratagem backfired. Both Jackson and Gagnon were members of the RCA and regularly exhibited with the body, as did the other members of the Group, indicating that they must have kept up a front of collegiality.

77 Jackson to Holgate, 9 February [1927], Canadian Museum of Civilization, Archives, Marius Barbeau Fonds, Correspondence with Edwin Holgate (1926-29, 1932, 1934, 1940), B204, f. 19 (hereafter CMC Holgate).

78 See Hill, *The Group of Seven*, 234-36; and Reid, *Le Groupe des Sept*, 201.

79 Jackson to Gagnon, 20 March 1927, MMCHA. In early 1927 Fosbury took his complaints concerning the Jeu de Paume to the ministerial level, but as he was isolated and without solid information, to which he did not have access, and with the "invitation" from the French government in place, he was obliged to retract. See Memorandum of a Meeting of the Board of Trustees held in the Offices of the Minister of Public Works, Parliament Buildings, 1 April 1927, NGCAJP, File 2.

80 "Ottawa artists to protest the selection of pictures – Formal Statement of Protest is to Come, Major Ernst Fosberry, Debate Re-Opened, Asserts that 'Group of Seven' Has Preponderance of Pictures for Paris Show," *The World* (Vancouver), 8 May 1927: "Mr. A.Y. Jackson, another member of the 'Group of Seven,' stressed still further the idea that any exhibition of Canadian art to be made in Paris would in the very nature of the case be of modernist type."

81 Eric Brown, "La Jeune Peinture canadienne," *L'Art et les Artistes* 75 (March 1927): 181-95. Corporate Canada came out in support of the review, with the Bank of Montreal and the Canadian National and Canadian Pacific Railways each taking out full- or half-page advertisements in the issue, as did Clarence Gagnon's publisher for the forthcoming *Le Grand Silence blanc*. Such placements were extremely unusual. The magazine's major, and almost exclusive, advertisers were galleries. The journal addressed a conservative bourgeois audience with a taste for refined objects, similar in many ways to *The Studio*'s. Most of the artists discussed within its pages at this time would now be known only by scholars and dedicated collectors, except for those featured in its twice yearly special issues, which were devoted entirely to such artists as Jean-Baptiste Siméon Chardin, Auguste Rodin, Claude Monet, Pierre Auguste Renoir, Jean-Louis Forain, Emile Bourdelle, Maurice Denis, Paul Gauguin, Gustave Moreau, and Francisco de Goya. Note that anyone emerging after 1900 is absent from this list. Although Gagnon and Brown had been hoping for such a "special" issue, Brown's article shared space with Gaston Contesse, an Art Deco sculptor of female nudes and children; Jac Martin-Ferrières, a landscapist and society portraitist; and Henri Deluermoz, who specialized in animal drawings. Significantly, Brown's title echoed André Salmon's earlier review of vanguard French painting published in 1912, *La Jeune Peinture française*, which had included a section on landscape that praised several conservative artists associated with *L'Art et les Artistes*; see Golan, *Modernity*,

25, which sees Salmon's text as a precursor to the regionalist movement of the twenties.

82 [Brown] to Gagnon, 16 July 1925, NGCAJP, File 1. It appears to have undergone several drafts. The final version was rewritten in late 1926 in English and translated in Paris for publication; see Gagnon to Brown, 28 November 1926, NGCAJP, File 1.

83 This would have directly paralleled his desire not to be seen publicly as responsible for the exhibition itself. Brown was no stranger to the advantages of the well-placed anonymous article and had produced several. "An Art Movement in Canada: 'The Group of Seven,'" *Christian Science Monitor* (Boston), 31 July 1922, 16, was an unabashed panegyric on the Group.

84 This, too, had been an integral part of the fiction for the exhibition.

85 Gagnon to Brown, 28 November 1926, NGCAJP, File 1. Gagnon gave extensive arguments for Brown taking responsibility for the article; for submission of the final draft with permission to use his name, see Brown to Gagnon, 17 December 1926, NGCAJP, File 1. For Dezarrois's problems with the Dutch show, see Gagnon to Brown, 1 August 1926, NGCAJP, File 1. See also Gagnon to Scott, 11 February 1927, MMCHA: "A special number of the revue 'L'Art et les Artistes' on Canadian Art with twenty illustrations is coming out just before the exhibition. The magazine is published under the supervision of Armand Dayot, which [sic] I know very well." In his letter, Gagnon discreetly made no reference to the fact that the article had been authored by Brown.

86 Brown, "La Jeune Peinture canadienne," 181, my translation.

87 H.O. McCurry to Gagnon, 9 December 1926, NGCAJP, File 1. See also Brown to Gagnon, 16 December 1926, NGCAJP, File 1. Without this material, Brown's British bias would have been even more evident.

88 Brown, "La Jeune Peinture canadienne," 182-83. Marius Barbeau, a folklorist and ethnologist, was investigating both at the time. Again, note that a small selection of Native material was included at the Jeu de Paume but nothing by the French carvers.

89 Ibid., 188, my translation.

90 Ibid., 190. Brown's position seems to indicate that he was unaware of Dayot's personal involvement with and commitment to this movement.

91 Ibid., 190.

92 Given Brown's lack of interest in Morrice, he may have been unaware that his treatment of the artist would have seemed presumptuous, if not offensive, to Dayot. He may not have known that Dayot had just previously championed him.

93 Brown, "La Jeune Peinture canadienne," 195.

94 The photographs from which the illustrations were selected were supplied by the NGC. Despite the exclusion of Morrice, there was even space for illustrations by painters not in the exhibition, such as the American artist Langdon Kihn, whose scenes of Native individuals and communities in the Upper Skeena River region of British Columbia, done while accompanying Marius Barbeau, had been included in Wembley but were excluded from Paris since he was not Canadian.

95 Thiébault-Sisson, "Une exposition d'art canadien au Jeu-de-Paume," *Le Temps*, 25 March 1927.

96 Hill cites this incident as an example of the French ignorance of Canadian art but does not identify that it was written by Brown's hired critical gun. It is uncertain where this tale arose, but one suspects Gagnon.

97 This story originated with Gagnon. He repeats it twice in letters to Scott, naming the figure as René Richard, or "Slim"; see Gagnon to Scott, 11 February 1927 and 4 March 1930, MMCHA. Gagnon later placed Richard in direct competition with both the Group and modernist movements, claiming that "he would become a greater artist than Tom Thomson" and that Richard "did not take long to see through the 'farce' of Modern Art"; see Gagnon to Scott, 4 March 1930, MMCHA.

98 My translation. The misspelling of Brown's name may have been a typo, but given the extreme anti-German sentiment in Paris, it also would not have done him, or by association the artists whom he supported, any good. Nor was this the only place where it occurred. In another advance notice published by *Comoedia*, not in the NGC files but alluded to twice in other articles, "Brandt" was also used; see Henri Letondal, "La Jeune Peinture canadienne en France," *La Patrie* (Montreal), 5 May 1927. Letondal, writing for the Montreal paper from Paris, notes that *Comoedia* also repeated the story of Thomson's demise at the hands of Indians. He also noticed the lack of French-speaking painters in the exhibition and asserted that Thomson's pose as an uncivilized trapper did not stand for all Canadians, especially those with a long history in Quebec.

99 Two days after the appearance of the article, Brown expressed hope that the writers in Paris would stop making him "personally responsible for everything done in Canada"; see Brown to McCurry, 27 March 1927, cited in Charles Hill, "The National Gallery, a National Art, Critical Judgement and the State," in Michael Tooby, ed., *The True North: Canadian Landscape Painting, 1896-1939* (London: Lund Humphries, 1991), 79. Again, one suspects mischief of some type here, but it could have come only from Clarence Gagnon.

100 *Exposition d'art canadien.*

101 An English version is in NGCAJP, File 2.

102 Eric Brown, "Quelques mots sur l'histoire de l'art canadien," in *Exposition d'art canadien*, 11-12.

103 Given that, following the format established at Wembley, there were only three French-speaking Quebec artists in the show, it would seem that he believed that little progress had been made. Conversely, women artists, even without Emily Carr, who was "discovered" by the NGC only a month after the Paris show, numbered sixteen. Despite the lack of French Canadian representation within the exhibition, Brown was aware that concessions had to be made to the French audience in order to underscore the colonial relationship to the host country. In a "confidential" letter to MacDonald, he outlined the requirements for the poster for the exhibition; see Brown to MacDonald, 2 December 1926, NGCAJP, File 1: "I think the French aspect of Canada should be stressed, perhaps the Citadel at Quebec or something which suggests an ancient city. The British arms should be replaced with French emblems I suppose. Perhaps the modern and ancient traffic on the St. Lawrence might come in."

104 Thiébault-Sisson, "La première exposition d'art canadien à Paris," in *Exposition d'art canadien*, 13-16, my translation of cited passages.

105 Ibid.

106 As a postscript, he noted the absence of French names in the catalogue but dip-
lomatically attributed this to a lack of desire for adventure and risk on the part
of the artists rather than to an attempt to make Canada's national identity exclu-
sively Anglo-Canadian.

107 By January, Brown did not know if a formal opening would occur; see Brown to
Gagnon, cable, 31 January 1927, NGCAJP, File 1.

108 Eric Brown to His Excellency, Governor General of Canada, 23 February 1927;
and Brown to Unknown, 26 February 1927, NGCAJP, File 1. As a Dominion
under the British Empire, Canada had no ambassador to France. Both Brown
and Gagnon were feuding with Roy but could not exclude him from the event;
see Gagnon to Brown, 3 February 1927, NGCAJP, File 1. On seeing all the snow
scenes, Doumergue is reported to have quipped, "Restons couverts, n'est-ce pas,
je crois que c'est plus prudent"; see "M. Doumergue inaugure l'exposition cana-
dienne," *Intransigeant* (Paris), 12 April 1927.

109 See letters to various Canadian officials, almost all of whom were anglophones,
sent out 21 and 22 March, in NGCAJP, File 2. Not all agreed to serve; see
McCurry to Brown, cable, 12 March 1927, NGCAJP, File 2: "Premier has
refused."

110 Brown to Dr. Sheperd, 23 February 1927, NGCAJP, File 1. In the same letter,
he noted that French names are "seriously lacking" on the "Canadian Committee
for the French Exhibition." He also stated that he was "very doubtful about the
advisability of asking the President of the Royal Canadian Academy who, if he
accepted without his Council's permission, might get into trouble and if he asks
its permission it may result in a recrudescence of the Wembley difficulty."

111 Brown to McCurry, 10 April [1927], NGCAJP, File 2.

112 See Gagnon to McCurry, with enclosed clippings, 25 April 1927, NGCAJP, File
2. McCurry to Belleau, 30 May 1927, NGCAJP, File 3: "We propose to publish
the volume about the middle of June." Belleau was the first choice of translator,
but he declined; see Belleau to McCurry, 1 June 1927, NGCAJP, File 3. Almost
all the letters confirming return of the works to their owners mention the forth-
coming publication of the reviews; see for example, McCurry to W.J. Morrice,
25 May 1927, NGC Morrice: "The Canadian exhibition in Paris was an unquali-
fied success ... It was well received by the Paris press and noticed extensively
also by the London papers. I had hoped to be able to send you clippings but as
these are so numerous and good we have decided to translate and print them in
pamphlet form so that they will be more widely available." In August, McCurry
foresaw the publication as imminent; see McCurry to Hennessey, 17 August
1927, NGCAJP, File 4: "The Press comments have been transplanted [sic] and
are going to press in a few days." However, by November, when the translations
were completed, the NGC doubted their accuracy, withheld partial payment
to the translator on the grounds that they were unsatisfactory, and asked for
a second opinion; see McCurry to Adele Trudeau, 24 November 1927 and 16
December 1927, NGCAJP, File 4. It appears that the revisions did not improve
their desirability.

113 Unless otherwise stated, all of the reviews of the exhibition that are referred
to in this chapter come from the two folios deposited in the Archives of the

National Gallery of Canada; see 1927 – Exposition d'art canadien, Dec/NG ex., 11 April to 10 May 1927.

114 Hill, *The Group of Seven*, 216, gives the impression of an uninformed, insensitive audience that could not overcome its stereotypes of Canada, stereotypes in which, it should be noted, the exhibition traded.

115 See Silver, *Esprit de Corps*; and Golan, *Modernity*, 1-5. Golan outlines the primacy of landscape in French painting after the war but especially between 1921 and 1926: "No contemporary paintings fared better [in France] than landscapes in the 1920s" (5).

116 Gustave Kahn, "L'Exposition de l'art canadien, Musée du Jeu de Paume," *Mercure de France*, 1 May 1927; Gustave Kahn, "L'Exposition d'art canadien (Salles du Jeu de Paume)," *Le Quotidien*, 14 April 1927. Kahn saw no connection between the landscapes and the Symbolist movement, which would have validated later claims to a northern tradition.

117 Kahn, "L'Exposition," *Le Quotidien*.

118 Kahn, "L'Exposition," *Mercure de France*.

119 René-Jean, "Exposition d'art canadien et ses beaux paysages," *Comoedia*, 10 April 1927, and "Devant l'Exposition canadienne," *Comoedia*, 11 [14?] April 1927. The files are unclear on the date of the latter article.

120 Holgate's *Lumberjack* duplicated the type of monumental peasant imagery found throughout the French regionalist movement. See, for example, Roger de la Fresnaye, *The Herdsman*, 1921, illustrated in Golan, *Modernity*, 42.

121 See Golan, *Modernity*, x. Golan lists Segonzac along with André Derain, Maurice de Vlaminck, and Auguste Herbin, as among those of the retrenchment of the 1920s; see also ibid., 6. René-Jean had written a monograph on Segonzac in 1922; see ibid., 19. The quotation that Golan cites from this source invokes the artist's relationship to a fertile, agrarian nature.

122 René-Jean, "Devant l'exposition canadienne."

123 Ibid., 7.

124 Ibid.

125 Like Dayot, Alexandre was an elder statesman of art who had supported Toulouse-Lautrec and had written a nine-volume history of caricature in France, among numerous other publications. Both he and Kahn had written articles for Dayot's journal in May 1925.

126 Silver, *Esprit de Corps*, 182, 247-49, 263, cites his increasingly conservative position – in that he saw Ingres and Delacroix as the founders of a truly French, as opposed to German, racial art in the early 1920s – and his role in an attack on the collector/couturier Paul Poiret in Henri Lapauze's moderately leftist journal on politics, economics, literature, and art, *La Renaissance politique, littéraire et artistique*, which had been the vehicle for an intense discussion of a French national art during the war (168-71).

127 Arsène Alexandre, "La Vie artistique: Les Peintres canadiens au Jeu de Paume," *Le Figaro*, 10 April 1927.

128 Arsène Alexandre, "Les Canadiens et le 'Primitivisme,'" *La Renaissance des arts français et des industries de luxe*, 15 April 1927. On *La Renaissance* as regionalist, see Golan, *Modernity*, 26. Alexandre founded the magazine in 1918. *La Renaissance*

also published a short notice on the prints and drawings; see Anonymous, *La Renaissance*, June 1927.

129 Alexandre named Florence [sic] Gagnon, Albert Robinson, J.H. MacDonald, Lawren Harris, F. Hennessey, MacCallen [sic], A.J. Casson, F. Carmichael, and F.H. Johnson as part of this enterprise.

130 Alexandre had published both on Henri Rousseau and on the art of the indigenous peoples of the French colonies. His position on the latter is articulated in Silver, *Esprit de Corps*, 263.

131 Golan, *Modernity*, 47: "The intent to secure ties of kinship between artists and the countryside also accounts for France's sudden infatuation with its *peintres naïfs*. All with humble and rural family backgrounds (and some of them illiterate), these artists stood as the ultimate encapsulation of the untrained 'primitive.'" This concept was hardly compatible with the self-image of the Canadian artists, although, because of Brown's insistence on their lack of influence and training, the two were often conflated by the French critics.

132 Gagnon, who, it will be recalled, had already disparaged Rousseau, did not appear to sympathize with this aspect of the regionalist movement.

133 As Pierre Bourdieu would say, "Fields of cultural production propose to those who are involved in them a *space of possibilities* that tends to orient their research, references, intellectual benchmarks (often constituted by the names of its leading figures), concepts in -*ism*, in short, all that one must have in the back of one's mind in order to be in the game. This is what differentiates, for example, the professionals from the amateurs or, to use a painter's idiom, the 'naïfs'"; see Pierre Bourdieu, *The Field of Cultural Production* (New York: Columbia University Press, 1993), 176, emphasis in the original. The Canadian artists were, it would seem, outside the game and lacking an "ism," even a "national-ism."

134 Cottington, *Cubism*, 54-55. The journal was first founded in 1899 as *Bulletin de l'Action française*. It was from the start a mouthpiece for a conservative, antirepublican French nationalism.

135 R.R., "Chronique des arts: Les peintres canadiens au Jeu de Paume: Un bel ouvrage qui n'est pas à sa place," *Action française*, 14 April 1927.

136 It did appear obliquely in 1929 in Brooker, "When We Awake," 12-13. Brooker reinterpreted it to make it a positive and, indeed, necessary Canadian component: "It is most natural that a genuine 'modern' to-day should react 'primitively' to his surroundings. In the first place, it is a sign, in any age, of a freshness and honesty of outlook, uninfluenced by the technical traditions of his forerunners. And, in the second place, a certain kind of 'primitiveness' is the most appropriate possible reaction to our particular time, for we are, in the strictest sense primitives, the first men of a new civilisation whose implications are incalculable." Conversely, European modernism exerted a "bad influence." He deemed the work of Piet Mondrian, Vasili Kandinsky, Man Ray, Jacob Epstein, and so on to be "unintelligible" (14-15). However, Brooker made no specific mention of the Group of Seven in relationship to either.

137 Charles Chassé, "Exposition canadienne à Paris," *Le Figaro hebdomadaire*, 13 April 1927, 8. Was it coincidence that the major critics who responded to the exhibition – Kahn, Dayot, Alexandre, and Chassé – were all associated with post-Impressionism, the movement that Brown wanted to bypass?

138 Ibid.

139 On the role of neomedievalism within the regionalist movement, see Golan, *Modernity*, 28-36.

140 Roger Dardenne, "Au Musée du Jeu de Paume, l'Exposition d'art canadien," *Le Figaro artistique*, 5 May 1927, 467-69.

141 Xavier d'Orfeuil, "L'Exposition d'art canadien," *Gaulois*, 10 April 1927.

142 Paul Fierens, "L'Exposition d'art canadien," *Journal des débats*, 11 April 1927. He also noted that Morrice, whom he calls the "father of Canadian painting, this 'raffiné,' has nothing of the primitive."

143 Marthe Maldidier, "Dans les galeries, l'exposition canadienne," *Rappel*, 12 April 1927. One feels the frustration of the NGC in noting that the first phrase was underlined in the document. Nudes were undergoing a revival in the 1920s; see Golan, *Modernity*, 19-21. However, Hill, *The Group of Seven*, 216, overstates the case when he says that "all articles claimed Morrice as a French painter, characterized the new 'Canadian primitives' by their lack of French refinement, and bemoaned the absence of nudes." He cites only two instances.

144 Anon., *L'Illustration*, 1 May 1927.

145 René Chavance, "Une exposition d'art canadien s'ouvre demain au Jeu de Paume," *Liberté*, 11 April 1927; Anon., "Salons et expositions, l'art canadien, les artistes de l'Yonne," *Petit Parisien*, 12 April 1927.

146 Gaston Varenne, *L'Amour de l'art*, May 1927.

147 Anon., *Intransigeant*, 12 April 1927.

148 L. Dumont-Wilden, "Paris-Canada," *Nation belge*, n.d.

149 D.B. Wyndham Lewis, "Day by Day in Paris, Art from Canada," *Weekly Dispatch*, n.d. In later years Lewis remained unrepentant. In 1946, following an enforced stay in Canada during the Second World War, he published a second article, which appeared in the *Listener*, August 1946, as a review of the Phaidon publication of *Canadian Painters*. His comments are reprinted in Douglas Fetherling, ed., *Documents in Canadian Art* (Peterborough, ON: Broadview, 1987), 106-11. Fetherling warns the reader in advance that Lewis's position is "notable for its misinformation and wrongheadedness: valuable proof of how isolated Canadian art was at the time from intelligent world opinion, and vice versa" (106). In Fetherling's view, Lewis undoubtably went astray in asserting that "the Anglo-Saxon genius has always displayed great affinity with primitive nature ... An Ossianic pantheism pervades the literature and the life of the Briton: a passionate inclination for the virginity of nature and the most unruly moods of the elements ... These are the things however that have spelled Empire" (107). This links the Group of Seven to their British, colonial, imperial roots. Such a view could only "lack intelligence" for failing to be blind to the inherent contradiction within their works.

150 Anon., "Art et curiosité, l'exposition d'art canadien," *Le Temps*, 12 April 1927.

151 René-Jean, *Petit Provençal*, 13 April 1927.

152 G. Denoinville, "Exposition d'art canadien," *Le Journal des arts*, 30 April 1927.

153 Dardenne, "Au Musée du Jeu de Paume, l'Exposition d'art canadien."

154 Anon., "Exposition d'art canadien," *Nord artistique*, June 1927.

155 Gagnon had also informed him that the French did not care for Harris, Jackson,

or Carmichael; see Gagnon to Brown, 11 May 1927, NGCAJP, File 3. There was a certain but limited awareness in Canada of what had transpired in France; see "Says Canadian Art Falls Flat in Paris," *Mail and Empire* (Toronto), 2 November 1927.

156 Brown to Robson, 30 May 1927, NGCAJP, File 3: "I am afraid the Wembley [sic] Exhibition is off, both here [NGC] and in Toronto." The reasons that Brown gave Robson, such as the demands from Montreal collectors for the immediate return of their Morrice canvases, that the Thomson works had been seen in Toronto, and that the pieces from the NGC were needed for a Jubilee summer show are all suspect. He concluded that "it would be much better for Canadian art in general and its future development, if the exhibition came to a natural and proper end abroad without revival in Canada." See also McCurry to Greig, 13 June 1927; and Greig to Brown, 13 June 1927, NGCAJP, File 3.

157 National Gallery of Canada, *Annual Report, 1927-28*, 9-18, my emphasis.

158 To these he added the review by the English critic for the *Paris Tribune*, who cannot be said, strictly speaking, to have been "a French art critic."

159 Eric Brown, "Canadian Art in Paris," *Canadian Forum* 84 (September 1927): 361.

160 As we have seen with Hill, *The Group of Seven*, this remains the line to this day.

161 See especially McInnes, *Canadian Art*; and Harper, *Painting in Canada*.

CHAPTER 4: CANADIAN PRIMITIVES IN PARIS

1 Gagnon to Brown, 7 January 1927, National Gallery of Canada Archives, Jeu de Paume, Canadian Exhibitions/Foreign 5.4P Paris, Canadian Ex, in 1927, File 1 (hereafter NGCAJP).

2 Hill takes the letter at face value; see Charles Hill, *The Group of Seven: Art for a Nation* (Ottawa: National Gallery of Canada, 1995), 216.

3 Gagnon and Scott were closely associated. Scott, who was active within the art community in Ottawa, served as a dealer for Gagnon's works throughout the 1920s while Gagnon was in Paris.

4 Gagnon to Scott, 11 February 1927, Gagnon correspondence, McCord Museum of Canadian History Archives (hereafter MMCHA): "I have asked him [Brown] to bring along with him some of the Pacific Coast Indian carvings specially the ones in black slate like you already have. Eric will have seen you about them. The director of the Luxembourg gallery is particularly anxious that we include some in our collection." As we have seen, Gagnon was no stranger to prevarication if it served his interests.

5 See Gagnon to Scott, 25 March 1926, MMCHA: "My decorations accompanying the illustrations in my book shall be in the style of the decorations from the 'totem poles' and eskimo craft."

6 Gagnon to Scott, 25 March 1926, MMCHA.

7 Brown appears to have bought into the message as it stood but shaped it to his own interests. In a letter to Dr. Collins, director of the Victoria Memorial Museum in Ottawa, 23 February 1927, NGCAJP, File 1, he stated: "The French Ministry of Fine Arts particularly requests that a small group of Canadian West Coast Indian sculpture be included in this exhibition and the Trustees of the National

Gallery request your permission to allow Mr. Barbeau and myself to make a selection from the material possessed by the Museum. From six to eight pieces are desired." No mention of specific quantities occurred in Gagnon's initial letter. Note that the source of the request changes yet again. By March, Brown was claiming that "I succeeded in getting about 12 pieces in slate and wood" included in the exhibition; see Brown to Gagnon, 12 March 1927, NGCAJP, File 4. He did not mention to Gagnon that his first request was for six to nine works.

8 See, for example, Marius Barbeau, "The French Influence on Canadian Art," *Montreal Star*, 24 March 1926; and Marius Barbeau, "Les Arts au Canada," *Le Devoir* (Montreal), 22 March 1926.

9 Barbeau found a powerful ally in Murray Gibbon, the publicity officer for the Canadian Pacific Railway (CPR), who saw traditional French Canadian culture as a tourist attraction. Gibbon attempted to reconcile the various cultures that made up Canada in his concept of the Canadian mosaic. His position can be seen in the advertisement that the CPR placed in *L'Art et les Artistes* 75 (March 1927): n.p., which states: "Visitez le Canada et particulièrement la province historique de Québec, remarquable par ses sites pittoresques et ses souvenirs toujours subsistants de l'ancien régime français."

10 Brown infantilized the subject of Jackson's Quebec village subjects as "quaint" and having a "feeling of trustful childlikeness"; see [Brown], "An Art Movement in Canada: 'The Group of Seven,'" *Christian Science Monitor* (Boston), 31 July 1922, 16.

11 In the summers of his student years, Barbeau studied in Paris, where he may have encountered the proposition that the so-called "primitive" arts could be viewed as art and linked to modernist developments. However, it is doubtful that his experiences would have been of sufficient duration for him to have become fully cognizant of the discursive frameworks that surrounded the relationship between the primitive and the modern.

12 See Annie Coombes, "Ethnography and the Formation of National and Cultural Identities," in Susan Hiller, ed., *The Myth of Primitivism: Perspectives on Art* (London: Routledge, 1991).

13 Richard Preston, "C. Marius Barbeau and the History of Canadian Anthropology," *Canadian Ethnology Society Proceedings*, no. 3 (1976): 122-36. Studies now exist linking the practice of ethnology in Canada to the policies of the state, particularly to the programmatic exclusion of the Indian from Canadian identity and the creation of a discourse of disappearance; see Peter Kulchyski, "Anthropology in the Service of the State: Diamond Jenness and Canadian Indian Policy," *Journal of Canadian Studies* 28, 2 (1993): 21-50. Kulchyski notes a reluctance in Canada to engage in a self-critical practice such as emerged in the United States under James Clifford and others.

14 Andrew Nurse, "'But Now Things Have Changed': Marius Barbeau and the Politics of Amerindian Identity," *Ethnohistory* 48, 3 (2001): 433-72.

15 Harlan Smith, "The Use of Prehistoric Canadian Art for Commercial Design," *Science*, 20 July 1917, 60-61. This was followed by Smith's "Distinctive Canadian Designs: How Canadian Manufacturers May Profit by Introducing Native Designs into Their Products," *Industrial Canada*, September 1917, 729-33. The latter was abstracted and revised in *Saturday Night*, 14 November 1917.

Smith indicates in the *Science* article that the idea originated while he was at the Peabody Museum. He gave frequent talks promoting the proposal at various places, including the British Columbia Provincial Museum in 1923. It is probable that Emily Carr was in attendance and that her engagement with pottery featuring Native designs in 1924 is connected to Smith's presentations; see Maria Tippett, *Emily Carr: A Biography* (Toronto: Oxford University Press, 1979), 132-34.

16 Harlan Smith, *An Album of Prehistoric Canadian Art*, Anthropological Series no. 8, Bulletin no. 37 (Ottawa: National Museum of Canada, 1923). The *Album* was almost 200 pages.

17 Edward Sapir, "Introduction," in Smith, *Album*, iii.

18 It is probable that Gagnon took his cue to use Native motifs in his own work from this initiative, which expanded to include graphic design.

19 On the history of the premise of the extinction of the Indian within the practice of ethnography prior to the advent of Barbeau, see Douglas Cole, "The Origins of Canadian Anthropology, 1850-1910," *Journal of Canadian Studies* 8, 1 (1973): 33-45. Cole's study stops with the appearance of Barbeau. For the persistence of the concept within the latter's practice, see the following chapters.

20 This second usurpation of Brown's prerogative is discussed in detail in Chapters 8 and 9.

21 The English version comes from Brown's initial typescript for the article; see Lectures and Articles (file 15, box 2), Eric and Maud Brown fonds, NGC Archives. The last sentence varies slightly in the French translation.

22 The importance of Krieghoff and Kane is underscored by the fact that Morrice and Thomson were the only other artists whom Brown named.

23 As is shown in Chapter 6, an artist who showed contemporary Natives in possession of their culture was excluded from the Paris exhibition, although he had been included in the Wembley exhibitions.

24 Thiébault-Sisson, "Une exposition d'art canadien au Jeu-de-Paume," *Le Temps*, 25 March 1927.

25 Most of this praise was deleted in the translation of the essay done for the NGC. The translation is filed with the reviews.

26 Thiébault-Sisson's ranking of the Northwest Coast art also leads to the question of where the Group's work would have placed on this scale.

27 Thiébault-Sisson, "La première exposition d'art canadien à Paris," in *Exposition d'art canadien ... au Musée du Jeu de Paume, à Paris, du 11 avril au 11 mai 1927* (Paris: Jeu de Paume, 1927), 13-16, my translation. One wonders what prompted such an assessment. It is known that this was Barbeau's position, which, as we have seen, he was pursuing in the Skeena Valley with Jackson and other artists, but it might well have arisen, as we will see, from the discourse of the primitive within the context of Paris itself.

28 See Chapter 9.

29 Marius Barbeau, "Les arts décoratifs des tribus indigènes de la côte nord-ouest de l'Amérique du Nord," in *Exposition d'art canadien*, 37-88.

30 Barbeau's promise of plenitude pointed directly to the exhibition to be held in the fall in Canada and indicated that the Parisian display was a prelude to this larger project.

31 Hill, *The Group of Seven*, does not make any references to this critical success.

32 Pierre Bourdieu, "Outline of a Sociological Theory of Art Perception," in *The Field of Cultural Production* (New York: Columbia University Press, 1993), 589-91 and especially 595.

33 The extensive literature on the primitive in Western art almost entirely excludes any mention of Britain prior to Henry Moore. Colin Rhodes, *Primitivism and Modern Art* (London: Thames and Hudson, 1994), 31, gives only the most cursory mention of Roger Fry, who did publish on the primitive in England. However, the impact of his two essays from 1910 and 1920 was limited and does not constitute a discursive framework that in any way parallels what was occurring in Paris. Rhodes does include an excellent summary of the literature on the topic. Charles Harrison, Francis Frascina, and Gill Perry, *Primitivism, Cubism, Abstraction: The Early Twentieth Century* (New Haven: Yale University Press, 1993), refer to Fry only in the context of his formalist theories and never in terms of his interest in "primitive" art. England plays no role in their discussions of the latter. One of the few places where Fry's interest is given an extended, if flawed, analysis is in Marianna Torgovnick, *Gone Primitive: Savage Intellects, Modern Lives* (Chicago and London: University of Chicago Press, 1990).

34 See Bourdieu, "Outline of a Sociological Theory of Art Perception"; Bourdieu, *The Field of Cultural Production* (New York: Columbia University Press, 1993); Bourdieu, *Distinction: A Social Critique of the Judgement of Taste* (Cambridge, MA: Harvard University Press, 1984).

35 See James Clifford, "Ethnographic Surrealism," in *The Predicament of Culture: Twentieth-Century Ethnography, Literature, and Art* (Cambridge, MA: Harvard University Press, 1988).

36 Ibid., 129-30.

37 Ibid., 122. See also pages 197-200, especially note 7.

38 Ibid., 136. Petrine Archer-Straw, *Negrophilia: Avant-Garde Paris and Black Culture in the 1920s* (London: Thames and Hudson, 2000), analyzes the passion and fashion for Negro culture in Paris as signs of modernism in the 1920s and points out that "similar notions ... could be used in reference to the native American 'Indian'" (14). Archer-Straw charts the channels of Negro culture's widespread distribution: "In pre-war Paris, numerous African carvings entered the art market and fueled the avant-garde's appetite for new forms of expression. Painting, sculpture, ethnography journals, exhibitions, Dadaist and surrealist 'negro' balls, photography, fashion and furniture design all reflected the range of responses to *l'art nègre*" (51). She also mentions books, art journals, music, fashion, jewellery, exhibitions, museums, and so on. In examining the shifts and ambiguities within this movement, she notes how the taste for *l'art nègre* cut across class lines, ranging from the very conservative haute bourgeoisie to the margins of the avant-garde, and how *l'art nègre* took on various meanings for various groups at various times (66).

39 It could be said, to a certain degree, that such imagery had penetrated popular culture in London. The *London Illustrated News*, 28 March 1925, 529, reported that a play entitled *Rose Marie* had delighted audiences at Drury Lane. The play was "a blend of musical comedy and melodrama, with excellent music and singing, a

plot that includes murder, and a picturesque setting." Although not entirely about Natives, the highlight of the performance, illustrated in the *News*, was a dance number called "Totem Tom Tom" during "the finale of the first act [which] takes place at 'Totem Pole Lodge, near Kootney [sic] Pass, in the Canadian Rockies.'" The accompanying illustration shows a weaving chorus line dancing before two totem poles within a picturesque mountain landscape. This single performance, however, in no way paralleled the situation in Paris.

40 Charles Chassé, "Exposition canadienne à Paris," *Le Figaro hebdomadaire*, 13 April 1927, 8.

41 Many of the critics thought that argillite was a type of clay. This misidentification indicates conclusively that the medium was not well known in Paris at the time and that there would have been no call to include it because of its recognition.

42 Anon., *Excelsior*, 12 April 1927.

43 Gaston Varenne, *L'Amour de l'art*, May 1927.

44 Paul Fierens, "L'Exposition d'art canadien," *Journal des débats*, 11 April 1927. His paragraph on the Native material was not translated for republication.

45 René Chavance, "Une Exposition d'art canadien s'oeuvre demain au Jeu de Paume," *Liberté*, 11 April 1927.

46 Gustave Kahn, "L'Exposition de l'art canadien, Musée du Jeu de Paume," *Mercure de France*, 1 May 1927.

47 Jean Bretigny, "A l'Exposition de l'art canadien," *La Presse*, 10 April 1927.

48 Martha Maldidier, *Rappel*, 12 April 1917.

49 R.R., *Action française*, 14 April 1927.

50 Henri Charliat, "L'Exposition canadienne: neiges et forêts," *Information*, 11 April 1927; Vanderpyl, *Petit Parisien*, 12 April 1927; Roger Dardenne, "Au Musée du Jeu de Paume, l'Exposition d'art canadien," *Le Figaro artistique*, 5 May 1927, 467-69.

51 Anon., *Intransigeant*, 12 April 1927. Again, this was more than he said about Thomson.

52 A.L., "M. Doumergue inaugure l'Exposition d'art canadien," *Le Soir*, 12 April 1927. He referred to the Native works only in passing as "curious." However, insofar as he mentioned them twice, he gave them more space than he did Morrice or Thomson.

53 It is not surprising that Konody, given his attachment to the NGC and his position as an intermediary between England and Canada, was the ideal audience and provided the "proper" reading of the exhibition. His assessment was completely opposed to the French view. He praised the Group of Seven and Thomson as the new nationalist painters who owed "little or nothing to foreign influence" and who created works that arose from "close and intimate contact with nature, grand, picturesque, and unspoilt by human hands." He disparaged Morrice as derivative and without "real significance" and ignored the Native work; see P.G. Konody, *Observer* (London), 23 April 1927. Note that he is able to reconcile the Group's picturesque sensibility with their claims to originality and nationality.

54 National Gallery of Canada, *Annual Report of the Board of Trustees for the Fiscal Year 1927-28* (Ottawa: King's Printer, 1928), 15-16.

55 Eric Brown, "Canadian Art in Paris," *Canadian Forum* 84 (September 1927): 361.
56 Ibid.
57 Ibid.
58 The term "battleground" was already familiar to his readership in reference to the relationship between the Group of Seven and the RCA. It clearly signalled which was to be seen as the privileged art form.

CHAPTER 5: BARBEAU AND KIHN WITH THE STONEY IN ALBERTA

1 P.G. Konody, "Art and Artists: The Palace of Arts at Wembley," *Observer* (London), 24 May 1925.
2 British Empire Exhibition, *Canadian Section of Fine Arts Catalogue, 1925* (London, 1925). A third Kihn painting, a portrait of a Gitxsan chief, *Hlengwah, Kitwanga Indian Portrait* – also known as *Earthquake* or as *Portrait of Jim Lahnitz* [there are various spellings] – which was more characteristic of his output, was also sent to Wembley but was not hung (see Figure 13); see McCurry to Kihn, 11 August 1925, W. Langdon Kihn papers, 1904-1990, Microfilm reels 3701-3713, Archives of American Art, Smithsonian Institution (hereafter Kihn Papers). Spellings of Gitxsan names vary widely in English transcriptions. For example, Gitxsan was formerly spelled Gitksan, the name of the village of Kitwanga also appears as Gitwanga, Gitwangak, and so on, while Gitwinkool may appear as Gitwinlkool, Kitwancool, Gilwinikool, and Gitwinikool, among other possibilities, with variations often appearing within the same document. This village is now known as Gitanyow. More recently, the Gitanyow have declared themselves distinct from the Gitxsan nation. As Kitwancool was the most commonly used form during the era examined in this study, it will be used here in reference to the village site, while the spelling used in titles of works of art will be taken from the source cited.
3 The illustration was mislabelled as *Totems du village indien de Kitwanga* (Totems at the Indian Village of Kitwanga); see Eric Brown, "La Jeune Peinture canadienne," *L'Art et les Artistes* 75 (March 1927): 194. The totem poles featured are not from the village of Kitwanga but from Kispiox; see Marius Barbeau, *Totem Poles of the Gitksan, Upper Skeena River, British Columbia*, Anthropology Series no. 12, Bulletin no. 61 (Ottawa: National Museum of Canada, 1929), 220-21, 246-47. (Kihn had done other works that featured totem poles at Kitwanga.) Brown's text made no reference to the work, under either title. In early February, Gagnon advised Brown of those that were to be illustrated, including the ones by Kihn; see Gagnon to Brown, 3 February 1927, National Gallery of Canada Archives, Jeu de Paume, Canadian Exhibitions/Foreign 5.4P Paris, Canadian Ex, in 1927, File 1 (hereafter NGCAJP).
4 Odette Arnaud, "An American Painter: W. Langdon Kihn," *L'Art et les Artistes* (October 1925): 9-12. Typescript, translated from the French by Garrett P. Serviss, Kihn Papers.
5 See Barbeau to Morgan, 30 December 1926, [copy], Kihn Papers. Concerning the other Paris exhibition, see Kihn to W.R. Mills, Gen'l Advertising Agent, Great Northern Railway, 8 January 1927, Kihn Papers. See also Kihn to Bar-

beau, 7 December 1926, Canadian Museum of Civilization, Archives, Marius Barbeau Fonds, Correspondence with Langdon Kihn (1922-28, 1931, 1939-53, 1956, 1958, 1961), B208, f. 42 (hereafter CMC Kihn). Barbeau had been aware that Kihn was planning European exhibitions as early as July 1925; see Barbeau to Kihn, 18 July 1925, Kihn Papers.

6 Kihn was not alone in having his Native works illustrated in Brown's article but not exhibited. *Aurore dans le Nord*, by "M. Crea" [McCrea?], showing a Native in a canoe, also appeared in Brown's article but was mentioned neither in his text nor in the catalogue; see Brown, "La Jeune Peinture canadienne," 182. The small sampling of works based on Native subject matter that were not paintings includes a portrait drawing by Challener, a drawing by W. Huntley, and sculptures by Hahn and Suzor-Coté. Hahn's sculpture in bronze, *Éclaireur indien*, depicting a male with long hair, an emaciated body, and a loincloth for clothing, was illustrated in the catalogue.

7 Annie Coombes, *Reinventing Africa: Museums, Material Culture and Popular Imagination in Late Victorian and Edwardian England* (New Haven: Yale University Press, 1994), 3, points out that "any analysis of how exhibitions and ethnographic museums defined and addressed their constituencies, and the question of their effectivity, has to be seen in relation to the rise of anthropology and ... in terms of its usefulness to the imperial state." This is as true for Canada as it was for England.

8 Gibbon's arrival corresponded with Eric Brown's appointment as director of the National Gallery, with Barbeau's new position as ethnographer at the National Museum, and with Scott's rise to deputy superintendent of the Department of Indian Affairs. For the close connections within the bureaucratic and cultural communities, see Mary Vipond, "The Nationalist Network: English Canada's Intellectuals and Artists in the 1920s," *Canadian Review of Studies in Nationalism* 7, 1 (1980): 32-52.

9 E.J. Hart, *Trains, Peaks and Tourists: The Golden Age of Canadian Travel* (Banff: EJH Literary Enterprises, 2000), 122.

10 See Stuart Henderson, "'While There Is Still Time ... ': J. Murray Gibbon and the Spectacle of Difference in Three CPR Folk Festivals, 1928-1931," *Journal of Canadian Studies* 39, 1 (2005): 139-74. Henderson offers a cogent analysis of the problems and potentials in the performance of Gibbon's pluralistic, yet hierarchical, notion of differing folk cultures in Canada and their role in establishing a national unity.

11 John Murray Gibbon, *Canadian Mosaic: The Making of a Northern Nation* (Toronto: McClelland and Stewart, 1938). Gibbon's book developed out of a series of radio programs that he undertook in the 1930s for what would become the Canadian Broadcasting Corporation. Anyone British apparently did not qualify as "foreign" – that is, there was a hierarchical structure to his inclusive ideas. Although Gibbon came to advocate "the general acceptance of Canadian citizenship made by each racial group and the desire to contribute to the building up of the new northern nation," his pluralistic notions of Canadian identity did not come to include Native identity: "The Canadian race of the future is being superimposed on the original native Indian races and is being made up of over thirty European

racial groups" (vi-vii). The "Canadian mosaic," a term that had been brought up for debate in the 1920s (see ix) and one of the foundations of multicultur-alism, is dedicated solely to emigrant European groups. Nonetheless, in the 1920s, in parallel with movements in the American Southwest, Gibbon took a positive attitude toward the role of Native culture as part of tourism and cultural spectacles.

12　Hart, *Trains, Peaks*, 123.

13　Henderson, "'While There,'" 154, notes that Gibbon's festivals, in being largely restricted to immigrants, generally excluded indigenous peoples.

14　Concerning these festivals, Gibbon, *Canadian Mosaic*, x, states: "These gave me the opportunity of getting to know more about the talent in music and handicraft brought to Canada by the Europeans, and also convinced me that in music these racial groups found contacts which helped greatly in making them understand each other and in creating good will for themselves among Canadians of Brit-ish Stock." That Gibbon did not mention that Banff Indian Days was an ongoing event and that it had been the basis for the cultural festivals is indicative of the ambiguous role that Natives played within his concept of the nation.

15　Charles Hill, *The Group of Seven: Art for a Nation* (Ottawa: National Gallery of Canada, 1995), 183.

16　Ibid., 178. Hill cites a variety of archival correspondence on the arrangements. See also Marius Barbeau, *Indian Days in the Canadian Rockies* (Toronto: Macmil-lan, 1923).

17　*Blackfeet Indians* (New York: Gramercy Books, 1935). The Blackfeet reside in Montana and are distinct from the Blackfoot in Alberta.

18　Gregory Edwards and Grant Edwards, "Langdon Kihn: Indian Portrait Artist," *The Beaver* (Winter 1984-85): 4-11. Charles F. Lummis was part of a collection of anthropologists and populists who were "by the late 1880s ... drawing conclu-sions about the continuity between present-day Pueblo peoples and the ancient inhabitants of the archeological sites they were excavating ... Similarly, 'eth-nophotographers,' whose travel in the southwest was facilitated by the Santa Fe Railway's desire to promote tourism, also contributed to the romanticization of Pueblo culture"; see Jackson W. Rushing, *Native American Art and the New York Avant-Garde: A History of Cultural Primitivism* (Austin: University of Texas Press, 1995), 4-5.

19　Remington was dead by this time but was still seen as a model by the public. Russell died in 1926. On the nostalgia attached to their work, and its attempt to hold time still, see Brian W. Dippie, "The Moving Finger Writes: Western Art and the Dynamics of Change," in Jules David Prown et al., *Discovered Lands, Invented Pasts: Transforming Visions of the American West* (New Haven: Yale Univer-sity Press/Yale University Art Gallery, 1992).

20　Kihn to Barbeau, [1923], CMC Kihn. Kihn would, in the following decade, go on to do historical "reconstructions" as illustrations for books and journal articles, especially after 1937 when he was employed by the National Geographic Society.

21　Barbeau later said of Kihn's portraits that they were "the first to characterize their [Indians'] Mongolian-like features in forceful portraits," confirming his

theory regarding the Mongolian origins of the peoples of the Northwest Coast; see Marius Barbeau, "The Indians of the Prairies and the Rockies: A Theme for Modern Painters," *University of Toronto Quarterly* 1, 1 (1931): 199. In connection with his theory, Barbeau also said: "The sharp contrast between these two stocks of Indians [i.e., Plains and West Coast] become more intelligible in the presence of characteristic portraits from both areas, those by Holgate, Kihn or Winhold Reiss ... The face of the Nootkas of Vancouver Island and of the Gitksan of the Skeena, is broad and square; the jaw is massive and the nose often flat. Their physiognomy is Mongolian" (200-1).

22 Anderson Galleries, *Portraits of American Indians by W. Langdon Kihn*, exhibition catalogue (New York, NY: Anderson Galleries, 1922). Eight of the works were landscapes of the Northwest Coast. Kihn to George William Eggers, Director of Denver Art Association, 31 October 1921, Kihn Papers. Forty of the works sold; see Kihn to *Revue du Vrai et du Beau*, 14 January 1924, Kihn Papers.

23 Memo on W.J. Kihn, [1925], Painter of Indian Portraits, Previous work among the Indians of U.S., date in pencil possibly added later, CMC Kihn.

24 Warwick Ford, "Immortalizing a Disappearing Race: What One Painter Is Doing to Perpetuate the Indian Physiognomy," *Arts and Decoration* 17 (May 1922): 13, 70.

25 See undated manuscript, Langdon Kihn, "Memoirs," Kihn Papers, n.p.

26 Ford, "Immortalizing," 13.

27 Kihn to Walter M. Grant, Exhibition Mgr., Anderson Galleries, 13 March 1922, Kihn Papers. Stewart Culin was curator of ethnology at the Institute of Arts and Sciences of the Brooklyn Museum and collected Native material from the Northwest, the Southwest, and California.

28 Ibid.

29 Kihn's exhibition predated by five years both the exhibition *Canadian West Coast Art, Native and Modern* and the exhibition at the Jeu de Paume.

30 Ford, "Immortalizing," 13.

31 On the commodification of Native art, see Ruth Phillips and Christopher Steiner, eds., *Unpacking Culture: Art and Commodity Culture in Colonial and Postcolonial Worlds* (Berkeley: University of California Press, 1999).

32 David W. Penny and Lisa Roberts, "America's Pueblo Artists: Encounters on the Borderlands," in Jackson W. Rushing, ed., *Native American Art in the Twentieth Century* (New York: Routledge, 1999), 22: "The institutional policies set in motion by the Dawes Act of 1887, also known as the Allotment Act, [were] ... intended to impose acculturating education, discourage traditional religious ceremonialism, and eliminate tribal principles of land tenure to replace them with the laws of private ownership, a policy which in practice resulted in white confiscation or purchase of reservation lands. Government Indian policy of the period between 1887 and the early 1920s was designed to break up the 'great tribal mass,' as Teddy Roosevelt called it, and speed the assimilation and absorption of Native societies into the American mainstream."

33 Marta Weigle and Barbara Babcock, eds., *The Great Southwest of the Fred Harvey Company and the Santa Fe Railway* (Phoenix: Heard Museum, 1996).

34 Penny and Roberts, "America's Pueblo," 31.

35 Molly Mullin, "The Patronage of Difference: Making Indian Art 'Art, Not Eth-
 nology,'" in George Marcus and Fred Myers, eds., *The Traffic in Culture: Refiguring
 Art and Anthropology* (Berkeley: University of California Press, 1995), 168-69. See
 also Penny and Roberts, "America's Pueblo," for further discussion of those "who
 fought to 'preserve' Pueblo culture ... because of a perception of its value to
 America, as a unique American 'contribution' to the world" (23). "The Pueblo
 peoples ... provided America with a cultural, historical legacy that urban intel-
 lectuals of the Santa Fe and Taos colonies wished to appropriate as the founda-
 tion for a uniquely American identity in a world they feared was dominated by
 Europe" (30). Penny and Roberts do not cite Mullin.
36 Penny and Roberts, "America's Pueblo," 22. Both Mullin, "The Patronage," and
 Penny and Roberts problematize this relationship and point out its ambiguous
 nature.
37 Penny and Roberts, "America's Pueblo," 32.
38 See Rushing, *Native American Art and the New York Avant-Garde.*
39 Ibid., 31-32.
40 Ibid., 31.
41 Marsden Hartley, "Red Man Ceremonials: An American Plea for American
 Esthetics," *Art and Archaeology* 9, 1 (1920): 13, cited in Penny and Roberts,
 "America's Pueblo," 30.
42 E.H. Cahill, "America Has Its 'Primitives,'" *International Studio* 75, 299 (1922):
 81.
43 Penny and Roberts, "America's Pueblo," 32.
44 In 1921 Kihn took up the cause of the Blackfeet of Montana and expressed his
 "anxiety concerning them for fear they may suffer during the coming winter."
 He received a nonsympathetic reply; see Commissioner, Department of the
 Interior, Office Commissioner of Indian Affairs to Kihn, 12 October 1921, Kihn
 Papers.
45 Penny and Roberts, "America's Pueblo," 30, 34.
46 Ibid., 32.
47 Ibid., 31.
48 Langdon Kihn, "Memoirs," Kihn Papers.
49 Parsons to Kihn, 23 October 1921, Kihn Papers. See also Parsons to Kihn, 5
 November 1921, Kihn Papers.
50 A.E. White to Kihn, 16 April 1925, Kihn Papers. See Penny and Roberts,
 "America's Pueblo," 32.
51 The date of the first Indian Days is uncertain and may be anywhere between 1889
 and 1894. Patricia Parker supports the early date in her nonscholarly history, *The
 Feather and the Drum: The History of Banff Indian Days, 1889-1978* (Calgary: Con-
 solidated Communications, 1990), 5.
52 Maureen Ryan, "Picturing Canada's Native Landscape: Colonial Expansion,
 National Identity, and the Image of a 'Dying Race,'" *RACAR* 17, 2 (1990): 138-49.
 Ryan established several principles on representing Native peoples in Canada in
 nineteenth century that I take up for the twentieth.
53 The complex links between the Canadian and American western railway pro-
 grams to use artists and Natives as part of their attractions have yet to be sorted
 out. But claims that the Santa Fe "'was the first road ... to take art seriously,

as a valuable advertising adjunct,'" are clearly exaggerated and ignore Canadian precedents; William H. Simpson, cited in Weigle and Babcock, eds., *The Great Southwest*, 3. In addition, Greyline had been offering bus tours in the Banff area before similar tours occurred in Sante Fe. However, there were crucial differences between the Canadian and American programs as they developed in the twentieth century.

54 Other parallels also existed. The article advocated the use of Native materials as a source for an American design. This corresponded to Harlan Smith's proposals. Smith may have been both a point of contact between Canada and the United States and a supporter of Kihn.

55 Although Kihn's father did ask him about "the ethnologist who was to join your party at Montreal on the way out," it is uncertain whether Kihn met Barbeau in western Canada; see "Dad" to Kihn, 17 June 1922, Kihn Papers. However, they had met by December 1922, when their correspondence begins; see Kihn to Barbeau, 30 December 1922, CMC Kihn. They met again in early 1923, when Barbeau travelled to New York.

56 Kihn to Barbeau, [1923], CMC Kihn.

57 Kihn to "Mother and Dad," 9 June 1922, Kihn Papers.

58 Langdon Kihn, "Memoirs," n.p., Kihn Papers.

59 Gibbon to Kihn, 11 July 1922, Kihn Papers: "Mr. H. Brodie, General Passenger Agent here, tells me that most of the totem poles at Alert Bay have been sold to rich Americans and that it would be better for you to go to Nootka on the West Coast of Vancouver Island."

60 Kihn to "Folks," 21 July 1922, Kihn Papers.

61 Edwards and Edwards, "Langdon Kihn," 5.

62 For Gibbon's assessment of the suitability of various immigrant groups, including Italians, Scandinavians, and especially those from Eastern Europe, particularly regarding their potential as labour, their political stances, and their potential to be assimilated into an English culture in Canada, see John Murray Gibbon, "The Foreign Born," *Queen's Quarterly* 27, 4 (1920), 331-51.

63 Langdon Kihn, "Memoirs," n.p., Kihn Papers.

64 Kihn to "Folks," 4 September 1922, Kihn Papers.

65 Ibid., emphasis in the original.

66 Langdon Kihn, "Memoirs," n.p., Kihn Papers.

67 Memo, [1925], CMC Kihn.

68 Laurence Nowry, *Marius Barbeau: Man of Mana* (Toronto: NC Press, 1995), 217.

69 Gibbon to Kihn, 8 December 1922, Kihn Papers. See also Kihn to Hugh S. Eayrs, 28 January 1923, Kihn Papers: "Mr. Barbeau and I have gotten together several times since he's been in town, and he feels he's coming along very quickly and satisfactorily with the text."

70 Christopher Bracken, *The Potlatch Papers: A Colonial Case History* (Chicago: University of Chicago Press, 1997).

71 Ibid., 224-25.

72 Brian Titley, *A Narrow Vision: Duncan Campbell Scott and the Administration of Indian Affairs in Canada* (Vancouver: UBC Press, 1986).

73 Ibid., 166.

74 Ibid., 167.

75 Ibid., 168. Titley cites one case in which bad press arose over the sentencing of an elderly, almost blind Native to two months hard labour.

76 Ibid, 168-69. Of interest here is the number of times that the phrase "nearly nude" comes up in horrified responses to the costumes worn by the dancers. In the eyes of white officialdom, unbridled sexuality was associated with the vision of the seminaked male Indian body in unrestricted movement. See also page 172 for Markel's response in 1907 to "male Indians in almost nude attire parading streets and other public places, giving so-called war and other dances for the edification of the wives and daughters of people who claim to be civilized and refined." Obviously, he is expressing terror at the prospect that a threatening sexuality lurked just below the veneer of his own civilization, particularly in its women and female children, that had to be doubly suppressed in women and Natives. David Laird, shortly thereafter, wanted ceremonies forbidden on the grounds of "indecent exposure" (173). Horror on the West Coast seems to have been reserved for "cannibalism" and the wanton destruction of property.

77 Ibid., 171. Sports days had also become an acceptable arena for gatherings at this time.

78 Ibid., 171-72.

79 "Banff Indian Days, July 21-22-23, '31," on file in the Archives of the Whyte Museum of the Canadian Rockies, Banff, Alberta.

80 Titley, A Narrow Vision, 172. McDougall was a "veteran Methodist missionary" (170).

81 Ibid., 173.

82 Ibid., 174.

83 Ibid., 174-75.

84 See also Douglas Cole and Ira Chaikin, An Iron Hand upon the People: The Law against the Potlatch on the Northwest Coast (Vancouver: Douglas and McIntyre, 1990), 107-9, for a more complete summary both of the relationship of the bill to the war and of its effect on the West Coast. The value of reading Titley with Cole and Chaikin is that each focused on a different region, one the Prairies and the other the West Coast, yet the same laws and policy of repression extended over both regions in which Kihn and Barbeau were active.

85 Titley, A Narrow Vision, 176.

86 Bracken, The Potlatch Papers, 209. Although his study is also limited to the West Coast, Bracken adds yet more details to the proceedings that may be missing from the other accounts.

87 Titley, A Narrow Vision, 176. Again, see also Cole and Chaikin, An Iron Hand.

88 On Halliday's initial lack of enthusiasm for enforcement of the law, see Cole and Chaikin, An Iron Hand, 109.

89 Titley, A Narrow Vision, 178.

90 Ibid. Compare with reports on proceedings on the West Coast, where the emphasis on the Cranmer prosecutions has sometimes given the impression that Native resistance at this time was ineffective.

91 Ibid., 179. By 1923 some alarmed missionaries noticed a "revival" of the sundance, although it is hard to imagine a "revival" of something that had not died out. It is possible that other more prominent concerns were now facing Scott and the federal government, namely land claims in British Columbia. Not only were

the Allied Tribes pressing to have Aboriginal title recognized, but the Privy Council in London had just established a precedent in Nigeria recognizing such claims. As we will see, the goal now became keeping the Allied Tribes from taking their case to the Privy Council.

92 The need to hold the Native body in check in order to deny it motion outside of a disciplining labour becomes evident in Graham's bid to stop not just traditional dances, but even dances that would demonstrate acculturation.

93 Titley, *A Narrow Vision*, 180.

94 Ibid., 181.

95 See James H. Gray, *A Brand of Its Own* (Saskatoon: Western Producer Prairie Books, 1985), 80-81.

96 Titley, *A Narrow Vision*, 183.

97 See especially Arthur C. Danto, "Bourdieu on Art: Field and Individual," in Richard Shusterman, ed., *Bourdieu: A Critical Reader* (Malden, MA: Blackwell, 1999), 214-19.

98 Jean McGill, "The Indian Portraits of Edmund Morris," *The Beaver* (Summer 1979): 34-41.

99 Morris to Walter Scott, Premier of Saskatchewan, cited in Michael Parke-Taylor, "Edmund Morris: The Government of Saskatchewan Portrait Commission," in Norman MacKenzie Art Gallery, *Edmund Morris "Kyaiyii," 1871-1913* (Regina: Norman MacKenzie Art Gallery, 1984), 47. Morris might have been the logical choice for the project in the 1920s if he had not died in 1913.

100 "A Painter of Indians," *Saturday Night*, 24 April 1909, 2.

101 See Deborah Root, *Cannibal Culture: Art, Appropriation, and the Commodification of Difference* (Boulder, CO: Westview, 1966). After viewing the proofs, Kihn had problems with the printing of the illustrations, as he disagreed with the use of the "glaring" white backgrounds, even though it was "true that the originals are white," and requested something less stark. The printing company was unable to accommodate him on the grounds that the alteration would add to the production costs; see Kihn to Eayrs, 21 March 1923, and Eayrs to Kihn, 27 March 1922, Kihn Papers.

102 Marius Barbeau, "An Artist among the Northwest Indians: Langdon Kihn Has Pictorially Recorded Some Types of a Little-Known Race," *Arts and Decoration* 26 (May 1923): 20, 27, 95.

103 Ibid., 27.

104 Ibid., 95.

105 Ibid.

106 Barbeau would maintain this position on the state of Native culture until after Scott retired and until after a shift in government policy toward the Indian question had emerged in the late 1930s.

107 Barbeau, "An Artist," 95. Barbeau repeated this claim almost verbatim in a pair of identical articles published some years later: "The Indians of the Prairies and the Rockies: A Theme for Modern Painters," *University of Toronto Quarterly* 1, 1 (1931): 197-206; and "The Canadian Northwest: Theme for Modern Painters," *American Magazine of Art* 24, 5 (1932): 331-38.

108 Gibbon was aware that his position in support of Banff Indian Days placed him in conflict with Scott. This conflict came to a head during the critical period

1926-27. Speaking of the 1926 ceremonies, Gibbon stated: "I am afraid that there might be some opposition from the Department of Indian Affairs if Indians were used for publicity, except the Stoneys, as these are not farmers"; see Gibbon to Barbeau, 28 May 1926, CMC Kihn. By the following year, when the Diamond Jubilee celebrations were held, Scott had decided to intervene directly in Indian Days as part of his program to bring such events under his control and to limit their impact; see Gibbon to Barbeau, 20 May 1927, Canadian Museum of Civilization, Archives, Marius Barbeau Fonds, Correspondence with John Murray Gibbon (1919, 1922-26), B197, f. 19 (hereafter CMC Gibbon). Barbeau served as liaison between Gibbon and Scott; see Barbeau to Gibbon, 10 June 1927 and 21 July 1927, CMC Gibbon, in the latter of which Barbeau states: "Duncan Campbell Scott is undertaking the responsibility of securing the necessary Indians, whom I think he wishes to draw from the Blackfeet, the Bloods and the Peigans. The time at our disposal for Indian events will be limited, so I do not think we should go beyond this." Limiting Indian involvement was an attempt to transform the ceremonies at Banff into a Highland festival in celebration of the country's Scottish heritage.

109 Barbeau, *Indian Days in the Canadian Rockies*.

110 Gibbon was ambivalent about the product. He wrote to Hugh Eayrs, the publisher at Macmillan: "I read Barbeau's manuscript last night. It is somewhat different from what I expected, but at the same time is very original and interesting, and I think it will serve the purpose"; see J.M. Gibbon to Eayrs, 1 May 1923, CMC Gibbon. Barbeau's text met with other difficulties. A chapter devoted to the Kootenay was deleted because of its potential for placing missionary activity in one region in a bad light; see J.M. Gibbon to Eayrs, 1 May 1923, CMC Gibbon: "The religious criticism is rather questionable in a publication intended to have a popular appeal, and I should suggest omitting chapter 5 on that account. The chapter would give great offense to the Missions in the Kootenays, which as a matter of fact have been doing excellent work." By 8 May the book had, according to Gibbon, "a satisfactory ending," and he forwarded the $400 payment; see Gibbon to Barbeau, 8 May 1923, CMC Gibbon.

111 Barbeau, *Indian Days in the Canadian Rockies*, 8.

112 The Macmillan Company to Kihn, n.d., Kihn Papers.

113 Barbeau, *Indian Days in the Canadian Rockies*, 207.

114 Ibid., 81-103.

115 Ibid., 105-44.

116 Ibid., 3, 6.

117 Ibid., 5-6, my emphasis.

118 Ibid., 6.

119 Ibid., 6-7.

120 Ibid., 7-8.

121 Ibid., 8.

122 Ibid., 6.

123 Ibid., 9.

124 Native use of photography from the late 1800s is documented in Carol Williams, *Framing the West: Race, Gender, and the Photographic Frontier in the Pacific Northwest*

(New York: Oxford University Press, 2003).

125 Glenbow collection, 63.29.3. The inscription on the verso of the *Joe Nana* portrait, also in the Glenbow collection, 63.29.4, includes his age: sixty years.

126 Helen Comstock, "Langdon Kihn, Indian Painter," *International Studio* (October 1925): 50-55.

127 Rushing, *Native American Art and the New York Avant-Garde*, 1, 3.

128 Eayrs to Kihn, 21 September 1923, Kihn Papers.

129 It should be noted that Kihn was concurrently exhibiting his Blackfeet and Pueblo pictures in numerous venues in the United States. He held thirteen such shows from New York to Los Angeles between March 1922 and the fall of 1923; see "Exhibitions of Pictures by W. Langdon Kihn," Kihn Papers.

130 Hill, *The Group of Seven*, 178, reports: "At the instigation of the book's publisher, Hugh Eayrs of the Macmillan Company of Canada, and through Lismer, the drawings were shown at the Arts and Letters Club in March 1924 and subsequently at the Art Gallery of Toronto." Kihn lists the dates for the two shows as 1 February to 15 March 1924 and 1 April to 30 April 1924, respectively; see "Exhibition of Pictures by W. Langdon Kihn," Kihn Papers. See also Eayrs to Kihn, 21 September 1923 and 30 January 1924, Kihn Papers, the latter of which asks for shipment of the works. The first exhibition could not have opened when Kihn says that it did since the work was not sent until early February and had still not been mounted on 4 February; see Kihn to Eayrs, 2 February 1924, and Eayrs to Kihn, 4 February 1924, Kihn Papers. It is more likely that the first show opened in mid-February. Eayrs says on 1 March that "we have had the pictures up at the Arts and Letters Club for nearly two weeks now"; see Eayrs to Kihn, 1 March 1924, Kihn Papers. Eayrs cites the "extravagant" critical raves that the work received and states that the request to continue the exhibition at the Art Gallery of Toronto came from Willie Grier. Eayrs also mentions that the Montreal Art Gallery wanted the show and the probability of an exhibition at the National Gallery. On Eayrs' recommendation, Kihn travelled to Toronto in early March; see Kihn to Barbeau, 12 March 1924, Kihn Papers. Here, he was introduced to "Lismer, Jackson, Jeffries and others"; see Langdon Kihn, "Memoirs," n.p., Kihn Papers. The show did go to the Art Gallery of Toronto in April; see Kihn to Eayrs, 14 April 1924, Kihn Papers.

131 Eayrs to Browne [sic], 2 May 1924, offering the work; Director [Brown] to Kihn, 23 June 1924, refusing the exhibition; Lismer to [Brown?], 20 June 1924, noting Walker's desire to purchase "one or two for Ottawa and for the Museum or Gallery in Toronto – but his death upset the arrangements"; [Brown?] to Lismer, 26 June 1924, stating that "they cannot be exhibited here for obvious reasons." All in NGC Archives, NGC Box 82-2.3 – W. Langdon Kihn, N.Y. 1924; 1942.

132 Kihn to Eayrs, 26 September 1923, Kihn Papers. It appears that the incentive to purchase some of Kihn's works for the National Gallery and the Art Gallery of Toronto (AGT) lay with Sir Edmund Walker, who died while negotiations were under way; see Eayrs to Kihn, 18 March 1924, Kihn Papers, suggesting that Kihn sell anywhere from three to eight works to the AGT for a total of $500, and Eayrs to Kihn, 4 April 1924, Kihn Papers, on the sudden death of Walker and the prospect that the sale would proceed. See also "Dad" to Kihn, 1 July 1924,

Kihn Papers, for the NGC's refusal of the exhibition, which had been sent to the NGC, and also the NGC's request for a discount if it decided to purchase. For final confirmation that the NGC had refused purchase, see Eayrs to A.C. Kihn, 25 July 1924, Kihn Papers. A.C. Kihn was Langdon's father and was conducting his son's business while the latter was in the field. He referred to the NGC as "a bunch of pikers"; see A.C. Kihn to Kihn, 28 July 1924, Kihn Papers.

133 "Exhibition of Pictures by W. Langdon Kihn," Kihn Papers.

CHAPTER 6: BARBEAU AND KIHN WITH THE GITXSAN IN BRITISH COLUMBIA

1 Cole Harris, *Making Native Space: Colonialism, Resistance, and Reserves in British Columbia* (Vancouver: UBC Press, 2002), x-xi.

2 Marius Barbeau, *Totem Poles of the Gitksan, Upper Skeena River, British Columbia*, Bulletin no. 61, Anthropological Series no. 12 (Ottawa: National Museum of Canada, 1929).

3 See Chapter 7.

4 See Chapter 8.

5 Marius Barbeau, *The Downfall of Temlaham* (Toronto: Macmillan, 1928). See Chapter 10.

6 The first mention of the project occurs in Barbeau to Kihn, 27 June 1923, W. Langdon Kihn Papers, 1904-1990, Microfilm reels 3701-3713, Archives of American Art, Smithsonian Institution (hereafter Kihn Papers). See also Barbeau to Kihn, 5 March 1924, Kihn Papers, in which he invited Kihn and his wife to the "picturesque" Skeena the following summer, at the CNR's instigation and expense, to work on the illustrations for the book, which had taken a firm shape and had acquired a deadline of April 1925. Barbeau mentioned both "the 100 totem poles" in the region and that "masks and other crests are plentiful and most varied in style." This was also the first mention that Barbeau intended to "camp out with cook and interpreter at Kitwinkool for about a month." Kihn confirmed his interest in Kihn to Barbeau, 12 March 1924, Kihn Papers, and thanked Barbeau for the "gorgeous photographs." For further details of the plan as it progressed, see Barbeau to Kihn, 23 April 1924, Kihn Papers. See also Kihn to Barbeau, 2 May 1924, Kihn Papers.

7 *Omineca Herald* (Terrace, BC), 6 February 1925, 1.

8 *Omineca Herald* (Terrace, BC), 19 March 1926, 2.

9 Kihn to Barbeau, 12 March 1924, Kihn Papers. In Langdon Kihn, "Memoirs," n.p., Kihn Papers, Kihn reports that in 1924 Barbeau came to New York City, "and persuades me to join him on his (Nat'l Museum) exhibition to the Skeena R., B.C. to study and paint the Tsimshian [and] Carrier. (He was twisting my arm.)"

10 Kihn to Barbeau, 12 March 1924, Kihn Papers.

11 On issuing passes for Kihn and Barbeau, and their families, Howard clarified the relationship: "You will of course understand, that this transportation is issued in return for publicity that we shall receive, as per our conversation"; see Howard to Barbeau, 26 May 1924, Canadian Museum of Civilization, Archives, Marius

Barbeau Fonds, Correspondence with C.K. Howard (1924-27, 1929-30, 1932, 1939), B204, f. 70 (hereafter CMC Howard).

12 See Barbeau to Kihn, 23 April 1924, Kihn Papers. See also Barbeau to Kihn, 27 May 1924, Kihn Papers. Kihn borrowed money from his father to finance the trip; see Kihn to "Dad," 27 August 1924, Kihn Papers.

13 Kihn to Barbeau, 2 May 1924, Barbeau to Kihn, 8 May 1924, and Barbeau to Kihn, 1 June 1924, Kihn Papers.

14 The following is summarized from Langdon Kihn, "Travel Diary," Kihn Papers.

15 Helen Kihn to "Mother and Daddy Kihn," 26 June 1924, Kihn Papers. She notes that "Barbeau's temperament" was at the root of the delay. See also Dad to Kihn, 7 July 1924, and Kihn to "Folks," 13 July 1924, Kihn Papers.

16 Langdon Kihn, "Memoirs," n.p., Kihn Papers, indicates that Barbeau purchased a large collection of materials, including "Indian masks, jewellery, ivory and argillite carving, costumes, bowls, baskets, cedar bark work, leggings, moccasins, blankets, horn spoons etc. etc." from a trader in Prince Rupert and from another one in Hazelton.

17 Kihn to "Folks," 13 July 1924, Kihn Papers. Plans were still in place also to visit Kitwancool in August for an extended stay, but as will be seen, this did not work out as anticipated. See also Langdon Kihn, "Memoirs," Kihn Papers.

18 Langdon Kihn, "Memoirs," n.p., Kihn Papers, reports that Barbeau also acquired a significant collection in Kitwanga, including "masks, a carved housepost, rattles, drums, blankets, etc., a beautifully painted partition board (for end of house inside) and I bought my fine raven mask (in studio). These purchases were made from (as I remember) Jim Larhnitz and Seemedeck." Kihn did large portraits of both as well as a smaller one of "young Larhnitz."

19 Kihn remained in the area during August, while Barbeau returned to Ottawa for a meeting of the British Association for the Advancement of Science; see Laurence Nowry, *Marius Barbeau: Man of Mana* (Toronto: NC Press, 1995), 118.

20 Langdon Kihn, "Memoirs," n.p., Kihn Papers.

21 Kihn to "Dad," 26 December 1924, Kihn Papers.

22 The length of Kihn's stay should be noted, as it was far longer than Carr would spend in the region either before or after this time.

23 Barbeau promised a room in the museum in which to work; see Kihn to "Folks," 12 November 1924, Kihn Papers. Including some of Kihn's works in the 1925 Wembley exhibition was also debated at this point; see "Dad" to Kihn, 3 December 1924, Kihn Papers.

24 [Marius Barbeau], "Public Spirit in Canada," Canadian Museum of Civilization, Archives, Marius Barbeau Fonds, Correspondence with Langdon Kihn (1922-28, 1931, 1939-53, 1956, 1958, 1961), B208, f. 42 (hereafter CMC Kihn). Barbeau's use of "past" here in reference to "Indian life" is characteristic. An inventory of Kihn's production in the Canadian Museum of Civilization itemizes sixty-three Skeena images, of which forty-five were portraits and eighteen landscapes; see the Langdon Kihn Collection of Indian Portraits and Landscapes of the Canadian Rockies, CMC, (hereafter Kihn Inventory CMC). The inventory supplies much information beyond the title of each work.

25 Kihn to "Folks," 12 November and 20 November 1924, and Kihn to "Dad,"

30 December 1924, Kihn Papers. Returning the drawings of the totem poles
to New York proved a difficult matter. To facilitate passage through customs,
Kihn chose, on Barbeau's advice, to send them first to the National Museum
in Ottawa, which was then to forward them to the Brooklyn Museum, where
Kihn's father was to retrieve them. They did not arrive. It appears that they were
found filed "by mistake" in Barbeau's possession. By January they were supposed
to have been forwarded to New York, but again they did not arrive; see "Dad" to
Kihn, 7 January 1925, and Kihn to "Dad," 9 January 1925, Kihn Papers. Repro-
ductions of them later appeared in Barbeau's book on Gitxsan totem poles.

26 McCord Museum, M927.102. Also cited in Kihn Inventory CMC as: number 4,
Hlengwah – "Earthquake" or Larahnitz – "Looking to both sides"; Raven head-
chief of the Kitwanga tribe; Head-dress: Gilladal, "Thunder-bird"; Blanket:
Chilkat; Raven rattle in his hand. *Solomon Harris* is cited in Kihn Inventory CMC
as: number 9, Lelt – "Snake"; a chief of the Raven phratry in Kitwanga; Head-
dress: Mawdzeks – "Hawk" with Frogs; Cane: Raven, Frog and Snake; Blanket
with buttons represents the crest "People of the Coppershield."

27 Sandra Dyck, "'These Things Are Our Totems': Marius Barbeau and the Indi-
genization of Canadian Art and Culture in the 1920s" (MA thesis, Carleton Uni-
versity, 1995), 105 n. 137 cites three instances in Kihn's Skeena works in which
objects or names not belonging to the proper individuals were illustrated with
them. In one of these cases, the frontlet worn by Tom Campbell is identified
as an "old Tsimshian carving." This may require further study in that Campbell
was one of the key figures in the Gitxsan's resistance to non-Native interference
in their affairs and was also a carver of totem poles. It is highly unlikely that
he would have "posed" in a frontlet to which he did not have hereditary rights.
Such an act would have caused grave offence, discredited his position within his
own community, undermined his own objectives, and violated the principles for
which he stood and for which the Indian Agents branded him a troublemaker
and a subversive. Although I have not seen the actual work, archival photographs
show enough discrepancies between the frontlet and the head of the sitter to
indicate that it may have been added to the portrait at a later date. It is not
known if photographs of the work were among those circulated by the National
Museum within the Gitxsan community; see Barbeau to Kihn, 28 June 1925,
Kihn Papers. In Figure 23, Campbell's portrait is next to the lower left corner of
the carved and painted screen. The question of Tom Campbell's frontlet aside,
other misplaced motifs or items do occur.

28 *Martha Mawlhan of Laksale* is cited in Kihn Inventory CMC as: number 3, Maw-
lahan, Woman-head-chief of the Gitsegyukla tribe; Head-dress: Maedzeks, "the
Hawk," with Frogs; Costume: of dyed cedar-bark, decorated with swan's down.

29 *Mrs. Johnny Larhnitz* is cited in Kihn Inventory CMC as: number 10, Gwinhu
(Mrs. Johnny Larahnitz) Woman chief of the Raven phratry of Gitwinlkool;
Head-dress: Hlkuwilkskum-kak – "Prince of Ravens"; Blanket: Kus-gyadem-
Kamats – "garment of Starfish person."

30 See Glenbow collection, catalogue number R806.4, listed as Eagle Chief, a
Tsimsian Indian, but possibly Kihn Inventory CMC, number 33, Semawgyet-
Gyemk, "Chief Sun" (Big Seymour, a Carrier), Chief of Hagwelget. This treat-
ment, derived from religious icons, is the only instance in which any of Kihn's

Native portraits is equated in any manner with "spirituality," references to which also never occur in his writings.

31 Kihn Inventory CMC, number 24. It is now in the McCord Museum, as *Hanamuh Kisgahast of Kitsegukla*, M928.78.

32 See Kihn Inventory CMC, number 28. *Tseewa or Thick Thighs* is illustrated in Langdon Kihn, "The Gitksan on the Skeena," *Scribner's Magazine* 79, 13 (1927): 175. It is now in the Glenbow collection, R2636.1, as *Mr. George Derrick "Tsegwa."*

33 Kihn Inventory CMC, number 19, now in the Canadian Museum of Civilization collection.

34 For an expression of his clear understanding of the difficulties involved before this excursion, see Kihn to "Folks," 26 August 1924, Kihn Papers.

35 Langdon Kihn, "Memoirs," n.p., Kihn Papers. In another typescript focusing on these events, of which several versions exist, some in fragmentary form, Kihn added: "Because of the serious turn the council had taken the day before, we felt that the Indians might resent our stealing, or our assuming this right, so we did it in secrecy. Our intelligent interpreter stood guard on the bench above the tents to warn us of any approach. We worked fast and happily for quite some time till suddenly a figure appeared on the crest of the slope. Mr Barbeau threw his camera in the brush and I ran into the tent and hid the sketch book in the maize [sic] of blankets. How like children we were. I felt quite like a thief"; see Langdon Kihn, "The Little Lhasa of America – The Forbidden Village," 4, Kihn Papers.

36 Kihn, "The Little Lhasa," 32, Kihn Papers.

37 Conversely, Barbeau never seems to have mentioned the experience, except elliptically.

38 This addition of colours may have been done under the influence of the totem-pole restoration project, which was going on concurrently and is investigated in the next chapter.

39 Leonard Richmond, "Indian Portraits of W. Langdon Kihn," *The Studio* 90, 393 (1925): 339-46. See Herbert B. Grimsditch to Leonard Richmond, 9 June 1925, Kihn Papers: "I put the suggestion of another Canadian Wembley article before the editor, but I am afraid it is not among his ideas for this year, and must therefore be abandoned. I also showed him the photographs of the work by Kihn, which you were kind enough to bring in, and, as I anticipated, he was very interested in these, and would like to do an article on the artist as soon as space permits." Grimsditch also requested an original so that a colour-plate could be produced; see Grimsditch to Kihn, 3 July 1925, Kihn Papers: "We hope to give considerable prominence to the article when the time comes, for we have a very high opinion of your work."

40 Gibbon to Kihn, 28 April 1925, Kihn Papers: "Mr. Leonard Richmond has been in town today, on his return from the West, and spoke of you in very apprecia-tive terms. He tells me he did pretty well on his trip and sold fourteen of his European pictures. He worked pretty hard out West and did some fine pastels of the Rockies, of which we have secured three." Kihn may have supplied Rich-mond with photographs of his works at this point.

41 Helen Comstock, "Langdon Kihn, Indian Painter," *International Studio* (October 1925): 50-55. By this point, *The Studio* and *International Studio* were two separate

publications, the latter centred in New York since the early 1920s.

42 Ibid., 51.

43 Ibid., 52. Kihn's factual portraits would have contrasted sharply with the highly romanticized fantasies of such artists as George de Forest Brush; see Lula Merrick, "Brush's Indian Pictures," *International Studio* (December 1922): 87-93.

44 Comstock, "Langdon Kihn," 53-54.

45 Ibid., 53-55.

46 Ibid., 55.

47 Odette Arnaud, "An American Painter – W. Langdon Kihn," *L'Art et les Artistes* (October 1925): 9-12, typescript, translated from the French by Garrett P. Serviss, Kihn Papers. The article included five illustrations of Kihn's portraits, three from his Prairie images, one from the Gitxsan, and one from the Pueblo.

48 Kihn, "The Gitksan." Kihn had written the article during the previous year; see Robert Bridges to Kihn, 19 June 1925, Kihn Papers, accepting the manuscript and offering $250 for its use with the illustrations. This was followed by negotiations for a book through Charles Scribner's Sons, Publishers; see [illegible] to Kihn, 22 June 1925, Kihn Papers.

49 Kihn, "The Gitksan," 170.

50 Ibid., 173. See also Kihn Inventory CMC, number 9. The text in the inventory is less specific concerning the objects than is the title in the article. The work is in the Vancouver Art Gallery collection, 31.114, where it is titled *Solomon Harris*.

51 Kihn, "The Gitksan," 176. His letters home were more specific; see Kihn to "Folks," 3 July 1924, Kihn Papers: "This week we came to Hazelton to see the potlatch ceremony of the Carrier Indians ... The potlatch lasts a week and is nearly over. The Babines, the Gitksan, the Carriers and others – a whole slew of them from hundreds of miles around are in – and a wonderful sight it is. Have been going out to their Indian village (4 miles from here) every day and making portraits of the old chiefs with masks and ceremonial costumes that belong to the tribes north of here and that I won't be able to see perhaps ever again because after the potlatch is over they all go back north."

52 See Chapter 7 for a more complete discussion of this point.

53 There is evidence that the Canadian press was carefully scrutinized concerning any comments about the Gitxsan. Self-policing of statements seems to have been expected; see Harlan Smith to Kihn, 5 February 1926, Kihn Papers: "If you give anything to newspaper people about our Skeena River friends, remember we must be very careful because they read those newspaper articles, and they go up in the air very easily. They were wild about something that was published about your work last summer." Smith's inability to fully articulate the problem left it undefined. It is unclear whether he is referring to Barbeau, Kihn, or any other writer and what the Native response was. His excess of tact and lack of text indicate the degree to which comments were expected to be circumspect.

54 See John Cove, *A Detailed Inventory of the Barbeau Northwest Coast Files* (Ottawa: National Museums of Canada, 1985), 59.

55 This is not to say that the Group was not getting something of the same international exposure. In particular, 1925 was a banner year since it included exhibitions not only at Wembley, but also at Ghent and Los Angeles. Nevertheless,

in contrast to 1925, 1926 saw many more exhibitions of their work in Canada, fewer outside the country, and none off the North American continent; see Charles Hill, *The Group of Seven: Art for a Nation* (Ottawa: National Gallery of Canada, 1995), 339. Nor did the Group's work occasion anything approaching the international critical response that Kihn received. Conversely, little on Kihn appeared in Canada. Perhaps not insignificantly, precisely at this time, in October 1925, Brown decided not to go ahead with the first plan for a show at the Jeu de Paume, postponing it for a year.

56 It is unclear who arranged for Kihn's inclusion in the 1925 Wembley exhibition; see Kihn to "Dad," 10 January 1925, Kihn Papers: "Campbell, publicity manager of Nat'l Parks suggest a show at Wembley Fair, England later in season."

57 See Kihn to "Dad," 9 January 1925, and Kihn to "Dad and Mother," 2 March [1925], Kihn Papers. Although the latter is dated 1924, the references within it indicate that it was actually written in 1925.

58 E.W.H., *Ottawa Citizen*, 13 March 1925.

59 "Exhibition of Pictures by W. Langdon Kihn," Kihn Papers. See also Kihn to "Dad and Mother," 2 March [1925], and Kihn to "Dad," 4 March 1925, Kihn Papers. The Montreal exhibition included work sent from New York that had been done during Kihn's first trip to western Canada; see "Shipper's Export Declaration," Kihn Papers, listing thirty-two works.

60 *Montreal Gazette*, 6 April 1925.

61 Barbeau to Kihn, 21 February 1926, Kihn Papers.

62 Kihn to "Dad," n.d., and Sapir to Kihn, 13 September 1925, Kihn Papers.

63 Kihn to Dad and Mother, 2 March [1925], Kihn Papers. This may have been the poster for Banff Indian Days.

64 See F.N. Southam to F. Cleveland Morgan, 13 May 1925, initially offering $500; F. Cleveland Morgan to Barbeau, 16 May 1925; Barbeau to Kihn, 18 May 1925; Morgan to Kihn, 26 May 1925, raising the offer to $600; and Morgan to Kihn, 11 June 1925, Kihn Papers. In 1921 A.Y. Jackson was asking $800 for *October Morning, Algoma*, while works like Arthur Lismer's *Pine Tree and Rocks* were listed at between $500 and $600. The latter's *Isles of Spruce, Algoma* was priced in 1922 at $750; see Hill, *The Group of Seven*, 314-17. Recall that the single Kihn work bought by Gibbon had sold for $750.

65 The seven works, currently in the McCord Museum collection, are *Galdik-Get of Lahsale, Tom Campbell*, 1924, M928.82; *Totem Poles at Kispayaks*, [c. 1924], M928.77; *Hanamuh Kisgahast of Kitsegukla*, 1924, M928.78; *Alimlahi Waudee of Kisgahast*, 1925, M928.81; *Gam-Na-Gi-Gusk (growing Beaver)*, 1924, M928.79; *Portrait of Agnes McDames of Gitzegyukla, "Axti-harkzak,"* 1924, M928.83; and *Hi-Dsi-Mach (the Sender) Lack Sael (Ravencrest) of Kitsegukla B.C.*, 1924, M928.80. Their accession numbers indicate that they were in the collection by 1928.

66 Morgan to Kihn, 30 April 1926, Kihn Papers. Kihn called the offer "damn tight"; see Kihn to Dad, 8 May 1926, Kihn Papers. See also Kihn to Morgan, 8 June 1926, confirming the sale; Southam to A.C. Kihn, re: purpose of purchase, 16 June 1926; "Dad" to Kihn, 16 June 1926, asking for selection of works; and Kihn to Morgan, 30 June 1926, listing works, Kihn Papers. The works were *Awa Watl, Captain Jack, descendent of old Chief Callicum, Fort Rupert tribe, Nootka Vancouver*

Island, 1922; *Chief Joseph, [Babine]*, [1924]; *Johnny William or Athlis of Raven Crest, Babine Tribe from Babine Lake, British Columbia*, 1924; and *Maggie Jackson, a Tsimshian Indian of Kisgagas and Bear Lake, British Columbia*, 1924. The four were donated to the British Columbia Provincial Museum (now the Royal British Columbia Museum) by Mr. and Mrs. John Nichol and are listed as catalogue numbers 17746, 17747, 17748, and 17749 respectively.

67 Morgan to Kihn, 13 August 1926, Kihn Papers, emphasis in the original.

68 Wellcome's patronage began in about 1925 and continued into the next decade. The Wellcome Institute for the History of Medicine possesses a substantial collection of Kihn's portraits. Although primarily composed of works from Montana, it also includes three portraits from the Skeena: *Selt or snake, Tsimsian of Gitwanga, British Columbia*; *Captain Jack or Grizzly Bear Paw, medicine man of Kisbyyoks, British Columbia*; and *Noch Slak, wife of Capt. Jack of Kisbyyoks, British Columbia*. *Selt* is a duplicate of the work known elsewhere as *Lelt* or *Solomon Harris*, which is in the Vancouver Art Gallery collection, 31.114. This is the only instance of duplication found. The *Selt* duplicate is not noted in Kihn Inventory CMC. See also Gregory Edwards and Grant Edwards, "Langdon Kihn: Indian Portrait Artist," *The Beaver* (Winter 1984-85): 9.

69 Kihn to Mills, 8 January 1917, Kihn Papers.

70 See "Dad" to Kihn, 18 August 1926, placing a value of $10,650 on all the works from both trips; A.C. Kihn to Morgan, 27 August 1926, giving a series of prices, depending on the selection; Southam to A.C. Kihn, 5 November 1926, confirming receipt of a list of forty-six works, including sizes and prices; Morgan to Barbeau, 17 November 1926, instructing Barbeau to come to Montreal, expenses paid, to discuss the affair with Southam; Barbeau to Kihn, 22 November 1926, confirming the offer and suggesting that the entire purchase was destined for the "projected Art Gallery of Vancouver"; Morgan to Kihn, 9 December 1926, suggesting that Kihn come to Montreal and advising him to offer a concession in price; Barbeau to Kihn, 11 December 1926, outlining various configurations of works that Barbeau had selected, with a proposed price for each configuration and places to which they could be distributed; Morgan to Kihn, 16 December 1926, naming 21 December for a meeting in Montreal; Morgan to Kihn, 21 December 1926, confirming sale of twenty-four pictures for $3,500 to be shipped to Morgan Trust Company, including a list of the pictures and the museums to which they were to be distributed and giving right of reproduction to those institutions; Kihn to Morgan, 27 December 1926, requesting information on the whereabouts of the two pictures from the 1925 Wembley exhibition, a portrait and a landscape (three were actually sent, but only the landscapes were hung); Barbeau to Morgan, 30 December 1926, indicating that only two pictures were kept by the National Gallery for Wembley, including the portrait that was not hung, and that they were in Barbeau's care, the portrait being in the director's room and the landscape being on display with the travelling Wembley exhibition (Barbeau also hints at the Paris exhibition); Kihn to Morgan, 4 January 1927, confirming shipping of twenty-two and sale of twenty-four pictures; and Morgan to Kihn, 22 January 1927, on forwarding of cheque and the distribution of pictures to Ottawa, Toronto, and Vancouver, Kihn Papers. Southam's total

purchase, counting the first two groups of seven and four, was, then, thirty-five works, of which thirty-one were distributed to galleries and museums. Hill, *The Group of Seven*, 289-90, reports that "F.N. Southam of Montreal finally purchased twenty-seven of Kihn's Skeena works, which he donated to museums in Montreal, Ottawa, Toronto, Winnipeg, Vancouver, and Victoria."

71 The one exception was *Portrait of Rosie Coyote-Woman, "Sunktoya-wiya,"* 1922, which went to the McCord Museum, M927.101.

72 Hill, *The Group of Seven*, 300, is incorrect as to the placement of the Southam bequest of Kihn's works. None went to Victoria, although, as has been said, the Royal British Columbia Museum (then the BC Provincial Museum) had earlier acquired two of Kihn's Nootka pieces from the CPR purchase and later received the four presented to Nichol.

73 According to the shipping list, the six canvases were *Totempoles (Gitwinkool)*, *Feast among the Kitksan*, *Jim Lagaznitz*, *William Ayles*, *Mark Weegyet*, and *Ahrawden (mask)*; see "Pictures by H. Langdon Kihn," Kihn Papers.

74 *Ahrawden (mask)*, also known as *Thoughtless Little Slave Woman or Foolish Little Slave Girl*, CMC no. 63035, was, according to records at the CMC, transferred to the Royal Ontario Museum, although it is not now listed in their holdings. Its whereabouts is unknown. The large *Portrait of Jim Lagaznitz*, no. 62983, also known as *Chief Earthquake or Looking to Both Sides*, showing him in a Chilkat blanket and frontlet and holding a Raven rattle, which had been sent to the 1925 Wembley exhibition but not hung and had been placed in the director's office in the National Museum, was almost immediately sent on to the McCord collection, M927.102. It is unclear why this was done, especially since both images contained much that was of ethnographic interest and since the McCord Museum was to receive a substantial collection of Kihn's works from the first Southam purchase.

75 Although a movement to underwrite a civic gallery was proposed as early as 1925, it was not built until 1931. The five Kihn works were held until then at the B.C. Art Gallery on Granville Street; see "Publishers Make Valuable Gift to Art Gallery," *Sunday Province* (Vancouver), 31 July 1927. These included: (1) *Kitwanga Totem Poles*; (2) *Anna Campbell* [in Kihn Inventory CMC as: number 5, Neestaw or Weeheldem-Gipaik – "Many Grouse Flying" (old Anna Campbell); Head-dress: Lawxumbalach – "Moth" and small grouse; Blanket with buttons; Cedar-bark dance ring]; (3) *Lelt*, as before [also titled *Solomon Harris*]; (4) *John Larchnitz* [in Kihn Inventory CMC as: number 6, Guraklh – "Small-Rat" (or Johny Larachnitz) of the Wolf phratry, in Kitwanga, a cedar-ring on his head; Blanket named: "Garment of Bravery"]; and (5) *Frank Clark* [in Kihn Inventory CMC as: number 37, Gimbaum-Gyet – "Wold Person" (Frank Clark, of Hazelton) Wolf phratry; Head-dress: Liks-Hus, "Lost Dog," his crest].

76 See "Pictures by H. Langdon Kihn," Kihn Papers.

77 The works for Winnipeg and Montreal were allocated in late January, after those destined for Ottawa and Vancouver had been distributed. The Winnipeg collection was primarily of Natives dressed in Western attire rather than traditional, ceremonial regalia. It included *Jack Fowler Kitwanga, B.C., a boy wearing a blue and beige sweater*; *Luke Fowler (Wee-ha) (Big Storm) Lack Saek (Raven Crest) of Gitwanga,*

B.C., *in beige shirt, red neck scarf and black hat*; *Peter John of Hazelton, B.C., Gughwaut (always invited) Kisgahast (Fireweed Crest) of Kispioks Medicine Man, in blue shirt, black jacket and gray hat*; *Chieftess of Kuldo, B.C., in a yellow head scarf* [this may be *Martha Wilson* as per the list "Pictures by H. Langdon Kihn," Kihn Papers]; *Lydia Wilson (Gip Ganow) (small frogs of Lahgeebod) Wolf Crest of Gitwanga, B.C.*; and *Alice Smith (Noch-Tsil of Kissbyoks Kisgahast), Fireweed Crest Medicine Woman, in plaid blanket and pink headscarf.* Spellings as per inscriptions on the verso of the works supplied by Karen Kisiow of the Winnipeg Art Gallery.

78 These works are listed as: *Stephen Morgan, Totem Poles Kispayaks, Mrs. John Larach-nitz, Charles Wesley,* and *Jack Kisgagas*; see "Pictures by H. Langdon Kihn," Kihn Papers.

79 There is some discrepancy between the inventory lists and the records of the ROM. In the latter, *Jack Kisgegas* appears as *Jack Sem Git Ge Ganich, of Kisgagas*; *Stephen Morgan* is listed as *Tsimshian Chief*; and *Totem Poles Kispayaks* is titled *Gilwinikool Totem Poles.*

80 It is unclear what happened to the second landscape, which is not listed in the inventories or the shipping lists as part of the sale.

81 The exhibition record of the NGC Kihn landscape is limited. By the time Hubbard was writing his catalogue of the NGC collection, the work had been shown in Edmonton in 1928, 1932, and 1933 and in Winnipeg in 1933; see R.H. Hubbard, *The National Gallery of Canada: Catalogue of Paintings and Sculpture,* vol. 2, *Modern European Schools* (Ottawa: University of Toronto Press for the Trustees of the National Gallery of Canada, 1959).

82 Barbeau to Kihn, 8 June 1925, Kihn Papers. By late June Barbeau was beginning to mention unnamed "difficulties" that stood in the way, although he still stressed "the great wealth of picturesque material"; see Barbeau to Kihn, 28 June 1925, Kihn Papers.

83 Kihn's reasons for turning down the offer remain unclear.

84 P.G. Konody, "Art and Artists: The Palace of Arts at Wembley," *Observer* (London), 24 May 1925.

85 Barbeau to Kihn, 18 July 1925, Kihn Papers.

86 See Marius Barbeau, "Public Spirit in Canada," undated typescript, CMC Kihn: Kihn's "pictures in time will help materially in spreading definite impressions of our picturesque North West Coast, of the wood carvings of the northern tribes and their totem poles that still constitute one of the most striking features of our continent. This, to the great benefit of all. For our national consciousness and character can develop to the full only through better knowledge of the highly diversified parts of our vast country, of its natural resources, and its wealth both artistic and spiritual." However, this untapped resource lay in landscapes, not portraits. He continued: "For scenic grandeur the Canadian Rockies along both Canadian railways stand unsurpassed." He goes on to extol these in poetic terms.

87 See Chapter 8 for a discussion of these artists' activities in the Skeena Valley area as well as an analysis of their production and Barbeau's use of it.

88 At this point Kihn's nationality does not seem to have been of major importance.

89 Barbeau to Kihn, 21 February 1926, Kihn Papers. In contrast to Kihn's dealings with the CNR, in 1926 the Great Northern Railroad paid for all travel, lodging, and meals for both himself and his wife as well as for sitters and promised to purchase at least ten paintings for a minimum of $3,000; see W.R. Mills to Kihn, 30 December 1925, and W.R. Mills to Kihn, 12 February 1926, Kihn Papers.

90 Barbeau to Kihn, 22 November 1926, Kihn Papers.

91 Kihn was also invited to Quebec City for the festival of folk art and craft held there; see Barbeau to Holgate, 22 February 1927, Canadian Museum of Civilization, Archives, Marius Barbeau fonds, Correspondence with Edwin Holgate (1926-29, 1932, 1934, 1940), B204, f. 19 (hereafter CMC Holgate).

92 Kihn to Mills, 8 January 1927, Kihn Papers, my emphasis.

93 A.C. Kihn had already inquired into problems in the relationship between Langdon and Barbeau in November 1926; see the hand-written note attached to the copy of the letter from Morgan to Barbeau that A.C. Kihn forwarded to Langdon, 17 November 1926, Kihn Papers; perhaps sensing some duplicity on the part of Barbeau and referring to the prospective purchase of paintings, he asked "Can Barbeau queer you? Or have you his goodwill?" See also "Dad" to Kihn, 26 November 1926, Kihn Papers.

94 Paul Tennant, *Aboriginal Peoples and Politics: The Indian Land Question in British Columbia, 1849-1989* (Vancouver: UBC Press, 1990), 104-13, especially 110.

95 Cited in ibid., 110.

96 For a succinct discussion based on Barbeau's research of the relationships between crests, the erection of totem poles, and the possession of territories among the Tsimshian and specifically the Gitxsan, see Marjorie Halpin, "The Crest/Territory Relationship," in "A Critique of the Boasian Paradigm for Northwest Coast Art," *Culture* 14, 1 (1994): 10-13.

97 Barbeau to Kihn, 16 June 1927, CMC Kihn.

98 Barbeau to Holgate, 12 May 1927, CMC Holgate.

99 Jackson to Barbeau, 13 June [1927], Canadian Museum of Civilization, Archives, Marius Barbeau Fonds, Correspondence with A.Y. Jackson (1925-30, 1932-33, 1935, 1938-40, 1942, 1948, 1959, 1961), B205, f. 53 (hereafter CMC Jackson).

100 Barbeau to Gibbon, 16 June 1927, Canadian Museum of Civilization, Archives, Marius Barbeau Fonds, Correspondence with John Murray Gibbon (1919, 1922-26), B197, f. 19 (hereafter CMC Gibbon).

101 Barbeau to Kihn, 16 June 1927, CMC Kihn.

102 These included: *The Gitksan Village of Kitwancool, Feast among the Skeena, Hanamuk (Fanny Johnson), George Campbell, Paul Haidzemerks, Totem Pole Landscape Kispayaks, Agnes McDames, Mark Wegyet, Hanawden, William Ayles, Glengwah, Feast among the Gitksan,* and *Tom Campbell*; see Invoice – Shipping Record, from the National Gallery of Canada to Hugh S. Eayrs, The Macmillan Company, 10 November 1927, NGC Archives. The intent or the effect of using the Campbell portrait, which by this time would have been sporting the misplaced frontlet, as discussed at note 27, and which would have been provocative, can only be surmised, as it was ultimately eliminated along with many of the other works.

103 The date at which Barbeau and the National Gallery became aware of Carr has been a point of scholarly contention for some time. In Barbeau to Eric Brown,

3 October 1927, Canadian Museum of Civilization, Archives, Marius Barbeau Fonds, Correspondence with Eric Brown (1928-33), B176, f. 4, Barbeau states: "I saw a number of her paintings at Hazelton, which she had given to someone there fifteen years ago. They are certainly from a genuine artist." If Barbeau did see Carr's work at this time, then he was holding her work in the wings waiting for precisely the most advantageous time to reveal it, and 1927 was such an opportune moment. As has been shown, Barbeau was not beyond such machinations. But neither was Brown, and it would also have been to his advantage not to "discover" her until just after it was too late to include her at the Jeu de Paume. Blanchard claims that her works were known and collected in Ottawa by Barbeau well before the Jeu de Paume plans were put into place; see Paula Blanchard, *The Life of Emily Carr* (Vancouver and Toronto: Douglas and McIntyre, 1987), 169.

104 The painting referred to is probably *Sroromlaha – "First in the Sky" (Jos. Brown, of Gitsegyukla), Fireweed crest, shown wearing a head-dress which represented his crest: Pitse'i, "The Grouse,"* Kihn Inventory CMC, number 22. The work was not part of the Southam purchases and is currently in the Edward Lyman Bill Collection at the Davison Art Centre of Wesleyan University.

105 Barbeau to Kihn, 4 November 1927, Kihn Papers. It is uncertain why Barbeau could not himself fulfill this function since the National Museum had taken a complete photographic record of Kihn's works.

106 Although the sale of $4,000 worth of work to Canadian patrons may have rankled Group of Seven members, as would have the critical recognition given to Kihn, money hardly motivated Jackson's willingness to displace Kihn from the *Temlaham* book project. Jackson had originally told Barbeau that he could have his work for the book for nothing. Having gained the commission, he then changed his mind and decided that $25 per illustration would be an appropriate sum; see Jackson to Barbeau, 15 June [1928], CMC Jackson. In total Jackson charged $75 for the use of three of his paintings and $35 for the initials that he produced. Barbeau got to keep the sketch of Port Essington: "The sketch of Port Essington will belong to you because it is absurd paying for the right to use a sketch when five dollars more would have bought it." The sketch is visible behind Barbeau in a photograph taken 6 July 1956; see Cove, *A Detailed Inventory*, 15.

107 CMB [Charles Marius Barbeau] to H.S. Eayrs, 23 January 1928, NGC Archives, *Canadian West Coast Art, Native and Modern*, Exhibition 1927-28 file. Unsaid here is that Barbeau had turned the book over to Jackson as early as May 1927 and that, at this point, Jackson had begun politicking to exclude Kihn entirely and to have the illustrations based solely on his and Holgate's work; see Jackson to Barbeau, 13 June [1927], CMC Jackson.

108 Barbeau to Holgate, 1 February 1928, CMC Holgate.

109 Jackson to Barbeau, 30 January 1928, CMC Jackson: "Think the Alexee [sic] had better be left out. It will not have much bearing on the book and the C.N.R. may think less of the other work if it is included." Barbeau to Jackson, 1 February 1928, CMC Jackson, confirms the decision.

110 Barbeau to Kihn, 14 March 1928, Kihn Papers, makes no mention of the reduction.

111 Barbeau to Kihn, 17 March 1928, Kihn Papers.

112 For an analysis of these works, see Chapter 8.

113 Kihn to Gibbon, 28 August 1931, Kihn Papers.

114 One exception was the five works given to Vancouver, which were shown locally in 1930; see Vancouver Exhibition Association, *Canada's Pacific Exhibition August 6th to 16th, 1930: Fine Art Section Catalogue* (Vancouver: Vancouver Exhibition Association, 1930).

115 When Kihn's work was subsequently used in advertising to promote tourist travel into the Skeena region, the portraits were excluded, and again his limited repertoire of fantastic landscapes and images of totem poles were favoured.

116 See Chapter 8.

117 Barbeau to Kihn, 22 November 1926, Kihn Papers.

118 Hill, *The Group of Seven*, 190. If this was his first encounter with Carr, Barbeau gave no indication of it. In Barbeau to Kihn, 22 November 1926, Kihn Papers, in keeping with his practice, Barbeau withheld from Kihn any indication of his encounter with the Victoria artist, who had painted similar subjects and who would have been of great interest to the American.

119 *Province* (Vancouver), 27 October 1926, 2.

120 *Province* (Vancouver), 28 October 1926, 2.

121 *Province* (Vancouver), 22 October 1926, 15.

122 "Dr. Barbeau Gives Two Addresses on Indian," *The Ubyssey* 9, 10 (1926): 1.

123 "Lectures Concluded by Dr. Barbeau," *The Ubyssey* 9, 11 (1926): 1.

124 Barbeau is reported to have repeated the state's position on the disappearance of the Indian as the main points of his talks when he spoke in Vancouver and Toronto in the following years; see *Province* (Vancouver), 7 October 1927, and *Prince Rupert Daily News*, 23 January 1928.

125 Marius Barbeau, "Ancient Culture, Vignettes Past," *Canadian National Railways Magazine* 15, 7 (1929): 30, my emphasis. Barbeau's assertion echoes a statement by the American artist George Catlin: "I have, for many years past, contemplated the noble races of red men who are now spread over these trackless forests and boundless prairies, melting away at the approach of civilization. Their rights invaded, their morals corrupted, their lands wrested from them, their customs changed, and therefore lost to the world; and they at last sunk into the earth, and the ploughshare turning the sod over their graves, and I have flown to their rescue – not of their lives or of their race (for they are 'doomed' and must perish), but to the rescue of their looks and their modes, at which the acquisitive world may hurl their poison and every besom of destruction, and trample them down and crush them to death; yet, phoenix-like, they may rise from 'the stain of the painter's palette,' and live again upon canvass, and stand forth for centuries yet to come, the living monuments of a noble race"; see George Catlin, *Letters and Notes on the Manners, Customs, and Condition of the North American Indians*, 2 vols. (London, 1841; reprint, New York: Dover, 1973), vol. 1, 16, emphasis in the original, cited in William Cronon, "Telling Tales on Canvas: Landscapes of Frontier Change," in Jules David Prown et al., *Discovered Lands, Invented Pasts: Transforming Visions of the American West* (New Haven: Yale University Press/Yale University Art Gallery, 1992), 50 n. 12. Cronon comments: "The goal of the ethnographer's art – and Catlin's commercial project as a painter – was to

preserve the memory of a 'race' whose traditional way of life had supposedly been timeless and unchanging until the intrusion of Europeans precipitated its collapse. Such a vision did violence to the complex cultural histories of Indian peoples, but had great romantic power" (50). By comparison, Kihn had already encountered the new discourse forming in the Southwest, which countered this view.

126 I have already noted Native resistance to government programs that contradicts the idea that Natives were soliciting the artists. The following chapters will demonstrate that the Native population did anything but "court" representations and either demanded payment or resisted the process entirely. In fact, it was the artists who followed Kihn who had to do the courting. Barbeau was creating an elaborate fiction that reversed the actual events.

CHAPTER 7: GIVING GITXSAN TOTEM POLES A NEW SLANT

1 Aldona Jonaitis, "Northwest Coast Totem Poles," in Ruth Phillips and Christopher Steiner, eds., *Unpacking Culture: Art and Commodity Culture in Colonial and Postcolonial Worlds* (Berkeley: University of California Press, 1999).

2 See Arthur C. Danto, "Bourdieu on Art: Field and Individual," in Richard Shusterman, ed., *Bourdieu: A Critical Reader* (Malden, MA: Blackwell, 1999), 214-19.

3 These arguments rely heavily on the links between the formation of a programmatic, official nationalism produced by the state, restored ruins, museums, the tourist, surveillance, and the print media that have been established by Benedict Anderson, *Imagined Communities*, rev. ed. (London and New York: Verso, 1991), 178-86. I agree with Anderson that "museums, and the museumizing imagination, are both profoundly political" (175).

4 David Darling and Douglas Cole, "Totem Pole Restoration on the Skeena, 1925-30: An Early Exercise in Heritage Conservation," *BC Studies*, no. 47 (Autumn 1980): 29-48. Douglas Cole, *Captured Heritage: The Scramble for Northwest Coast Artifacts* (Vancouver: Douglas and McIntyre, 1985), 271-77. Although the latter provides more of a context for the project, it lacks many of the detailed footnotes to the extensive archival sources that appear in the first. The first also details many of the interpersonal conflicts that plagued the project. These were edited out of the book. Jonaitis, "Northwest Coast Totem Poles," recapitulates and summarizes Cole.

5 Ronald W. Hawker, "Accumulated Labours: First Nations Art in British Columbia, 1922-1961" (PhD diss., University of British Columbia, 1998), 106-21.

6 Darling and Cole, "Totem Pole Restoration," 40. They do mention "contrasting views of the potlatch law" as a point of contention but do not elaborate on what potlatch ceremonies were or who held them.

7 It should be noted that although Cole brings up these ongoing effects of the state's Indian policy, he does so only to dismiss them as possibly related to the Gitxsan's response to the totem-pole project and never pays them any further attention (ibid., 40).

8 The history of the Gitxsan is now beginning to receive attention and has begun to be sketched out in James A. McDonald and Jennifer Joseph, "Key Events in the Gitksan Encounter with the Colonial World," in M. Anderson and M. Hal-

pin, eds., *Potlatch at Gitsegukla: William Beynon's 1945 Field Notebooks* (Vancouver: UBC Press, 2000). See also Leslie Dawn, "'Ksan: Museum, Cultural and Artistic Activity among the Gitksan Indians of the Upper Skeena, 1920-1973" (MA thesis, University of Victoria, 1976).

9 McDonald and Joseph, "Key Events," 201. Neil J. Sterritt et al., *Tribal Boundaries in the Nass Watershed* (Vancouver: UBC Press, 1998), is a significant contribution to Gitxsan and Gitanyow history.

10 Jonaitis, "Northwest Coast Totem Poles."

11 Dawn, "'Ksan," 22: "The CNR subsequently developed a proprietary attitude towards all totem poles, and used several obtained through Barbeau and other agents as gifts to various institutions around the world."

12 Darling and Cole, "Totem Pole Restoration," 33.

13 Ibid.

14 Dawn, "'Ksan," 22.

15 The history of the potlatch ban has received extensive attention in the past thirty years; see Forrest La Violette, *The Struggle for Survival*, 2nd ed. (Toronto: University of Toronto Press, 1973); and Douglas Cole and Ira Chaikin, *An Iron Hand upon the People: The Law against the Potlatch on the Northwest Coast* (Vancouver: Douglas and McIntyre, 1990). Christopher Bracken, *The Potlatch Papers: A Colonial Case History* (Chicago: University of Chicago Press, 1997), adds yet more archival research. These are only three among a vast, diverse, and growing literature. The latter two will be used in combination since each adds elements missing in the other.

16 Douglas Cole, "The History of the Kwakiutl Potlatch," in Aldona Jonaitis, ed., *Chiefly Feasts: The Enduring Kwakiutl Potlatch* (Seattle: University of Washington Press, 1991), 285 n. 3, indicates that there are certain problems with dating the beginnings of the repression of the potlatch: "The dates are sometimes confused in the literature. In June 1883 the cabinet passed an order-in-council requesting the Indians to abandon the custom; on 7 July the Governor General issued a proclamation to 'enjoin, recommend, and earnestly urge' Indians to abandon the potlatch. On 19 April 1884, an amendment to the Indian Act, effective 1 January 1885, made anyone engaging or assisting in a potlatch ceremony guilty of·a misdemeanour."

17 Bracken, *The Potlatch Papers*.

18 Perhaps the best short description of the problem of defining the term "potlatch" occurs in Wayne Suttles, "Streams of Property, Armor of Wealth," in Jonaitis, ed., *Chiefly Feasts*, 284 n. 6. Suttles opts in the end for a universal Northwest Coast definition: "One might reasonably question whether the term 'potlatch' actually refers throughout the region to the same kind of event. However, descriptions of these events suggest that in fact from one end of the region to the other what are called potlatches do have a number of features in common ... But the common features seem to justify identifying the potlatch as a single, region-wide institution. Explaining this institution has become a major concern in anthropological work in the region and a minor industry in anthropology in general." And, one might add, for English professors as well. Bracken, *The Potlatch Papers*, 112, counters: "When the law borrows these Chinook terms to name acts that have different names and take different forms in different communities,

it reduces the diversity of the coastal First Nations to an unbroken sameness. It is as if, to the Euro-Canadian gaze, aboriginal societies were all in the last analysis the same – despite the differences that separate them from each other and divide them within themselves."

19 Bracken, *The Potlatch Papers*, 114-15.

20 Ibid., 114.

21 Ibid., 116.

22 Ibid., 118-19.

23 Ibid., 136-39.

24 Ibid., 131-56. As will be shown, Boas's stance on the matter would continue with his student, Edward Sapir, which would cause a split in the ranks of ethnographic practice in Canada.

25 Ibid., 186.

26 Ibid., 179.

27 Ibid., 180-81.

28 Ibid., 218.

29 The Division of Anthropology was under the Geological Survey of Canada but in 1920 became part of the Victoria Memorial Museum, later known as the National Museum of Canada; see Regna Darnell, "The Sapir Years at the National Museum, Ottawa," *Canadian Ethnology Society Proceedings*, no. 3 (1976): 100-2.

30 Bracken, *The Potlatch Papers*, 219.

31 Ibid. Harlan Smith's letter must have been particularly galling: "Those who have caused all the trouble of thus persecuting these Indians, ... dragging them many miles before the courts and imprisoning them, so far as I have ever been able to find out, knew little or nothing about Indians" (ibid.).

32 Sapir to Barbeau[?], uncited letter, quoted in Laurence Nowry, *Marius Barbeau: Man of Mana* (Toronto: NC Press, 1995), 161. Nowry's uncritical biography of Barbeau assumes that he contributed to this defence of the potlatch but admits that "his reply is not on record" (ibid.). Although he has done much archival research, he provides no notes for his sources.

33 Bracken, *The Potlatch Papers*, 220.

34 Ibid., 233, states that in 1921 and 1922 demands were made in the House of Commons for the release of the potlatch report. Bracken claims that Scott lied about its contents, and his minister went so far as to prevaricate about his knowledge of its existence to the House. They refused to release it, and in the end it was suppressed. Bracken may not be correct here. There is a greater possibility that it was never completed and that Scott lied not about its contents but about its existence. Barbeau's project was excessively ambitious from the start. He proposed a study of five to six hundred pages based on all of the literature to date, including fieldwork by Sapir and himself. It is most probable that it was never written but only existed in the outlines, which have survived; see "Native Property Rights and Transactions (Potlatch) among the Indians of British Columbia," National Archives (hereafter NA), RG 10, volume 3630, file 6244-4, pt. 2. Conversely, this three-page summary, while not completely explicit, seems to reject the potlatch ban as nonproductive and insists that only an authority such as the author can ensure positive actions. Barbeau may then have decided that his interests lay

with his immediate superior. Sapir, in fact, forwarded the summary to Scott, with a suggestion that the latter should assist in its publication. The ironic intent is obvious; see Sapir to Scott, 23 April 1918, NA, RG 10, volume 3630, file 6244-4, pt. 2. Requests for copies of the completed report met with statements that it was not available; see Dickie DeBeck to Scott, 19 July 1921, NA, RG 10, volume 3630, file 4244-4, pt. 1. No manuscript exists within Barbeau's files. However, Scott needed to keep up the appearance that he was the authority on the subject, even more so than the Natives themselves, and thus always implied that he had it in hand. Otherwise, he would have been obliged to admit that he did not fully understand what he was doing and did not have the backing of government specialists in the area.

35 Nowry, *Marius Barbeau*, 197, describes Sapir as "a fervent partisan of native rights and traditions [who] had inveighed against outlawing the potlatch. His outrage of course included the damaging anthropological implications, but he was perhaps more sensitive to the hurt and unhappiness visited on inoffensive people." Nowry's assessment patronizes both Sapir and the Natives and misses the main issues at stake here.

36 Paul Greenhalgh, *Ephemeral Vistas: The Expositions Universelles, Great Exhibitions and World's Fairs, 1851-1939* (Manchester: Manchester University Press, 1988), 96: "Recent work on the history of British anthropology has shown, as with the French, that in order to acquire establishment recognition, research often strayed a long way from any objective basis in order to support predominant views in imperial circles on the degeneracy of non-white races." See also Annie Coombes, "'For God and for England': Contributions to an Image of Africa in the First Decade of the Twentieth Century," *Art History* 8, 4 (1985): 453-66. For the conjunction between ethnographic practice and the interests of the state in Canada, especially concerning Jenness, see Peter Kulchyski, "Anthropology in the Service of the State: Diamond Jenness and Canadian Indian Policy," *Journal of Canadian Studies* 28, 2 (1993): 21-50; and Andrew Nurse, "'But Now Things Have Changed': Marius Barbeau and the Politics of Amerindian Identity," *Ethnohistory* 48, 3 (2001): 433-72.

37 Sapir to [Barbeau], [1920], uncited letter, quoted in Nowry, *Marius Barbeau*, 197.

38 Darling and Cole, "Totem Pole Restoration," 47.

39 Kihn had expressed sympathy to Barbeau concerning the latter's "feelings" toward Sapir; see Kihn to Barbeau, 4 March 1924, Canadian Museum of Civilization, Archives, Marius Barbeau Fonds, Correspondence with Langdon Kihn (1922-28, 1931, 1939-53, 1956, 1958, 1961), B208, f. 42 (hereafter CMC Kihn). In 1925 Sapir published "Are the Nordics a Superior Race?" *Canadian Forum* 5, 57 (1925): 265-66. The issues raised in this scathing, yet prescient, attack on hierarchical notions of English-speaking racial superiority may have been at the heart of the matter. He concluded with the invocation: "It is too much to expect the average man to be entirely free from racial prejudices. Tolerance of any kind comes hard. But, at least, let no 'scientists' bolster up the prejudices of the laity with unproven and dangerous dogmas. It should never be forgotten that 'science,' like unsound statistics, can be made to pander to every kind of ill-will that humanity is heir to" (266).

40 Jenness's promotion over Barbeau as head of the National Museum also pro-
duced problems. They apparently seldom spoke again for the duration of their
long careers.

41 Barbeau to Kihn, 21 February 1926, W. Langdon Kihn papers, 1904-1990,
Microfilm reels 3701-3713, Archives of American Art, Smithsonian Institution
(hereafter Kihn Papers).

42 Sapir to Kihn, 1 March 1926, Kihn Papers.

43 Cole and Chaikin, *An Iron Hand*, 107-9.

44 Bracken, *The Potlatch Papers*, 181.

45 NA, RG 10, volume 3630, file 6244-4, pt. 1.

46 Bracken, *The Potlatch Papers*, 181-82.

47 *Omineca Herald*, Terrace, BC, 7 January 1921, 1. This was one of Loring's last
acts as Indian Agent; shortly thereafter he would resign and become the region's
justice of the peace. His posted notice did, in fact, contain a caveat that displayed
his attempt to put a loophole into the law. After stating the ban, it concluded:
"But, it may be stated that, with regard to the above, no objections will be raised
to have social gatherings for a feast with the opposing features [i.e., distribution
of gifts], as set forth, thereat omitted"; see NA, RG 10, volume 3630, file 6244-
4, pt. 1.

48 Nowry, *Marius Barbeau*, 201-2.

49 Corpl., Bag No. 6108, to Commanding Officer, W.C. Mounted Police, Prince
Rupert, 6 January 1921, NA, RG 40, volume 3630, file 6244-4, pt. 1.

50 Nowry, *Marius Barbeau*, 197.

51 Bracken, *The Potlatch Papers*, 213. See also Cole and Chaikin, *An Iron Hand*, 124-
25. McDonald and Joseph, "Key Events," 208, state: "In 1921 Agent Hyde brought
charges against Edward Saxsmith, Robert Wilson, and John M. Morrison for
participating in a feast. They received suspended sentences from Agent/Justice
of the Peace Loring." McDonald and Joseph omit Peter Wilson's name, men-
tioned in Cole and Chaikin.

52 *Omineca Herald* (Terrace, BC), 7 July 1922. Barbeau attended the second of these
"potlatches" and took photographs but does not seem to have taken field notes,
hence depriving history of an important ethnographic record.

53 *Omineca Herald* (Terrace, BC), 13 July 1923.

54 *Omineca Herald* (Terrace, BC), 27 July 1923.

55 "Aged 102, Wasm la tha Robinson Goes to Happy Hunting Grounds," *Daily Prov-
ince* (Vancouver), 20 May 1923.

56 *Omineca Herald* (Terrace, BC), 9 January 1925.

57 Langdon Kihn, "The Gitksan on the Skeena," *Scribner's Magazine* 79, 13 (1927):
170-77.

58 Ibid. Bracken, *The Potlatch Papers*, 215-16, reports similar instances among the
Kwakwaka'wakw. Even though Halliday had stated that the potlatch had died, he
then stated that it had come to life again in 1923. By 1927 full-scale potlatching
was reported in the area.

59 *Omineca Herald* (Terrace, BC), 19 March 1926.

60 McDonald and Joseph, "Key Events," 208. See also Cole and Chaikin, *An Iron
Hand*, 125.

61 It is unclear whether it was Loring who was handing out these less-than-punitive punishments for violation of the potlatch ban, but it would be in keeping with his position.

62 See Cole and Chaikin, *An Iron Hand*, 125, citing Dawn, "'Ksan"; McDonald and Joseph, "Key Events," for a partial account; and Dawn, "The Pre-History of 'Ksan: A Case for Gitxsan Cultural Continuity," paper presented at the conference "Boundaries in the Art of the Northwest Coast of America," British Museum, London, 18-20 May 2000, which documents the flourishing cultural activity among the Gitxsan from the 1920s through the 1940s. It should be noted that prosecutions did not entirely stop. In the spring of 1931 charges were brought against John Smith and Tom Campbell; see Babine Agency to Scott, 17 April 1931, NA,RG 10, volume 3631, file 6741-5. Campbell, as has been shown, was the subject of a portrait by Kihn and was noted as an instigator of resistance to government policies. These charges corresponded to reports in the local papers of large-scale ceremonies that had been going on "for several days" at both Kitwanga and Kitwancool, where a new totem pole was to be erected; see *Omineca Herald*, Terrace, BC, 14 January 1931, 1. The Depression, however, brought a period of decreased surveillance and increased leniency, the latter probably related to the contribution of the ceremonies to the non-Native economies of the region.

63 Hill, *The Group of Seven*, 189.

64 Darling and Cole, "Totem Pole Restoration," 35.

65 *Daily Province* (Vancouver), 28 June 1925, mag. sec. 2.

66 P.W. Luce, "Halt! Red Men Bar Whites from B.C. Lands," *Saturday Night*, 27 June 1925, n.p. A copy of this article is in the Harlan Smith Papers in the Royal British Columbia Museum (RBCM). He had kept the article in his personal possession until his death.

67 This incident is not mentioned in Sterritt et al., *Tribal Boundaries*, but several other similar situations are recorded there.

68 Luce.

69 The Kitwancool did not relinquish this position. Some thirty years later, before a restoration program sponsored by the British Columbia Provincial Museum could proceed, a formal statement on Kitwancool territorial claims and cultural continuity had to be published; see Wilson Duff, ed., *Histories, Territories, and Laws of the Kitwancool*, Anthropology in British Columbia Memoir No. 4 (Victoria: Provincial Museum of British Columbia, 1959).

70 See Homi K. Bhabha, "Of Mimicry and Man: The Ambivalence of Colonial Discourse," *October*, no. 28 (1984): 125-33, reproduced in Annette Michelson et al., eds., *October: The First Decade, 1976-1986* (Cambridge, MA: Massachusetts Institute of Technology Press, 1987), 317-25, for a discussion of mimicry in colonial encounters.

71 *Saturday Night*, 27 June 1925, n.p. The source of this remarkable quotation, which freely mixes legal jargon and specific land-claims statements with rhetoric stated in stereotypical Native patois, was not given in the article.

72 Harlan Smith Papers, RBCM.

73 Ibid.

74 Smith, referring to himself in the third person, reported to Scott that "the Indians had been advised in the fall of 1926, and had approved. Now some of them raised objections, so that for two weeks Smith could do nothing. He then moved to Usk, obtained the goodwill of the Indians who owned the poles at Kitselas Canyon, and worked at these poles throughout the summer"; see Smith, Memorandum to Dr. Campbell Scott, 5 December 1927, Harlan Smith box, Canadian Museum of Civilization (CMC) Archives.

75 *Prince Rupert Daily News*, 20 May 1927, 1. Cole, *Captured Heritage*, 274, offers a different version of this incident.

76 Smith to the Indians of Kitselas, 27 June 1927, Folder W. Harlan Smith file, CMC Archives, my emphasis.

77 Darling and Cole, "Totem Pole Restoration," 43.

78 Letter from Harlan Smith to unknown person from Kitwanga, BC, 22 July 1925, Harlan Smith Papers, RBCM.

79 Eric Brown, "La Jeune Peinture canadienne." *L'Art et les Artistes* 75 (March 1927): 181-98.

80 See Ruth Phillips, "Nuns, Ladies and the 'Queen of the Huron,'" in Phillips and Steiner, eds., *Unpacking Culture*, 33-50. The term "revival," like many of the terms treated in this volume, had various meanings during the 1920s. Either it could refer to a renewal of the production of traditional objects, which, it was argued, had stopped, or it could mean the production of objects using Native motifs by non-Native industry. Smith would use the term in both ways.

81 Darling and Cole, "Totem Pole Restoration," 41-42.

82 Smith's letter indicates that the revival project continued to be discussed well into the execution of the program. Indeed, it became something of a sore point between Barbeau and Smith and is repeated continuously in Smith's reports. However, Smith does not figure in Hill's research.

83 Harlan Smith, "Preserving a 'Westminster Abbey' of Canadian Indians: Remarkable Totem Poles Now under Government Care," *London Illustrated News*, 21 May 1927, 900-1, my emphasis.

84 Anonymous, "The Inlet People: Clansmen of a Dying Race," *London Illustrated News*, 18 April 1925, 684-85.

85 Marius Barbeau, *Totem Poles of the Gitksan, Upper Skeena River, British Columbia*, Bulletin no. 61, Anthropological Series no. 12 (Ottawa: National Museum of Canada, 1929), 1. Note Barbeau's repetition of Kihn's term "stronghold" and his reassessment of the continuity of Native culture.

86 Ibid., 7.

87 Dawn, "'Ksan," 33.

CHAPTER 8: REPRESENTING AND REPOSSESSING THE SKEENA VALLEY

1 Paul Tennant, *Aboriginal Peoples and Politics: The Indian Land Question in British Columbia, 1849-1989* (Vancouver: UBC Press, 1990), 96-113.

2 Ibid., 259 n. 14, 79-85.

3 See Anatole Romaniuc, "Aboriginal Population of Canada: Growth Dynamics under Conditions of Encounter of Civilizations," *Canadian Journal of Native Studies*

20, 1 (2000): 95-138. "The process of depopulation reached its nadir at the turn of
the 20th Century and a slow journey towards demogaphic recovery began thereaf-
ter" (108). Romaniuc gives the total Aboriginal population in 1901 as 106,900 and
in 1921 as 120,700. This is a rise of over 10 percent. By 1931 the number had risen
by another 10 percent, roughly a 25-percent increase since the turn of the century.
Obviously, any claim that the Native population was on the verge of extinction by
this time was stated in the face of clear statistics to the contrary.

4 Jackson had already come west with J.W. Beatty in 1914, as far as Jasper, on a
trip underwritten by the Canadian Northern Railway with the intent that "the
paintings would be used in an advertising campaign"; see Dorothy M. Farr, *J.W.
Beatty, 1869-1941* (Kingston: Agnes Etherington Art Centre, 1981), 28. How-
ever, Jackson was dissatisfied with much of his work on this trip and destroyed
most of it. The railway went bankrupt shortly thereafter and never completed
the commission for the work. Jackson repeated his trip west in 1924, going as
far as Alberta with Harris, "as we planned to do some work for the Canadian
National Railway"; see A.Y. Jackson, *A Painter's Country: The Autobiography of A.Y.
Jackson*, rev. ed. (Toronto: Clarke, Irwin, 1967), 88. I have already mentioned
that this collaboration had begun as early as 1886, when the railway to the West
Coast was first completed; see Dennis Reid, *Our Own Country Canada: Being an
Account of the National Aspirations of the Principal Landscape Artists in Montreal and
Toronto, 1860-1890* (Ottawa: National Gallery of Canada, 1979); and Lynda Jes-
sup, "Canadian Artists, Railways, the State and 'The Business of Becoming a
Nation'" (PhD diss., University of Toronto, 1992). The Canadian Northern Rail-
way subsequently became part of the Canadian National Railway.

5 Initially, Jackson reported success; see Jackson to Barbeau, 25 February [1926],
A.Y. Jackson file, National Gallery of Canada (NGC): "Harris is very anxious to
put in a few weeks on the Skeena and it sounds very interesting to me. I spoke
about an exhibition of Indian masks to the ex. Committee of the Art Gallery and
they think it will be fine for the autumn." As cited earlier, Barbeau also wrote
Kihn in early 1926 indicating that he had the cooperation of Jackson and Harris
and "possibly some others of the Seven"; see Barbeau to Kihn, 21 February 1926,
W. Langdon Kihn Papers, 1904-1990, Microfilm reels 3701-3713, Archives of
American Art, Smithsonian Institution (hereafter Kihn Papers). Jackson eventu-
ally had to report that the Group of Seven's support had diminished; see Jackson
to Barbeau, [1926], Canadian Museum of Civilization, Archives, Marius Barbeau
fonds, Correspondence with A.Y. Jackson (1925-30, 1932-33, 1935, 1938-40,
1942, 1944, 1948, 1959, 1961), B205, f. 53 (hereafter CMC Jackson): "Harris
and MacDonald seem definitely committed to the CPR [Canadian Pacific Rail-
way] country while Lismer cannot get away from his family." Nonetheless, Bar-
beau was still reporting to Kihn in November 1926 that he expected Jackson,
Harris, and Holgate to join him the following summer (i.e., 1927). None of them
did. See Barbeau to Kihn, 22 November 1926, Kihn Papers.

Harris visited the Rockies every summer between 1924 and 1928 and did some
of his most recognized work in the region of Jasper – that is, on the Canadian
National Railway line – down the tracks from the Skeena.

6 Barbeau to Holgate, 26 May 1926, Canadian Museum of Civilization, Archives,

Marius Barbeau Fonds, Correspondence with Edwin Holgate (1926-29, 1932, 1934, 1940), B204, f. 19 (hereafter CMC Holgate). The precise dates of the promised exhibitions do not seem to have been set at this time and would not be solidified until the following year.

7 A.Y. Jackson, "Rescuing Our Tottering Totems: Something about a Primitive Art, Revealing the Past History of a Vanishing Race," *Maclean's Magazine*, 15 December 1927, 23, 37.

8 Jackson, *A Painter's Country*, 89. Charles Hill, *The Group of Seven: Art for a Nation* (Ottawa: National Gallery of Canada, 1995), 190, reports that "Barbeau arranged for Jackson and Holgate to visit the Skeena on passes provided by the C.N.R. in the summer of 1926."

9 Jackson, *A Painter's Country*, 89.

10 Jackson, "Rescuing Our Tottering Totems," 23.

11 Jackson, *A Painter's Country*, 89.

12 Ibid., 90.

13 Marius Barbeau, "Totem Poles: A Recent Native Art of the Northwest Coast of America," *Geographical Review* 20, 2 (1930): 258-72.

14 Tennant, *Aboriginal Peoples*, 109-12.

15 Jackson, "Rescuing Our Tottering Totems," 23.

16 Barbeau was extremely supportive of Jackson's Quebec works. He both arranged for the sale of the work to a host of clients and encouraged the artist to undertake further production, telling him to paint multiple images to meet the high demand; see Barbeau to Jackson, 4 June 1926 and 1 February 1928, CMC Jackson.

17 Jackson could conflate French Canada and the Indian in word as well as image. In 1927 he wrote that "the picturesque side of Quebec is rapidly disappearing" and that "one regrets the passing of the habitant"; see A.Y. Jackson, "Winter Sketching," *McGill News* 8, 3 (1927): n.p., cited in Sandra Dyck, "'These Things Are Our Totems': Marius Barbeau and the Indigenization of Canadian Art and Culture in the 1920s" (MA thesis, Carleton University, 1995), 83.

18 Jackson, "Rescuing Our Tottering Totems," 23. He was referring to a remark made by the conservative American critic Thomas Craven in "Northern Art," *New York Herald Tribune Books*, 2 May 1926, 13.

19 Jackson, "Rescuing Our Tottering Totems," 23. This statement by Jackson may have been the source for Brown's contention that the relationship between Native and *native* Canadian art would produce a "battleground" within Canadian studios. Eric Brown, "Canadian Art in Paris," *Canadian Forum* 7, 84 (September 1927): 360-61.

20 Jackson, "Rescuing Our Tottering Totems," 23. Dropped articles, a lack of verb agreement, and abbreviated and colloquial phrasing were common tropes for rendering a parody of "Indian" speech at the time. Jackson does not mention that he and Barbeau were in the midst of producing a second such book. For further evidence from Jackson that "the Indians were not too friendly when I was there," see Dyck, "'These Things Are Our Totems,'" 57.

21 For an example of the Gitxsan being silenced and prevented from delivering their land claims to the bureaucracy, see Tennant, *Aboriginal Peoples*, 97.

22 Jackson, "Rescuing Our Tottering Totems," 23.

23 Dyck, "'These Things Are Our Totems,'" 53.

24 Pierre Landry, ed., *Canadian Art: Catalogue of the National Gallery of Canada*, vol. 2 (G-K) (Ottawa: National Gallery of Canada, 1994), 200-22, 17449r-17552. The publication of Jackson's sketches from the Skeena region, acquired by purchase from the artist in 1973, allows for a clearer tracing of his creative process.

25 Hill, *The Group of Seven*, reports that "A.Y. Jackson painted at least six canvases from studies made during his trip to the Skeena River in 1926." Hill notes that at "the 1927 show of West Coast art, Jackson exhibited *Gitsegyukla Village* (McMichael Canadian Art Collection, 1968.8.27), *Totem Poles, Hazelton* (collection unknown), and *Kispayaks Village* ... He lists *Night, Skeena River* in a Montreal collection in 1933. In 1941 he painted a work titled *Souvenir of Kispayaks* (collection unknown)" (327). A small study, *Rocher de Boule*, in the Edmonton Art Gallery, may be one of the "collection unknown" works. *Skeena Crossing*, also known as *Village of Gitseguklas* or *Skeena River*, is a watercolour in the Robert McLaughlin Gallery. An image entitled *Spukshu or Port Essington, a Mission Village, at the mouth of the Skeena* is reproduced in Marius Barbeau, *The Downfall of Temlaham* (Toronto: Macmillan, 1928). A sketch on panel showing two totem poles and a Victorian-style house is in the collection of the Hamilton Art Gallery.

26 The one instance in which Jackson may have appropriated the sculptural style of the Native is in his rendition of capital letters for Barbeau's *The Downfall of Temlaham*; see Landry, *Canadian Art: Catalogue*, vol. 2, 17456, "Studies for Illuminated Letters for 'The Downfall of Temlaham,'" and 17457, "Study for Illuminated Letter for 'The Downfall of Temlaham.'" But even here, in the published versions, the solid, black, Roman letters remain separate from the Native motifs that form their backdrop.

27 Jackson to Barbeau, 15 January 1928, CMC Jackson.

28 Jackson, *A Painter's Country*, 90. It is true that Jackson's statement about the limited number of paintings that he produced as a result of the Skeena excursion occurred well after the fact in his memoirs, but it is confirmed by the scarcity of paintings by him depicting Skeena subject matter.

29 Joan Murray, *Northern Lights: Masterpieces of Tom Thomson and the Group of Seven* (Etobicoke: Prospero Books, 1994), 162, reports: "*Indian Home* was one of Jackson's favourite paintings. He considered it one of his best Skeena River subjects, and liked to include it in shows, as his niece, Naomi Jackson Groves, recalled." Hill, *The Group of Seven*, 327, states that although the work was not shown at the *West Coast Art* exhibition, it was highly visible and had a national and international exhibition history. He lists: "Group, 1928, no. 39; London, 1928, no. 117 *Indian Home (British Columbia)*; AAM Canadian 1928, no. 31; NGC 1929, no. 79, $400; AFA (2) 1930, no cat. no. *Indian House*, $300; Roerich 1932, no. 31; Group 1936, no. 125, *Indian Home* (incorrectly listed as property of the artist)." It seems that none of Jackson's limited production of paintings from the trip ever entered the collection of the National Gallery of Canada, although it now holds a large number of sketches acquired in the 1970s; see Landry, *Canadian Art: Catalogue*, vol. 2, 200-22. The scandals and protests that surrounded what was considered favouritism by the NGC for the Group of Seven, which arose at this time and

focused on the "Wembley controversy," may have made the NGC shy about making its regular purchases of the Group's work, but the change in subject would seem to have warranted at least a modest acquisition. That no acquisition was made may be a comment on the quality of the work, especially as perceived by the artist himself. Or it may be taken as evidence of a less-than-positive response by Eric Brown to the project.

30 A painted oil-on-panel sketch, *Indian Home, Port Essington*, 1926, is in the McMichael Canadian Art Collection.

31 Landry, *Canadian Art: Catalogue*, vol. 2, 203, 17486.

32 As stated by G.H.R. Tillotson, "The Indian Picturesque: Images of India in British Landscape Painting, 1780-1880," in C.Y. Bayley, ed., *The Raj: India and the British, 1600-1947* (London: National Portrait Gallery, 1990), 142, picturesque conventions included the "ruin that was both picturesquely irregular in itself and a reminder of man's transience."

33 In fact, Jackson's *Indian House* corresponds closely to compositions by the American artist John Burchfield.

34 The totem poles occur in one of three sketches for Jackson's *Indian House* in the National Gallery; see Landry, *Canadian Art: Catalogue*, vol. 2, 203, 17459, "Composition Sketch for 'Indian Home.'" The drawing appears to be inscribed with the directions "blank, deserted, stark."

35 Landry, *Canadian Art: Catalogue*, vol. 2, 203, 17475, "First Sketch for 'Indian House.'"

36 Johnathon Bordo, "Jack Pine: Wilderness Sublime or Erasure of the Aboriginal Presence from the Landscape," *Journal of Canadian Studies* 27, 4 (1992-93): 98-128.

37 See George F. MacDonald, *The Totem Poles and Monuments of Gitwangak Village* (Ottawa: National Historic Parks and Sites Branch, Parks Canada, 1984), 131, figure 157. The house was owned by Jim Laganitz and was a prominent tourist attraction. Jackson did, in fact, make a drawing called "Collapsing House," which may have depicted this structure but which did not find its way into a painting; see Landry, *Canadian Art: Catalogue*, vol. 2, 215, 17519.

38 It must be kept in mind that Jackson's article "Rescuing Our Tottering Totems" was published to coincide with the opening of the exhibition *Canadian West Coast Art, Native and Modern* in Ottawa and that it would have served as an introduction to the issues for the general public.

39 Jessup, "Canadian Artists," 43-64, offers a well-researched account of Barbeau's program in the early 1920s to enlist the Group of Seven, and especially Jackson and Lismer, to paint in Quebec as a means of making the province part of the collective Canadian identity.

40 Ibid., 59, conflates Jackson's and Barbeau's views on both Quebec cultural traditions and those among the Skeena to a single image. For example, Jessup states that Jackson saw carving traditions in Quebec as "relegated to the past, becoming the surviving evidence of an earlier tradition of creativity in Quebec." Barbeau did not share this opinion on the traditions' temporal placement.

41 In contradistinction to Jackson's normal practice, the Kitwanga sketches are frequently not named by their location, especially those showing totem poles.

Conversely, almost all of those showing grave houses, the schoolhouse, and pure landscapes are identified as at Kitwanga; see Landry, *Canadian Art: Catalogue*, vol. 2, 201-17, 17452r, 17452v, 17477, 17478r, 17478v, 17479, 17512, 17513, 17514, 17515, 17516, 17517r, 17518, 17519, 17520, 17521, 17522, 17523v, 17523r, 17525, 17526, 17528, and 17529r.

42 Jackson, *A Painter's Country*, 110.

43 Because of the changes that had occurred since Kihn's expedition, Jackson and Holgate were not allowed into the village of Kitwancool; see Dyck, "'These Things Are Our Totems,'" 57.

44 Compare, in Landry, *Canadian Art: Catalogue*, vol. 2, 219-20, sketches 17537, 17538, and 17539, all of Kispiox totem poles, with sketches 17546 and 17547, on which Jackson's *Kispayaks Village* seems to be based.

45 However, subsequent to *Kispayaks Village*, Jackson did pick up the Skeena theme again in 1943 with the painting *Souvenir of Kispiox*.

46 Jessup, "Canadian Artists," 84 n. 1, identifies the original title of Jackson's *Skeena River Crossing* as *Gitsegyukla Village* and the work's position within the 1927 exhibition *Canadian West Coast Art, Native and Modern*.

47 Landry, *Canadian Art: Catalogue*, vol. 2, 215, 17519.

48 Ibid., 17551r, may have been the base for Jackson's *Gitsegyukla Village*, but again the house in the drawing, done on site, is in a much better state of repair.

49 Edmonton Art Gallery collection.

50 Landry, *Canadian Art: Catalogue*, vol. 2, 17468r, "Poster Designs for Canadian National Railway"; 17468v, "Poster Design for Canadian National Railways"; and 17469, "Poster Design for Canadian National Railways," all dated 1926. The actual picture could not have been done until 1928; see Jackson to Barbeau, 15 January [1928], CMC Jackson: "Mine [Skeena work] is rather a fizzle ... I would just as soon keep it out of the [*Temlaham*] book. I might make a[n] illustration of Gitseguklas from across the river. I have a pencil drawing which has possibilities." See also Barbeau to Jackson, 19 January 1928, CMC Jackson.

51 Dyck, "'These Things Are Our Totems,'" 78, in particular, gives an extensive catalogue of modern elements that do not appear in Jackson's Skeena production.

52 Jackson to Barbeau, 13 June [1927], CMC Jackson.

53 John Barrell, *The Dark Side of the Landscape: The Rural Poor in English Painting, 1730-1840* (Cambridge: Cambridge University Press, 1980), 131-65.

54 See also Ann Bermingham, *Landscape and Ideology: The English Rustic Tradition, 1740-1860* (Berkeley: University of California Press, 1986), 75.

55 Rosalind Krauss, "The Originality of the Avant-Garde," in *The Originality of the Avant-Garde and Other Modernist Myths* (Cambridge, MA: Massachusetts Institute of Technology Press, 1985), 151-70.

56 Dennis Reid, *Edwin H. Holgate* (Ottawa: National Gallery of Canada, 1976).

57 Landry, *Canadian Art: Catalogue*, vol. 2, 138, 3495, dated 1926. Hill, *The Group of Seven*, 300 n. 65, assesses Holgate's limited work as far superior to Kihn's, although he does not provide any detailed analysis: "Holgate drew large expressive portraits, far more accomplished than Kihn's finished illustrations." A comparison of Holgate's academic portrait of *Chief Jim Laranitz* (1926, Musée du Québec, 35-01) with Kihn's portrait of the same person (McCord M927-102)

does not support Hill's assessment, and points to Holgate's unimaginative and derivative style.

58 Landry, *Canadian Art: Catalogue*, vol. 2, 138, 3494, dated 1926.

59 Hill, *The Group of Seven*, 300 n. 65. This number of portraits by Holgate in the exhibition *Canadian West Coast Art, Native and Modern* does not compare to Kihn's sixty some works.

60 Landry, *Canadian Art: Catalogue*, vol. 2, 139, 4426.

61 A second painting by Holgate, titled *Hazelton Graveyard*, is even more macabre in its concentration on a melancholic image of death. It shows the same figure wandering through the unique grave houses that are characteristic of the region. The figure also occurs in a woodcut, *Totem Poles, No. 3*.

62 Ian Thom, *The Prints of Edwin Holgate* (Kleinburg, ON: McMichael Canadian Art Collection, 1989), n.p., figure 18.

63 Ibid., n.p.

64 See Anne McDougall, *Anne Savage: The Story of a Canadian Painter* (Montreal: Harvest House Press, 1977; reprint, Ottawa: Borealis Press, 2000), 58. McDougall gives the date of Savage's trip as 1928, an impossibility given that her Skeena work was included in the 1927 *Canadian West Coast Art, Native and Modern* exhibition and featured in Barbeau's *The Downfall of Temlaham*, printed in July 1928.

65 Dyck, "'These Things Are Our Totems,'" 57.

66 Ibid., 61, "Untitled Oil Sketch."

CHAPTER 9: WEST COAST ART, NATIVE AND MODERN

1 Brown to F. Cleveland Morgan, 29 October 1927, National Gallery of Canada (NGC) Archives: "This is the first time that such an exhibition has been attempted from a purely artistic and ethnological standpoint."

2 Warrick Ford, "Immortalizing a Disappearing Race: What One Painter Is Doing to Perpetuate the Indian Physiognomy," *Arts and Decoration* 17 (May 1922), 13, 70.

3 Sandra Dyck, "'These Things Are Our Totems': Marius Barbeau and the Indigenization of Canadian Art and Culture in the 1920s" (MA thesis, Carleton University, 1995), 114. Jackson to Barbeau, 21 January [1926], Canadian Museum of Civilization, Archives, Marius Barbeau Fonds, Correspondence with A.Y. Jackson (1925-30, 1932-33, 1935, 1938-40, 1942, 1944, 1948, 1959, 1961), B205, f. 53 (hereafter CMC Jackson): "I suggested the exhibition of masks and the committee think it a fine idea for the next season." Barbeau established contact with the Art Gallery of Toronto through an exhibition of paintings, sculptures, and handicrafts that traced an ongoing history from at least 1669 down to the present; see Anonymous, "Art in French Canada," *Canadian Forum* 6, 69 (1926): 265-66.

4 Jackson to Barbeau, 25 February [1926], CMC Jackson: "I spoke about an exhibition of Indian masks to the ex. Committee of the Art Gallery of Toronto and they think it will be fine for the autumn."

5 Barbeau to Holgate, 26 May 1926, Canadian Museum of Civilization, Archives, Marius Barbeau Fonds, Correspondence with Edwin Holgate (1926-29, 1932,

1934, 1940), B204, f. 19 (hereafter CMC Holgate). This corresponds precisely to the material submitted to the Jeu de Paume exhibition in February 1927.

6 Eric Brown to Dr. Charles Camsell, December 1926, National Gallery of Canada Archives, File 5.5W, Exhibitions in Gallery, West Coast Art – Native and Modern – Exhibition 1927-28 (hereafter NGC/WCA).

7 It is possible that Brown was still in the dark about Barbeau's involvement. Barbeau attempted to conceal his position at this time. In Barbeau to Jackson, 28 December 1926, Art Gallery of Ontario (AGT) Archives, he wrote that "the preliminaries should be directed in such a way as to have the trustees of the Toronto Art Gallery make a formal request for the loan of the specimens and paintings for an exhibition. The loan of our Indian specimens, at least, might not be obtained otherwise, for I would not like to appear either as an organizer or as the manager of this exhibition." Afterward, of course, he would claim full responsibility for the show. My thanks to Gerta Moray for bringing this material to my attention. It should be kept in mind that at precisely this moment Barbeau was also negotiating with Brown on the matter of the Native material to be sent to Paris for the Jeu de Paume exhibition, a matter in which Barbeau was also careful not to appear as the instigator.

8 Barbeau to Vincent Massey, 30 December 1926, AGT Archives. Again, my thanks to Gerta Moray for bringing this correspondence to my attention.

9 Edward Greig to Eric Brown, 24 February 1927, NGC/WCA.

10 Duncan Campbell Scott, "Indians Step Beyond Role of Their Ancient Romance; Many Government Wards Become Self-Supporting; last year they harvested nearly 1,000,000 bushels of wheat," *Mail and Empire* (Toronto), 1 July 1927, 27.

11 Ibid.

12 Stan Dragland, *Floating Voices* (Concord, ON: Anansi, 1994), 123. Dragland's study, which attempts to bring together both Scott's administrative policies and his poetry, is written largely in response to Brian Titley, *A Narrow Vision: Duncan Campbell Scott and the Administration of Indian Affairs in Canada* (Vancouver: UBC Press, 1986). Dragland notes that the passage quoted had occurred at least three other times in Scott's writings since 1920. He also notes Scott's continual cannibalizing of his own texts. Dragland, it should be said, is very sympathetic to Scott.

13 Scott, "Indians Step Beyond," 27.

14 Marius Barbeau, "Native[s] Have [Su]ffered Change," *Mail and Empire* (Toronto), 1 July 1927, 27, page torn. Note the repetition of phrases from Marius Barbeau, "An Artist among the Northwest Indians," *Arts and Decoration* 26 (May 1923): 20, 27, 95, quoted in Chapter 5.

15 One can only speculate about what William Beynon – Barbeau's "half-breed" informant and translator who supplied him with much of his material from the field and is now considered his co-ethnographer – thought of Barbeau's assessment.

16 No mention of Kihn attending the opening of the exhibition *Canadian West Coast Art, Native or Modern* occurs in the CMC Archives, in the NGC Archives, or in W. Langdon Kihn Papers, 1904-1990, Microfilm reels 3701-3713, Archives of American Art, Smithsonian Institution (hereafter Kihn Papers). In early

November, Barbeau, anticipating a great success for the exhibition, extended an invitation to Kihn and instructed him to apply for a pass from Gibbon, since the railways "are interested in the exhibition and there will be here quite a gathering of artists for the occasion"; see Barbeau to Kihn, 4 November 1927, Canadian Museum of Civilization, Archives, Marius Barbeau Fonds, Correspondence with Langdon Kihn (1922-28, 1931, 1939-53, 1956, 1958, 1961), B208, f. 42 (hereafter CMC Kihn). See also Henry Cleveland Morgan to Kihn, 22 November 1927, Kihn Papers, in which he thanks Kihn for a drawing and looks forward to seeing him at the exhibition. Conversely, neither Barbeau nor Morgan supplied the date for the official opening, which, as has been shown, continuously shifted. In the last letter on file from Barbeau to Kihn before the opening, Barbeau refers to the exhibition in a postscript: "Our West Coast Exhibition takes place here at the Art Gallery ... [Your work] will be exhibited with our other things most of December. Then they will be sent to Toronto early in January"; see Barbeau to Kihn, 18 November 1927, Kihn Papers. The letter supplied neither a date for the opening nor any further mention of Kihn attending. It could be speculated that one way to ensure that Kihn did not arrive was to withhold this crucial information. Kihn got similar treatment elsewhere. Throughout December, he was also in frequent communication with Gibbon on an aborted calendar project, but Gibbon's letters mention neither passes, nor the exhibition, nor the possibility of Kihn attending. There is also no record of anyone sending, or of him receiving, a copy of the catalogue or even a notification of its existence. Despite superficial cordialities, it appears that Kihn was no longer welcome.

17 National Gallery of Canada, *Exhibition of Canadian West Coast Art, Native and Modern*, Ottawa edition (Ottawa: National Gallery of Canada, 1927). There is no record of when the addendum noting Kihn's participation was inserted.

18 The one anomaly among the list of Kihn's works included in the *West Coast Art* exhibition is the second work, *Gitksan Feast*. Although it is evident that there are two such works, one currently in the CMC collection and one illustrated in Marius Barbeau, *The Downfall of Temlaham* (Toronto: Macmillan, 1928), it is unclear where the second went or how it was acquired since only one work by this title is listed in the inventories and shipping lists for the final Southam purchase.

19 Brown to Phillips, 23 November 1927, and Phillips to Brown, 24 November 1927, NCG/WCA.

20 See Ann Katherine Morrison, "Canadian Art and Cultural Appropriation: Emily Carr and the 1927 Exhibition of *Canadian West Coast Art, Native and Modern*" (MA thesis, University of British Columbia, 1991), 55.

21 It will be recalled that Jackson had initially proposed the inclusion of Alexie's works as part of the illustrations for Barbeau's *The Downfall of Temlaham* but that, on consideration, he had discarded the idea because he anticipated that people would think less of the book. Alexie's name is also sometimes spelled "Alexee" and "Alexcee."

22 National Gallery of Canada, *Exhibition of Canadian West Coast Art*, Ottawa ed., 13.

23 The hierarchicized model by which the competency of Native artists was ranked

below that of non-Natives corresponded to the tropes cited earlier in the writings of A.Y. Jackson and elsewhere in the popular press. Native speakers are rendered as different insofar as they are deprived of linguistic competency. When they do speak, they are inarticulate or capable only of employing a naive patois. This disrupts their attempts at communication and deprives them of cognitive authority. The stereotypical grunts "ugh" and "uhm" are their identifying syllables. Conversely, the writers' full mastery and command of language is inscribed within their texts and emphasized by the contrast.

24 National Gallery of Canada, *Exhibition of Canadian West Coast Art*, Ottawa ed., 2.

25 Ibid., 4.

26 Ibid., 2.

27 Ibid., 3.

28 Ibid., 2, my emphasis.

29 Invoice, NGC/WCA.

30 Small Native objects on display at the *West Coast Art* exhibition were placed in vitrines. For a detailed discussion of the symmetrical arrangements, see Morrison, "Canadian Art," 67-8.

31 National Gallery of Canada, *Exhibition of Canadian West Coast Art*, Ottawa ed., 3.

32 I am here extending and modifying ideas initially put forward by Morrison, "Canadian Art," 67-8.

33 My thanks to Dr. John O'Brian for providing this cogent reference.

34 A brief notice of the coming *West Coast Art* exhibition, based on an interview with Barbeau, did appear in the *Evening Citizen* (Ottawa), 10 November 1927, which outlined its basic premises and introduced Carr. A second notice, announcing the loans from the Dawson collection at McGill University and the inclusion of works by Kihn, appeared in the *Montreal Star*, 14 November 1927, CMC Archives. Both gave the opening date as 20 November.

35 See Brown to Holgate, 27 October 1927, NGC/WCA. See also Director [Brown] to Collins, 9 November 1927, NGC/WCA. Note that this is the day before the announcement in the *Evening Citizen* (Ottawa), 10 November 1927, and five days before the notice in the *Montreal Star*, 14 November 1927, CMC Archives. Internal communications on the matter do not seem to have been good.

36 As has been said, Barbeau had already told Kihn in November that the railways "are interested in the exhibition and there will be here quite a gathering of artists for the occasion"; see Barbeau to Kihn, 4 November 1927, CMC Kihn.

37 Emily Carr, "Journal," British Columbia Archives, MS-2181, Box 2, File 14, Journal 1. Much of her journal entry of 5 December has been edited out of her biographies, but her comments on the relationship between Brown and Barbeau are useful in understanding and establishing their differences. Her assessment was that the opening was more than a mere "disappointment." It was "horrid" and a "humiliation" for her and Barbeau and demonstrated a deep conflict. She stated:

> Mrs. Barbeau's eyes were flashing angrily, her body was tense, it was tho [sic] she could stab [?] the browns [sic]. Look at my husband she said, they've wounded him and humbled him and hurt him, what can I say.

I hate them. Mr. Barbeau never said a word, his face was set and hard and all
the light and enthusiasm was gone from it. A little after 10 we went to the
Browns and had coffee and met some dull people. Mr. Brown [was?] gay
and ask[ed] us facetiously "how we like[d] it, wasn't it splendid" ... I could
have cried for Mr. Barbeau. He had worked so hard to make it a success,
old Brown led him on and tricked him into believing it was a big affair,
assuring there were 2000 invitations with a crush you couldn't move and
a great feed of refreshments. No invitations were sent out except to a few
artists and others in the buildings. (Emphasis in the original)

It is usual to cite only the last sentence of this passage and to imply that the
failure to send out the promised invitations was an innocent mistake on Brown's
part. Carr's first-hand assessment of Brown's duplicity and open display of mal-
ice is probably more accurate. The animosity between Brown and Barbeau is
here more than evident. This indicates that Brown now saw Barbeau as a danger-
ous rival with a conflicting vision that had to be stopped. By assuring Barbeau
that he was making the arrangements, Brown had prevented Barbeau from doing
so himself.

38 Ibid. With Kihn not in attendance, Carr could take centre stage, even if for a
 small house. But this raises the question of the presence of the other artists at the
 opening. It appears that few of those in the show actually attended. This leads
 to speculation about what role this exhibition would ultimately have played in
 the narration of Canadian art and culture if not for Carr's "discovery," which
 ensured its place. Would it, without her, have fallen into the same obscurity as
 the Jeu de Paume exhibition?

39 Eric Brown, "Canadian Art in Paris," *Canadian Forum* 7, 84 (September 1927):
 360.

40 Greig to Brown, 7 January 1928, NGC/WCA.

41 Other exhibitions at the National Gallery held in December that closed before
 January were generally concluded by 22 December. While it was not uncommon
 to have exhibitions of three weeks, or even fewer, it was generally not the rule
 for major shows.

42 Jackson to Brown, Saturday, n.d., NGC/WCA. Hill, *The Group of Seven*, 192,
 300 n. 76, assumes that this letter was sent from Montreal and thus that it was
 about the show there, but nothing on the document indicates that it originated
 in that city. He also reports that the recorded attendance in Toronto was "good,"
 citing records of the Art Gallery of Toronto that place the figure at 7,742. How-
 ever, this number is small when compared with that given for other exhibitions.
 Brown frequently cited 30,000 visitors to exhibitions at the National Gallery,
 in a much smaller city. Hill does not cite the letter from Greig indicating the
 limited attendance at the opening.

43 The first mention that Montreal wanted to host the *West Coast Art* exhibition
 occurs in Cleveland Morgan to Barbeau, 22 November 1927, NGC/WCA. How-
 ever, Morgan had known of the exhibition since at least late October; see Direc-
 tor [Brown] to F. Cleveland Morgan, 28 October 1927, NGC/WCA.

44 Director [Brown] to Greig, 29 November 1927, NGC/WCA.

45 Shepherd to McCurry, 14 December 1917, NGC/WCA.

46 Brown to Pinkerton, 26 January 1928, NGC/WCA.

47 Pinkerton to Brown, 31 January 1928, NGC/WCA.

48 American Museum of Natural History to National Gallery of Canada, 12 January 1928, NGC/WCA.

49 Gertrude Herdle to Brown, 18 January 1928, NGC/WCA. For confirmation that the *West Coast Art* exhibition could be facilitated at the Memorial Art Gallery in Rochester, see Director to Hurdle, 21 February 1928, but also Greig to Brown, 27 January 1928, NGC/WCA.

50 Canadian National Exhibition to Brown, 17 January 1928, NGC/WCA.

51 Brown to Herdle, 23 January 1928, NGC/WCA.

52 Director to Mr. Phillips, The American Legation, Ottawa, 21 February 1928, NGC/WCA.

53 Hill, *The Group of Seven*, 217, 340. Hill does not mention that these shows in Rochester and Buffalo and at the CNE were substitutes for the original requests for a version of the *West Coast Art* exhibition.

54 *Ottawa Citizen*, 20 November, 2 December, 3 December 1927.

55 *Globe* (Toronto), 3 December 1927.

56 Guy Rhoades, "West Coast Indian Art, Unique Exhibition in Progress at the National Gallery, Ottawa," *Saturday Night*, 18 December 1927, 3. Rhoades was a reporter for the *Ottawa Citizen*.

57 Rhoades to Kihn, 17 March 1926, Kihn Papers.

58 Franz Boas, *Primitive Art* (Oslo: H. Aschehoug and the Oslo Institute for Comparative Research in Human Culture, 1927; reprint, Cambridge: Harvard University Press, 1928; reprint, New York: Dover, 1955), 183. The section of the book on Northwest Coast Native art had first appeared as the essay "The Decorative Art of the Indians of the North Pacific Coast of America," *Bulletin American Museum of Natural History* 9 (1897): 123-76.

59 "West Coast Indian Art," *Globe* (Toronto), 12 January 1928; "Art of B.C. Aborigines Deemed Equal to Aztecs," *Toronto Star*, 9 January 1928; "Arts Abandoned with Beliefs of Paganism," *Mail and Empire* (Toronto), 11 January 1928. The latter was reprinted as "Indian Art Is Fine Heritage," *Daily Colonist* (Victoria), 25 January 1928.

60 "West Coast Indian Art," *Globe* (Toronto), 12 January 1928.

61 "Art of B.C. Aborigines Deemed Equal to Aztecs," *Toronto Star*, 9 January 1928.

62 "Arts Abandoned with Beliefs of Paganism," *Mail and Empire* (Toronto), 11 January 1928, reprinted as "Indian Art Is Fine Heritage," in *Daily Colonist* (Victoria), 25 January 1928. One wonders if Barbeau himself wrote the article.

63 Stewart Dick, "Canada's Primitive Arts," *Saturday Night*, 21 January 1928, 2. Given the date, and Rhoades's review of the Ottawa show, Dick was probably reviewing the Toronto show.

64 "West Coast Indian Art," *Canadian Forum* 8, 89 (1928): 525.

65 Eric Brown, "Canadian Art in Paris," *Canadian Forum* 7, 84 (September 1927): 361.

66 Eustella Burke, "Indian Dramatic Masks," *The Studio* 94, 417 (1927): 417-19, my emphasis.

67 Douglas Leechman, "Native Canadian Art of the West Coast," *The Studio* 96, 428 (1928): 331-33.

68 Ibid., 331.

69 Ibid., 333. Note the difference between Leechman's view of the influence of new tools on Native art and Barbeau's view that access to Western tools was responsible for the growth of Native arts.

70 One wonders what Sapir, by comparison, would have made of the *West Coast Art* exhibition. Leechman's talent as a journalistic writer who could address a nonspecialized audience was put to use in the production of his book *The Native Tribes of Canada* (Toronto: W.J. Gage, 1957). It went through many editions and became a standard popular text. Unlike Barbeau, whose style seems to have been either dryly academic or over-the-top purple prose, Leechman wrote in a casual, engaging fashion that, while reasonably informative, catered to its audiences' prejudices and stereotypes.

71 See Eric Hobsbawm, "The Nation as Invented Tradition," in John Hutchinson and Anthony Smith, eds., *Nationalism* (Oxford: Oxford University Press, 1994), 76-83; see 78-81 on the invention of the "mass production of public monuments" as one of three key components for fostering the concept of the nation. It should be noted that at the same time as Barbeau was inscribing the disappearance of Native sculptural practices, he was also diligently writing about continuities in French Canadian sculpture and ensuring that the latter was receiving wide recognition within English-speaking Canada.

72 It is no coincidence that immediately following the *West Coast Art* exhibition, the state and the NGC began to actively support and display "Canadian" sculpture that followed English precedents. After this point, public sculpture based on British precedents proliferated in Canada.

73 *Province* (Vancouver), 12 July 1925.

74 On the "invention of public ceremonies," see Hobsbawm, "The Nation," 77. He notes several examples in France of the "tendency ... to transform the heritage of the Revolution into a combined expression of state pomp and power and the citizens' pleasure. A less permanent form of public celebration were the occasional world expositions which gave the Republic the legitimacy of prosperity, technical progress – the Eiffel Tower – and the global conquest they took care to emphasise" (78). Canada needed a Wembley of its own. It would not have one until Expo 67, in Montreal, at which a new era would be announced with the inclusion of (an admittedly controversial) Native pavilion.

CHAPTER 10: THE DOWNFALL OF BARBEAU

1 By contrast, another of Barbeau's publications, *Totem Poles of the Gitksan, Upper Skeena River, British Columbia*, Anthropology Series no. 12, Bulletin no. 61 (Ottawa: National Museum of Canada, 1929), as an ethnographic study, had a very restricted and specialized audience. In this publication, Kihn's pencil sketches of the totem poles were illustrated, but all portraits were excluded, even though the book discussed various individuals who were portrayed by Kihn in their regalia and who owned the poles.

2 Although Barbeau's characterizations of the Gitxsan in *The Downfall of Temlaham* (Toronto: Macmillan, 1928) bear some similarity to the categories found in Terry Goldie, *Fear and Temptation: The Image of the Indigene in Canadian, Australian, and New Zealand Literatures* (Montreal and Kingston: McGill-Queen's University Press, 1989), as does the basic plot line of disappearance, the hybrid structure of Barbeau's oeuvre differs from all of those outlined by Goldie, who does not mention it in his study.

3 Barbeau's "fictionalized history" of the Gitxsan still exerts authority. Terry Glavin relies on it in *A Death Feast in Dimlahamid* (Vancouver: New Star Books, 1998), 165-69, although he substantially modifies Barbeau's account with other evidence. Susan Crean, in her innovative recounting of Emily Carr's life, *The Laughing One: A Journey to Emily Carr* (Toronto: HarperCollins, 2001), 262, recapitulates Barbeau's account without critical comment, although she also cites Glavin.

4 Barbeau, having had no scruples about taking surreptitious photographs of Kitwancool and its totem poles after he had been asked to stop during his aborted visit with Langdon Kihn, now further ignored the Gitxsan's desire. One might speculate that in writing his own version of the "history" of the Kitwancool, one that witnessed the Gitxsan's defeat, Barbeau sought to deal with the trauma of his unceremonious expulsion and all that it would have meant to him personally both as an ethnographer and as a representative of state authority.

5 Barbeau, *The Downfall of Temlaham*, 141.

6 See especially the central, pivotal section, "Christians and Heathens," in which the Gitxsan's confrontation with non-Native ways is articulated clearly and at length.

7 It must be acknowledged that Barbeau's Native speakers in *The Downfall of Temlaham* were, unlike many of their counterparts in popular rendition, passionate, articulate, and thoughtful.

8 Barbeau, *The Downfall of Temlaham*, 6-7; for Kamalmuk's "faith in progress and modernity" and his rejection of traditional ceremonies, see 29; for his worries about a "relapse into savagery," see 48; for Sunbeams' son as a "weakling" and "helpless," see 32; as "in distress," see 35; and as "humbled," "immature," and "contemptible," see 37.

9 Kamalmuk's inability to adapt is a classic example of Bhabha's concept of the dangerous mimic man; see Homi K. Bhabha, "Of Mimicry and Man: The Ambivalence of Colonial Discourse," *October*, no. 28 (1984): 125-33, reproduced in Annette Michelson et al., eds., *October: The First Decade, 1976-1986* (Cambridge, MA: Massachusetts Institute of Technology Press, 1987), 317-25.

10 Barbeau, *The Downfall of Temlaham*, 68-69.

11 Ibid., 161-63.

12 Again, a "small painting (a sketch) showing Kitwanga totem poles and houses, with a pale blue green sky" was eliminated at some point close to publication of *The Downfall of Temlaham*. This also would have confirmed Native presence; see "Tentative List," W. Langdon Kihn Papers, 1904-1990, Microfilm reels 3701-3713, Archives of American Art, Smithsonian Institution Kihn Papers (hereafter Kihn Papers).

13 Gerta Moray, personal communication, 24 July 2001. The "Tentative List," Kihn
 Papers, cites Holgate's *The Upper Skeena, near the site of Temlaham — the Good-land-
 of-yore*, as *Kispayaks mountain*.

14 It should also be noted that, in addition to *Young Gitksan Mother with a Cradle, at the
 edge of the Skeena*, Holgate did another image of the area, using the same female
 figure. Although not illustrated in Barbeau's text, *Hazelton Graveyard* directly
 links the figure to death.

15 Barbeau, *The Downfall of Temlaham*, vii.

16 Ibid., 175. A second beheading occurs parenthetically a few pages later; see 173
 and 184. And a third occurs on 216.

17 The meaning of *naxnox* is complex. Joanne MacDonald, *Gitwangak Village Life:
 A Museum Collection* (Ottawa: Environment Canada, 1984), 11, summarized the
 term as referring "to a personal spirit power which was revealed to participants
 in sacred ceremonies called 'haliat' preceeding a potlatch; 'naxnox' implies the
 idea of power exhibited by the person wearing the mask." The owner of the right
 to display the *naxnox* could also assume *naxnox*'s name, which would be used on
 an everyday basis.

18 Barbeau, *The Downfall of Temlaham*, 218.

19 Imagine, for example, if Barbeau's entire book had been composed only of paint-
 ings by Kihn and Carr.

20 The "Tentative List," Kihn Papers, also names by Carr a "Large painting of
 Gitsegyukla village, with totem poles, Indians and houses." See also Barbeau to
 Carr, 15 March 1928, Canadian Museum of Civilization, Archives, Marius Bar-
 beau Fonds, Correspondence with Emily Carr (1926, 1942), B179, f. 5 (hereafter
 CMC Carr), blaming the printers for leaving it out "because they hadn't found it
 practical to reproduce it."

21 Barbeau was to make this reading of Carr's work explicit in "The Indians of the
 Prairies and the Rockies: A Theme for Modern Painters," *University of Toronto
 Quarterly* 1, 2 (1931): 203, in which he said of her 1911 and 1912 paintings that
 "her work is of things that without her would have been lost, for they have since
 disappeared."

22 Barbeau, *The Downfall of Temlaham*, 242-43.

23 Anne McDougall, *Anne Savage: The Story of a Canadian Painter* (Montreal: Harvest
 House Press, 1977; reprint, Ottawa: Borealis Press, 2000), 60.

24 "Tentative List," Kihn Papers.

25 Barbeau, *The Downfall of Temlaham*, 11.

26 Ibid., 73-4.

27 Ibid., 243-44.

28 See *Delgamukw v. British Columbia*, 1997, Appeal from the Court of Appeal for
 British Columbia, File no. 23799.

29 Barbeau to Gibbon, 30 May 1927, Canadian Museum of Civilization, Archives,
 Marius Barbeau Fonds, Correspondence with John Murray Gibbon (1919, 1922-
 26), B197, f. 19 (hereafter CMC Gibbon). Scott's involvement in Barbeau's plans
 is made explicit here.

30 Pegi Nichol, "Where Forgotten Gods Sleep," *Canadian National Railways Maga-
 zine*, March 1931, 25.

31 Ibid.

32 Joan Murray, ed., *Daffodils in Winter: The Life and Letters of Pegi Nicol MacLeod, 1904-1949* (Moonbeam, ON: Penumbra, 1984), 24-5. One illustration is given as *Indian Girl*, from 1927.

33 Sandra Dyck, "'These Things Are Our Totems': Marius Barbeau and the Indigenization of Canadian Art and Culture in the 1920s" (MA thesis, Carleton University, 1995), 45. See also Barbeau, "The Indians of the Prairies and the Rockies," 197. Cozé, who travelled to western Canada on four trips, seems to have produced the most substantial body of work. His portraits were used as illustrations in Diamond Jenness, *The Indians of Canada* (Ottawa: National Museum of Canada, 1932).

CHAPTER 11: REVISITING CARR

1 Gerta Moray, "Northwest Coast Native Culture and the Early Indian Paintings of Emily Carr, 1899-1913" (PhD diss., University of Toronto, 1993), 372: "She [Carr] included the people as she met them, showing their contemporary situation – partly acculturated but with their past culture achievements still in evidence."

2 In the mid-1920s Carr became friends with the ethnologist Erna Gunther, who was also an exponent of the "discourse of Native disappearance"; see Moray, "Northwest Coast," 380.

3 In 1928 Carr read both Barbeau's *Indian Days in the Canadian Rockies* (Toronto: Macmillan, 1923) and his *The Downfall of Temlaham* (Toronto: Macmillan, 1928); see Moray, "Northwest Coast," 392, 397 n. 133.

4 Moray, "Northwest Coast," 247: "Carr made very few native portraits in her later career." In fact, only one portrait was done while she was in the Skeena villages on her 1928 trip. Although Native resistance to portraiture, which had arisen since Kihn, may account for part of this shift, it is also clearly evident in work from outside her Skeena production, such as *Blunden Harbour*, which is uninhabited despite being painted from a photograph that showed many people; see Maria Tippett, *Emily Carr: A Biography* (Oxford: Oxford University Press, 1979), 164.

5 Doris Shadbolt, *The Art of Emily Carr* (Vancouver: Douglas and McIntyre, 1990 [1979]).

6 Shadbolt, *The Art of Emily Carr*, 50.

7 Moray, "Northwest Coast," 386.

8 Moray, ibid., 402, is unclear about whether the Indian's disappearance was Carr's preoccupation or whether it arose from the influence of Barbeau. Indeed, Moray tends to conflate the two: "The other major theme found in the Indian paintings from 1928 on is an elegiac note of mourning. We have seen that this takes its cue from Barbeau's call to artists to chronicle the Indian tragedy, and from his own attempt to do so with his novel, *The Downfall of Temlaham*." It is useful here to recall Harlan Smith's article "Preserving a 'Westminster Abbey' of Canadian Indians: Remarkable Totem Poles Now under Government Care," *London Illustrated News*, 21 May 1927, 900-1, in which he states that the youth of the Gitxsan were adamant about preserving the value of the totem poles and that they resisted the encroachment of non-Native restorers. It is also relevant

to recall that full-scale potlatching had resumed among the Kwakwaka'wakw
by this time. Carr's preoccupation, then, was more in line with the discursive
framework than with the empirical evidence.

9 See Brown to Carr, 3 October 1927, National Gallery of Canada Archives, File
 5.5W, Exhibitions in Gallery, West Coast Art – Native and Modern – Exhibition
 1927-28 (hereafter NGC/WCA); and Tippett, *Emily Carr*, 174. Brown told Carr
 that he had framed ten of her watercolours and that he was also going to include
 two of her oil paintings from the *West Coast Art* show. Director [Brown] to Carr,
 14 January 1928, National Gallery of Canada, Archives, National Gallery of
 Canada Fonds, Box 257, File B, File Correspondence with/re artists Carr, Emily
 (hereafter NGC Carr). This is confirmed by the catalogue; see National Gal-
 lery of Canada, *Annual Exhibition of Art, January 24 to February 28, 1928* (Ottawa:
 National Gallery of Canada, 1928), whose brief introduction states: "The work
 of two artists from the West, who have not so far exhibited in the East, James
 Henderson of Fort Qu'Appelle, Saskatchewan, and Miss Emily Carr of Victoria
 has also been specially invited." Henderson's six portraits of Natives, which were
 conservative in style and contained no modernist elements and which were more
 compatible with precedents set by artists who insisted on Native disappearance,
 seem to have replaced those by Kihn, who was not mentioned.

10 Both Tippett, *Emily Carr*, 154, and Blanchard, *The Life of Emily Carr* (Vancouver
 and Toronto: Douglas and McIntyre, 1987,) 184, state that Brown assisted in
 Carr's return to the Skeena region, but neither supplies a source for the claim.

11 Neither Tippett, *Emily Carr*, nor Blanchard, *The Life of Emily Carr*, mentions
 Brown's antipathy to modernism, which was not yet documented when they
 were writing.

12 It is here that I most differ with the standard biographies of Carr, which seem
 biased toward a deferential, if not protective, treatment of Brown at the expense
 of Carr.

13 Lack of money was hardly the reason for the NGC's not acquiring any of Carr's
 earlier oils, although both Tippett, *Emily Carr*, and Blanchard, *The Life of Emily
 Carr*, cite it as at the heart of the matter. Tippett claims that the NGC's "purchase
 budget was severely limited after the Depression set in" (206). Blanchard reports
 that "Brown pleaded hard times" (233). This was not precisely the case. The
 National Gallery of Canada's *Annual Report of the Board of Trustees for the Fiscal Year
 1927-28* (Ottawa: King's Printer, 1928) indicates that Brown had sufficient funds
 to purchase a pair of major canvases by the Group of Seven that year, Harris's
 Maligne Lake, Jasper Park and J.E.H. MacDonald's *Batcheqwana Rapid*, as well as
 Clarence Gagnon's *Quebec Village*. Insofar as an oil by a Group member could go
 for around $700 at this time, this purchase represents a probable expenditure of
 over $2,000. By comparison, a major canvas by Carr would have cost between
 $150 and $300. Nor was there any shortage of funds to buy Old Masters. Any
 expenditure on Carr would also have been substantially less than the price of
 Charles Cottet's landscape, *Coast of Brittany*, which was also acquired that year.
 Contrary to the impression created by Carr's biographers, there were no cuts
 to the acquisitions budget the following fiscal year nor the year afterward – that
 is, 1929-30, when, even with the beginning of the Depression, the budget was
 increased almost twenty-fold to $113,910; see National Gallery of Canada, *Annual*

Report of the Board of Trustees for the Fiscal Year 1929-1930. Ottawa: King's Printer, 1930. There would be no further acquisitions of Carr's paintings by the NGC until 1937, ten years after the opening of the *West Coast Art* exhibition.

14 See Blanchard, *The Life of Emily Carr*, 233. In March, announcing the purchase of the watercolours, Brown initially informed Carr that "the purchase of an oil painting was left until the return of the West Coast Exhibition from Montreal, which contained the most interesting ones and I will advise you about it later." Director [Brown] to Carr, 1 March 1928, Annual Exhibition of Canadian Art (file 2), Exhibitions in Gallery, National Gallery of Canada fonds, National Gallery of Canada Archives.

15 See Moray, "Northwest Coast," 384-85: Carr "resumed exhibiting in Victoria at the Island Arts and Crafts Club in 1924, at the Provincial Fair in 1926, and at the Annual Pacific North West Exhibitions in Seattle from 1924 on." See also Tippett, *Emily Carr*, 131-32.

16 See Carr to Barbeau, 5 May 1928, Canadian Museum of Civilization, Archives, Marius Barbeau Fonds, correspondence with Emily Carr (1926, 1942), B179, f. 5 (hereafter CMC Carr).

17 McCurry informed Carr: "The Art Gallery of Rochester, N. Y., have [sic] applied for it [the West Coast show] next, through the United States Minister here, and it is altogether likely that the request will be granted." McCurry to Carr, 7 March 1928. By early April Carr had heard that she was not to be included in the venue; see Carr to McCurry, 12 April [1928], both NGC Carr.

18 Carr to Brown, 11 August 1928, NGC Carr, outlines her trip and her production. When Brown did not respond, she wrote again, indicating that her production had been substantial, and included "some 30 large watercolors." See Carr to Brown, 1 October 1928, NGC Carr. Brown showed no interest in these. She had also been working up her earlier sketches since the New Year; see Carr to Barbeau, 22 January and 12 February 1928, CMC Carr.

19 "Vancouver Loan 1928," file 5.14n, New Westminster, BC (Loans – Western Canada), National Gallery of Canada fonds, NGC.

20 Tippett, *Emily Carr*, 203, calls Carr's request for the return of her watercolours a "whim." It was certainly more than this, but such statements are characteristic of how she is represented as an emotionally troubled female in contrast to her longsuffering, but more stable, male counterparts.

21 Blanchard, *The Life of Emily Carr*, 185, with no small amount of ingenuity, attributes the failure to return Carr's works and report on sales to an excess, rather than to a lack, of communication!

22 Brown to Carr, 8 October 1928, NGC Carr.

23 Tippett, *Emily Carr*, 174. Nonetheless, Tippett still claims that "the National Gallery ... channelled her paintings to every possible show" (206) but does not enumerate the venues.

24 Ontario Society of Artists, *Catalogue of the Fifty-Seventh Annual Exhibition of the Ontario Society of Artists* (Toronto: Art Gallery of Ontario, 1927), 7, indicates that Carr showed two works, *Skidegate* and *Totems, Kitwancool*. They are listed for sale at $175 each.

25 See Tippett, *Emily Carr*, 178, for "Harris as a father figure" to Carr. See also Ann

Davis, *The Logic of Ecstasy: Canadian Mystical Painting, 1920-1940* (Toronto: University of Toronto Press, 1992), 12-13.

26 Blanchard, *The Life of Emily Carr*, 185.

27 Charles Hill, *The Group of Seven: Art for a Nation* (Ottawa: National Gallery of Canada, 1995), 208.

28 Tippett, *Emily Carr*, 144, and Blanchard, *The Life of Emily Carr*, 170, 186, differ on the number of works that Carr sent to Ottawa for the *West Coast Art* exhibition. And both underestimate the actual total. The catalogue for the exhibition lists twenty-six works by Carr; see National Gallery of Canada, *Exhibition of Canadian West Coast Art, Native and Modern*, Ottawa edition (Ottawa: National Gallery of Canada, 1927). A list in the NGC Archives cites twenty-one works as not exhibited, for a total of forty-seven. Insofar as titles and prices are given for all of these works, this list seems definitive; see Carr to Brown, 28 September [1927], and "Lists of Emily Carr's Paintings of the West Coast Now in the Keeping of the National Gallery, 1. Pictures on Exhibition, 2. Pictures Not on Exhibition," NGC/WCA. This number is in keeping with the established fact that Carr sent more works than Brown had initially requested as well as with her claim that only half of the works that she sent were hung. The *West Coast* exhibition, it will be recalled, went from Toronto to Montreal in February and March, so the work hanging would not have been available, nor would have the ten watercolours and two oils in the NGC's 1929 annual exhibition of Canadian art. However, this still left nine from which to choose. It may be safely assumed that one or two of these would have been worthy of display, especially given the comparable quality of other works in the expanded Group of Seven exhibition. Further, the number of Carr's paintings in the photographic record of the *West Coast Art* exhibition does not correspond to the catalogue, indicating that some may have been listed as "shown" but actually left out. Finally, the two Carr paintings for Marius Barbeau's *The Downfall of Temlaham* (Toronto: Macmillan, 1928) were in Toronto at the time; see Barbeau to Carr, 15 March 1928, CMC Carr, in which Barbeau states that "neither were used for the Group of Seven Show, nor any others. I believe that the conflict of their exhibition and the others in which your pictures were engaged prevented the occurrence."

29 Hill, *The Group of Seven*, 209.

30 Ibid., 257-60.

31 Harris to Carr, 8 January 1928, British Columbia Archives, Emily Carr MS 30, D 215 vol. 2, Carr-Harris Correspondence, 1943 (hereafter BCA Carr).

32 Blanchard, *The Life of Emily Carr*, 198. *Totems, Kitwancool* was also included in Bertram Brooker, ed., *The Yearbook of the Arts in Canada, 1928-1929* (Toronto: Macmillan, 1929). However, there was little mention of the 1927 *West Coast Art* exhibition and no place given to Native arts, although Barbeau did contribute a section on "French and Indian Motifs in Our Music." Arthur Lismer, "Art Appreciation," in Brooker, ed., *Yearbook*, 57-71, was the most vocal on both Carr and Native arts, the latter of which he placed in the past. Of Carr, he stated: "Miss Emily Carr, living in Victoria, has given us pictures of the Indian – peeps into his past, strangely saturated with the spirit of the past" (60). His references to Native arts were characterized by both possession and dispossession: "Art is

the outward expression of the self-assertion of a nation – the totem of our tribe" (66). He later noted, in referring to the recognition of various Native arts, especially those of the American Southwest, that "through the efforts of men like Marius Barbeau, it has been made still more evident that we have a rich heritage of our own and that we are in some measure related to it" (68). He concluded with a statement on who now possessed and had title to their arts, stating that "the Indian" may have "memories that may be returned to him and crafts that he may have forgotten, but that he may re-learn" (69). However, his main interest was in how Native arts could be appropriated by non-Native artists. He concluded with a lengthy discussion of Holgate's pastiches of Gitxsan motifs in the short-lived Skeena Tea Room of the Château Laurier Hotel. Characteristically, another image of totem poles by Carr, *Skidegate*, was also included in the OSA show.

33 Harris to Carr, [1929], BCA Carr.

34 Ibid.

35 Harris's advice to Carr is frequently cast as both paternal and prescient, but it must be recalled that when he gave it, the empty landscape was coming up for criticism as an exhausted convention and was being seen as a Canadian form of academicism. He himself would abandon it some years later for abstraction.

36 See Hill, *The Group of Seven*, 217, 236, and 262, for Carr's inclusion in the exhibition of sixty Canadian works by thirty-three artists selected by the American Federation of Arts in the spring of 1930, which opened at the Corcoran in Washington, DC, and toured to five other galleries. Fred Housser's foreword to the catalogue stressed the national character of the works. Harris dominated the exhibition with three large canvases. A reviewer noted, in response to the claim by one artist that they were not very popular, that "they have at least found discriminating patronage on the part of those in authority – the directors and purchasing committees of their art museums"; see L.M., "Paintings by Contemporary Canadian Artists: An Exhibition Assembled and Circulated by the American Federation of Arts," *The American Magazine of Art* (May 1930): 262-70. The reviewer attributes the impetus for the exhibition to Vincent Massey, who was representing Canada in Washington. It was financed by the Carnegie Foundation.

37 Harris to Carr, 1 January 1930, and Harris to Carr, 25 January 1930, BCA Carr.

38 Harris to Carr, 7 February 1930, BCA Carr.

39 Shadbolt, *The Art of Emily Carr*, 206, and Davis, *The Logic of Ecstasy*, 9-14. In Harris to Carr, [1930], BCA Carr, Harris indicates that a buyer had purchased *Indian Church* and that Lismer also approved of it. In Harris to Carr, 12 March [1930], BCA Carr, Harris corrected himself and expressed his own desire to have the work, calling it "a grand thing."

40 Blanchard, *The Life of Emily Carr*, 216.

41 Harris to Carr, June 1930, BCA Carr.

42 Harris to Carr, June [1930], BCA Carr. For *Indian Church*'s inclusion in the extension of the American Federation of Art exhibition, see Harris to Carr, 13 October 1930, BCA Carr. He found *Indian Church* incrementally gratifying: "I do want it to be seen as much as possible. It improves and improves the oftener seen."

43 Hill, *Group of Seven*, 330, reports that five of Carr's paintings were listed in the cata-
 logue for the Group of Seven's 1930 show. Blanchard, *The Life of Emily Carr*, 216,
 is probably incorrect in claiming that "she had six major canvases on the walls."
 Blanchard also claims that "it was not until December 1931 that she showed any
 of her new forest studies" (233). Hill, *Group of Seven*, 263, notes that the Group of
 Seven exhibition also went to Montreal, minus a number of works. Tippett, *Emily
 Carr*, 174, sees Carr's inclusion as a continuing stage in her triumph, proof that "she
 had been accepted by the artists who had inspired her three years earlier." Tippett
 does not note that this inclusion had been preceded by rejection.

44 Tippett, *Emily Carr*, 174-75.

45 Shadbolt, *The Art of Emily Carr*, 205.

46 Davis, *The Logic of Ecstasy*, 103.

47 Ibid., 12, interprets Carr's *Indian Church* as a "new integration." However, Davis's
 later application of precisely the same terms to Carr's *Nirvana* tends to confuse
 her analysis (103).

48 Blanchard, *The Life of Emily Carr*, 210.

49 Tippett, *Emily Carr*, 192. Tippett reports that the positive response to Carr's 1930
 one-person show of works depicting Native subjects was international and cites a
 request that the exhibition travel to Berkeley (194). See also Moray, "Northwest
 Coast," 403.

50 The catalogue lists Carr's *Poles in Early Skidegate* and *Queen Charlotte Island Village*,
 both offered for sale at $350; see Art Institute of Seattle, *Sixteenth Annual Exhibi-
 tion of Northwest Artists* (Seattle: Art Institute of Seattle, 1930), n.p. Carr's show
 at the Henry Gallery would not occur until 1950.

51 See Tippett, *Emily Carr*, 191.

52 Carr to Hatch, 11 November [1931], Letters from Emily Carr to John Davis
 Hatch, Jr., Dir. of Seattle Institute of Art, and Letters from Director Hatch
 to Emily, MS 2792, Box 2, File 9, Edythe Hembroff-Schleicher Papers, BC
 Archives. The letter mentions two works by Carr that were returned from Paris
 in ruinous condition.

53 Shadbolt, *The Art of Emily Carr*, 202, suggests that Carr's *Indian Village, B.C.* was
 also sent to the *Baltimore Pan-American Exhibition*, held in early 1931.

54 Harris to Carr, [1931], BCA Carr.

55 Ibid., emphasis in the original.

56 Shadbolt, *The Art of Emily Carr*, 199.

57 Space for Carr's work in the Group of Seven's December 1930 show would have
 been limited, given that fifteen of Harris's own works were on display, several of
 which were huge and most of which had already been exhibited, in addition to
 fifteen by A.Y. Jackson; see Hill, *The Group of Seven*, 268. Hill incorrectly states
 that Carr sent in five works rather than six.

58 The precise identity of Carr's "Thunderbird" picture is unclear. It may have been
 the painting now known as *Big Raven*, completed by early 1931, which was one of
 her major works to the time and one that she would certainly have wanted seen.
 Edythe Hembroff-Schleicher, *Emily Carr: The Untold Story* (Saanichton: Hancock
 House, 1978), 373, notes that Carr consistently called the painting her "Thun-
 derbird" picture, although this has subsequently been seen as a misidentification
 of the image and the painting has been retitled. However, it may also be either

of the two pictures titled *Thunderbird*, identified by Moray, "Northwest Coast," vol. 2, 17, and currently in the Thomson collection. All correspond to Harris's description of the work.

59 Harris to Carr, December [1931], BCA Carr.

60 Ibid.

61 Harris to Carr, 29 January 1932, BCA Carr.

62 Not all of "the boys," as Harris called them, in the Group of Seven were ready to accept Carr into their circle. Blanchard, *The Life of Emily Carr*, 233, notes A.Y. Jackson's scathing comments concerning sketches that Carr had sent for critique. See also Tippett, *Emily Carr*, 208. Again, Tippett attributes Carr's break with Jackson and the rest of the Group during the 1930s to her social ineptness and hypersensitivity rather than to his insults or the other Group members' indifference and antipathy.

63 Carr was by this time fed up with the expense of sending works east and having them rejected and not hung as well as tiring of Brown's perfunctory attitude and Jackson's malicious criticisms. She did not directly submit to the NGC's 1932 annual exhibition of Canadian art, but Brown, although avoiding direct communication with Carr and working through a third party, did ask for a submission; see Hembroff-Schleicher, *Emily Carr*, 375, citing Carr to Nan Cheney, 14 December 1931, and Carr to Nan Cheney, 13 February 1932.

64 See Tippett, *Emily Carr*, 167.

65 There are no entries in Carr's journals during the crucial period between 28 September 1931 and 3 November 1932 – that is, for over a year – a fact not much commented on by her biographers. Susan Crean, *Opposite Contraries: The Unknown Journals of Emily Carr and Other Writings* (Vancouver: Douglas and McIntyre, 2003), 38, in retrieving those parts of her journals that had been edited out of previous publications, did find a set of loose pages with the 1930-33 journal. One of these begins with the lament, "I am groping horribly lost, trying to search for that thing." Crean mistakingly appends this to another sheet written on her 1933 trip to Pemberton – that is, at the end of the journal. However, a check of the original document shows that this statement is on different paper stock and probably from a different time.

66 See John O'Brian, "Introduction: Iconic Carr," in Mendel Art Gallery, *Gasoline, Oil, and Paper: The 1930s Oil-on-Paper Paintings of Emily Carr* (Saskatoon: Mendel Art Gallery, 1995). For the antipathy of the Group of Seven to Carr's new work, see Blanchard, *The Life of Emily Carr*, 246.

67 Unlike the other members of the Group of Seven, Harris, who would engineer his own escape into abstraction, avoided being criticized for stagnating.

68 Tippett, *Emily Carr*, 206. On Lismer's critique and Jackson's "slighting comments" in 1931, which seem to have been a scathing critique of Carr's new work, see Blanchard, *The Life of Emily Carr*, 248.

69 Tippett, *Emily Carr*, 206. Blanchard, *The Life of Emily Carr*, 249, notes that Brown also continued to display Carr's old works instead of her recent production and again refused to keep her notified of when and where they were shown.

70 Tippett, *Emily Carr*, 202-3.

71 Although Carr did not return to the Gitxsan villages, she did make a trip to northern Vancouver Island in 1940.

72 This aversion to representations of both the Gitxsan and the Skeena region in Canadian art seems to have persisted for decades. Moray, "Northwest Coast," 301 n. 156, reports: "It is significant that the National Gallery retrospective of Carr's work in 1990 omitted her Skeena paintings of 1912, although ostensibly for reasons of space."

CONCLUSION

1 Marius Barbeau, "Our Indians: Their Disappearance," *Queen's Quarterly* 38 (Autumn 1931): 701.
2 Marius Barbeau, "The Indians of the Prairies and the Rockies: A Theme for Modern Painters," *University of Toronto Quarterly* 1, 2 (1931): 198.
3 Ibid., 204.
4 Brown to Barbeau, 24 June 1929, Canadian Museum of Civilization, Archives, Marius Barbeau Fonds, Correspondence with Eric Brown (1928-33), B176, f. 4 (hereafter CMC Brown). At a later date, a letter from Brown to Barbeau confirmed the NGC's purchase of a carved and painted Haida box for $150 plus transportation costs. However, this was a rare and exceptional instance; see Brown to Barbeau, 10 March 1933, CMC Brown.
5 Liston M. Oak to Kihn, 19 March 1931, W. Langdon Kihn Papers, 1904-1990, Microfilm reels 3701-3713, Archives of American Art, Smithsonian Institution (hereafter Kihn Papers). The claim of Native cultural continuity was repeated in the critical response to the *Exposition of Indian Tribal Arts*. See Anonymous, "Indian Tribal Arts," *American Magazine of Art*, April 1931, 303-4. This exhibition joined two other major shows of Native arts that were touring at the time, both organized by the American Federation of Arts.
6 Diana Nemiroff, "Modernism, Nationalism and Beyond," in Diana Nemiroff, Robert Houle, and Charlotte Townsend-Gault, *Land Spirit Power: First Nations at the National Gallery of Canada* (Ottawa: National Gallery of Canada, 1992), 16-17.
7 The exhibition *A Century of Canadian Art*, at the Tate Gallery in London in 1938, included two Chilkat blankets and a selection of argillite totem poles, mounted adjacent to early French Canadian carvings.
8 Paula Blanchard, *The Life of Emily Carr* (Vancouver and Toronto: Douglas and McIntyre, 1987), 261, attributes the NGC's renewed interest in Carr's work to a concern for her health; that is, Blanchard personalizes this attention rather than placing it within the shifting policy toward the Native that was occurring in Canada at the moment: "Word of her illness galvanized her old friends in the East, and there was a sudden, unprecedented surge of interest in her work."
9 See Leslie Dawn, "Policing the People of the Potlatch," paper presented at a conference of the Native American Art Studies Association (NAASA), Salem, MA, 5-8 November 2003.
10 Erna Gunther, "The Northwest Coast of America," in *Golden Gate International Exhibition*, Pacific Cultures exhibition, catalogue (San Francisco: Schabacher Frey, H.S. Crocker, 1939), 99-113.

11 Graham McInnes, *A Short History of Canadian Art* (Toronto: Macmillan, 1939). By the time McInnes had expanded this text into *Canadian Art* (Toronto: Macmillan, 1950), the chapter on "Native Arts" had become four pages (5-8), but much of his entry was taken up with the discussion of non-Native artists who had worked with Native imagery rather than with the discussion of Native art itself. He mentioned nothing of any contemporary production. Nonetheless, this was indicative of a change, as the programmatic "revival" of Native culture and art as commodity was fully under way by this time. See Leslie Dawn, "'Ksan: Museum, Cultural and Artistic Activity among the Gitksan Indians of the Upper Skeena, 1920-1973" (MA thesis, University of Victoria, 1976).

12 Marius Barbeau, *Totem Poles of the Gitksan, Upper Skeena River, British Columbia*, Anthropology Series no. 12, Bulletin no. 61 (Ottawa: National Museum of Canada, 1929), 7.

13 Margaret Anderson and Marjorie Halpin, eds., *Potlatch at Gitsegukla: William Beynon's 1945 Field Notebooks* (Vancouver: UBC Press, 2000).

14 See Leslie Dawn, "The Pre-History of 'Ksan: A Case for Gitxsan Cultural Continuity," paper presented at the conference "Boundaries in the Art of the Northwest Coast of America," British Museum, London, 18-20 May 2000.

Bibliography

MANUSCRIPT SOURCES

Archives du Louvre, Exposition d'art canadien, 10 April to 10 May 1927.
Archives of American Art, Smithsonian Institution, W. Langdon Kihn Papers.
British Columbia Archives, Emily Carr fonds and Edythe Hembroff-Schleicher fonds.
Canadian Museum of Civilization, Archives, C. Marius Barbeau Collection.
McCord Museum of Canadian History Archives, C. Gagnon Correspondence.
Montreal Museum of Fine Arts Archive, Exhibitions Lists, 1905-1931.
Montreal Museum of Fine Arts Archive, Memorial Exhibition of Paintings by the Late James W. Morrice.
National Gallery of Canada Fonds. National Gallery of Canada Archives.
Royal British Columbia Museum, Harlan Smith fonds.
Whyte Museum of the Canadian Rockies, various files relating to Banff's Indian Days.

BOOKS AND ARTICLES

Adamson, Jeremy. *Lawren S. Harris: Urban Scenes and Wilderness Landscapes, 1906-1930.* Toronto: Art Gallery of Ontario, 1978.
Ainslie, Patricia. *Images of the Land: Canadian Block Prints, 1919-1945.* Exhibition catalogue. Calgary: Glenbow-Alberta Institute, 1984.
Allwood, John. *The Great Exhibitions.* London: Studio Vista, 1977.
Altmeyer, George. "Three Ideas of Nature in Canada, 1893-1914." *Journal of Canadian Studies* 9 (August 1976): 21-36.
Anderson, Benedict. *Imagined Communities.* Rev. ed. London and New York: Verso, 1991.
Anderson, Margaret, and Marjorie Halpin, eds. *Potlatch at Gitsegukla: William Beynon's 1945 Field Notebooks.* Vancouver: UBC Press, 2000.
Anderson Galleries. *Portraits of American Indians by W. Langdon Kihn.* Exhibition catalogue. New York, NY: Anderson Galleries, 1922.
Andrews, Malcolm. *Landscape and Western Art.* Oxford: Oxford University Press, 1999.
—. *The Search for the Picturesque: Landscape Aesthetics and Tourism in Britain, 1760-1900.* Aldershot: Scholar Press, 1989.

Anonymous. "Art in French Canada." *Canadian Forum* 6, 69 (1926): 265-66.

Archer-Straw, Petrine. *Negrophilia: Avant-Garde Paris and Black Culture in the 1920s.* London: Thames and Hudson, 2000.

Arnaud, Odette. "Un Peintre américain: W. Langdon Kihn." *L'Art et les Artistes* (October 1925): 9-12.

Art Gallery of Toronto. *Catalogue of an Exhibition of Canadian West Coast Art, Native and Modern, and of a Group of Water Colour Paintings by Robert D. Norton.* Toronto: Art Gallery of Toronto, 1928.

Art Institute of Seattle. *Sixteenth Annual Exhibition of Northwest Artists.* Seattle: Art Institute of Seattle, 1930.

Ashton, James. "Landscape Art in Australia." In Charles Holme, ed., *Art of the British Empire Overseas*, 37-52. London: *The Studio*, 1916-17.

Barbeau, Marius. "Ancient Culture, Vignettes Past." *Canadian National Railways Magazine* 15, 7 (1929): 13, 30-31, 33.

—. "An Artist among the Northwest Indians." *Arts and Decoration* 26 (May 1923): 20, 27, 95.

—. "Backgrounds in Canadian Art." *Proceedings and Transactions of the Royal Society of Canada*, 3d ser., 35 (1941): 29-39.

—. "The Canadian Northwest: Theme for Modern Painters." *American Magazine of Art* 24, 5 (1932): 331-38.

—. *The Downfall of Temlaham.* Toronto: Macmillan, 1928.

—. "Frederick Alexie: A Primitive." *Canadian Review of Music and Art* 3, 11 and 12 (1945): 19, 21-22.

—. *Indian Days in the Canadian Rockies.* Toronto: Macmillan, 1923.

—. *Indian Days on the Western Prairies.* Anthropological Series no. 46, Bulletin no. 163. Ottawa: National Museum of Man, 1960.

—. "The Indians of the Prairies and the Rockies: A Theme for Modern Painters." *University of Toronto Quarterly* 1, 2 (1931): 197-206.

—. "Our Indians: Their Disappearance." *Queen's Quarterly* 38 (Autumn 1931): 691-707.

—. "The Potlatch among the B.C. Indians and Section 149 of the Indian Act." Unpublished ms. 1934. Canadian Museum of Civilization, 11007.13, B12, f.2, VII-X-46M.

—. *Totem Poles.* 2 vols. Ottawa: Canadian Museum of Civilization, 1950.

—. *Totem Poles of the Gitksan, Upper Skeena River, British Columbia.* Anthropology Series no. 12, Bulletin no. 61. Ottawa: National Museum of Canada, 1929.

Barbier, Carl Paul. *William Gilpin: His Drawings, Teaching, and Theory of the Picturesque.* Oxford: Oxford University Press, 1963.

Barrell, John. *The Dark Side of the Landscape: The Rural Poor in English Painting, 1730-1840.* Cambridge: Cambridge University Press, 1980.

Bayly, C.A., ed. *The Raj: India and the British, 1600-1947.* London: National Portrait Gallery, 1990.

Behiels, Michael D., and Marcel Martel, eds. *Nation, Ideas, Identities.* Don Mills, ON: Oxford University Press, 2000.

Berlo, Janet Catherine, ed. *The Early Years of Native American Art History: The Politics of Scholarship and Collecting.* Seattle: University of Washington Press, 1992.

Bermingham, Ann. *Landscape and Ideology: The English Rustic Tradition, 1740-1860.* Berkeley: University of California Press, 1986.

—. "The Popularisation of the Picturesque Taste." *Studies on Voltaire and the Eighteenth Century* 265 (1989): 1212-13.

—. "System, Order, and Abstraction: The Politics of English Landscape Drawing around 1795." In W.J.T. Mitchell, *Landscape and Power*, 77-101. Chicago: University of Chicago Press, 1994.

Beverley, John. *Subalternity and Representation: Arguments in Cultural Theory.* Durham: Duke University Press, 1999.

B.F. [Barker Fairley]. "Toronto." *The Studio* 86, 364 (1923): 54-58.

Bhabha, Homi K. "DissemiNation." In Homi K. Bhabha, ed., *Nation and Narration*, 291-322. London and New York: Routledge, 1990.

—. "Introduction: Narrating the Nation." In Homi K. Bhabha, ed., *Nation and Narration*, 1-7. London and New York: Routledge, 1990.

—. *The Location of Culture.* London and New York: Routledge, 1994.

—. "Of Mimicry and Man: The Ambivalence of Colonial Discourse." *October*, no. 28 (1984): 125-33, reproduced in Annette Michelson et al., eds., *October: The First Decade, 1976-1986*, 317-25. Cambridge, MA: Massachusetts Institute of Technology Press, 1987.

—, ed. *Nation and Narration.* London and New York: Routledge, 1990.

Blackfeet Indians. New York: Gramercy Books, 1935; reprint, Random House, 1995.

Blanchard, Paula. *The Life of Emily Carr.* Vancouver and Toronto: Douglas and McIntyre, 1987.

Boas, Franz. "The Decorative Art of the Indians of the North Pacific Coast of America." *Bulletin American Museum of Natural History* 9 (1897): 123-76.

—. *Primitive Art.* Oslo: H. Aschehoug and the Oslo Institute for Comparative Research in Human Culture, 1927; reprint, Cambridge: Harvard University Press, 1928; reprint, New York: Dover, 1955.

Bordo, Jonathan. "Jack Pine: Wilderness Sublime or Erasure of the Aboriginal Presence from the Landscape." *Journal of Canadian Studies* 27, 4 (1992-93): 98-128.

—. "Picture and Witness at the Site of Wilderness." In W.J.T. Mitchell, ed., *Landscape and Power*, 2nd ed., 291-315. Chicago: University of Chicago Press, 2002.

Boswell, David, and Jessica Evans, eds. *Representing the Nation: A Reader: Histories, Heritage and Museums.* London: Routledge, 1999.

Bourdieu, Pierre. *Distinction: A Social Critique of the Judgement of Taste.* Cambridge, MA: Harvard University Press, 1984.

—. *The Field of Cultural Production.* New York: Columbia University Press, 1993.

—. "Outline of a Sociological Theory of Art Perception." In *The Field of Cultural Production*, 215-37. New York: Columbia University Press, 1993.

Bracken, Christopher. *The Potlatch Papers: A Colonial Case History.* Chicago: University of Chicago Press, 1997.

Bradley, Jessica, and Lesley Johnstone, eds. *Sightlines: Reading Contemporary Canadian Art.* Montreal: Artextes, 1994.

Brettell, Richard R. *Modern Art, 1851-1929: Capitalism and Representation.* Oxford: Oxford University Press, 1999.

Brody, J.J. *Indian Painters and White Patrons.* Albuquerque: University of New Mexico Press, 1971.

Brooker, Bertram. "When We Awake." In Bertram Brooker, ed., *The Yearbook of the Arts in Canada, 1928-1929*, 1-7. Toronto: Macmillan, 1929.

—, ed. *The Yearbook of the Arts in Canada, 1928-1929.* Toronto: Macmillan, 1929.

Brown, Eric. "Canada's National Painters." *The Studio* 103, 471 (1932): 311-23.

—. "Canadian Art in Paris." *Canadian Forum* 7, 84 (September 1927): 360-61.

—. "Foreword." In British Empire Exhibition, *Canadian Section of Fine Arts Catalogue, 1924*, 3-4. London, 1924.

—. "La Jeune Peinture canadienne." *L'Art et les Artistes* 75 (March 1927): 181-98.

—. "Landscape Art in Canada." In Charles Holme, ed., *Art of the British Empire Overseas*, 3-36. London: *The Studio*, 1916-17.

—. "The National Gallery of Canada in Ottawa." *The Studio* 58, 239 (1913): 15-21.

—. "Quelques mots sur l'histoire de l'art canadien." In *Exposition d'art canadien ... au Musée du Jeu de Paume, à Paris, du 11 avril au 11 mai 1927*, 11-12. Paris: Jeu de Paume, 1927.

—. "Some Recent Purchases by the National Gallery of Canada." *The Studio* 62, 255 (1914): 96.

—. "Studio-Talk." *The Studio* 64, 265 (1915): 209-11.

Brown, Maud F. *Breaking Barriers: Eric Brown and the National Gallery.* Port Hope, ON: Society for Art Publications, 1964.

—. "Canadian Art in Paris." *Canadian Homes and Gardens* 4, 8 (1927): 20-56.

British Empire Exhibition. *Canadian Section of Fine Arts Catalogue, 1924.* London, 1924.

—. *Canadian Section of Fine Arts Catalogue, 1925.* London, 1925.

Bumsted, J.M. *A History of the Canadian Peoples.* Toronto: Oxford University Press, 1998.

Burke, Eustella. "Indian Dramatic Masks." *The Studio* 94, 417 (1927): 417-19.

Cahill, E.H. "America Has Its 'Primitives.'" *International Studio* 75, 299 (1922): 80-83.

"Canadian Art at Manchester." *Connoisseur* 76, 302 (1926): 128.

Cann, Louise Gebhard. "L'Oeuvre de Caroline Armington et Frank M. Armington." *L'Art et les Artistes* 78 (June 1927): 302-6.

Carlson, Keith, Melinda Jetté, and Kenichi Matsui. "An Annotated Bibliography of Major Writings in Aboriginal History, 1990-99." *Canadian Historical Review* 82, 1 (2001): 122-71.

Carr, Emily. *The Complete Writings of Emily Carr.* Vancouver: Douglas and McIntyre, 1993.

Cassidy, Maureen. "The Skeena River Uprising of 1888." *British Columbia Historical News* 16, 3 (1983): 6-12.

Catlin, George. *Letters and Notes on the Manners, Customs, and Condition of the North American Indians.* 2 vols. 1841. Reprint, New York: Dover, 1973.

Ciolkowska, Muriel. "A Canadian Painter: James Wilson Morrice." *The Studio* 59, 245 (1913): 176-82.

Ciolkowski, C.F. "J.W. Morrice." *L'Art et les Artistes* 62 (December 1925): 90-94.

Clifford, James. "Ethnographic Surrealism." In *The Predicament of Culture: Twentieth-Century Ethnography, Literature, and Art*, 117-51. Cambridge, MA: Harvard University Press, 1988.

—. "Of Other Peoples: Beyond the 'Salvage' Paradigm." In Hal Foster, ed., *Discussions in Contemporary Culture*, 121-30. Seattle: Bay Press, 1987.

—. *The Predicament of Culture: Twentieth-Century Ethnography, Literature, and Art.* Cam-

bridge, MA: Harvard University Press, 1988.

—, ed. *The Invented Indian: Cultural Fictions and Government Policies*. New Brunswick, NJ: Transaction, 1990.

—, and George Marcus, eds. *Writing Culture: The Poetics and Politics of Ethnography*. Berkeley and Los Angeles: University of California Press, 1986.

Cloutier, Nicole, curator. *James Wilson Morrice, 1865-1924*. Montreal: Montreal Museum of Fine Arts, 1986.

Cole, Douglas. "Artists, Patrons and Public: An Enquiry into the Success of the Group of Seven." *Journal of Canadian Studies* 13 (Summer 1978): 69-78.

—. *Captured Heritage: The Scramble for Northwest Coast Artifacts*. Vancouver: Douglas and McIntyre, 1985.

—. "The History of the Kwakiutl Potlatch." In Aldona Jonaitis, ed., *Chiefly Feasts: The Enduring Kwakiutl Potlatch*, 135-68. Seattle: University of Washington Press, 1991.

—. "The Invented Indian/The Imagined Emily." *BC Studies*, nos. 125 and 126 (Summer 2000): 147-62.

—. "The Origins of Canadian Anthropology, 1850-1910." *Journal of Canadian Studies* 8, 1 (1973): 33-45.

—, and Ira Chaikin. *An Iron Hand upon the People: The Law against the Potlatch on the Northwest Coast*. Vancouver: Douglas and McIntyre, 1990.

Colgate, William. *Canadian Art: Its Origins and Development*. Toronto: Ryerson Press, 1943.

Comstock, Helen. "Langdon Kihn, Indian Painter." *International Studio* (October 1925): 50-5.

Cook, Ramsay. "Landscape Painting and the National Sentiment in Canada." *Historical Reflections* 1, 2 (1974): 263-83.

Coombes, Annie. "Ethnography and the Formation of National and Cultural Identities." In Susan Hiller, ed., *The Myth of Primitivism: Perspectives on Art*, 189-214. London: Routledge, 1991.

—. "'For God and for England': Contributions to an Image of Africa in the First Decade of the Twentieth Century." *Art History* 8, 4 (1985): 453-66.

—. "National Unity and Racial and Ethnic Identities: The Franco-British Exhibition of 1908." In *Reinventing Africa: Museums, Material Culture and Popular Imagination in Late Victorian and Edwardian England*, 187-213. New Haven: Yale University Press, 1994.

—. *Reinventing Africa: Museums, Material Culture and Popular Imagination in Late Victorian and Edwardian England*. New Haven: Yale University Press, 1994.

Corbett, David Peters, Ysanne Holt, and Fiona Russell. "Introduction." In David Peters Corbett, Ysanne Holt, and Fiona Russell, eds., *The Geographies of Englishness: Landscape and the National Past, 1880-1940*, ix-xix. New Haven: Yale University Press, 2002.

—, Ysanne Holt, and Fiona Russell, eds. *The Geographies of Englishness: Landscape and the National Past, 1880-1940*. New Haven: Yale University Press, 2002.

Cosgrove, Denis, and Stephen Daniels, eds. *The Iconography of Landscape*. New York: Cambridge University Press, 1988.

Cottington, David. *Cubism in the Shadow of the War: The Avant-Garde and Politics in Paris, 1905-1914*. New Haven: Yale University Press, 1998.

Cove, John. *A Detailed Inventory of the Barbeau Northwest Coast Files*. Ottawa: National Museums of Canada, 1985.

Craven, Thomas. "Northern Art." *New York Herald Tribune Books*, 2 May 1926, 13.

Crean, Susan. *The Laughing One: A Journey to Emily Carr*. Toronto: HarperCollins, 2001.

–. *Opposite Contraries: The Unknown Journals of Emily Carr and Other Writings*. Vancouver: Douglas and McIntyre, 2003.

Cronon, William. "Telling Tales on Canvas: Landscapes of Frontier Change." In Jules David Prown et al., *Discovered Lands, Invented Pasts*, 37-87.

Crosby, Martha. "Construction of the Imaginary Indian." In Stan Douglas, ed., *Vancouver Anthology: The Institutional Politics of Art*, 267-91. Vancouver: Talonbooks, 1991.

Crowley, John E. "'Taken on the Spot': The Visual Appropriation of New France for the Global British Landscape." *The Canadian Historical Review* 86, 1 (2005): 1-28.

Danto, Arthur C. "Bourdieu on Art: Field and Individual." In Richard Shusterman, ed., *Bourdieu: A Critical Reader*, 214-19. Malden, MA: Blackwell, 1999.

Darling, David, and Douglas Cole. "Totem Pole Restoration on the Skeena, 1925-30: An Early Exercise in Heritage Conservation." *BC Studies*, no. 47 (Autumn 1980): 29-48.

Darnell, Regna. *Edward Sapir: Linguist, Anthropologist, Humanist*. Berkeley: University of California Press, 1990.

–. "The Sapir Years at the National Museum, Ottawa." *Canadian Ethnology Society Proceedings*, no. 3 (1976): 98-121.

Davis, Ann. *The Logic of Ecstasy: Canadian Mystical Painting, 1920-1940*. Toronto: University of Toronto Press, 1992.

–. "The Wembley Controversy in Canadian Art." *Canadian Historical Review* 54 (March 1973): 48-74.

Dawn, Leslie. "'Ksan: Museum, Cultural and Artistic Activity among the Gitksan Indians of the Upper Skeena, 1920-1973." MA thesis, University of Victoria, 1976.

–. "Policing the People of the Potlatch." Paper presented at a conference of the Native American Art Studies Association (NAASA). Salem, MA, 5-8 November 2003.

–. "The Pre-History of 'Ksan: A Case for Gitxsan Cultural Continuity." Paper presented at the conference "Boundaries in the Art of the Northwest Coast of America." British Museum, London, 18-20 May 2000.

Dick, S. "Canada's Primitive Arts." *Saturday Night*, 21 January 1928, 3.

Dippie, Brian W. "The Moving Finger Writes: Western Art and the Dynamics of Change." In Jules David Prown et al., *Discovered Lands, Invented Pasts*, 89-115.

–. *The Vanishing American: White Attitudes and United States Indian Policy*. Middletown, CT: Wesleyan University Press, 1982.

Dodd, Philip. "Englishness and the National Culture." In Robert Colls and Philip Dodd, eds., *Englishness: Politics and Culture, 1880-1920*, 1-28. London: Croom Helm, 1986.

–. "Englishness and the National Culture." In David Boswell and Jessica Evans, eds., *Representing the Nation: A Reader: Histories, Heritage and Museums*, 87-108. London: Routledge, 1999.

Dominguez, V. "Of Other Peoples: Beyond the 'Salvage' Paradigm." In Hal Foster, ed., *Discussions in Contemporary Culture*, 131-37. Seattle: Bay Press, 1987.

Dragland, Stan. *Floating Voices*. Concord, ON: Anansi, 1994.

Duff, Wilson. "Contributions of Marius Barbeau to West Coast Ethnology." *Anthropologica*, n.s., 6, 1 (1964): 63-96.

—. *The Indian History of British Columbia*. Vol. 1, *The Impact of the White Man*. Anthropology in British Columbia Memoir No. 5. Victoria: Provincial Museum of British Columbia, 1964.

—, ed. *Histories, Territories, and Laws of the Kitwancool*. Anthropology in British Columbia Memoir No. 4. Victoria: Provincial Museum of British Columbia, 1959.

Dyck, Sandra. "'These Things Are Our Totems': Marius Barbeau and the Indigenization of Canadian Art and Culture in the 1920s." MA thesis, Carleton University, 1995.

"Echos des Arts." *L'Art et les Artistes* 71 (November 1926): 70.

Edwards, Gregory, and Grant Edwards. "Langdon Kihn: Indian Portrait Artist." *The Beaver* (Winter 1984-85): 4-11.

E.S. "Studio-Talk, Toronto." *The Studio* 57, 237 (1912): 245-51.

Exposition d'art canadien ... au Musée du Jeu de Paume, à Paris, du 11 avril au 11 mai 1927. Paris: Jeu de Paume, 1927.

Fabricant, Carole. "The Aesthetics and Politics of Landscape in the Eighteenth Century." In Ralph Cohen, ed., *Studies in 18th Century Art and Aesthetics*, 49-81. Berkeley: University of California Press, 1985.

Farr, Dorothy M. *J.W. Beatty, 1869-1941*. Kingston: Agnes Etherington Art Centre, 1981.

Fetherling, Douglas, ed. *Documents in Canadian Art*. Peterborough, ON: Broadview, 1987.

Finlay, J.L., and D.N. Sprague. *The Structure of Canadian History*. Scarborough, ON: Prentice-Hall, 1979.

Finley, Gerald E. *George Heriot, 1759-1839*. Ottawa: National Gallery of Canada, 1979.

Fletcher, Allan. "Industrial Algoma and the Myth of the Wilderness: Algoma Landscapes and the Emergence of the Group of Seven, 1918-1920." MA thesis, University of British Columbia, 1989.

Ford, Warwick. "Immortalizing a Disappearing Race: What One Painter Is Doing to Perpetuate the Indian Physiognomy." *Arts and Decoration* 17 (May 1922): 13, 70.

Foucault, Michel. *The Archeology of Knowledge and the Discourse on Language*. New York: Pantheon Books, 1972.

—. *Discipline and Punish: The Birth of the Prison*, New York: Vintage Books, 1977.

—. *The History of Sexuality*. Vol. 1, *An Introduction*. New York: Vintage Books, 1978.

—. *Power/Knowledge: Selected Interviews and Other Writings, 1972-1977*. New York: Pantheon Books, 1972.

Fox, Caroline, and Francis Greenacre, eds. *Painting in Newlyn, 1880-1930*. London: Barbicon Art Gallery, [1985].

Francis, Daniel. *The Imaginary Indian: The Image of the Indian in Canadian Culture*. Vancouver: Arsenal Pulp Press, 1992.

Fry, Roger. *Vision and Design*. London: 1922; reprint Harmondsmith: Penguin, 1937.

Frye, Northrop. "Canadian and Colonial Painting." In Douglas Fetherling, ed., *Documents in Canadian Art*, 89-92. Peterborough, ON: Broadview, 1987.

Gagnon, François-Marc. "Painting in Quebec in the Thirties." *Journal of Canadian Art History* 3 (Fall 1976): 2-20.

Galois, R.M. "The Burning of Gitsegukla." *BC Studies*, no. 94 (Summer 1992): 59-81.

Gaunt, William. "Two Canadian Painters." *The Studio* 88, 380 (1924): 260-63.

Gibbon, John Murray. *Canadian Mosaic: The Making of a Northern Nation.* Toronto: McClelland and Stewart, 1938.

–. "The Foreign Born." *Queen's Quarterly* 27, 4 (1920): 331-51.

Gillson, A.H.S. "James W. Morrice: Canadian Painter." *Canadian Forum* 5, 57 (1925): 271-72.

Gilpin, William. *Three Essays: On Picturesque Beauty; On Picturesque Travel; and On Sketching Landscape.* Farnborough, UK: Gregg International, 1972 [1794].

Gisday Wa and Delgam Uukw. *The Spirit in the Land: The Opening Statement of the Gitksan and Wet'suwet'en Hereditary Chiefs in the Supreme Court of British Columbia.* Gabriola, BC: Reflections, 1989.

Glavin, Terry. *A Death Feast in Dimlahamid.* Vancouver: New Star Books, 1998.

Glickman, Susan. *The Picturesque and the Sublime: A Poetics of the Canadian Landscape.* Montreal and Kingston: McGill-Queen's University Press, 1998.

Golan, Romy. *Modernity and Nostalgia: Art and Politics in France between the Wars.* New Haven: Yale University Press, 1995.

Goldie, Terry. *Fear and Temptation: The Image of the Indigene in Canadian, Australian, and New Zealand Literatures.* Montreal and Kingston: McGill-Queen's University Press, 1989.

Graburn, Nelson. *Ethnic and Tourist Arts: Cultural Expressions from the Fourth World.* Berkeley: University of California Press, 1976.

Grant, George, ed. *Picturesque Canada: The Country as It Was and Is.* 2 vols. Toronto: Beldon Brothers, 1882-84.

Gray, James H. *A Brand of Its Own.* Saskatoon: Western Producer Prairie Books, 1985.

Greenhalgh, Paul. *Ephemeral Vistas: The Expositions Universelles, Great Exhibitions and World's Fairs, 1851-1939.* Manchester: Manchester University Press, 1988.

Gunn, Hugh, ed. *The British Empire: A Survey in Twelve Volumes.* London: W. Collins, [1924].

Gunther, Erna. "The Northwest Coast of America." In *Golden Gate International Exposition, Pacific Cultures* exhibition, catalogue, 99-113. San Francisco: Schabacher Frey, H.S. Crocker, 1939.

Halpin, Marjorie. "A Critique of the Boasian Paradigm for Northwest Coast Art." *Culture* 14, 1 (1994): 10-13.

Harper, J. Russell. *Painting in Canada: A History.* Toronto: University of Toronto, 1966.

Harris, Cole. *Making Native Space: Colonialism, Resistance, and Reserves in British Columbia.* Vancouver: UBC Press, 2002.

Harris, Lawren. "Creative Art and Canada." In Bertram Brooker, ed., *The Yearbook of the Arts in Canada, 1928-1929,* 177-86. Toronto: Macmillan, 1929.

–. "Foreword." In *Group of Seven Catalogue of Paintings, 1920,* n.p. Toronto: Art Gallery of Toronto, 1920.

Harrison, Charles. "The Effects of Landscape." In W.J.T. Mitchell, ed., *Landscape and Power,* 2nd ed., 203-39. Chicago: University of Chicago Press, 2002.

—. *English Art and Modernism, 1900-1939.* New Haven: Yale University Press, 1981.

—, Francis Frascina, and Gill Perry. *Primitivism, Cubism, Abstraction: The Early Twentieth Century.* New Haven: Yale University Press, 1993.

Hart, E.J. *Trains, Peaks and Tourists: The Golden Age of Canadian Travel.* Banff: EJF Literary Enterprises, 2000. Reprint of *The Selling of Canada: The CPR and the Beginnings of Canadian Tourism.* Banff: Altitude, 1983.

Hartley, Marsden. "Red Man Ceremonials: An American Plea for American Esthetics." *Art and Archaeology* 9, 1 (1920).

Hawker, Ronald W. "Accumulated Labours: First Nations Art in British Columbia, 1922-1961." PhD diss., University of British Columbia, 1998.

—. "Frederick Alexie: Euro-Canadian Discussions of a First Nations Artist." *Canadian Journal of Native Studies* 11, 2 (1991): 229-52.

—. *Tales of Ghosts: First Nations Art in British Columbia, 1922-1961.* Vancouver: UBC Press, 2003.

Heaman, E.A. *The Inglorious Arts of Peace: Exhibitions in Canadian Society during the Nineteenth Century.* Toronto: Toronto University Press, 1999.

—. "Making a Spectacle: Exhibitions of the First Nations." In *The Inglorious Arts of Peace: Exhibitions in Canadian Society during the Nineteenth Century,* 285-310. Toronto: Toronto University Press, 1999.

Hembroff-Schleicher, Edythe. *Emily Carr: The Untold Story.* Saanichton: Hancock House, 1978.

Henderson, Stuart. "'While There Is Still Time … ': J. Murray Gibbon and the Spectacle of Difference in Three CPR Folk Festivals, 1928-1931." *Journal of Canadian Studies* 39, 1 (2005): 139-74.

Herbert, Robert L. *Seurat and the Making of La Grande Jatte.* Chicago: Art Institute of Chicago, 2004.

Hill, Charles. *The Group of Seven: Art for a Nation.* Ottawa: National Gallery of Canada, 1995.

—. "The National Gallery, a National Art, Critical Judgement and the State." In Michael Tooby, ed., *The True North: Canadian Landscape Painting, 1896-1939,* 64-83. London: Lund Humphries, 1991.

Hiller, Susan, ed. *The Myth of Primitivism: Perspectives on Art.* London: Routledge, 1991.

Hobsbawm, Eric. "The Nation as Invented Tradition." In J. Hutchinson and A. Smith, eds., *Nationalism,* 76-82. Oxford: Oxford University Press, 1994.

Holme, Charles, ed. *Art of the British Empire Overseas.* London: The Studio, 1916-17.

Holt, Ysanne. *British Artists and the Modernist Landscape.* Aldershot: Ashgate, 2003.

Housser, F.B. *A Canadian Art Movement: The Story of the Group of Seven.* Toronto: Macmillan, 1926.

Hubbard, R.H. *An Anthology of Canadian Art.* Toronto: Oxford University Press, 1960.

—. *The National Gallery of Canada Catalogue of Paintings and Sculpture.* Vol. 2, *Modern European Schools.* Ottawa: University of Toronto Press for the Trustees of the National Gallery of Canada, 1959.

Hunter, Andrew. "Mapping Tom." In Art Gallery of Ontario and National Gallery of Canada, *Tom Thomson,* 19-45. Toronto and Ottawa: Art Gallery of Ontario and National Gallery of Canada, 2002.

Hutchinson, John, and Anthony Smith, eds. *Nationalism.* Oxford: Oxford University Press, 1994.

Jackson, A.Y. "Artists in the Mountains." *Canadian Forum* 5, 52 (1925): 112-14.

—. *A Painter's Country: The Autobiography of A.Y. Jackson.* Rev. ed. Toronto: Clarke, Irwin, 1967.

—. "Rescuing Our Tottering Totems: Something about a Primitive Art, Revealing the Past History of a Vanishing Race." *Maclean's Magazine,* 15 December 1927, 23, 37.

Jenness, Diamond. *The Indians of Canada.* Ottawa: National Museum of Canada, 1932.

Jensen, Robert. *Marketing Modernism in Fin-de-Siècle Europe.* Princeton: Princeton University Press, 1994.

Jessup, Lynda. "Canadian Artists, Railways, the State and 'The Business of Becoming a Nation.'" PhD diss., University of Toronto, 1992.

—. "The Group of Seven and the Tourist Landscape in Western Canada, or The More Things Change ..." *Journal of Canadian Studies* 37, 1 (2002): 144-79.

—, ed. *Antimodernism and Artistic Experience: Policing the Boundaries of Modernism.* Toronto: University of Toronto Press, 2001.

Jonaitis, Aldona. "Northwest Coast Totem Poles." In Ruth Phillips and Christopher Steiner, eds., *Unpacking Culture: Art and Commodity in Colonial and Postcolonial Worlds,* 104-21. Berkeley: University of California Press, 1999.

—, ed. *Chiefly Feasts: The Enduring Kwakiutl Potlatch,* Seattle: University of Washington Press, 1991.

—, ed. *A Wealth of Thought: Franz Boas on Native American Art.* Vancouver: Douglas and McIntyre, 1995.

Karp, Ivan, and Steven D. Lavine, eds. *Exhibiting Cultures: The Poetics and Politics of Museum Display.* Washington: Smithsonian Institution Press, 1991.

Kihn, Langdon. "The Gitksan on the Skeena." *Scribner's Magazine* 79, 13 (1927): 170-77.

Killick, E.A.S. "Landscape Art in New Zealand." In Charles Holme, ed., *Art of the British Empire Overseas,* 85-111. London: The Studio, 1916-17.

King, Jonathan. "A Century of Indian Shows: Canadian and United States Exhibitions in London, 1825-1925." *European Review of Native American Studies* 5, 1 (1991): 35-42.

Konody, P.G. "Art and Artists: The Palace of Arts at Wembley." *Observer* (London), 24 May 1925.

Krauss, Rosalind. "The Originality of the Avant-Garde." In *The Originality of the Avant-Garde and Other Modernist Myths,* 151-70. Cambridge, MA: Massachusetts Institute of Technology Press, 1985.

Kulchyski, Peter. "Anthropology in the Service of the State: Diamond Jenness and Canadian Indian Policy." *Journal of Canadian Studies* 28, 2 (1993): 21-50.

La Violette, Forrest. *The Struggle for Survival.* 2nd ed. Toronto: University of Toronto Press, 1973.

Lamoureux, Johanne. "Places and Commonplaces of the Picturesque." In Jessica Bradley and Lesley Johnstone, eds., *Sightlines: Reading Contemporary Canadian Art,* 284-309. Montreal: Artextes, 1994.

Landry, Pierre, ed. *Canadian Art: Catalogue of the National Gallery of Canada.* Vol. 2 (G-K). Ottawa: National Gallery of Canada, 1994.

Larisey, Peter. *Light for a Cold Land: Lawren Harris's Work and Life: An Interpretation.* Toronto: Dundurn, 1993.

Laurin, Carl, Emil Hannover, and Jens Thiis. *Scandinavian Art.* 1922. Reprint, New York: Benjamin Blom, 1968.

Lears, Jackson. *No Place of Grace: Antimodernism and the Transformation of American Culture, 1880-1920*. New York: Pantheon Books, 1981.

Leechman, Douglas. "Native Canadian Art of the West Coast." *The Studio* 96, 428 (1928): 331-33.

—. *Native Tribes of Canada*. Toronto: W.J. Gage, n.d. [1957].

Lewis, Wyndham. "Canadian Nature and Its Painters." In Douglas Fetherling, ed., *Documents in Canadian Art*, 106-111. Peterborough, ON: Broadview, 1987.

L.M. "Paintings by Contemporary Canadian Artists: An Exhibition Assembled and Circulated by the American Federation of Arts." *The American Magazine of Art* (May 1930): 262-70.

Longden, A.A. "The Art of the Empire." In Edward Salmon and A.A. Longden, eds., *The Literature and Art of the Empire*. Vol. 11 of Hugh Gunn, ed., *The British Empire*. London: W. Collins, [1924].

Luce, P.W. "Halt! Red Men Bar Whites from B.C. Lands." *Saturday Night*, 27 June 1925, n.p.

MacDonald, George. *The Totem Poles and Monuments of Gitwangak Village*. Ottawa: Parks Canada, 1984.

MacDonald, J.E.H. "A Landmark of Canadian Art." In Douglas Fetherling, ed., *Documents in Canadian Art*, 37-42. Peterborough, ON: Broadview, 1987,.

McDonald, James A., and Jennifer Joseph. "Key Events in the Gitksan Encounter with the Colonial World." In M. Anderson and M. Halpin, eds., *Potlatch at Gitsegukla: William Beynon's 1945 Field Notebooks*, 193-214. Vancouver: UBC Press, 2000.

MacDonald, Joanne. *Gitwangak Village Life: A Museum Collection*. Ottawa: Environment Canada, 1984.

McDougall, Anne. *Anne Savage: The Story of a Canadian Painter*. Montreal: Harvest House Press, 1977; reprint, Ottawa: Borealis Press, 2000.

McGill, Jean. "The Indian Portraits of Edmund Morris." *The Beaver* (Summer 1979): 34-41.

McInnes, Graham. *Canadian Art*. Toronto: Macmillan, 1950.

—. *A Short History of Canadian Art*. Toronto: Macmillan, 1939.

McLaren, Angus. *Our Own Master Race: Eugenics in Canada, 1885-1945*. Toronto: McClelland and Stewart, 1990.

Macnair, Peter, and Jay Stewart. *To the Totem Forests: Emily Carr and Contemporaries Interpret Coastal Villages*. Exhibition catalogue. Victoria: Art Gallery of Greater Victoria, 1999.

—, Robert Joseph, and Bruce Grenville. *Down from the Shimmering Sky: Masks of the Northwest Coast*. Vancouver and Toronto: Douglas and McIntyre, 1998.

Mair, G.H. "Contemporary British Landscapes in Water-colour." *The Studio* 86, 369 (1923): 304-8.

Marcus, George E., and Fred R. Myers, eds. *The Traffic in Culture: Refiguring Art and Anthropology*. Berkeley: University of California Press, 1995.

Mellen, Peter. *The Group of Seven*. Toronto: McClelland and Stewart, 1970.

Merrick, Lula. "Brush's Indian Pictures." *International Studio* (December 1922): 87-93.

Michelson, Annette, et al., eds. *October: The First Decade, 1976-1986*. Cambridge, MA: Massachusetts Institute of Technology Press, 1987.

Miller, David. "Primitive Art and the Necessity of Primitivism to Art." In Susan

Hiller, ed., *The Myth of Primitivism: Perspectives on Art*, 50-71. London and New York: Routledge, 1991.

Miller, Jay, and Carol M. Eastman, eds. *The Tsimshian and Their Neighbours of the North Pacific Coast*. Vancouver: UBC Press, 1984.

Mitchell, W.J.T. "Imperial Landscape." In W.J.T. Mitchell, ed., *Landscape and Power*, 2nd ed., 5-34. Chicago: University of Chicago Press, 2002.

—, ed. *Landscape and Power*. 2nd ed. Chicago: Chicago University Press, 2002.

Moray, Gerta. "Northwest Coast Native Culture and the Early Indian Paintings of Emily Carr, 1899-1913." PhD diss., University of Toronto, 1993.

—. "Wilderness, Modernity and Aboriginality in the Paintings of Emily Carr." *Journal of Canadian Studies* 33, 2 (1998): 43-65.

Morrison, Ann Katherine. "Canadian Art and Cultural Appropriation: Emily Carr and the Exhibition of *Canadian West Coast Art, Native and Modern*." MA thesis, University of British Columbia, 1991.

"Mr. Lewis Hind Broadcast." *Connoisseur* 75, 303 (1926): 190.

Mullin, Molly. "The Patronage of Difference: Making Indian Art 'Art, Not Ethnology.'" In George Marcus and Fred Myers, eds., *The Traffic in Culture: Refiguring Art and Anthropology*, 166-98. Berkeley: University of California Press, 1995.

Murray, Joan. *The Art of Tom Thomson*. Toronto: Art Gallery of Ontario, 1971.

—. *Tom Thomson Trees*. Toronto: McArthur, 1999.

—, ed. *Daffodils in Winter: The Life and Letters of Pegi Nicol MacLeod, 1904-1949*. Moonbeam, ON: Penumbra, 1984.

Nasgaard, Roald. *The Mystic North: Symbolist Landscape Painting in Northern Europe and North America, 1890-1940*. Toronto: Art Gallery of Toronto, 1984.

National Gallery of Canada. *Annual Exhibition of Art, January 24 to February 28, 1928*. Ottawa: National Gallery of Canada, 1928.

—. *Annual Report of the Board of Trustees for the Fiscal Year 1923-1924*. Ottawa: King's Printer, 1924.

—. *Annual Report of the Board of Trustees for the Fiscal Year 1924-1925*. Ottawa: King's Printer, 1925.

—. *Annual Report of the Board of Trustees for the Fiscal Year 1925-1926*. Ottawa: King's Printer, 1926.

—. *Annual Report for the Board of Trustees for the Fiscal Year 1926-1927*. Ottawa: King's Printer, 1927.

—. *Annual Report of the Board of Trustees for the Fiscal Year 1927-28*. Ottawa: King's Printer, 1928.

—. *Annual Report for the Board of Trustees for the Fiscal Year 1929-1930*. Ottawa: King's Printer, 1930.

—. *Exhibition of Canadian West Coast Art, Native and Modern*. Exhibition catalogue. Ottawa edition. Ottawa: National Gallery of Canada, 1927.

—. *Press Comments on the Canadian Section of Fine Arts, British Empire Exhibition, 1924*. Ottawa: National Gallery of Canada, [1924].

—. *Press Comments on the Canadian Section of Fine Arts, British Empire Exhibition, 1924-1925*. Ottawa: National Gallery of Canada, [1925].

"Nationality in Landscape." *Connoisseur* 77, 305 (1927): 58-59.

Nemiroff, Diana. "Modernism, Nationalism and Beyond." In Diana Nemiroff, Robert

Houle, and Charlotte Townsend-Gault. *Land Spirit Power: First Nations at the National Gallery of Canada,* 14-41. Ottawa: National Gallery of Canada, 1992.

—, Robert Houle, and Charlotte Townsend-Gault. *Land Spirit Power: First Nations at the National Gallery of Canada.* Ottawa: National Gallery of Canada, 1992.

Nichol, Pegi. "Where Forgotten Gods Sleep." *Canadian National Railways Magazine* 17, 1 (1931): 25, 52.

Nicks, Trudy. "Indian Villages and Entertainments: Setting the Stage for Tourist Souvenir Sales." In Ruth Phillips and Christopher Steiner, eds., *Unpacking Culture: Art and Commodity in Colonial and Postcolonial Worlds,* 301-15. Berkeley: University of California Press, 1999.

Norman MacKenzie Art Gallery. *Edmund Morris "Kyaiyii," 1871-1913.* Regina: Norman MacKenzie Art Gallery, 1984.

Nowry, Laurence. *Marius Barbeau: Man of Mana.* Toronto: NC Press, 1995.

Nurse, Andrew. "'But Now Things Have Changed': Marius Barbeau and the Politics of Amerindian Identity." *Ethnohistory* 48, 3 (2001): 433-72.

O'Brian, John. *Capitalizing the Scenery: Landscape, Leisure and Tourism in British Columbia.* Vancouver: University of British Columbia and Morris and Helen Belkin Art Gallery, 1995.

—. "Introduction: Iconic Carr." In Mendel Art Gallery, *Gasoline, Oil, and Paper: The 1930s Oil-on-Paper Paintings of Emily Carr,* 7-19. Saskatoon: Mendel Art Gallery, 1995.

—. "Morrice's Pleasures (1900-1914)." In Nicole Cloutier (curator), *James Wilson Morrice, 1865-1924,* 89-97. Montreal: Montreal Museum of Fine Arts, 1986.

Ontario Society of Artists. *Catalogue of the Fifty-Seventh Annual Exhibition of the Ontario Society of Artists.* Toronto: Art Gallery of Ontario, 1927.

Ord, Douglas. *The National Gallery of Canada: Ideas, Art, Architecture.* Montreal and Kingston: McGill-Queen's University Press, 2003.

Osborne, Brian S. "The Iconography of Nationhood in Canadian Art." In Denis Cosgrove and Stephen Daniels, eds., *The Iconography of Landscape,* 162-68. New York: Cambridge University Press, 1988.

Pal, Pratapaditya, and Vidya Dehejia. *From Merchants to Emperors: British Artists and India, 1757-1930.* London: Cornell University Press, 1986.

Palin, Tutta. "Picturing a Nation." In Tuomas M.S. Lehtonen, ed., *Europe's Northern Frontier,* trans. Philip Landon. Jyvaskyla, Finland: PS-Kustannus, 1999.

Parker, Patricia. *The Feather and the Drum: The History of Banff Indian Days, 1889-1978.* Calgary: Consolidated Communications, 1990.

Parke-Taylor, Michael. "Edmund Morris: The Government of Saskatchewan Portrait Commission." In Norman MacKenzie Art Gallery, *Edmund Morris "Kyaiyii," 1871-1913,* 47-62. Regina: Norman MacKenzie Art Gallery, 1984.

Penny, David W., and Lisa Roberts. "America's Pueblo Artists: Encounters on the Borderlands." In Jackson W. Rushing, ed., *Native American Art in the Twentieth Century,* 21-38. London: Routledge, 1999.

Phillips, Ruth. "Nuns, Ladies and the 'Queen of the Huron.'" In Ruth Phillips and Christopher Steiner, eds., *Unpacking Culture: Art and Commodity Culture in Colonial and Postcolonial Worlds,* 33-50. Berkeley: University of California Press, 1999.

—, and Christopher Steiner, eds. *Unpacking Culture: Art and Commodity Culture in Colonial and Postcolonial Worlds.* Berkeley: University of California Press, 1999.

Preston, Richard. "C. Marius Barbeau and the History of Canadian Anthropology." *Canadian Ethnology Society Proceedings*, no. 3 (1976): 122-36.

Prown, Jules David, et al. *Discovered Lands, Invented Pasts: Transforming Visions of the American West*. New Haven: Yale University Press/Yale University Art Gallery, 1992.

Raibmon, Paige. *Authentic Indians: Episodes of Encounter from the Late-Nineteenth-Century Northwest Coast*. Durham: Duke University Press, 2005.

—. "Theatres of Contact: The Kwakwaka'wakw Meet Colonialism in British Columbia and at the Chicago World's Fair." *Canadian Historical Review* 81, 2 (2000): 157-90.

Reid, Dennis. *A Concise History of Canadian Painting*. Toronto: Oxford University Press, 1973.

—. *Edwin H. Holgate*. Ottawa: National Gallery of Canada, 1976.

—. *Le Groupe des Sept/The Group of Seven*. Ottawa: National Gallery of Canada, 1970.

—. *Our Own Country Canada: Being an Account of the National Aspirations of the Principal Landscape Artists in Montreal and Toronto, 1860-1890*. Ottawa: National Gallery of Canada, 1979.

Rhoades, G.E. "West Coast Indian Art." *Saturday Night*, 17 December 1927, 3.

Rhodes, Colin. *Primitivism and Modern Art*. London: Thames and Hudson, 1994.

Richardson, B. *People of Terra Nullius: Betrayal and Rebirth in Aboriginal Canada*. Vancouver: Douglas and McIntyre, 1993.

Richmond, Leonard. "Canadian Art at Wembley." *The Studio* 89, 182 (1925): 16-23.

—. "Indian Portraits of W. Langdon Kihn." *The Studio* 90, 393 (1925): 339-46.

—. "The Lure of Wembley." *The Studio* 87, 375 (1924): 312-16.

—. "A Portfolio of Drawings by Members of the Canadian Group of Seven." *The Studio* 91, 397 (1926): 244-47.

Robson, Albert. *Canadian Landscape Painters*. Toronto: Ryerson Press, 1932.

Romaniuc, Anatole. "Aboriginal Population of Canada: Growth Dynamics under Conditions of Encounter of Civilizations." *Canadian Journal of Native Studies* 20, 1 (2000): 95-138.

Root, Deborah. *Cannibal Culture: Art, Appropriation, and the Commodification of Difference*. Boulder, CO: Westview, 1966.

Rushing, Jackson W. *Native American Art and the New York Avant-Garde: A History of Cultural Primitivism*. Austin: University of Texas Press, 1995.

—, ed. *Native American Art in the Twentieth Century*. New York: Routledge, 1999.

Ryan, Maureen. "Picturing Canada's Native Landscape: Colonial Expansion, Native Identity, and the Image of a 'Dying Race.'" *RACAR* 17, 2 (1990): 138-49.

Rydell, Robert W. *All the World's a Fair: Visions of Empire at American International Expositions, 1876-1916*. Chicago: Chicago University Press, 1984.

Said, Edward. *Culture and Imperialism*. New York: Vintage Books, 1994.

—. *Orientalism*, New York: Vintage Books, 1978.

Salé, Marie-Pierre. "Entre mythes et histoires: Le renouveau de la peinture nationaliste." In *1900*, 202-12. Paris: Galeries nationales du Grand Palais, Réunion des Musées Nationaux et Le musée d'Orsay, 2000.

Salmon, André. *La Jeune peinture française*. N.p., 1912.

Salmon, Edward, and A.A. Longden, eds. *The Literature and Art of the Empire*. Vol. 11 of Hugh Gunn, ed., *The British Empire: A Survey in Twelve Volumes*. London: W. Collins, [1924].

Sapir, Edward. "Are the Nordics a Superior Race?" *Canadian Forum* 5, 57 (1925): 265-66.

—. "Introduction." In Harlan Smith, *An Album of Prehistoric Canadian Art*, iii. Anthropological Series no. 8, Bulletin no. 37. Ottawa: National Museum of Canada, 1923.

Schrader, Robert Fay. *The Indian Arts and Crafts Board: An Aspect of New Deal Indian Policy*. Albuquerque: University of New Mexico Press, 1983.

Seguin, Margaret, ed. *The Tsimshian: Images of the Past, Views for the Present*. Vancouver: UBC Press, 1984.

Shadbolt, Doris. *The Art of Emily Carr*. Vancouver: Douglas and McIntyre, 1990 [1979].

Shapiro, Michael J. *Methods and Nations: Cultural Governance and the Indigenous Subject*. New York: Routledge, 2004.

Silcox, David P. *The Group of Seven and Tom Thomson*. Toronto: Firefly Books, 2003.

Silver, Kenneth. *Esprit de Corps: The Art of the Parisian Avant-Garde and the First World War, 1914-1925*. Princeton: Princeton University Press, 1989.

Simmins, D. "Frederick Alexcee: Indian Artist, c.1857-c.1944." *Journal of Canadian Art History* 14, 2 (1991): 83-93.

Smith, Harlan. *An Album of Prehistoric Canadian Art*. Anthropological Series no. 8, Bulletin no. 37. Ottawa: National Museum of Canada, 1923.

—. "Distinctive Canadian Designs: How Canadian Manufacturers May Profit by Introducing Native Designs into Their Products." *Industrial Canada*, 17 September 1917, 729-33.

—. "Preserving a 'Westminster Abbey' of Canadian Indians: Remarkable Totem Poles Now under Government Care." *London Illustrated News*, 21 May 1927, 900-1.

—. "Restoration of Totem Poles in British Columbia." *National Museum of Canada Annual Report for 1926*. Ottawa: King's Printer, 1928.

—. "The Use of Prehistoric Canadian Art for Commercial Design." *Science*, 20 July 1917, 60-61.

Smith, Pamela, and Donald Mitchell, eds. *Bringing Back the Past: Historical Perspectives on Canadian Archaeology*. Mercury Series, Archaeology Survey of Canada, Paper 158. Ottawa: Canadian Museum of Civilization, 1998.

Soulier, Gustav. "Le Pavillon de Finlande à l'Exposition universelle." *Art et Decoration* 8, 1 (1900).

Stacey, Robert. "The Myth – and Truth – of the True North." In Michael Tooby, ed., *The True North: Canadian Landscape Painting, 1896-1939*, 36-63. London: Lund Humphries, 1991.

Sterritt, Neil, et al. *Tribal Boundaries in the Nass Watershed*. Vancouver: UBC Press, 1999.

Stewart, Susan. *On Longing: Narratives of the Miniature, the Gigantic, the Souvenir, the Collection*. Durham: Duke University Press, 1993.

"Studio-Talk, London." *The Studio* 57, 237 (1912): 236-45.

Suttles, Wayne. "Streams of Property, Armor of Wealth." In Aldona Jonaitis, ed., *Chiefly Feasts: The Enduring Kwakiutl Potlatch*, 71-133. Seattle: University of Washington Press, 1991.

—, ed. *Handbook of North American Indians*. Vol. 7, *Northwest Coast*. Washington: Smithsonian Institute, 1990.

Tennant, Paul. *Aboriginal Peoples and Politics: The Indian Land Question in British Columbia, 1849-1989*. Vancouver: UBC Press, 1990.

Thiébault-Sisson. "La première exposition d'art canadien à Paris." In *Exposition d'art canadien ... au Musée du Jeu de Paume, à Paris, du 11 avril au 11 mai 1927*, 13-16. Paris: Jeu de Paume, 1927.

—. "Une exposition d'art canadien au Jeu-de-Paume," *Le Temps*, 25 March 1927.

Thom, Ian. *The Prints of Edwin Holgate*. Kleinburg, ON: McMichael Canadian Art Collection, 1989.

Thomas, Nicholas. *Colonialism's Culture: Anthropology, Travel and Government*. Princeton: Princeton University Press, 1994.

—. *Entangled Objects: Exchange, Material Culture and Colonialism in the Pacific*. Cambridge, MA: Harvard University Press, 1991.

—. *Possessions: Indigenous Art/Colonial Culture*. London: Thames and Hudson, 1999.

Thompson, John Herd, with Allen Seager. *Canada 1922-1979: Decades of Discord*. Toronto: McClelland and Stewart, 1985.

Tillotson, G.H.R. "The Indian Picturesque: Images of India in British Landscape Painting, 1780-1880." In C.A. Bayly, ed., *The Raj: India and the British, 1600-1947*, 141-249. London: National Portrait Gallery, 1990.

Tippett, Maria. *Art in the Service of War: Canada, Art, and the Great War*. Toronto: University of Toronto Press, 1984.

—. *Emily Carr: A Biography*. Oxford: Oxford University Press, 1979.

—. *Stormy Weather: F.H. Varley, a Biography*. Toronto: McClelland and Stewart, 1998.

Titley, Brian. *A Narrow Vision: Duncan Campbell Scott and the Administration of Indian Affairs*. Vancouver: UBC Press, 1986.

Tobin, Beth Fowkes. "Cultural Cross-Dressing in British America." In *Picturing Imperial Power: Colonial Subjects in Eighteenth-Century British Painting*, 81-109. Durham: Duke University Press, 1999.

—. *Picturing Imperial Power: Colonial Subjects in Eighteenth-Century British Painting*. Durham: Duke University Press, 1999.

Tooby, Michael. *The True North: Canadian Landscape Painting, 1896-1939*. London: Lund Humphries, 1991.

Torgovnick, Marianna. *Gone Primitive: Savage Intellects, Modern Lives*. Chicago and London: University of Chicago Press, 1990.

Town, Harold, and David Silcox. *Tom Thomson: The Silence and the Storm*. Toronto: McClelland and Stewart, 1977.

Townsend-Gault, Charlotte. "Kwakiutl Ready-Mades?" In Jessica Bradley and Lesley Johnstone, eds., *Sightlines: Reading Contemporary Canadian Art*, 144-53. Montreal: Artextes, 1994.

Traquair, Ramsay. "Montreal." *The Studio* 81, 335 (1921): 81-82.

—. "Montreal." *The Studio* 85, 361 (1923): 236-39.

Vancouver Exhibition Association. *Canada's Pacific Exhibition August 6th to 16th, 1930: Fine Art Section Catalogue*. Vancouver: Vancouver Exhibition Association, 1930.

Varnedoe, Kirk. *Northern Light: Nordic Art at the Turn of the Century*. New Haven: Yale University Press, 1988.

Vipond, M. "The Nationalist Network: English Canada's Intellectuals and Artists in the 1920s." *Canadian Review of Studies in Nationalism* 7, 1 (1980): 32-52.

Walton, Paul H. "The Group of Seven and Northern Development." *RACAR* 17, 2 (1990): 171-79.

Warnke, Martin. *Political Landscape: The Art History of Nature*. Cambridge: Harvard University Press, 1995.

Watson, Scott. "Race, Wilderness, Territory and the Origins of Modern Landscape Painting." *Semiotexte(e) Canadas* 6, 2 (1994): 93-104.

Weaver, Lawrence. "Introduction." In *Catalogue of the Palace of Arts, British Empire Exhibition*. Holborn, UK: Fleetway Press, 1924.

Weber, E. *Peasants into Frenchmen: The Modernization of Rural France, 1870-1914*. London: Chatto and Windus, 1979.

Weigle, Marta, and Barbara Babcock, eds. *The Great Southwest of the Fred Harvey Company and the Santa Fe Railway*. Phoenix: Heard Museum, 1996.

"Wembley: The Palace of Arts." *Connoisseur* 73, 237 (1925): 186.

Whitelaw, Anne. "'Whiffs of Balsam, Pine, and Spruce': Art Museums and the Production of a Canadian Aesthetic." In Jody Berland and Shelly Hornstein, eds., *Capital Culture: A Reader on Modernist Legacies, State Institutions, and the Value(s) of Art*, 123-37. Montreal and Kingston: McGill-Queen's University Press, 2000.

Williams, Carol. *Framing the West: Race, Gender, and the Photographic Frontier in the Pacific Northwest*. New York: Oxford University Press, 2003.

Wilton, Andrew, and Lyles, Anne. *The Great Age of British Watercolours, 1750-1880*. Munich: Prestel-Verlag, 1993.

Young, Robert. *Colonial Desire: Hybridity in Theory, Culture and Race*. London: Routledge, 1995.

Illustration Credits

1. A.Y. Jackson, *The Red Maple*, November 1914, oil on canvas, 82 x 99.5 cm. National Gallery of Canada, 1038, purchased 1914. Courtesy of the estate of Dr. Naomi Jackson Groves.

2 and 3. The Tom Thomson and Group of Seven room in the Canadian Section of Fine Arts at the *British Empire Exhibition*, Wembley, 1924, 23 April-24 October, 1924. Courtesy of National Gallery of Canada Library and Archives, NGC MBAC Ex 50.

4. A.Y. Jackson, *Landscape with Willows*, 1903, watercolour over graphite on wove paper, 28.3 x 39.1 cm. National Gallery of Canada, 16686, purchased 1971. Courtesy of the estate of Dr. Naomi Jackson Groves.

5. Lawren Harris, *Pines, Kempenfelt Bay*, [1921], oil on canvas, 97.6 x 112 cm. Art Gallery of Hamilton, Bequest of H.S. Southam, Esq., CMG, LL.D, 1966.

6. Lawren Harris, *First Snow, North Shore of Lake Superior*, 1923, oil on canvas, 123.4 x 153.5 cm. Collection of the Vancouver Art Gallery, Founders Trust Fund, VAG 50.4. Photograph: Jim Gorman.

7. A general view of the *Exposition d'art canadien*, Musée du Jeu de Paume, Paris, 11 April-10 May 1927. Courtesy of National Gallery of Canada Library and Archives, NGC MBAC Ex 77.

8. James Wilson Morrice section, *Exposition d'art canadien*, Musée du Jeu de Paume, Paris, 11 April-10 May 1927. Courtesy of National Gallery of Canada Library and Archives, NGC MBAC Ex 77.

9. Tom Thomson retrospective, *Exposition d'art canadien*, Musée du Jeu de Paume, Paris, 11 April-10 May 1927. Courtesy of National Gallery of Canada Library and Archives, NGC MBAC Ex 77.

10. Northwest Coast material, *Exposition d'art canadien*, Musée du Jeu de Paume, Paris, 11 April-10 May 1927. Courtesy of National Gallery of Canada Library and Archives, NGC MBAC Ex 77.

11. W. Langdon Kihn, *Curly Bear Acawyutsishe*, 1920-1925, coloured pencil, crayon, graphite on board, 63 x 49.9 cm. McCord Museum of Canadian History, Montreal, M986.84. Courtesy of the estate of Phyllis Kihn.

12. W. Langdon Kihn, *Rosie Coyote-Woman*, *"Sunktoya-wiya,"* 1922, coloured pencil and graphite, 61.2 x 48.5 cm. McCord Museum of Canadian History, Montreal, M927.101. Courtesy of the estate of Phyllis Kihn.

13. W. Langdon Kihn, *Portrait of Chief Hlengwa, Earthquake of Kitwanga Village*, 1924, coloured pencil and graphite, 110.8 x 85.3 cm. McCord Museum of Canadian History, Montreal, M927.102. Courtesy of the estate of Phyllis Kihn.

14. W. Langdon Kihn, *Solomon Harris*, 1924, watercolour on paper, 75.3 x 49.6 cm. Known elsewhere as *Lelt*. Collection of the Vancouver Art Gallery, Gift of Mr. F.N. Southam, VAG 31.114. Photograph: Tim Bonham. Courtesy of the estate of Phyllis Kihn.

15. W. Langdon Kihn, *Martha Mawlhan of Laksale, (A Woman Chief of the Raven Clan of Gitsegukla, B.C.)*, 1924, coloured pencil on paper, 100 x 75 cm. Art Gallery of Hamilton, Gift of Arthur B. Gill, 1971. Courtesy of the estate of Phyllis Kihn.

16. W. Langdon Kihn, *Mrs. Johnny Larhnitz*, 1924, pastel on paper, 85.5 x 60.5 cm. Royal Ontario Museum, 927.104.5. Courtesy of the estate of Phyllis Kihn.

17. A.Y. Jackson, *Kispiox*, 1926, graphite on wove paper, 20.4 x 25.2 cm. National Gallery of Canada, 17537, purchased 1973. Courtesy of the estate of Dr. Naomi Jackson Groves.

18. A.Y. Jackson, *Three Totem Poles, Gitsegukla*, 1926, graphite on wove paper, 25.2 x 20.4 cm. National Gallery of Canada, 17484r, purchased 1973. Courtesy of the estate of Dr. Naomi Jackson Groves.

19. A.Y. Jackson, *Indian Home, Port Essington*, 1926, graphite on wove paper, 14.5 x 22.7 cm. National Gallery of Canada, 17486, purchased 1973. Courtesy of the estate of Dr. Naomi Jackson Groves.

20. A.Y. Jackson, *First Sketch for "Indian House,"* 1926, graphite on wove paper, 14.5 x 22.7 cm. National Gallery of Canada, 17475, purchased 1973. Courtesy of the estate of Dr. Naomi Jackson Groves.

21, 22, and 23. *Exhibition of Canadian West Coast Art Native and Modern*, National Gallery of Canada, Ottawa, 1927. Courtesy of National Gallery of Canada Library and Archives, NGC MBAC Ex 0085.

24. W. Langdon Kihn, *Alimlahi Waudee of Kisgahast*, 1925, coloured pencil on tinted board, 54.3 x 41.7 cm. McCord Museum of Canadian History, Montreal, M928.81. Courtesy of the estate of Phyllis Kihn.

25. W. Langdon Kihn, *Hanamuh Kisgahast of Kitsegukla*, 1924, coloured pencil, gold metallic paint, silver metallic paint, ink on tinted board, 54.3 x 41.6 cm. Depicting Sunbeams/Fanny Johnson. McCord Museum of Canadian History, Montreal, M928.78. Courtesy of the estate of Phyllis Kihn.

Index

Note: Page numbers in **bold** refer to figures